OBJECTS OF MYTH AND MEMORY

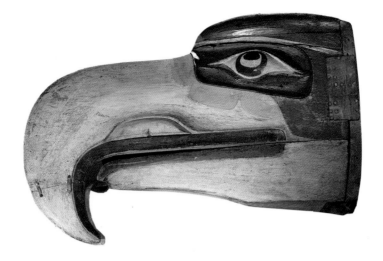

*American
Indian Art
at The
Brooklyn
Museum*

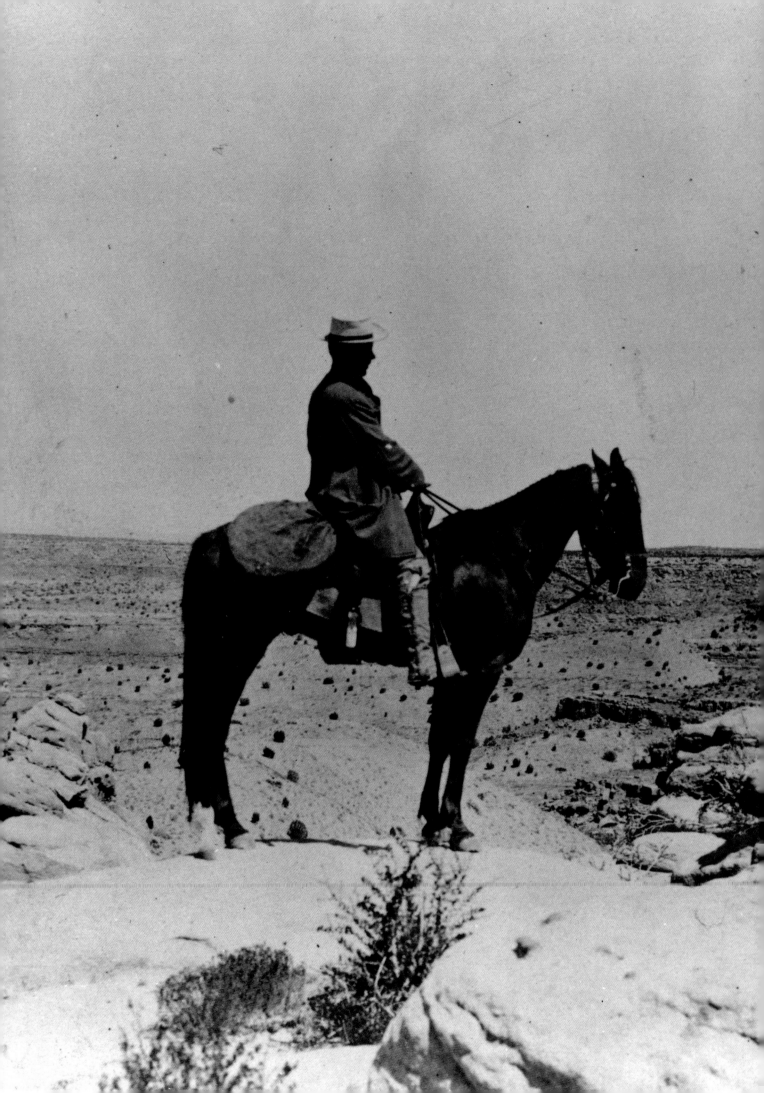

OBJECTS
OF
MYTH
AND
MEMORY

American Indian Art at The Brooklyn Museum

DIANA FANE

IRA JACKNIS

LISE M. BREEN

The Brooklyn Museum
in association with
University of Washington Press

Exhibition Itinerary

THE BROOKLYN MUSEUM
 October 4–December 30, 1991

THE OAKLAND MUSEUM
 February–May 1992

THE HEARD MUSEUM, Phoenix
 October 1992–January 1993

This publication was organized at The Brooklyn Museum by Rena Zurofsky,
Vice Director for Marketing, and Elaine Koss, Assistant Director for Publications.
Editor: Joanna Ekman
Designer: Dana Levy, Perpetua Press.

This exhibition and catalogue were made possible with the generous support of The
Luce Fund for Scholarship in American Art, a program of The Henry Luce Foundation,
Inc.; the Rockefeller Foundation; and the National Endowment for the Humanities and
the National Endowment for the Arts, federal agencies. Additional support for the cata-
logue was provided by the B. Gerald Cantor Art Foundation and The Andrew W.
Mellon Foundation.

PHOTOGRAPHER: JUSTIN KERR

Library of Congress
Cataloging-in-Publication Data

Fane, Diana.
 Objects of myth and memory : Ameri-
can Indian art at the Brooklyn Museum /
Diana Fane, Ira Jacknis, Lise M. Breen.
 p. cm.
 Catalog of an exhibition held at the
Brooklyn Museum, Oct. 4–Dec. 30, 1991.
 Includes bibliographical references.
 ISBN 0-87273-122-7 soft cover
 ISBN 0-295-97023-5 hardcover
 ·1. Indians of North America—Art—
Exhibitions. 2. Indians of North America—
Antiquities—Exhibitions. 3. United
States—Antiquities—Exhibitions. 4.
Brooklyn Museum—Exhibitions. 5. Culin,
Stewart, 1858–1929—Art collections.
I. Jacknis, Ira. II. Breen, Lise M.
III. Brooklyn Museum. IV. Title.
E98.A7F36 1991
973.1—dc20 89-13356
 CIP

*FRONTISPIECE: Stewart Culin, The Brooklyn
Museum's first Curator of Ethnology, on a field
trip to the Southwest. Photograph from 1901
expedition report.*

COVER: Kachina Doll. Zuni (No. 80)
BACK COVER: Peyote Rattle. Osage (No. 318)

Contents

6
Foreword

8
Preface and Acknowledgments

11
Notes to the Catalogue

13
The Language of Things:
Stewart Culin as Collector
Diana Fane

29
The Road to Beauty:
Stewart Culin's American Indian Exhibitions at The Brooklyn Museum
Ira Jacknis

45
The Southwest
Diana Fane
Southwest Catalogue Entries

161
California
Ira Jacknis
California Catalogue Entries

233
The Northwest Coast
Ira Jacknis
Northwest Coast Catalogue Entries

281
The Osage of Oklahoma
Lise M. Breen
Osage Catalogue Entries

308
Notes

313
References Cited

317
Index

320
Photograph Credits

Foreword

Throughout this century The Brooklyn Museum has played a major role in presenting and interpreting American Indian art. Its commitment to this field began in 1903, when R. Stewart Culin was appointed curator of the newly created Department of Ethnology. Convinced that the department should rely on its own expeditions for exhibition material, Culin set out across the country in search of "valuable and representative" collections of Indian artifacts. By 1912 he had acquired and installed more than 9,000 objects in the Hall of American Ethnology.

When in the early 1930s the department's focus switched from ethnology to art, Culin's collection proved to be a rich resource for masterworks; it has been the basis for all subsequent installations of Native American art at The Brooklyn Museum. Culin's acquisitions have also been selected for most of the national and international exhibitions of American Indian art, including the Exposition of Indian Tribal Arts held in New York in 1931 and Frederic H. Douglas and René d'Harnoncourt's pioneer exhibition *Indian Art of the United States* at The Museum of Modern Art, New York, in 1941.

In 1984 a grant from the National Science Foundation supported the first comprehensive inventory of this great early collection and its associated documentation. This catalogue and exhibition are based on a critical evaluation of the collection as a whole and extensive research in Culin's papers and annual expedition reports. Organized as a narrative of collecting, *Objects of Myth and Memory* includes more than 300 objects with information on the social and economic context in which they were acquired. Individual artists, vendors, interpreters, and guides who worked with Culin in the field are identified and their role in the formation of the collection is described. In making this hitherto unpublished documentation available, we hope to enhance the public's understanding of a vital part of our national artistic heritage.

Diana Fane, Curator of African, Oceanic, and New World Art, has been responsible for the conception and direction of this project from its start. She has also written the essay on Culin as a collector and the Southwest portion of the catalogue. Ms. Fane has been ably assisted by Dr. Ira Jacknis, an anthropologist, whose interest in Culin dates to 1984, when he participated in the NSF inventory. Dr. Jacknis has provided a valuable anthropological perspective on the collection and has written a substantial portion of the catalogue, including the Northwest Coast and California

sections. Lise M. Breen's contribution to the project also started with the NSF inventory. In addition she researched Culin's later career in the Museum's archives. Her familiarity with the collection as a whole has greatly facilitated the planning of the exhibition. Ms. Breen wrote the Osage section of the catalogue and some of the Southwest entries.

A generous grant from The Luce Fund for Scholarship in American Art allowed Museum staff to collaborate with outside scholars on the research and writing of this catalogue. We are extremely grateful to this program of The Henry Luce Foundation, Inc. for its support. We would also like to acknowledge the contribution of the Rockefeller Foundation, which provided funds for the project staff to travel and consult with regional specialists on various aspects of the catalogue and exhibition. The publication has been made possible with the generous support of the B. Gerald Cantor Art Foundation and The Andrew W. Mellon Foundation. Finally, we would like to express our appreciation to the National Endowment for the Humanities and the National Endowment for the Arts, whose support has been fundamental to the realization of the exhibition.

ROBERT T. BUCK
DIRECTOR
THE BROOKLYN MUSEUM

Preface and Acknowledgments

This catalogue and the exhibition it accompanies are the culmination of more than seven years' research and planning involving many different individuals and departments within The Brooklyn Museum as well as colleagues and consultants across the country. From the start, the primary goal of the project has been to make the extensive North American Indian collection that Stewart Culin assembled in the first decade of this century more accessible and better known to both scholars and the general public. We are extremely grateful to the National Science Foundation for supporting an inventory and improved storage of the entire collection and to Jean Wagner and Helen Hubbard Marr, who assisted us with this essential first step. As NSF Research Associates, they went far beyond the requirements of the inventory, enthusiastically undertaking additional detective work to decipher an incomplete number or to reunite parts of a set and alerting us to exceptional pieces.

Although the inventory confirmed that the collection was essentially intact, there had been some losses. Over the years small lots from various regions had been deaccessioned or exchanged with other institutions; other objects, such as the tule sandals that Culin discusses in detail in his expedition report, have not been located. Some of Culin's documentation is missing, most notably the original catalogue cards for the Osage collection. There are also imbalances in the documentation of the different regions. Culin lectured on the Southwest and wrote a series of fictional accounts of collecting in New Mexico and Arizona. Equivalent personal and interpretive material does not exist for the other areas.

The Luce Fund for Scholarship in American Art supported the initial catalogue research and manuscript preparation. Matching the objects with Culin's daily entries in his expedition reports was a demanding but extremely rewarding task. The relationship between object and collecting story proved to be complex and unpredictable; rich narratives adhered to sticks and stones as well as to ceremonial regalia. In the process of reevaluating Culin's collection, we inevitably reevaluated our own preconceptions about American Indian art and history.

At a critical point in the development of the exhibition's themes, the Rockefeller Foundation provided funds for travel to the sites of Culin's collecting. This gave us an opportunity to compare Culin's acquisitions with the best regional collections and to exchange information with

curators, collectors, and artists concerned with the preservation and presentation of Native American artistic traditions. Individuals who responded enthusiastically to our questions and suggested new avenues for research include the following:

The Southwest: Lynn Brittner of the School of American Research, Santa Fe; Bruce Bernstein of The Wheelwright Museum of the American Indian, Santa Fe; Michael Andrews of Saint Michaels, Arizona; Harry Walters of the Ned A. Hatathli Cultural Center Museum, Tsaile, Arizona; Richard Hart of the Institute of the North American West, Albuquerque; Joe Dishta, Alex Seowtewa, Rose Wyaco, and the members of the Zuni Tribal Council in Zuni; Bernard Fontana of the University of Arizona, Tucson.

The Northwest Coast: Peter Macnair, Alan Hoover, Richard Inglis, and Dan Savard of the Royal British Columbia Museum, Victoria; G.A. (Bud) Mintz of Vancouver.

California: Suzanne Abel-Vidor and Sandra Metzler of the Grace Hudson Museum & the Sun House, Ukiah; Lee Davis, Lawrence Dawson, and Coleen J. Kelley of the Robert H. Lowie Museum of Anthropology, University of California, Berkeley; Sheila O'Neill of the Bancroft Library, University of California, Berkeley.

Exhibition planning was supported by a generous grant from the National Endowment for the Humanities, which allowed us to consult with the following regional specialists: Bill Holm, Thomas Burke Memorial Washington State Museum, University of Washington, Seattle; Craig Bates, The Yosemite Museum, Yosemite National Park; Sally McLendon, Hunter College, New York; Edmund Ladd, Museum of Indian Arts and Culture, Museum of New Mexico, Santa Fe; and James Faris, University of Connecticut, Storrs. Each of these individuals spent several days at The Brooklyn Museum reviewing the collection and its documentation, including Culin's original catalogue cards and expedition reports. In addition to evaluating the cultural and historical significance of the objects, the consultants identified materials and techniques and advised us on the display and interpretation of ceremonial materials. They also directed our attention to comparable pieces in other collections and read and commented on the regional essays and catalogue entries.

The NEH grant also funded a conservation review of the preliminary checklist. As Conservation Assistant, Carol Brynjolfson (under the supervision of Ellen Pearlstein, Conservator) examined and wrote reports on more than 600 objects and responded to research questions about materials and techniques. The information from her meticulous reports has been incorporated into the catalogue entries. In addition, Dale Kronkright of the Pacific Regional Conservation Center, Honolulu, examined the baskets, and Christine Giuntini of The Metropolitan Museum of Art, New York, reviewed the textiles.

In making our final selection of the objects for this publication and exhibition, we were guided by the following criteria: a desire to "represent" the collection fairly in terms of its relative strengths and diversity of artifacts; an equal desire to "represent" the collecting process; and the goal of displaying the finest pieces. In writing the catalogue entries we have relied primarily on Culin's own observations and comments and on the work of his contemporaries in the field.

Although all major exhibitions tax the resources of the institution, *Objects of Myth and Memory*, drawn exclusively from the permanent collections, has required an unusual degree of collaboration within the Museum. We are grateful to the following departmental staff and interns, past and present, for general assistance in organizing and researching the Culin

materials: Maria Manzari Cohen, Anne D'Alleva, Arlene Davila, Mary Ann Durgin, Ellen Kuenzel, Dita Moore, David Penney, Julie Pomerantz, Margaret Reid, and Diana Schlesinger.

Throughout the project, Roy Eddey, Deputy Director, Linda Ferber, Chief Curator, and Ken Moser, Chief Conservator, have provided direction and encouragement. Barbara La Salle, Registrar from 1963 to 1989, was an invaluable guide to the history of the collection at the Museum. We have also relied on the following individuals' knowledge and expertise: Ellen Pearlstein, Conservator; Beverly Perkins, Assistant Conservator; Cathryn Anders, Collections Manager; David Horak, Principal Art Handler; Jeffrey Strean, Chief Exhibition Designer; Rena Zurofsky, Vice Director for Marketing Services; Elaine Koss, Assistant Director for Publications; Karen Putnam, Vice Director for Development; Eileen Lenahan, Manager for Government Grants; Deborah Schwartz, Vice Director for Education; Missy Sullivan, Manager, Public Programs and Media; Dara Meyers-Kingsley, Film Coordinator; Sonnet Takahisa, Manager of School, Youth, and Family Programs; Dierdre E. Lawrence, Principal Librarian; Deborah Wythe, Archivist; Elizabeth Reynolds, Registrar; and Terri O'Hara, Assistant Registrar.

For sensitive editing of a complex manuscript, we are indebted to Joanna Ekman. Her critical reading of the text and constructive suggestions have greatly improved this catalogue. We would also like to express our gratitude to Barbara and Justin Kerr for the excellent catalogue photography.

Many different exhibitions could be organized from this rich corpus of material, expressing as many different points of view. We hope that this exhibition and catalogue will open Culin's collection up to further research and interpretation.

DIANA FANE
IRA JACKNIS
LISE M. BREEN

Notes to the Catalogue

The catalogue sections have been arranged in keeping with this volume's emphasis on Culin's documentation. The four sections correspond to the main regions of Culin's collecting. Within each section, entries are grouped to reflect time and place of acquisition first and medium or function second. Culin's cultural attributions have been used throughout, and precise collection dates have been given in lieu of general attributions such as "late 19th/20th century."

In the catalogue entries, statements attributed to National Endowment for the Humanities consultants are based on conversations with the authors between November 1988 and October 1989. Dimensions for objects are given in inches, and unless otherwise indicated, credit line is Museum Expedition, date, Museum Collection Funds. Throughout, citations for material quoted from Culin's expedition reports are given in the text, enclosed in parentheses: e.g. (1902a:225).

BROOKLYN INSTITUTE MUSEUM

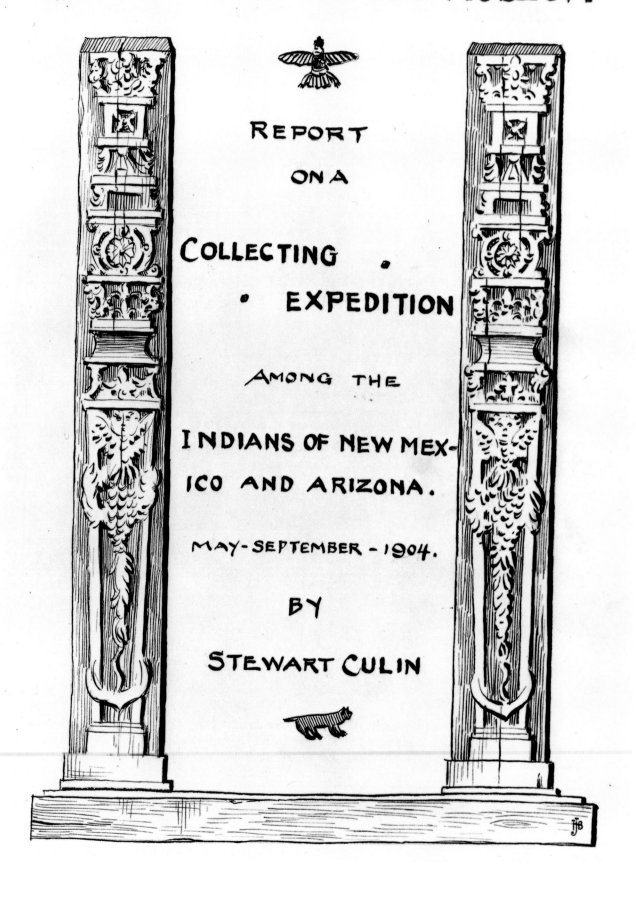

REPORT

ON A

COLLECTING

EXPEDITION

AMONG THE

INDIANS OF NEW MEX-
ICO AND ARIZONA.

MAY - SEPTEMBER - 1904.

BY

STEWART CULIN

The Language of Things

Stewart Culin as Collector

Diana Fane

ON FEBRUARY 18, 1903, the *Brooklyn Daily Eagle* announced that the museum of The Brooklyn Institute of Arts and Sciences (now The Brooklyn Museum) was about to embark on a new era "building up great ethnological collections, sending out expeditions for acquiring of antiquities, first over all America, then over the entire world." The man selected to head up this ambitious program of global collecting was R. Stewart Culin, formerly of the Museum of the University of Pennsylvania in Philadelphia.

According to the article, Culin's credentials were somewhat unconventional: "True tales, well authenticated by scientific men, are related of Mr. Culin—who is not to be spoken of [as] Dr. Culin, coming from no university, possessing no degree—and the wonderful way he manages to pick up valuable objects." His talents included the ability to attract wealthy patrons, to buy rare and curious things for very little money, and to ingratiate himself with natives so that "liking him they give him object after object where another man would get nothing."[1]

Although he was self-taught, Culin was not without impressive professional experience and connections. In fact, as a review of his background shows, he had played a leading role in the development of museum ethnology during the last decade of the nineteenth century. In addition, he was a "born" collector with a seemingly insatiable curiosity about cultural artifacts of all kinds. Given the Brooklyn Institute's stated goals, he was unquestionably the right man for the job.

The Philadelphia Years, 1858–1903

In a brief appreciation written in 1913, George A. Dorsey, curator of anthropology at the Field Columbian Museum of natural history in Chicago, confessed that he could not think of Culin as "having been born, or having had the measles, or childhood." Instead of associating his longtime friend with any such mundane events, Dorsey imagined him as "always Culin, always a sage, always a philosopher, and always a perpetual youth."[2] Culin would have had no trouble recognizing himself in Dorsey's description; it is very much the way he presented himself in interviews with the press. His reticence about his family life and early education is all the more striking in view of the fact that he maintained scrapbooks and diaries—forms of record keeping usually associated with personal memo-

Drawing by Herbert B. Judy of the pilasters from the church in Zuni. Frontispiece of 1904 expedition report.

Fig. 1. R. Stewart Culin (1858–1929)

ries and revelations. Significantly, Culin's scrapbooks and diaries exclusively concern his professional interests and field trips. As a result it is difficult to consider the man apart from his work.

Our knowledge of Culin's childhood is limited to a few names and dates. A twin, he was born on July 13, 1858, in Philadelphia, where his father, John Culin, was a merchant. Culin appears to have been a good student in high school, but there is no indication that he ever was interested in a university education; upon graduation he entered his father's mercantile business. Practically nothing is known of the next period of his life until the late 1880s, when he suddenly emerged as an expert on the Chinese in America with the publication of a series of articles on their games, religious ceremonies, medical practices, and secret societies.[3]

How did he get from the merchant business to ethnology? By Culin's own account, written many years later, he

> fell under the spell of a problem which involved a knowledge of the Chinese language. It was…the elucidation of the origin of the Chinese game which recently has become widely known and popular under the name of mahjongg. I might have gone to school and taken lessons from a professor. Instead I went to live in one of our Chinese settlements, where in time I came not only to speak the language but, eager and curious, saturated myself with the spirit of these interesting and capable people. It was the direct road to what I wanted to accomplish and I acquired a knowledge of the Chinese that has lasted with me to this day.[4]

We should be cautious about accepting Culin's rather self-congratulatory recollection as the whole truth,[5] but a review of his articles shows that he certainly did rely on firsthand experience and direct observation rather than library research. In order to learn more about Chinese materia medica, he consulted a local Chinese doctor about his cold and used the prescription he received as the basis for his first article, "The Practice of Medicine by the Chinese in America" (1887a). In another study of Chinese medicine, he took the point of view of the clerk behind the counter in a drugstore and traced every step in filling a prescription from the processing (slicing, grinding, mixing) of the raw materials through the weighing, packaging, and sale of the medicine to the customer. The clerks' knowledge, Culin observed, "is derived almost entirely from experience, no books on the subject being used or studied by them."[6] Embarking on his own innovative research into various aspects of the Chinese community, Culin must have felt a degree of sympathy with these clerks.

Culin soon added collecting to experience as a method of inquiry. "There is no way one can become so well acquainted with things as in the process of buying them," he observed,[7] thereby giving his acquisitive spirit free reign in the name of scientific investigation. All the objects used to illustrate his paper "The Gambling Games of the Chinese in America" (1891) belonged to him. Presumably his career as a merchant fostered this passion for shopping and provided him with the necessary negotiating skills and ready access to a wide range of goods from various parts of the world.

In addition to Culin's published articles and personal collection, two remarkable scrapbooks containing clippings dating from 1882 to 1888 document his interest in Philadelphia's Chinese community.[8] They include newspaper articles about legal cases; vicious political cartoons; New Year's cards (some made expressly for Culin); business cards; advertisements (Fig. 2); and announcements of public events. With each item carefully labeled, these scrapbooks provide a fascinating record of an immigrant community in the late nineteenth century and testify to Culin's meticulous record keeping.

本店自製藥水功效如神山附等症
內店傷發冷惡毒浮腫生瘋生㾣瘋濕
滋陰補氣補血暑暈大概除症不盡
録俱皆應騐凡男子飲食始食壹池
美每日三次隨次暫進如小童興及
女人隨次飲少恐飲之後問有效
猛皮膚浮澁亦無防遲三幾天再食
全愈此藥水体告中外藥材硝寄賣
紐約棋畤十三街六號東路門牌壹百五七三噂謹啟

Fig. 2. Advertisement from Culin's scrapbook taken from a telegraph pole on Mott Street on September 26, 1885. Culin noted in the scrapbook that the public notices of the Chinese were usually fastened on this pole.

The premise underlying Culin's Chinese research was that folk customs survived, even in the inhospitable conditions of the modern city. "I feel assured," he wrote, "there is more folk-lore to be gleaned from any one of the...Chinamen we see shambling about our streets than could be collected among our entire native population."[9] The key word here is "gleaned," indicating a search of scattered and unlikely sources. This was precisely the ability Culin prided himself on. He found his clues in the objects academic scholars had overlooked or taken for granted—games, medicines, and toys—and delighted in playing "that illusive [*sic*] and engrossing game of hunting the origin of familiar things."[10] If he managed to overturn the conventional ideas on the subject, so much the better. All the hallmarks of Culin's mature style of ethnographic research are present in his early work: having selected the "direct road" at the start of his career, he never abandoned it. There are also hints of the future museum curator in his constant attention to, and acquisition of, objects.

Philadelphia at this time was in many ways an ideal place for a young man with Culin's interests to educate himself.[11] The intellectual life of the city was rich and varied, with numerous amateur and professional societies open to serious students. In 1883 Culin became the recording secretary for the Numismatic and Antiquarian Society of Philadelphia, and in 1888 he founded the Oriental Club. He was a founding member of the American Folk-Lore Society (and its president in 1897) and, in 1902, of the American Anthropological Association. Other important affiliations were with the American Philosophical Society and the American Association for the Advancement of Science. Culin did not limit his memberships to scientific organizations or to the city of Philadelphia. He joined the Contemporary Club of Philadelphia and the Salmagundi Club of New York City. He was on friendly terms with several Philadelphia artists, including Thomas Eakins. In the Pennsylvania Academy's Annual Exhibition in 1901, Eakins exhibited a life-size portrait of Culin entitled *The Archaeologist*.[12]

Local scientific societies were central to the practice of anthropology in Philadelphia in the last quarter of the nineteenth century.[13] Through his participation in them, Culin met the renowned Americanist Daniel Brinton (1837–1899), who became his mentor and guide to the study of Native American language and mythology. As the first university professor of anthropology in the United States, Brinton bridged the transition "from the scholarly society to the specifically anthropological institution in which full-time professional employment was possible."[14] His support of Culin assured the young businessman a role in the growing professionalism of American anthropology.

In 1890 both Culin and Brinton were elected members of the Board of Managers of the newly created Museum of the University of Pennsylvania. Through this honorary position, Culin was encouraged to extend his research beyond the Chinese community and was introduced to the complex and challenging world of the museum.

The year 1892 was decisive for Culin in terms of his status as a professional and his national and international reputation. In quick succession, he organized a major loan exhibition of objects used in religious ceremonies, became the director of the Museum of the University of Pennsylvania,[15] and took charge of the museum's contribution to the Columbian Historical Exposition in Madrid. He also agreed to head a section on "Folk Lore and Primitive Religions" for the World's Columbian Exposition in Chicago in 1893. Abandoning his "mercantile interests,"[16] Culin devoted himself full-time to his new responsibilities.

The exhibition Culin organized for the Chicago World's Fair consolidated his fame as an ethnologist and linked his name to the subject with

which he is still most closely associated today: games (see Fig. 3). Instead of trying to cover all aspects of folklore and religion, Culin chose to focus on games "as they have developed and trace them around the entire world."[17] In his display (Fig. 4) he arranged the games in an orderly sequence to illustrate the progression from the sacred to the secular. "One of the neatest stories in his showcase," a popular guide noted, "is the evolution of playing-cards from dice, and of dice from the knuckle-bones of sheep."[18]

The Chicago fair brought many of the leading ethnologists together and provided a forum for the exchange of information and artifacts. Culin participated at every level—as collector, exhibitor, practicing ethnologist (duly noting the death rites of the Javanese when "several of their little company" died unexpectedly),[19] and critic. Among the exhibitions he singled out for praise was a group of life-size effigies of the participants in a Zuni ceremonial, arranged under the direction of William H. Holmes and Frank Hamilton Cushing. "The details of this group," wrote Culin, "were represented with a fidelity which has never been equalled."[20]

Fidelity, or authenticity, was a quality that Cushing (1857–1900), the pioneer ethnologist who had lived among the Zuni from 1879 to 1884, invariably conveyed in his public appearances. He often dressed in Indian costume (Fig. 5), sang Indian songs, and recited Indian stories and myths. According to John Wesley Powell, the director of the Smithsonian's Bureau of American Ethnology (BAE), "there was nothing that a Zuni could make that [Cushing] could not reproduce with greater skill."[21] Culin had first met Cushing in Washington, where he was employed by the BAE, the national center for American Indian studies. The two men, only a year apart in age, had much in common, including a lack of formal education. They soon discovered a mutual interest in games and planned an ambitious comparative study of the games of the Old and New worlds.

This project formed the basis of an intense intellectual friendship between Cushing and Culin that lasted until Cushing's premature death in 1900. From Washington, Cushing provided inspiration, encouragement, and, most important, examples of games and arrows, many made with his

Fig. 4. *University of Pennsylvania's exhibit at the Chicago World's Fair, 1893. Culin's folklore exhibit was installed in the horizontal cases.*

own hands (Fig. 6). In addition, he sent drawings that graphically demonstrated the sacred and divinatory origins of certain gaming pieces (Fig. 7). In Philadelphia, Culin began to assemble a representative collection of Indian games and expert accounts of the rules for playing them, relying primarily on the contacts he had made at the Chicago fair such as George A. Dorsey, the Harvard-trained anthropologist who became the curator of anthropology at the Field Museum in 1897.

By 1895 it was clear that Cushing's chronic health problems and other commitments made it impossible for him to co-author a book. Culin went ahead and published his half of the project, a comprehensive study of Korean games, in a lavishly illustrated limited edition. Two years later he selected "American Indian Games" as the topic for his presidential address to the American Folk-Lore Society in Baltimore. Gradually, with Cushing's encouragement, Culin took the subject as his own and in 1907, seven years after Cushing's death, his massive *Games of the North American Indians* was published in the BAE's Twenty-fourth Annual Report. It proved to be his most substantial scholarly work and is still a standard reference on the subject.[22]

Games of the North American Indians shows Culin's extraordinary diligence in gathering evidence to support the ideas he and Cushing had spent years discussing. Not comfortable with writing a theoretical text, Culin assembled masses of examples that could speak for themselves. He drew on the collections of all the leading ethnological museums and obtained field photographs and drawings wherever artifactual evidence was lacking. Like his early Chinese scrapbooks, Culin's book on American Indian games allows us to observe him mastering a subject, and it is clear that collecting—of data, descriptions, and photographs, as well as objects—was both his primary research method and his main goal.

In 1900, with his first field trip for the Museum of the University of Pennsylvania, Culin embarked on a new phase in his career. For once, he did not strike out on his own, but went in the company of George Dorsey, who "had had much experience in field collecting" (1901a:1). The trip was a

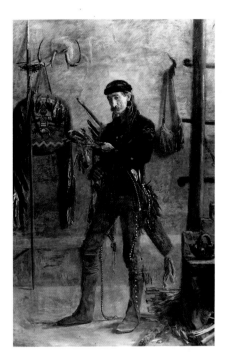

Fig. 5. Frank Hamilton Cushing, *by Thomas Eakins, 1895. Oil on canvas, 90 x 60 inches. The Thomas Gilcrease Institute of American History and Art, Tulsa, Oklahoma.*

whirlwind tour of Indian reservations, an itinerary that Dorsey, a man of prodigious energy and ambition, favored because it allowed him to buy faster than anyone else. Culin's travel expenses and purchases of more than two thousand objects were supported by John Wanamaker, Philadelphia's department-store magnate and a patron of the museum's American collections.

Wanamaker also funded Culin's second museum expedition, to Cuba in 1901. By now a seasoned field worker, Culin went alone, rushing off in response to the news that a tribe of wild Indians had been discovered living in the mountains of the eastern part of the island. The rumor proved to be false, but Culin nevertheless managed to assemble a small collection that included water jars imported from Spain as well as snail shells "used as playthings by children" (1902a:225).

On two final field trips Culin made for the Museum of the University of Pennsylvania in 1901 (see Fig. 8) and 1902, he concentrated on the Southwest, acquiring collections he ranked "at least fourth among the Museums of the entire world."[23] These trips gave Culin new material to install at the museum and exciting topics for lectures and articles.[24] An accomplished self-publicist from the start of his ethnological career (the press followed his Chinese research with interest and admiration), he soon attracted headlines that stressed the sensational over the scientific; "Strange Rites Transmitted to the Young by means of Curiously wrought Dolls," for example, introduced an article on the kachina cult of the Southwest.[25] Culin was proud of his flair for publicity and used it as a means of soliciting private funds to support his curatorial program.

Within the museum, where Culin had a long history of problems with the administration, his fieldwork provided ammunition for his enemies. According to one newspaper reporter (whose statement was later cautiously retracted), Culin was "accused of incompetency, and it was said that his expensive trips in this country and abroad had been productive of little good: that his specimens had to be deciphered and classified by others and that everything he wrote had to be revised and edited by his secretary."[26] Culin was simply moving too fast for the conservative members of the Board of Trustees. They were not ready to see the museum expand at the rate required by his acquisitions, nor did they approve of his excited rhetoric, especially when it was echoed by the press. In January 1903, the incumbent trustees defeated the alternative ticket Culin proposed and demanded his resignation.

The timing could not have been better for the museum of The Brooklyn Institute of Arts and Sciences, whose director, Franklin W. Hooper, envisioned an institution where "it should be possible to read the history of the world."[27] A section of the grand new building designed by McKim, Mead & White had opened in 1897 (Fig. 9), and construction on another wing was well under way. There was room for a man with Culin's proven collecting skills and broad interests. On February 13, 1903, at a meeting of the Board of Trustees, the Institute voted unanimously to establish the Department of Ethnology and selected Culin as its first curator.

The implications of the appointment were not lost on the anthropological establishment. In an interview with the press a few months later, Franz Boas of the American Museum of Natural History in New York reviewed the history of ethnological collecting in America and named "the seven or eight great collections" in the country. "The Brooklyn Institute to be" was among the institutions on his list.[28]

In Pursuit of the Vanishing Indian

Culin was in an enviable position at Brooklyn. The department was new, the museum was expanding, and expedition funds were guaranteed.

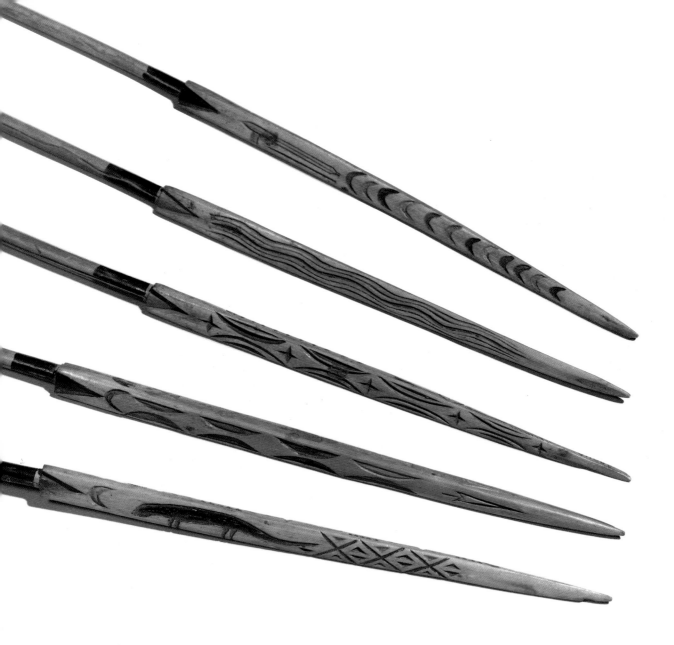

Fig. 6. Kiowa arrows made by F. H. Cushing. Wood, feathers, fiber, pigment, L. 26½ inches. The Brooklyn Museum, 30.780.1–6, Estate of Stewart Culin, Museum Purchase.

Anything seemed possible. For several reasons he made an American Indian collection his top priority. First, he considered the field "of the greatest scientific importance as well as general interest."[29] Second, he was already familiar with it. Through his research on games and collecting trips for the Museum of the University of Pennsylvania, he had met ethnologists, missionaries, and traders throughout the country. These were valuable contacts, as he explained to the director in a letter reviewing his plans for his initial expedition for Brooklyn: "The success of the trip I have proposed to you depends very largely upon the personal relations of your representative with the people of the region. As a rule they are extremely generous and objects which money would not purchase can often be obtained as gifts."[30] Finally, and most important, he was convinced that the supply of valuable Indian objects was dwindling and would soon be gone. Returning from his first continental collecting trip for the Philadelphia museum in 1900, he had announced to the press: "If our museums are ever to have good collections of Indian things they must waste no time in setting out after them, for none will be left ten years from now." "There are," he added ominously, "no real Indians among the young."[31]

In evoking the specter of the "vanishing Indian," Culin was very much a man of his discipline and his times. Nineteenth-century ethnology was "built on the assumption of Indian decay,"[32] and the theme of a dying race pervaded the art and literature of the period as well. Because the conviction

that the Indian had no future played such a determinative role in Culin's collecting, it is worth considering its origins and implications in greater detail.

By the second half of the nineteenth century native cultures all over the world appeared to be in decline. The situation in America was particularly acute. Not only had warfare and disease decimated Indian populations, but the government was determined to "civilize" the tribes that remained. The "Indian-as-savage," as Culin observed to a museum trustee in Philadelphia, was "soon to disappear."[33]

Mixing grim statistics about the future with nostalgia for the past, the rhetoric of the vanishing Indian was well established by the mid-1800s. The common concern of artists, writers, and men of science was not the Indian, but his "unwritten" history; the variables were the timetable (every speaker situated himself just before the end) and the solution proposed. In 1832, for example, the artist George Catlin (1796–1872) chose "literal and graphic delineation" as the most effective means of "lending a hand to a dying nation, who have no historians or biographers of their own to pourtray [*sic*] with fidelity their native looks and history; thus snatching from a hasty oblivion what could be saved for the benefit of posterity."[34]

Beginning with the Centennial Exposition in Philadelphia in 1876, ethnologists turned to collecting as a means of salvaging an Indian

Fig. 8. A Hopi at the door of the cabin where Culin stayed on Second Mesa, Arizona, in 1901. Photograph from 1901 expedition report. The Hopi from neighboring villages rode up on burros to trade with Culin.

heritage. O. T. Mason, who later became the first curator of ethnology in the Smithsonian Institution's U.S. National Museum, justified the Philadelphia project as follows: "The fact that the monuments of the past and the savage tribes of men are rapidly disappearing from our continent, and that, ere another century will renew an incentive so great and universal as this Exposition, they will have disappeared forever, should be all the stimulus required to give to the enterprise the conscientious labor which it demands."[35]

What was new with the Philadelphia Exposition was not the interest in Indian things, but the approach to collecting that the prospect of a vanishing race inspired. Previously traders, missionaries, and military men had acquired Indian artifacts for a variety of reasons ranging from outright aggression to idle curiosity. Nathan Sturgis Jarvis, a surgeon stationed in the 1830s at Fort Snelling, Minnesota, for example, "amused" himself "making a collection of the dresses, arms, and domestic implements of the various tribes of Indians inhabiting those distant regions."[36] Primarily considered personal "souvenirs" of exotic encounters, such collections were haphazardly stored and rarely exhibited. The Jarvis collection, deposited in the New-York Historical Society in 1848, remained, for the most part, in storage until 1937, when it was transferred as a loan to The Brooklyn Museum, where it is now part of the permanent collection.

In brief, the collecting of American Indian artifacts before the last quarter of the nineteenth century had been frankly subjective, necessarily fragmentary, and mildly diverting—an incidental result of warfare, colonization, and adventure on the American frontier. Beginning with the Philadelphia Exposition, museum-sponsored collecting expeditions reversed this pattern. Systematic collections were "gathered for a specific purpose and according to a definitive plan, which would make them representative of the material culture of a native society."[37] It was no longer sufficient for Indian things to surprise or entertain: they had to work in unison to create an authoritative account of Indian cultures before contact. Subsequently, exhibitions became the main medium for presenting the story of America's aboriginal race to the general public. With characteristic eloquence, Cushing summed up the challenge the first generation of museum ethnologists faced in the late nineteenth century: "Ours is a New World where things speak as in time primaeval, and our museums become books and histories or should become so, for the History of Man in America is, thank heaven, a natural history and an unwritten one!"[38]

Culin worked within this tradition of systematic ethnological collecting. His twin goals for Brooklyn's American Indian collection were that it be representative and complete. Committed to telling the whole story, he was convinced that he could discover it in the remnants and recollections of a vanishing race:

> America presents to the ethnologist a most fertile field. He finds here not only the graves of the remote dead with their relics of bone and stone, but numerous tribes of their direct descendants, who, whatever may be their present condition and mode of life, are able, at least, to recall traditions of the past, and who retain a more or less perfect knowledge of their ancient arts and industries (1904b:2).

Culin in the Field, 1903–11

As the historian Douglas Cole has pointed out in his review of anthropological collecting, "The race against time was also a race against museum rivals."[39] In setting out for the field, Culin knew that he was off to a late start and that the competition was stiff. That same year, the American Museum

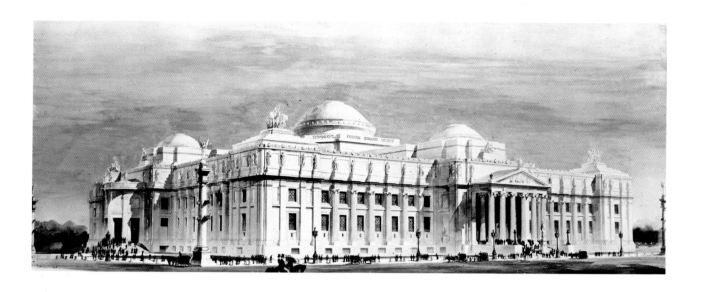

of Natural History was planning no fewer than nine expeditions to the West and Southwest. The Field Museum in Chicago already had a collection of Hopi material that, in Culin's estimation, surpassed "in extent and completeness any collections from a single tribe in any museum in the world" (1904b:10).

In addition to competition from other museums, Culin faced a number of other challenges in the field. Acculturation had rendered certain native artifacts obsolete. Most of the games that Culin had spent years studying, for example, were no longer in use. The California Indians were playing baseball(see Fig. 10) and, in New Mexico, a basketball game was on the program for the Fourth of July along with the traditional Navajo foot race (1903:107). Because intermarriage between Indians and whites (see Fig. 11) was increasingly common, domestic items and everyday dress often reflected Anglo-American influence. What Culin described as the "unifying processes of civilization" were everywhere apparent.[40]

Tourism, a booming industry in certain regions, had also brought about changes in the material culture. In his 1907 report, Culin commented on "tourists in livery teams on their way from the Snake Dance or the Grand Canyon, 'doing Zuni' " (1907a:176). The influx of vacationers encouraged trade in antiquities (see Fig. 12), raised the prices on attractive "collectibles" such as California baskets and Navajo textiles, and fostered the production of cheap souvenirs.

Culin also had to contend with legal restraints imposed by both the U.S. Government (for archaeological material on federal lands) and the Indian tribes (for sacred objects). Before he left for the field, he had asked Brooklyn's director to get the necessary permissions for collecting on the Indian reservations. In spite of Hooper's assurances to the authorities in Washington that the Museum was working with "no commercial or speculative purposes, but...directly in the interest of the Science of Ethnology," the request was denied on the grounds that "the government has no right under the treaties with the Indians, to grant such permission."[41] In most Indian communities sacred and ceremonial objects were difficult to see and impossible to purchase. "The things which the scientific collector most desires," Culin had reported in 1901, "such as masks, and the paraphernalia of the dances and ceremonies, are usually the property of a society and cannot be legitimately disposed of" (1901b:18).

Authenticity was another problematic issue for Culin. The first systematic collecting expedition to the Southwest, sponsored by the BAE, had

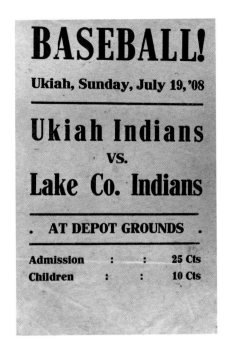

BASEBALL!

Ukiah, Sunday, July 19, '08

Ukiah Indians
vs.
Lake Co. Indians

. AT DEPOT GROUNDS .

Admission	:	:	25 Cts
Children	:	:	10 Cts

Fig. 10. Announcement of a baseball game in Ukiah, California. Flyer from 1908 expedition report.

inadvertently stimulated new industries. "At present," a rival collector reported in 1902, "the less orthodox men will manufacture almost anything the collector may desire. Spurious ancient fetishes are made by the sackful and passed off as genuine. So it is also with the masks and altars. Any number of fraudulent objects may be obtained at the prices set by the clever Indians."[42] The "vanishing" Indian was making a comeback as a purveyor of traditional goods. Collecting was not simply a matter of hastily gathering up what was there: a critical eye and a competitive strategy were necessary to assure the Brooklyn Institute a share of the spoils.

Culin proceeded with his expeditions "systematically," keeping the Hall of American Ethnology that he planned for Brooklyn foremost in his mind. In 1903 and 1904 he collected in the Southwest, emphasizing the Zuni and the Navajo so that he could contrast Pueblo and non-Pueblo cultures. By 1905 he had installed the first part of his Southwest collection. That same year he added California and the Northwest Coast to his annual itinerary in order to gather material for the hall "devoted to the ethnology of the Indians of the Pacific Coast"[43] (see "The Road to Beauty," p. 31). He continued to concentrate on these regions until 1911 when, with a final stop in Oklahoma for an Osage collection, he in essence declared the field exhausted and his collection complete. Between 1903 and 1911 Culin had selected, transported, and installed more than 9,000 American Indian artifacts. As a curator, he took great personal pride in the collection and considered it "for the tribes represented about the best in the world."[44]

After each season in the field, Culin submitted an "exhaustive illustrated typewritten report"[45] to the trustees, following a pattern he had established with his first field trip for the Museum of the University of Pennsylvania. Written in the style of a personal travel diary with daily entries, these reports went far beyond the record keeping required by the Museum or the discipline of ethnology. By nature and training incapable of keeping himself out of the picture, Culin documented the process of collecting as well as the collection itself. We can, therefore, consider Culin's actual strategies in the field in relation to his professed goals and methods.

The Language of Things: Culin on Collecting

Stewart Culin defined the "ideal" museum as one in which all the collections had been "secured in the field by the trained representatives of the museum itself." This acquisition policy ensured the vitality of things ("the fewer hands they pass through, the better") and their cultural authenticity. "Ordinary collections," he noted, "even in museums, usually reveal more of the psychology of their collector than they do of the people who originated them."[46]

Fieldwork for Culin, however, did not entail participating in Indian society or taking the Indian's point of view. This is dramatically demonstrated by an episode he recorded in his expedition report of 1903. While staying in Gallup, New Mexico, he received a Navajo suit that he had commissioned for a plaster model of a medicine man in his display (see "The Road to Beauty," p. 33). "Anxious to see how the figure would look when properly dressed," Culin put on the costume (see No. 23 for hat). Not for a moment did he identify with the Navajo: instead, his friends christened him "Robinson Crusoe," and he encouraged this masquerade (Fig. 13) by writing a new version of the classic story. Significantly, Culin's hero is not only an adventurer, but also a collector: "Ro-bin-son for a long time past has harried the country in our neighborhood. He is reported to have come from the East where he had ammassed [sic] a great store of the Wampums and other objects which our Indians value most" (1903:137).

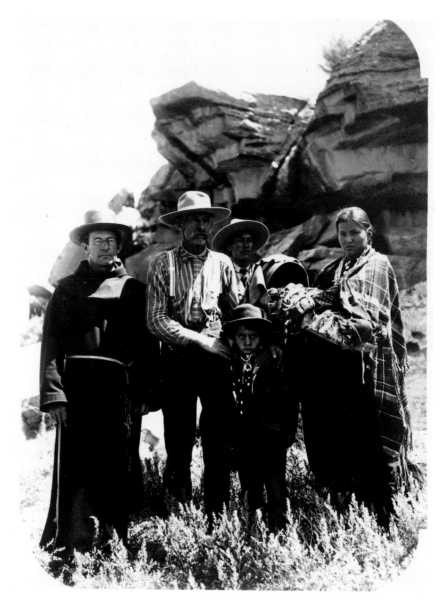

Culin considered objects, not Indians, his primary informants. An ethnologist, he insisted, "must learn the language of things, unprejudiced by their apparent age or the place where he may happen to find them."[47] The metaphor of language was central to Culin's philosophy of collecting. His professed goal as a curator was to make things tell him their story and then to coax and arrange them to tell this story to the world.[48]

By making the objects the speaking subjects, Culin dismissed the Indians as a source of historical knowledge. Instead, he found the solution to an incomplete and acculturated material record in the ethnologist's ability to read in the surviving objects "the message of their faraway creator."[49] Like Brinton and Cushing, the scholars who had introduced him to the American Indian field, Culin believed in the homogeneity of Indian cultures through time and space; thus he justified the use of "survivals" in the present to interpret the "lost arts" of the past. Collecting was a question of careful selection, omission ("My chief saving I am tempted to say," Culin confessed to a friend, "is knowing what not to buy"[50]), and commissions, to which Culin alluded in a letter. "The old things have gone," he lamented. "They cannot be ordered from the Indians, but can only be secured by an

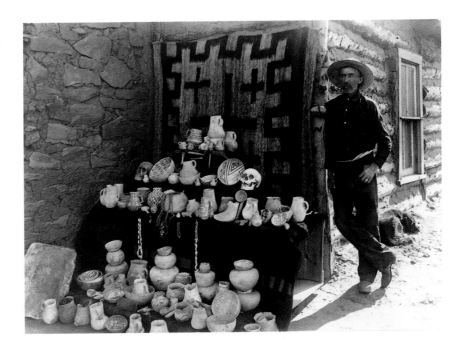

Fig. 12. *Joe Foley with his collection from Red Rock. Photograph from 1904 expedition report.*

intelligent collector who knows what he wants. The Indians themselves do not know."[51]

It was the ethnological collector, not the Indian or the commercial dealer, who knew the "relative value of the new and old wares" (1901a:110). Such a collector could also distinguish the fake from the real, conjure up lost arts, and make fragments whole again. "A medicine bag," Culin stated in an interview with the press, "is a mere curiosity to the relic hunter. To the ethnologist it is an open book of Indian life and history."[52] The conceit of the language of things allowed Culin to assume authorship as well as ownership of the Indian past and to restore the bits and pieces to their fullness of meaning in the exhibition case (see "The Road to Beauty").

Objects of Myth and Memory: Culin's Collection Reconsidered

Self-consciously a salvage operation, undertaken "just in time," Stewart Culin's American Indian collection in many ways exemplifies the attitudes and assumptions underlying the pursuit of the vanishing Indian during the heyday of ethnological collecting. The collection is unique, however, in the extent and detail of its documentation. As a result, we are able to examine critically Culin's collecting rhetoric, particularly the terms "representative" and "comprehensive," in relation to the reality of collecting in communities where the material culture was anything but stable and where objects were only one manifestation (albeit the most visible and portable one) of complex ongoing social, religious, and economic systems.

Culin actually did acquire a large portion of the collection by means of direct observation and interrogation, the methods he had advocated throughout his career, but his expedition reports show that this process was neither as scientific nor as objective as he claimed. In each community he looked for things that appeared old and used, or rare and unusual, and purchased them regardless of whether he found them in an Indian's house, a missionary's basement, or a curio shop. Often very little was known about these objects, and Culin had to rely on his own judgment in making his selections. In order to avoid overlooking anything that might subsequently prove to be of value, he bought "with a lavish hand" (1904b:46), sometimes taking an entire collection for the sake of one piece. Culin's personal taste

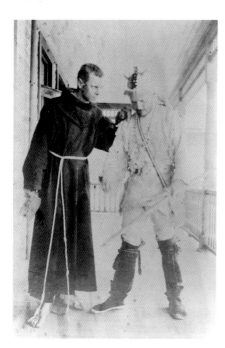

Fig. 13. Stewart Culin, dressed as a Navajo, and Father Michael Dumarest. Father Juillard photograph from 1903 expedition report.

and interests certainly came into play in his door-to-door collecting. Most of the objects appeared in response to his questions, which usually progressed from the general category of "old things" to queries about particular games, dolls, and, finally, when he had established a good trading relationship, ceremonial things.

Culin did not depend solely on his own observations and knowledge, however. Faced with a bewildering mix of the old and the new, he looked to the published literature and existing museum collections for help in defining his goals. Naturally, he was most influenced by the men he had personally met and admired, such as Brinton and Cushing. As both had died shortly before he began to collect for Brooklyn, he welcomed the opportunity to confirm and complete their research.

In his reliance on his predecessors in the field, Culin reversed his model of the language of things: the story came first, and he collected the objects to illustrate it. He was, in fact, extraordinarily successful in closing the gap between the written record and museum collections. Changed economic and social circumstances often allowed him to acquire objects that had been described before but previously had not been for sale, while economic need or religious conversion brought family heirlooms and ceremonial artifacts into circulation. Culin valued these objects as much for their place in the history of collecting as for their cultural significance. He was a master of provenance and an expert on museum collections: when presented with a throwing stick from the cliff dwellings in the Southwest, he knew immediately that it was the "sixth recorded" and could name the location of the other five discovered (1902b:20).

As a competitive collector, Culin not only rejoiced in acquiring what others had failed to get but was determined to go beyond the existing literature and collections and break new ground. In seeking out the overlooked, unrecorded, and unobtainable, he had no choice but to consult with contemporary Indians. In spite of his faith in the ethnologist as a privileged interpreter of things, Culin recognized the limitations of an outsider's knowledge. Therefore, in almost every community where he collected extensively, he established a close working relationship with at least one Indian resident who shared his interest in the past. Each of these individuals provided access to different kinds of materials. In Jemez, for example, José Toya directed Culin's attention to his own family's possessions, whereas in Zuni, Nick Graham, the adopted son of the trader Douglas Graham, had particularly good contacts with the Anglo-American community.

The most concrete evidence of Culin's collaboration with natives is the number and variety of commissioned pieces in the collection. Whenever he discovered that an object was not for sale, no longer made, or was missing from a set, he asked a native artisan to make a replica. Although some of his colleagues looked askance at this practice,[53] Culin considered commissions an essential step in recovering and revitalizing the past, and a curatorial obligation. The museum's object, he stated in a letter to Cushing, "is manifestly conservation and instruction. The conservation should extend not only to the material object, but to its traditions, and where these have been lost, it should be the duty of the curator to endeavor of [sic] revive them, thereby converting what may be regarded as dead specimens into live ones."[54] Indeed, Culin did play an active role in these "revivals," providing his native interpreters and guides with lists of what he needed, the "correct" materials, and even mailing labels when he was not able to stay until the piece was finished (1908:7).

Conversely, the Indians were quick to think of ideas for objects that they had once used or seen. As news of Culin's interests spread, enterpris-

ing artisans anticipated his order and were already at work making the old games, hunting equipment, or implements of war when he arrived in the village. Under pressure to assimilate, many Indians had become more vigilant and self-conscious about safeguarding their heritage and willingly participated in Culin's program of redemption.

These replicas are certainly the most problematic objects in Culin's collection in terms of their cultural authenticity and historical significance. Summoned into existence by the collecting process itself, they "speak" of a past in which they played no part. Although Culin commissioned the replicas to complete the record, they in fact call attention to the fiction of the totality he constructed. At the same time, they contradict the underlying premise of his collecting—the myth of the "vanishing Indian"—and provide us with an invaluable corpus for the study of individual creativity and knowledge within Indian communities in the first part of this century.

The discards, heirlooms, and replicas that Culin acquired in the field embody the myths and memories of a variety of people, both Indian and non-Indian. Because of Culin's fascination with collecting and his detailed expedition reports, we have a rare opportunity to observe these objects at the moment when they changed hands. Seen from this perspective, his acquisitions transcend cultural boundaries and reveal surprisingly rich and varied histories.

HOPI DOLL
FIND IT IN THE RAINBOW ROOM
BROOKLYN MUSEUM

The Road to Beauty

Stewart Culin's American Indian Exhibitions at The Brooklyn Museum

Ira Jacknis

WHILE STEWART CULIN was a passionate collector, it was in the form of the museum display that he most eloquently spoke the language of things. "I have continued on with no other thought than of making things tell me their story," he wrote, "and then of trying to coax and arrange them to tell this story to the world."[1] As an ethnologist, Culin was dedicated to describing cultures through their concrete expressions. His goal of stimulating the public's imagination, moreover, made the medium of the museum display particularly congenial for him. A review of the stories Culin coaxed and arranged his collections to tell, however, will reveal that they were not the simple narratives he suggested: contained in the objects were many stories, which included those Culin initially selected, those he later emphasized in his installations, and those his successors evoked in their exhibits.

By the time he came to Brooklyn, Culin was already experienced in the art of museum display, having won several gold medals for his exhibits at international expositions (see Fig. 4). Though Culin was essentially self-taught as a curator, his early museological mentors were G. Brown Goode, the director of the U.S. National Museum, and Frederic Putnam, the director of Harvard's Peabody Museum of Archaeology and Ethnology. Like many of his colleagues, he made a trip to Europe to study museum methods, and he claimed that this 1898 "journey was decisive in forming my career"; he was a tireless visitor of museums in every city he passed through.[2] However, as in many other things, Culin's prime role model was his friend George Dorsey of the Field Museum.[3] After his 1903 expedition, he spent several days in Chicago, "making a very careful study of the Field Museum cases, methods of installation, catalogues, etc.," and upon his return he modeled his department's cases and catalogue cards after those in the Chicago museum (Fig. 14).[4]

Nevertheless, Culin felt that museum display could not be reduced to set principles: "Largely a matter of feeling and personality, it has no rules that are effective nor can it be taught successfully."[5] Elsewhere he commented, "The making of a museum, of a great, vital museum, requires knowledge, taste and a genius little short of miraculous."[6] In the end, he regarded museum installation as an art form: "My ideal museum, above all a museum that is to represent the outcome of human activities, should be a work of art."[7]

Prizewinning poster for the Rainbow House by Pratt Institute student Natalie MacDonald, Brooklyn Daily Eagle, *May 22, 1927.*

Culin's personal aesthetic approach to the science of ethnology was encouraged by the unusual disciplinary orientation at the Brooklyn Institute. The Institute was unique among major nineteenth-century museums in its combination of the arts and sciences. Most ethnology departments of the time were either distinct or combined with natural history. At Brooklyn, Ethnology was one of three major departments–along with Fine Arts and Natural Science. Responding to the director's letter outlining the scope of his department, Culin regarded "the division of the work between the Department of Fine Arts and Ethnology, as necessarily emperical [*sic*]. Personally if I were drawing up a plan, I should make no such division or distinction."[8]

At Philadelphia Culin was only one of many interested in ethnology, while at Brooklyn he had the subject all to himself. This, plus the chronic shortage of staff at the Museum, probably encouraged his development of an individual style of museum exhibition. Culin felt that the art of display, like other aesthetic forms, should be "the result of individual effort," and at the opening of his reinstallation he thanked "the enlightened direction of the Brooklyn Museum that never has attempted to curb or influence my somewhat impetuous spirit."[9]

American Indian Ethnology Halls, 1905–12

The American Indian displays at the Brooklyn Institute were literally the foundation of the Museum's exhibits. The main ethnology galleries, devoted to the American collections, were given the first floor (current third floor) of the West Wing, the oldest part of the Museum, opened in 1897. Thus the American Indian artifacts were directly off the Entrance Hall, in the central section, which contained classical casts and modern sculpture. The East Wing, finished in 1907, held the Egyptian and Classical Antiquities and, on the basement floor below, Polynesian, Chinese, and Japanese Ethnology. Above Ethnology, on the second floor, were the Natural History collections, with the paintings exhibits of the Fine Arts department on the top floor.

Like most anthropological curators of his day, Culin arranged his exhibits by region. The first displays of the Hall of American Ethnology,

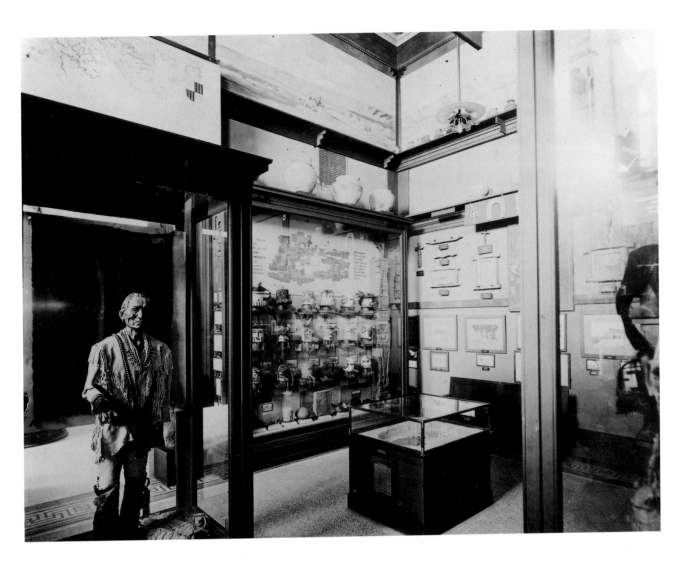

Fig. 15. Southwestern Indian Hall, The Brooklyn Museum, ca. 1910.

devoted to the Southwest, opened to the public on June 1, 1905. The principal Southwest gallery was essentially completed in 1907 (Fig. 15), when Culin published a guide to the Hall, though the section for the Rio Grande Pueblos, in the small hall near the stairwell, was finished the following year. The California Hall was begun in 1909 and partly installed and opened to the public later that year (Fig. 16). It was completed and reopened in spring 1911, following Culin's travels in Japan. Labeling, however, continued into the next year. The third and final component of the American halls—the Northwest Coast—opened in 1912 (Fig. 17).[10]

The geographical or "ethnic" approach was carried through to the tribal arrangement of cases within a hall, and within each region, one group was chosen for in-depth presentation: the Zuni in the Southwest, the Pomo in California, and the Haida in the Northwest Coast. For example, in justifying his focus on the Zuni, Culin claimed "that Zuni stands for the entire existing culture of the Southwest, and, adequately represented, would do away with the necessity of exhibiting at least, much material from other less favored localities."[11]

Within these tribal units, objects were grouped by functional type: costumes, games, religious articles, and so on. A special feature of the Southwest Hall—the largest and most complex—was its inclusion of prehistoric material, which would "illustrate the inter-dependence and relationship of the exisiting tribes with those of the past."[12] This point was

further developed by material from "the more recent historic [Hispanic, not Anglo] period," such as door frames, saddles, iron tools, and the Zuni church columns (Nos. 130, 131). The other main goal for this hall was to explore the "religion and decorative art" of the region.[13]

Culin's exhibits were distinctive on several counts. First, virtually all the objects exhibited had been collected on museum expeditions, by a single curator.[14] Second, his displays were opened in a rapid and continual succession, paralleling these expeditions. And finally, throughout his museum career Culin followed a practice of near-total display. When it opened in 1907, the Southwest Hall held 4,703 artifacts, and by the following year Culin could report that "practically all" the Southwestern material was on display.[15] As he fairly noted in 1920, "This condition of collections being displayed is without parallel in any other museum in America."[16] For Stewart Culin, exhibitions—not research—were the prime motivation for collecting. He criticized the Peabody Museum at Harvard as "a museum in which the museum idea [by which he seems to have meant exhibition] has been made more or less incidental and subordinate to investigation, instruction, and publication" (1911a:172).

Though he might choose a representative approach for tribes within a region, Culin strove for completeness for his featured ethnic groups: "If Zuni dolls and masks [seem] to predominate in the Southwestern Indian Hall, it is to be remembered that these to-day form the only complete series in existence and their very numbers show at a glance that this tribe is characterized by the number of its religious ceremonies."[17] Culin's displays were meant to serve as a place of record for ethnological facts. However, Culin's "complete series" were something of a fiction, and his exhibits were a partial representation, at best (see p. 24).

As in other ethnological museums of the time, Culin's objects were part of a larger multimedia assemblage: large and small cases, oil and watercolor paintings, framed photographs and engravings, maps and diagrams, architectural models, mannequins, and specimen and topical labels. They were also accompanied by lectures, printed guides, and other publications. While none of these features were unique to Culin's displays, his exhibitions were distinguished by their rich and complex combination of elements.

Labels were extensive and detailed. Each specimen had a label giving the artifact type, people, location, source and date of collection, and museum number. For "the visitor who desires more information than is thus afforded,"[18] he prepared topical labels. In these "the language, arts and customs of the Indians are discussed, and the general significance and relation of the collections explained."[19] Much of Culin's scholarly energy went into the writing of these "minute explanatory labels."[20] As a Museum publication put it, in words that were probably Culin's own, "Owing to lack of time only general labels have as yet been placed on the cases [in the Southwest Hall] as the full labelling of this extensive collection demands much time, being practically the writing of a book on the manners and customs of the Pueblo Indians."[21] The Museum did make available a seven-page *Guide to the Southwestern Indian Hall* and "lists of books for the guidance of the student" on the Zuni, Navajo, and Cliff Dwellers.[22]

Like other museum ethnologists of his day, however, Culin omitted from his labels the name of the maker and the place and date of construction (which he often knew because he had commissioned many of the objects).[23] Although he usually noted this information in his expedition reports and often on his catalogue cards, by the time he was annotating his exhibits, Culin was arranging Indian artifacts to stand as anonymous and timeless representations of a vanishing race. With the partial exception of

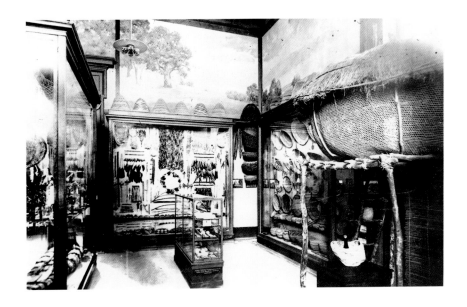

the Southwest Hall, his displays created an "ethnographic present" by juxtaposing in one case objects that may have had radically diverse histories—some treasured heirlooms, others commissioned models.

At the time Culin was arranging his American Indian exhibits, the latest style in ethnographic museum display was the "life group." Although single mannequins had long presented native costumes and appearance, groups of figures acting out a dramatic·scene had only been introduced to American ethnological museums at the Chicago World's Fair.[24] With the assistance of Frank Cushing, William Holmes created several dramatic tableaux for the Smithsonian, and the style was soon popularized by George Dorsey at the Field Museum.

In 1903 Culin wrote from the Southwest with enthusiasm about his plans: "The proposed Navajo and Zuni figures would use up most of the material I have bought, to great advantage."[25] For the Navajo display he was thinking of a "medicine man and a woman in old dress, the latter possibly, being healed, and reclining on a sand painting," and for the Zuni he mentioned, at various times, a dancer, a woman with a water bowl, a male warrior, a shell-bead maker, a silversmith and his assistants, and a woman making pottery.[26]

Artist and Franciscan friar Michael Dumarest of Gallup, New Mexico, cast the "head and hand of an old Navajo" for the medicine-man figure.[27] Culin "was amazed and delighted with the result.... It is better work than I have ever seen in a Museum, the cast having been made over in clay and animated, so that it is a work of art."[28] Most other museum mannequins were strict "life casts," direct plaster impressions, but Culin preferred an aesthetic interpretation. Wanting his groups or figures to be "reproductions of actual people, well known to every visitor,"[29] he had Dumarest cast the head, limbs, and trunk of his consultant "Zuni Dick." From these elements Dumarest "expected to be able to model the entire figure" for a dancer mannequin.[30] Culin gathered many artifacts for these groups and commissioned Little Singer, a Navajo medicine man, to make a buckskin suit for the medicine-man figure (see Nos. 22–24).

Despite his early enthusiasm, Culin's exhibits held no life groups— only the single costumed figure of the Navajo medicine man.[31] The reason for this absence of groups is unclear. We do know that Culin was somewhat critical of groups: "I am prejudicial against most attempts at figures...."

Fig. 17. *Northwest Coast Indian Hall, The Brooklyn Museum, ca. 1912.*

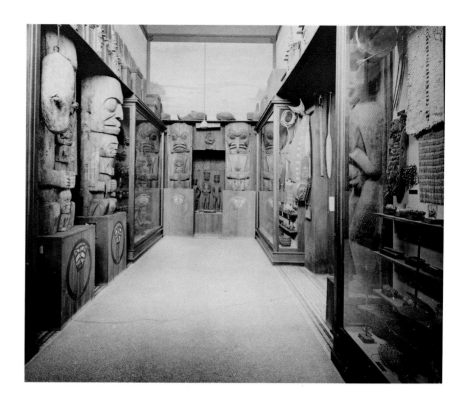

[They have] been made carelessly and are very inaccurate."[32] Such displays were probably precluded at The Brooklyn Museum by the expense and effort they required and by the great amount of space they occupied.

An important part of Culin's American installations were the murals by staff artist Herbert B. Judy (1874–1946).[33] As Culin wrote, "An attempt has been made by the aid of Mr. Judy's paintings and sketches to give an idea of the southwestern country and afford an artistic and instructive setting for the collection."[34] Judy accompanied Culin several times to the field (Fig. 18): to the Southwest in 1904 (Zuni and Chinle), 1905 (Hopi), and 1906 (Laguna); and to California in 1906 and 1908 (Clear Lake). He traveled alone to the Queen Charlotte Islands in British Columbia in 1910.

The murals covered the top portion of the walls of each gallery. The one in the Southwest Hall ran along three sides (the painting of the longest wall was composed of five panels, each twenty-two feet long).[35] The California mural—and, evidently, the Northwest Coast one—completely encircled the hall. Each series of panels formed a panorama, seen from a definite position: the First Hopi Mesa in the Southwest gallery, the villages of Laguna and Isleta in the Rio Grande Pueblo room, Pomo country around Clear Lake in the California Hall, and the Haida village of Masset for the Northwest Coast Hall. Judy's murals were an innovation in American ethnology displays. Soon they were followed by those at the American Museum of Natural History in the Eskimo, Northwest Coast, Plains, and Southwest halls. Depicting specific vistas, the murals at Brooklyn were a step toward the backdrops within diorama cases popularized at the Milwaukee Public Museum and in the Southwest Hall at the Museum of Natural History.[36]

The cases contained smaller oils and watercolors, with Zuni house interiors and the surrounding region, and Canyon de Chelly among their subjects.[37] In addition, the ethnology cases were liberally illustrated with photographs and engravings, many taken from BAE publications, as well as maps and diagrams of tribal locations and village plans.[38]

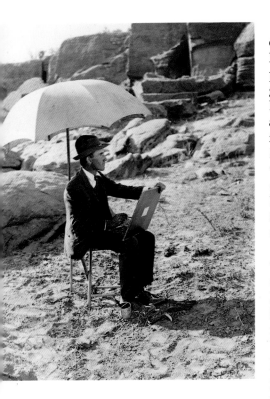

Fig. 18. Herbert B. Judy painting in Arizona. Simeon Schwemberger photograph, 1904, from 1904 expedition report.

Culin carefully arranged his collections for visual effect. In each hall, certain key objects stood out, symbolizing the whole. In the Southwest Hall it was the mannequin of the Navajo medicine man and the Eakins portrait of Cushing (Fig. 5); in the California gallery, the large Pomo granary (Fig. 50); and in the Northwest Coast room, the Kwakiutl and the Bella Bella house posts (No. 293). Culin desired these impressive artifacts as much for their appearance as for their ethnological value. In a letter to his field agent, he requested "some carved poles to use in the decoration of our Northwest Coast room." He would take as many as he could, "as old and as well carved as I can get, preferably not too high."[39] In all three halls, many of the objects were directly exposed to the viewer's gaze, without the barrier of glass. In each room a row of major container forms—pots for the Southwest, baskets for California, and boxes and bowls for the Northwest Coast—ran around the top of the cases.

His visual flair led Culin to adopt native artistic motifs in his galleries: "The symbolic designs employed as decorations in the [Southwest] hall are of Indian origin and appropriate to the purpose for which they are used."[40] Here he used the characteristic stepped design on wall brackets. For the interior woodwork on the walls of the Northwest Coast Hall, he incorporated "some large, old, roughly-hewn planks" from the roof of a house in Victoria.[41] The Bella Bella house posts were mounted on simulated boxes, painted with a design copied from a box drum in the Museum collection.[42] At the same time, Culin strove to minimize possible distractions. The four large wall cases in the California Hall were made not of metal, but of oak, "finished a dull olive brown in harmony with the room and objects."[43] Furthermore, he felt that "all fixtures and mechanism...should be unobtrusive and as far as possible concealed."[44]

Culin found fault with the displays at Harvard's Peabody Museum, which lacked the appropriate atmosphere he sought in his galleries. Nowhere in it, he felt, "does one get any of the feeling of the land or the people. One is always in the Peabody Museum, looking at museum specimens." In the Plains Hall, he argued, "the collections and methods of display is such that the specimens create no atmosphere of the Indian, and even their beauty is lost or obscured."[45] His friend George Dorsey understood exactly what Culin was after when he commented that one could "stand in the Japanese Hall [installed by Culin in 1910] of the Brooklyn Museum and forget one is in Brooklyn."[46]

These exhibits were quite favorably received. As Culin himself wrote to a friend: "I have just opened my Southwestern American Hall. It is very beautiful, really beautiful."[47] The *Brooklyn Eagle* reported that the hall was "destined to take rank with the very best collections of its kind in any museum the world over." The papers also appreciated Culin's style of display. According to the *New York Evening Post*, "The collection gains much of its distinction from the admirable manner in which it is arranged." Another paper thought that Culin's general ethnology hall was "highly interesting, instructive and satisfying," particularly praising "the simple and clearly intelligible manner in which the exhibits have been labeled and described." The article noted Culin's success in speaking to "common, everyday people."[48]

Reviewers were not insensitive to the aesthetic merits of the artifacts. According to one, "the vari-colored dress and decoration [of the Zuni kachina dolls] have elicited the admiration of several artists who have seen the collection. The sense of proportion and color harmony possessed by these Indians puts the impressionism of twentieth century art to shame."[49] This kind of comparison, encouraged by Culin's displays, was also fostered by the juxtaposition of the art and ethnology halls at The Brooklyn

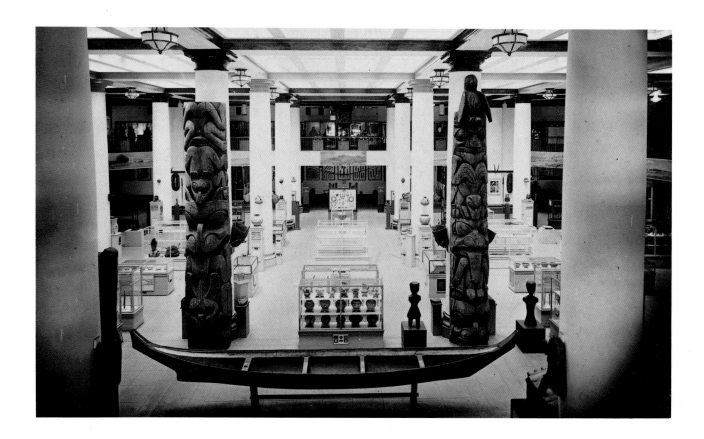

Fig. 19. The Rainbow House, Gallery of Ethnology, The Brooklyn Museum, 1930. By the time this picture was taken, a year after Culin's death, his installation had been slightly rearranged.

Museum; the general ethnology hall opened on the same day in 1905 as the Hall of Sculpture.[50] Culin's American Indian exhibits were thus among the first to be perceived as art and not just ethnology.

From Ethnology to Art, 1911–25

After his last American Indian collecting trip in 1911, Culin's interests turned to other regions. He cited 1909 as the time when he concluded "that however valuable these Indian collections might be in themselves other fields would prove more immediately helpful through the possibility of the application of the collection to the needs of the American artists in connection with industry."[51] Specifically, he began to focus on textiles and their relation to fashion design.

In 1920 he took stock of his prior collecting in North America (1903–11) and the Orient (1909–14) as he turned to a new field in Europe (1920–28). Each of these units, he felt, was "more or less complete in itself." Culin was not alone in shifting his focus to the Old World. Most anthropology museums felt that they had "done" American Indians. By 1905 Dorsey's Field Museum was sending out expeditions to New Guinea, the Philippines, and East Asia. Galleries were filled, and there was a general perception that there was nothing left to collect among Native Americans.

From 1911 until Culin's death in 1929, The Brooklyn Museum acquired relatively few American Indian objects, and most of these were gifts. Significantly, one reason that Culin used to justify his meager American Indian acquisitions was a lack of space. As he explained in 1926, "Heretofore I have been indifferent about acquiring Indian collections as I had no place to show them."[52] This was a very telling remark, for most other ethnology curators were happy to acquire research collections that they had no intention of displaying.

Fig. 20. The Rainbow House of the Zuni Indians. *Watercolor by Alice Mumford Culin. Reproduced in Stewart Culin's 1927 essay "The Road to Beauty."*

The few plans for American Indian collecting and exhibition that Culin made during these years were abortive. Citing competition from the American Museum of Natural History, he proposed making a summer field trip to Zuni in 1916 for "completing the data and verifying [his] field notes."[53] He also wished to purchase specimens to fill gaps in the collection. There is no evidence that Culin ever made the trip. The following year he traveled to Long Island and New England, in contemplation of an innovative gallery combining Euro-American and Indian material. He collected nothing Indian on the trip, however, and the hall was never built.[54] Though his interests had drifted elsewhere, it was through exhibits that Stewart Culin returned to the art of the American Indian.

The Rainbow House, 1925–29

For over a decade, Culin's North American halls remained unchanged. As early as 1910 the Museum's curator-in-chief was complaining of the congestion in the Ethnology Department, "where any expansion at present is impossible, and even the corridors have been used for exhibition halls."[55] Though the City of New York began construction of a new wing in 1913, it was not turned over to the Museum until 1925. Given space in the new building, Culin was at first upset at having to move: "It seemed as though Brooklyn was hopeless. I found I had to transfer all my collections to a new wing and it seemed as though the labor of years had been wasted."[56] As he began to plan the installation in early 1925, however, he evolved his idea of the Rainbow House.[57] Though the hall was dedicated that December, the American Indian collections were not moved until early in 1926, when the Rainbow House was opened to visitors, and installation work continued until early 1928.[58]

The Rainbow House included most of the Ethnology collections: the Hall of the Primitive Races (American Indian, African, and Oceanic) in the lower court, and the oriental and eastern European galleries on an upper mezzanine. A Chinese Hall of State was arranged on the floor above, at the entrance.[59] Only one photograph of the Rainbow House is known (Fig. 19), but it reveals that the hall was open and spacious. Many items were exposed, hanging from the columns or resting on top of cases and pedestals. Dominating the space were the two halves of a Haida totem pole, in front of a Kwakiutl canoe and other Northwest Coast objects. The material in wall cases was decoratively arranged in symmetrical patterns (a popular Victorian style). Many elements—architectural models, photographs and maps, labels, and some of Judy's smaller murals and paintings—were recycled from Culin's original installation.

Culin regarded his hall as a kind of *imago mundi*: "I am newly installing my ethnological collections in a square hall symbolic of the world....The races of the four world quarters are distinguished by the colors of the settings."[60] As far back as the 1880s, Culin had perceived four-quarter symbolism on many gaming implements. Yet the hall was not only a cosmic model; it was also a personal simulacrum, containing all Culin's collections from his many world travels. Having long since left their original habitats, these objects took on a new significance as they were again ordered in novel patterns. Culin was making explicit the metaphoric relationship, usually left unsaid, of the ethnographic display to the world: "This Gallery of Ethnology...is not merely a symbol of the people of the world. It is intended as the home of their spirit. [It is meant] as a place for its concrete expression."[61]

The Rainbow House took its name from the array of colors used to differentiate each region symbolically. As a newspaper described it, "Each

Fig. 21. Newspaper advertisement for an exhibition of women's blouses drawn from The Brooklyn Museum collections, New York, 1922. Note the American Indian costumes in the middle of each side.

ethnological group [was] represented by a color that to [Culin] typifies the inner meaning of their contributions to art development of the human race."[62] Culin painted the Zuni cases pink and those of the California Indians red ("a deep strong red I call madrona, from the ruddy tree that everywhere enlivens the color of the coastal landscape"). The Caribbean area was given a blue for its ocean depths, South America a tawny yellow. Green in different shades was used for both the shallow waters of the Pacific islands and the tropical forests of Africa. "The maturer and more highly developed East" was marked with "the pure and intense color" of vermilion.[63]

Culin drew on many sources for his rainbow scheme. He claimed that he borrowed "the idea as well as the name" of the Rainbow House from the Zuni. Though Culin noted that the Rainbow House was the abode of the personified rainbow spirit, it was also an actual place—a sacred spring east of Zuni, used as a war shrine and an augury in hunting. Culin was also familiar with the rainbow scheme at the Pan-American Exposition, held in Buffalo during 1901, where each pavilion was marked by a different color of paint and light.[64] Perhaps the most decisive influence was his wife, Alice Mumford Roberts Culin (1875-1950), a painter whom he married in 1917: "Mrs. Culin has been very helpful to me and my unrestrained feeling for color is due to her influence." Culin selected thirty-four of her watercolors for the installation (fourteen illustrating Zuni Indian folktales and eighteen with Congo themes), including one depicting the Rainbow House of Zuni myth (Fig. 20).[65]

The Rainbow House was actually the culmination of many years of Culin's experiments with the colors of museum display. His first oriental halls had been "repainted in bright tones and form an effective setting for the Oriental collections."[66] In 1923 he employed the polychrome idea in his exhibition of European and Asian decorative arts, where each country's exhibit cases were painted a different color. Underlying this work was a more general poetic theory of color that Culin developed during these years: "Color is the most potent of all agencies that arrest our attention and stimulate our imagination."[67]

Culin's Rainbow House installation must also be seen as an expression of his interest in department stores and shop window display. Just as he drew on his experience as a merchant for his collecting, so, too, did he apply lessons from the world of commerce to his exhibitions. During his Philadelphia years he had established a friendship with John Wanamaker, who funded his expeditions for the Museum of the University of Pennsylvania and was especially known for his impressive displays. Culin maintained a very high opinion of stores, which he felt were becoming "the aesthetic center of our urban communities":

> More congruous than many of our residences, our shops display things far better, and more agreeably, than do our public institutions. The Zuni Indians whom Frank Cushing took many years ago to Washington, described our National Museum as a great shop where nothing was sold. If our shops showed their wares as uninvitingly as do many of our museums, they would sell nothing.[68]

For inspiration, Culin looked to these lively shop windows, which he likened to theatrical stages.

By the late twenties, Culin had reacted against the dominant display strategies of his youth, including those of his original installations: "The main idea of the museum has been either to create a neutral setting for its treasures, one that would accommodate itself to varied sorts of things, or a realistic background that would simulate their original environment."[69] In

contrast, he now preferred the vibrant colors used in contemporary shop displays:

> [The Rainbow House] is better than my old halls for it is shown in clear light and the vivid colors of the cases and all the settings add greatly to the visibility of the objects. The old idea was to make cases and walls neutral in tone. It seemed reasonable, but in fact their contents merged with the neutral or black cases and gloom resulted. Things are seen much more vividly in colored cases.[70]

Despite his intense interest in Old World cultures, Culin announced that "my own Ethnographical galleries shall be American first."[71] In fact, reinstallation of the collection was an act of rediscovery: "We are now about to display our collections from the North American Indians. They are much more important than I realized."[72] As he formulated his ideas, the Zuni returned to the center of his personal philosophy. In 1904 Culin had made little of the Rainbow House site, where he had stopped for lunch on the way to a Zuni shrine.[73] Yet in his talk at the hall's dedication, he associated it with the paradisal "Summer Land in the South" of the Zuni.[74]

Although Culin was vague about the meaning of his Rainbow House, images of youth and creation were central to his conception. Culin liked to think of "the races of antiquity as younger and not older than the people of our own age." Among them he could "refresh" himself, in order to "feel myself younger and more vital." Dawn imagery also suffused his remarks: "I have realized my dreams among savages in whose lives and thoughts I have had glimpses of the dawn of the world"; "The Zuni were an ever-smiling people, looking forward into the dawn [symbolized, perhaps, in the pink cases he gave them]."[75] Culin was here poetically synthesizing his own youth with that of the Zuni and all humanity.

Culin's radical reinterpretation of the Zuni is evident from the use of paintings in his two installations. Judy's documentary panoramas, based on field sketches, had depicted the view from a specific vantage point. Alice Culin's images, on the other hand, were imaginative re-creations of Zuni myths, based on Culin's stories. In fact, the entire visual style of the display bore out this difference. Where the first had been crowded, objective, and mimetic in its decorative elements, the reinstallation was spacious, expressionistic, and symbolic. Aesthetics, implicit in the original halls, were overt in the Rainbow House.

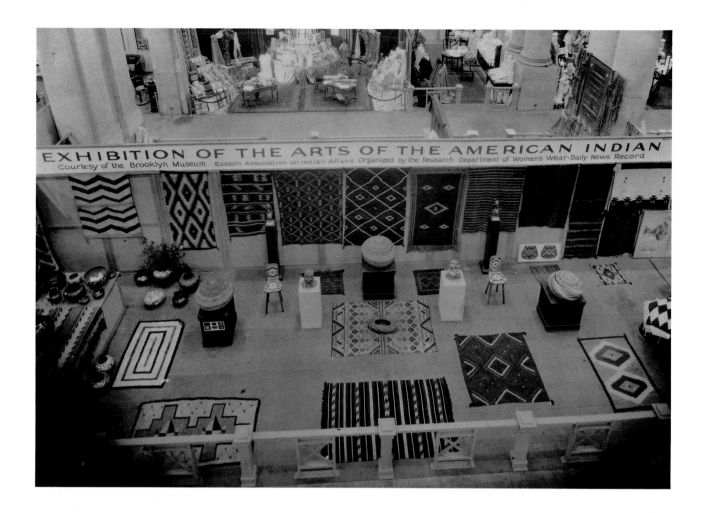

EXHIBITION OF THE ARTS OF THE AMERICAN INDIAN

Courtesy of the Brooklyn Museum Eastern Association on Indian Affairs Organized by the Research Department of Women's Wear-Daily News Record

Fig. 23. Exhibition of the Decorative Arts of the American Indian, *New York, 1925.*

Despite his initial misgivings about having to move his exhibits, Culin soon came to prefer the new arrangement: "The scheme has been so successful, it promises to revolutionize our museums."[76] Elsewhere, he wrote:

> Never before in a museum have carvings and basketry, textiles and pottery, the varied products of aboriginal industry appeared to such advantage. Once dead and inert, they have come to life, and blossomed under the glowing color of their immediate surroundings. To bring them to life, to coordinate them with living things had been always my object, but never before had that object been so nearly achieved.[77]

To judge from press reaction, Culin had accomplished his goal. For Helen Appleton Read, the art critic of the *Brooklyn Daily Eagle,* The Brooklyn Museum was "the first and, to my knowledge, the only museum in this country to show its ethnological collections artistically and as objects which have an interest over and above the purely scientific. In other words, the collections are displayed in such a way that their artistic qualities may be seen at a glance for those who are interested in that aspect."[78] The aesthetic approach, noted by reviewers of Culin's first installations, had now blossomed.

Helen Read was quite accurate in her assessment of Culin's achievement. With a few exceptions, the twenties were not good years for anthropology museums. The institutional setting of anthropology had changed radically, from the museum to the university.[79] Two of the largest ethnological collections had moved to new buildings—the U.S. National

Museum in 1910 and the Field Museum in 1922—yet in both cases, the exhibits were transferred virtually intact. The anthropology displays at the American Museum of Natural History had changed little since the mid-teens, suffering under a hostile administration more interested in dinosaurs and big-game dioramas.

At the time the Rainbow House opened, among the more recent anthropological displays were those at the Milwaukee Public Museum and the Museum of the American Indian. In the former, curator and then director Samuel Barrett brought the anthropological exhibits closer to the style of habitat dioramas, and in the latter (founded in 1916 but not opened to the public until November 1922), exhibits were crowded and traditional (Fig. 22). Perhaps the only real exception to Helen Read's claim was at The Denver Art Museum, where a Department of Indian Art had just been established in 1925.[80]

Culin's polychrome scheme also received praise. *The New York Times* reported that Culin's exhibit was "of the gayest and brightest of colors—pink, red, yellow, green, all of the brightest tints. At the same time there is no conflict of colors; all of them blend harmoniously and charm the eye." Culin's friend M. D. C. Crawford wrote: "It makes a new departure in museum arrangement. There is a feeling of lightness and charm and virility of color that makes the sensation of visiting a museum a new and most delightful one."[81] By February 1927 Culin was able to report, "The Rainbow House gains in popularity and is becoming more interesting."[82]

"A Laboratory for Culture": Extension Programs

Stewart Culin hoped his exhibits would have an active effect on visitors. Proudly reporting the reaction of "a few selected visitors" to the soon-to-be opened hall, he wrote:

> I find after seeing it they do not care to look at anything else in my department and disregard the galleries with which they before had expressed satisfaction. Those who are in the industries go away with a light in their eyes. They have been stimulated and plan things they have means to carry out. Others who have no such outlet, express annoyance and regret.[83]

Accordingly, Culin resorted to several means of broadening the Museum's influence: lectures to school and design classes, an active loan program for manufacturers, and special exhibitions in department stores.[84]

Culin was quite pleased with the use of his exhibits by school groups. Helen Read noted, "There is no similar instance of a museum collection which is so unqualifiedly given over for the purpose of stimulating creative ideas."[85] In the spring of 1927 the Museum sponsored a poster contest for students, who were to base their designs on objects from the Rainbow House (see p. 28).[86] As Culin wrote to the director of the Pratt Institute, "These classes...have given me an opportunity to put the machinery I am creating into practice. It works. I can see its effect on the students. Their natural gaiety is stimulated....The reactions of the Pratt classes to our things are the most direct and useful indications of their value at my command."[87]

During Culin's tenure at The Brooklyn Museum, the borough's population swelled greatly, with the largest increase occurring in the 1920s.[88] At the same time the population center shifted closer to the Museum, east from Brooklyn Heights to central Brooklyn. The extension of subway service to the Museum in 1920 boosted attendance still further. Culin wanted to reach this audience, to "draw crowds like 'the movies.'"[89] Again, he looked to the department stores for a model: "Ten thousand people visit a department store to gratify their curiosity, to see new things, [as com-

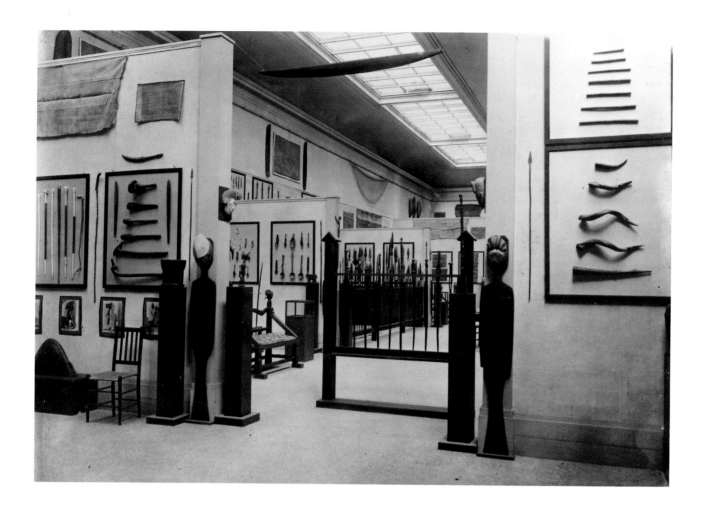

Fig. 24. *The exhibition* Primitive Negro Art, *The Brooklyn Museum, 1923.*

pared] to one who resorts to a museum or similar education institution."[90]

Perhaps the audience that most inspired Culin during these years was that of fashion designers. Although he was a pioneer in encouraging active cooperation between museums and industry, Culin was actually part of a larger movement. Many of the great American museums were founded with the intention of establishing a close working relationship with the industrial-design community. As early as 1910, The Metropolitan Museum of Art had a textile study room, and several more opened during the teens. At the same time, John Cotton Dana at The Newark Museum was leading his colleagues in museum display of crafts and industrial design.[91]

In 1919 Culin collaborated with ethnologist Herbert Spinden and writer M. D. C. Crawford, both then at the American Museum of Natural History, on an exhibition juxtaposing contemporary fashions and the museum objects that had inspired them.[92] Editor of the trade journal *Women's Wear Daily* and an amateur scholar of textile history, Morris de Camp Crawford (1882-1949) was Culin's most dedicated protégé. Responding to Culin's suggestion that he write a book on costumes and textiles, Crawford wrote, "I shall always look upon you as the greatest influence in my life—and if I write it will be as much an interpretation of your influences as my own ideas." Until his death in 1929, Culin worked closely with Crawford, becoming contributing editor to the Design Department of the paper in January 1920.[93]

The Brooklyn Museum loaned objects to several exhibits organized by Crawford and *Women's Wear Daily*. Many of these shows were held in department stores or at meetings of trade associations. The 1925 *Exhibition*

of the Decorative Arts of the American Indian (Fig. 23), for example, contained historic material from Museum collections (Navajo blankets, Pomo baskets, Hopi pots, Zuni masks, and the two Zuni shields made for Culin [see No. 114], among others), complemented by contemporary art supplied by the Eastern Association on Indian Affairs.[94]

Bringing the museum to the artist and manufacturer—an ideal dating back to the mid-nineteenth century—was Culin's goal for the Rainbow House. In a talk on museums and advertising, he characterized the museum as a "laboratory for the culture and ferments that are necessary for the stimulation of the creative activities.... My idea is a museum in which the things of the past are vitalized. My collections are kept alive and are shooting into new life and development in the present-day world, a world greedy for fertile ideas."[95]

Culin's Legacy

Although Stewart Culin had been one of the founders of the American Anthropological Association, his death in 1929 went unmarked in the pages of the *American Anthropologist*. Several factors account for Culin's meager reputation among later anthropologists. Though Culin's disciplinary focus may have shifted radically over his career, intellectually the change was not as great. All his life he maintained an interest in the evolution of general human types, an approach effectively critiqued by Franz Boas in the 1890s. His thought of the 1920s—quite at variance with museum ethnology from about 1900, let alone with the field at the time—was not, in fact, far from his writings at the beginning of his career. Culin was also limited by his institutional focus: the museum and local professional organizations rather than the university. Like earlier Smithsonian anthropologists, Culin's reputation was hampered by a lack of students, a means to disseminate one's ideas. Furthermore, Culin had the more specific problem of his relative lack of scholarly publications, which virtually ceased after his appointment to Brooklyn.[96]

Probably the most decisive reason that he was not remembered by anthropologists, however, was his shift to a fundamentally aesthetic approach. During his time in Philadelphia, Culin belonged to several art societies and befriended artists such as Thomas Eakins. His expedition reports are filled with aesthetic evaluations of the artifacts he was collecting, and his flair for the visual was quite apparent in his decorative exhibitions. Culin's participation in the aesthetic realm seems to have greatly increased after his marriage to Alice Mumford Roberts in 1917 and his collaboration with Morris Crawford. Among Culin's best-known achievements is his 1923 exhibition of African art (Fig. 24), widely regarded as the first exhibition of African artifacts as art in an American museum.[97] At his death, Culin was memorialized by publications such as *Art News* and the *Art Digest*, almost all of which mentioned his work with fashion and design, and his popular museum exhibitions.[98]

At heart, Stewart Culin was a "museum man." His research centered on objects; the public expression of this research took the form of exhibits; and his entire professional life was spent in museums. Few of his contemporaries were as focused as Culin on the "language of things." Although he has long been remembered for his compendium on North American Indian games, the extent of his achievement was obscured when his collections were removed to storage and separated from their rich documentation. Now that many of them are being exhibited for the first time in decades, we can reevaluate his accomplishments. These objects remain as Stewart Culin's true legacy.

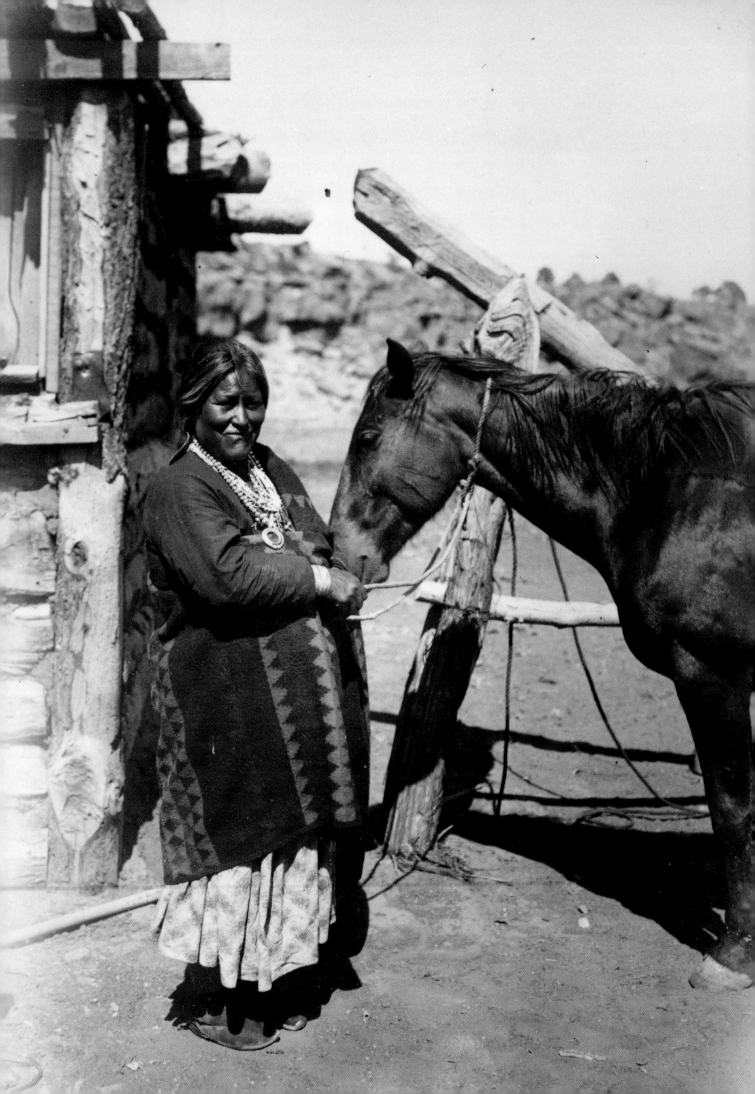

THE SOUTHWEST

Diana Fane

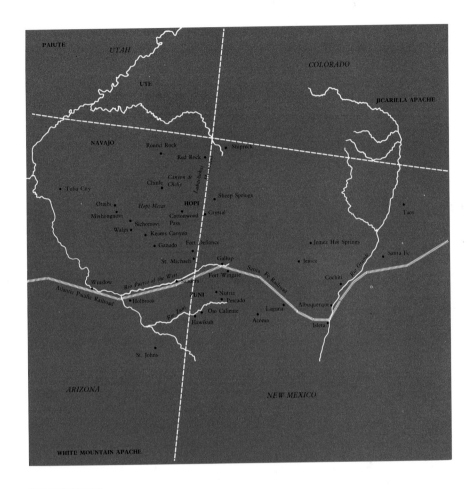

A Navajo Woman at Saint Michaels. Simeon Schwemberger photograph from 1904 expedition report.

THE AMERICAN SOUTHWEST, where Culin assembled his first and most ambitious collection, occupies a special place in the history of Indian-white relations. In 1872 Francis A. Walker, the commissioner of Indian affairs, praised the Indians of New Mexico and Arizona for their "sobriety, industry, and docility." "They are, indeed," he added, "scarcely to be considered Indians in the sense traditionally attached to that word."[1] In contrast to the nomadic Plains Indians, who had come to stand for the antithesis of civilization, the Southwestern Indians, living in settled agricultural villages, seemed to exemplify civilization's fundamental attributes and values. In fact, the surviving cultures were perceived as offering a glimpse into the very origins of civilization. The picturesque adobe pueblos (Fig. 25), echoing the prehistoric ruins nestled in the dramatic landscape (Fig. 26), created the impression of a harmonious world that history had left untouched.

This image of Southwestern Indian cultures in the last quarter of the nineteenth century invited comparisons with ancient Greece. F. H. Cushing, for example, entitled the "remarkable mythologic epic" he recorded while living among the Zuni "The Zuni Iliad."[2] Dealers advertised black-on-white pots of "peculiar forms, very similar to the early Greek Ascos and

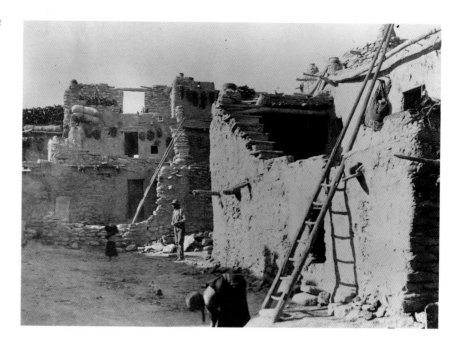

Fig. 25. The Hopi village of Mishongnovi in Arizona. Photograph from 1905 expedition report.

Rhyton,"[3] and the theme was later picked up in fiction. In Willa Cather's novel *The Professor's House*, a priest inspecting some newly discovered pots in New Mexico remarked: "I have seen a collection of early pottery from the island of Crete. Many of the geometrical decorations on these jars are not only similar, but, if my memory is trustworthy, identical."[4]

Direct historical connections with ancient Greece were not proposed; rather, the Southwest was considered a prototype that belonged, in Culin's words, to "an earlier and fresher stratum than that of the oldest historic civilizations."[5] Here, where settlement had been continuous, ethnologists discovered a unique opportunity to study early man's intimate relationship with nature and to explore the origins and meaning of symbolic expression. In a lecture on a journey he had made to the Southwest in 1896, the German art historian Aby Warburg posed the question that intrigued the first generation of investigators: "To what extent can these remnants of pagan cosmology still obtaining among the Pueblo Indians help us to understand the evolution from primitive paganism, through the highly-developed pagan culture of classical antiquity, down to modern civilized man?"[6]

Each scholar brought his own concerns and methods to this quest for origins. One of the most controversial early fieldworkers was F. H. Cushing (Fig. 5), who had been a member of the BAE's first expedition to the Southwest in 1879. In order to study the Zuni, Cushing became a Zuni, thus initiating what is known as the participant-observation method in anthropology. Although many of his colleagues questioned the scientific validity of this approach, Cushing claimed that it had not only given him an understanding of Zuni myths and arts but had "enlarged upon my understanding of the earliest conditions of man everywhere as nothing else could have done."[7]

In selecting Arizona and New Mexico as the destination for his first collecting expedition for Brooklyn, Culin was profoundly influenced by Cushing. "The Southwest field was chosen as the richest and most immediately fruitful," he explained in a lecture delivered in 1904. "Personal inclination on the part of the Curator and collector also led this way." He then described in frankly emotional terms his friendship with Cushing and

46

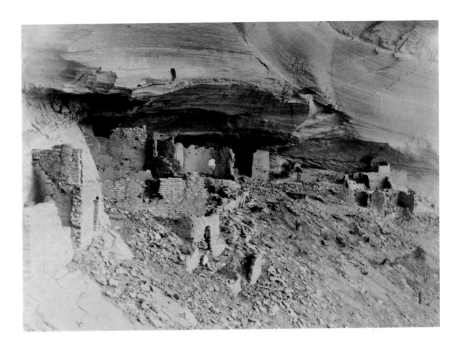

the impact of the man's death on his career: "It led me to leave the East and turn my own steps to the Southwest and try to pick up and recover the broken clue. It became the dream of my life to go to Zuni and complete the work" (1904b:4, 5).

Within the Southwest, Culin went on, he planned to emphasize certain cultures. Although he considered the Hopi "the more important and interesting" of the Pueblo people, he realized that Dorsey had already "done" the Hopi in his exhibitions at the Field Museum in Chicago. Culin therefore selected the village of Zuni, which remained "so far as objective collecting, an unworked field," as "the best source from which to draw our museum illustrations of the Pueblo culture." For the non-Pueblo peoples, he again made his choice based on Chicago's collections and "selected the Navajo as the principal object of my study among the nomadic tribes. No adequate or representative collections have been made among them, while the Apache are extremely well represented at Chicago" (1904b:10, 11). Culin's motives for avoiding duplication were mixed. As a scientist, he was genuinely concerned with providing a comprehensive representation of all the cultures of the Southwest for the future, but as a competitive collector, he also wanted collections that could never be duplicated.

Documenting the Remote Past

In his 1904 lecture, Culin discussed the ruins that littered the southwestern landscape and relegated them to second place in the ethnologist's priorities. "These graves and ruins contain sufficient material, a hundred fold, to supply all the museums in the world. Except for the fact that they are being greedily and carelessly despoiled by relic hunters they might wait for ages to tell their story." The arts of the "surviving tribes," on the other hand, were "being lost" and required immediate attention (1904b:12).

In favoring the art of the "living races" over archaeological remains, Culin was expressing a common theme of early southwestern ethnology: ruins could wait.[8] In addition to the conviction that the vital clues to the past were vanishing, there were economic reasons for concentrating on ethnological collecting. As Culin pointed out, "Millions of dollars are spent

Fig. 27. Advertisement for C. W. Riggs. The Brooklyn Institute of Arts and Sciences is among the institutions Riggs cites as evidence of his ability as a "Museum Maker."

in the endeavor to secure the records of the life of Greece, Rome, and Egypt, when a few thousand dollars would preserve the fleeting records of the present."[9]

It was impossible for Culin to ignore the archaeological material altogether, however, as his whole justification for an ethnological collection was to assist in interpreting the past. Moreover, the Museum already had holdings of southwestern archaeological material, a fact that had to be taken into consideration in planning his acquisition policy. An ongoing involvement concerned Tabira (also called Gran Quivira) in New Mexico, where a Jesuit mission had been located. The Museum had been considering sponsoring excavations at this site for some time, and one of Culin's first responsibilities as curator was to investigate it. He decided against an excavation on the grounds that ruins of the Spanish period threw "little light on the remote past."[10]

Prehistoric ceramics already at the Museum included a miscellaneous lot of "about 350 specimens" (see No. 9) that had been purchased from an enterprising dealer named C. W. Riggs (Fig. 27), who billed himself as a "museum maker."[11] The problem with the Riggs collection was not the pots (many of which are of outstanding quality), but the way in which they had been collected. There was no documentation. O. T. Mason of the U.S. National Museum—to whom Brooklyn's director, Franklin Hooper, had appealed for help in evaluating the acquisition—noted that "a skilled man like Dr. Fewkes [a staff ethnologist] could arrange the Riggs pieces and give them good ethnological standing."[12] Eventually Culin did just that, by recovering information about them in the field.

In addition to the Riggs collection, the Museum had a considerable number of pots from the Four Corners region (where the boundaries of Arizona, Colorado, New Mexico, and Utah come together) donated by Charles Schieren, a trustee (and the mayor of Brooklyn). Schieren had purchased most of his collection from Charles Deane, curator of the War Relic Room (a private collection) in Denver. Shrewdly sensing an untapped market, Deane continued to send shipments of pots for Schieren's consideration, but he apparently was unable to get the "rare and exceptional" pieces Schieren wanted for the Museum, while duplicates and broken specimens kept turning up.[13] In a final letter to the Brooklyn curator of natural sciences (then in charge of Pueblo pottery), Deane rested his case, but not without a parting shot at the eastern establishment and its scientific presentations: "I am informed," he wrote with biting sarcasm, "that some years ago a would be donor to an Eastern museum gave an order for two fossil mammoths, but stipulated that they must be absolutely perfect specimens, and that one should be a male, the other a female. My impression is that a guaranteed pedigree was also required, but I am not sure as to that."[14]

Like the donor Deane mocked, Culin valued the pair and the pedigree and was convinced that he could provide Brooklyn with a valuable archaeological collection without the time and expense of an excavation. On his first expedition in 1903, "his objective point was Chin Lee [Arizona] where [he] intended to examine a collection of prehistoric objects belonging to the trader, Mr. Charles L. Day, and collected by him, his father and two brothers from the cliff-dwellings of the Cañons de Chelly and del Muerto" (1903:3).

Representing the spoils of repeated family outings, the Day collection was anything but systematic. When Culin first examined it, he found it "stored in boxes and barrels, without labels or distinguishing marks" (1903:22). He was intent on acquiring it for Brooklyn, however, for several reasons. It was large (with more than 2,643 catalogue entries), varied

Fig. 28. Representation of a Cochiti witch. Michael Dumarest watercolor from 1905 expedition report. Michael Dumarest provided Culin with illustrations for his brother Noel Dumarest's Cochiti manuscript.

(including grave goods, household refuse, and ceremonial deposits), and met his requirements for vitality in field collections: the Days had been the first Anglo-Americans to enter many of the caves.

The Days were featured in several semifictional pieces Culin wrote. He portrayed them as energetic, adventurous, and not averse to taking the law into their own hands. "By a curious paradox of fate," Culin wrote in a story entitled "Mummy Cave Cavern," Charley, "who himself had taken everything away from the cañon he could find, had through the intervention of a clerical friend at Washington...been appointed Conservator of the Cañon, keeper of its antiquities, and its monuments."[15] Charles Day was actually appointed to this position while Culin was negotiating to buy the collection for Brooklyn. As a result, there was considerable intrigue surrounding the sale, including an attempt on the part of the U.S. National Museum to outbid Culin. Culin reported all this in vivid detail to Franklin Hooper, who responded with enthuasiasm. "Your two letters," he wrote back to Culin in the field, "read like an Arabian Night's tale."[16] The trustees approved the sum of $4,000 to purchase the entire collection. Writing to Culin shortly after the purchase had been approved, Hooper conveyed a message from one of the donors:

> Mr. Healy wishes me to say to you in writing that he very greatly appreciates your services in effecting the purchase. He is equally certain that you will take every possible precaution to see that every specimen in the Day collection is forwarded and that no valuable specimen be permitted to remain behind. He is aware that there is a temptation on the part of the collector [Day] to reserve a few valuable specimens, the loss of which from the collection would very considerably reduce its value.[17]

Having acquired the Day collection for the Museum, Culin set about making sense of it by classifying and cataloguing its contents and succeeded in transforming it into a meaningful totality. The acquisition provided the Museum with an exceptional archaeological collection and some fascinating historic Navajo and Hopi material.

Recording the Present

Although the Navajo and Zuni collections were Culin's main interest, once he was in the field he enlarged his program to include other cultures. In 1903 he acquired a few pieces in the New Mexican pueblos of Acoma and Laguna, and in 1905 he visited the Hopi mesas in Arizona "for the purpose of collecting Hopi masks and ceremonial objects to be placed in the southwestern hall for comparison with those of Zuni." That same year he was also fortunate to acquire a "valuable collection of carved stone images, masks and fetiches [*sic*] from the Indians of Cochiti, New Mexico" that had been assembled by Father Noel Dumarest. Culin purchased the collection, which included a vocabulary and "an extensive unpublished account of the ceremonies" of Cochiti (see Fig. 28), from Noel Dumarest's brother.[18] In 1907 he spent a few weeks in and around Jemez, where he "obtained an interesting collection, chiefly referring to the local customs and industries."[19]

In addition to the Dumarest manuscript, Culin collected several other unpublished studies and vocabularies that previous investigators had compiled, as well as numerous photographs.[20] In his selection of photographs, he emphasized images of places he had been so that he could use them as illustrations in his expedition reports. After his trip to Jemez, for example, he "went over the photographs in the Bureau [BAE] and selected a number for the illustration of this report, comprising a series of pictures made by Mr. A. C. Vroman of Pasadena...of the pueblo of Jemez [Fig.

Fig. 29. The Plaza at Jemez. A. C. Vroman photograph from 1907 expedition report.

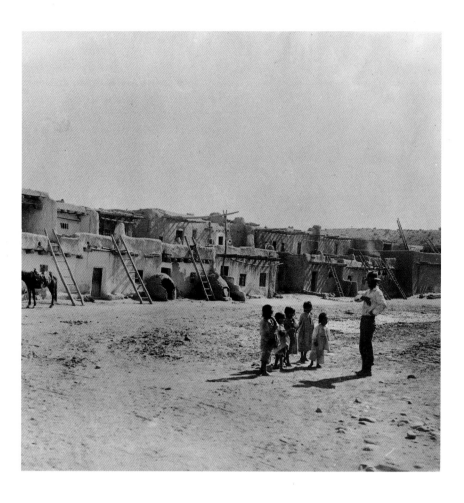

29]...and a very good photograph of the old church at Jemez Hot Springs made by Hillers" (1907a:216).

All this material provided a background for the Navajo and Zuni collections, which Culin justifiably considered his main achievement in the Southwest.

Discovering the Art of the Navajo

Occupying a "reservation of some 12,000 square miles in northeastern Arizona, and northwestern New Mexico" and constituting a population of 28,500, the Navajo presented Culin with some unique challenges. First, he had to find them: "Their homes hidden and inconspicuous, are scattered all over the country, both on and off the reservation, seldom in communities of even two or three together, but isolated, often many miles apart, their location being determined usually by water and arable land in which they plant their corn." When he did come upon one of their distinctive hexagonal houses, or hogans (Fig. 30), it was only to discover that their personal possessions were "extremely meagre. A few baskets and earthen pots, a mealing stone, with two or three grass brushes, constitute with an iron frying pan and a few dishes and tin cups the usual furnishings of a hogan." Culin summed up the dilemma he faced: "It will be understood that the Navajo, apart from a few baskets and their silver ware, offer few opportunities to the collector. Their masks and ceremonial objects are practically never sold, and are guarded with infinite care" (1904b:50, 54, 55).

The Navajo's complex ceremonial life had been studied by Washington Matthews, an army surgeon, whom Culin knew and admired. In 1902 Matthews published a monograph on the Night Chant, or Yebichai, "the

50

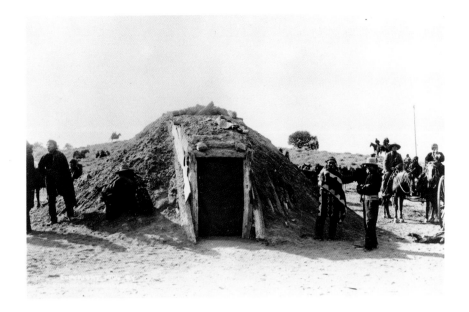

Fig. 30. *The medicine lodge of the Yebichai dance at Saint Michaels. Simeon Schwemberger photograph from 1906 expedition report.*

most popular ceremony, at the present time."[21] An elaborate nine-night performance, the Yebichai includes a public display of the God Impersonators, wearing buckskin masks. These masks, Culin wrote to the director in a letter outlining his plans for the first expedition to the Southwest, "do not exist in any Museum and are of great interest and value."[22] Consequently, he made a set of Yebichai masks his top priority for the Navajo collection.

While Culin coveted Navajo religious paraphernalia, he deplored the effect the religion had on the people: "The domination of the medicine man is the most harmful of all their native traditions. They impoverish themselves for the sick, almost invariably to the disadvantage of the patient" (1902b:24–25). As far as work was concerned, however, he found the Navajo praiseworthy: "The Navajo is distinguished among Indians for his capacity for hard, unremitting work. The women are industrious weavers and the men only need an opportunity for profitable labor. As Indians go, they are extremely well-to-do, their wealth consisting of herds of sheep and goats" (1904b:50). He also admired their physical appearance, especially that of the women, who "frequently retain their beauty until they are well advanced in years" (1904b:49).

Culin's work stands at the threshold of systematic collecting among the Navajo. Whereas the neighboring pueblos had been subjected to decades of scientific collecting, the Navajo were just beginning to be "inventoried." Although Culin was most attracted to the ceremonial objects, he recognized the need to document all aspects of the material culture in the interest of science in general and for his display at the Museum, where he wanted to compare Pueblo and non-Pueblo cultures. Thanks to the rich and varied stock he found at Day's trading post in Chinle, Arizona (Fig. 31), he was able to acquire material illustrating Navajo history, religion, games, and domestic life with one major purchase. By April 16, 1903, Culin could confidently write to the director, "With what I have already secured, you will have the best collection from this tribe ever made."[23]

At Day's, Culin began by sifting through a "considerable accumulation of old Navajo material, chiefly unredeemed pledges." He selected a complete costume for a man and a woman, a "very complete collection" of musical instruments and "practically everything that is contained in the hogan: mush pots, bowls, stirring sticks and the bunches of grama grass that are used both for the hair and all domestic purposes." Of agricultural

Fig. 31. Day's trading post at Chinle, Arizona. Ben Wittick photograph from 1904 expedition report.

implements, however, he was only able to find a planting stick (1903:9, 12–13).

Charles Day, who spoke Navajo fluently, helped Culin with his purchases. Culin found him "honest, frank and intelligent" and thought he "would make an admirable museum assistant and collector in the American field."[24] Culin's most important acquisition at Day's was a collection of historic material from Canyon del Muerto. "It consisted of the relics of a band of Navajo who were killed by Mexicans in the cañon about 100 years ago, the tragedy giving the cañon its name." The collection had been brought down by Mr. Day and his sons from a ledge "about half way up the perpendicular sides of the cañon at a place about 16 miles north of Chin Lee," where the walls of the canyon are from 700 to 800 feet in height. Culin noted admiringly that Charles "went in first. No white man had visited the place before" (1903:13–14). The Canyon del Muerto collection included household utensils, hunting implements, games, and textile fragments, all dating to the early nineteenth century. The term "never to be duplicated," which Culin tended to use rather indiscriminately, was fully justified in regard to this rare material, which gave his Navajo collection unusual depth.

Charles introduced Culin to Little Singer (Ha-ta-tsi Ya-zhi), a young medicine man who happened to be visiting the trading post (Fig. 32). Little Singer proved to be an imaginative and talented individual and Culin immediately put him to work "making the old time things."[25] He began by fabricating and explaining the implements for the principal Navajo games. Then, as usual, Culin moved toward the sacred and employed Little Singer to replicate the prayer sticks for some curing figures and a weathered set of ceremonial objects (Nos. 17, 18) that Charles Day had found in a crevice in the rocks above a cliff dwelling. Little Singer discussed everything he made in terms of its origins, materials, and significance (1903:21–22).

Knowing that medicine bags were very "difficult to procure," Culin considered himself "fortunate" to find three at Day's. Two of the bags had "been placed in pawn and not redeemed" (1903:16). In an informal report to the director, he described these as "the best Indian things I ever col-

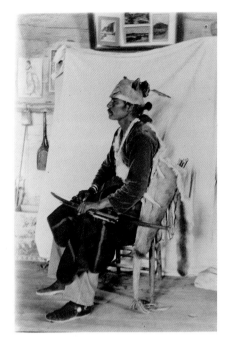

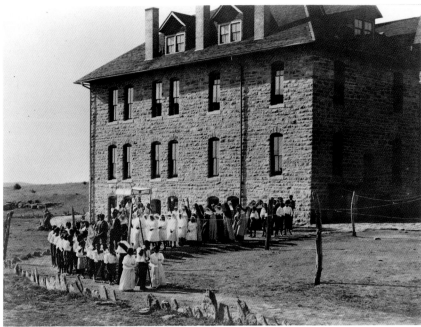

Fig. 32. Little Singer at Day's trading post. Charles Day photograph from 1903 expedition report.

Fig. 33. Procession at the school at Saint Michaels. Simeon Schwemberger photograph from 1904 expedition report.

lected."[26] Somewhat to Culin's surprise, Little Singer was not willing to make the sticks that were missing from one of the medicine bags. He also refused to make a shield: " 'He did not know the prayers' was his excuse" (1903:26). From these disappointments Culin learned about the specialization of knowledge among Navajo medicine men.

Several times Culin appealed to Little Singer "to identify doubtful things" in the archaeological material he catalogued at Day's. He was delighted when the medicine man "instantly recognized" an object made of twigs as a "charm used by the Navajo to keep away the Chinde [ghosts]." This identification also led to the acquisition of additional objects for the collection (see No. 12). Anxious to illustrate his point, Little Singer "went out and shortly returned with two old specimens, precisely like those in the cliff dweller collection, which he obtained from an old hogan near Chin Lee" (1903:24).

Culin's primary base in the Navajo region (in the absence of any settled village) was Saint Michaels in Arizona, a mission founded by the Franciscan friars in 1900. When Culin first visited the mission in 1902, the three friars were living in an "old Indian trading store" but a new house and school (see Fig. 33) were planned. Recognizing that a knowledge of the language was essential to their work, the friars were "preparing a dictionary of the Navajo language, of which the English-Navajo part, some 4,000 words," was practically complete. This project necessarily involved the friars in Navajo culture and religion, and they "showed the greatest interest" in Culin's work. Culin wasted no time taking advantage of this situation and employed the friars' Navajo interpreter "to make cat's cradles which I preserved by pinning to stiff paper" (see Nos. 39, 40) (1902b:19).

Subsequently, Culin provided the friars with objects he had collected to use as a basis for discussions and, conversely, drew on their research for ideas for his collection. In 1908, for example, reviewing the dictionary with Father Berard Haile, he learned of several objects "not in our collection which I should like to have reproduced in the museum" (1908:7). In 1910 the friars published *An Ethnologic Dictionary of the Navajo Language*. More an encyclopedia than a dictionary, the book includes a large number of

their children, or similar purposes. Dolls and images of some animals, however, are at times carved in cottonwood for ceremonial purposes, which suggests a possible motive for the social taboo placed on some of them. When the death of a snake, a duck, a chicken, a bear, a dog, or a pig, and of a child, has been witnessed by a pregnant woman, or by her husband during her pregnancy, or have been at any time killed by them, and subsequently indisposition and sickness overtakes the woman or her offspring, a singer is called upon to remove such a cause by performing certain features of a given rite over her. In the snake rite (nat'óye bakháji), for instance, the singer carves the image of the species of snake, the rattler, for instance, which presumably has caused the sickness, and after placing it on the affected parts of the patient's body, the

Doll.

image is deposited into the hole of that snake, together with the prayerstick made for it. Similarly, the image of the bear is deposited in the den of a bear, and that of a coyote into the coyote's den. The image of the dog is carried to an open field, barren of brush and tree, which has not been used as a thoroughfare (qadoholt'éji, or k̓ihunezláji, an open field). Here it is placed on the ground with the snout pointing in the direction of tséyi'i, a cañon near Los Torreones. The awéshchin, or dolls, the bisóde, pig, mósi, the cat, and nahóqsi, the chicken, are deposited in any of the numerous cliff dwellings or ruins (níyá'k̓ĕd, níyá'k̓ĕgo, underground place) with which the Navaho country abounds. The prayers accompanying the application of these four images are recited in a foreign language, but the fact that descendants of Hopi clans are usually called upon to make

Duck.

Fig. 34. Page from An Ethnologic Dictionary of the Navajo Language *illustrating the duck and doll Culin acquired at Day's (Nos. 14, 15).*

drawings "from actual specimens on exhibit in the Museum of the Brooklyn Institute of Arts and Sciences"[27] (see Fig. 34).

In the company of the energetic friars, Culin explored the Navajo reservation in 1903, going north to the Lukachukai Mountains. Whereas the friars were interested in locating missions, Culin saw "great prospects for collecting" at remote trading posts.[28] Nor was he disappointed. Recently the Navajo had "agreed among themselves not to buy each others pawned stuff," and Culin "as an outsider" was able "to make many excellent purchases of unredeemed pledges" (1903:72). In addition, he met the famous Navajo chief Black Horse, whose "face showed character and intelligence and…manners were the perfection of courtesy." Luckily, Culin had his camera with him because "contrary to usual Indian custom" (1903:65), Black Horse was happy to pose with his family (Fig. 35). Although Culin was not always successful with his camera,[29] 1903 was a good year and he returned to the Museum with 286 photographic negatives.

As an amateur photographer, Culin was able to appreciate the fine work of Simeon Schwemberger, a lay brother at the mission. In addition to doing the cooking and domestic work of the mission house, jobs that he apparently accomplished without skill or grace, Brother Simeon was the official photographer for first communions and other events at the school. He constantly expanded his photographic work to include Indian subjects, for which there was a commercial market. Culin was a steady customer, purchasing more than ninety prints, which he included in his expedition reports. Whether the subject was the interior of the kitchen in which he reluctantly worked (Fig. 36) or a Navajo in full warrior's regalia on horseback (Fig. 37), Schwemberger managed to create a clear and evocative image. He was also adept at conventional touristic portraits.[30] A good example of his early commercial work is the photograph of Culin, rifle in hand, in front of a Navajo textile (Fig. 38).

In addition to photographs, Culin used drawings made by the children at the mission school to illustrate his expedition reports. He was particularly pleased with one (Fig. 39) that was "very well executed, of the Yebichai dancers," done by a nine-year-old boy. The boys at the school had started a small industry casting ornaments in molds that had been cut in the rocks with solder collected from old tin cans. "They did this work secretly, and when they were approached, concealed the materials so that no evidences were visible" (1908:6). One of the Franciscan friars, understanding the breadth of Culin's interests, kindly provided him with two examples of this illicit jewelry.

Another major influence on Culin's Navajo collection was the trader J. Lorenzo Hubbell, whose hospitality in a land where "the guest is sacred and always welcome" was legendary. Culin considered traders his "best and truest of friends, and my faithful allies in my work in the field." He described Hubbell as living "in a patriarchal state, dwelling in a great adobe house, amid his servants and retainers" (1904b:7). Mexicans and Indians benefited as much as visiting easterners from Hubbell's generosity and expertise on local topics, whether textiles, politics, or collecting. It was Lorenzo Hubbell who first set Culin "upon the track" of a set of Yebichai masks. This was the beginning of one of Culin's longest and most delicate negotiations, which is documented in detail in his expedition reports and correspondence with the director. In the end, Culin's patience and persistence paid off. The set of masks he finally purchased in 1904 (Nos. 52, 53) "proved to be the very set which Dr. Matthews had tried, unsuccessfully, to obtain" (1904b:55, 59).

Culin admired Hubbell as a patron of Navajo textile arts, noting that he

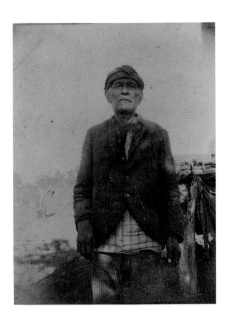

Fig. 35. Black Horse. S. Culin photograph from 1903 expedition report.

"has done more than any other man to improve the Indian blanket industry. His blankets are works of art, examples of the one native American art that survives as a living, profitable, industry, and are vastly different from the tawdry fabrics constantly sold as Navajo blankets throughout the country" (1902b:22). In spite of his close friendship with Hubbell, Culin purchased very few Navajo textiles for the Museum. Those he did acquire were utilitarian blankets, used in daily life (No. 41). All of them show signs of wear, and several have been mended.

One argument Culin made against buying Navajo textiles was that the Museum already had a "representative" collection, but this claim is not supported by the evidence. Although there are a number of unprovenanced textiles in the Museum storeroom, which were included in an exhibition Culin organized in 1925 (see "The Road to Beauty," p. 42), they can hardly be considered representative. Nor were Navajo textiles listed in Culin's review of the previous holdings of the department.[31]

Clearly, Culin did not overlook Navajo textiles from lack of interest. He was quick to buy blankets for his personal collection and in one instance purchased "an old blanket, apparently Navajo, with red and green cross stripes" for a considerable price. This acquisition, however, reflects Culin's competitive spirit as much as his aesthetic preference. Another collector had offered forty dollars for the blanket. On hearing this, Culin was "tempted to try to buy it" and "did so; paying $45" (1907a:40–41).

Toward the end of his life, Culin wrote to an acquaintance revealing what was perhaps the real reason for Brooklyn's scant Navajo textile holdings:

> Navajo blankets and Navajo weaving fill my mind. I did not feel justified in buying blankets for the Museum when I made our collection. They did not seem to fit in with the somewhat severe ethnological exhibits I had in mind. At the same time, I could not resist the opportunities I had and bought myself at a fraction of present prices some very fine old blankets which I can draw upon when we need such material for our display.[32]

In the end, Culin was most impressed by Navajo religious arts; the focal point of his first Navajo display was a model of a medicine man. In an address delivered at the opening of his final installation (see "The Road to Beauty," p. 37), Culin dismissed textiles along with pottery-painting and basketmaking as "the work of women," which had little in common with the "real art" of the American Indian. Reminiscing about the time he spent in a Franciscan monastery "in the heart of the Navajo Indian country in Arizona," he recalled his initiation into the dark secrets of an alien but vital religion:

> All day the sun shone and the wind blew and Indian visitors, men, women, and children, fierce, serious folk, untouched by Christian influence would come and go....The Navajo singers, the priests, the necromancers were frequent visitors and the Fathers sheltered a youth charged with witchcraft whose life was threatened. In this house I.learned of those ceremonies by which the world was recreated, rain produced, crops insured and life maintained. I learned of the malignant arts by which a distant enemy may be destroyed....In this house I learned of those strange pictures, never seen by profane eyes, drawn with colored sand upon the clay floor of the hogan, epitomising the cosmos, the winds, the thunder, all nature's forces.[33]

Ironically, in a Christian monastery, Culin learned to respect the ceremonial arts of the Navajo. With the passage of time, Navajo art became for him a model of pagan virility, a place to return "as a source of refreshment" in an increasingly bland and homogenized world.[34]

Fig. 36. The kitchen at Saint Michaels. *Simeon Schwemberger photograph from 1904 expedition report.*

Collecting Cushing's Legacy at Zuni

The memory of his close friend and colleague Frank Hamilton Cushing constantly guided Culin's collecting in Zuni. Cushing had lived at Zuni for four and a half years, from 1879 to 1884, and had succeeded in becoming a member of the tribal council and the Bow Priesthood. Other prominent anthropologists had worked at Zuni,[35] but Culin considered Cushing its "real discoverer" (1904b:5) and himself Cushing's heir. Looking down on the town for the first time in 1902, Culin was filled with emotion: "Zuni was at last a reality. No longer vague and far away, the centre of a world of fancy which the genius of my dear friend Cushing had created, but a solid substantial Indian town" (1902b:2).

When Culin began collecting for Brooklyn in 1903, the population of Zuni was estimated to be 1,540. In addition to the main town, located forty-five miles southwest of Gallup, New Mexico, there were three "dependent farming villages": Nutria, Pescado, and Ojo Caliente. After the harvest, the occupants of these villages moved back to Zuni, where the houses were "compactly built, with a large plaza or court in the centre, within which are the church [Fig. 40] and graveyard." Culin found the effect of the town "harmonious and pleasing" (1904b:38, 39). He enjoyed the people as well, noting they were "courteous and hospitable," and "kind and affectionate to their children." Like the U.S. Government, however, he considered the old town a source of health problems and predicted its demise: "The process of disintegration, now started, will progress rapidly, and old Zuni as it exists today, will soon disappear" (1903:101, 102). During the three seasons he collected there—1903, 1904, and 1907—nothing he observed reinforced this gloomy prediction, but he continued to maintain it.

Each year he went to Zuni, Culin spent from two to five weeks in the town, and his expedition reports include many photographs of the village and the countryside, and vivid descriptions of the community. He usually stayed with Andrew Vanderwagen (see Fig. 41), the missionary who opened and closed a trading store during the period Culin was a regular visitor. He was also friendly with Douglas Graham, a trader who had resided in Zuni since 1879 and was a "warm admirer" of Cushing (1902b:2). With these contacts, Culin was inevitably caught up in communal events.

 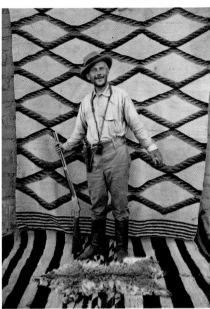

Fig. 37. Hashke Yazhe. Simeon Schwemberger photograph from 1906 expedition report.

Fig. 38. Stewart Culin at Saint Michaels. Simeon Schwemberger photograph.

He observed traditional dances and participated in the annual picnic of the Zuni training school. Depressed and alarmed by an outbreak of diphtheria, he helped to secure serum for a sick child. In contrast, he was pleased to see the church repaired and reported enthusiastically on progress on the construction of a new school and the building of a new dam at Black Rock. Most of his time, however, he spent collecting, relying primarily on Nick (Fig. 42), the adopted son of Douglas Graham, as his Zuni interpreter and guide.

Nick (Tumahka) was one of two interpreters in Zuni. The other was known as Zuni Dick (Tsinehe). Both these men had worked with other anthropologists and were familiar with their needs and interests. After an initial trial with Dick, Culin selected Nick, with whom he developed a close professional relationship. In addition to Nick's command of English, Culin benefited from his "excellent memory," "intimate knowledge of Zuni ceremonies" (1907b:1), and familiarity with the competition in town. Nick provided Culin with information on his rivals in the field, especially Matilda Coxe Stevenson, who was determined to claim Zuni as her own. This formidable lady also had a proprietary interest in Nick, as is indicated by a brief note she wrote to Culin in Zuni: "If Nick who is regularly employed by me, can be of any service to you tomorrow please let me know by bearer and I shall be very pleased to send him over to you."[36]

Matilda Stevenson had accompanied her husband, the ethnologist James Stevenson, and Frank H. Cushing on the BAE's 1879 collecting trip to Zuni and, after James Stevenson's premature death, had continued his work. Not only were she and Culin in competition over objects and informants, but they disagreed completely on the subject of Cushing. Culin was convinced that she would stop at nothing "in her efforts to blacken Cushing's character." He responded by ridiculing her whenever the opportunity arose and by doubling his own efforts to validate Cushing's work by acquiring every artifact described by Cushing or associated with him, including several "relics of Cushing" (1904a:24), such as the camp stool he had used at Zuni.

Nick assisted Culin in writing museum labels and, in the process, made Culin aware of what was needed to complete the collection. In 1904, for example, Culin's list of missing items included "the shell and deer hoof

Fig. 39. *Yebichai dancers. Drawing from 1908 expedition report. The Navajo boy who made this drawing was a student at Mother Catherine's school at Saint Michaels, Arizona.*

rattles, the sheep skin drum and the tallies used in keeping count of days and sheep" (1904a:50). Eventually, he had the sheepskin drum made to order and Nick himself carved a tally stick for him. Nick also was able to reproduce most of the games Culin wanted (see No. 119) and enthusiastically restored incomplete pieces. Observing a painted gourd that Culin had purchased earlier from the trader Emmet Pipkin (1903:28), Nick explained that it "was employed in the Harvest Dance mounted on a long pole, along which was stretched a decorated g-string. A fox skin was attached to the gourd and parrott [sic] feathers and red goat hair affixed to the top. Nick procured a pole for me, and redecorated the gourd so that I could reconstruct the object in its original form" (1903:105). Although Culin valued Nick's advice on objects, he did not always follow it. Nick questioned the authenticity of a pecked stone head a woman said had been found at the ruined Zuni village of Hawikuh, but Culin, finding both the stone and the story convincing, purchased it for twenty-five cents (1904a:25).

In addition to assisting Culin in the selection, evaluation, and production of artifacts, Nick served as his primary informant for an ambitious compilation of "Zuni Notes." Consisting of 370 typescript pages, "Zuni Notes" is organized as a comprehensive encyclopedia starting with the "Universe" and ending with "Miscellaneous," a category that includes "Memory, Palmistry, Pictographs, Sign Languages, and Sight." The source for Culin's categories is unclear, but obviously it was not Nick, as there are several topics (including "hydrophobia," "enemata," "the evil eye," and "vampire") on which he has nothing to say. Culin may have been relying on a questionnaire designed for European folklore studies or may have simply covered every topic he could think of in hope of discovering new information. The entries always include the native terms and explanations of their

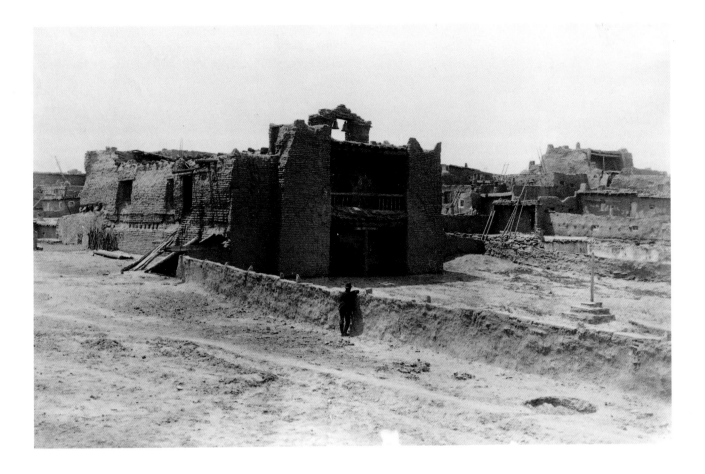

Fig. 40. The church in Zuni, New Mexico.
Ben Wittick photograph from 1904 expedition
report.

significance with concrete examples drawn from both past and present. Cushing is by no means absent from the "Notes" and remains for Nick as well as Culin the ultimate authority on the way things were. The whole project has a close relationship with the Navajo ethnologic dictionary, which was being compiled at the same time. In 1907 Culin reviewed his "Zuni Notes" with Father Haile, one of the authors of the dictionary, and "promised to send him copies so he could interrogate the Navajo along the same lines" (1907a:207). While language was Father Haile's main interest, however, it was for Culin a means to an end: through language, he hoped to discover the meaning and origins of things.

Culin and Nick made the rounds of the village in search of "old things," a strategy that yielded more than five hundred catalogue items and earned Culin the nickname Inotai, or Old Thing. "I came just at the right time," Culin wrote to the director. "The people were crazy to sell, and for many things 5 cents, the smallest coin, was enough." He went on to describe his acquisitions, stressing their comprehensiveness: "I got all the games...all the musical instruments...all the agricultural implements, all the weapons...I also succeeded in getting two complete old costumes, a man's and a woman's....The man's is a replica of the one Cushing wore."[37]

What Culin was able to purchase readily in Zuni was, in fact, household refuse, things the Zuni no longer used that the women (Culin's "best purveyors") were happy to convert into cash. Culin simply bought everything he was offered and then set about making sense of it by commissioning what was missing in relation to recorded pieces. His commissions at Zuni included several major productions, such as a pair of shields (see No. 114), a plough, and a complete man's costume. For the outfit, Culin managed to find the blue woolen shirt (see No. 104), "one of the two or

59

three left in town," but "the buckskin trousers ornamented with silver buttons, had entirely disappeared." Nick took him to the house of "a very old man named Ma-li-na" (Fig. 43) from whom Culin ordered the breeches and moccasins, providing the buckskin himself (1903:93, 94).

There is one poignant failure in Culin's commissions. He was particularly interested in stone blades, those quintessentially Indian tools. He had seen Cushing deftly making one and found the "process, as illustrated by Mr. Cushing, was one of amazing rapidity" (1904b:19). Nick told him that the old Zuni were still able to make stone arrowheads, and the tailor Culin employed "promised to show me when he got the material" (1903:92). The tailor never fulfilled his promise, however, and Culin finally gave up his efforts "to find any one in Zuni who is familiar with the old art of flint chipping" (1904a:33). As far as Culin was concerned, Cushing was the last arrow maker in Zuni.

Ironically, everything Culin collected firsthand in Zuni was either very old or very new; practically none of the objects were in use when Culin acquired them. For exhibition purposes, neither the particular history of the object, nor its present function concerned Culin as long as the form and materials were correct and they told the story of Cushing's Zuni.

Sacred and ceremonial things were essential to this story, but they were not available in the village and even Nick made "a point of not selling masks, dolls, prayer sticks, and other sacred things in Zuni" (1907b:2). In 1902 the women had "declined to sell the dolls at any price," and when Culin managed somehow to buy a few masks, "a cryer was sent around, who called out to the people and cautioned them against selling me any masks, and I was told that the sale of masks was punished by death" (1902b:4). In 1903 he experienced the same disappointment: "The only things they did not offer were masks, dolls, and sacred objects." Furthermore, he was informed that "men deputized for the purpose were constantly watching my purchases to see that no one sold me masks or ceremonial objects. That this may have been true is suggested by the fact that no such objects were offered me" (1903:89, 104).

Nevertheless, sacred things were in circulation among traders. In 1903 Vanderwagen told Culin that "in the interval since my last visit he had secured some 50 different wooden dolls, or effigies of the dancers, and 21 different masks, as well as the entire contents of three of the most ancient and sacred of the Zuni shrines from the neighboring mountains" (1903:32). Culin had begun negotiations with Vanderwagen for some of this material when he was still at the Museum of the University of Pennsylvania. Having examined them anew, he was determined to secure them for Brooklyn.

Culin had great respect for Zuni religion.[38] In 1902, on viewing a Zuni dance, he "was deeply impressed with the reverence and propriety with which the ceremony was conducted" and concluded, "The summary abolishment of the dances, in accordance with the recent order of the Indian Department must work an absolute harm to these unoffending people" (1902b:13). That same year, the sight of the shrine of the War God moved him to exclaim, "He would be an iconoclast indeed who would disturb this altar" (1902b:9). In subsequent years he had many opportunities to observe the strength and vitality of the religion. In 1907 he noted that the "ceremonies performed by the Kanakwe appeared to vary little, from those described by Mrs. Stevenson in her recent volume....They formed a 'U' shaped figure in the plaza, and sang with a peculiar rising quiver, a strange, and by me indescribable sound, that seemed as though it might have power to sway the earth in its orbit" (1907a:195). He also heard that "the recent Corn dance in Zuni was given for the first time in seventeen years" (1907a:166). In spite of all this evidence, Culin remained firmly

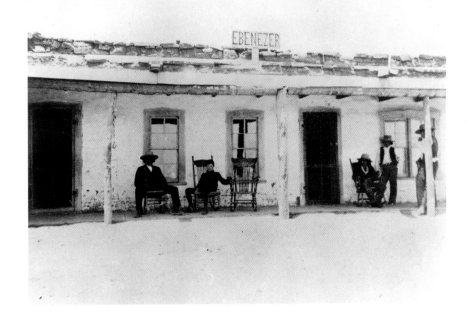

Fig. 41. Andrew Vanderwagen's house in Zuni, New Mexico. Photograph from 1903 expedition report.

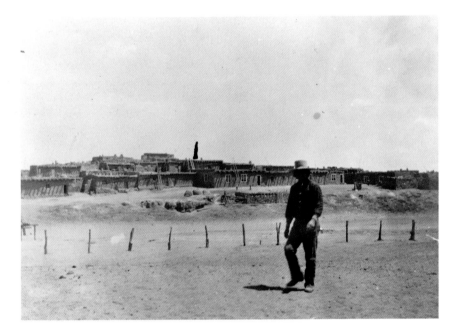

Fig. 42. The pueblo of Zuni from the south with Nick Graham in the foreground. Photograph from 1904 expedition report.

convinced that Zuni religion would vanish before its richness had been properly recorded and studied. For Culin, this richness resided not in the participants or in the dances and songs, but in the objects. The essence of Zuni religion was embodied in Vanderwagen's treasure trove.

"These things," he wrote to the director, "have been coveted by every visitor in Zuni since Cushing's time, and what he has, with what I have picked up here would give you the best Zuni collection in existence." "You could," he concluded dramatically, "do for Zuni what the Field Museum has done for the Hopi."[39]

Before a decision was reached, the Vanderwagen collection had grown. The final list included seventy-five dolls and twenty-three masks as well as the shrine material. Culin continued to press for the acquisition: "I have never in all my Museum experience seen a collection I was more anxious to secure, or one of more value, at any price, for Museum purposes." He also revealed his long-term goal: "I think it is likely we can get Aiken's [*sic*] portrait of Cushing and Cushing's Zuni costume from Mrs. Cushing, if we attempt to make Zuni a feature in our American collections."[40] In December 1903 the Museum approved the purchase.

Culin had an opportunity to supplement the collection of masks and dolls in 1904. Vanderwagen had engaged several Zuni ("ostensibly [employed] in sinking a well") to make kachina dolls and masks in his basement. Culin "purchased the entire lot...all different from the seventy-three secured in Vanderwagen's last collection," as well as all the masks (1904a:9–10).

In 1905 Vanderwagen met Culin in Gallup and announced that he had stored at his ranch "some twenty Zuni masks and about fifty dolls which he had made during the past winter. These he offered me at the same price I had heretofore paid. They are all different from those we have and would be an important addition to our collection" (1905:88). Culin was not able to purchase the dolls in 1905, and by 1906 it was clear that the Museum administration did not share Culin's enthusiasm for masks and dolls, at least not in such great quantities. The sum of $500 was approved for the purchase of ethnological specimens with one stipulation: "It is the desire of the Executive Committee that none of this amount be expended for the purchase of dolls and masks of the Southwestern Indians."[41] Culin ignored this clear signal and purchased the rest of Vanderwagen's collection in 1907, even though many of the masks had "been damaged by moths" (1907a:164).

Vanderwagen's cottage industry not only made it possible for Culin to acquire the "unobtainable," but also gave him control over the series, since the trader knew Brooklyn's collection and avoided duplication. Authenticity and quality, however, could not be guaranteed. Working in secrecy and under the pressure of a deadline, the Zuni doll makers had to mass-produce hastily what under normal conditions they would have turned out in a more leisurely fashion (see Nos. 82, 83). Furthermore, there was no critical audience within the culture, as the dolls passed directly from Vanderwagen's hands to the Museum collection.

The ceremonial objects Vanderwagen had acquired during his residency in Zuni presented different problems. In contrast to commissions, looting is not systematic and leaves the collector facing ethical questions and partial evidence; thus, Culin had somewhat misrepresented the completeness of the Vanderwagen collection's shrine material in his desire to persuade the Museum to purchase it. Once it was the Museum's property, however, he searched out the missing pieces, going to considerable trouble and expense to reunite a group of War Gods. Culin justified removing this material from Zuni on the grounds that he could restore and preserve it for the future.

Using much the same arguments, he carried off the carved columns of the old church in Zuni (Nos. 130, 131) and purchased the smithy's forge, "which had existed in Zuni as long as Mr. Graham could remember and had always been considered one of the sights of the town." If it were not confirmed by evidence in the Museum's storeroom, this remarkable acquisition might be considered a parody of comprehensive collecting: in addition to the anvil and bellows and all the tools, it included "all the clothing which the smith wore (see No. 106), two baskets of charcoal, a wooden seat or horse, powder and stone for polishing, and a stone mould for crosses" (1903:92).

Both the church columns and the forge documented Hispanic influence on Indian cultures. Culin was exceptional among early curators in his inclusion of this material. His guide to the Southwest Hall published in 1907 called attention to the fact that "the more recent historic period has not been ignored" and lists saddles, iron tools, ploughs, and "a number of interesting relics from the old church of Our Lady of Guadalupe" and the carved wooden columns "said to have originally formed part of the interior decorations of the church in the now ruined town of Hawikuh."[42] In assessing these acquisitions, which seem to contradict Culin's earlier dismissal of Hispanic material as irrelevant to the "remote past," it is important to keep several considerations in mind. First, both the forge and the columns had been discussed frequently in the literature. As landmarks familiar to every visitor to Zuni, they were desirable. Second, they were available, although in the case of the church columns, they were definitely not on the open market. As an avid collector, Culin could not resist the challenge they posed. He referred to the forge, which weighed 1,000 pounds, as the Zuni prize.[43] Finally, Culin used these acquisitions to make it appear that the collection was indeed comprehensive.

Nevertheless, the most recent period of Zuni history had been totally ignored. Culin's collection and exhibition still denied any traces of Anglo-American influence, with one notable exception: the focal point of the installation was the portrait (Fig. 5) of "Mr. Cushing, in his costume of a priest warrior of the Zuni order of the Bow, painted from life by Mr. Thomas Eakins of Philadelphia."[44] Culin's Zuni collection was as much a memorial to Cushing as a representation of the Zuni.

Prehistoric

1. Ladle

Anasazi; 900–1300
Ceramic, slip, L. 13¼, W. 5¼
Collected by Charles Day in Double Cave
Ruin, Canyon de Chelly, Arizona; pur-
chased in Chinle, 1903
03.325.10847
Purchased with funds given by A.
Augustus Healy and George Foster
Peabody

Culin purchased the trader
Charles Day's entire cliff-dwelling
collection, consisting of hundreds of
objects from several different ruins
within the Canyon de Chelly.
Although the collection was ran-
domly stored, Culin was able to
organize some of the material by site
"as identified by the Days" (1903:22).
This fine example of the black-on-
white painting style came from Dou-
ble Cave Ruin. Much of the pottery
from the ruins was chipped and bro-
ken. Culin noted on the catalogue
card with obvious satisfaction that
the ladle was "large" and "perfect." It
has a rattle handle, which would
have sounded whenever the ladle
was picked up. DF

2. Carrying Band

Anasazi; 1100–1300
Plant and animal fibers, L. 18½, W. 3
Collected by Charles Day in Canyon de
Chelly, Arizona; purchased in Chinle, 1903
03.325.11655
Purchased with funds given by A.
Augustus Healy and George
Foster Peabody

A variety of prehistoric textiles
have been preserved in the inner
rooms of the Canyon de Chelly. Two
sites that have yielded "major finds"
are Antelope House and White
House.[1] Culin noted on his cata-
logue card that this carrying band,
or tumpline, woven in a combination
of interlocked and slit tapestry
weave, came from the "1st ruin on
the right" in the canyon. It would
have been worn across the chest or
over the forehead to assist in sup-
porting a load on a person's back. DF

1. Kent 1983a:15.

3. Frog

Pueblo?; Canyon del Muerto, Arizona
Stone, L. 7½, W. 5½
Collected by Charles Day in Mummy Cave
Ruin, Canyon del Muerto; purchased in
Chinle, 1903
03.325.12362
Purchased with funds given by A.
Augustus Healy and George Foster
Peabody

This massive frog is one of several
puzzling objects Culin acquired
with the Canyon de Chelly material.
In 1907 Sam Day provided him with

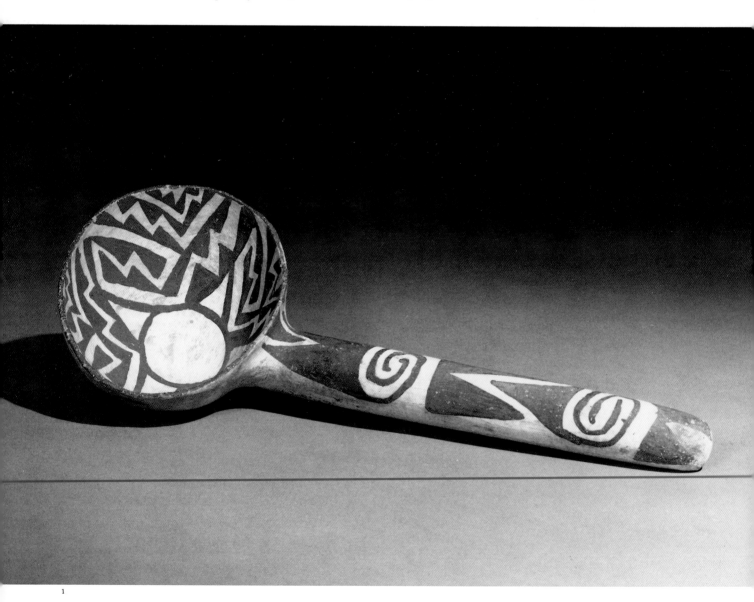

1

64

some additional information on the sculpture: "He told me, among other things, that the white stone frog in our collection came from the Mummy Cave ruin in the Cañon del Muerto" (1907a:80). A brief article on this frog published in 1953 raises interesting questions about the piece and suggests a Zuni origin.[1]

Both the material and the subject have special significance in the Southwest. The frog is associated with rain and fertility, and quartz is used in healing rituals and is often found in medicine bundles. A noteworthy feature of the frog is the way in which it is carved to conform to the natural shape of the stone boulder. DF

1. Chatfield 1953.

3

2

4, 5. Pitchers
Anasazi; 900–1300
Ceramic, slip, H. 8, Diam. 6¼; H. 6¾,
Diam. 5
Excavated by Joe White at Red Rock,
Arizona; purchased in Red Rock, Arizona,
1903
03.325.4162; 03.325.4175

One way to circumvent the problem of unprovenanced pots was to go directly to the relic hunters and examine the sites firsthand. This is the course Culin followed shortly after he arrived in Arizona in 1903. Hearing that "much pottery had been excavated" at Red Rock (also known as Red Round Rock and Hunter's Point), he drove north from Saint Michaels to inspect the ruins. Two former soldiers, Joe White and his partner J. B. Foley (see Fig. 12), had been digging at Red Rock for some time, and White was happy to offer Culin dinner and show him the "excavation." White had become

something of an expert and pointed out to Culin "what he regarded as the remains of an extensive ditch, with which the old inhabitants irrigated their fields." These two pitchers were included in a collection of sixty-eight pieces Culin bought from Foley for forty dollars (1903:4–5). Culin subsequently refused several lots that White offered him because he thought the price was too high (1904a:7). He was anxious to record the setting for exhibition purposes, however, and in 1905 sent the artist H. B. Judy to make a sketch of the "red rock which gives the place its name" (1905:34). DF

6. Bracelet
Anasazi; 1100–1300
Shell, H. 1, Diam. 3¾
Excavated by Joe White at Red Rock,
Arizona; purchased from Samuel E. Owen
in Gallup, New Mexico, 1903
03.325.4155

7. Pipe
Anasazi; 1100–1300
Ceramic, slip, H. 1, L. 2¾
Excavated by Joe White at Red Rock,
Arizona; purchased from Samuel E. Owen
in Gallup, New Mexico, 1903
03.325.4156

Joe White seems to have had a monopoly on antiquities in the Red Rock region. This bracelet and pipe were in a group of seventy-six pieces Culin purchased from Samuel Owen, "who was superintending the erection of the new Mission building at Saint Michaels"; most of the pottery had been dug up by White at Red Rock. Culin singled out these two pieces in his expedition report: "With it [the pottery] was a shell bracelet, carved with a frog, of great beauty. This bracelet was found in a small finely painted bowl, with a very perfect painted pipe of grey ware" (1903:74). The shell bracelet

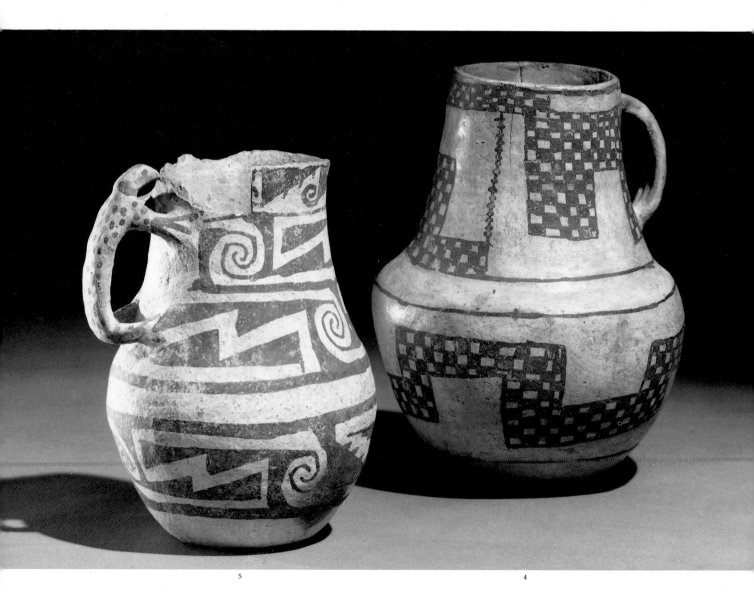

5 4

may well have been an import from the Hohokam people, based in the Gila and Salt river valleys of the Sonoran Desert, who exported both shell and finished artifacts made of shell to the Anasazi. DF

8. BOWL WITH CONTENTS
Anasazi; 900–1300
Ceramic, slip; contents: 10 stones of various sizes, H. 2½, Diam. 4½
Excavated in the vicinity of Saint Johns, Arizona; purchased from Reamer Ling in Saint Johns, 1903
03.325.3981.1–.11

Culin visited Saint Johns, located on the west bank of the Little Colorado River, in search of archaeological material to supplement his Canyon de Chelly acquisitions. He was impressed by both the quantity and the quality of the pottery from the location: "The entire hillside was covered with graves, from most of which artistically decorated bowls, pitchers, and ladles were recovered." No "systematic excavations" had been undertaken; most of the graves had been dug up by local Mexican residents (1903:39). The pottery was being sold by the firm of Ling and Barth. Culin made "a careful, but necessarily brief superficial examination of the ruins and the adjacent diggings" and purchased from Reamer Ling "a collection of small objects and some very choice bowls, including two which contain the remains of medicine men's outfits."[1] Ling informed Culin that the two bowls had been excavated by a Mexican in 1901 at Prospect, twenty-five miles north of Saint Johns.

The smaller bowl, illustrated here, has a rattle bottom. Originally there were nineteen stones inside: one stick of asbestos, one polished variegated tapering stone, one stone with a ring around the larger end, two polished water stones, four natural concretions, one polished jasper, three polished chalky stones, two crystals, two milky quartz pebbles, and two polished black stones.[2] Only ten pieces have been located, including the stick of asbestos.

The contents of this bowl confirmed Culin's faith in the strong connections between past and present in the Southwest. The Navajo and Zuni both valued the same kinds of stones and included them in medicine bundles and ceremonial offerings. DF

1. S. Culin to F. Hooper, May 14, 1903, Departmental Records.

2. List provided by R. Ling, Reamer Ling Collection, Object Files, Culin Archives.

7 6

8

9. BOWL

Anasazi; 1350–1400
Fourmile Polychrome: ceramic, slip, H. 4½,
Diam. 9½
Collected by J. Lorenzo Hubbell in the
vicinity of Saint Johns, Arizona; purchased
from C. W. Riggs, 1902
02.257.2562
Museum Purchase, 1902

One of a group of Fourmile
Polychrome wares the Museum pur-
chased in 1902 from the dealer C. W.
Riggs, this bowl is notable for the
charming procession of animals
painted on the outside. The trader
J. Lorenzo Hubbell was known to be
the original collector of these bowls,
and in 1908 Culin

took advantage of the opportunity to
interrogate Mr. Hubbell about the
painted pottery bowls which he sold a
man named Riggs many years ago and
which were subsequently acquired by
the Brooklyn Institute Museum. Mr.
Hubbell told me that these bowls came
from a cave close to Mineral, about
thirty miles southwest of St. Johns, Ari-
zona. The cave was first discovered by
two Mexicans who found the open-
ing....Mr. Hubbell heard of the cave, at
the time they had commenced to get
out the stuff. He bought the entire con-
tents for $330.

The interior of the cave was intricate,
with paths branching out in several
directions. "The pottery was in the
first and second caves, in little bun-
ches along the path, and arranged in
a semi-circle, the bowls piled on top
of each other" (1908:4–5). DF

10. EIGHT STONE IMAGES

Mimbres culture?; 1000–1100
Stone, pigments, H. 2¼–4¾, W. 1–2
Found near Sanders, New Mexico; pur-
chased from Cronemeyer and Schember in
Allantown, Arizona, 1903
03.325.4527–.4534

This extraordinary group of stone
images was found in a "painted gray
pot" by a Navajo named Dog Bite
near Sanders, New Mexico.[1] Culin
bought them from Cronemeyer, a
German trader, after a long negotia-
tion. Returning to Cronemeyer later
that year, Culin "secured another of
the painted sandstone images, one
which Mr. Cronemeyer said he had
obtained subsequently, but which I
regard as belonging to the original
collection...which I purchased on
my former visit" (1903:121). This
image (03.325.4005) is, in fact, con-
siderably less detailed than the

others, and its association with them
cannot be proved.

Except for the fact that they were
deposited together, little is known
about these figures. They range from
an abstract, grooved rectangle to a
relatively realistic depiction of a male
with his hands on his knees. Two
clearly represent females, but the sex
is not indicated for the others. One
of the female figures (left, second
row) may have originally been a
two-sided birth figure; the back has
broken off.

Culin was offered a similar group
of stone figurines by Reamer Ling of
Saint Johns, Arizona. These were
eventually purchased by Charles
Lummis (1859–1928), the writer and
ethnologist, whom Culin considered
a man of "exquisite taste" (1907a:159).
They are now in the collection of the
Southwest Museum, Los Angeles.[2]

In several respects the figures
resemble those painted on Mimbres
pots that were produced in south-
western New Mexico during the
eleventh century. Similarities include
the round heads, the thin arms in
angular postures, and the placement
of the facial features. A related stone

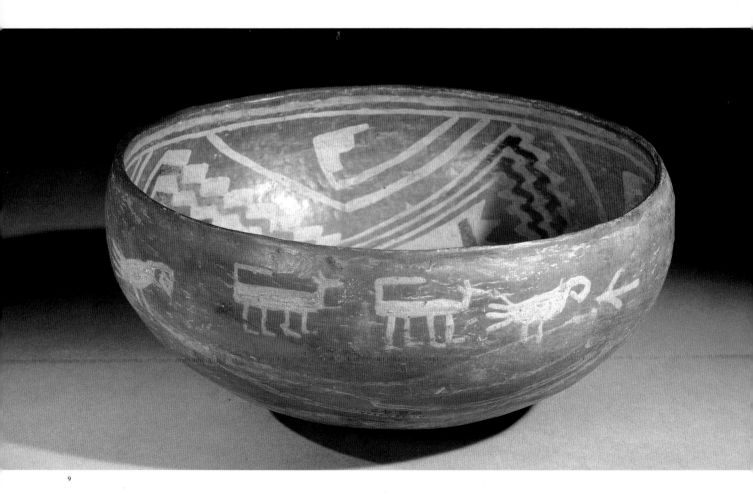

9

carving attributed to the Mimbres culture is in the collection of The Art Institute of Chicago.[3]

The significance of this rare prehistoric cache was not lost on Culin. After purchasing the group, he wrote to Franklin Hooper, Brooklyn's director: "I returned today with a collection of small objects, including seven painted stone images (idols) found in a jar, the most remarkable things of the kind ever discovered in the Southwest." Hooper responded with enthusiasm: "Your account of obtaining the seven sand-stone images or idols suggests the importance of working in the field rather than at arm's length, from an eastern museum."[4] DF

1. Culin locates Sanders in New Mexico. He was probably referring to the Sanders in Arizona on the map in this catalogue.

2. For an illustration of this group, see Moneta 1985:47. The figurines have retained much more of their original paint than those in Brooklyn.

3. Illustrated in Maurer 1979, fig. 2.

4. S. Culin to F. Hooper, June 26, 1903; F. Hooper to S. Culin, June 18, 1903, Departmental Records. In speaking of seven idols, Culin was obviously excluding the strange rectangle.

11. BOWL
Sikyatki; 1400–1625
Ceramic, slip, H. 3¾, Diam. 10½
Given by Father Anselm Weber in Saint Michaels, Arizona, 1903
03.325.4328
Gift of Father Anselm Weber

Returning to Saint Michaels after a brief trip, Culin found that "Brother Simeon had been looking out for [him]" during his absence and had purchased a small group of choice objects, including this "prehistoric Hopi painted bowl with two figures of extraordinary interest" (1903:110). The bowl, which had come from a ruin three miles from Keam's Canyon, is a wonderful example of the Sikyatki style, named after the prehistoric Hopi site located on the eastern terraces of First Mesa. J. W. Fewkes, the Smithsonian archaeologist who began excavating the site in 1895, considered Sikyatki ceramics "superior to any pottery made by ancient or modern Indians north of Mexico."[1]

Although the painting in the interior of the bowl, representing a hunter and his prey, is in good condition, the bottom of the exterior of the bowl is very worn. Several losses in the rim have been restored. DF

1. Fewkes 1898:650.

10

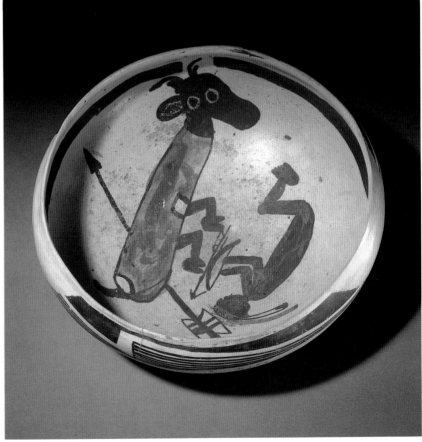

11

69

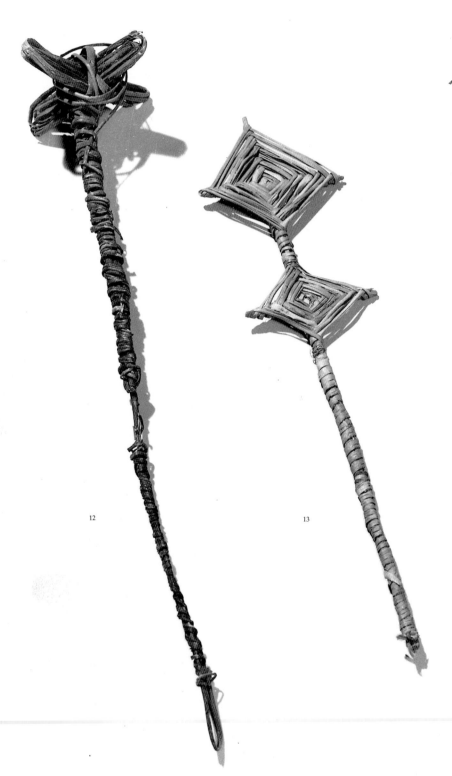

12

13

NAVAJO

12, 13. OWL CHARMS

Navajo
No. 12: Plant fibers, pigment, H. 16½,
W. 4¼
No. 13: Made by Little Singer
Plant fibers, H. 13¾, W. 3¼
Purchased from Little Singer in Chinle,
Arizona, 1903
03.325.3676; 03.325.3677

Included in the cliff-dweller mate-
rial Culin had purchased at Day's
were "a number of objects made of
twigs" similar to an artifact in the
Museum of the University of Penn-
sylvania F. H. Cushing had
identified as a "shuttle cock used at
betrothal." The medicine man Little
Singer, however, instantly recog-
nized them as charms "used by the
Navajo to keep away the chinde
[ghosts or spirits], and called them
nashja, or 'owl.' Some call them
bats." Little Singer proved his point
not only by finding an owl charm
hanging in an old hogan (No. 12),
but also by making one (No. 13). He
explained that the owl "is regarded
as an evil spirit. Ever since there
were chinde they have had these
charms. The chinde are afraid of
them. They are made of basketwood
and when people make baskets, they
make an owl first and put it up to
keep the chinde away" (1903:24).
Both these charms are illustrated
in the ethnologic dictionary with the
additional information that "they
were usually hung up in the evening
when, favored by the scant illumina-
tion of the hogan, the fancy of a
child might easily be led to believe
that the owl sitting there should
carry [him] off."[1] DF

1. Franciscan Fathers 1910:495.

14. DUCK
Navajo
Wood, pigments, L. 6¼, W. 1¾
Purchased from Charles Day in Chinle,
Arizona, 1903
03.325.3749.1

15. DOLL
Navajo
Wood, pigments, H. 7, W. 1½
Purchased from Charles Day in Chinle,
Arizona, 1903
03.325.3750.1

16. COTTONWOOD IMAGE
(HOPI DOLL)
Navajo
Wood, shell, pigments, H. 8, W. 1¾
Given by Father Leopold Ostermann,
O.F.M., Saint Michaels, Arizona, 1906
06.331.7887
Gift of Father Leopold Ostermann

One of the first Navajo ceremonial objects Culin saw was a "duck carved in cottonwood root" (No. 14). The trader Charles Day gave him the following information about it:

When a man is sick, his illness is attributed to some animal; dog, bear, snake, turtle, fish, duck, lizard, man, water dog or squirrel, and an image of one of these animals is carved and hidden away. No one will touch it afterwards.

The duck was made when the duck was the cause. The holes in the back are for white beads to represent the joints. It is put in a place where there is water, with a katan [prayer stick; see No. 49].

One of the Days had found the image in a field and brought it into the trading post. At the post Culin also found a figure of a man (No. 15) which he learned "represented a Hopi god, and was made when the Hopi god was regarded as the cause of the illness. It was offered up with a katan in some old ruin" (1903:15–16).

In purchasing these figures, Culin discovered Little Singer's potential as a collaborator. After "some hesitation," he agreed to make Culin copies of the "particular katan that are offered with each image. They are placed directly in front of the effigies. The doll is stood erect, and the duck, as if swimming" (1903:16).

In 1906 Culin acquired a third example of a Navajo figurine (No. 16) when Father Leopold gave him an image "representing a Hopi doll" that he had found at Chinle (1906a:107). This doll resembles the "Hopi god" (No. 15) in being very simply carved with thin legs and prominent calves.[1] Such an anatomical emphasis is characteristic of Navajo two-dimensional art, as well. (See, for example, the prayer board painted by Little Singer, No. 17.)

The figurines purchased at Day's, along with the *ketans* made by Little Singer, are illustrated in the ethnologic dictionary with some explanation of the Hopi association (see Fig. 34):

The prayers accompanying the application of these four images are recited in a foreign language, but the fact that descendants of the Hopi clans are usually called upon to make the dolls and images, and recite the prayers, would suggest that the language and the custom itself, as adapted to the Navaho, is of recent introduction and of Hopi origin.[2] DF

1. This doll has a small piece of shell embedded in the wood between the legs. In the other doll there is a hole that perhaps originally had a shell.
2. Franciscan Fathers 1910:496–97.

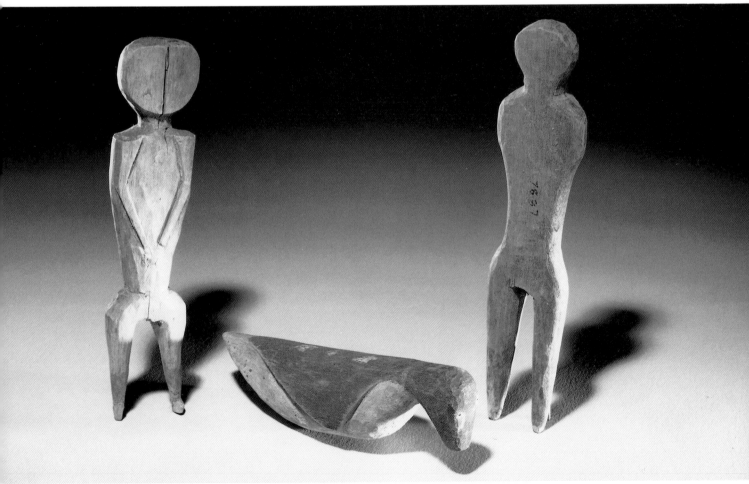

15 14 16

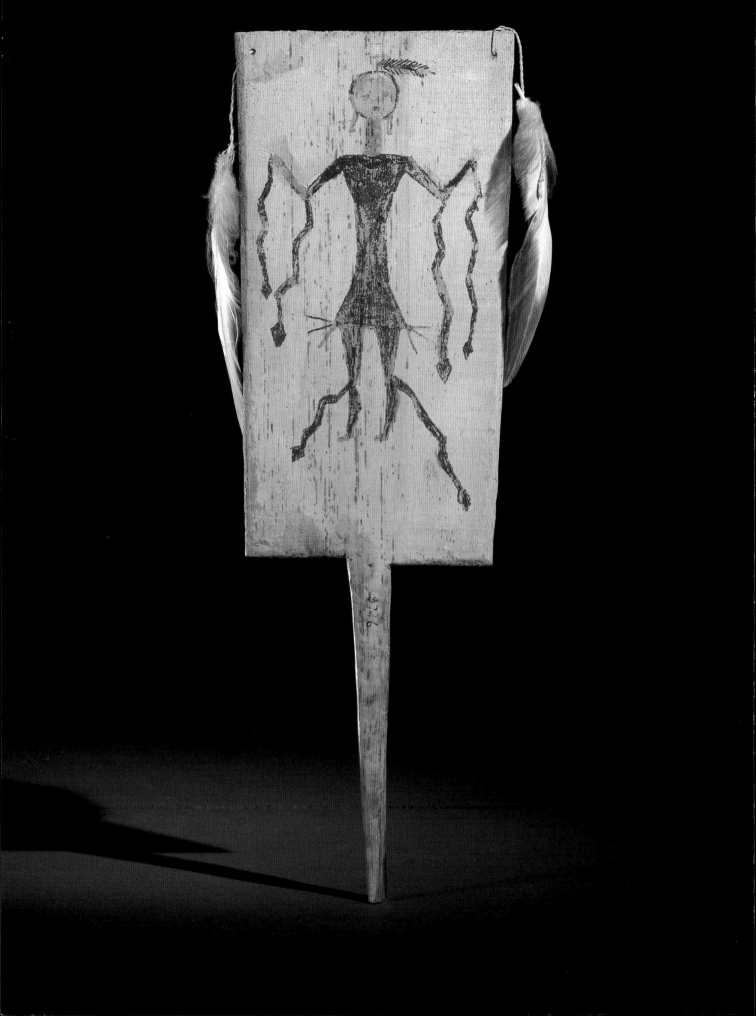

17. Wind-Altar Prayer Board
Made by Little Singer; Navajo
Wood, pigments, cotton, feathers,
H. 17¼, W. 5¾
Purchased from Little Singer in Chinle,
Arizona, 1903
03.325.3776.5

18. Wind-Altar Snakes
Made by Little Singer; Navajo
Wood, pigments, cotton, feathers,
L. 18, W. 2¾
Purchased from Little Singer in Chinle,
Arizona, 1903
03.325.3776.1–.4

After purchasing some "weather worn sticks" that Charles Day had found in a crevice above a cliff dwelling in Canyon de Chelly, Culin asked Little Singer to identify them.

He informed Culin that the "crooked" sticks had been used in a Navajo Wind Ceremony, although many of the pieces were missing. Culin at first proposed that Little Singer repaint the set and replace the missing sticks, but "reconsidered the matter [and] succeeded in inducing him to make me a new set, leaving the old ones as they were." The prayer board is "painted white and [has] on one side a figure of a man painted blue, called…'Blue Wind' and on the other that of a man painted black called…'Black Wind'" (1903:21–22).

The prayer board and snakes illustrated here were included in the Wind Altar that Little Singer fash-

ioned for the Museum. Although Culin did not comment on the rituals involved in the Wind-curing ceremony, he did repeat Little Singer's prescription for placement of the pieces: the altar consists of a "ridge or pillow" of sand running north and south. On the east side, six plume sticks are placed at equidistant intervals and the snakes are placed opposite them, on the west side, in the directional order of white, yellow, blue, and black. A feathered crook and the broad prayer board are "stuck in the ground" to the northwest of the altar. LMB

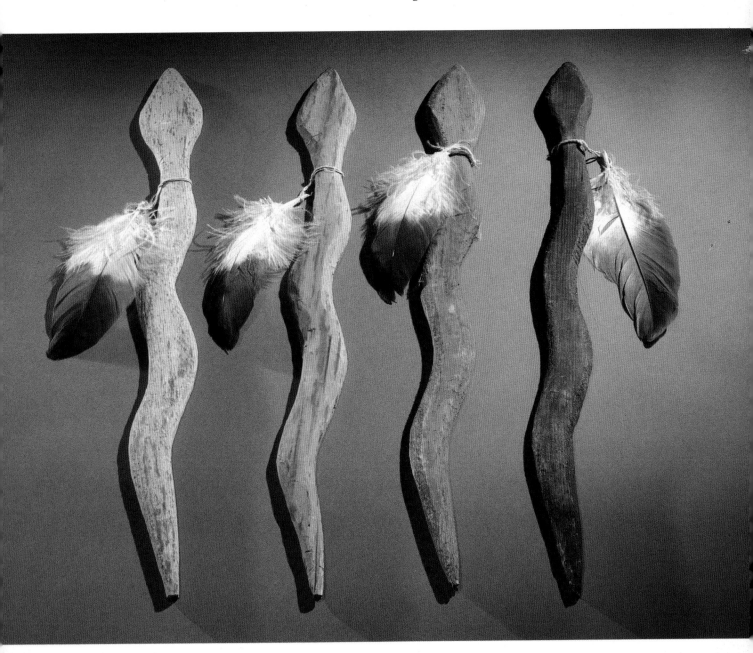

19. Carved Ornament

Hopi
Wood (probably cottonwood), pigments,
sinew, H. 15½, W. 24
Collected by Charles Day in Canyon de
Chelly; purchased in Chinle, Arizona, 1904
04.297.5633a

Among the many Navajo objects
that Culin purchased from Charles
Day was a cache of Hopi ceremonial
objects found in "an old Navajo
shrine," a cave thirty feet deep in
Canyon de Chelly. The discovery of
this Hopi "ornament" helped corrob-
orate a claim by the Asa Hopi clan
that their ancestors had lived in the
Navajo canyon for a short period
during the nineteenth and, perhaps,
the eighteenth century.[1]

A Navajo man, Billy Jones, told
Day about the shrine and its history,
and Culin repeated the information

in his expedition report. Long ago,
he said, the Navajo who lived in the
canyon gave shelter to a starving
Hopi woman and baby. When the
boy grew up, he visited his mother's
village and learned Hopi ways.
Some Hopi followed him back to the
canyon, where they performed Hopi
ceremonial dances during his life-
time. After the leader's death,
Navajos concealed the Hopi ceremo-
nial objects in the cave, where Day
found them (1904a:65–66).

According to Culin, Day had hired
Jones to make copies of sand paint-
ings for the photographer Edward
Curtis. "His mother told [Jones] that
her father said that he had seen one
of the dances which had gone on for
many years before.... Other Indians
told Charlie the same story"
(1904a:65).

Similar objects have been
observed held by the Hopi Yaya
priests in the "Lesser New Fire Cere-
mony" at Walpi.[2] This ornament
may have been used by the priests
to call on ancestral beings to bring
rain and other blessings: when the
wand is tilted, the two pendants
slide and clatter against their slots.
LMB

1. Culin 1906b:81, 1907f:113. J. W. Fewkes
said that this object furnishes "corrobora-
tive" evidence that the Asa clan, a Tanoan
people "now domiciled" in the Hopi pueblo
of Sichomovi, have lived at Zuni and have
"sojourned" in the Canyon de Chelly for
several years (Fewkes 1906:664).

2. This object is discussed in Fewkes 1906.
Illustrations of the wands carried by the
Yaya priests appear in Fewkes 1901.

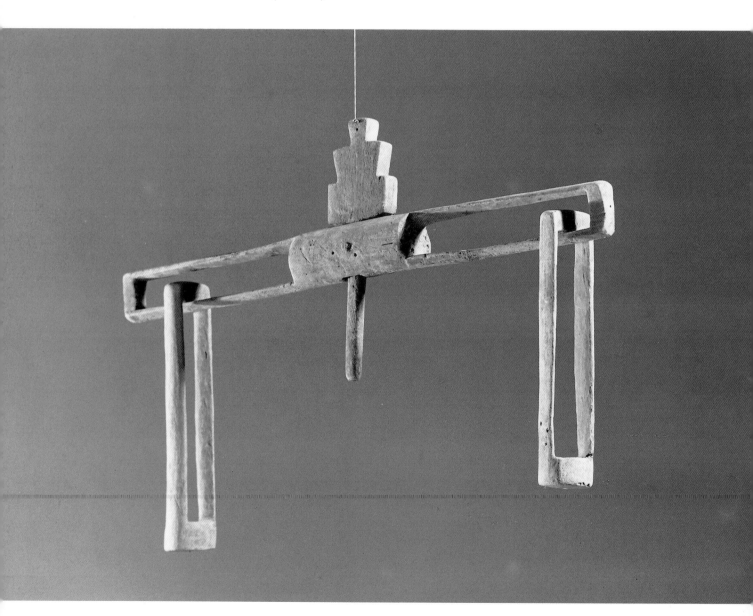

20. WOMAN'S BELT
Navajo
Wool and cotton commercial yarns, beads,
ribbon, L. 130, W. 3⅜
Purchased in Chinle, Arizona, 1903
03.325.3752

21. MAN'S GARTER
Navajo
Wool and cotton commercial yarns,
L. 43½, W. 2¼
Purchased in Chinle, Arizona, 1903
03.325.3755a

One of Culin's primary objectives was to acquire a "complete costume" of a Navajo woman and man. Disappointed that "the men dress in American clothes, with a felt hat with an imitation silver band," and that the women wore calico dresses with "about the only remains" of their old costume being buckskin moccasins and a woven red belt, he sought out the Navajo dress of an earlier era.

Finding that Day's trading post held a "considerable accumulation of old Navajo material, chiefly unredeemed pledges," Culin bought the "complete costume" of a Navajo woman—including this belt, which is unusual in that a length of red ribbon and one coral bead and one white bead are tied to its fringe (1903:9). These would not have been visible when the article was worn, however, because a Navajo woman traditionally secured her belt by tucking in the fringe. The extraordinarily fine garter was part of the purchase of the man's outfit; it was used in fastening leggings knitted by men.

Narrow band weavings such as the sash and garter were generally woven by women on a backstrap loom, but some "Indian informants consistently state that belts, garters, etc. are made on the same looms as the blankets."[1] The trader J. L. Hubbell showed Culin sketches that he had made of different Navajo looms, including those for belts, sashes, hair cords, saddle cinches, and cradle bands (1908:5). LMB

1. B. Haile to S. Culin, March 12, 1908, Correspondence. On Navajo belt looms, see Kent 1985: 30–31. B. Haile to S. Culin, March 12, 1908.

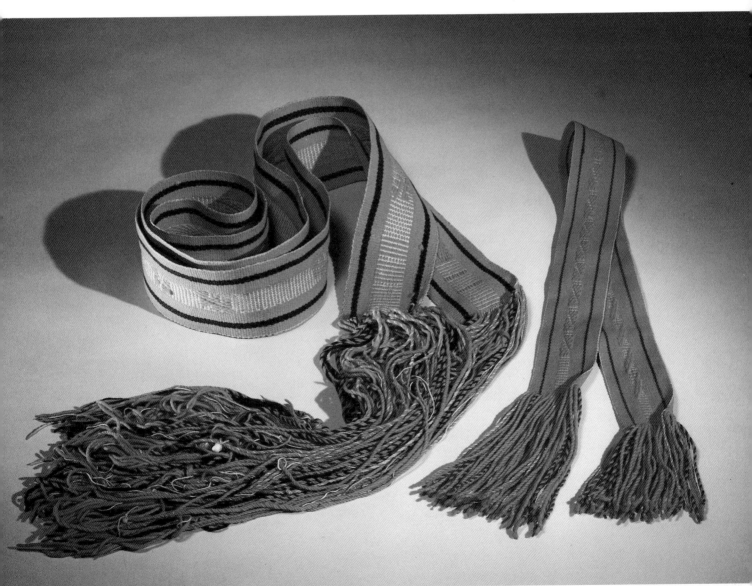

20 21

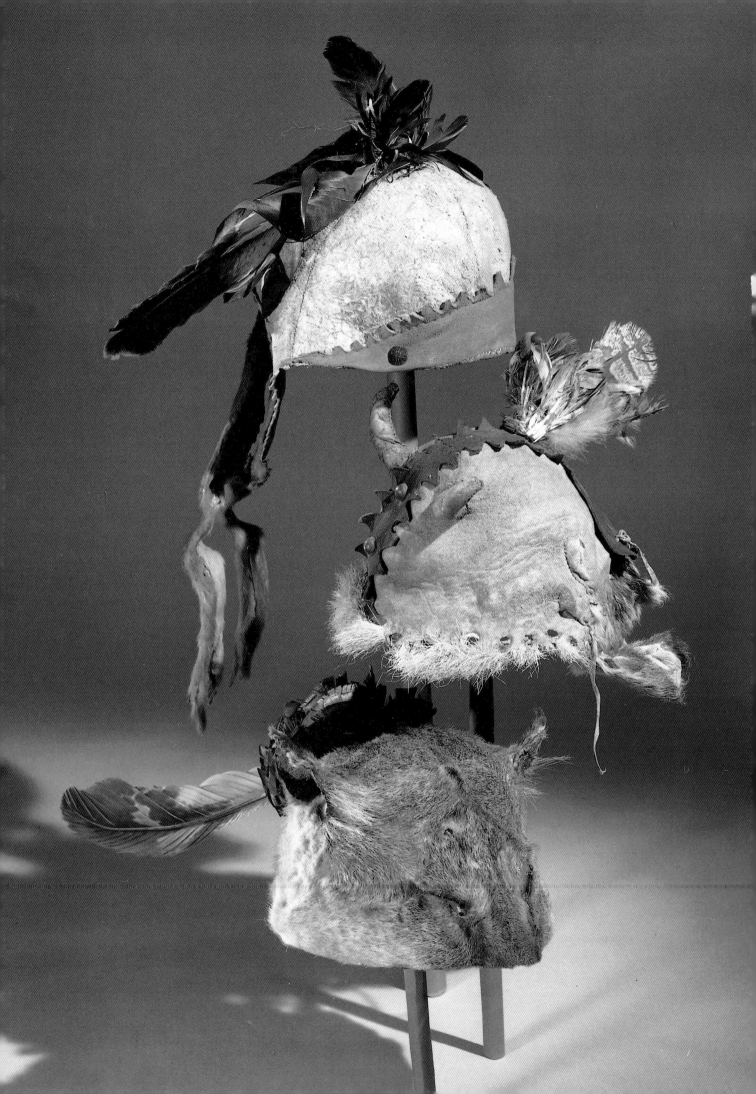

22–24. WAR BONNETS

Navajo

No. 22: Fur, hide, pigment, feathers, sinew, plant fiber, H. 6½, W. 9, L. 15
Purchased in Chinle, Arizona, 1903
03.325.3759

No. 23: Made by Little Singer
Hide, dye, fur, metal, feathers, sinew, wool, H. 8, L. 19
Purchased from Little Singer in Chinle, Arizona, 1903
03.325.3680

No. 24: Made by Little Singer
Hide, pigment, fur, feathers, metal (brass?), cotton, sinew, H. 6½, L. 14
Purchased from Little Singer in Chinle, Arizona, 1903
03.325.3772

Navajo caps such as these were worn by warriors on attacks and journeys.[1] They were commonly made of buckskin, although some clans preferred mountain-lion and wildcat skins, and offered considerable variation in style; many were decorated liberally with feather rosettes and abalone shell or shaped with artificial ears and high peaks.

Culin purchased No. 22 at Day's. His expedition report includes a photograph of Little Singer posed in this fur cap with a bow and arrow on his lap (see Fig. 32).

Subsequently, Culin commissioned Little Singer to make, under Charles Day's "direction," "a buckskin suit with a leather cap such as was formerly worn by the Navajo" (1903:56). He planned to use the suit for a life cast of a Navajo medicine man for his exhibition halls (see "The Road to Beauty," p. 33). Culin paid more than forty-five dollars for the outfit; the cost for the labor alone was twenty-five dollars. In the end, Little Singer had enough buckskin to fashion two caps: No. 23, with metal buttons, and No. 24, with artificial horns.

Anxious to see how the costume had turned out, Culin put on the suit and the horned cap and went to show off his commission to the Franciscan friars. There is a photograph of him in the expedition report play-acting the improbable part of Robinson Crusoe undergoing a "christening" (1903:137). The cap is clearly visible affixed to Culin's bowed head (see Fig. 13). No cap appeared, however, on the cast Navajo medicine man in the Museum's installation (see Fig. 15). LMB

1. Franciscan Fathers 1910:460.

25. CONCHA BELT

Navajo

Leather, silver conchas, iron buckle, brass rivet, L. 38¾, W. 3¼
Purchased in Chinle, Arizona, 1903
03.325.3682

Culin probably intended that this belt would adorn his Navajo woman's costume. Although it is the most expensive piece of Navajo jewelry that he purchased, Culin paid just twenty dollars for it. According to the ethnologic dictionary, the silver in each of the oval forms known as conchas was worth about three dollars. This belt of eight conchas is illustrated in that work, but the authors point out that most belts worn in 1910 consisted of ten to twelve conchas and were worth about forty dollars each.[1]

The belt is certainly an older example, as seen by the conchas' cut-out slots, through which the leather is laced. Once the smiths perfected the art of soldering, loops of silver or copper were attached to the underside of the silver conchas so that they could be left solid. LMB

1. Franciscan Fathers 1910:280–81.

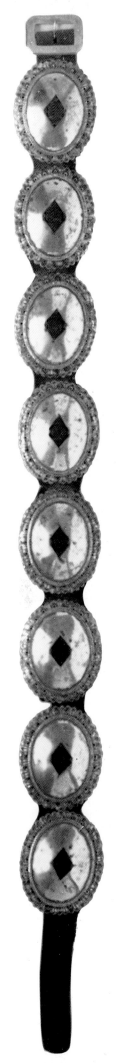

26, 27. Bracelets
Navajo
Copper, L. 2½, W. 2¾; L. 2½, W. 1¾
Purchased in Chinle, Arizona, 1903
03.325.3688; 03.325.3689

Culin bought a number of copper bracelets because they represented the fashion of an older era. Before silver became plentiful, about 1890, Navajos bought wire or small sheets of copper and brass at the trading posts or would cut the metal from kettles and pans.[1] Copper bracelets, Culin reported, passed as currency at the value of ten cents each (1903:76). LMB

1. Franciscan Fathers 1910:276. The authors add that the pots were sometimes issued by the government.

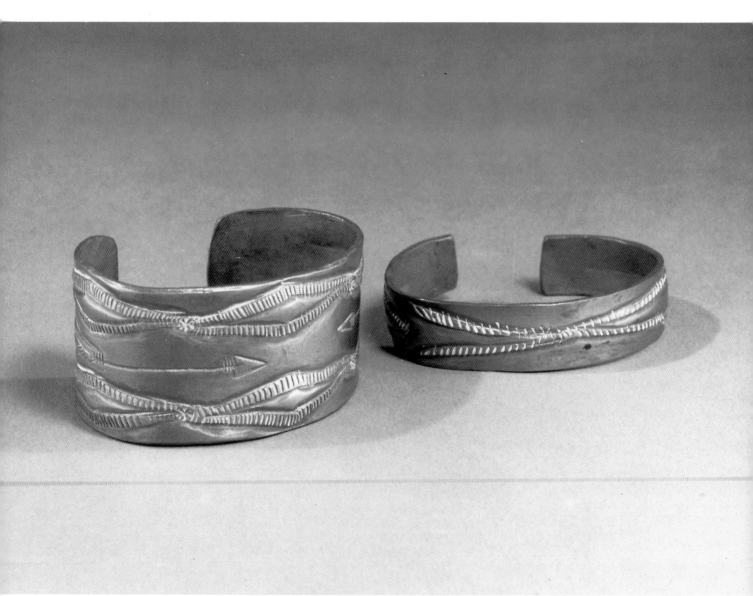

26 27

78

28, 29. WRIST GUARDS

Navajo
No. 28: Silver, brass, leather, L. 3½, W. 3¼
No. 29: Silver, hide, leather, L. 7¼, W. 3½
Purchased in Saint Michaels, Arizona, 1908
08.491.8927; 08.491.8933

Wristlets, or *ketohs*, were originally worn on a man's left arm as a guard against the snap of the bowstring. By the turn of the century, however, they were generally worn for purely decorative purposes. Ornamented by a silver plate, they are backed with a leather band that laces closed. The pieces shown here are outstanding in their composition. No. 28, unusual in its asymmetry, is illustrated in the ethnologic dictionary; No. 29 is particularly complex. LMB

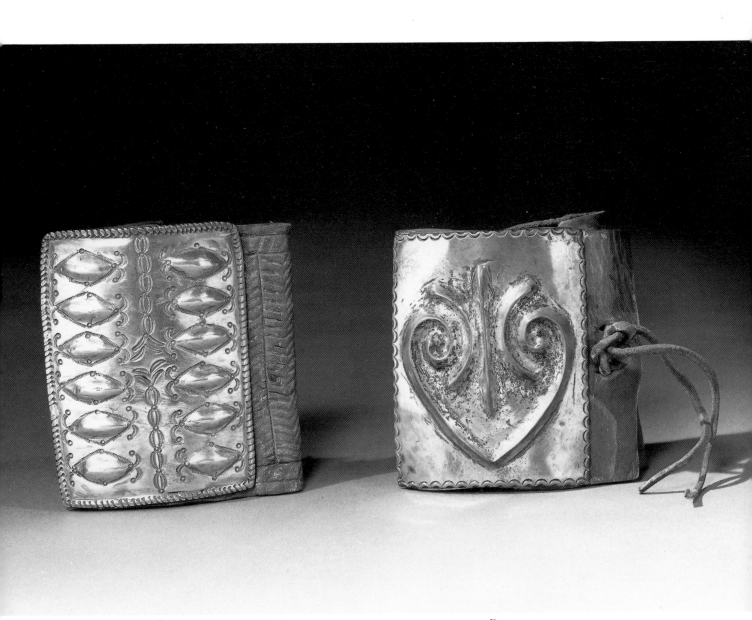

29 28

30, 31. BRACELETS

Navajo
No. 30: Silver, green stone, L. 2½, W. 2
X994.2

No. 31: Silver
L. 2½, W. 1¾
Purchased in Chinle, Arizona, 1903
03.325.3695

Although Culin did not comment on these particular pieces he no doubt agreed with the authors of the ethnologic dictionary, who held the work of Navajo silversmiths in high esteem. The authors stated that a description of the smiths' work would "hardly do it justice" and insisted that "it must be seen."

Toward that end, they illustrated several Brooklyn Museum examples, including this green stone bracelet (No. 30), as a "real work of art."[1]

Bracelets were crafted by men, but anyone could wear them on one or both arms and in any number. By the turn of the century, traders had introduced several other design elements to the smiths' wide repertory; among them were swastikas and, as shown, chiseled arrows (No. 31). LMB

1. Franciscan Fathers 1910:282.

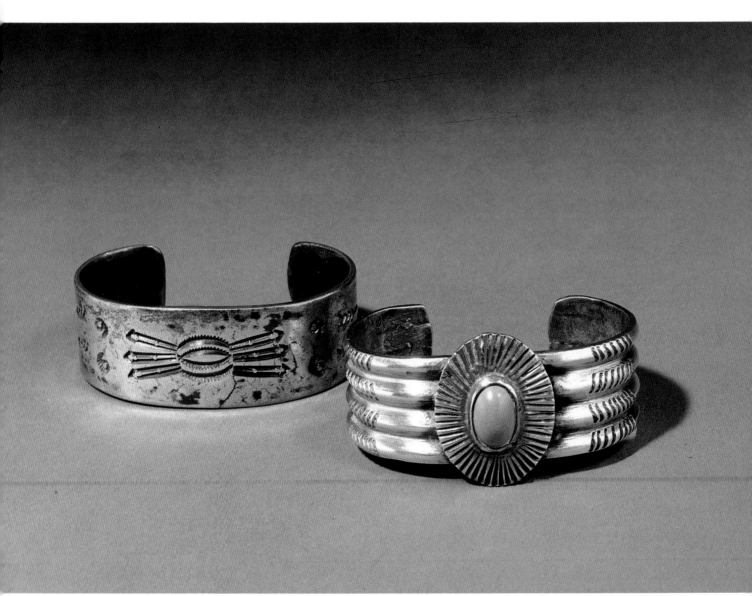

31 30

32. PAIR OF BRIDLE BUTTONS
Navajo
Silver, brass, solder, hide, L. 2¾, W. 2½
Purchased in Saint Michaels, Arizona, 1903
03.325.3719a–b

33, 34. TWO PAIRS OF BUTTONS
Navajo
Silver, copper, wire, H. ¼, Diam. 1 (each)
Purchased in Saint Michaels, Arizona, 1903
03.325.3723a–b; 03.325.3728a–b

Culin purchased thirteen pairs of silver buttons to adorn his Navajo "old style" costumes. The Navajo used buttons not so much to fasten clothing as to decorate it. A row of silver buttons was attached to the outer seams of leggings and breeches or down the front of a woman's velveteen blouse. Such buttons adorned bandolier straps and pouches, pistol holsters, coats, hats, and moccasins.

One pair of buttons displayed here (No. 33) was undoubtedly made from old coins, as each is notched and has the number 88 on the interior. Both Mexican and American coins were often pounded down and fashioned into these decorative elements by soldering a copper loop to the button's underside. Culin wrote that silver ornaments were still used as currency on the reservation and that the silversmith would be paid "twice the weight in coin of the object to be made. Afterwards…the ornament would command only the coin value of the silver." The buttons, Culin wrote, are "classed as worth ten, twenty-five, fifty cents or one dollar according to the coin from which they are made" (1903:76). Culin paid fifty cents for each pair of buttons.

The pair of star-shaped silver "buttons" (No. 32) is illustrated in the ethnologic dictionary, where it is stated that each ornament decorated one side of a bridle's browband. The star-shaped bridle ornament is not nearly as common as the concha form.[1] LMB

1. Franciscan Fathers 1910:281.

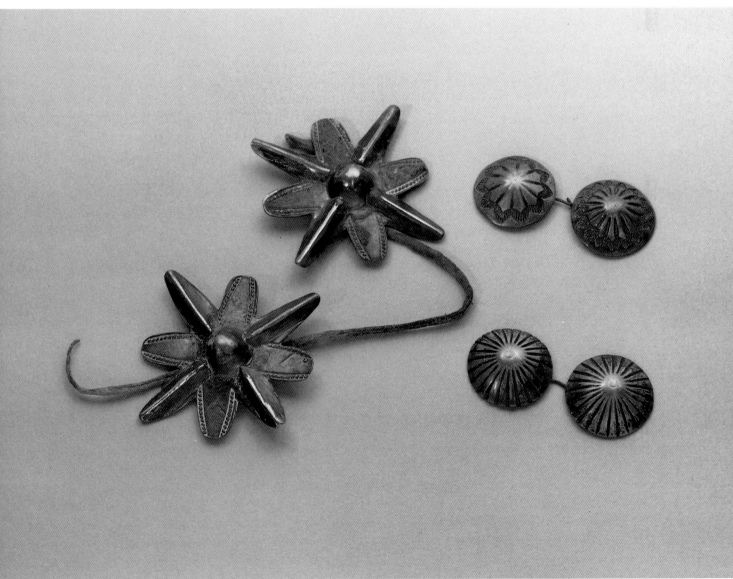

32 34 33

35. NECKLACE
Navajo
Shell, stone, cotton, L. of strand 31½
Purchased from Harry Scorse in Holbrook,
Arizona, 1903
03.325.4350

Culin's records offer little detail
about this particular piece. He states
that it was "made by Navajo" on his
catalogue card but implies it is of
prehistoric or Hopi manufacture in
his expedition report.

Culin had particularly wanted to
stop at the town of Holbrook, situ-
ated over fifty miles from Hopi
territory, because it was the closest
rail station for the Hopi reservation.[1]
On making the "round of stores" in
Holbrook, Culin examined Scorse's

collection of 1,200 pieces of gray
ware and red ware. Instead of pur-
chasing pottery, Culin "bought from
him a number of strings of shell
beads and pottery disks, stone amu-
lets, etc., all the small objects, in
fact, that had been brought in with
the pottery. The exact locations from
which these things came was
unknown, but they were all from

within a radius of thirty miles from
Holbrook" (1903:79).

Although the ethnologic dictio-
nary noted that traders sold red
stone, olivella and conch shell, black
stone, and tortoiseshell for jewelry,
Culin reported that necklaces of
white beads and turquoise were
most commonly worn by both men
and women. He added that the "fine
old white beads from the ruins are
most highly prized and command
extravagant prices," but the Navajos
obtained a "cheaper white stone
bead" from the Pueblos, and that the
"newer beads" were made of clam-
shell (1903:10). LMB

1. S. Culin to F. Hooper, Feb. 27, 1903,
Departmental Records.

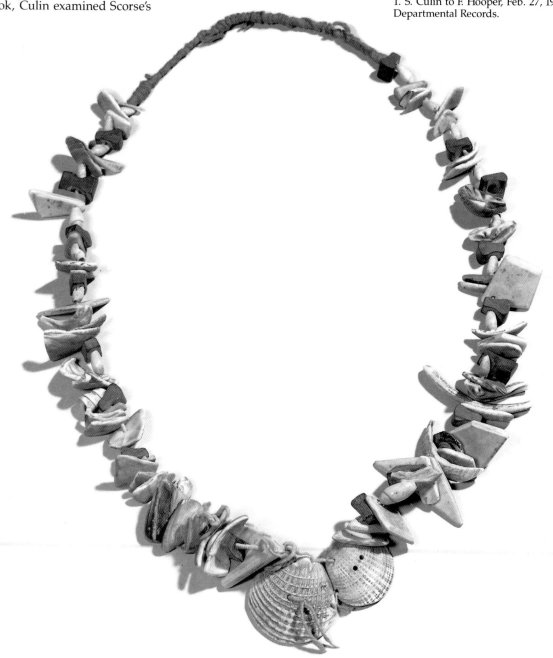

36. SHIELD

Made by Tjiyoni; Navajo
Hide (with fur), pigments, wool cloth,
feathers, Diam. 20¼
Given by J. Lorenzo Hubbell, 1903
03.325.4599
Gift of J. Lorenzo Hubbell

When Culin first met Little Singer and commissioned him to make the costume elements and ceremonial pieces he needed for his display in Brooklyn, the only object Little Singer refused to fabricate was a shield. "'He did not know the prayers' was his excuse" (1903:26). According to several sources, making a shield was a task that required special qualifications and knowledge. There were even restrictions on the way it was stored.[1] This explains Little Singer's reluctance to comply with Culin's request.

Subsequently Culin "arranged with [the trader J. Lorenzo Hubbell] to have Tjiyoni at Ganado make [Culin] a shield like the one made by him which hangs in Mr. Hubbell's

hall" (1903:26). It is quite possible that Tjiyoni is the "chief Tja-yo-ni" pictured on Hubbell's stationery.[2] Little Singer's refusal ultimately worked to Culin's advantage when Hubbell generously donated the shield to the Museum as a gift.

This shield has a buckskin cover painted with a simple design that represents a rainbow. The shield itself is thickly painted in black with a blue face in the center, flanked by beige paws, and a snake at the bottom. A strip of red wool hung with black feathers is sewn around the edge of the shield. The wool is very similar to the trade material (provided by Hubbell) that adorns two Zuni shields (No. 114). When the shield was not in use, the feathered border rested in its concavity.

A drawing of a similar shield encased in its cover is included in the ethnologic dictionary, along with a detailed description of its fabrication and use. After the rawhide had been shaped over an anthill,

the entire outer rim of the shield was decorated with eagle feathers, to preserve which many shields were provided with a crease in the center, so that they might be quickly opened and closed by stepping on them. In addition, the outer surface of the shield was richly emblazoned with figures relating to war, such as figures of the sun, half sun, rainbow, crescent, a bear's foot, and the Slayer of Enemies.

The entry on the shield concludes with the observation that "shields may still be found among the family relics."[3] It is noteworthy that in all the trading posts Culin visited, he never saw a shield for sale. DF

1. Kluckhohn et al. 1971: 368–72.

2. See J. L. Hubbell to S. Culin, Sept. 19, 1903, Correspondence.

3. Franciscan Fathers 1910: 317. The drawing may be of Hubbell's shield or of this one.

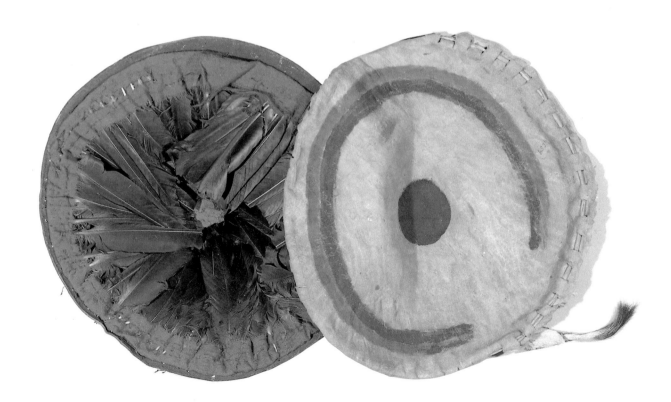

37. CRADLE

Navajo
Wood, hide, shredded bark, cotton trade
cloth, wool carrying strap, L. 33, W. 11½
Purchased in Saint Michaels, Arizona, 1903
0.3.325.3669

According to the ethnologic dictionary, the split-back cradle was a Navajo baby's fourth and final cradle. The earlier cradles, improvised of twigs, were designed to protect the child within the hogan. Strapped into this much more substantial bed, the child could be carried securely on the mother's back. The cradle could also be "leaned against the walls of the hogan or placed any-where under the direct and constant supervision of the mother."[1]

The cradle is lined with shredded bark and has a wool carrying band, woven in diamond twill. It is also equipped with a hide cover (not illustrated), which served as a canopy over the wooden hoop.

The band may be a later addition. In a letter concerning a cradle he was sending to Culin, Mr. Welsh, manager of the Round Rock trading post, wrote that he had paid fifty cents extra "for the carrying band that is quite new." The cradle, on the other hand, had "been used to raise five children."[2]

Navajo cradles of this type were reused unless the child had died. In that case, the cradle "is buried with the child. Previously, however, all knots are untied, the thongs washed, and all parts of the cradle are placed near the child in its grave."[3] DF

1. Franciscan Fathers 1910: 472.
2. Welsh to S. Culin, June 6, 1906, Correspondence. There is some confusion about the provenance of this cradle. Although the catalogue card gives Saint Michaels as the source, it could be the cradle Welsh sent from Round Rock.
3. Franciscan Fathers 1910:472.

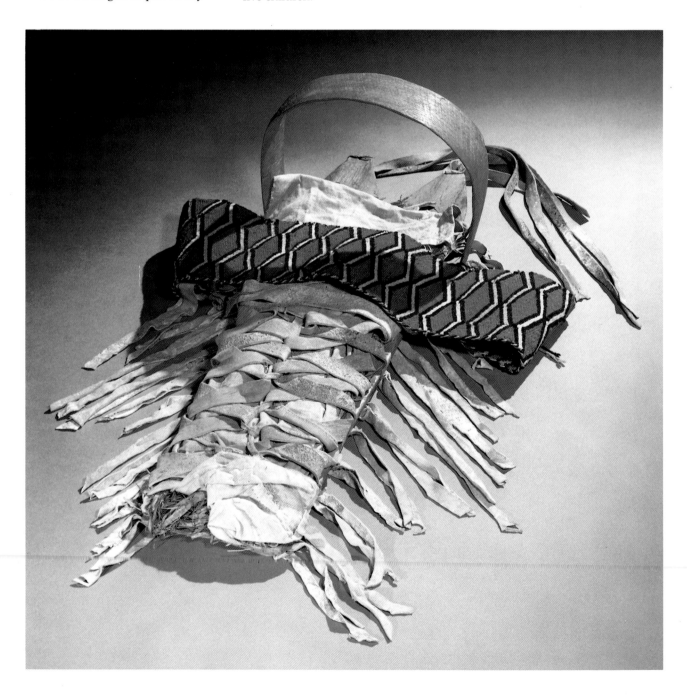

38. "OLD STYLE" CRADLE

Made by Little Singer; Navajo
Twigs, yucca, sinew, hide, yellow pigment,
L. 35, W. 13¼, Diam. 10¾
Purchased from Little Singer in Chinle,
Arizona, 1903
03.325.3668

This wicker cradle made by Little Singer in the old style provided Culin with a prototype for the modern Navajo cradle (see No. 37) and occasioned a discussion of child-rearing practices among the Navajo. When Culin showed the cradle to Mr. Chublock, an agent of the Interior Department, who was in Chinle investigating irrigation possibilities, "he expressed an extremely unfavorable opinion as to the Navajo cradle in general, urging that it produced an unnatural flattening of the child's head, which could be remedied by a different pillow." Culin, on the other hand, "had been impressed with the apparent comfort of the Navajo babies, who seldom, if ever, cry, and had assigned the cradle to a very high place among the many ingenious contrivances by which this nomadic people are enabled to live in the desert" (1903:56). DF

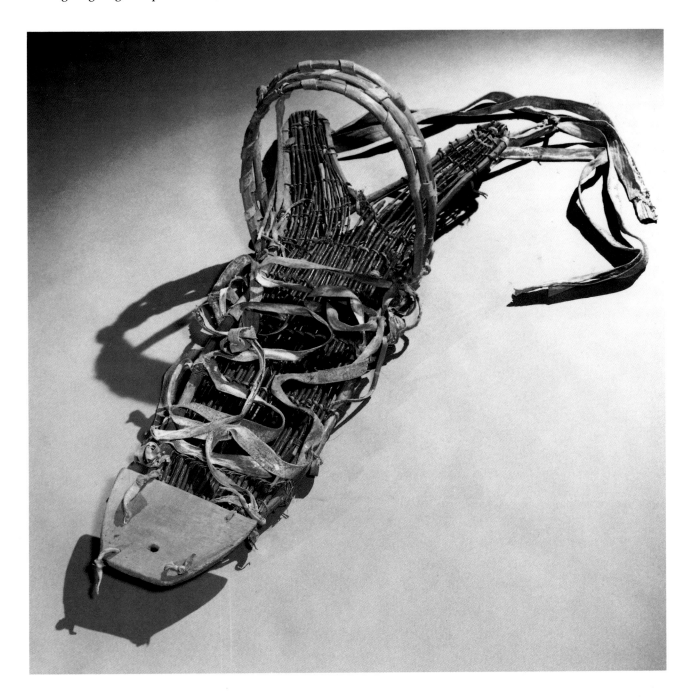

39, 40. CAT'S CRADLES
Cotton string on cardboard mount
No. 39: Navajo
L. 12¾, W. 7

No. 40: Made by Francisco Chaves; Cochiti
L. 10, W. 6½
Collected in Saint Michaels, Arizona, 1904
04.297.5456; 04.297.4979

While visiting the Franciscan mission on the Navajo reservation, Culin collected a string game "made by a Navajo," which he identified as "coyotes running apart" (No. 39). He illustrated a piece by the same name and pattern in his *Games of the North American Indians*. Other Navajo string figures include those depicting the Pleiades and lightning, owls and horned toads. Still others convey a more dynamic element, such as one called "carrying wood" and "coyotes running apart."

Culin also observed a Cochiti boy working in the mission kitchen and commissioned several games from the young Francisco Chaves. Among some other games Chaves produced for the Museum were several cat's cradles variously titled, "butterfly," "bow," and "bat." Chaves also made the string game No. 40 and called it, appropriately, "chicken foot."

Upon questioning Father Haile,

Culin learned that the Spider People of Navajo legend taught the Navajo to make the cat's cradles. Therefore, the string games are not made in the winter when the spiders sleep and cannot see the figures.[1] LMB

1. Culin 1907c (1975 edition:764–66); also see Franciscan Fathers 1910:507.

41. SADDLE BLANKET
Navajo
Hand-spun wool (weft), commercial cotton (warp), L. 33, W. 47¾
Purchased in Red Rock, Arizona, 1903
03.325.3667

Almost all the Navajo textiles Culin bought were utilitarian. He bought this saddle blanket from the "old cavalry soldier" Joe White (see Nos. 4–7), along with a pinto pony, "a California saddle with a high pommel, and an excellent bridle" in order to travel in Western style (1903:5).

In lieu of using saddle blankets of "their own weave," Culin reported that the Navajo sometimes used pieces of old buffalo robes (1903:10). This blanket may have been meant to be a decorative saddle throw, as it has decorative fringing along one edge and has a rather elaborate design. LMB

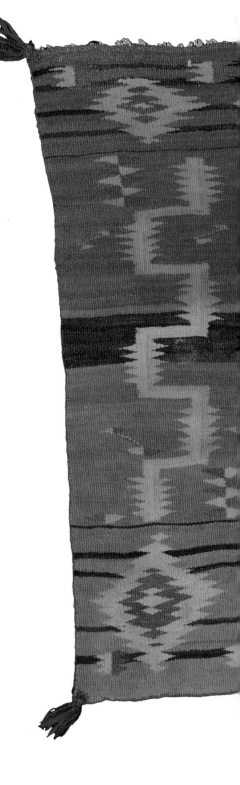

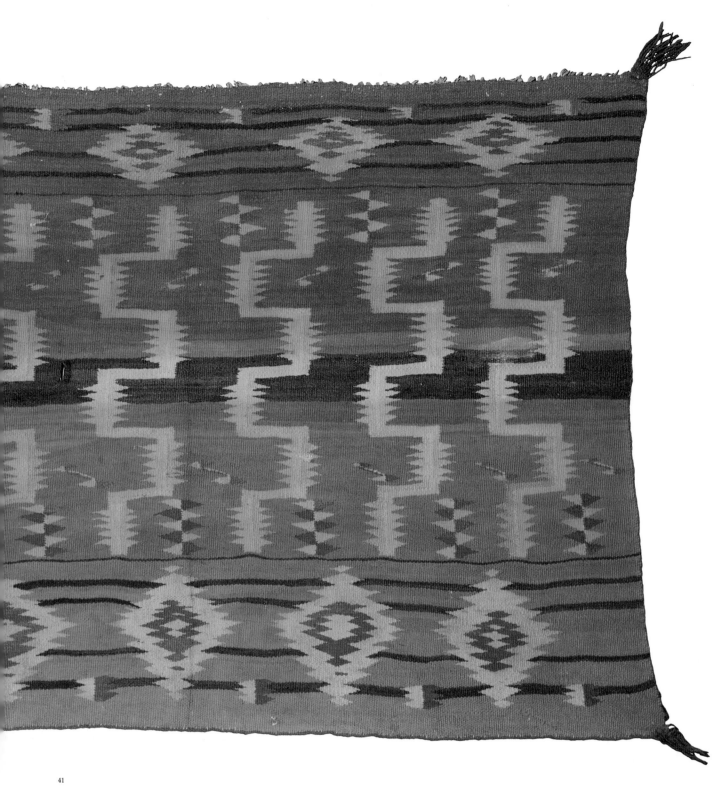

41

42, 43. DIPPERS
Navajo
Ceramic, slip, L. 7, W. ¾; L. 6¼, W. 3¾
Purchased from Charles Day in Chinle,
Arizona, 1903
03.325.3783; 03.325.3785

44. BOWL
Navajo
Ceramic, slip, H. 4¼, Diam. 9¾
Purchased from Charles Day in Chinle,
Arizona, 1903
03.325.3794

Culin was somewhat surprised by
the quantity and variety of Navajo
pottery. In addition to the "ordinary
black pots" that "were used for
mush," he found "everywhere finely
made bowls, etc., of a reddish
brown clay of native manufacture.

These were frequently decorated
with colored designs, the only one
of which I could learn the name, the
cloud-terrace, symbol of the Pueblos,
they call 'doll clouds'" (1903:13).

Culin took the opportunity to pur-
chase a representative collection of
Navajo pottery, which was rarely
displayed in museums in the East,
in contrast to Pueblo pottery. This
bowl and two dippers were among
the pieces he purchased at Day's
trading post. Although the dippers
are both covered with a dark red slip
(liquid clay), they illustrate two quite
different painting styles: one empha-
sizing lines and the other, solid
geometric forms. The vinelike pat-
tern on the interior of No. 42 is

exceptionally finely drawn.
The bowl is slipped in white and
painted in dark red and brown. The
design on the interior is very similar
to one illustrated in the ethnologic
dictionary.[1] Like other life forms on
Navajo pottery, it is freely drawn
and suggests movement and growth.
The stepped pattern on the outside
of the bowl is presumably a version
of the "doll clouds" mentioned by
Culin.

The dippers are in good condition,
but the bowl has been broken and
repaired. DF

1. Franciscan Fathers 1910:287.

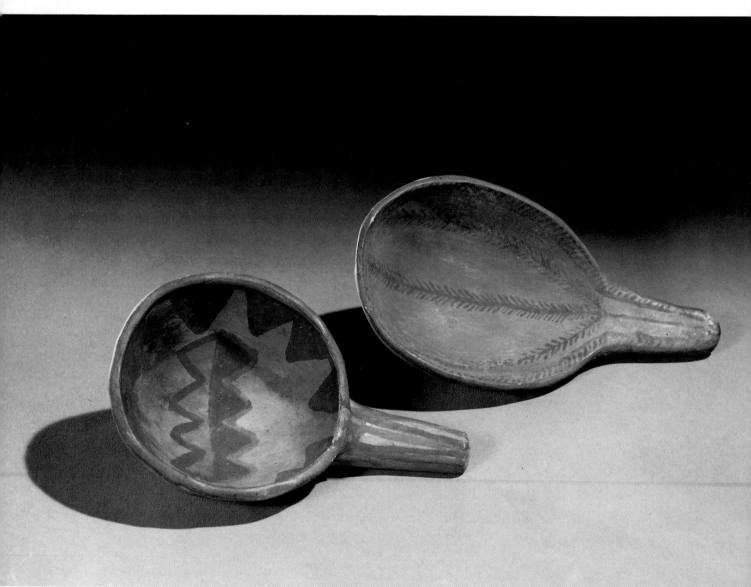

43 42

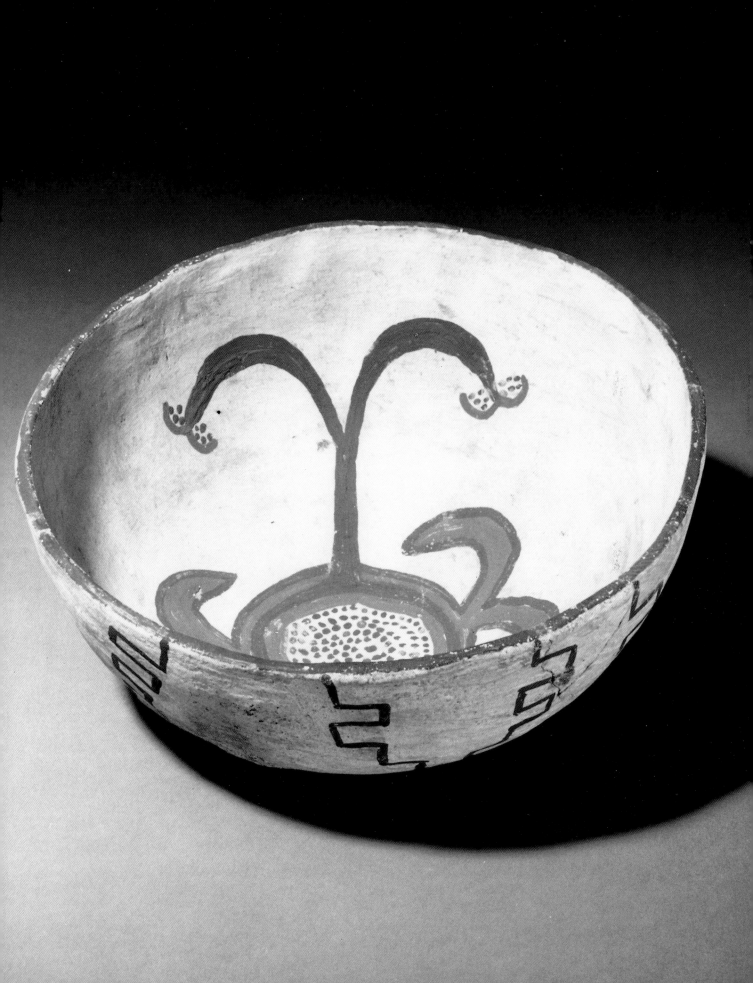

45. BOWL

Navajo
Ceramic, slip, H. 3½, Diam. 7½
Purchased from Mr. Welsh in Round Rock,
Arizona, 1903
03.325.3804

At the trading store at Round Rock, an old Indian brought Culin "a large and perfectly finished old bowl which he said came from the ruins and was made by the Anasassi [*sic*]." By now Culin was something of an expert on Navajo ceramics and he recognized that the bowl "was clearly of Navajo manufacture." Mr. Welsh, who managed the store, sold him another bowl "of the same hard, highly polished, yellow clay, painted within with several animals, a man on horseback, a deer, etc. in deep brown" (1903:61). This bowl differs from the one he purchased at Day's (No. 44) in that it is slipped in yellow-orange rather than white and is much heavier. Two men on horse-back alternating with horned animals are painted in dark brown and red on the interior. Although drawn on a small scale, they have something of the mystery and power of southwestern petroglyphs. DF

46. BOWL

Navajo
Ceramic, slip, H. 3¾, Diam. 8¾
Purchased from Joe Wilkin in northwestern
New Mexico, 1903
03.325.3799

On an extended trip through the Navajo reservation, Culin stopped off at Joe Wilkin's trading store, located at the eastern foot of Beautiful Mountain.[1] He described Wilkin as "another of the many interesting characters one meets in this region, where men all have an originality rarely found in the East." Wilkin sold him "some painted Navajo pottery, which he had had made for sale to curio dealers" (1903:72).

Despite the fact that the pots Culin bought from Wilkin were made for sale rather than native use, their designs seem to be well within the traditional Navajo repertory. Although the motifs on this bowl and those on the Round Rock bowl (No. 45) are very similar, the overall composition and style of drawing are nevertheless dramatically different. Moreover, the exterior of the Round Rock bowl is plain, whereas this bowl has an enigmatic little square and a bull painted on the outside. This exuberant painting style may have been developed for an outside market. DF

1. Culin describes Wilkin's store as "at the base of the mountain" but does not specify which mountain (1903:71). On the basis of Frank McNitt's reconstruction of Wilkin's career, one can assume that it was the post at the base of Beautiful Mountain that Culin visited (McNitt 1962:348).

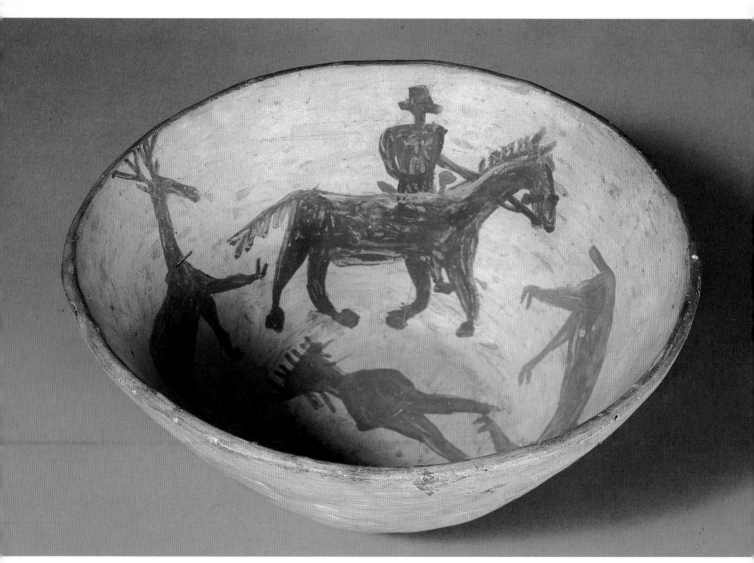

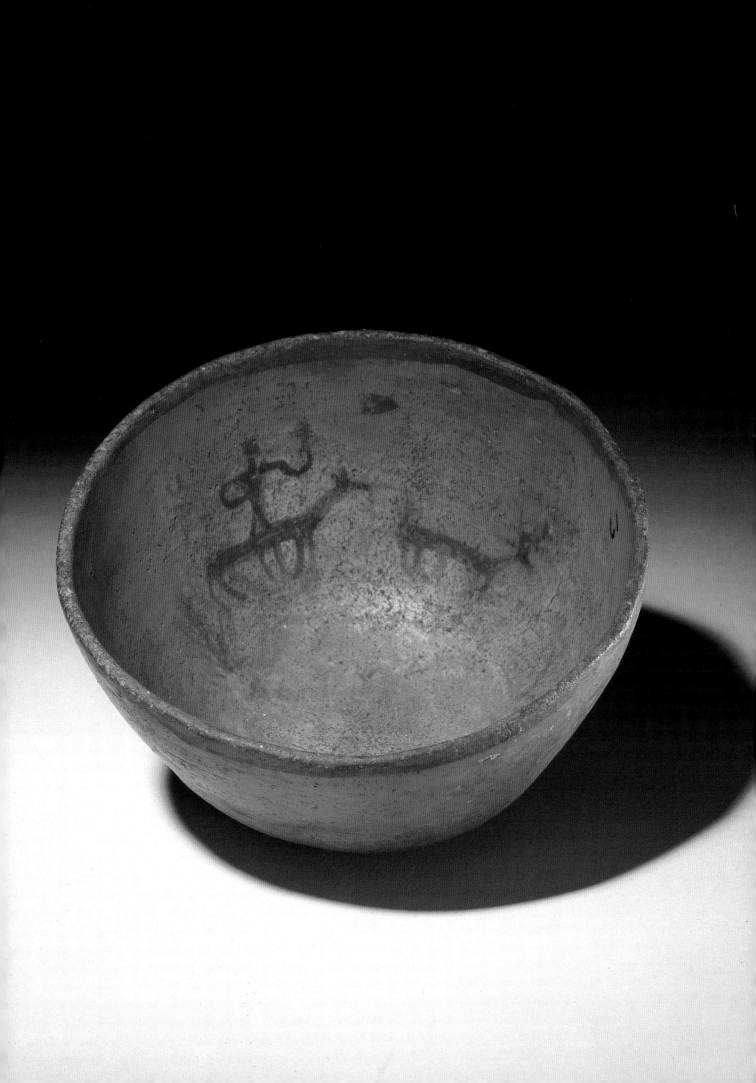

47, 48. Baskets
Navajo
No. 47: Coiled, plant fibers, dyes, cotton cloth (plug), H. 3½, Diam. 10¼
Purchased from J. Lorenzo Hubbell in Ganado, Arizona, 1903
03.325.3606

No. 48: Coiled: plant fibers, dyes, H. 3, Diam. 11¼
Purchased from the Round Rock trading post, Round Rock, Arizona, 1903
03.325.3609

In 1902 Culin observed that the "Navajo weave a few of the so-called wedding baskets which they use in their ceremonies, but buy most of them from the Paiute" (1902b:22). Subsequently, he learned some additional facts about Navajo basket makers from Father Haile at Saint Michaels: "Baskets are made exclusively by Navajo women of the Ute and Paiute clan. The Navajo buy the Ute and Paiute girls at a tender age whom they marry" (1905:2).

Baskets were constantly in demand for ceremonies, and Culin had no trouble finding them at trading posts throughout the Navajo reservation. He purchased a variety, selecting them according to their condition and price. At Round Rock,

for example, where he bought No. 48, he noted that the baskets were "much cheaper than any [he] has seen elsewhere on the reservation" (1903:61).

These two baskets show something of the range of designs favored by the Navajo. According to the ethnologic dictionary, no special rules "were laid down with regard to the blending of colors, or the number of figures and circles in a design," but "it was essential that every design be broken or intersected by a line of uncolored twigs." This line, which is evident on both these baskets, "was prescribed lest the sewer, in bending all her energies and application upon her work, *enclose* herself and thus lose her sight and mind."[1] In ceremonies, this line was always oriented toward the east.

In addition to serving as directional indicators, baskets were used as receptacles for herbs, medicines, prayer sticks, and other ceremonial paraphernalia. When inverted, they became drums and were beaten "with a beater made of yucca stems" (1903:13).

No. 48 is a simplified version of

the "wedding"-basket pattern (see No. 49). Baskets with this distinctive band bordered by triangles were required for a wedding but could also be used in other ceremonies. There is some confusion about the documentation on No. 47 (the number is not entirely legible), which may have been purchased from Joe White rather than Hubbell. Notably, it still has a cotton plug in the hole that was formed at the start of the basket. Whiteford observes that the "wooden peg or scrap of cloth" used to plug this hole was "usually removed by traders and collectors."[2] DF

1. Franciscan Fathers 1910:294–95.
2. Whiteford 1988:38.

49. Basket with Prayer Sticks
Navajo
Coiled: plant fibers, wood, cane, pigments, cotton thread, H. 4, Diam. 16 (basket); L. 2½, W. ¼ (sticks)
Purchased from Charles Day in Saint Michaels, 1905
05.588.7118

When Culin arrived in Arizona in 1905 he learned that Charles Day

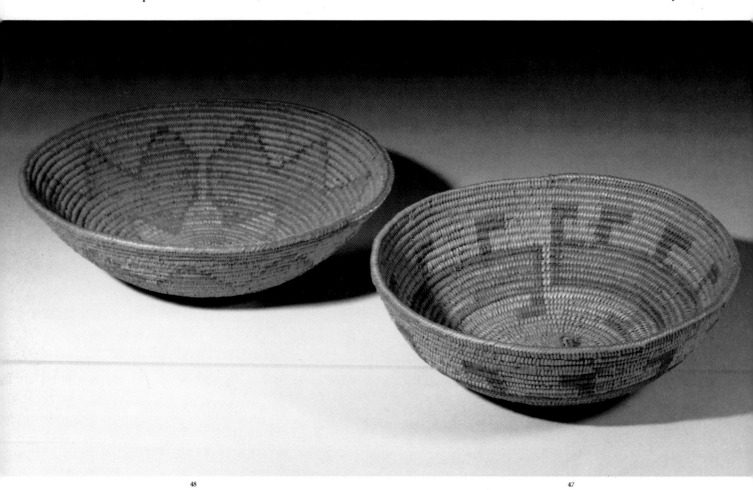

48

47

had sold his trading post at Chinle and built a new store "on the hill on the road leading to Ganado," a short distance from Saint Michaels (1905:2). There he had a collection of Navajo ceremonial paraphernalia waiting for Culin's consideration. It included an outfit for the Bead Chant and several sets of *ketan,* or prayer sticks, as well as "a ceremonial basket, with the k'etan for the Yebichai, a spruce bough mask used in the Yebichai, a set of k'etan for the...Mountain Chant, and the tablets for an altar" (1905:34). Culin bought the entire lot for $150.

An entry in the ethnologic dictionary is devoted to the subject of prayer sticks. An essential offering in most Navajo ceremonies, they were made "anew for each occasion. The material to be used in their preparation is minutely described by ritual and tradition." The thicker sticks represent the males, "while the thinner is at times, though not always, provided with a facet decorated with eyes and mouth to represent the female divinity." In addition to prayer sticks, tobacco is offered in "cigarettes," made of "the

hollow internode of reed...the bottom of which is previously closed with feathers of small birds....It is then sealed with a layer of pollen."[1]

This wedding basket lined with colored prayer sticks has four of the "cigarettes." Although the documentation on the various sets of prayer sticks Culin acquired is confusing,[2] this must be the basket and prayer sticks for the third day of the Yebichai, or Night Chant. A similar arrangement is described and illustrated in the ethnologic dictionary[3] and by Washington Matthews:

The four cigarettes are placed in the centre on a little pile of corn-meal, in the usual order, tips east. The wooden kethawns [*ketans*] are arranged in four groups, side by side around the centre, tip ends outward, radiating slightly as the form of the basket compels. The twelve white kethawns are put in the eastern quarter of the basket; the twelve blue, in the southern quarter; the twelve yellow, in the western quarter; and the twelve black, in the northern quarter. In laying them down, male and female kethawns are made to alternate and the male takes the precedence, in order, of the female.[4]

Here there are twenty-five prayer sticks in each group rather than the twelve described by Matthews and the cigarettes are placed around, rather than in, the center. Without further documentation, it is difficult to determine the significance of these variations. One thing is certain, however. In a Navajo ceremony the prayer sticks would never be attached to the basket. Having been carefully prepared and placed in the basket, they are taken out one by one by the God Impersonators and ritually disposed of on the third night of the ceremony. These sticks may well have been made as models for display purposes and attached to the basket for safekeeping. Another ceremonial basket with prayer sticks attached, dated late nineteenth century, is illustrated in Turnbaugh and Turnbaugh, 1986.[4] DF

1. Franciscan Fathers 1910:394–98.

2. The catalogue numbers for the *ketan* for the Mountain Chant and the Nightway seem to have been reversed.

3. Franciscan Fathers 1910:396–97.

4. Matthews 1902:93–94.

5. Turnbaugh and Turnbaugh 1986:57.

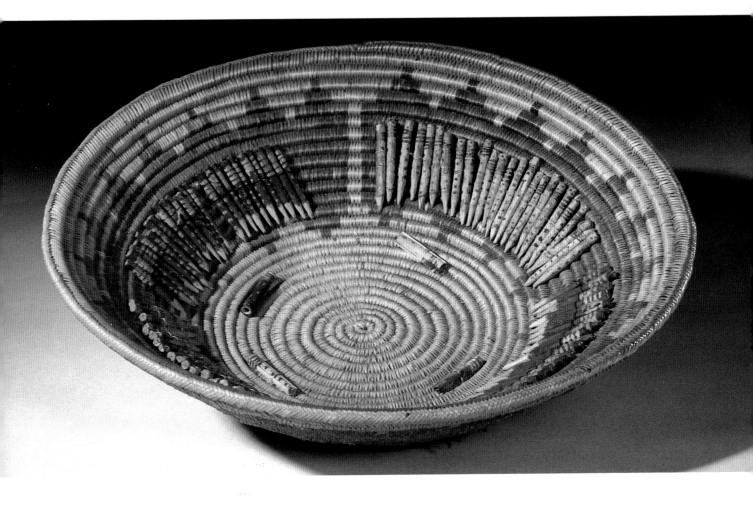

50. PRAYER STICKS
Navajo
Wood, pigments, string, L. 33¾, H. 8¾ (longest stick)
Purchased from Charles Day in Saint Michaels, 1905
05.588.7117.2

Purchased along with a basket (which has not been located), these prayer sticks are presumably those for the Mountain Chant that were accompanied by an unfinished manuscript "taken down from Charley's dictation by Father Leopold" (1905:34). This impressive set includes 101 prayer sticks of different sizes, colors, and patterns, strung together. Except for the association with the Mountain Chant, Culin does not provide any further documentation on the arrangement.

Some singers, the ethnologic dictionary reported, kept "a sample roll of prayer sticks...to aid in the making of the various prayer sticks for the chants, or certain parts of the chants requiring special prayer sticks, and tracing the order in which they should follow. Not every singer is possessed of the sample roll as most of them rely upon memory in preparing and ordering them."[1] This may be such a sample roll, or like the Night Chant basket (No. 49), it may have been prepared for display purposes, since the sticks were destroyed during the ceremony. DF

1. Franciscan Fathers 1910:398.

51. COLLAR WITH BONE WHISTLE
Navajo
Hide, fur, sinew, claws, wool, quill, cotton, plant fibers, pigment, dye, resinous material, L. 27, W. 4
Purchased from Charles Day in Chinle, Arizona, 1904
04.297.5430

Culin purchased two collars with whistles at Day's in 1904, and two collars were included in a bundle he acquired later that year, giving him a total of four of these impressive ceremonial neckpieces. Culin noted that this collar and a headdress he bought with it were worn in the "hash kan dance."[1] This collar is richly decorated with claws (possibly a bear's) and fur appendages wrapped with colorful quillwork and yarns. The whistle is made from bird bone.

In his list of "items of nonspecific equipment that may be used in various ceremonials," Wyman includes a fur collar and describes it as "a badge of recognition for singer or patient...with an attached eagle wing bone whistle to signal, summon, and attract the Holy People."[2] A number of photographs of singers wearing fur collars have been published.[3] In Washington Matthew's article on the Mountain Chant, he described the dressing of couriers with fur collars as follows: "Downy eagle feathers were fastened to their hair; necklaces of shell and coral were hung around their necks, and over these were laid collars of beaver skin, with whistles attached, which had lain in front of the lodge the day before, near the plumed wands." As the couriers set out for their journey, the chanter, pointing to the fur collar, said: "This will be a means of recognition for you. For this reason it hangs around your neck."[4] DF

1. Unfortunately, Culin does not say anything further about this dance and it does not correspond to any Navajo ceremony in the literature of the period.
2. L. Wyman, in Ortiz 1983:549.
3. See, for example, Wyman 1983:18.
4. Matthews 1887:424–25.

52, 53. GOD IMPERSONATOR MASKS
Navajo
No. 52: Female mask (hastsebadd)
Leather, hide, pigment, hair, dye, cotton, wood, wool, shell, H. 14¼, W. 12½, D. 2

No. 53: Male mask (hastsebaka)
Hide, sinew, pigments, gourd, fur, hair, wool, dye, cotton, H. 18, W. 12, D. 9
Purchased from Laughing Doctor in Cottonwood Pass, Arizona, 1903
03.325.3890; 03.325.3903

The mask of the female god is immediately recognizable by its square shape that covers only the face. Her notched wooden "ears" enable her to hear the Holy Winds, which give her guidance. Her mask is painted blue (though this example has faded) and has a curtain of red cloth decorated with disks of abalone shell attached at the throat.

The male God Impersonator mask, like the female one, is painted blue to represent the sky, with a horizontal yellow streak at the bottom to symbolize the evening twilight and crossed by black lines to represent rain (Matthews 1902:16). The mouth, Culin said, consists of a gourd tip painted blue and is surrounded by a whiskerlike strip of fox skin that represents vegetation (1904a:69).

Masks such as these were worn by Navajo impersonating deities during a portion of the Nightway curing ceremony. Because the masks can compel the attention of the Holy People, their construction and care are ritually regulated. Customarily, they are "dressed" before each performance with paint and feathers and afterward stored flat in a sacred bundle along with other Nightway ceremonial equipment.

Boasting that "no [other] set of these masks, not even a single one, has ever been obtained," Culin considered his acquisition of nineteen Nightway masks a personal triumph.[1]

After spreading the word that the Museum was interested in acquiring a Nightway "outfit," the trader Lorenzo Hubbell soon informed Culin that a set might be obtained because its owner had recently died. He thought the set had been claimed by the medicine man's son, Laughing Doctor, who might be willing to sell the masks because he had been friendly with the anthropologist Washington Matthews and with the Franciscan friar Anselm Weber.

With the help of Hubbell, Weber, and the trader J. B. Moore, Culin met Laughing Doctor, a "cheerful, smiling, prosperous old man, who well deserved his name." Culin offered the huge sum of $200 for the set, sight unseen. After a long negotiation, the medicine man agreed to deal, providing that "no one should hear of the transaction" (1903:113). During the intervening week's wait for funds to arrive, Culin worried that the medicine man would renege: "One can never be sure, dealing with an Indian, until one has possession."[2]

The nineteen masks were delivered as promised by Laughing Doctor with his assurance that they were of special value because "the deer from which the skins were obtained, had all been run down and strangled without other injury" (1903:122). Culin reported that the masks were "the identical set" that years ago Matthews had tried to obtain from Laughing Doctor's father, Night Chanter.[3] Matthews reportedly told Culin: "Failing to buy a ready-made set of masks, I tried to get the Indians to make a set for me, and of ordinary buckskins. I assured them that they were not to be used in the rites, but only for exhibition, yet I could not prevail on them to make the masks of anything but sacred and unwounded buckskins, and these I could not obtain" (1903:132–33).

The following year Culin employed another Navajo Nightway singer, Harry Tsaigi (Mr. His Voice),

for five days to "make the additional appliances I needed to complete my set."[4] Tsaigi's main task was to provide hair for eleven masks. Ordinarily the hair was twisted from a long fleece that "grows on [sheep's] legs," and Tsaigi had to tease threads out of a saddle cover even though the "wool cuts the skin on the fingers" (1904a:67).

Decades later, Father Berard Haile, who was familiar with the details of Culin's transaction, questioned the authenticity of masks bought for museum display. Although he did not name any institution or individual, he cautioned that masks collected between 1906 and 1910 were made from horsehide rather than properly fashioned from deer that had been ritually strangled and dedicated during a Nightway ceremonial:

> Everyone was satisfied. The trader got your money and sold you a nice bill of goods. You kept your set of masks and the natives chuckled over your ingenuity. The Museum curator accepted the set of masks as genuine "made by the Navajo" and perhaps they served the purpose in his museum exhibits. At any rate reproductions in horse hide were made for "foreigners" but never replaced genuine buckskin sets. In matter of fact the spurious sets go out to enemy country and can do no harm to the Navajo.[5]

Although it is possible that these masks were not manufactured according to Navajo ritual standards, it is more likely that Culin's purchase encouraged the market for horsehide sets.[6] LMB

50

1. In 1895 four Nightway masks that are now in the Field Museum were collected by A. Montzheimer. Culin was probably the first of a long line of museum curators to obtain masks directly.

2. S. Culin to F. Hooper, July 17, 1903, Departmental Records.

3. While this may be one set that Matthews tried to obtain, James Faris points out that this is not the set that Matthews illustrated. Faris argues that Laughing Doctor may have made the masks illustrated by James Stevenson in 1891 and that those may be ones that were sold to Culin (Faris 1990 and in correspondence, Aug. 16, 1989).

4. Culin gave both the names listed here. Faris 1990 states that Tsaigi was also known as Speech Man.

5. Haile 1947:80–88.

6. In the case of these masks, hide analysis would not yield definite results. However, the masks do appear to have been used (Faris personal communication, Aug. 16, 1989), and Culin refers to them as "all old" (S. Culin to F. Hooper, July 20, 1903, Departmental Records).

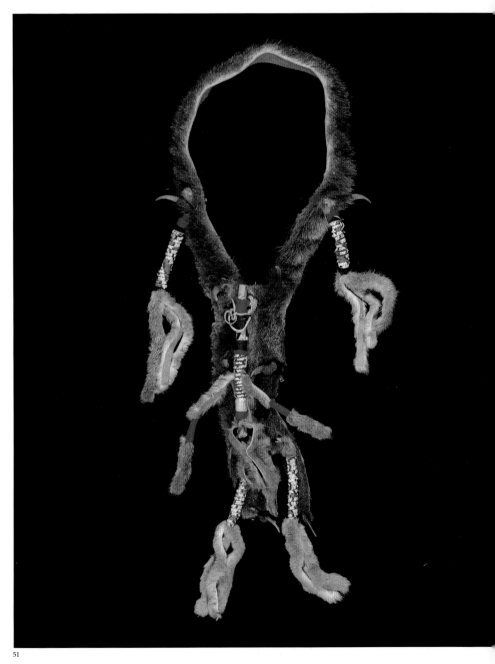

51

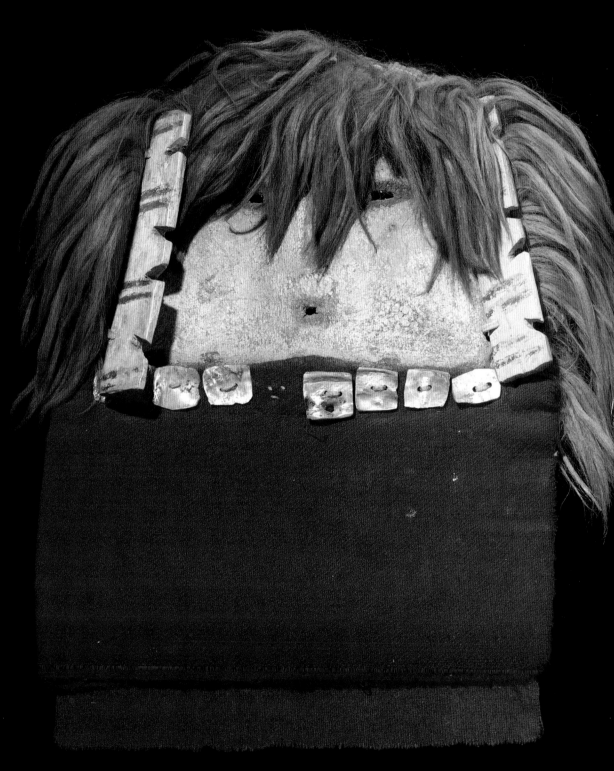

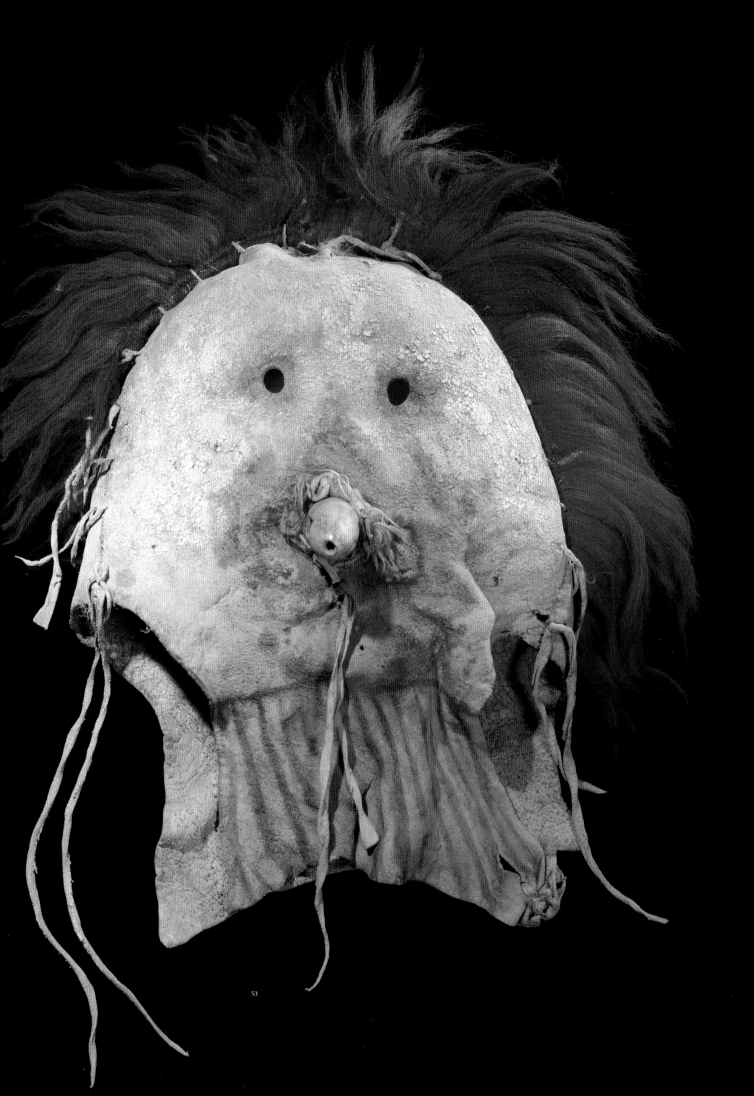

ZUNI

54. POLISHING STONES
Zuni
Stone, L. 2½, W. 2¼
Purchased in Zuni, New Mexico, 1903
03.325.3461.1–.7

In a lecture on the Indians of the Southwest, Culin noted the Indian's "constant and wide-spread use of stone in his various mechanical arts. He displays the nicest discrimination in the selection of stone for different uses and in the quality and temper of the material which he thus employs" (1904b:18). This fine set of polishing stones for pottery confirms Culin's observation. The women in Zuni sold Culin this set and several others along with a "vast number of old stones, of the greatest variety and shape, size, material and color" (1903: 89–90).

Culin gives a detailed description of pottery making in Zuni at the time of his visit (see Nos. 93, 94). Pots were polished after the pot had dried and a slip had been applied. This gave a burnished appearance to the surface of the fired pot. Some of these stones still have traces of clay on them. Stones have remained the preferred material for polishing pots and are still in use today. DF

55, 56. FETISHES
Zuni
No. 55: Stone, thread, leather, H.½, W.¼, Diam. of hide 2¼

No. 56: Stone, paint, H. 1¼, L. 3½
Purchased in Zuni, New Mexico, 1903
03.325.3427; 03.325.3434

Because of Frank Hamilton Cushing's work on Zuni fetishes,[1] which Culin cites in his 1903 expedition

54

56

55

report, he had no trouble understanding the function of these carved animals. Culin described charms and fetishes as the most "numerous and interesting" objects among the material the women offered him for sale. He was wary, however, of fakes. On his first trip to Zuni in 1902, the boys offered him stone and shell hunting fetishes, "some new, some old, but most of them hastily made upon their learning I was a possible customer" (1902b:4). On his second trip in 1903, he noted that the "new ones are roughly finished and of little or no value" (1903:90).

Both these fetishes show the signs of age that Culin valued. He identified the small white animal (No. 55) as a bear. In his entry on bears in "Zuni Notes," Culin reported that

people regarded a white bear as a "War Chief. They regard it as sacred to the Below" (1907b: 27). This is one of many miniature fetishes he acquired, but it is the only one that is secured to a piece of leather. Other fetishes in the collection have arrows or beads tied to their backs.

The larger painted animal (No. 56) represents a mountain lion, distinguished by the long tail over the back. This piece has an ancient history. Culin noted on the catalogue card that it came from Hawikuh, a ruined pueblo that the Zuni had formerly occupied. According to Cushing, fetishes that "have been found by the Zunis about pueblos formerly inhabited by their ancestors" are in the class that is "most highly prized."[1] DF

1. Cushing 1883:12.

57. FETISH
Zuni
Stone, paint, H. 4½, L. 7¾
Purchased in Zuni, New Mexico, 1904
04.297.5053

One of two large animal carvings Culin acquired on his second trip to Zuni, this fetish was catalogued by him as a bear. The emphasis on the eyes and teeth is characteristic of painted representations of the animal in Zuni sacred art. The image can be compared with the animal depicted on the side of the jar drum (No. 95). According to Culin, black, gray, and brown bears are all sacred to the West (1907a: 27). DF

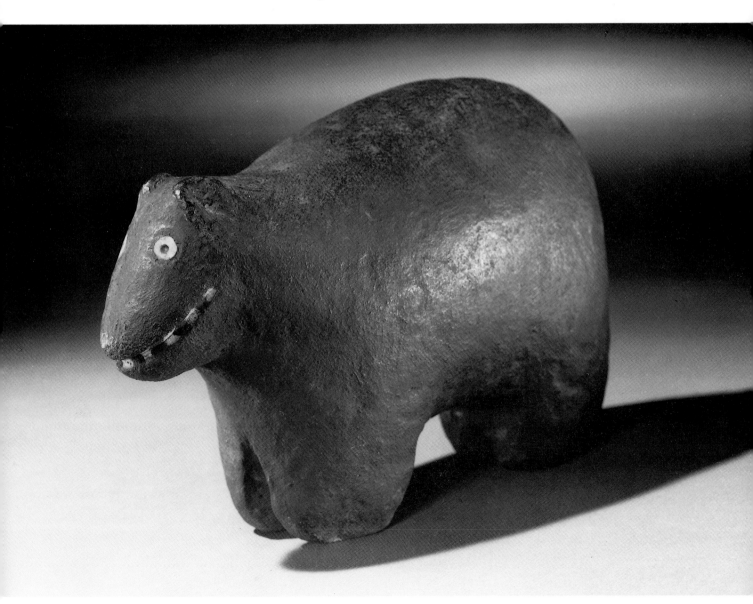

58–60. CHARMS
Zuni

No. 58: Ax Charm
Shell?, turquoise, black stone, wood, cane, sinew, pigment, L. 8¼, W. 1¼

No. 59: Sun Charm
Shell?, turquoise, black stone, resinous material, Diam. 1¼

No. 60: Fish Charm
Shell?, turquoise, resinous material, L. 1¾, W. ¾
Purchased in Zuni, New Mexico, 1903
03.325.3318; 03.325.3398; 03.325.3407

Although closely related in scale, material, and technique, these three charms do not constitute a set. Culin acquired each individually in 1903. He purchased an additional "shell sun" from the trader and missionary Andrew Vanderwagen as part of a shrine group. Beautifully crafted, these charms show the fineness of Zuni inlay work, which had a long history. A shell pendant set with turquoise and jet was excavated at the ancient Zuni village of Hawikuh.[1] DF

1. Smith 1966:256.

61. PAINT MORTAR WITH PESTLES
Zuni

Stone, traces of paint, H. 1½, L. 12¼ (mortar); L. 8½, 15½ (pestles)
Purchased in Zuni, New Mexico, 1903
03.325.3459.1–.3

Culin purchased several stone mortars with pestles in Zuni. This example is unusual in that the mortar is very regularly and precisely carved instead of being an adaptation of a natural boulder. Incised around the borders of the depressions are images associated with fertility: sun, tadpoles, and frogs. The three divisions of the mortar show traces of three different colors of pigment: yellow, white, and black. Only two of the three pestles Culin collected with the mortar have been found. In contrast to the mortar, they are naturally shaped stones. One has been used for the black pigment, and the other for the yellow. Culin reported that "while stone knives have disappeared, stone mortars, rasps, and crushing implements are still largely used" (1904b:19). DF

62. NAVAJO STYLE EAR PENDANTS
Made by Manta: Zuni
Turquoise, coral-colored beads, cotton string, L. (doubled) 3¼
Purchased from Manta in Zuni, New Mexico, 1907
07.467.8454.1–.2

This pair of earrings is exceptionally well documented. Culin provided the turquoise and observed the manufacturing process from start to finish. The commission got off to a slow start when Manta, a Zuni bead maker, rejected the various mortars that Culin and Vanderwagen offered him and went in search of his own equipment. When he returned, however, he applied himself wholeheartedly to the project: "Manta worked on my turquoise until he could not see. The first piece cracked in spite of his great care, the lower part dropping off, thus reducing the size. He would rub the turquoise a few times on the slab, then dip it in water and examine it minutely. This process he repeated, over and over." Working with two slabs, a fine one for polish-

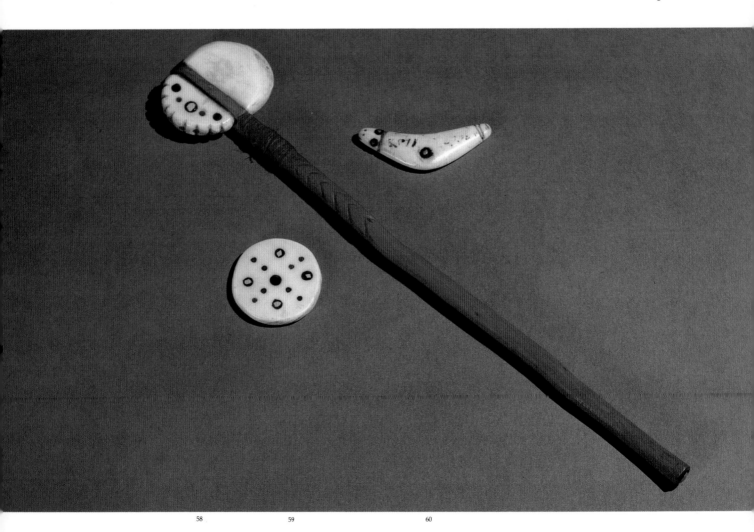

58 59 60

100

ing and a coarse one for the "first rubbing down," Manta drilled the ear pendants "with a lead whorl, the drill point being a sharpened, three-cornered file.... His only implement, in addition to the drill, was a small pair of steel pincers, with which he chipped off the matrix" (1907a: 167).

When the ear pendants were finally finished, Culin showed them to the Navajo men who came to Vanderwagen's store to trade and received a rather low estimate of their value from a man named Skeat. Later, Vanderwagen told him that Skeat's "disparagement was due to his wanting to buy them" (1907a: 168, 171).

In 1903 Culin had bought a Navajo necklace with ear pendants suspended from it and described their significance: "These ear rings are worn in the ears by virgins.... At marriage they are usually suspended from the shell or coral necklace, and are handed down in families to adorn successive generations of unmarried daughters" (1903: 71, 72). The Zuni women did not wear the turquoise eardrops but the wealthier men's necklaces included "one or more pairs of turquoise bead ear rings" (1907b: 149). DF

62

61

63. SPOON
Zuni
Wood, L. 7, W. 2½
Purchased in Zuni, New Mexico, 1903
03.325.3154

64. HOOK
Zuni
Wood, L. 5½, W. 3½
Purchased in Zuni, New Mexico, 1903
03.325.3148

65. LOUSE TRAP
Zuni
Wood, cotton string, L. 4½, W.½ (each stick)
Purchased in Zuni, New Mexico, 1903
03.325.3210

Culin spent much of his time in Zuni in 1903 "in a little room adjoining the barn where the women and girls would come with old things for sale. They were wretchedly poor, and ransacked their houses for old stones, bone and wooden tools and miscellaneous rubbish from which I would buy with a lavish hand" (1904b:46). In this manner he acquired discarded domestic items such as those shown here.

In 1879 James Stevenson reported that wooden utensils were "not frequently met with"; ceramic ladles, fashioned more quickly and easily, had superseded them.[1] Stirring sticks and gourd ladles were used for preparing and eating food. No. 63 is one of seven wooden spoons Culin purchased. All carved from a single piece of wood and showing signs of use, they range from a large ladle for communal feasts to regularly shaped utensils that appear to have been copied from tin teaspoons. This spoon has an elegant stepped decoration on the end of the handle. The stepped motif is found on a number of other domestic implements Culin collected, including a bread shovel and a snow shovel.

Culin also acquired several hooks that were used inside the house for suspending foodstuffs and equipment. The patina on No. 64 suggests years of use.

The louse trap (No. 65), on the other hand, is a unique item in the Zuni collection. Although it is difficult to imagine these slender wooden sticks functioning as tweezers, Culin gives a clear description of their purpose in his "Zuni Notes": "Lice are killed with an implement made of ku-si wood, three, four or five little flat sticks tied together, tslep-to-nai, 'wood-tied'" (1907b:74). He may well have seen them in action. Matilda Stevenson reported in 1901 that "one of the favorite pastimes is to sit outside the house and search in the hair for vermin."[2] Zuni louse traps are not common in collections, but at least one other pair, collected in 1911, exists in the Pitt Rivers Museum, Oxford, England.[3] According to the ethnologic dictionary, the Navajo used a very similar implement for killing lice "in earlier days."[4] DF

1. J. Stevenson 1883:370.
2. M. C. Stevenson 1904:371.
3. Kaemlein 1967:56
4. Franciscan Fathers 1910:170–71.

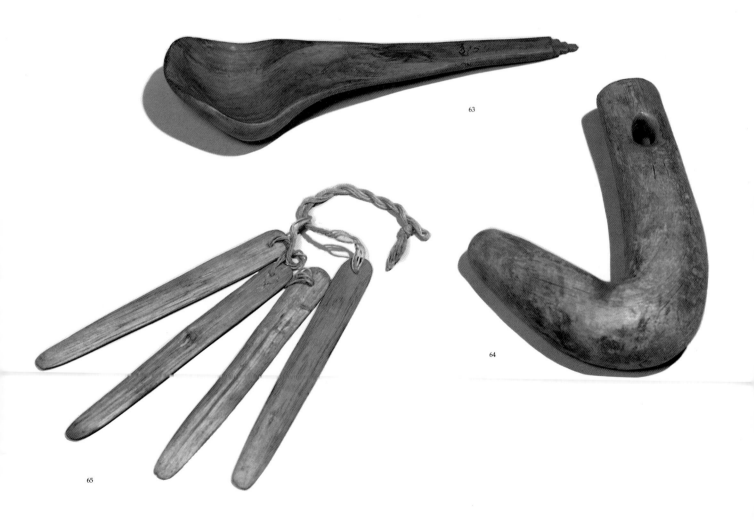

63

64

65

66. WEAVING COMB
Zuni
Wood, L. 7¼, W. 1¼
Purchased in Zuni, New Mexico, 1903
03.325.3143

67. NEEDLES (4)
Zuni
Wood, L. 4–4½
Purchased in Zuni, New Mexico, 1907
07.467.8455.1–.4

Culin had an easier time obtaining Zuni implements for weaving than the weavings themselves. At the time he visited, the Zuni were doing "very little weaving" and relied on the Navajo for blankets and the Hopi for ceremonial garments (1907b: 186). The wooden tools he collected were, therefore, obsolete. The comb (No. 66), carved from a single piece of wood, has short teeth and would have been used to pack the weft threads into position.

According to Culin's exhibition label, the finely crafted wooden needles (No. 67) were used for sewing sinew. He also reports that wooden needles, made of oak, were used for sewing cloth (1907b:208). It is possible that these needles were made for Culin; they are included in a list of objects a Zuni brought to Nick's store that "he had collected and made for me" (1907a:186). Culin also acquired wooden knitting needles and cactus needles. DF

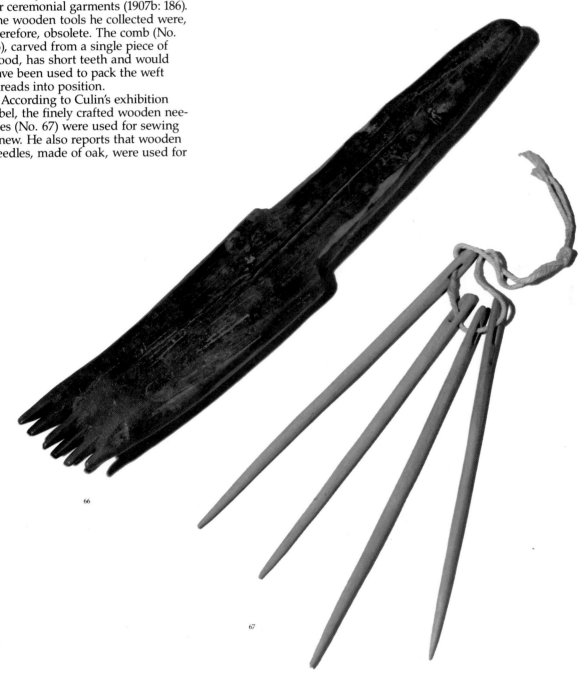

66

67

68. DOLL ON CRADLE BOARD
Zuni
Wood, resinous material, hide with fur, string, fabric, feather, pigments, H. 16½, W. 4½
Purchased in Zuni, New Mexico, 1903
03.325.3196

69. DOLL IN CRADLE
Zuni
Wood, cotton fabric, H. 14½, W. 5½
Purchased in Zuni, New Mexico, 1903
03.325.3195

This pair of dolls illustrates Zuni child-rearing practices. The doll on the cradle board (No. 68) was cut from a flat plank of wood and has a long peg for a nose. Remains of paint, feathers, and a string braid suggest that it was once more elaborately costumed. There are also holes for pegs (now missing) to represent the ears. A similar doll collected by James Stevenson in 1879 has features painted on the face.[1]

More realistic, although still without features or arms, the doll in No. 69 lies in a miniature cradle that is almost identical in form to a full-size cradle Culin collected. The frame at the top is for buckskin or muslin to keep off the flies. Cradles were among the few discarded household items the women were reluctant to sell. One man asked Culin to return a cradle that his wife had sold him, "saying that his wife had sold it thoughtlessly. Dick explained...that they have a superstition that if a mother parts with a baby's cradle the child will die" (1903:89).

Culin included a lengthy description of the use and ornamentation of the cradle in his "Zuni Notes": "The baby is tied in its cradle ten days after its birth by its grandmother, and is kept in it until it can walk. Turquoise and shell beads are set in the wood under the baby's head, and in the middle of its back, with a sweet food preparation of the yucca fruit called tsup-pa-chi, to insure the baby's health." He also reported that the "cradle must be carried straight on the back, not at an angle or sidewise as among the Navajo, as it is said that will cause the baby to grow up with a hump on its back" (1907b:323).

It is odd that Culin, who was so fascinated by kachina dolls, said nothing about this type of doll. DF

1. J. Stevenson 1883:Fig. 487.

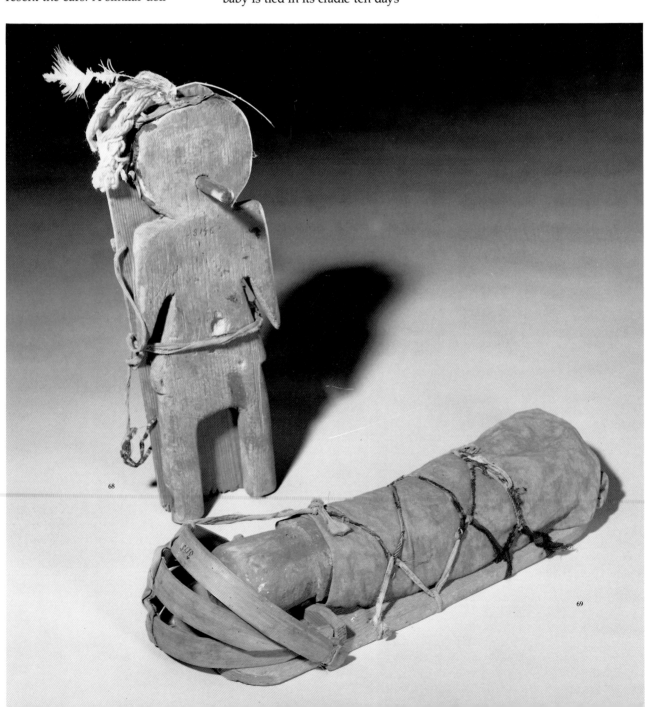

68

69

70–73. KACHINA DOLLS

Zuni

No. 70: Wood, hide, pigments, H. 9¾, W. 3

No. 71: Wood, pigments, hide, cotton, wool, silk, plant fibers, feathers, sinew, H. 9¾, W. 3

No. 72: Wood, pigments, hair, cotton, wool, hide, sinew, H. 12, W. 3½

No. 73: Wood, pigments, furs and hide, wool, feathers, cotton, H. 12, W. 3¾
Purchased in Zuni, New Mexico, 1903
03.325.3202; 03.325.3203; 03.325.3204; 03.325.3205

In every pueblo Culin visited in the Southwest, he looked for kachina dolls. He invariably noted their presence, their absence, their attributes, their availability, and their names. There are several explanations for his intense interest in these dolls. First, as an extension of his research on games, he was fascinated by the sacred associations of toys. Second, for the most part the dolls were unobtainable and Culin could not resist such a challenge. Third, and perhaps most important, they made very attractive and appealing exhibitions. In his own pioneer exhibitions at the World's Fair in Chicago, Culin had illustrated the "value of toys as museum specimens." Toys of all countries, he observed, "abound in representations of mythological personages and animals, of implements used in religious and ceremonial observances, and not less interesting, domestic and agricultural utensils, which are often those of a past age."[1]

Zuni kachina dolls, which Culin defined as "dolls, made as playthings for children," that "represent the masked and costumed personages who appear in their religious ceremonies and dances" (1907b:242), were especially desirable. Made of wood, with the arms carved separately and nailed on, they were elaborately dressed and carried miniature replicas of ceremonial paraphernalia. It was difficult, if not impossible, to purchase them, however. Culin summed up the situation in his "Zuni Notes": "Dolls are considered sacred, and it is forbidden to sell or dispose of them, this being regarded as a crime and severely punished" (1907b:242).

In his letters to the director of the Museum as well as in his expedition reports, Culin insists that he was offered no kachina dolls in Zuni. These four dolls provide contradictory evidence. All were purchased in the village in 1903 for prices ranging from five to fifty cents.

Culin's indifference to these dolls and their appearance suggest that kachina dolls were one category where Culin preferred the new to the old. No. 70 has lost all its paint as well as its clothing. Culin simply called it a doll and gave no other name for it.[2] It makes an interesting comparison with the fully dressed No. 71 (bok-chi-a-la-kwai) that is about the same size and also wears a leather visor.

No. 72 (ya-mu-hak-do) shows signs of wear but is readily identifiable by the stick on its head as the kachina who "comes to bring all kinds of things for the people, so that they may get property easily. He prays for the trees so that they may have wood for their houses and for firewood."[3] In contrast, No. 73 (hai-a) is a strange pastiche of attributes. The arms are missing, and except for the prominent crooked mouth, there are no facial features. DF

1. Culin 1894:51–52.
2. On almost every catalogue card, Culin identified the kachina as "doll," followed by the Zuni name supplied by Vanderwagen. These names (with Culin's spelling) have been given in parentheses throughout the catalogue entries.
3. Bunzel 1932:967.

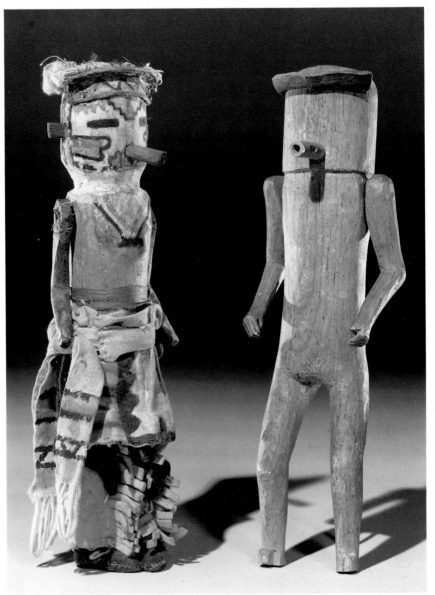

71 70

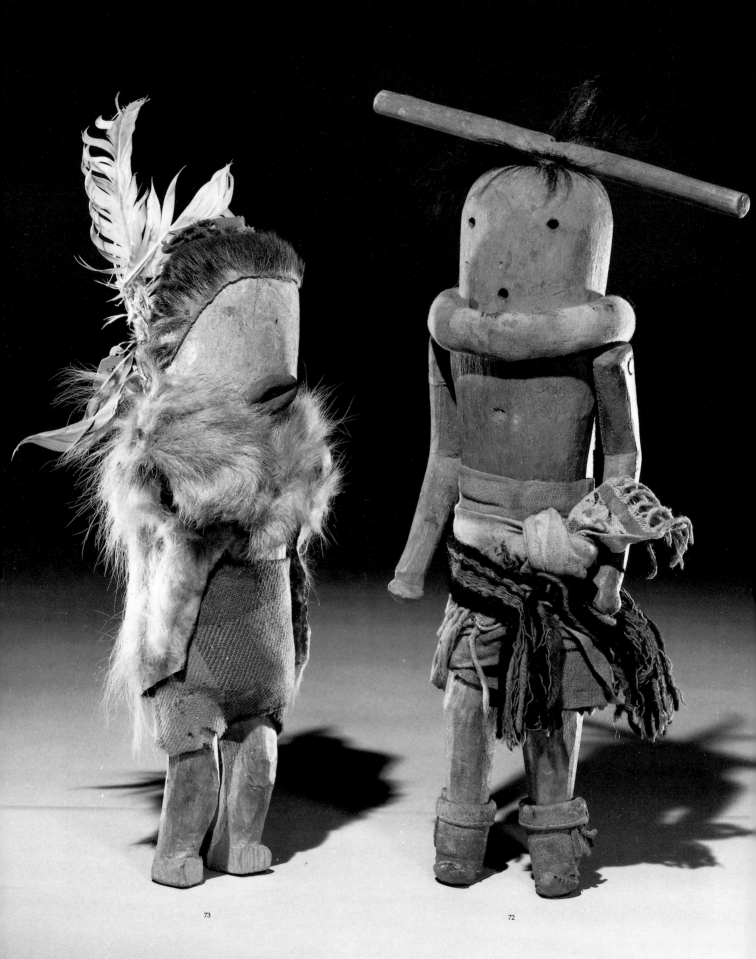

73 72

74–76. Kachina Dolls

Zuni

No. 74: Wood, pigment, wool, cotton, H. 16. W. 5

No. 75: Wood, pigment, wool, H. 12½, W. 4

No. 76: Wood, pigment, wool, feather, H. 16, W. 5½
Collected by Andrew Vanderwagen; purchased in Zuni, New Mexico, 1903
03.325.4601; 03.325.4602; 03.325.4606

Culin was certainly familiar with Cushing's memorable description of Zuni clowns, or mudheads:

Sprawling about the ground in front of and behind the row of dancers, in attitudes grotesque yet graceful, I observed for the first time ten most ludicrous characters, nude save for their skirts and neck-cloths of black tattered blanketing, their heads entirely covered with flexible, round, warty masks. Both masks and persons were smeared over with pink mud, giving them the appearance of reptiles in human form that had ascended from the bottom of some muddy pool and dried so nearly the color of the ground and the surrounding houses that at first it had been difficult to distinguish them.[1]

On May 27, 1904, Culin himself had an opportunity to observe the clowns in action. They played games in the plaza before the dancers appeared and afterward "they formed in line like the dancers and mimicked their song and actions" (1904a:14). Finally, one of the clowns gave a kachina doll (representing Siatosha) "to an infant held by a mother in her arms. He addressed it at the same time a few words, which I was told were friendly admonition. The clowns give away dolls on such occasions, and parents are always anxious to secure them for their chil-dren." Culin later learned that one of the clowns "had hurt his foot on the way from Ojo Caliente, and could not take part in the dance. An eleventh Koyemshi [mudhead] is always provided for such emergencies" (1904a:14–15).

Significantly, ten dolls representing clowns were included in Vanderwagen's collection. To judge from an old installation photograph, Culin displayed them all in his first Southwest exhibition. There are minor differences in the knobby masks each clown wears. No. 76, for example, has a feather above one of the knobs on his head. They also have individual names. Culin recorded the following for these three: *nathla she; muya po na; pakwen.*
DF

1. Cushing 1882–83:4–5.

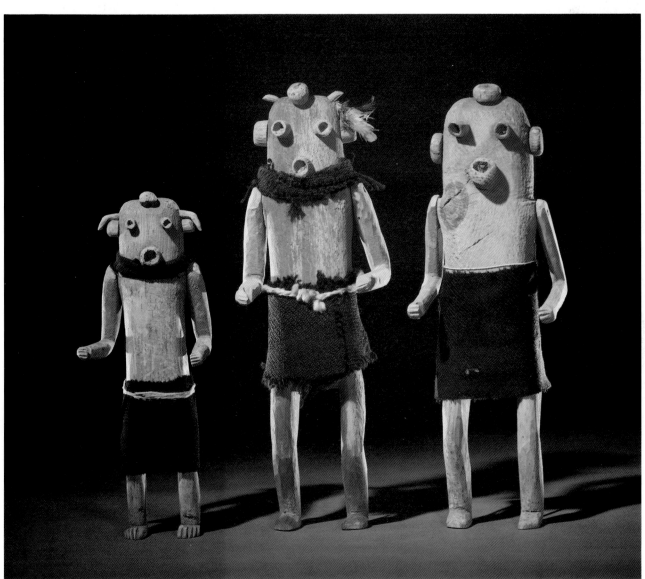

75 76 74

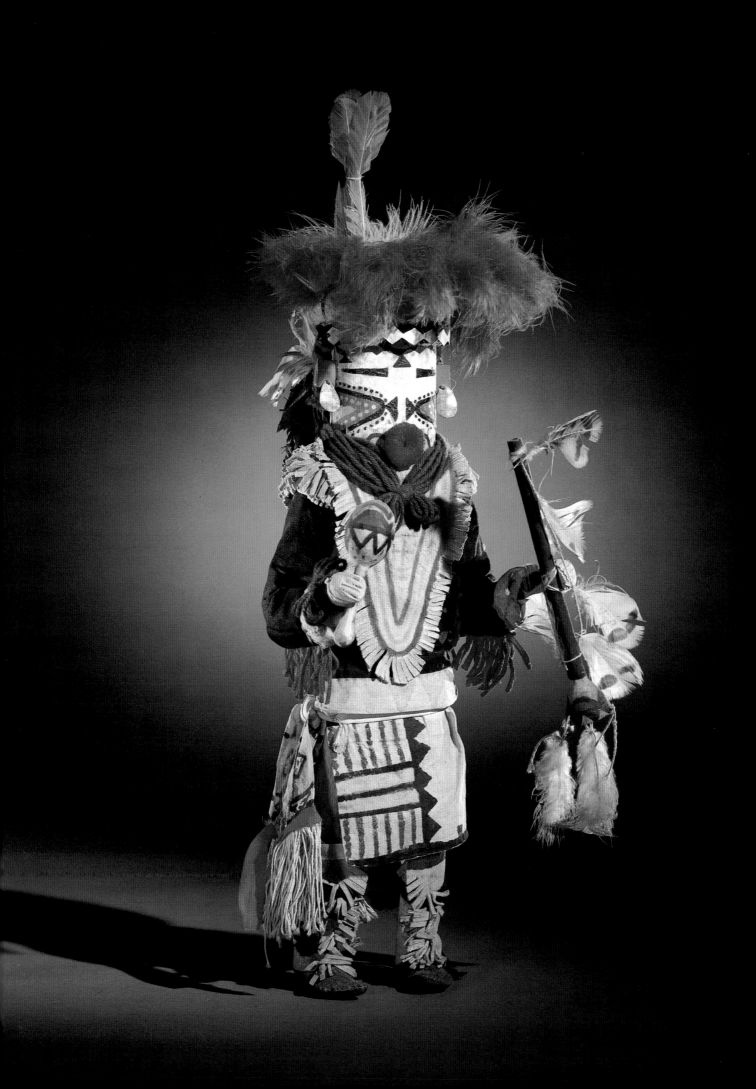

77–79. KACHINA DOLLS
Zuni

No. 77: Wood, pigments, wool, hide, feathers, cotton, tin, H. 22½, W. 9

No. 78: Wood, pigments, horsehair on hide, cotton, feathers, hide, tin, H. 20, W. 6½

No. 79: Wood, pigments, hair, fur hide, cotton, wool, yucca, H. 19, W. 6
Collected by Andrew Vanderwagen; purchased in Zuni, New Mexico, 1903
03.325.4631; 03.325.4648; 03.325.4653

These three dolls are among the most dramatic in the collection of seventy-three that Culin purchased from Vanderwagen in 1903. Their previous history is somewhat unclear. In 1902 Culin reported that "in recent years, the Zuni have made a few models of the kachinas, similar to the dolls for the collections, but even this is done with the greatest secrecy" (1902b:4). Andrew Vanderwagen may well have initiated this practice. In 1903 he told Culin that in the interval since his last visit "he had secured some 50 different wooden dolls, or effigies of the dancers" (1903:32). He did not say that he had commissioned them, however. Vanderwagen had resided in Zuni since 1898 and over the years had put together a very varied and valuable collection; it is possible that he had managed to purchase kachina dolls from time to time.

Whatever the source of the dolls, the Zuni were not pleased when they discovered the kachinas and other ceremonial objects in Vanderwagen's house, and "as a matter of precaution, the missionary determined to remove the collection from the town." Culin was only too willing to assist and accompanied the cargo to Gallup (1903:48). The community remained concerned about the consequences of Vanderwagen's acquisitions: "it was common opinion in Zuni that the sale of dolls to Vanderwagen, the violations of the ancient shrine, and other acts of impiety, would result in drought and failure of the crops" (1903:95–96).

Later, Culin expressly stated that all the kachina dolls on view at the Museum were new, were made of piñon (rather than cottonwood), and "were especially manufactured for the present exhibition, as, while they are identical with the dolls given by the dancers, and made by the same men, they represent the entire range of Zunian mythology, instead of only a few of the more prominent characters, as is the case with the dolls ordinarily made as presents."[1]

One of the most elaborately dressed dolls in the entire collection is No. 77 (chilchi), who holds a dance flute and rattle. Considerable time must have been taken in making the costume, which includes a feather headdress and a fringed buckskin collar with a Maltese cross painted on the front and a bustle with ribbons on the back.

A stuffed image of a snake hanging from the mouth of No. 78 (awen-noshhok we-a) enhances its frightening appearance. The snake is repeated on the kilt. No. 79 (tam-tam kushokta) has a protruding leather tongue and carries a bundle of yucca whips in his hand. DF

1. Culin 1907d:78–79.

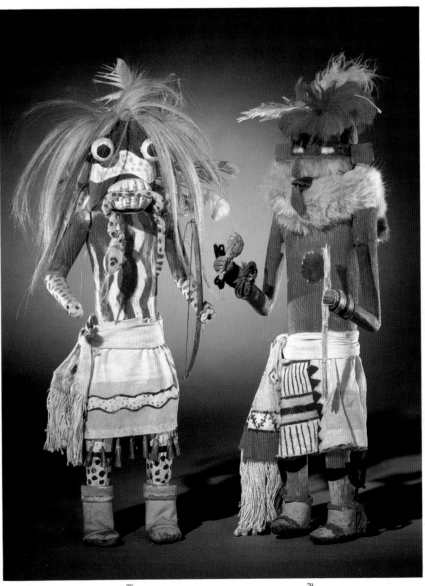

78 79

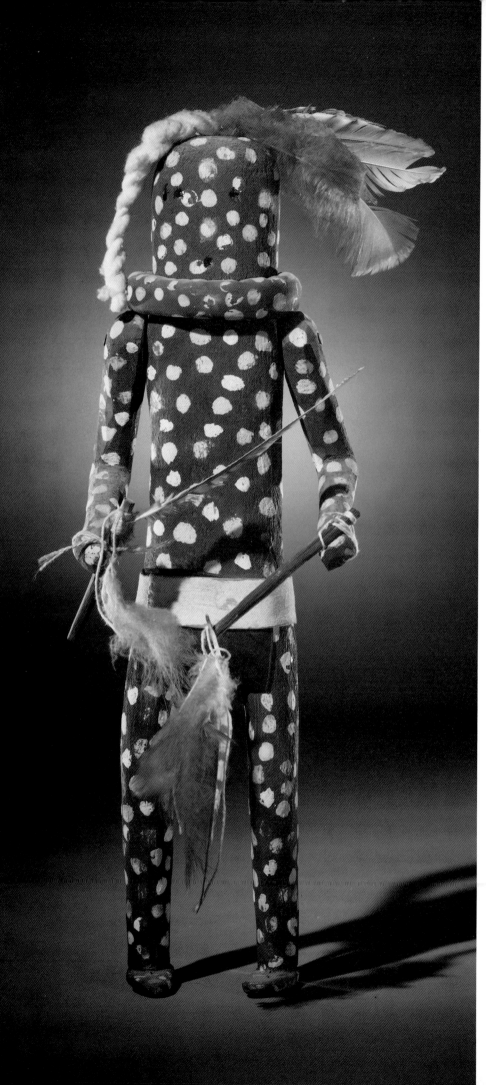

80. KACHINA DOLL
Zuni
Wood, feathers, wool, cotton, hide, silk, H. 17¾, W. 6
Collected by Andrew Vanderwagen; purchased in Zuni, New Mexico, 1903
03.325.4651

This doll (*shulawitsa kohana*) is a striking representation of the Fire-God Impersonator, a kachina who wears body paint rather than a costume. According to Culin, "For the body, dried smut...from the corn is used for black. It is put in a dish with water and rubbed on with the hands" (1907b:336). DF

81. KACHINA DOLL
Zuni
Wood, pigments, cotton, hide, wool, feather, paper, metal, H. 15, W. 3½
Collected by Andrew Vanderwagen; purchased in Zuni, New Mexico, 1903
03.325.4623

Culin identifies this doll as a *kyanaque ko-ha-na*, which he also spells as *Kanakwe*. In 1907 he carefully recorded the arrival of the "Kanakwe" dancers in the plaza in Zuni. The majority were dressed in embroidered white Hopi blankets...All of the maskers wore pot-shaped leather masks with the face surrounded with an oval, rainbow-like, mark. On top of the mask was a plume...with two feathers, and the mouth-piece consisted of a serrated tube called po-cho-to-nai, "teeth sticking out." The sides of the mask were decorated with little, conical, ear rings, po-sa-to-wai....In their right hands they carried a tortoise-shell rattle, which they shook with vigor when they danced, and in the left hand, a bundle of prayer sticks, tied up in corn husk, with a kind of handle attached, by which it was held. There were two leaders, who stood together inside the broken circle formed by the others when they danced. These two wore white masks decorated with tadpoles and dragonflies, and both of them had four small objects tied both on the front and on the back of their embroidered cotton blankets (1907a:190–91).

This doll (which has tadpoles painted on the back of its head) matches Culin's description of the dancers almost exactly.

Although Culin enjoyed watching the dance, he did not appreciate his fellow spectators: "Among them the whites were conspicuous, grotesque, and incongruous" (1907a:195). DF

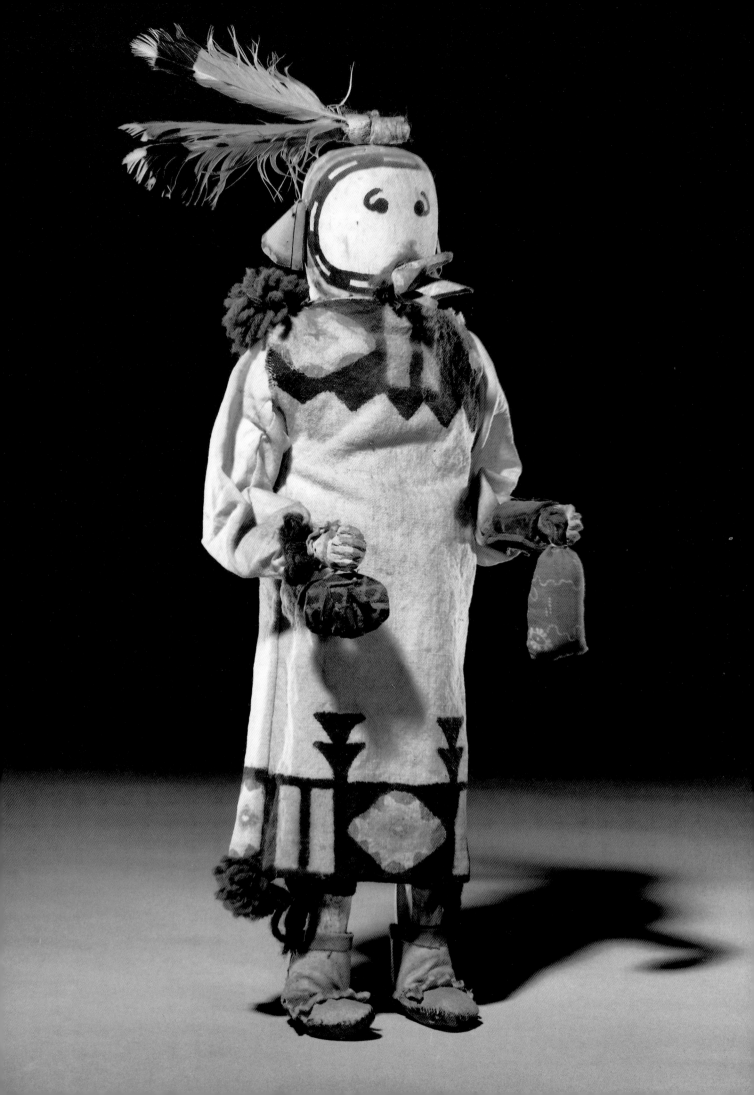

82, 83. KACHINA DOLLS

Zuni: 1904
Wood, pigments, fur, cotton, wool, feathers,
H. 14½, W. 4½; H. 18, W. 5½
Purchased from Andrew Vanderwagen in Zuni, New Mexico, 1904
04.297.5341; 04.297.5362

In 1904 Culin purchased an additional fifty dolls from Vanderwagen. These dolls were definitely made expressly for the Museum. Vanderwagen had employed three Zuni "ostensibly in sinking a well. The Indians had been working in a locked room in the dwelling, and the masks and dolls were contained in a securely fastened box and two trunks" (1904a:9). Obviously Vanderwagen was not taking any chances.

Culin purchased the entire lot— "fifty dolls at $4 apiece, all different from the seventy-three secured in Vanderwagen's last collection." Vanderwagen probably made Culin act faster by shrewdly reporting that "Mrs. Stevenson had tried every means possible to learn what Vanderwagen was doing, and had offered him...$25 for one of the masks." Culin did not get a chance to discuss the dolls with the artists because just before his visit "the men who had been engaged in this

work had become frightened, and left the place precipitately" (1904a:10).

On the catalogue cards for the dolls, Culin gives the Zuni name and cites his 1904 report. Even if this documentation were not available, however, the dolls could be identified as a contemporaneous group on the basis of the comparative uniformity of materials and technique. These two, *tse-poth-le* (No. 82) and *thla-hak-tona* (No. 83) are representative examples. The paints not only are the same color but also are applied in the same way. On both dolls the feet have been made separately and nailed on and the moccasins are painted on, rather than fabricated. While feather and fur are plentiful, the dolls do not carry any paraphernalia and their kilts are not hemmed. Moreover, they are not common kachinas.

It is rare to be able to date kachina dolls so precisely. This group provides us with valuable information on individual carving styles and on the techniques and materials in use in 1904. DF

84, 85. KACHINA DOLLS

Zuni
No. 84: Wood, pigments, fur, cotton, wool, H. 13½, W. 5¼

No. 85: Wood, pigments, cotton, hair on hide, hide, yucca, resinous material, H. 14½, W. 7
Purchased from Andrew Vanderwagen in Zuni, New Mexico, 1907
07.467.8416; 07.467.8440

On his last trip to Zuni, Culin bought another group of dolls from Vanderwagen, almost, it seems, out of habit or charity. Culin had first heard about these dolls, which Vanderwagen had "had made during the past winter," in 1905. Although he thought that they would be "an important addition" to the collection, he did not make any great effort to acquire them (1905:98). In 1907 Vanderwagen showed him "the Zuni material he had put away, dolls in his house, and dolls and masks in an outbuilding. The latter, he said, had been damaged by moths." After some discussion, Culin "bought all the dolls that Vanderwagen had on hand, taking them just as they are, at a uniform price of $1.25 apiece" (1907a:164, 167–68).

There are a number of interesting dolls in this group, including this powerful bear kachina (*ainshi koko*) with oversize black paws and the figure with carved facial features (*patchu*). DF

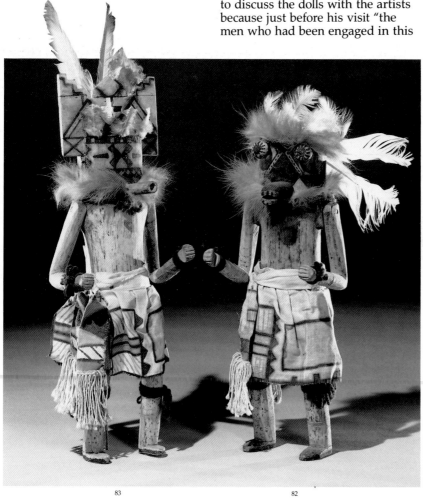

83 82

112

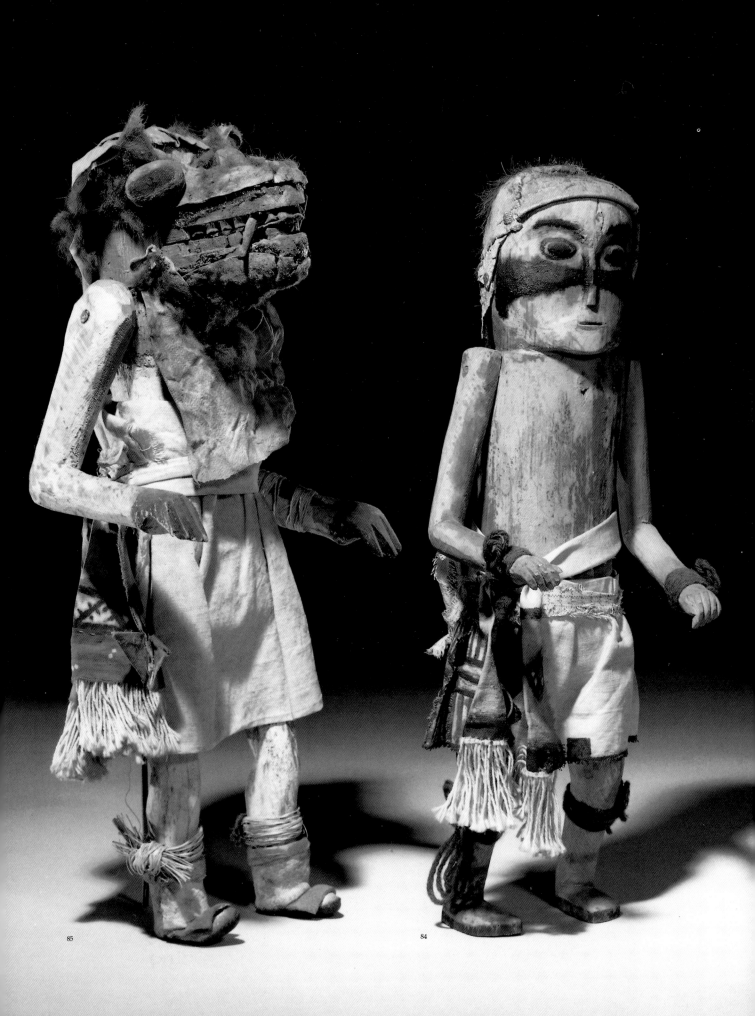

85 84

86. WATER JAR

Zuni: 1700–1750
Ashiwi Polychrome: ceramic, slip, H. 10¾,
Diam. 13½
Purchased from Andrew Vanderwagen in
Zuni, New Mexico, 1903
03.325.4739

Among the most historically interesting objects Culin purchased from Vanderwagen in 1903 were several jars from the Siatosha shrine. According to Culin, "about twelve old jars" had originally been deposited at the shrine (1903:98). When he first visited it in 1903, they had all been removed and were in the hands of various dealers and collectors. Culin subsequently learned the whereabouts of eight: Vanderwagen had six; Mr. Alcott in Los Angeles had one; and Miss Palin had one. Determined as always to reunite objects that were known to belong

together, Culin managed to acquire all the Vanderwagen pieces as well as the Alcott piece. Miss Palin, however, is never mentioned again.

The shrine jars constitute a concise history of Zuni ceramics. This magnificent example of Ashiwi Polychrome, a style that is ancestral to Zuni polychrome, was in the Vanderwagen group. The upper portion of the vessel is decorated with a diagonal sweep of red and black feathers alternating with geometric designs. DF

87. WATER JAR

Zuni, 1825–50
Ceramic, slip, H. 12¾, Diam. 12¾
Purchased from Andrew Vanderwagen in
Zuni, New Mexico, 1903
03.325.4723

Culin singled out one ceramic piece on Vanderwagen's list as an "old jar—remarkably fine."[1] This is the vessel that caught his eye. Unfortunately Vanderwagen did not note the previous history of the jar, which must have been made at least fifty years earlier. A distinctive feature of this period of Zuni ceramics is the sculptural emphasis on the mid-body of the vessel. The evolution from this shape to a more spherical one (see Nos. 93, 94) was gradual. DF

1. "Vanderwagen's Collection," n.d., Object Files: Vanderwagen Collection, Culin Archives.

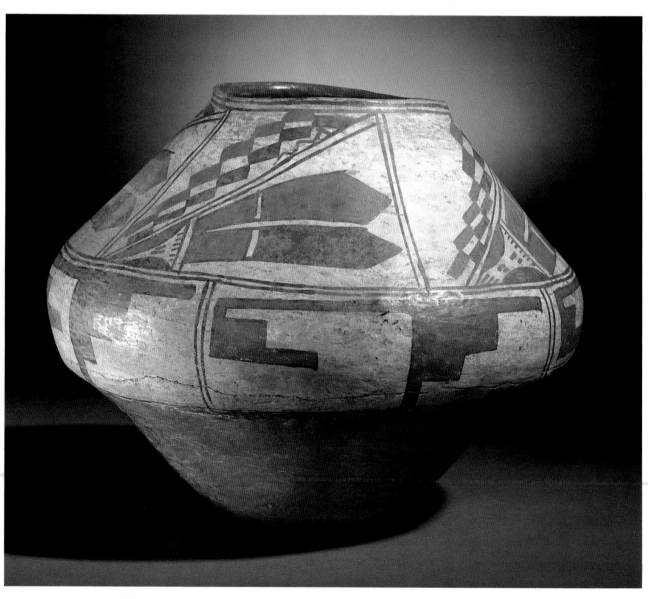

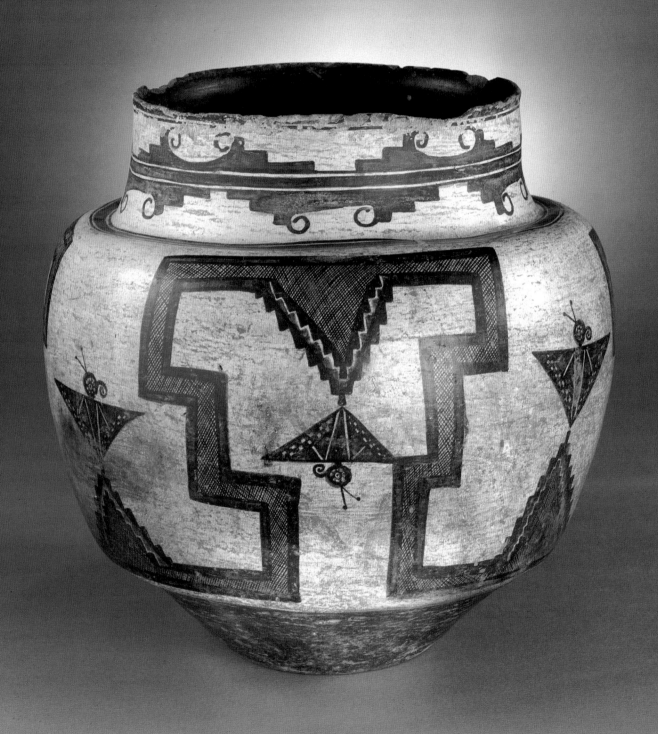

88. CEREMONIAL BOWL

Zuni
Ceramic, slip, H. 8½, Diam. 14¾
Purchased from Andrew Vanderwagen in
Zuni, New Mexico, 1903
03.325.4721

One of two "medicine bowls" included in the first Vanderwagen collection, this terraced bowl is painted with images associated with fertility: tadpoles, dragonflies, frogs, and the serpent with a feathered topknot ("ko-lo-wis") whom Culin described as "a mythic snake that lives in Sacred Lakes" (1907b:54). Two of these snakes are represented in dark brown with red tongues on the interior of this bowl, which is worn and stained.

Culin observed that these "special bowls" were "used for medicine water.... [They] always have four raised cloud terraces arranged at equal distances around their edge" (1907b:333). DF

89. DANCE FLUTE

Zuni
Wood, gourd, plant fibers, pigments, feathers, cotton cloth, L. 24½, Diam. of bell 4½
Purchased from Andrew Vanderwagen in
Zuni, New Mexico, 1903
03.325.4700

This is one of two flutes included in the material Culin purchased from Vanderwagen in 1903. Culin was able to learn a considerable amount about this Zuni musical instrument, which was "used in many dances." Flutes were "played to secure rain, it being believed that if the flute is not played, rain will not come." There were two kinds: a dance flute and a sacred flute. The dance flute

is now made of a gun barrel or of cotton wood, but formerly of sun flower stalk. The stem of the sacred flute is unpainted, but that of the dance flute, if of wood, is painted black. Both kinds have a bell, that of the sacred flute being always made of gourd, which is sometimes painted, while that of the

dance flute is made of gourd painted and sometimes of painted clay, or of colored yarn wound around wires in the form of a squash flower.

Although the bell on the flute does not augment the sound, "some Zuni believe that if a man blows a flute without a bell, his wife will bear a deformed child (1907b:247–48)."

Dance flutes are "both hollow and practical, or made of a solid piece of wood and give no sound" (1907b: 248). This example is the latter type and in almost every respect conforms to Culin's description of a dance flute. The stem is painted black and the bell is made of gourd painted in blue, yellow, black, and white. Sprigs of fir are tied around the middle. A vivid portrayal of a ceremonial dancer with a flute is provided by the elaborately costumed kachina doll (No. 77). The flute the kachina doll holds is hollowed out, so it must represent an instrument that, unlike this one, could actually be played. DF

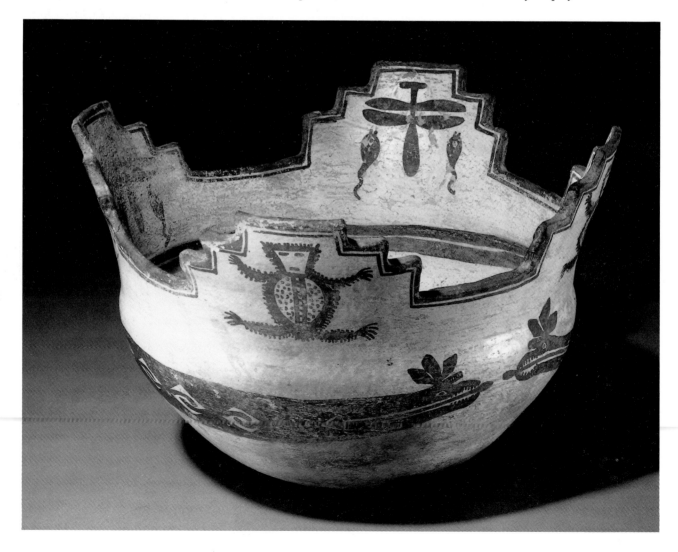

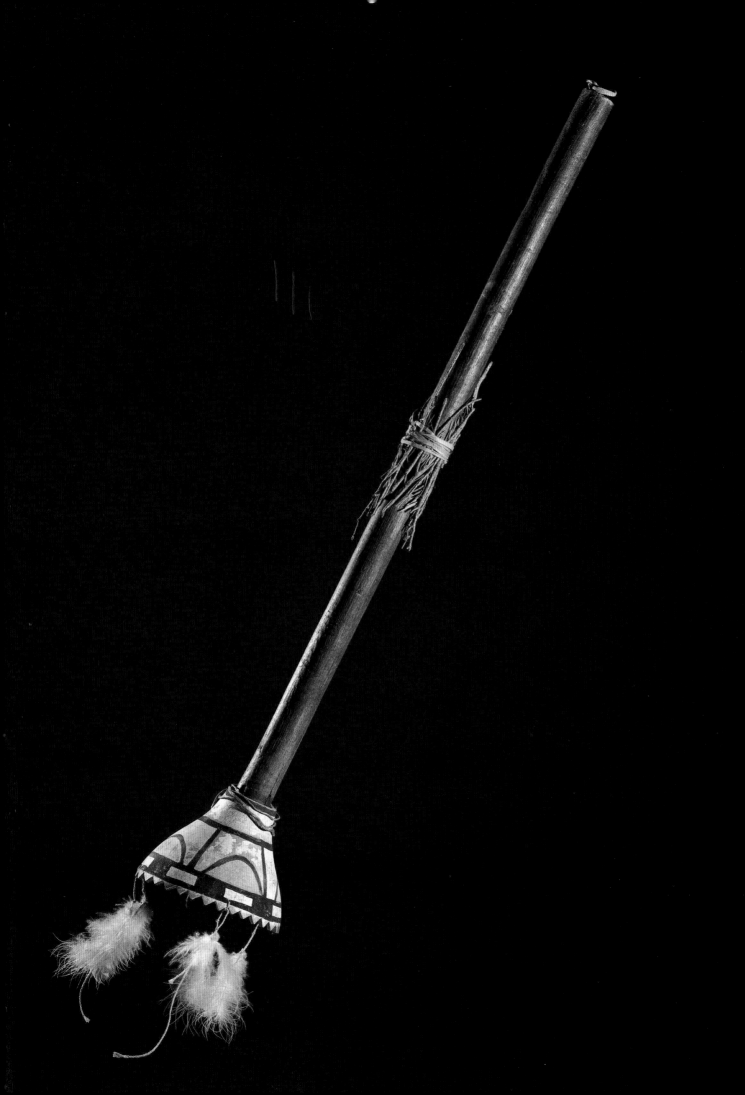

90. Rattle

Zuni
Tortoise shell, hide, deer hooves, L. 7¼, W. 5¼
Purchased from Andrew Vanderwagen in Zuni, New Mexico, 1904
04.297.5005

Culin purchased this rattle as a single item from Vanderwagen. According to his "Zuni Notes," the tortoiseshell rattle was one of seven kinds of rattles used by the Zuni. Made of "the shell of the tortoise …from the Sacred Lake," it "has pendants of deer hoofs or metal dangles. It is tied on the right leg with a buckskin thong and worn in all dances" (1907b: 246). The rattle would sound every time a dancer marked the rhythm with his right foot.

The upper part of this shell has two holes on either end for attachment. The underside is very smooth and polished. A tortoiseshell rattle is realistically represented in miniature on the wrist of a kachina doll in the 1903 Vanderwagen purchase (No. 81). DF

91, 92. Figures of Navajos

Zuni
Ceramic, slip, H. 6¾, W. 3¾; H. 8¾, W. 3¾
Purchased in Zuni, New Mexico, 1904
04.297.5301; 04.297.5302

In 1902 Culin spoke disparagingly of the "inartistic innovations" that "have been created to supply a demand for novelties," citing pottery moccasins as an example (1902b:16). Obviously, he did not include these whimsical sculptures of Navajo men in this category, because he purchased two for his own collection as well as these two for the Museum.

The Zuni represented the Navajo in a variety of media, including dance performances. On these figures the most distinctive features of Navajo dress—the jewelry and headband—are carefully delineated in paint. Anglo-Americans and Mexicans were also popular subjects for Zuni sculptors in clay. In 1879 James Stevenson acquired a large collection of these "statuettes," including a "man with a hat and clothing" as well as an "Indian boy without clothing and wearing moccasins."[1] DF

1. J. Stevenson 1883: 366.

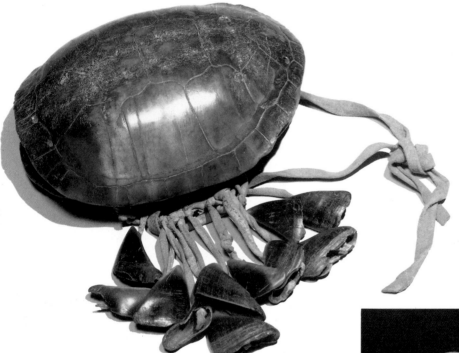

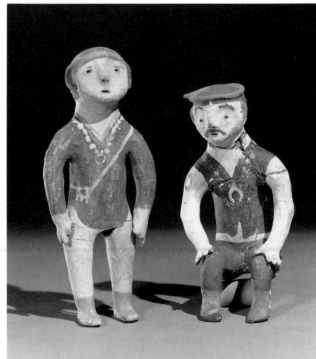

92 91

93, 94. WATER JARS
Zuni
Ceramic, slip, H. 11, Diam. 13¾; H. 12,
Diam. 14½
Purchased in Zuni, New Mexico, 1904
04.297.5248; 04.297.5249

Culin did not commission any pottery in Zuni. In 1904, however, he observed pottery making during the month of June, the traditional time for this artistic activity:

For some time past, [he wrote in his expedition report,] the women have been making pottery. They carry the hard dark blue clay from the top of Tow-oyalnai [Corn Mountain]. The clay is broken in small fragments with an axe on a special stone on the floor of the living room of the house. Then, after being reduced nearly to a powder with a grinding stone, it is mixed with water into a thick gray paste in an ordinary food bowl. Powdered fragments of old pottery are often added to the mass. In making a bowl, a woman rolls a piece of the clay on a flat stone until it assumes a cylindrical form. She then takes this piece and coiling it around, at the same time flattening it and crimping

it with her fingers, gradually builds up the bowl with successive coils.

After the vessel was smoothed ("with a rounded fragment of gourd shell") and dried, a "paste of white kaolin" was applied to the surface "inside and out in the case of a bowl, or the exterior only in that of a jar." The jar was then burnished with polishing stones and decorated: "The paint is applied with a little slip of yucca stem. The designs are all more or less symbolic, and are repeated from memory" (1904a:37).

Firing took place next:

The vessel is supported upon some fragments of adobe and a kind of furnace is built up of dung entirely around it. When the fire is applied the last pieces of dung are added, with some large fragments of old jars to prevent the fuel coming in direct contact with the jar. The operation of burning lasts about half an hour. The dung is reduced to an ash, leaving the vessel, white and bright, ready to be lifted from the ashes, and put into practical use as soon as it has cooled (1904a:37–38).

In "Zuni Notes" Culin stressed the precautions that were observed during the firing: "Great care is exercised to prevent the jar from becoming smudged or distorted, two women usually holding blankets if there is a wind so that the fire will burn evenly. A man whose wife is pregnant, or a pregnant woman, must spit on the jar in passing, or it will be crooked or blackened. A woman when painting a jar must not talk aloud or the same thing will happen" (1907b:184).

Jars were used to store water in the house, as well as to carry water "from the wells and from circular pits dug in the river bed" to the gardens, which were exclusively cultivated by the women (1903:94).

Collected in 1904, these handsome jars are fine examples of two popular late nineteenth-century painting styles. Both show signs of wear, especially around the neck; they may well have been made a decade or two before they were collected. DF

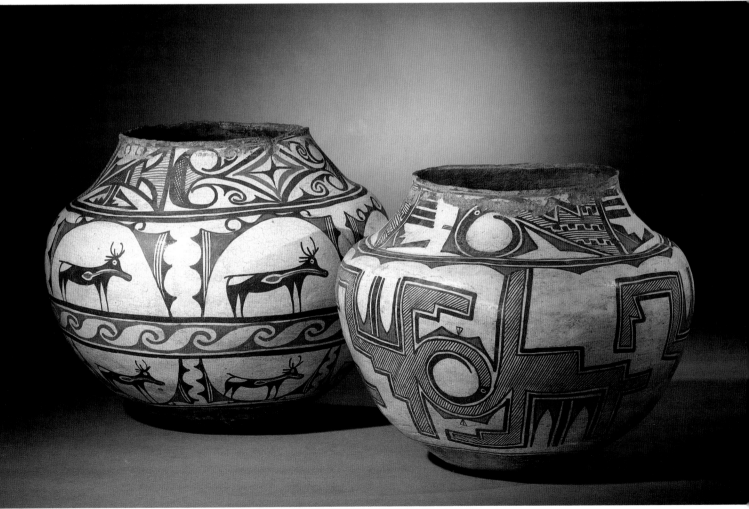

94 93

95, 96. JAR DRUMS
Zuni
Ceramic, slip, H. 17¾, Diam. 21; H. 15, Diam. 17
Purchased in Zuni, New Mexico, 1903
03.325.3255; 04.297.5279

Culin collected a number of different jar drums in Zuni and described the various types in "Zuni Notes":

Jar drums consist of large, specially-made jars, nearly globular, with a large mouth which is covered with goat skin tied on with raw hide or horse hair rope. They are always beaten with a drum hoop,...a piece of sapling, curved and tied to form a hoop at the striking end. Jar drums are used to accompany the dance in the Fraternity house. Each Fraternity has its own jar drum, either plain, or painted with religious pictures. The drum of the Big Fire society is painted with a rattlesnake; that of the Shu-ma-kwai, with four Morning Stars; that of the Eagle Society with eagles and all kinds of animals, and that of the Little Fire with bear, mountain lion, badger and wild cat. The drums of the Rattlesnake, U-hu-hu-kwai, Yellow and Blue corn societies are plain" (1907b:249).

In purchasing the drums, he learned some additional facts about their function. An old jar drum that formerly belonged to the Rattlesnake Society, for example, "had been built into the wall and used to store bread in, a common custom." Although the

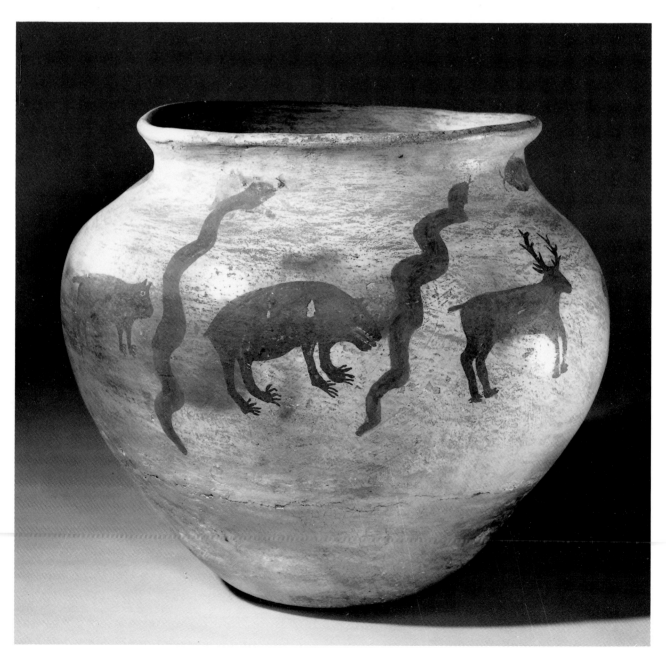

men were willing to part with the old drum, they would not sell the newer drum (1904a:35).

Culin did not identify the society to which No. 95 belonged. Two butterflies and two dragonflies are painted inside the drum. On the outside, the major motif is a raptorial bird with outstretched wings. Snakes, a bear, a mountain lion, and a deer are also depicted. While the deer frequently appears on secular water jars, the other motifs are primarily found on ceremonial vessels.[1]

In contrast to the intricate and realistic animal designs on No. 95, the pattern on No. 96 is simple and abstract. Culin noted on the cata-

logue card that the drum was "used when the girls grind corn."

Such large ceramics were difficult to ship across the country. It is not surprising, therefore, that shortly after they arrived in Brooklyn, Culin wrote to the director requesting permission to have several jar drums mended.[2] No. 95 has an old repair around the lower half. DF

1. Bunzel illustrates a similar drum and discusses the differences between the sacred and secular designs in 1929:23–27.
2. See S. Culin to F. Hooper, Nov. 7, 1903, Departmental Records.

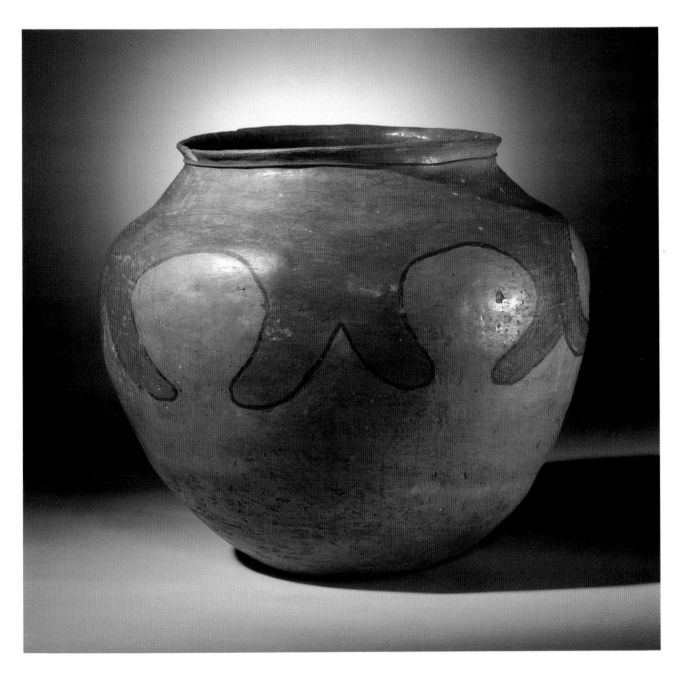

97, 98. FOOD BOWLS

Zuni
Ceramic, slip, H. 4¼, Diam. 11½; H. 5¼, Diam. 13
Purchased in Zuni, New Mexico, 1904
04.297.5266; 04.297.5298

Culin paid only fifteen cents apiece for these polychrome bowls, which document the coexistence in 1904 of two very different painting styles in Zuni. The simple design in white on an orange ground on No. 97 can be compared to the bold patterning on the jar drum (No. 96). According to Margaret Hardin, who recently studied the Smithsonian's collection of Zuni pottery, this painting style "is rare on jars, but occurs more commonly on canteens and bowls." She also observes that "the large designs ceased to be actively used by the turn of the century."[1]

The exterior design on No. 98 is very common on bowls and has been interpreted as a representation of feathers. The painting inside this bowl is exceptionally fine.

The bowls were used for serving food. After a dance, Culin observed the women carrying "bowls into the house. In most of them the content was not visible, but one was filled with slices of red water melon, artistically displayed" (1904a:50). DF

1. Hardin 1983:15.

99. CANTEEN

Zuni
Ceramic, slip, H. 16, W. 17
Purchased in Zuni, New Mexico, 1904
04.297.5272

Pottery canteens "variously painted and decorated" were used to "carry water, and milk to the sheep camps." Nick knew of three different kinds: "the round canteen, with handles at the two sides..., the double gourd...and the long canteen with two lobes" (1907b:127).

According to Culin's catalogue card, this large and extremely heavy canteen was used "in the springtime at Ojo Caliente to carry water to the kolowis." An effigy of the *kolowisi* (feathered serpent) presides at boys' initiation rites.[1] The floral motif on the front of the canteen is usually identified as a sunflower. The underside of the canteen is unpainted.

In an imaginative article on the origins of Pueblo pottery, Frank Hamilton Cushing suggested that the "flat-bellied canteen" was inspired by "the human mammary gland, or perhaps its peculiar form may have suggested a relationship between the two."[2] DF

1. For an earlier description of carrying water from Ojo Caliente to the *kolowisi*, see M. C. Stevenson 1904:94.

2. Cushing 1886:512.

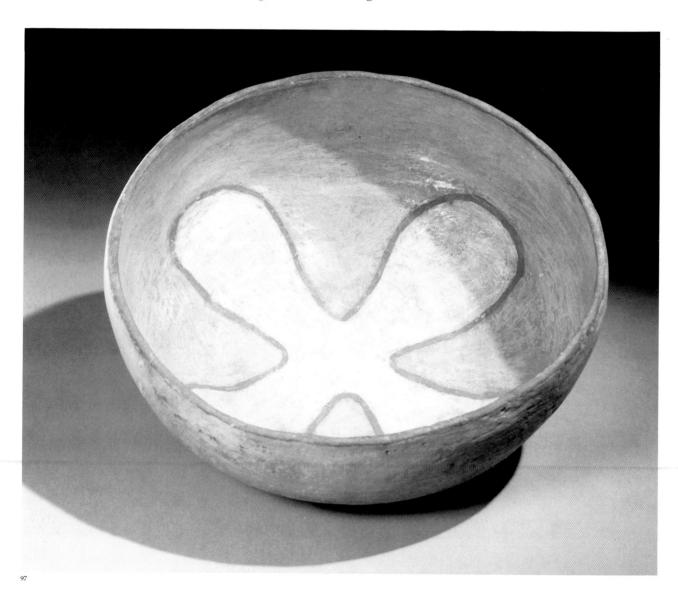

97

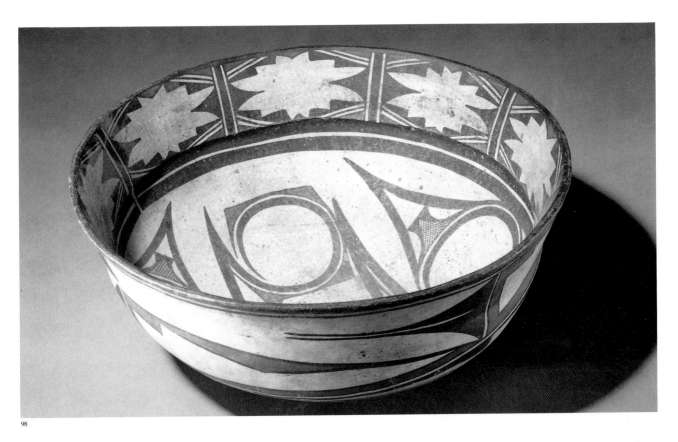

98

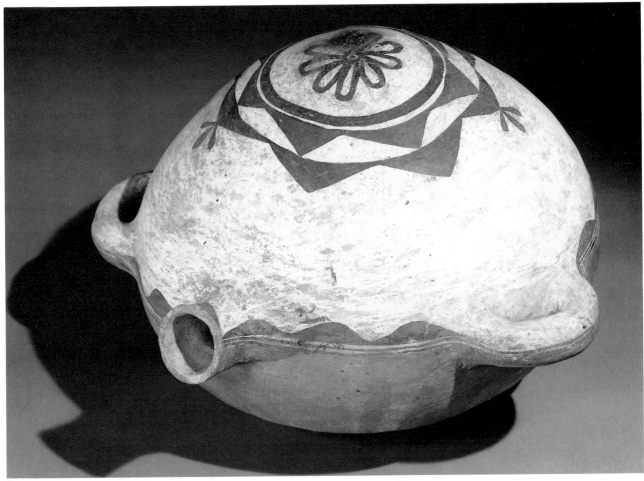

99

123

100. WATER JAR
Zuni
Ceramic, slip, H. 9¾, Diam. 11¼
Purchased in Ojo Caliente, New Mexico, 1904
04.297.5259

101. FOOD BOWL
Zuni
Ceramic, slip, H. 5½, Diam. 11½
Purchased in Zuni, New Mexico, 1904
04.297.5261

These vessels document the ceramic styles of two of the Zuni farming villages. Accompanied by Nick, Culin rode over to Ojo Caliente in 1904. The trip took about three hours and gave him an opportunity to observe "several fields, one planted with squashes, where among the sticks tied with rags which were set up as scarecrows, I saw a tall peeled sapling tied with a piece of black cloth which Nick explained was a warning to sheep herders to keep their sheep off" (1904a:19). Culin's "chief object at Ojo Caliente…was to procure an old wooden plough" to illustrate Zuni agricultural practices, but as usual, he was on the lookout for other old things as well. Disappointed in the quality of the ceramics, "he bought but one of reddish or brown color with white decoration, such as are infrequent in Zuni" (No. 100). Nick told him that this "was the kind commonly made and used" in the farming village of Pescado (1904a:20).[1]

The food bowl Culin acquired in Zuni the same year is equally distinctive and also from a farming village. On the catalogue card Culin noted that it was made in Nutria. DF

1. For another illustration of Zuni "white-on-red" see Batkin 1987:165.

102. TOAD EFFIGY
Zuni
Ceramic, slip, H. 5¾, L. 7½
Purchased from Dr. T. A. Waring in Gallup, New Mexico, 1907
07.467.8298

The story of Culin's acquisition of this surrealistic pottery effigy illustrates the problems of evaluation he encountered in the field. When he purchased it from Waring's drugstore (where it had been displayed in the window), he was told that it represented a "turtle upon which the first Indian came into this country" and that it had been dug up "by Old Billy Crane on his ranch near Guam" (1907a:94).

In Zuni, however, Culin heard quite a different account of the object's origin and meaning from the sister of Capitan, the head War Chief. She explained "that the effigy

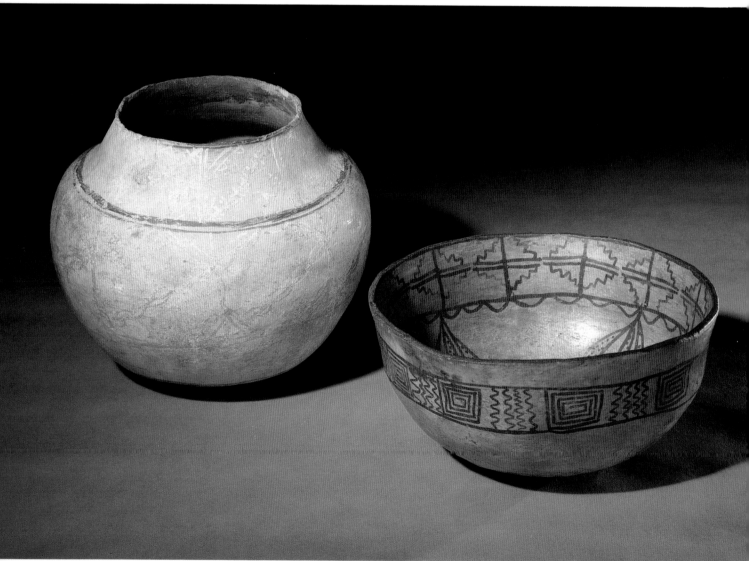

100

101

jar I bought from Dr. Waring was made by the Zuni, that it was not very old, and that it was made to sell, and represented an ant toad" (1907a:187). Culin paid $.50 for this information, which brought the total cost of the piece up to $10.50.

Culin finally concluded that the effigy was probably intended to be a horned toad, a reptile that "is sacred and is never killed" (1907b:51). Its combination of reptilean features with a human head is unusual.[1] One of the creature's front limbs was missing when Culin purchased it; the toad originally may have had back legs as well. DF

1. For a more conventional Zuni sculpture of a horned toad, see Batkin 1987:174.

103. WATER JAR
Zuni
Ceramic, slip, H. 10¼, Diam. 13½
Purchased from Nick in Zuni, New Mexico, 1907
07.467.8395

On Culin's final trip to Zuni in 1907, Nick told him "he had an old Siatosha jar at his house. It proved to be of recent make, but covered with decorations of an old pattern, which I shall try to have explained" (1907a:163). Culin bought it for a dollar. This transaction shows both the extent to which Nick was attuned to Culin's interests and Culin's confidence that he could use objects to elicit information about the past.

The designs on the jar are indeed anachronistic, recalling the widespread black-on-white Anasazi style (see No. 1). The shape of the vessel, however, confirms the modern date Culin assigned to the piece. DF

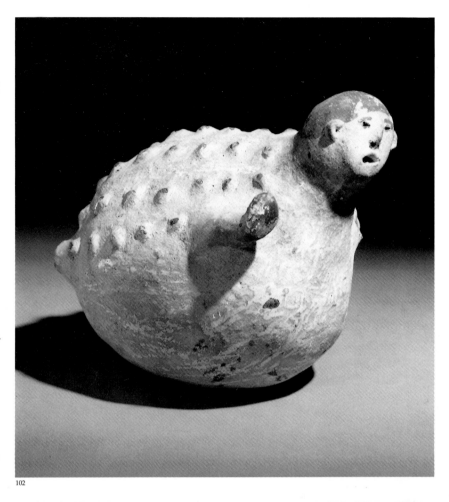

102

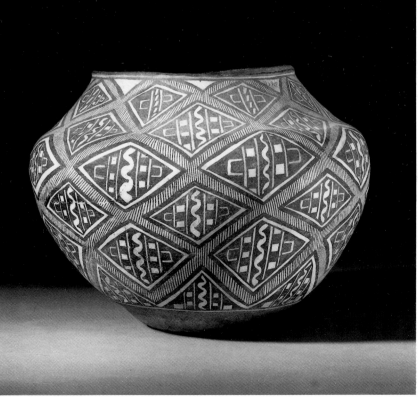

103

104. MAN'S SHIRT
Zuni
Handspun wool, L. 27¾, W.
(with sleeves) 58
Purchased in Zuni, New Mexico, 1904
04.297.5316

Culin arrived in Zuni determined to secure "two old Zuni costumes, a man's and a woman's with a view to...setting them up on plaster lay figures." He proposed to dress the man "as a warrior, with all his arms, etc."[1] Although he noted in his expedition report of 1903 that he had "succeeded, after a long negotiation, in buying a blue woolen shirt with sleeves" (1903:93), no shirt is recorded in the ledger book for that year. The following year, however, he acquired this twill-woven shirt, which is in the old style but shows few signs of wear.

Culin commissioned the remaining parts of the man's costume from the tailor Ma-li-na. His objective was to replicate as closely as possible the outfit Frank Hamilton Cushing wore in Zuni in the early 1880s (see Nos. 132–37). DF

1. S. Culin to F. Hooper, June 25, 1903, Departmental Records.

105. CHILD'S PONCHO
Zuni
Hand-spun and commercial wool, L. 25, W. 18¼
Purchased in Zuni, New Mexico, 1903
03.325.3373

In addition to the dark blue shirt, the Zuni wove shirts with blue and red stripes, a color combination they favored in their dress in general. This handsome poncho is a good example of the striped type, which was sometimes sleeveless. The hole for the neck has been cut and sewn. The sides were not seamed but could be tied together. Culin considered the sleeveless shirts the older style (1903:93). The several repairs on this poncho suggest that it had been worn for a long time before it was acquired.

Although Culin catalogued this garment as a child's poncho, it seems to be large enough for an adult. In general, children's garments (with the exception of moccasins) are not included in Culin's collections. Presumably such clothing, having been worn out or passed on to the next generation, was not available. DF

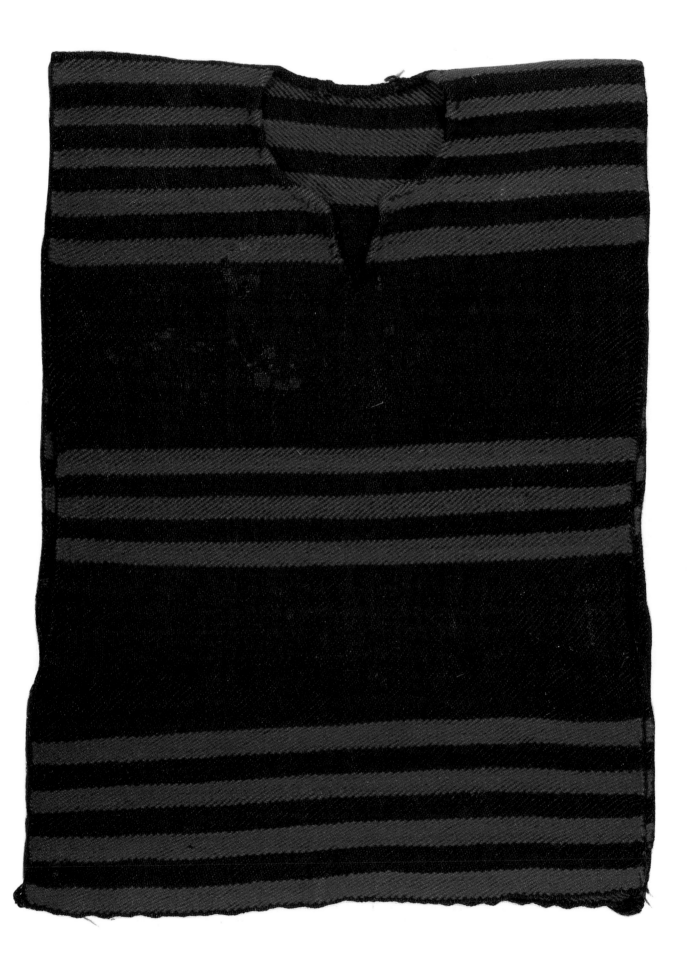

106. Man's Stockings
Zuni
Knitted: hand-spun wool, L. 14¾, W. 5¾
Purchased from the silversmith in Zuni,
New Mexico, 1903
03.325.3550a–b

107. Socks
Zuni
Knitted: hand-spun wool, L. 9, H. 5
Collected in Zuni, New Mexico, 1903
03.325.3366a–b

In a report on Zuni dress in 1879, Matilda Coxe Stevenson noted that the men wore "a footless stocking knit of native blue yarn" with their buckskin moccasins. In cold weather, the foot was "wrapped in old cloth" for additional warmth.[1] When Culin arrived in 1903, the footless stockings were still in fashion but were worn with "American clothes" (1903:93). He purchased this pair (No. 106) from the silversmith, along with a white cotton shirt and pants.

Culin also acquired a hank of indigo-dyed yarn and five wooden knitting needles with a partially knit stocking so that he could document the knitting process.

In addition to the footless stockings, or leggings, the Zuni knit socks and gloves (1907b:178). Although Culin did not acquire any gloves, he collected this pair of orange-and-white socks (No. 107) in the village in 1903. Footed socks with checkerboard designs were a specialty of the Zuni and were not produced in the other pueblos.[2] DF

1. M. C. Stevenson [1879] 1987:285.
2. Fox 1978:61.

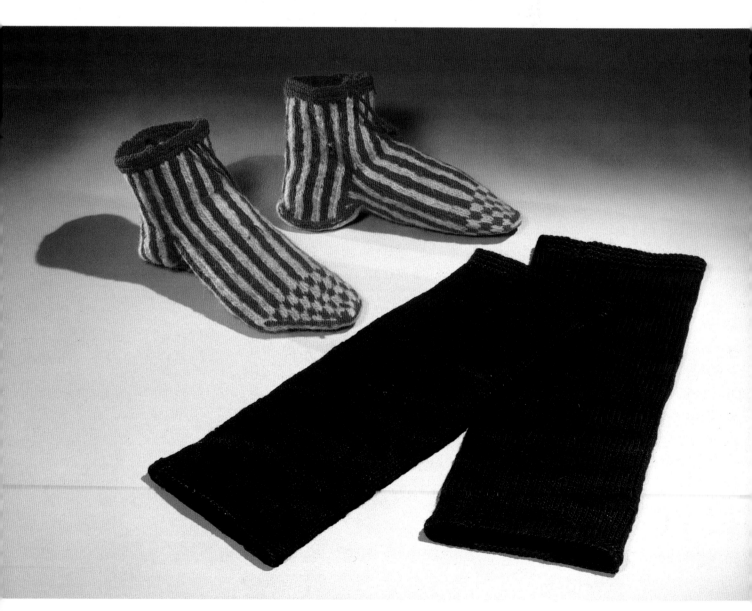

108. Woman's Dress

Zuni
Wool, hand-spun and commercial yarns,
L. 42½, W. 30
Purchased in Zuni, New Mexico, 1904
04.297.5315

In his "Zuni Notes," Culin gives a succinct history of women's fashion: "The old Zuni costume for women, now only worn on festival occasions, consisted in principal part of a blue black woolen dress made of a blanket sewed up the right side, and worn with the left arm exposed and bare....Before this, in olden days, a similar white cotton dress...was worn, and again, before this, a dress of yucca fabric" (1907b:135). He also observed that "at the present time the Zuni do very little weaving, purchasing most of their saddle blankets from the Navajo, and the women's black shawls, yarn dresses,...and embroidered cotton blankets and dance kilts from the Hopi" (1907b:186).

In spite of the fact that the dark handwoven wool dresses were mainly obtained by trade and were treasured as heirlooms, Culin succeeded in acquiring two for the Museum, as well as one for his personal collection. H. B. Judy, the staff artist who sometimes traveled with Culin, also collected a woman's dress, which he later donated to the Museum, in Zuni.

This dress, with its richly embroidered borders and yarn ring tassels, would have been worn with a red woven belt (see No. 110). Although a portion of the red-yarn decorative stitching along the side seam has been repaired (perhaps where the belt rubbed against the yarns), the garment is in very good condition. Culin had a chance to observe the women wearing their traditional dresses when they appeared after a dance "in their best holiday attire, with a good showing of silver necklaces" (1904a:49). DF

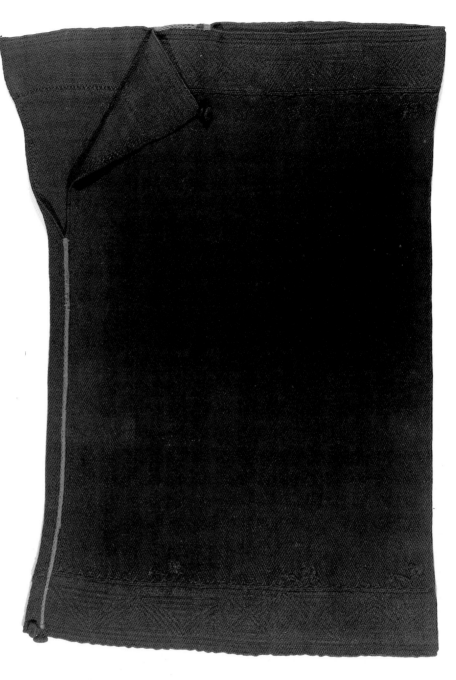

109. WOMAN'S DRESS, OR MANTA
Zuni or Navajo
Hand-spun wool, L. 43¾, W. 50¾
Collected by James Judd in Ojo Caliente,
New Mexico, 1895; purchased in 1909
09.940.8955
Museum Collection Fund

This extremely fine dress, or *manta*, was one of a group of "Indian curios" Culin bought from James Judd in 1909. Judd had "literally taken" the blanket from a girls' head in the Zuni farming village of Ojo Caliente in the summer of 1895.[1] Although the *manta* was definitely being worn by a Zuni girl, it may have been made by the Navajo and traded to the Zuni. The diamond twill borders and designs woven in red are characteristic of Navajo *mantas* that "were worn as dresses or shawls by Pueblo women (mainly at Acoma and Zuni) between about 1850 and 1880."[2] DF

1. The blanket is one of two described by Judd as "squaw blankets, natural dye. Purchased from Zuni girls near Ojo Caliente—were both in service and literally taken from the girls' heads" (list enclosed with J. Judd to S. Culin, Feb. 9, 1909, Object Files: Judd Collection).

2. Kent 1983c:156–57. Kent discusses this group of Navajo *mantas* in some detail.

110. WOMAN'S BELT
Zuni
Hand-spun wool, commercial cotton twine,
L. 130, W. 3½
Purchased in Zuni, New Mexico, 1903
03.325.3376

The smaller handwoven costume elements such as belts, garters, and hair strings were more plentiful than the dresses and were still being made in Zuni at the time of Culin's visits. There was considerable intertribal trade in warp-faced belts, which were woven in two styles. This belt is a fine example of what is known as the Navajo style.[1] It had obviously been passed down through several generations before Culin purchased it in 1903, and it offers an interesting comparison with the unfinished Hopi-style belt on the loom (No. 111).

According to Matilda Coxe Stevenson, the belt "was wrapped around the waist, the woman being careful to draw the belt tightly, fastening it at the left side with a tuck-in, allowing the long fringe to hang."[2] DF

1. See Kent 1983b: 83–88, for a discussion of the differences between the Navajo and Hopi-style belts.

2. M. C. Stevenson 1987 [1879]:286.

111. BELT LOOM WITH BELT
Zuni
Wood, wool, hide, cotton (string and cloth), hair, L. 26¾, W. 6¾
Purchased in Zuni, New Mexico, 1903
03.325.3140

This back-strap loom has a hole-and-slot heddle, a European innovation that was used by Pueblo weavers around the turn of the century but was "discarded in favor of the indigenous shed rod and string-loop heddle later in the twentieth century."[1] The hair rope on one end would have been attached to a stationary object, while the woven red garter on the other end would have gone around the weaver's waist. On the loom, a Hopi-style belt, with red, green, and black warps and a black weft, is in process. All the yarns are commercial.

Looms were difficult to acquire, and Culin noted that this one was "complete." Later, however, several parts were exchanged with the Field Museum, including a front stick and a comb.

Eventually, Culin managed to acquire looms from the Navajo and Hopi as well as the Zuni so that he could illustrate the range of south-western weaving technology in his installation. DF

1. Kent 1983b:38.

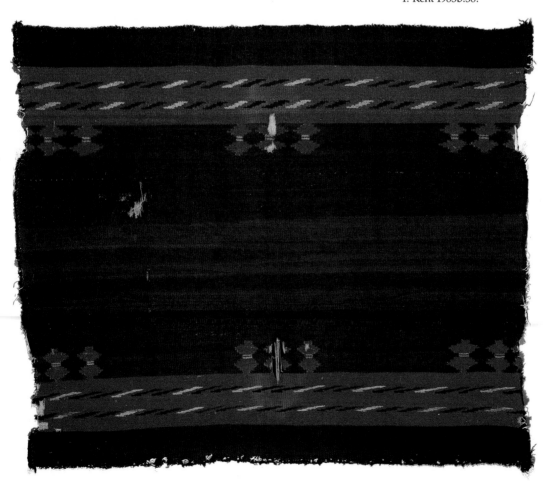

110

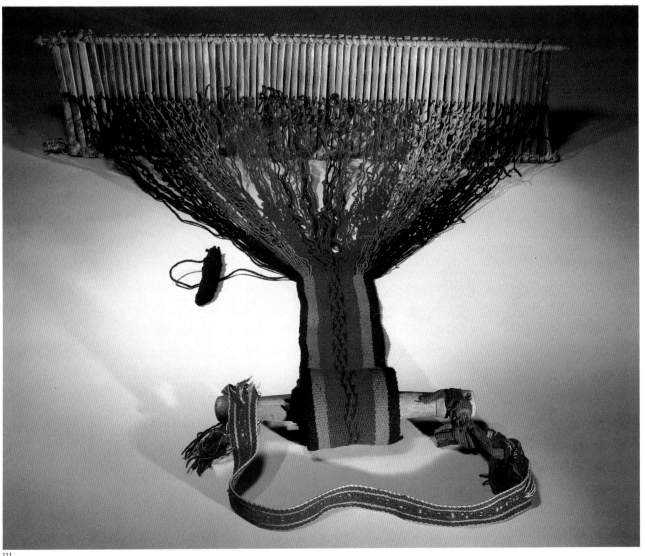

111

131

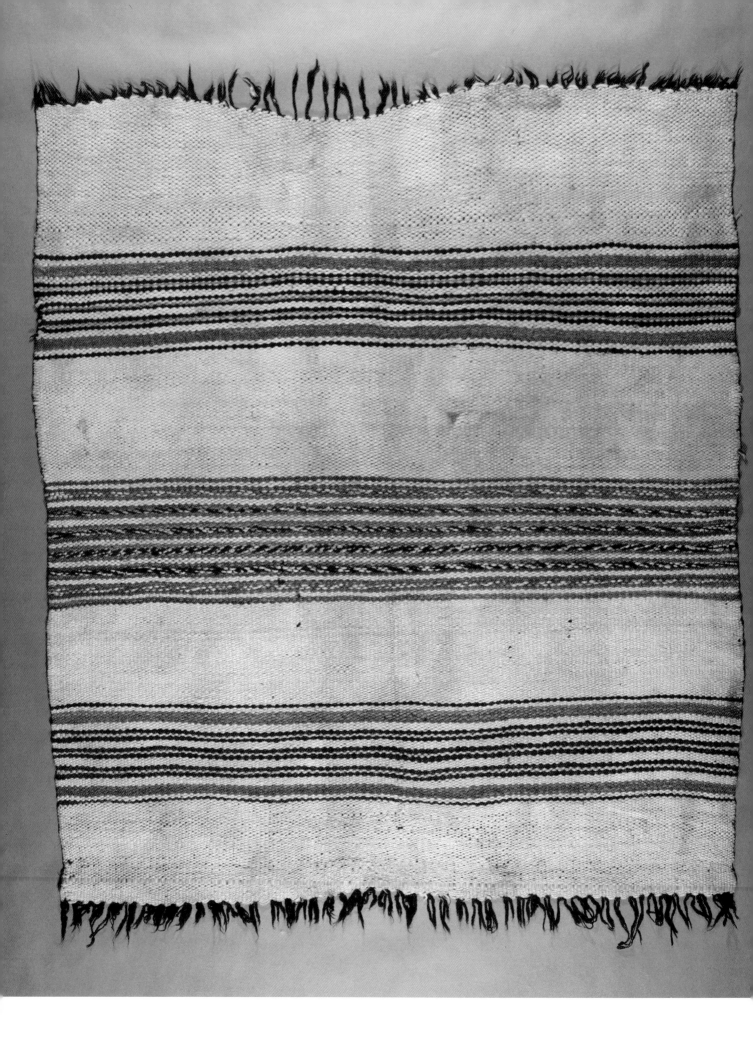

112. BLANKET

Zuni
Hand-spun wool, L. 58, W. 52⅜
Purchased in Zuni, New Mexico, 1904
04.297.5422

"In the old days," Culin reported, "blankets made of twined rabbit skin, wild cat skins sewed together, or buffalo robes obtained from Cochiti and other Rio Grande Pueblos were both worn and used to sleep on. Woolen blankets were derived from the Mexicans, and finally copied and made by the Zuni themselves." The bed blankets made by the Zuni in Culin's time were "loosely woven of wool, either plain grey or white or grey and white, black, blue and sometimes red stripes" (1907b:137–38). These util-itarian textiles could be acquired at relatively low prices: Culin paid only $2.50 for this blanket.

In at least one instance, special precautions were taken in the sale of a blanket. When Culin bought a "large plain white wool blanket" for his own cot, the old woman who owned it cut a thread from the edge before he took it away. "Nick explained that this is an old custom, invariably practiced when clothing, a house or sheep or any similar valu-able objects is disposed of. A hair is cut from the horse's tail or a bit of wool from a sheep. The fragment is hidden in a crevice in the house, so that more blankets, horses and sheep may accrue again" (1904a:34). DF

113. DANCE KILT

Zuni
Cotton, pigments, tin, buckskin, L. 28, W. 40
Purchased in Zuni, New Mexico, 1904
04.297.5090

Making the rounds of the village with Nick, Culin bought this "dance kilt…belonging to the dance war-rior, and decorated at the bottom with metal bangles" (1904a:23). The sun-face and star motifs are very similar to those painted on the shield (No. 114) and are also depicted on the kilts of several kachina dolls in the collection (see No. 78). In motion, the tin bangles would have made a ringing sound. DF

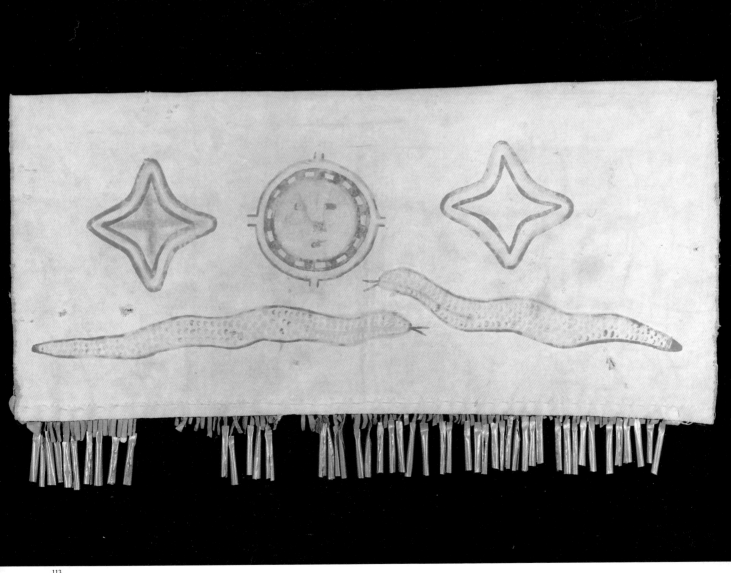

113

133

114. Dance Shield

Made by Jasha-a; Zuni
Hide, pigments, wool fabric, feathers, cotton string, Diam. 26
Purchased from Jash-a in Zuni, New Mexico, 1903
03.325.3505

Culin's entry in "Zuni Notes" implies that shields were not in evidence either in dances or in warfare during the years he collected in Zuni:

In the old days a shield…made of rawhide was used in warfare. They formerly had a strip of dyed buckskin to which large eagle feathers were attached. This was subsequently replaced by bayeta or red flannel. The face of the shield was painted in colors with various devices, such as the mountain lion, bear, rattlesnake, eagle and sun. The choice of figures appears to have been left to the taste of the owner. Until recently, hide shields were used in some of the dances, especially the war dance. These dance shields were often quite small in size" (1907b:232).

This striking shield, made by a Zuni named Jasha-a,[1] is one of a pair Culin commissioned for the Museum. Although Vanderwagen helped him locate an individual who knew how to make the shields, all the necessary materials were not available in Zuni. The trader Lorenzo Hubbell was appealed to and provided the red fabric (bayeta), which he had in stock at his post in Ganado. This shield, therefore, is something of an anachronism and owes its existence to the collaboration between Culin, a Zuni craftsman, and several traders.

It is unclear whether the idea of making a pair rather than a single shield came from Culin, the artist, or some other source. It is noteworthy, however, that the color scheme on one is the reverse of the other. Whereas this shield is painted with a blue sun face and red stars, its mate has a red face and blue stars. Otherwise the shields are very similar, with the exception of a slight variation in size and in the motif on the lower edge. DF

1. Jasha-a may well be the Zuni name for Ma-li-na, the tailor who completed the man's costume (see No. 104) for Culin. Culin gives the tailor's Zuni name as "Yai-shai-ai" (1903:93). Vanderwagen describes Jasha-a as the "man who made the moccasins" (A. Vanderwagen to S. Culin, July 24, 1903, Correspondence).

115. Pair of Dragonflies

Zuni
Wood, pigments, animal material, L. 4½, W. 2½, 2¾
Purchased in Zuni, New Mexico, 1903
03.325.3278.1–.2

The Zuni associated dragonflies with fertility and power. The insects were believed "to return to the south, where it is always warm, in winter." Moreover, when a chief died, he became a dragonfly. The chiefs "pray to them, and from time to time catch a dragonfly which they kill and keep in their house, wrapped in corn husk. No one else touches or harms them" (1907b:72).

Culin catalogued these charming painted objects as toys. They were hung in houses for good luck in commemoration of the time a dragonfly had helped provide nourishment for a boy and girl who had been abandoned in the ancient village of Hawikuh (1907b:72). DF

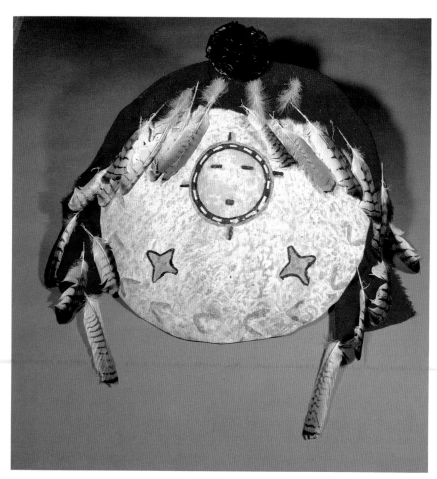

116. PARROT

Zuni
Wood, pigments, L. 6, H. 2
Purchased in Zuni, New Mexico, 1903
03.325.3275

The parrot, Culin reported, "is not found in the neighborhood of Zuni, and its feathers, which are prized, are obtained by trade with the Indians of Santo Domingo and San Felipe. Now, as they are very scarce, white pigeon, duck, eagle or chicken feathers are dyed yellow or red as substitutes." Parrots live in the South, "where the present Zuni believe the descendents of their ancient relatives still reside." (1907b:63).

Carved and painted representations of birds were fairly plentiful in Zuni. This parrot is one of several different birds Culin purchased for five or ten cents in 1903. Originally it was on a stick (now broken off), indicating that it could have been held in the hand, attached to something, or stuck in the ground. DF

115

116

135

117. PAIR OF BIRDS
Zuni
Wood, pigment, resinous material, L. 3¼, W. 1½
Wood, pigments, L. 3¾, W. 1¾
Purchased in Zuni, New Mexico, 1904
04.297.5108.1–.2

118. BIRD
Zuni
Wood, pigments, L. 7¼, W. 2¼
Purchased in Zuni, New Mexico, 1904
04.297.5107

In 1904 Culin acquired several additional wooden birds (see No. 116), along with some information on their production and use. The pair of small birds with round staring eyes (No. 117) was made by a ten-year-old boy; presumably the set was a toy.

The larger bird balanced on chunky legs (No. 118) represents a wild pigeon and was used by the Big Fire Society. The beak and legs of this bird have been carved separately and pegged in.

These acquisitions document the continuum between the sacred and the secular that fascinated Culin and inspired his investigation of games and toys. DF

119. KICKING STICKS (15)
Made by Nick; Zuni
Wood with bark, L. 4¾, Diam. ¾
Purchased from Nick in Zuni, New Mexico, 1904
04.297.4994.1–.15

Used in clan races in the spring, this set of kicking sticks testifies to

Nick's skill as a craftsman. "Each clan has its own stick…which is cut with a mark to distinguish it. Each clan is represented in this race by as many men as possible."[1]

Culin observed and photographed a kicked-stick race in Zuni in 1904. The race commenced toward sundown: "The contestants wore shirts and G strings, but their legs were bare. They started in the arroyo near the corall where they had been shearing sheep and ran around the town, going first to the southeast, and then to the north, a circuit of about five miles. I saw them racing long after sundown" (1904a:17). DF

1. Culin 1907c (1975 edition:695).

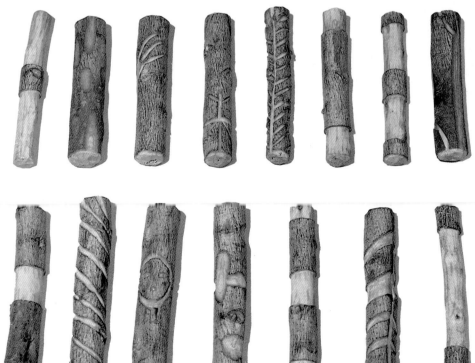

118

117

119

136

120. CANE DICE (4)
Zuni
Cane, pigment, L. 6, W. ¾
Purchased in Zuni, New Mexico, 1904
04.297.4984a–d

Culin relied primarily on Frank Hamilton Cushing for his interpretation of the game of *sholiwe*, in which these cane dice were employed. According to Cushing, *sholiwe*, one of four games associated with the twin War Gods, "developed from the use of actual arrows for divination."[1] Culin illustrated this set of cane dice, etched with graphic designs on the outer side and painted in bands of black on the inner side, in his monograph on North American Indian games, noting that "the etched figures on the dice represent the water bug."[2] DF

1. Quoted in Culin 1907c (1975 edition 214).
2. Ibid.: 212.

121. PAIR OF SHUTTLECOCKS
Zuni
Plant fibers, feathers, H. 7½, W. of each 1¾, 2
Purchased in Zuni, New Mexico, 1903
03.325.3087.1–.2

Among the most elegant of the gaming implements Culin collected, this pair of shuttlecocks is made from light and dark corn husks (interlaced to form a checkerboard pattern on one) with down feathers protruding from the centers. In his book on games, Culin cites Matilda Coxe Stevenson's account of the game played with these shuttlecocks —which took its name from the fact that "the sound produced by the shuttle cock coming in contact with the palm of the hand is similar to the noise of the tread of a jack rabbit upon frozen snow." According to Stevenson, it was a betting game played by younger boys as well as their elders. The player bet that he could toss the shuttlecock a given number of times, using one hand only.[1] DF

1. Culin 1907c (1975 edition: 720–21).

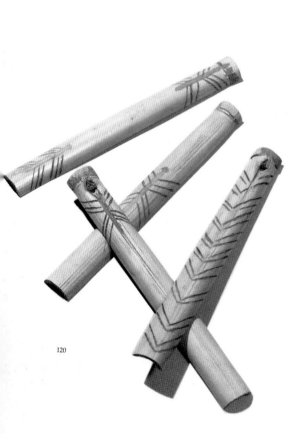

120

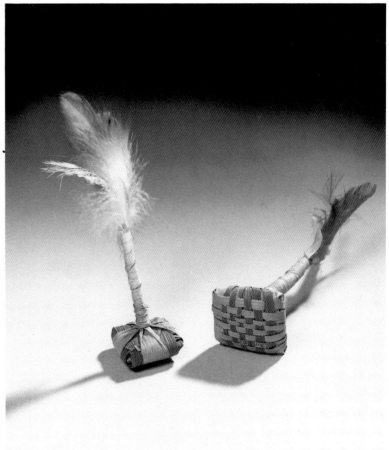

121

122. "Corn Stone"

Zuni
Stone, traces of pigment, L. 5¾, W. 3¼
Given by Chuyati in Zuni, New Mexico,
1903
03.325.3441
Gift of Chuyati

Chuyati, the brother of the former governor of Zuni, "under strict promise of secrecy" made several games for Culin. On the night before Culin was to leave Zuni in 1903, Chuyati presented him with this "flat water-worn stone, engraved with the figure of a cornplant." Nick, who was present at the time, explained that it was called a "corn stone…and was set up as a kind of altar in the corn fields" (1903:95). Both sides of the stone are engraved with an image of a corn plant.

In offering the present to Culin, Chuyati showed his understanding of Culin's interest in ritual stone objects. He also hoped that Culin would return the favor and bring him seashells from the East for making beads. DF

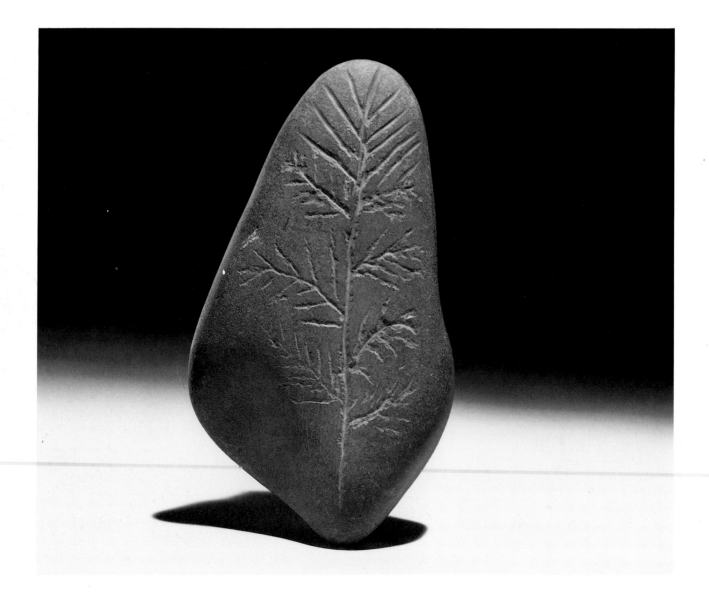

123. BASKET

Western Apache
Coiled: plant fibers, dyes, H. 2¾, Diam. 9
Purchased in Zuni, New Mexico, 1903
03.325.3577

124, 125. JAR-SHAPED BASKETS

No. 124: Apache or Paiute
Coiled: plant fibers, resinous material, hide,
H. 5½, Diam. 9¼

No. 125: Western Apache
Coiled: plant fibers, hide, H. 12¼, Diam. 11
Purchased in Zuni, New Mexico, 1903
03.325.3590; 03.325.3591

Tightly coiled baskets made by the Apache and the Paiute were common in Zuni households. Culin reported that the Zuni used them "in their houses to hold corn meal in connection with milling and bread making and esteem fine old baskets very highly" (1907b:171). These imports were also valued by local dealers and traders and commanded high prices. Culin paid five dollars for the large jar-shaped basket (No. 125) and three dollars for the smaller one (No. 124). By comparison, locally made ceramics were extremely cheap. Culin only paid fifteen cents apiece for the fine food bowls he acquired in 1904 (see Nos. 97, 98).

There was a sufficient number of old Apache baskets available in the village so that Culin could reject the ones that were "very poor and broken" (1904a:20). All these baskets show signs of wear, but thanks to their careful construction, they retain their shape. There is some question about the cultural attribution of No. 124. According to Culin's exhibition label, it is Paiute, but on his catalogue card he identifies it as Apache. DF

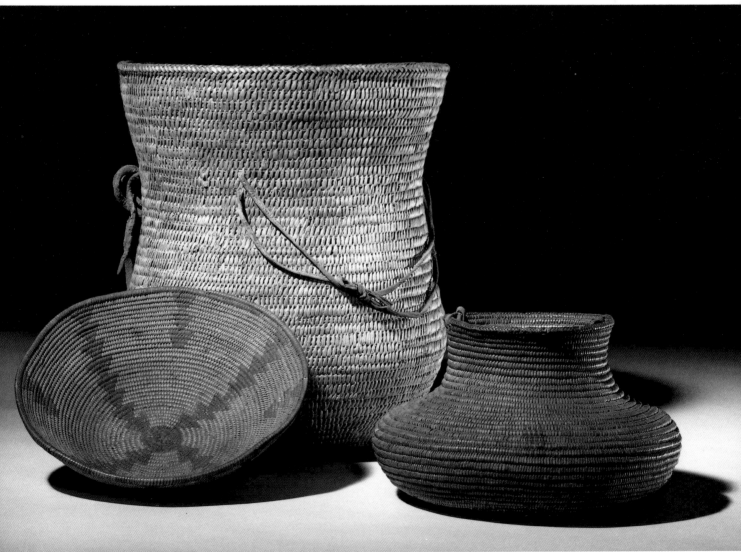

123 125 124

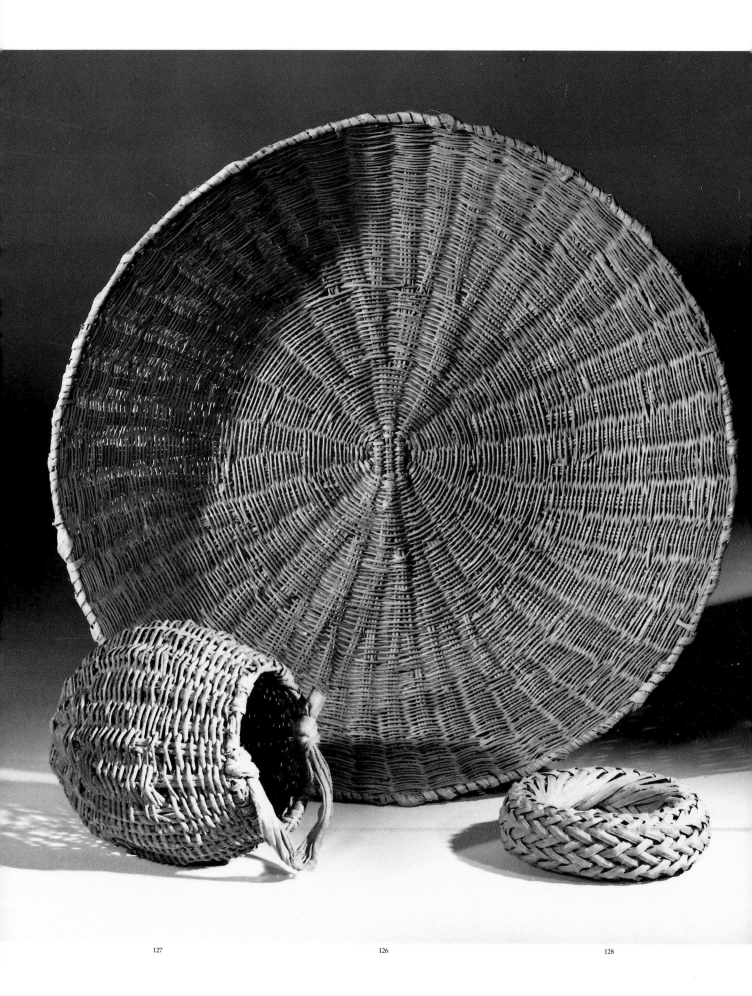

126. BASKET

Zuni
Plaited: plant fibers, H. 4¾, Diam. 18
Collected by Nick; purchased in Zuni, New
Mexico, 1904
04.297.5177

127. GLOBULAR BASKET

Zuni
Plaited: plant fibers, pigment, cloth handle,
H. 6¾, Diam. 6
Purchased in Zuni, New Mexico, 1903
03.325.3357

128. POT RING

Zuni
Plant fibers, H. 1¾, Diam. 5¼
Purchased in Zuni, New Mexico, 1903
03.325.3218

Although Culin described Zuni-made baskets as "poor and little valued," he acquired a representative collection of the local basketmaking tradition. The industry was "entirely confined to women," who used six different kinds of willow and worked with a deerhorn awl (1907b:171).

Each of these baskets had a special function. The large tray, made of "salt willow," was used as a sieve for wheat and beans. Some willow baskets were painted or stained and used for prayer sticks, but those intended for the preparation of food were left plain. The small globular basket was used to "collect locusts...for food" (1907b:172).

The nicely crafted pot ring is very similar to one James Stevenson collected in 1879.[1] These rings were used to support a jar on the top of the head as well as on the ground. After a dance in 1907, Culin observed "a large number of women, all dressed in the old costume" carrying bowls of food. "These bowls, they invariably supported on their heads by means of the little woven wicker boss" (1907a:193). DF

1. J. Stevenson 1883:fig. 486.

129. CHAIR

Zuni
Wood, stain, iron nails, H. 22¾, W. 14½
Purchased in Zuni, New Mexico, 1904
04.297.5130

On the subject of Zuni seats, Culin was brief but authoritative: "The Zuni sit on the floor, or on a small wooden seat...often made of a single block of wood. Rude, low chairs, copied from the Mexicans, are sometimes found. A guest is always offered a seat" (1907b:130).

Culin collected several of the low stools and this side chair in the Mexican style, which was by far the rarer type. Constructed with mortise-and-tenon joints, the chair's crestrail and side stretchers have an irregular scalloped edge. A simple gouge-carved design of squares and dots provides an additional decorative effect. The rear stiles of the chair are stepped, and in the center of the crestrail's back a face has been lightly incised, drawn according to Zuni conventions, with small rectangles indicating the eyes and mouth. It appears to be an afterthought, almost like a graffito.

Although Culin did not mention the incised face, the Indian inspiration for the stepped finials was clear to him; they represented the "cloud terraces."[1] He purchased the chair in a house but was later told that such chairs had been used in the church. On the basis of this information, he published the chair as an "ancient kneeling chair."

The chair was the beginning of Culin's Hispanic collection and led him "to make a systematic search for similar objects in the town."[2] It is possible that its influence extended even further: Culin ends an article on this collection by noting that the small chair "has become a parent of a brood of chairs, the story of which remains to be told."[3] DF

1. Culin 1918:233. For examples of other chairs with the stepped motif see Taylor and Bokides 1987:25.
2. Ibid.:235.
3. Ibid.:239.

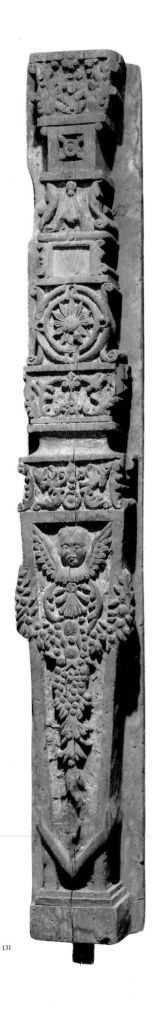
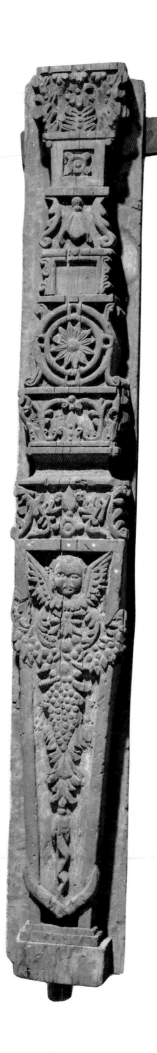

131 130

130, 131. CARVED PILASTERS
From Our Lady of Guadalupe; Zuni, 18th century
Wood, pigments, H. 103½, W. 14; H. 103¾, W. 14½
Purchased in Zuni, New Mexico, 1904
04.297.5143; 04.297.5144

The ruined church of Our Lady of Guadalupe was a landmark in Zuni, commented on by almost every visitor. In 1902 Culin made his first assessment of the structure and its condition:

The old church in Zuni dates from about 1700 when it was rebuilt, after the Pueblo was destroyed in [sic] It is falling into even greater decay. The two bells, which were in place in Mr. Cushing's time, have been taken down. The roof is entirely gone and the interior is open to the sky. A few carved beams, obscured with plaster, remain in place in the interior, and two fine old carved wooden columns are lying on the ground within, tempting the cupidity of almost every visitor (1902b:15).

Others may have been tempted, but none proved to be as tenacious as Culin in his pursuit of the carved columns. When he heard that they were no longer in the church in 1904, he moved quickly to discover their location and succeeded in purchasing all four of the columns. Transporting them unobtrusively from their hiding place proved to be the most difficult part of the negotiation. Disguised in blankets, Culin and the Museum's staff artist H. B. Judy crept through the village at night, inadvertently setting off a chorus of barking dogs. It required "an hour to move one timber. More would have been impossible, and we turned in, agreeing to make other arrangements for the succeeding nights" (1904a:29).

The story of the acquisition of the columns was one of Culin's favorites, and he included a variation of it in an article published in 1918, in which he also discussed the chair (No. 129). Casting himself more as an audacious adventurer than as a museum curator, he devoted almost the entire article to describing the discomfort and danger he endured getting the columns and said practically nothing about the columns themselves.[1]

In contrast to the detailed account of the removal of the columns, information on their original production and placement is meager. A late nineteenth-century photograph shows the pilasters and framework of the altar screen still in place in the interior of the ruined mission.[2]

E. Boyd has attributed them to the Spanish-born Captain Bernardo Miera y Pacheco (ca. 1742–1785) and suggested that they may have been commissioned by Father Vélez de Escalante, who is known to have redecorated the Zuni church in the late 1770s. Several sculptures that were presumably part of this artistic program were collected by James Stevenson in 1879 and are now in the Smithsonian.[3]

In 1966 the Pueblo of Zuni, the Roman Catholic Diocese of Gallup, the Bureau of Indian Affairs, and the National Park Service collaborated to restore the Zuni Mission Church, and it has now been fully reconstructed. In the interior, on the north and south walls of the nave, the Zuni artist Alex Seowtewa has painted life-size figures of ceremonial dancers, thus bringing "the Zuni council of the gods right into the new church."[4] DF

1. Culin 1918.
2. Published in Kessel 1980:fig. 177.
3. Boyd 1974:102.
4. Kessel 1980:212.

132–37. FRANK HAMILTON CUSHING'S ZUNI COSTUME
Zuni
Estate of Stewart Culin, Museum Purchase

132. SHIRT
Hand-spun wool, commercial yarns, silver buttons, L. 26, W. (with sleeves) 58
30.799

133. BELT
Hand-spun and commercial wool, commercial cotton, L. 51, W. 4⅛
30.803

134. GARTER
Hand-spun wool, commercial cotton, L. 38, W. 2⅛
30.804a

A legendary figure in the history of anthropology, Frank Hamilton Cushing was a member of the first collecting expedition sent to Zuni in 1879 by the Bureau of Ethnology.[1] To his colleagues' surprise, he chose to remain in Zuni rather than return to Washington. During his residence in the pueblo, from 1879 to 1884, Cushing adopted Zuni dress and customs, learned the language, and became a member of the Bow Priesthood, thus initiating the "participant-observation" method in anthropology.

By Cushing's own account, the decision to discard his Western clothes in favor of a Zuni outfit was not his own:

One day...the Governor's wife came through the door-way with a dark blue

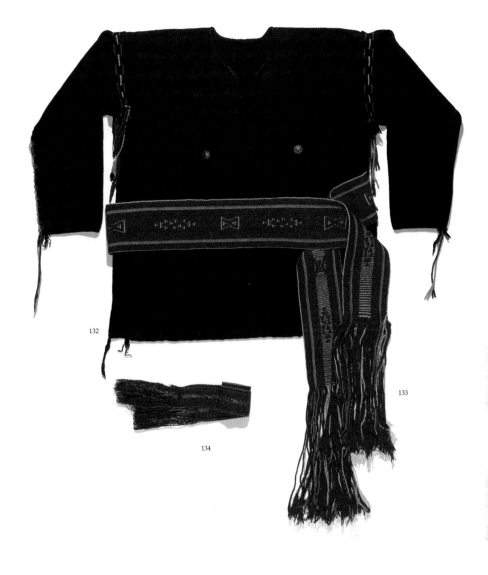

132

133

134

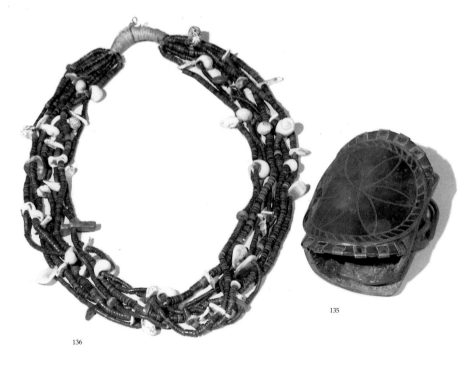

135

136

bundle of cloth, and a long, embroidered red belt. She threw the latter on the floor, and unrolled the former, which proved to be a strip of diagonal stuff about five feet long by a yard in width. Through the middle a hole was cut, and to the edges, either side of this hole, were stitched, with brightly colored strips of fabric, a pair of sleeves. With a patronizing smile, the old woman said—"Put this on. Your brother will make you a pair of breeches, and then you will be a handsome young man."

Although Cushing considered the shirt uncomfortable, he wore it as an experiment. Finding that it made a good impression on the Zunis, he decided to accept the Governor's sartorial recommendation. "In fact," he noted, "it would have been difficult to have done otherwise, for, on returning to my room, I found that every article of civilized clothing had disappeared from it."[2]

The warp-patterned belt in bright red and green (No. 133) was part of the initial package brought to Cushing. He had to wait for the woven garters (No. 134) and had "nearly given up seeing a pair…when one day, all bustle and smiles, the 'Little Mother' (the Governor's wife) came in bearing them.

"They were beautiful and well-made,—they endure even yet,—and with matronly pride she laid them before me."[3]

In his writings, Cushing artfully used the costume as a metaphor for his close identification with the Zuni. In practice, however, the elaborate costume he adopted for everyday wear set him apart: in 1879 the men dressed in white cotton or calico shirts and only wore the dark woven wool shirts on special occasions.[4]

Whether the finely woven shirt (No. 132) is the one Cushing received first or a garment he added to his Zuni wardrobe later, is not known.[5] It is clearly the shirt he wore when posing for the Philadelphia artist Thomas Eakins in 1895 (see Fig. 5). After Cushing's death in 1900, the costume and the portrait remained together, first at the Museum of the University of Pennsylvania and then at The Brooklyn Museum. The portrait was purchased by the Museum in 1928,[6] but the costume, which Culin owned, did not officially enter the collection until after Culin's death.

On at least one occasion, Culin also adopted Zuni dress. A newspaper clipping of 1904 reported that Stewart Culin, disguised as a Zuni boy in a blue woolen shirt and buckskin trousers, had won the gold medal at the annual costume dinner of the Salmagundi Club in New York: "The dress was the same as that worn by Frank Cushing during his sojourn with the Zunis as a member of the bow society."[7] DF

1. Renamed the Bureau of American Ethnology in 1894.

2. Cushing [1882–83] 1967:27–28.

3. Ibid.:36.

4. M. C. Stevenson [1879] 1987:282.

5. Photographs of Cushing indicate that he owned (or wore) several different shirts.

6. The portrait is now in the Collection of the Thomas Gilcrease Institute of American History and Art, Tulsa, Oklahoma.

7. *New York Herald*, April 3, 1904, Clippings, 1904.

135. WRIST GUARD
Leather, hide, silver, L. 4½, W. 3¼
30.798

136. NECKLACE
Stone, shell, plant fiber, L. 28
30.808

Jewelry of shell and turquoise was highly valued by the Zuni. "Apart from the herds," Culin wrote, "the chief wealth of the Zuni consists in their personal adornments. Men wear necklaces of white shell beads interspersed with pendants of turquoise, red shell, cannel coal…and old shell ornaments from the ruins." In contrast the women limited themselves to silver jewelry and "only wear shell-bead necklaces when they dance" (1907b:149).

When Cushing was first presented with his Zuni clothes, "one of the young men gave [him] a crude copper bracelet, and the old priest presented [him] with one or two strings of black stone beads for a necklace."[1] This seven-strand necklace of black stones interspersed with different kinds of shells and bits of turquoise indicates the high status Cushing eventually achieved in Zuni. Similarly the wrist guard with the finely engraved silver disk would have been fully competitive with that of any well-dressed Zuni man. Describing Zuni dress in 1879, M. C. Stevenson wrote of the men's adornments: "The greater the wealth, the greater display of necklaces. Quite frequently a leather bow wristlet ornamented with silver was seen on the wrist."[2] DF

1. Cushing [1882–83] 1967:28.

2. M. C. Stevenson [1879] 1987:285

137. BOW PRIEST'S CAP
Zuni
Hide, feathers, shells, plant-fiber cord, cotton string, sinew, H. 5¾, W. 11
Stewart Culin Estate Purchase
30.797

The culmination of Cushing's career in Zuni was his acceptance into the Bow Priesthood, one of thirteen "orders or societies, some of which were actually esoteric, others of a less strict nature, but all most elaborately organized and of definitely graded rank, relative to one another." According to Cushing, the Bow Priesthood was "at once the most powerful and the most perfectly organized of all native associations, in some respects resembling the Masonic order, being strictly secret or esoteric; it is possessed of twelve degrees, distinguished by distinctive badges."[1]

Cushing first became aware of this society when he saw a procession of "three priests of the bow, in plumed helmets and closely-fitting cuirasses, both of thick buckskin—gorgeous and solemn with sacred embroideries and war-paint, begirt with bows, arrows, and war-clubs, and each distinguished by his badge of degree—coming down one of the narrow streets."[2] This cap of perforated buckskin with a tuft of feathers is one of the badges of office in the priesthood.[3] Like almost everything Cushing owned, it is exceptionally finely crafted, especially in comparison to a Bow Priest's cap Culin purchased from Vanderwagen (05.588.7087). Whereas Cushing's cap is made of buckskin and richly decorated with olivella and abalone shell, the Vanderwagen cap is made from felt and has a green silk ribbon around the edge in place of shells.

Cushing's three-part article "My Adventure in Zuni," published in 1882–83, included an illustration entitled "A Zuni War-Party." The perforated cap is clearly represented on two of the three warriors in the picture.[4] DF

1. Cushing [1882–83] 1967:30.

2. Ibid.

3. M. C. Stevenson 1904:588.

4. The illustration is by H. F. Farny, who never went to Zuni. It may be based on a sketch provided by Cushing who, in spite of the Zunis' objections, was rarely without his sketchbook.

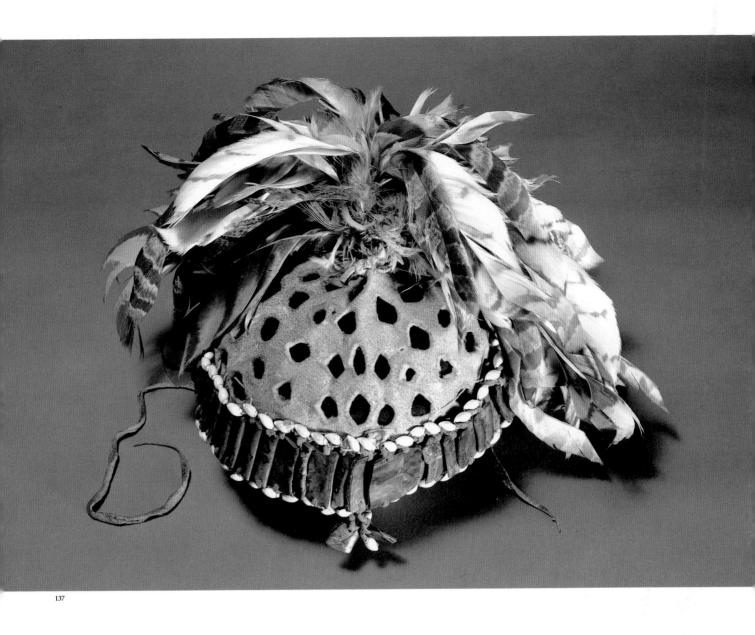

137

HOPI

138. MARAU PADDLES WITH REPRESENTATION OF ALOSAKA
Hopi
Wood, pigment, cotton, feather, H. 20¼, W. 5, D. ¼; H. 20½, W. 5, D. ¼
Purchased in Walpi, First Mesa, Arizona, 1905
05.588.7182a–b

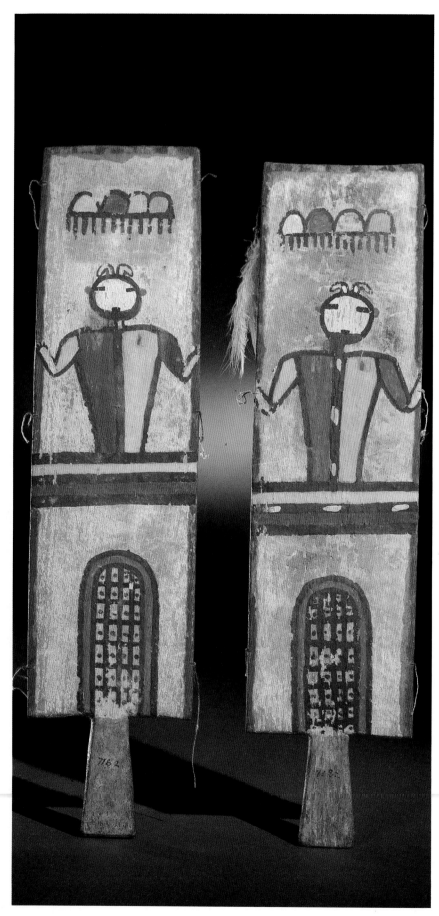

During his first visit to the Hopi mesas, Culin reported that the women tried to sell "the painted wooden paddles or bahos they use in their Marau katcina [Mamzrau]" dances.[1] The ease with which the processional paddles could be purchased and the fact that they were women's ceremonial objects did not impress him. He was "disappointed" because the "masks and ceremonial objects [were] the property of men" and they would not let them go (1901b:14).

In 1904 Culin purchased twelve "marau bahos" (two pairs and eight single pieces) from a trader for The Brooklyn Museum, and in 1905 he collected almost as many at Walpi. Although the "girl's dance" was "almost, if not entirely festal," Percy Pasaina, one of Culin's Hopi guides, explained that the dance was "now abandoned" at Walpi "in consequence of Burton's [the Indian agent] orders" (1905:25).[2]

The women's ceremony of Mamzrau is often performed to ensure fertility.[3] Women in the Mamzrau society held their paddles in each hand by the short handle and, with the more elaborate side forward, waved them up and down from side to side slowly in time to the singing.

These objects are painted on the reverse with a series of short red dashes, perhaps to represent tracks.[4] Originally, feather plumes tied to cotton string dangled from the sides of the tablets and slender stalks of grain attached to the tablets waved at the sky.

Culin identified the figure depicted on this pair as Alosaka, one of the Germ Gods, who controls the growth of all things; appropriately, an ear of corn is also depicted on the lower section. The figures are surmounted by clouds with falling rain. LMB

1. Culin used the misnomer "marau bahos" after he probably heard the Spanish word *paho* (stick) referring to the Marau prayer sticks used by women in the Mamzrau society dances.

2. Culin's guide, Percy, explained that a Mrs. Gates put on a headdress and danced with them. "The school master heard of this and sent word to Burton who at once ordered her to desist" (1905:25). Apparently, the Hopi girls followed suit. In contrast, Elsie Clews Parsons attributed the demise of the ceremony to the conversion of Sa'liko, the "woman chief" of First Mesa, to Christianity "about 1907" (Introduction to Stephen 1936:865).

3. Indeed, in the final dance "there is a dramatization of lightning striking in the corn field 'which is regarded as the acme of fertilization'" (E. Parsons, Introduction to Stephen 1936:865, quoting J. W. Fewkes and A. M. Stephen).

4. Voth 1912:67; p. XVIII.

139, 140. WEDDING BLANKET AND SASH

Hopi-Tewa or Hopi
No. 139: Cotton, W. 74, L. 61

No. 140: Cotton, wrapped corn-husk? rings, W. 8, L. 101
Purchased from George Pabetsa on First Mesa, Arizona, 1905
05.588.7162; 05.588.7163

Culin bought these two textiles from "the Tewa Indian," George Pabetsa (see No. 142), who told him they had belonged to his wife (1905:11). These, along with several other textiles, are presented to a woman who marries for the first time. Traditionally, they were spun and woven by her husband's male relatives. Many Hopi women treasured their wedding outfits throughout their lives and were buried with them.

The blanket is still covered with a fine silt. It has been reported that in order to avoid soiling the garment, the weavers smeared their hands with a thin liquid of white clay before they worked. When the textile was completed it was thoroughly soaked with the clay, allowed to dry, and then the excess was beaten off with a twig and picked off with fingers.[1]

The bride wore one of her robes over her shoulder during the ceremony, and she carried another manta and girdle rolled in a reed mat. After Culin purchased the wedding outfit, word quickly spread that he was looking for such a mat, or "suitcase." The following day, Culin bought the reed case from Tinabi, who was also called Pitkina, in order to make the outfit complete.
LMB

1. Stephen 1936:1183.

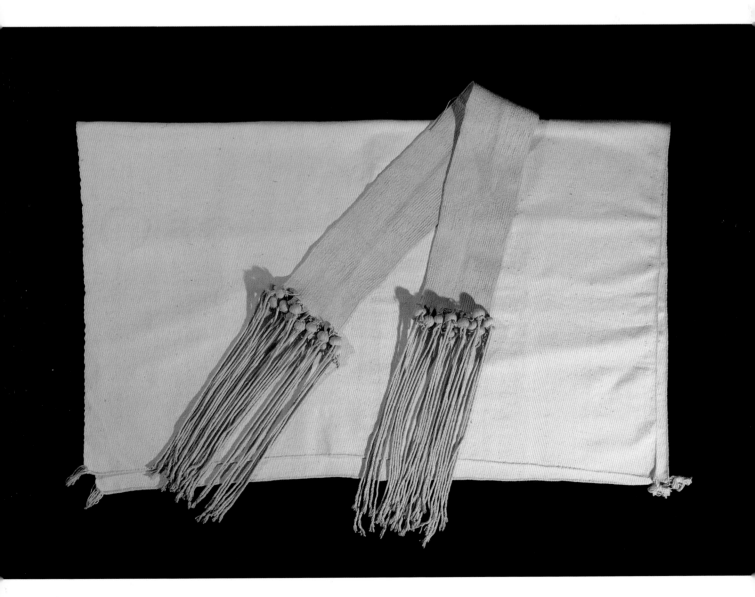

141. SNAKE DANCER'S KILT
Hopi
Cotton hand-spun cloth, pigments (clays?), and dye, H. 21¾, L. 41¾
Purchased from Lomawiya on First Mesa, Arizona, 1905
05.588.7173.1

Culin purchased various pieces of a Snake dancer's costume from Lomawiya, a Hopi man. Lomawiya sold two Snake kilts to Culin: one of commercial fabric and this hand-spun cloth kilt, which belonged to his father, Tiwasmi (1905:12). The outfit included a leather pouch, whip, armbands, and bandolier. Such costumes were worn in public performances by Snake dancers in a ceremony designed primarily to bring rain.

The kilt was wrapped around the waist and tied on the right side. According to an early ethnographer (A. M. Stephen, whose notes Culin purchased),[1] the design can be interpreted in the following manner: the painted zigzaglike design depicts the plumed water serpent; the short parallel strokes indicate the face painting of the War Gods; the angular marks are frog's tracks; and the colored stripes symbolize the rainbow.[2] LMB

1. Culin also met the Walpi Snake priest, Harry Supela, and showed him some of Stephen's notes. They went over the names of Stephen's informants, and "one by one, Harry told me that they were almost without exception dead" (1905:6). Culin pasted a sketch of Supela by the artist A. L. Groll into his 1905 report.

2. Stephen 1936:650, fig. 355.

142. GAME BOARD
Hopi-Tewa?
Sandstone, L. 8¾, W. 8½
Purchased from George Pabetsa in Sichumnovi, First Mesa, Arizona, 1905
05.588.7128

Culin had observed the game "To-to-los-pi," which is associated with this board's being played at the Hopi-Tewa village of Hano in 1901 and had become especially interested in its history when he heard that Tewa speakers at Isleta and Nambe called it "Patole." The Aztecs, Culin believed, used a similar board for their game of "Patolli" (1901b:25).

Culin commissioned a number of games from George Pabetsa.[1] He made a point of asking Pabetsa to

142

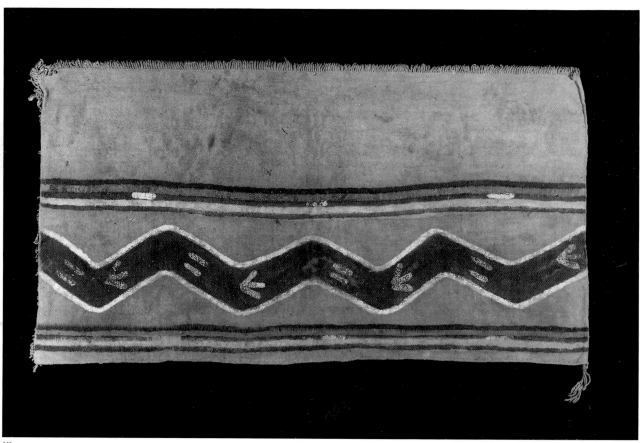

141

148

produce the stone slab for the game of "To-to-los-pi" (1905:9). In his book on North American Indian games, Culin commented that the game is not unlike checkers, and to capture the pieces of the opponent seems to be the main object of the game. The "checkers," however, must always be moved toward the southeast corner (1907a:796). This game board can also be used to play a game called "Tuknanavuhpi," another checkerlike game. LMB

1. Culin stated that George was "the boy or man who made pictures for Dr. Fewkes." Presumably, Culin meant that Pabetsa contributed to the series of Hopi kachina paintings made in 1900 and published by the BAE. Since Fewkes names three of the four artists whom he employed, it is possible that Pabetsa is the "boy who had attended a Government school in Lawrence, Kansas," whose paintings were not reproduced because they showed the "influence of instruction" (Fewkes 1903:13–14).

143. SASH
Hopi-Tewa or Hopi?
Cotton warp, cotton or wool weft, L. 86, W. 16
Purchased from George Naspee on First Mesa, Arizona, 1905
05.588.7167

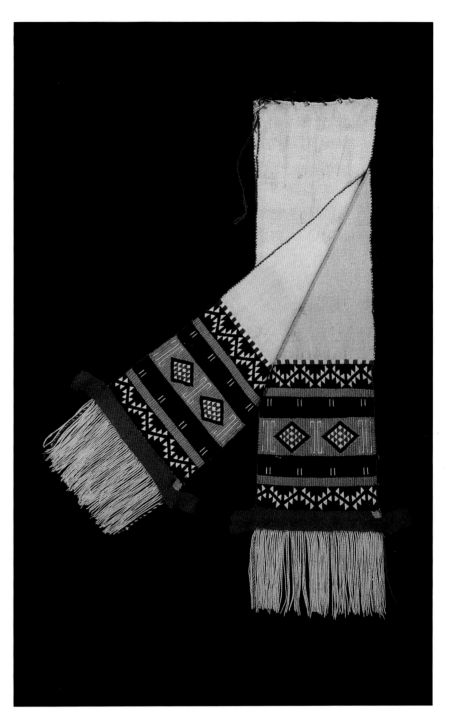

After negotiating for almost a week, Culin bought several new textiles from George Naspee (Bobitza), a Hopi-Tewa man (1905:8,12). Among them was this piece, which Culin identified as an "embroidered cotton girdle" although it is not embroidered. Its colorful decoration was woven by a male weaver in a technique known as "Hopi brocade."

Design elements on the sash are almost completely standardized but have been given various interpretations by nineteenth-century ethnographers. According to Stephen, the ethnographer whose notes Culin purchased, the design represents the mask of the Broadface kachina, one of the class of guardian kachinas who protect other kachinas. The zigzags indicate his bared teeth; the diamonds are his bulging eyes; and the hooks and paired vertical lines are painted face markings characteristic of warriors.

This type of textile is generally referred to as a dance sash because it is often worn in ceremonies with the brocaded ends swinging from the dancer's right side. On other occasions, as Culin observed, a male dancer may wrap it as a breechcloth or girdle, so that its brocaded ends cover and extend over both front and back (1905:18–19). LMB

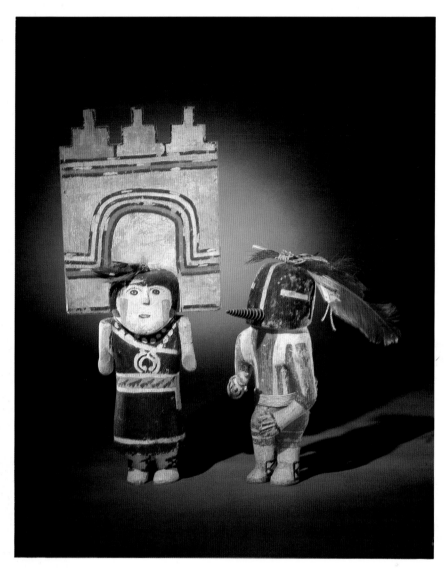

144, 145. KACHINA DOLLS
Hopi
No. 144: Wood, cotton, hide, feather, horsehair, wool, pigment, H. 13, W. 5¾

No. 145: Wood, cotton, feather, pigments, H. 22, W. 9¼
Purchased from Wetzler Brothers in Holbrook, Arizona, 1904
04.297.5575; 04.297.5592

Although these kachina dolls are massive in size, Culin was not particularly impressed with his first Hopi kachina-doll acquisitions: "I bought from Wetzler a lot of rather poor Hopi dolls, etc. for $35. They were cheap and formed a good start for a Hopi collection" (1904a:85). Perhaps Culin did not appreciate this group because it included fairly common figures from the Hopi pantheon. No. 145 (female) is well known as a *poli mana* type, and its arms were originally carved from the same piece of wood and were immobile. No. 144, representing *kokopol* (identified by Culin as *kokopell*), is missing its phallus, and its right arm is held together with hide thong, indicating a possible native repair. LMB

146. KACHINA DOLL
Hopi
Wood, fur, cotton, horsehair, feather, shell, horn, stone, H. 12¼, W. 5
Purchased on First Mesa, Arizona, 1905
05.588.7193

This is perhaps the only Hopi kachina doll that Culin collected on his own. Other than stating that it cost one dollar, Culin said nothing at all about the circumstances under which it was collected and offered no clues to its identity.

The male figure's bulging eyes and protruding snout convey a fierce aspect. A fur cape is thrown over its shoulders, and feather plumes adorn its head. Dangling from a necklace of hand-spun cotton and hide thong is a mysterious trio of objects: a red stone blade, a small shell, and a carefully incised portion of horn. LMB

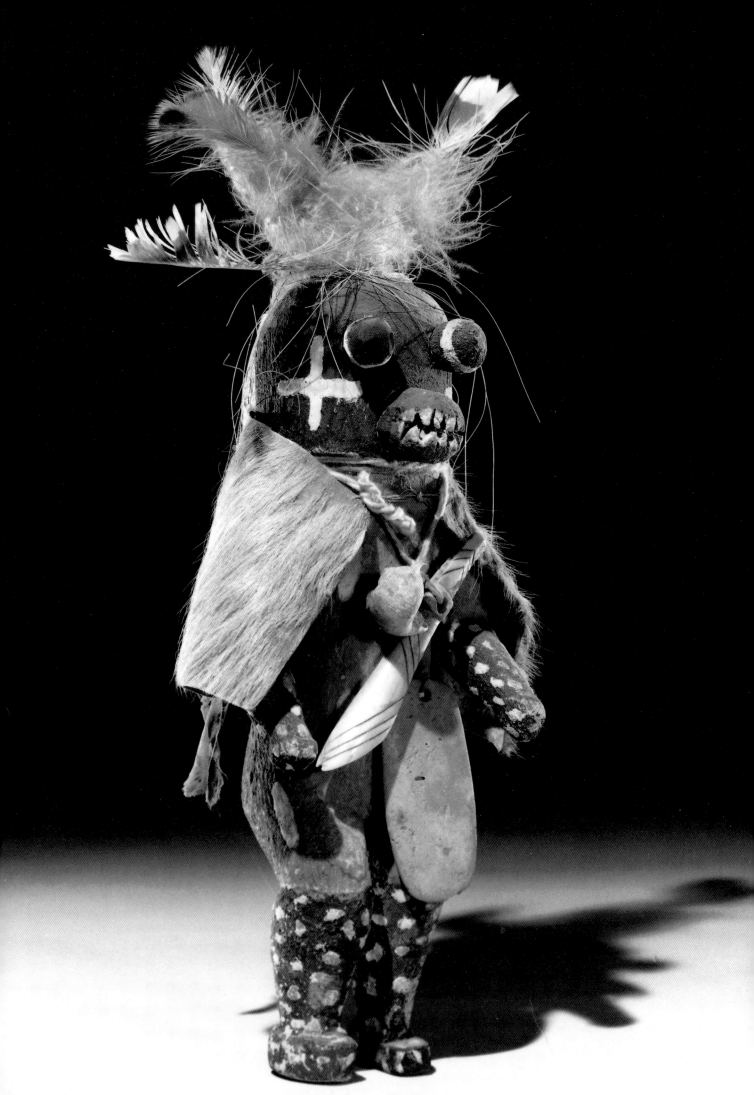

147. Dancing Shoes

Hopi
Hide, pigments, sinew, porcupine quill, hair, wool, H. 7½, W. 4
Purchased on First Mesa, Arizona, 1905
05.588.7175a–b

The color combination of these men's moccasins indicates that they may have been worn by kachina impersonators.[1] The red fringe was colored with a dye made from alder bark or rubbed with an iron oxide, and the moccasins were probably painted with a copper carbonate paint to produce green.[2] A band covered with porcupine quills is sewn over the heels. The Pueblo people did little quillwork, except for anklets. Generally, porcupine quills were dyed, split, and worked over horsehair with a series of half-stitches.[3] LMB

1. Wright 1979:23.
2. Stephen 1936:1191–95.
3. Hough 1918:263.

148. Ceremonial Blanket

Hopi
Commercial cotton twine (warp), hand-spun cotton (weft), woolen borders with indigo and synthetic dyes, L. 40, W. 48
Purchased in Mishongnovi, Second Mesa, Arizona, 1905
05.588.7170

Culin planned to spend a week on Second Mesa as the village was "far wilder, less changed, and more romantic than the towns on the First Mesa" (1905:15). In a few days, however, his attitude changed; he "found the people far less courteous, and more grasping than our friends at the First Mesa." He cut his visit short and concluded that the "visit was not very profitable" because he managed to buy just one item: this "woman's red and white blanket at the somewhat high price of $8" (1905:21).

Culin referred to this piece as a "ceremonial blanket" because he often had seen ceremonial dancers wearing such textiles, but women wore them on special occasions, as well. In Hano, Culin observed that young women watching the kachina clowns perform were "coquettishly grouped together, two or three wearing red and white cotton blankets." This style was not ubiquitous: watching from the rooftops was an "Indian girl with a hat and dress such as an American girl might wear on a Sunday outing in the east" (1905:24). LMB

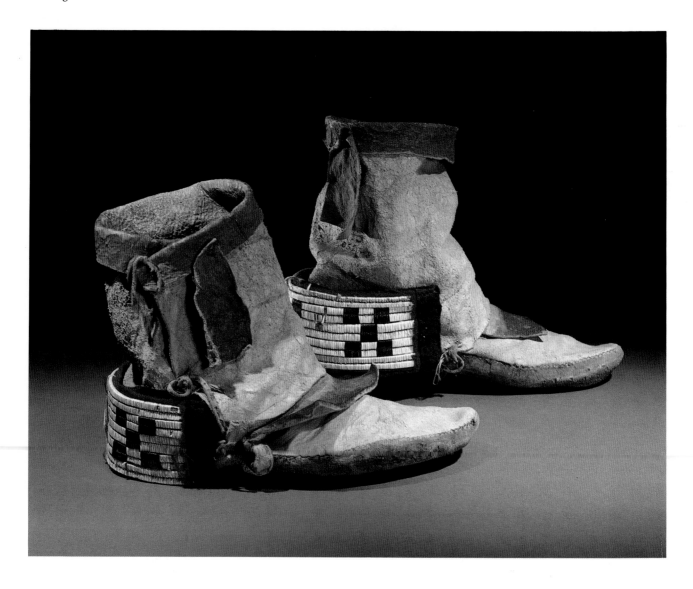

152

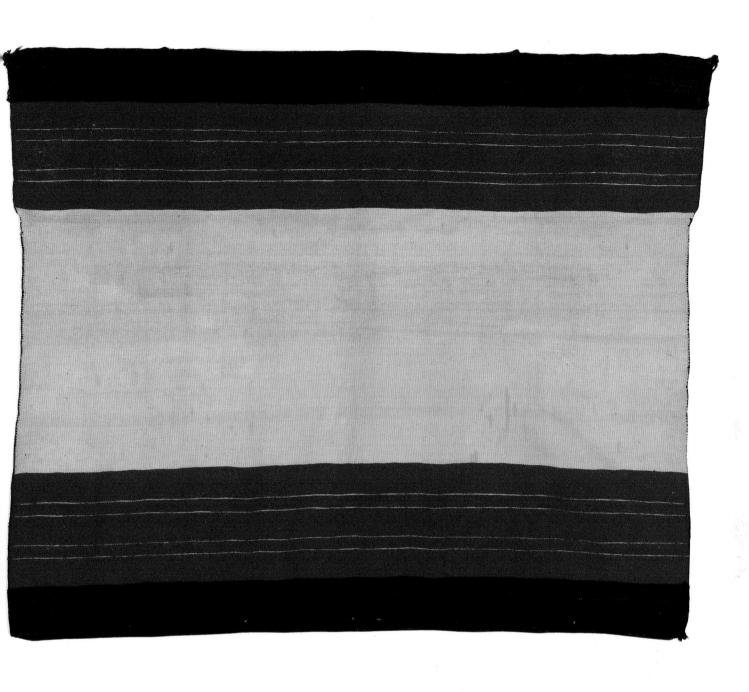

153

OTHER PUEBLOS

149. IMAGE IN CRADLE
Cochiti
Wood, iron nails, cotton string and fabric, pigments, H. 10½, W. 1¾, D. 1½ (image); H. 11, W. 4, D. 2 (cradle)
Collected by Father Noel Dumarest, probably in Cochiti, New Mexico, ca. 1895–1900; purchased from Father Michael Dumarest in Gallup, New Mexico, 1905
05.588.7686 (image); 05.588.7687 (cradle)

Although Culin visited Cochiti briefly in 1907, he collected no objects there himself. Rather, he acquired a small selection of Cochiti objects largely from one source. He purchased sixty-seven objects from the estate of the Franciscan missionary-cum-ethnographer, Father Noel Dumarest.

Stationed at the pueblos of Cochiti, Santo Domingo, and San Felipe in 1894, Dumarest became an astute observer of the Keres-speaking people. In addition to his ethnographic work, he "helped his parishioners through the long epidemic of 'los frios' or malaria, both as a priest and a physician" until he finally contracted the disease in 1900 and died in 1903.[1]

Culin stated that this image "represents a female child given to squaws in dances as a sign of future fecundity." Father Dumarest's exegesis is richer: he explained that the image, known as an *oaka*, represents the spirit of a dead child. A pregnant woman or a woman who desired a child received a wooden baby and miniature cradle from a masked dancer. "The woman will carry the oaka on her back as she would a baby. She will say to it, 'Oh how you cry, you keep me from doing anything. Your father is coming already. He will have nothing to eat...' She rocks it. She may take it to bed with her. If the woman die [sic] the oaka is buried or hidden with other things."[2]

Female *oakas* can be identified by the stepped board at the top of the head representing a terraced headdress worn by women dancers. Although some of the headdress pieces are missing on this image, the large prong extending from the image's head indicates that such a board was originally attached. The stepped motif is repeated in paint on the figure's face and carved on the cradleboard. LMB

1. S. Culin, Preface, in Dumarest 1919:139.
2. Ibid.:141–42.

150. *KOSHARE* IMAGE
Cochiti
Wood, pigments, H. 19¼, W. 4½, D. ½
Collected by Father Noel Dumarest, probably in Cochiti, New Mexico, ca. 1895–1900; purchased from Father Michael Dumarest in Gallup, New Mexico, 1905
05.588.7645

The striped *koshares* are sacred clowns who are closely associated with burlesque performances. Culin identified this image as that of the "puyatyama," or "Father Clown." His catalogue card notes that this figure "represents a man created from clay by Uretsete (the mother of the Indians) whose adepts are charged during the dances to break monotony and keep away all gloomy thoughts from the people."

After witnessing the *koshares* perform in the burlesques, Father Noel Dumarest concluded that it is "in their farces that [the Cochiti] imagination is most alive." Indeed, one performance featured a *koshare* "dressed as an American... carrying in one hand a piece of bread and, in the other hidden behind his back, a big whip." The missionary explained that the moral of the pantomime was "always to beware of Whites, whatever their appearance."[1] LMB

1. Dumarest 1919:185–86.

151. DOLL

Laguna
Wood, pigments, H. 9¾, W. 3½
Purchased in Laguna, New Mexico, 1903
03.325.3009

Culin did not hold high expectations for making a Laguna collection. During the twenty-five years before his visit to the pueblo, many people had scattered to small farming settlements: "The town was almost deserted, and many buildings were falling in ruins...only the old, conservative pagans remain" (1903:125).

On his arrival, Culin met the local miller and surveyor, Mr. John M. Gunn, who collected Laguna tales. Together they managed to commission for the Museum a few game pieces from one boy and to purchase seven dolls from two or three households. Culin was pleased with his afternoon's work; the previous year he had been able to purchase just one woman's doll only after he promised "not to show it to any of the [other] Indians" (1902b:27).

He described the dolls in his expedition report:

[They are of] two kinds: simple, round billets, and simple flat billets or tablets, both painted red with rude heads of different colors. They represent the personages of the dances but, according to Mr. Gunn, only a few special ones out of the entire number. Feathers are attached to the head and sprigs of spruce [are] tied to the body of the image. Dolls are kept on a little bracket attached to the walls of the house (1903:125–26).

This flat doll represents a girl kachina; the cylindrical billet type generally represents the male impersonators. The doll has lost its head feathers and some color over the years, but its painted head still retains enough features to resemble a kachina mask. LMB

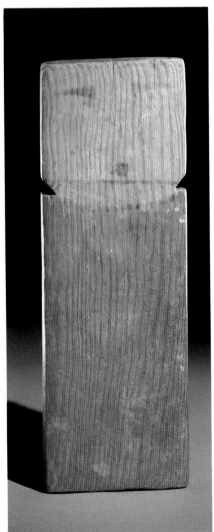

150

151

155

152. CANTEEN
Zia
Ceramic, slip, cotton cloth strap, plug
wrapped in cloth and paper, H. 6¾, W. 7
Purchased in Jemez, New Mexico, 1907
07.467.8259

153. WATER JAR
Zia
Ceramic, slip, H. 11, Diam. 11
Purchased in Jemez, New Mexico, 1907
07.467.8283

Before starting to collect in Jemez,
Culin obtained an overview of the
village crafts:

The Jemez Indians are agricultural and
have few manufactures, living entirely
on the product of their lands. One
woman I was told, does a little weaving.
Their Indian blankets they buy from the
Navajo who come from Toreones. They
make a few yucca baskets, the same one
sees among the other pueblos....They

buy their painted jars from the Sia and
only manufacture a little of the black
pottery of poor quality like that of Santa
Clara (1907a:8–9).

Culin had passed the pueblo of
Zia, located on the east bank of the
Jemez River, on the trip from Albu-
querque to Jemez, but he had not
stopped there. With the purchase of
these two vessels, he acquired good
examples of the Zia pottery style
and confirmed the pattern of trade
between the two villages.

Both pieces were bought from
Jemez individuals on Culin's door-to-
door rounds of the village. To judge
by the frayed cotton strap, the can-
teen had been used as a water
container for a long time. The plug,
covered with cloth and paper, was
presumably in the canteen when
Culin purchased it. DF

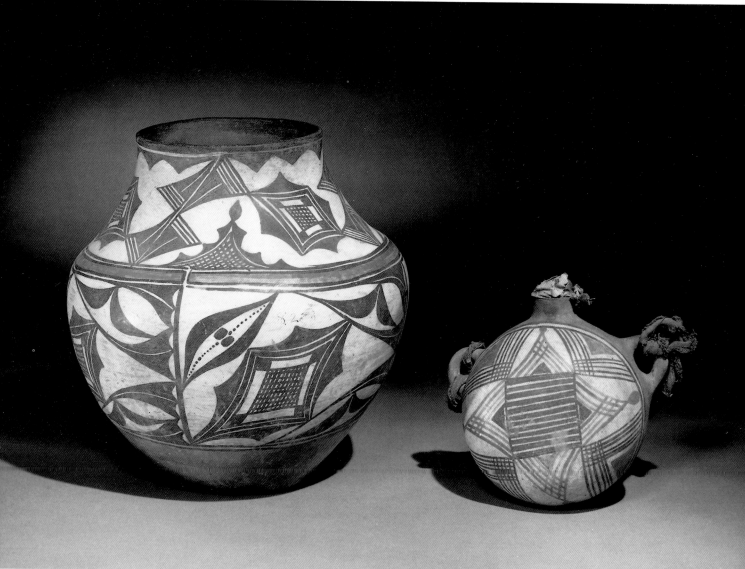

153 152

154. DISH
Jemez; 17th century?
Ceramic, slip, H. 2¼, Diam. 7¾
Purchased from Dr. J. M. Shields in Jemez
Hot Springs, New Mexico, 1907
07.467.8271

Shortly after arriving in Jemez, Culin made a trip to the Jemez Hot Springs, located thirteen miles to the north. There he called on Dr. J. M. Shields, a Presbyterian minister who had settled in Jemez in 1878 and practiced medicine at the Springs. This was the first of several visits Culin paid Dr. Shields, whom he described as "an honest, kindly-disposed old man." He was disappointed, however, in Shields's knowledge of the Indians: "Like all the other white people here, he knew little or nothing" (1907a: 32–33).

Dr. Shields did have an interest in archaeology, however, and had excavated some material from the ruins of the old church near Jemez Hot Springs. He sold Culin several of his finds, including this unusual dish decorated with black crosses, which Culin thought "may have been made under Spanish influence" (1907a:40).

Culin did a little excavating on his own at the church and picked up a number of pottery fragments. Father Haile later informed him that the name of the church was San Diego and that it had been destroyed in 1680, but the location of the ruins suggests that they are those of San José de los Jémez, a seventeenth-century mission church and monastery.[1] This dish may well be related to a small group of ecclesiastical items "manufactured of Jemez Black-on-white pottery" that have been found at this site.[2] DF

1. On his catalogue card, Culin records the locality as Perea, New Mexico. There is some confusion in the early literature between San Diego de Jémez and San José de Jémez. San Diego de Jémez was built in the pueblo of Jemez.

2. Lambert 1981:224.

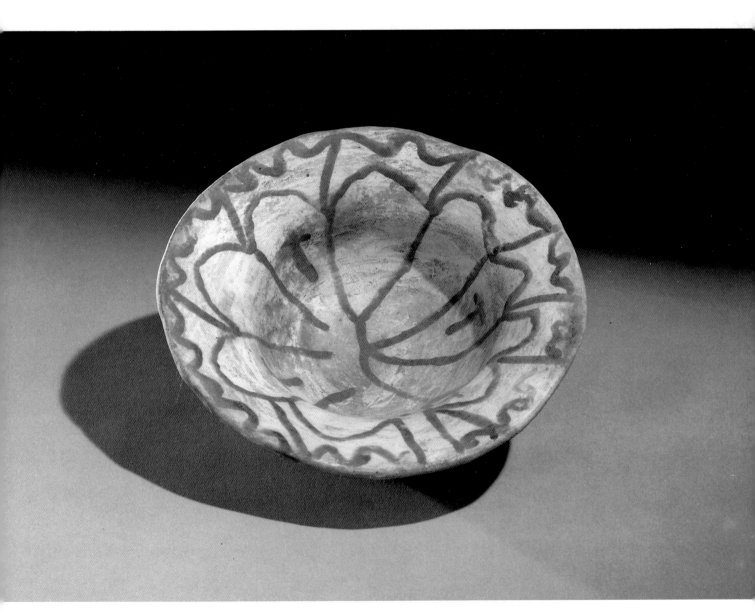

155. Unfinished Basket

Made by Felipe Yepa; Jemez
Coiled: plant fibers, dyes, H. 1½, Diam. 5
Purchased from Felipe Yepa in Jemez, New
Mexico, 1907
07.467.8229

José Reyes Toya, the young sacristan of the church in Jemez, introduced Culin to his cousin Filipe Yepa, "a maker of baskets" who wove "a basket bowl with an ornamental pattern in red and black, precisely like the kind I have hitherto attributed to the Navajo and Paiute." Yepa was one of "five or six men in Jemez who make these baskets. Filipe makes the best." Culin bought this unfinished basket along with a finished one (not located) and a "bunch of basket material," thus fully documenting Filipe Yepa's work. The red dye used in the baskets was obtained from the Armenian trader in the town. Most of the other baskets Culin saw in Jemez were Apache "ornamented with bright colored designs in analine [sic] dyes. In some houses the baskets that were not in use were suspended from the rafters, bottom up, in a neat row" (1907a:15,16).

In Jemez today, men of the Gachupin family make coiled baskets. Alcario Gachupin reportedly "learned basketmaking from Felipe Yepa."[1] DF

1. Whiteford 1988:168.

156. Flute

Jemez
Etched cane, L. 24, Diam. 1
Purchased in Jemez, New Mexico, 1907
07.467.8245

Inquiring about Jemez musical instruments, Culin learned that the "Indians have a kind of flute they used in their public dances," as well as a notched stick rattle "which was used to imitate the sound of corn grinding." Later he succeeded in purchasing this "etched cane flute": "The owner, the man who made it, was not at home, and his wife sold it to me." When Culin returned to the house where he was staying, his companion, José Reyes, examined the flute with him, pointing out the various motifs, which include clouds, the moon, stars, rattlesnakes, a rainbow, a butterfly, cloud terraces, a flute player "playing a cane flute with a gourd bell shaped like a squash blossom," and the sun (1907a:9,17,21–22).

The flute was used in a dance associated with agricultural fertility. The flute player "preceeds [sic] the dancers in the circle dance in September, when two parties, from the two estufas [social divisions] dance alternately, each preceded by a fluter" (1907a:21–22).

Elsie Clews Parsons published this flute in her study of the Jemez, along with a detailed description of a flute dance she witnessed on September 17, 1921. The costume worn by the flutist on that occasion corresponds closely to the one depicted on the musician etched on this flute: "white shirt, white embroidered dance kilt, pendent foxskin and long fringed dance belt…under each knee is tied with yarn a circlet of brass bells."[1] DF

1. Parsons 1925:83.

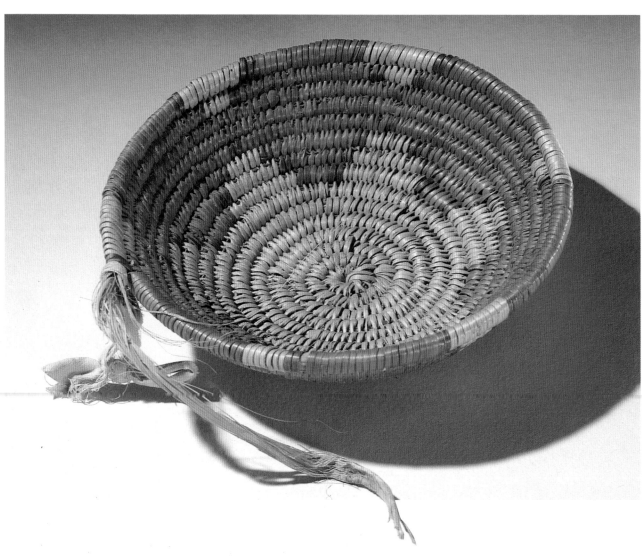

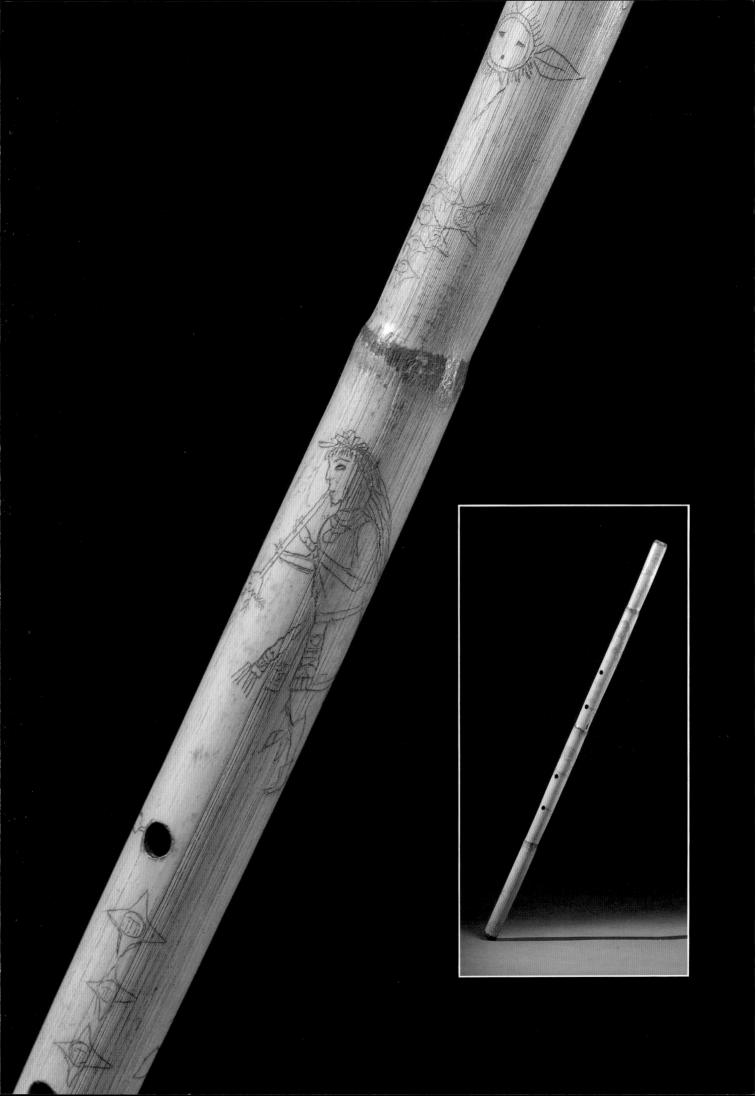

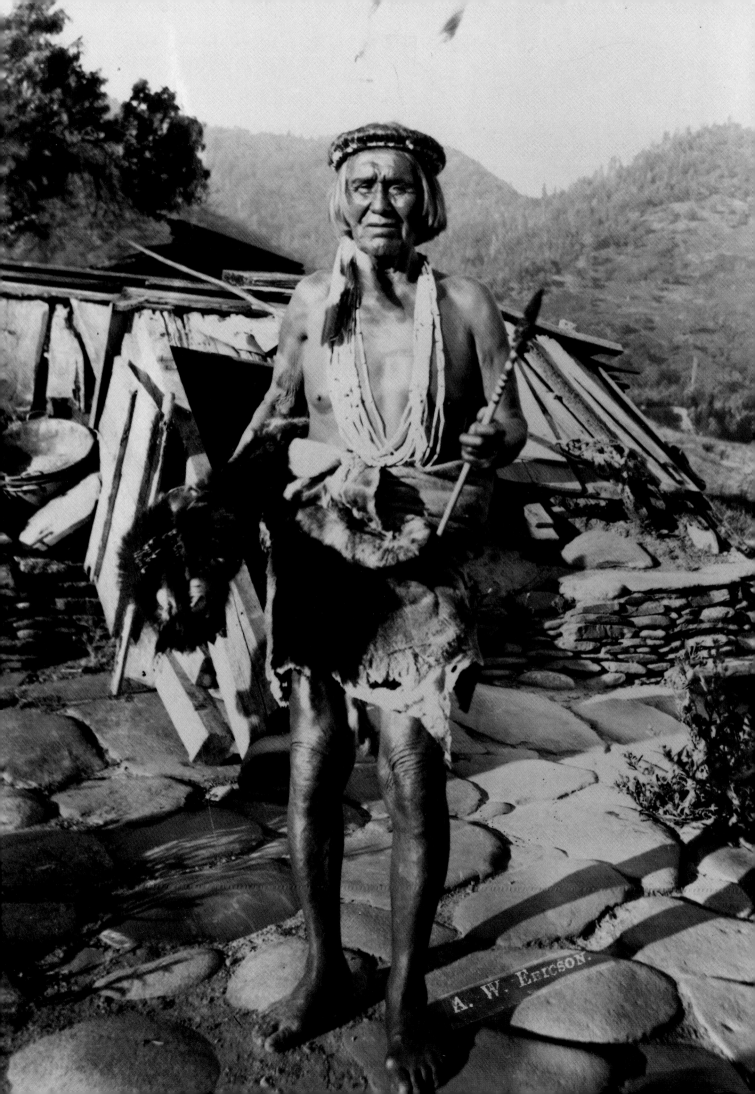

A. W. ERICSON.

CALIFORNIA

Ira Jacknis

C ALIFORNIA, a major focus of Culin's collecting, is an area of
dramatic diversity in native cultures, languages, and envi-
ronments. This complexity was at once stimulating and
defeating for early ethnologists and collectors.

Though Russian, English, French, and Spanish explorers had made
early collections, the effective beginning of systematic study came in the
1870s, with the collecting and writings of journalist Stephen Powers, who
published the first summary of native California culture in 1877. During
the 1890s Dr. John W. N. Hudson (1857–1936), a physician living in Ukiah,
began to study the cultures of the neighboring Pomoan peoples. In 1899
Hudson sold his basketry collection to the U.S. National Museum, which
up until then had important but largely undocumented holdings from the
region. The Hudson collection, along with others, was exhaustively studied
by museum ethnologist Otis T. Mason for his classic monograph *Aboriginal
American Basketry*.[1] Another important early collector was Charles P.
Wilcomb, who had been gathering baskets and other native artifacts since
the early 1890s.[2]

The serious interest in Californian ethnology seems to have exploded
at the end of the nineteenth century, perhaps stimulated by the sale of the

Hudson collection. Just about the time Culin set out for California, John Hudson was ending his five years of collecting in the state for the Field Museum. Hudson soon became a close friend and invaluable scholarly resource to Culin. Beginning in 1899, the American Museum of Natural History sent Roland Dixon out to California for six summer field seasons. Sponsored by the Huntington family, Dixon worked mostly among the Northern Maidu and Shasta. In 1900 the American Museum also purchased a collection of Pomo baskets from Carl Purdy, an early settler turned basket dealer in Ukiah. At about the same time that these museums were pursuing Californian artifacts, the academic tradition began, with the founding of an anthropology department and museum at the University of California at Berkeley in 1901.[3] Directed by Alfred Kroeber, the Berkeley department soon became the center for the study of the Californian Indians. Although Culin had cordial relations with Kroeber, he had little to do with these scholars and academic collectors.

In addition to these institutions, there were important independent collectors such as C. Hart Merriam and Grace Nicholson. Merriam, a biologist, seems to have begun his ethnographic research in California around 1902. Buying predominantly from native vendors, he made an extensive collection of mostly utilitarian baskets, with detailed documentation. One of Merriam's sources was the Pasadena dealer Grace Nicholson, who made her first sale to the scientist. Within a year of her move to Pasadena in 1901, she had opened a shop for American Indian art, and by 1903 she was making regular trips to Indian communities in California, the Northwest Coast, and the Southwest. Although Nicholson made her living by selling, more often to private patrons than to museums, she took a serious interest in native culture and most of her collections are well documented.[4]

Simultaneously supporting and hindering this scholarly interest in California Indians was the turn-of-the-century "craze" for collecting American Indian baskets. The Arts and Crafts movement had stimulated an appreciation for natural materials and handcraftsmanship, and for a few years no stylish house was complete without its basket nook. This taste was especially developed in the Los Angeles–Pasadena area by writer-collectors such as George Wharton James and Culin's friend Charles F. Lummis.[5] As Culin and many other museum ethnologists were to find, popular demand had a serious effect on the production and retention of baskets by California Indians.

Culin was quite familiar with these public and private collections as he set out for California. Every year during his decade of American expeditions, in fact, he stopped in Chicago to compare his acquisitions with the Field Museum's. Before his summer's work in 1908, Culin "carefully examined the Pomo material, trying to discover objects not in our museum" (1908:1). As the years went on, Culin's envy for the collections of others diminished in proportion to his increasing satisfaction with Brooklyn's holdings.

Culin's largest California collections were made among the Pomo, whose culture was the principal one represented in his California Hall (see Fig. 16). During a total of about four months, spread over three expeditions in 1906, 1907, and 1908, Culin gathered 500 Pomo specimens.[6] Filling out the exhibit were cases devoted to the Hupa and Yurok, the Maidu, and the Yokuts, groups that he only visited once—in 1905, 1908, and 1911, respectively. Although he spent only six days among the Hupa and Yurok, Culin was able to gather 211 objects, largely with the help of dealers. In comparison, his thirty-three days among the Maidu netted him 196 specimens.[7] His last trip to California was made in 1911, in order to secure "objects to round

 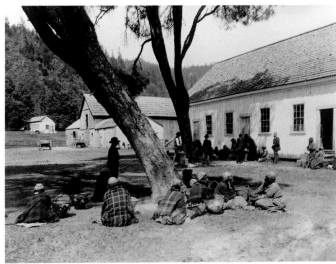

Fig. 44. *Joseppa Dick, Central Pomo basket weaver, and her family in Yokaya. Henry W. Henshaw photograph, 1892, from 1906 expedition report.*

Fig. 45. *Ration day at Hoopa Valley Indian reservation. Augustus W. Ericson photograph from 1905 expedition report. On each of his trips to the Klamath River area, Culin purchased a large set of pictures from Ericson, an Arcata photographer.*

out the case" of Yokuts material included in the two exchanges of 1905 and 1907 from the Field Museum, most of which had been collected by Dr. Hudson (1911a:74). Over nine days on the Tule River Indian reservation, he collected 86 specimens.[8] With objects from these four major cultures, Stewart Culin created an image of California Indian culture at The Brooklyn Museum.

Hupa and Yurok: A Collection of Old Things

On his first California trip for Brooklyn, Culin returned to the Klamath River area, the site of his first collecting expedition in the state, undertaken when he was at the Museum of the University of Pennsylvania (1901a:104–17). As he noted in 1900, Yurok "customs appeared identical with those of Hupa, and the specimens I collected among them differ in no way from those of the valley except in name," but "the language is absolutely dissimilar" (1901a:116). Though of radically different language families, the three principal tribes of Northwest California—Hupa, Yurok, and Karok—share a common culture. With their salmon subsistence and concern with wealth, these tribes of the Klamath River region represent the southernmost influence of the Northwest Coast culture area.

The coastal town of Arcata, a center for the redwood industry, was Culin's base for his Hupa and Yurok collecting. Here he found merchants who offered him useful advice, sold him artifacts, and helped him ship his collections. Foremost among them was Alexander Brizard (1839–1904). The French-born Brizard had come with his father in 1850 to Arcata, where, in 1863, they established a general grocery store and dry-goods business, with branches in Hoopa; Weitchpec (Yurok territory); Somes Bar and Orleans (Karok). After his death in 1904, his widow and three sons ran the business.

From Arcata, Culin rode into Hoopa Valley, where he was given a "cordial welcome" at Brizard's store, stayed in the Hupa Hotel, and called on the Indian agent. Culin was especially taken with the region, remarking, "Of all the Indian reservations on the continent, there are none more romantic and beautiful" (1901a:104). Established in 1864, the reservation of 150 square miles flanking the Trinity River was fairly isolated until a road was built in 1891 (see Fig. 45). Besides the Brizard store, which purchased "most of the basketry made by the Indians" (1901a:106), the reservation in

163

1900 had a school, a lay missionary, and a population of about 570. The missionary, Pliny Goddard, had been living at Hoopa for three years and supplied Culin with much information.[9]

In Hoopa Valley, Culin perceived a moribund material culture ("The native industries of the Hupa, with the exception of basket making, fostered by Mr. Brizard have almost entirely disappeared"), though he noted that pipes and bows and arrows were still made (1901a:114). In fact, Culin's concern over the loss of Hupa and Yurok culture was exaggerated; while under some strain, their culture was actually more intact than that of many groups in the state. Culin found old and new things dramatically and physically separated among the Hupa: "The Indians generally have two houses, one a modern cabin, built on their allotment where the younger generation live, and the squaws are to be found, weaving basket hats for sale, and the other the old house which they inhabited at the time of the white discovery" (1901a:109). In the five years since his first visit, Culin felt the Hupa had declined. The old people were dying, and "the old houses at Hupa are falling into decay and appear to be used only for storage purposes" (1905:66). It was in these semisubterranean plank houses that Culin found his "old things."

Native ceremonialism still thrived. In 1900 Culin had had trouble obtaining the valuable ritual objects, finding that treasures were not to be sold (1901a:111). Captain John, a leading Hupa (see p. 160), did agree to sell him some less-valued items. Culin had little more success in 1905: "The Hupa are not very satisfactory people to trade with. They commonly ask excessive prices for the sacred objects which they themselves value, although ordinary old baskets and household things they let go at about their current value" (1905:66). Though Culin did see a white deerskin and feathers (1905:64), prized dance paraphernalia, his 1905 collection contained comparatively fewer ceremonial things than his earlier one; the few ceremonial items he did obtain came from dealers.

With an interpreter and a boatman who had guided Dr. Hudson (1905:62), Culin headed down the Klamath River, through Yurok territory. "It was a delightful ride...and the scenery indescribably beautiful" (1905:67). At their periodic stops, Culin inquired about traditional artifacts in the small, isolated communities he passed. From an old Yurok man named Canyon Tom, he bought a suit of armor made of sticks and twine. The suit had been made for Dr. Kroeber, "who had not come after it." Culin was "delighted to find an object I had particularly wanted right at my hand," especially as he "did not propose staying long enough to make it worth while even to inquire into the possibility of having one made" (1905:68).[10] Hardly traveling in ethnologically virgin territory, Culin had purchased a true "museum piece."

Unlike his extensive Pomo trips, Culin's Hupa and Yurok trip was a simple linear voyage down the Trinity and Klamath rivers. Not staying very long in any one place, he had little time to commission artifacts or question informants. For this reason the documentation is much thinner. Many times he did not list the vendor's name, and the artist and native name is usually missing. He even had problems learning the native use for several items–the louse crushers (No. 173) and the hair-braid ornaments (No. 174). Though he always supplemented his field collections with purchases from dealers and private collectors, on this trip he depended more on them for important pieces that he was unable to obtain directly from the Indians.

The dealers were valuable to Culin for their supply of traditional artifacts (although they also supported the trade in baskets, the only new things being made in great numbers). At the end of his trip, Culin had purchased from the Brizards "eleven large storage baskets, all very perfect

and at very moderate rates" (1905:79), and he felt quite lucky to get these old and smoke-stained containers: "The river Indians do not appear to make any more of the large storage baskets" (1905:73). Even in the five years between his two Klamath River trips, Culin found fewer sources for the "old things" that could document the culture of the "vanishing Indian."

Maidu: A Fortuitous Collection

The purchase of a spectacular Maidu feathered belt from the Upper Lake Pomo lured Culin to visit the group. Just as he was leaving Ukiah in 1907, he asked John Hudson about the Indians at Chico—where, he was told, the belt originated. The doctor supplied him with directions and references of people who could assist him (1907a:151). Dwelling on the eastern edge of the Sacramento Valley and the adjacent Sierra Nevada mountains, the Maidu are subdivided into three linguistic groups: the Konkow or Northwestern Maidu; the Mountain or Northeastern Maidu; and the Nisenan, or Southern Maidu. Culin traveled to the two northern groups, which, following common usage of the time, he referred to as simply Maidu.[11]

On his 1908 California expedition, Culin spent four days in Chico at the beginning of June and returned for about a week more at the beginning of July, after a trip to the Mountain Maidu. He found Chico to be "a large, bustling California town, consisting chiefly of attractive frame residences set in gardens embellished with palms and a great profusion of flowers" (1908:25). As was his custom, Culin stayed at the town's hotel, traveling out each day to the Indian community, about a mile away.

The local Maidu were then living on the ranch of John Bidwell, built on the site of their ancient village of Mikchopdo.[12] Mikchopdo was well known for its wealth and affluence, which continued after white contact. Following his arrival in the area in 1849, Bidwell employed the local Maidu as laborers, paying them wages comparable to those earned by whites. Relatively protected from harassment, they continued their pursuit of traditional ceremonies and art. In 1868 Bidwell married Annie Kennedy, who sought strenuously to bring Christianity to the Maidu. As Culin noted, "The Indians here were largely supported by Mrs. Bidwell, for whom, although they lived upon her, and submitted to being baptized, and went to church, they had little or no respect" (1908:35). At the Maidu rancheria Culin found a "frame church and a number of well-built white-washed houses. There is nothing about them to suggest that they are inhabited by Indians, nor did the people themselves at first sight, suggest that they were either" (1908:26).[13]

By chance, the first person Culin met at the rancheria was Mary Azbill, a remarkable woman recommended to him by Dr. Hudson: "I met first a tall, vigorous, middle-aged woman, who used good English.... This woman became my guide, and with her I went about among the houses" (1908:26). Mary Kea'a'ala Azbill (1864–1932) was a leader of the Maidu community at Chico.[14] Her mother was a Konkow and her father a Hawaiian who had come to California in the 1840s. Azbill was widely traveled—she had lived for a time in the Royal Palace in Hawaii—and spoke many languages, both Indian and European, and as Culin noted, she was "an expert basket maker" (1908:35).

The first house Culin visited belonged to Amanda Wilson (1860s– 1946), cousin of Mary Azbill.[15] Though she initially refused to sell him the baskets she was using, he ended up buying more baskets (eight) from her than from anyone else in Chico. Wilson's mother was a Konkow and her father a white man, and she lived her entire life at Chico, her birthplace. Around 1900 Azbill divorced her first husband, Holai Lafonso, the village

leader, and married Santa Wilson, another Maidu leader. She herself was a leader in the woman's dance society, though like many, she destroyed her regalia at the death of Lafonso. Amanda Wilson became a close friend of Annie Bidwell and was active in the local Presbyterian church. Culin acknowledged the information he received from Amanda Wilson (1908:28), who continued to serve as an important consultant to ethnographers through the twenties and thirties.

Like Amanda Wilson, "the people were at first chary about showing me anything" (1908:26), and Culin's first purchases were baskets and other household items. His visit proved to be especially opportune for acquiring important ceremonial regalia. With Holai Lafonso's death two years earlier, the Maidu at Chico were faced with a cultural dilemma. According to tradition, the ceremonial dance house that had been built at his election to leadership had to be destroyed, a successor picked, and a new dance house built. The people were ambivalent. Some thought they should follow tradition, others that they should continue to use the old house, given the lack of interest among the young people. After an accident involving the house shortly before Culin's arrival, the leaders decided to destroy it and dissolve the dance society.[16]

Endowed with supernatural power, the dance regalia was "subjected to specific rules for construction, handling, storage and ultimate disposal."[17] As such, it was rarely shown, let alone offered for sale, to non-Indians. Billy Preacher, the highest-ranking member of the dance society and nearly seventy at the time, was the first to sell Culin some of his regalia. Then Mike Jefferson offered to sell his dance regalia to Culin, who made a selection from his complete set (1908:31). Culin's most spectacular purchase of this kind, however, was the regalia of George Barber (ca. 1833–1918), a captain in the society and next in rank to Preacher, who was about the same age. As the old man explained, "he wanted to sell his dance costume. The sweat house was gone, he did not dance any more and proposed to sell everything he had" (1908:60).

The sale of ceremonial material was still a sensitive issue. "The people are all more or less sore about the things Mike Jefferson sold me," Culin reported, though as with the Pomo, some of these complaints may have sprung from lost personal opportunity. Mrs. Azbill "explained that she had refrained from interfering or taking any part in my trades, as she did not wish to excite the displeasure of the others. After Dr. Hudson's visit she had much trouble through being accused of furnishing him with information about secret things" (1908:34, 35).

Like other Californian groups, the Maidu destroyed personal property at death, and they repeated such destruction at anniversary mourning ceremonies called "burnings." Though native sentiment was divided on the matter, Mrs. Bidwell adamantly opposed burnings (1908:34), which ceased at Chico about 1910.[18] Culin was thus especially lucky to obtain the prize of his Maidu collection: from Mrs. Barber he bought a feathered and beaded belt (No. 246), similar to the one he obtained at Upper Lake, but even finer. By the time he collected it, the last man who knew how to make them had passed away (1908:34). Altogether, Culin bought more than fifty ceremonial pieces at Chico, comprising a third of his collection from the community and including dance regalia, rattles and doctoring implements, and ceremonial offerings. Two other ritual artifacts unique in museum collections are a pitch-covered mourning necklace and a burial rope used for tying the corpse.

Culin's Chico Maidu collection was quite comprehensive, although smaller than the Pomo one. Its thirty baskets document the full range of the art form, and the collection is unusual for its other utilitarian objects, such as a complete set of the six Maidu games. As he did elsewhere, Culin

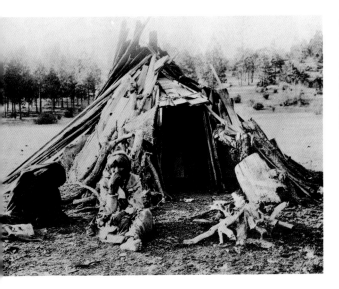

Fig. 46. Old Molly and Piney, Maidu Indians, near Quincy. Photograph from 1908 expedition report. As Culin does not mention these people in his report, he probably purchased the picture from a local photographer.

Fig. 47. House frames at Eastern Pomo fishing village, near Upper Lake. Oil sketch by Herbert B. Judy, 1906. Judy used sketches like this one as models for his panoramic mural in the California Indian Hall.

commissioned a number of household articles. One man had "fairly started making things when I left and was prepared even to anticipate my wants. He said there were many other things he could construct." Meanwhile, two brothers "named a number of things which they said were used in the old time, and which they declared I needed." As Culin proudly wrote in his expedition report, "I had almost all of them" (1908:73,74).

Culin also spent about three weeks among the Mountain Maidu, traveling repeatedly between the towns of Quincy, Greenville, Oroville, Taylorsville, and Prattville in Plumas and Butte counties, until he returned to Chico. By and large, the Indians lived in small, scattered camps (see Fig. 46). In Quincy he met C. D. Hazzard, a leading citizen with mining interests: "Mr. Hazzard told me that when he first came here some fifteen years ago [1893] the Indians were quite numerous, and lived more or less in their old way. He had bought some old baskets from them, to their great astonishment, and was the first white person to buy Indian baskets in this region. Now the Indians lived much as white people and had few of their old possessions" (1908:40). In addition to whatever miscellaneous things the Indians still had on hand—including baskets, mortars, hairbrushes, rattles—Culin commissioned many of the domestic artifacts he wanted, such as games, rattles, a scratching stick, and a basket hopper.

The overwhelming majority of the Mountain Maidu objects that Culin purchased were baskets. Usually he bought from Indians, but some came from dealers. While most were old and used, a few were new or commissioned. Many local residents—such as a druggist, a missionary, and the wife of a postmaster-cum-general-store keeper—had basket collections, and some also bought and sold. "I was told I would find baskets in the shops in Prattville, but there were none of any consequence" (1908:53). Of one Greenville collection Culin noted, "They were all new and made for sale, but most of them were fine and had good designs" (1908:46). In contrast to the situation in Chico, among the Mountain Maidu the heavy trade in baskets stimulated the creation of innovative forms for sale (see No. 235).

While in the Mountain Maidu area, Culin ran into C. S. Hartman, Grace Nicholson's collecting agent. Hartman dogged Culin in his travels around the camps, even following him to the same hotel in Chico. "I realized that to secure what I wanted I had to get to the rancheria before him, so instead of sleeping, I devoted most of the night to refreshing

myself, and at about six o'clock, went over to the settlement." Nevertheless, Hartman did manage to buy a flute that Culin had commissioned (1908:60, 61).

On his way back to Brooklyn from California, Culin stopped at the Field Museum, as was his custom, to review "the Maidu collection to ascertain what I had neglected or overlooked." While impressed with the number and beauty of their large mush baskets, he was pleased to report that in most respects "my collection is much more important and complete, and the individual specimens, in general, equal to, if not superior in quality" (1908:104). Although his was not the first or largest Maidu collection, Culin had been especially successful during his brief Maidu expedition.

Pomo: A Comprehensive Collection

In 1906, when Culin first arrived in the Eastern Pomo community of Upper Lake, he "started in buying here, purchasing freely at the prices named almost everything that was offered" (1906a:10). On his first and longest Pomo collecting expedition, he bought almost everything he could find, including a wide range of artifact types—from simple games to fine ceremonial regalia. His later 1907 and 1908 trips were more selective, as he filled in the gaps, purchasing some important baskets on the second trip and many stone objects on his third. By the time he was finished, he had a Pomo collection that could clearly match others in the country in diversity and documentation, if not in sheer size.[19]

When visiting the various Pomo groups, Culin invariably stayed in hotels—whether in Ukiah, Upper Lake, Lakeport, or Lower Lake—traveling out during the day by stage and hired wagon to the Indian communities. Ukiah, about one hundred twelve miles north of San Francisco, was the base for his Pomo collecting.[20] The seat of Mendocino County and a railroad terminus, the town had an estimated population of thirty-five hundred in about 1910. Ukiah became known to students of Pomo material culture because it was the home of the well-known collectors and writers John Hudson, Carl Purdy, and Samuel Barrett.

Although generally known as the Pomo, there was no unified Pomo "tribe." Composed instead of seventy-two autonomous social units speaking seven distinct yet related languages, Pomo culture was an areal type of great variety and complexity more accurately referred to as Pomoan.[21]

Culin visited the Pomoan communities of Potter Valley, Redwood Valley, Coyote Valley, Pinoleville, Mushtown (Northern Pomo); Yokaya and Hopland (Central Pomo); Upper Lake and Big Valley (Eastern Pomo); and Sulphur Bank (Southeastern Pomo). He also traveled to several non-Pomoan communities in the Clear Lake area, such as Cache Creek (Patwin) and Coyote Valley (Lake Miwok), many of which included Pomoan residents. Like Hudson and Barrett, Culin focused on communities speaking the three Pomoan languages closest to Ukiah.[22]

Upper Lake (see Fig. 47) was the community in which Culin spent most of his time by far; there may have been several reasons for this concentration. When he first arrived in Ukiah, he was told that the local Yokaya Indians were in the hop fields, "and their settlements deserted. Those at Upper Lake, 32 miles distant, were possibly at home" (1906a:7). As he was looking for striking scenery for his murals, he would have been attracted to the area around Clear Lake, surrounded by mountains that rise steeply from the long and narrow lake. Upper Lake may have appealed to Culin because of his interest in securing a boat made of tule reeds, which he commissioned as soon as he arrived in the village. With its distance from Ukiah, Upper Lake was perhaps less acculturated than Yokaya (see Fig. 48). Perhaps the most decisive reason, however, was that here, in contrast to many of the other Pomoan groups he visited, was a thriving community.

The Indian village of Upper Lake was about a mile from the town of the same name, itself two miles from the lake (1906a:9). As at Yokaya, members of the Eastern and Northern Pomo communities around Upper Lake had banded together in 1878 and 1879 to purchase ninety acres of land. Here they formed a "successful transitional community, organized on essentially traditional lines."[23] The hotel proprietor in Upper Lake told Culin "that 10 or 12 years ago the Indians all lived in tule houses. At that time one of them built a board house, and the others quickly followed. Since then they had changed rapidly" (1906a:18). By the turn of the century, Upper Lake had a population of 250 and consisted of twenty-seven houses built of wood in the style of the white settlers, a large wooden dance house, and several barns. Culin found "no trace of Indian costumes" there: "Men, women and children dress like whites, unless it may be they show a preference for brighter colors, reds and blues" (1906a:32), and he noted that "most of the people, in fact, nearly all I met spoke excellent English" (1906a:10).

The Upper Lake Pomo had a mixed economy; they raised some food of their own and also harvested commercial crops, as a group, for wages. As late as 1906, they continued as much traditional hunting, fishing, and gathering as they could, and Culin noted that "acorns [were] still considerably used as food" (1906a:68). Culin often found the Indians at their fishing camps or in the bean fields. Every spring for two or three months, the Indians camped near the lake to catch and dry fish for the following year (1906a:37). During the summer they picked string beans for a local cannery at the rate of a dollar and half per day (1906a:39). Remarking the sewing machines and coffee mills at the bean camp, Culin observed that "the tule mats and the wicker carrying baskets and plates were about the only aboriginal things" they had with them (1906a:31).

Culin's principal tutor in Californian, especially Pomoan, ethnology was John Hudson (Fig. 49). After coming to Ukiah from Tennessee in 1889, Dr. Hudson had married the painter Grace Carpenter the following year. During the nineties he spent more and more time with collecting and ethnological research. The summer of 1899 was the turning point in his life, when he sold his basket collection to the U.S. National Museum and met

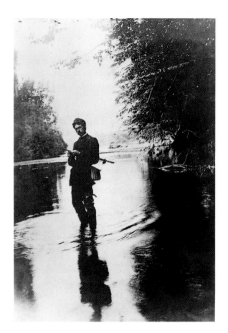

Fig. 49. Dr. John W. Hudson fishing in Navarro River. Photograph from 1906 expedition report.

George Dorsey, curator at the Field Museum. With his appointment as assistant ethnologist at the Chicago museum in 1901, Hudson gave up medicine. By the time his contract ended in 1905, he had collected about 3,500 objects from 20 Californian groups.[24]

Stewart Culin was probably introduced to Hudson by his friend Dorsey, when their paths crossed in Chicago in early 1902. Impressed with Mrs. Hudson's artistic skills, Culin arranged for her to draw Field Museum specimens for his book on Indian games.[25] As soon as he arrived in the Pomo area in 1906, Culin went directly to see Hudson. The pair reviewed the locations of Pomoan villages, and Hudson offered Culin "much information as to what they promised" (1906a:7). It was from Hudson that Culin learned the existence of objects. A reading of the doctor's Upper Lake notes at the end of his 1906 trip alerted Culin to his failure to get a set of doctoring sticks (1906a:88).

Though John Hudson was an indispensable source of guidance and ethnological data for Culin, he supplied relatively few specimens to The Brooklyn Museum; most of Brooklyn's Pomo collection was obtained by Culin directly from the Indians. Generally, the forty or so items that Hudson secured were special, rare, or unusual: a tule canoe, several invitation sticks (Nos. 183–84), a Big-Head headdress (No. 223), an acorn granary (Fig. 50), and a stone anchor (No. 186). Although Culin usually did the buying, Hudson often accompanied him on his visits to Pomo communities, especially to Yokaya and other rancherias near Ukiah. Hudson also served as a collecting subcontractor, ordering things to be made for Culin and arranging for their collection and shipment after the curator had returned to Brooklyn.

Of all the objects that Hudson acquired for Culin, certainly the most spectacular and most troublesome was the large acorn granary, about six feet tall and seven feet in diameter. During the summer of 1908 Hudson had Old Joe Beatty of Yokaya construct an openwork storage basket and its platform, and by early December it was set up in his backyard.[26] As Hudson reported, "The exhibit in my yard has attracted so much attention that I had thought of either charging admittance or locking up the gates— However I listen to all aboriginal criticism and have profited greatly."[27] Unfortunately, its size and fragility proved a problem for shipping by the railroad, and in March Hudson was still having difficulty arranging for its departure: "Now my dear Culin, if this elephant cant travel what shall I do with him? Am more than willing to return him to my back yard, awaiting your disposal indefinitely. And as it is well-behaved and dont eat, age and weathering will add a museum beauty not easily acquired otherwise."[28] With the basket finally sent off in mid-April, Hudson commented: "As I think it over this specimen will prove worthy of all the trouble and expense to any museum, therefore we can exchange congratulations on its acquisition—tis unique and from the attention it has aroused among our Indians, price, destination, purpose, you would feel proud of it."[29] Evidently Culin agreed, for he installed the granary as the focal point of his original California Hall (see Fig. 16).[30]

Culin encouraged Hudson to publish his extensive notes, suggesting in 1911 a volume of illustrated vocabularies on the model of the Navajo ethnologic dictionary (see p. 53). Culin hoped to "profit from this material in writing the labels for the collections in our California hall, and proposed to have [Hudson's] illustrations drawn in part at least from our collections," but Hudson never completed the work (1911a:69). The two corresponded in 1913 and 1914 about the purchase of Nomlaki costumes and a basket collection, and with a gap during the war years, their relationship continued until Culin's death.[31]

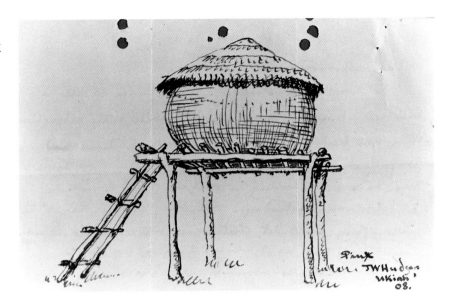

Fig. 50. Pomoan acorn granary, the central feature of Culin's California Indian Hall (see Fig. 16). Pen-and-ink drawing by Dr. John W. Hudson, 1908 (from the back of a letter to Culin describing the basket's acquisition).

Another important source of artifacts and information for Culin was William Benson (ca. 1862–1937). A son of a white father and an Eastern Pomo mother, "Benson was born on the Benson ranch at Kelseyville, but had married a Yokeye woman and settled there" (1907a:114). Benson's career was notable on two counts: his service as consultant for many Pomo ethnologists and his talents as an artist. William Benson and his wife, Mary Knight Benson, a well-known basket weaver, had a special relationship with Grace Nicholson, for whom they made baskets and other crafts in exchange for an annual stipend. Earlier, Benson had also worked with Hudson, who took the Bensons to the Saint Louis World's Fair in 1904. William Benson (Fig. 51) made many objects now in museum collections, almost all distinguished by their exquisite artistry.[32]

Although Culin tried to meet Benson in 1906, their paths did not cross until the following year. Announcing that his "chief object was to find Will Benson" (1907a:97), Culin found him at home at the Yokaya rancheria. Benson explained that he had been in Pasadena during the winter working for Grace Nicholson. As he had done with Hudson, Culin reviewed with Benson the various Indian settlements of Lake and Mendocino counties (1907a:101–2). As soon as they met, "I told him what I wanted, and wrote out a list of the objects which he promised to start making at once" (1907a:98). Culin also bought some objects that Benson had made and some that he had collected (1907a:112; 1908:13). Culin especially desired a pair of carved elk-horn daggers (see No. 189), for which he supplied the material, and a ceremonial hairpin. Of the twenty-one objects Culin collected from Benson, eight were made on commission. Culin seems to have regarded him well: "Benson proved a very agreeable fellow, and very sane and sensible" (1907a:98).

Although they had previously cooperated in acquiring objects for the Field Museum, Benson and Hudson maintained an ambivalent relationship. Frequently Hudson acted as an intermediary between Benson and Culin—acquiring, for instance, the elk-horn daggers (1908:12). Once Benson had a disagreement with Dr. Hudson over a payment, and "as a result, he was inclined to discredit Dr. Hudson's work and character" (1907a:100), even accusing Hudson of making some of the Indian things himself.[33] In his expedition reports, Culin recorded their disagreements on several ethnological issues: the use of a netted bag, the puberty basket (No. 199),

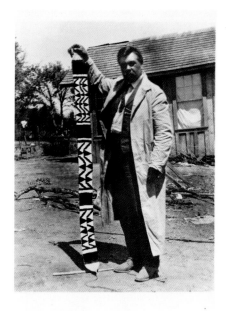

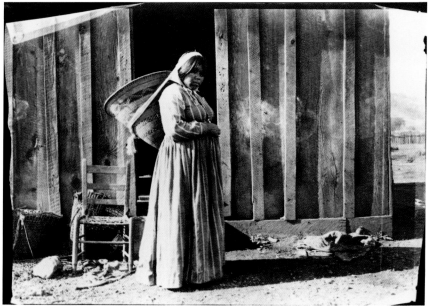

Fig. 51. William Benson holding Maidu belt. Grace Nicholson photograph from 1907 expedition report. In 1907 Culin purchased this belt in Upper Lake, and the following year he bought a similar one (No. 246) in Chico.

Fig. 52. Central Pomo woman with carrying basket, near Ukiah. Henry W. Henshaw photograph, 1892, from 1906 expedition report. This is one of thirty-three Henshaw photographs that Culin obtained on exchange from the Bureau of American Ethnology.

and the stone anchor (No. 186). Furthermore, "Some of the things Dr. Hudson told me about, Benson declared were not known to him, and never existed among the Pomo" (1907a:101)—for example, leggings of netted *masha* (Indian hemp), a ring game, and the tule sandals (see below). Although it is difficult to find the truth in these conflicts, usually Benson's opinion was corroborated by the other Pomoan people Culin consulted. Evidently, Culin sided with Benson: "Benson is vastly more intelligent and better informed than any one I have met in this region, not excepting Mr. Meredith [a local clergyman interested in Indians; see Nos. 180, 201, 202] or Dr. Hudson" (1907a:103).[34]

While Benson's artistry was widely acknowledged, some had reservations about its place in a museum of ethnology. Culin remarked on the "very beautifully decorated bow" that Benson was making for him, and his skill in flaking obsidian (1908:13, 18). On the other hand, Dr. Hudson said of a feather headdress he had commissioned Benson to make for Culin that "he was uncertain how it would come out. Benson would probably make it entirely too beautiful" (1908:15). What he meant was that it would be much finer than was usual for Pomo artifacts and thus not a fair representation of Pomo culture. The fact that Culin was so eager to work with Benson indicates his aesthetic appreciation of American Indian artifacts.

Perhaps Culin's most important Pomo consultant was Penn Graves (1862–1919), "an intelligent middle-aged man" who was the first person he met at Upper Lake (1906a:9).[35] Although Culin refers to him throughout his expedition reports as William Pengraves, his name was actually Pennsylvania Graves (or Penn Graves), as Culin later found out (1908:24). Named after his father, Elliot Graves—a white man from Illinois who married an Eastern Pomo—Graves was one of the few Indians registered to vote (1906a:36).[36] "Pengraves told me he came from Big valley," near Clear Lake (1906a:66). Altogether, Culin bought thirty-seven objects from Penn Graves and another fifteen from his wife, Susana Bucknell Graves. So heavy was his reliance on Graves, that "the other men were scolding and complaining to [Penn Graves] that he was doing all the trading with me" (1906a:40).

Penn Graves also helped Culin with ethnographic commentary, identifying some photographs of Upper Lake Indians that Culin had purchased

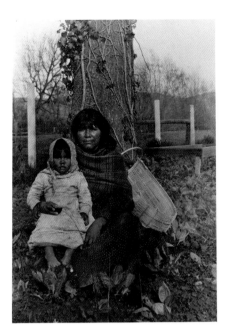

Fig. 53. *Mary Francisco and daughter, Pomoan Indians. Photograph from 1907 expedition report. Culin bought a miniature basket (No. 213) from Mary Francisco's daughter, probably the girl in this picture.*

at a drugstore (1907a:129). He also served as an interpreter, for instance, with a group of old men commenting on the tule sandals (1907a:138), and as a guide, taking Culin to the Pomo stone quarry near Upper Lake (1907a: 136–37). As late as 1913, Graves was still offering artifacts to Culin (1913:423).

Another of Culin's major sources was Goose, a fifty-year-old crippled man, recommended to Culin by Hudson. With a father from Upper Lake and a mother from Potter Valley, Goose spoke both Eastern and Northern Pomo (1906a:16, 61) and was an endless source of native terminology for Culin. Culin seems to have been rather fond of Goose, calling him "the old philosopher" (1907a:127). From him, Culin bought thirty objects, most of them commissioned and most of them quite simple. Perhaps his physical condition gave Goose the time and inclination to make objects.

Some "traditional" technology was still practiced during Culin's visits. When he first arrived in Upper Lake, he observed a scene of native industry: "Some of the men were making shell beads...and women were making baskets" (1906a:10). Changes had been made, though; they were now using metal bead chippers, and steel-tipped basket awls. Some things he was able to buy in the process of manufacture: an unfinished tray, a pestle, and a basket (1908:14–16).

Pomo mortuary practices caused special problems for a collector interested in "old things." As an old resident of Upper Lake told Culin, "when she came to this country the Indians burned their dead. They would wrap the body in a blanket and put it upon the logs, throwing their most valuable possessions upon the fire. Some of the old people were burned, she thought, down to ten years ago." Added Culin, "This accounts for the absence of old things in the Indian camps" (1906a:44).[37]

Another drain on native artifacts was the commercial and ethnological market. A woman at Hopland "explained that they had sold practically everything. Baskets were bought as soon as they made them" (1906a:22–23). The Upper Lake boy who sold Culin a rough basket flail told him that "they used to have fine ones, but had sold them all" (1906a:34). The situation was the same for pestles: "The Indians do not appear to make them any more and have sold most of their old ones. For the few that are left they ask high prices" (1906a:32). Following upon the shift to commercially available goods or the death of the last practitioners, the sale and collection of Indian possessions as curios could be the final blow to native craft traditions.

Culin's presence was a stimulus to native creativity: much of his Pomo collection did not even exist when he first visited the communities. He commissioned a wide range of objects, most of which were utilitarian, ephemeral, or no longer being made; lacked a collectors' market; and could be produced relatively easily. The only baskets he commissioned were the rough work containers made by the men, because finely twined and coiled ware would have been too time-consuming to construct and because they were readily available. Although sometimes Culin supplied raw materials, usually he did not. One exception was *masha* (*Apocynum cannabinum*). This material runs like a theme through Culin's California collection. Wherever he could, he had nonaboriginal cordage materials such as hop twine replaced with *masha*. These replacements often ended up being a collaborative project, with some Pomo reconstructing objects they had not made.

The Indians actively participated in re-creating their "traditional" material culture: "Pengraves has been trying to think of things to make for me" (1906a:82). Finding Penn Graves and others in a store upon his arrival in Upper Lake for the 1907 season, "we all of us then talked over things they could make" (1907a:126), among them a fish trap, climbing hook, sticks

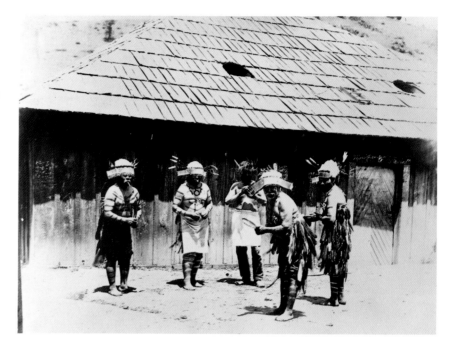

used in healing, and a ring-and-pole game. Culin's commissions were followed keenly in the local community. John Denison told him that "he had heard of the things that were being made for me and was afraid that they were not made right" (1906a:47).

Perhaps the most intriguing of Culin's commissions was the pair of tule sandals. At the end of his first trip, Dr. Hudson had reported that "the Indians formerly had tule sandals" (1906a:92), and the following year Nancy Graves of Upper Lake told Culin "that they did wear tule sandals in the old days, and promised to make me a pair" (1907a:132). When he picked up the completed pair of sandals, Culin commented, "I am not satisfied that these are aboriginal, but they are so perfectly made she must have made similar shoes before" (1907a:140).

Culin proceeded to investigate the authenticity of the sandals. When he had first asked about them at Upper Lake, the Indians "denied that they ever had any foot covering" (1906a:92). When Culin showed the completed shoes to John Denison, he said "he had never seen them, but that whoever made them had made them before, and they were not made for the first time, especially for me." The eldest man in Upper Lake agreed, saying "they were all right, and were the kind formerly worn here" (1907a:142). Culin then convened a little ethnographic seminar, but the result was again inconclusive: "I took advantage of the presence of these old men, and of Pengraves, who interpreted, to inquire about tule moccasins. Captain Jack said the Pitt River Indians had them. Fisherman Jim agreed with Pengraves, and insisted that the Upper Lake Indians never had them" (1907a:138). Benson and Goose both denied that the Pomo ever had tule sandals (1907a:101, 125). Evidently from Culin's commission, however, the sandals have made their way into the literature of Pomo material culture.[38] Culin's detailed and open-ended report on the matter allows us to draw our own conclusions.

Generally, Culin was well received among the Pomo. The Reverend H. C. Meredith told him that he was "very popular with the Indians," and Culin added, "They seem to appreciate kindly treatment, and are infinitely better mannered than the white people" (1906a:81). He thought the Upper

Fig. 55. The Foxes, *by Grace Carpenter Hudson, 1919. Painting of Culin Mitchell. Oil on canvas, 24 x 18 inches. Private Collection.*

Lake people "were remarkable for their ceremonious courtesy. They seemed amazingly honest, too, and indisposed to take advantage" (1906a:10). Several times Culin purchased objects out of charity for destitute Indians such as an old Yokaya basket (No. 208) and a string of shell beads (1907a:150). The complaints of the Indians that Culin has recorded are perhaps related to his failure to buy anything from them: "Many appear sore over my purchase of the Chico belt [bought at Upper Lake], whether because of my buying it, or through jealousy, I cannot tell" (1907a:146).

The most poignant tie between Culin and the Pomo was the child who was named after him. Culin Mitchell (1900–1981) was one of Grace Hudson's favorite subjects, appearing in about twenty of her canvases (Fig. 55). Her father, Tom Mitchell (see No. 223), was an Eastern Pomo living in Yokaya, and Mrs. Hudson painted more portraits of the family than of any other. Grace Hudson "was often consulted on the choice of the appropriate English name for a new baby," and she named "numbers of the Indian children after her eastern and San Francisco friends."[39] Although he was quite aware of the "California Culin" and included one of Grace's portraits in his expedition report, over the years Culin lost touch with his namesake. Still, for many years this woman was a living reminder of Stewart Culin's warm relations with the Pomo and of his collecting in California.

HUPA AND YUROK

157. BASKET HAT
Made by Mary; Hupa
Twined: hazel shoots, willow root, conifer root, bear grass, maidenhair-fern stems, H. 3, Diam. 7
Purchased from Mary in Hoopa Valley, California, August 23, 1905
05.588.7464

158. BASKET HAT
Yurok
Twined: conifer root and bear grass wefts, H. 3¾, Diam. 6½
Purchased from Canyon Tom near Weitchpec, California, August 26, 1905
05.588.7515

Basketry hats, treasured items of female apparel among the Hupa and Yurok, were still being made when Culin visited their communities. Noting that the Hupa "dress in white man's clothes," he observed that "about the only article of native costume surviving" was "the basket hat which the older women manufacture for their own use and for sale" (1905:66). Expert weavers sold hats to other Indians, as well as to whites.

Coming upon an old woman, Mary, as she was making basket hats, Culin bought from her several baskets and a selection of basketry materials. Appropriately, he found this finely woven, "new basket hat" (No. 157) in her new house (1905:64). He then went over with her to her old house, "the same one, I believe, in which I bought some old baskets on my last visit," and bought a mortar rim and stone pestle.

Culin purchased No. 158, which is older than No. 157, from Canyon Tom, an old Yurok man, and the uncle of Shan Paktah, Culin's guide. Though he lived at Weitchpec, Tom was then camped with his wife in a tent on the Trinity River. Culin bought a number of items from him, including the slat armor that he had made for the anthropologist Alfred Kroeber (see California essay). Culin later learned that Tom "had brought these things here by appointment with Shan to show me" (1905:68).

While the biggest difference between the two hats is probably their age, they also differ in type and quality. Simply decorated work hats were the only kind worn by men, during fishing and hunting. Women wore two kinds of hats. Their work hats were rounder, fitting the head snugly to help support burdens. Ceremonial hats, like Mary's, are flatter at the top and are also made from a wider range of mate-

rials with much more elaborate decoration; they are a weaver's finest work.[1] Because of its taller, more rounded top and cruder workmanship, this old hat appears to be a work hat. Culin gives no sign that he was aware of these distinctions, many of which are discussed by his friend Pliny Goddard in his 1903 monograph.

Instead, Culin comments on his search for old things and the current prices: "It was interesting to rummage among these accumulations of discarded things [in the old houses], which the women, after a few preliminary objurations, were willing to sell for trifling sums. Not so the new basket hats for which they asked uniform and definite prices. Only the experienced collector knows the relative value of the new and old wares" (1901a:110). IJ

1. O'Neale 1932:41–43.

159. BOILING BASKET
Hupa
Twined: willow or conifer root, bear grass, H. 5¾, Diam. 10
Purchased in Hoopa Valley, California, August 1905
05.588.7479

As they traveled down the Klamath River, Culin and his party

"stopped from time to time at rancherias along the shore, I climbing the hill with one of the men… and buying a lot of old baskets" (1905:68). This old basket was used for boiling acorn mush with hot rocks—a nearly universal native Californian mode of cooking the staple food. The domed bottom allows the rocks to be stirred more easily. Cooking baskets usually have one or two extra weft rods added as in this example; the technique, called lattice twining, strengthens the basket for heavy use. The design seen here— which the Hupa called the "frog foot" pattern[1]—is treated in inverted symmetry.

The rich patina attests to the age and use of this basket. According to Culin, the Hupa "commonly ask excessive prices for the sacred objects which they themselves value, although ordinary old baskets and household things they let go at about their current value" (1905:66). For this basket Culin paid a dollar; No. 157 went for fifty cents and No. 158, for a quarter. IJ

1. Literally, "frog his hand" (Goddard 1903:46).

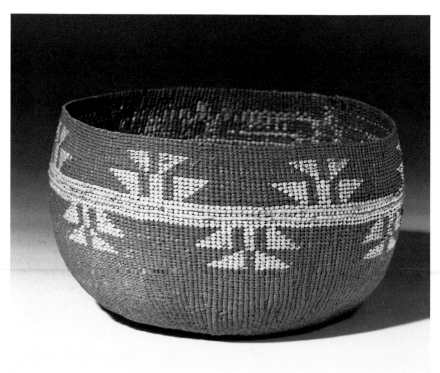

159

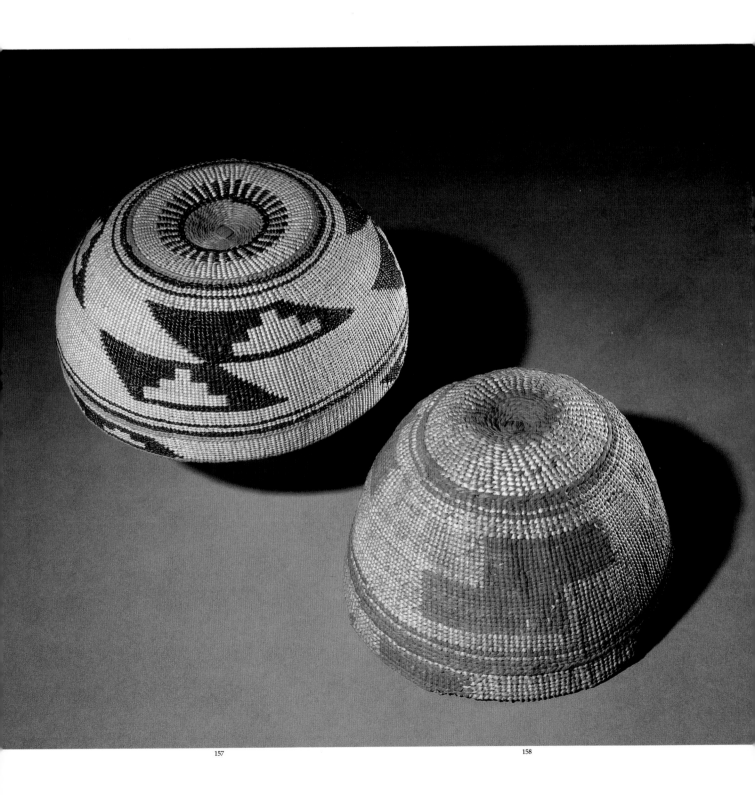

157 158

160. SALMON-BONE CATCHING GAME
Hupa
Salmon vertebrae, wood, iris fiber?, L. of pin 4
Purchased from Mary in Hoopa Valley, California, August 23, 1905
05.588.7445

In response to Culin's request for games, Mary brought out a set of mussel-shell dice and this salmon-bone pin game. "The cup and ball game is represented by four salmon bones [this example has ten] strung on a cord, and caught, when swung in the air on a pointed stick" (1901a:115). Culin collected a variant of this game among the Pomo (No. 215). In the same house he bought a stick-game set. With the purchase of a tied billet and stick for the tossing game, he was later able to announce that he had "completed the four games I know of among the Hupa" (1905:65). On his first visit in 1900 Culin had noted that the Hupa had "practically abandoned their old games, using white man's cards" (1901a:114). By his second trip, then, games may have been easier to find, because they were now "discards," or, conversely, harder, because they were no longer being made. In any event, Culin was successful in documenting for the Hupa his special field of interest. IJ

161. PIPE
Hupa
Hardwood, steatite?, L. 6, Diam. 1½
Purchased from Mary in Hoopa Valley, California, August 23, 1905
05.588.7451

This is one of seven Hupa and Yurok pipes that Culin collected on his 1905 trip. In 1900 he had found that tobacco pipes are also still made. Those in common use were tubes of wood, expanding at the mouth like a trumpet, and tipped with a ring of steatite. The ordinary ones were some five inches in length and carried in a tubular pouch, which also serves to hold tobacco. The longer ones, eight to twelve inches in length, were described as doctor's pipes or as used in the sweat-house. The steatite is brought from over the mountains some distance from the valley. The men seemed to make their own pipes, as many carried partly finished ones in their pocket (1901a:114).

Often smoked in the sweathouse, pipes were used with locally grown tobacco. They could be made of all wood or all stone, but wood stems and stone bowls were most common. Though their regular, finely polished forms suggest production on a mechanical lathe, Hupa pipes were handmade. They were usually made of madrone, manzanita, oak, or some other hardwood, which was worked with sandstone and polished with fibers of horsetail rush.[1] IJ

1. Goddard 1903:37

162. CROCHETED BAG
Hupa
Cotton, L. 8½, W. 2¾
Purchased from Sam Brown in Hoopa Valley, California, August 24, 1905
05.588.7496.1

From his interpreter, Sam Brown, Culin bought this bag, which contained an obsidian blade (now missing). Brown had found the eight-inch blade in the ground of the school garden. The Indian agent told Culin that when he came to Hoopa

160

161

162

Valley, "there was said to be but one old man who was able to chip stone" (1905:64). Though Pliny Goddard had told him in 1900 "that there were men still living who practiced the art of chipping stone" (1901a:114), by 1905 Culin observed, "It seems that the art of making these blades is lost, but they still constitute, with white deer skins, the chief treasures of the Indians of this region" (1905:66).

In contrast to the ancient art of stone chipping was the novel technique (and material) of the blade's container, although the bag's function remained aboriginal. For several decades native girls had been taught crocheting, and there was a good deal of interplay between crocheting designs and those of basket weaving.[1] This example is particularly finely woven. Culin omits any comment on the bag's technique, most likely because he did not realize its recent introduction to the Hupa. If he had been aware of the novelty of crocheting, he probably would have avoided the object. IJ

1. O'Neale 1932:82–83.

163. NECKLACE
Hupa
Seeds (juniper berries?), dentalium shells, glass beads, cotton string and cloth, L. (doubled) 31½
Purchased from Frank Kyselka in Hoopa Valley, California, August 24, 1905
05.588.7501

164. CEREMONIAL KNIFE
Hupa
Obsidian blade, wood, feathers, wool and cotton cloth, cotton string, silk, resin, L. 27, W. 3¼
Purchased from Frank Kyselka in Hoopa Valley, California, August 24, 1905
05.588.7505

Though seemingly unrelated, this woman's necklace and ceremonial knife were part of a single transaction. The local Indian agent

explained to [Culin] that he had made a private collection of Hupa objects which he had concluded to dispose of. Among other things he had an old basket for

the "basket dance" [or Jump Dance] and a necklace of black seeds strung with dentalium shells. In addition, he had four stone knives, mounted on bundles with feathers, colored braid and cotton cloth, which are used in dances. He was not anxious to sell the dance basket but offered, if I would take the knives for what he paid for them, $25, to let me have the basket for $5. I wanted the latter, and, as the knives were not dear, I took the lot at his price, and the beads for $3 (1905:65).

Actually, both objects reflect the Northwest Californian concern with wealth. Strings of dentalium shells, a kind of marine snail, were used as money and kept in horn purses, and obsidian blades were among the most treasured items displayed in the annual World Renewal Ceremonies. IJ

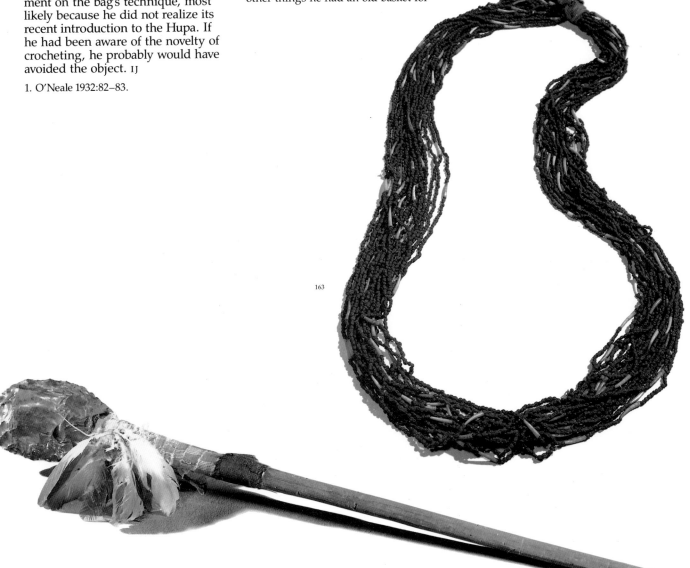

163

164

179

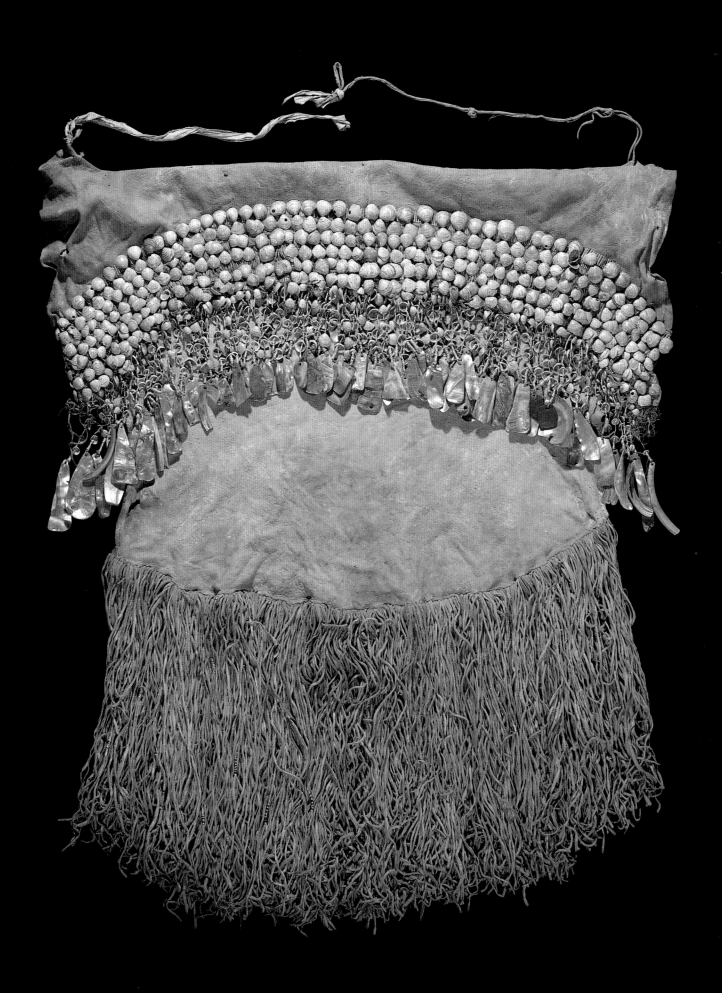

165. WOMAN'S SKIRT

Hupa?
Deer hide, abalone shells and clamshells, bear grass, maidenhair fern, iris fiber, copper, L. 36, W. 36
Purchased in Trinity-Klamath River area, California, 1905?
06.331.7923

Culin himself seems to have forgotten how he obtained this spectacular piece, which he entered in his catalogue with the note, "exact tribe and locality uncertain." As it is unlikely that he would have failed to mention such a major piece in his expedition report, we may guess that it came with one of his shipments from local merchants. Women wrapped such skirts around from the back to the sides; the open front was covered by a fringed apron. Culin reported that these highly decorated versions, which were restricted to ceremonial occasions, were still worn in 1900 (1901a:114). This one has seen a good bit of use.

The general decorative style of this skirt is common in the material culture of Northwest California. The fibers—the principal ones used in basketry—are found, for example, on the hair-braid ornaments (No. 174), which also employ the same kind of clamshells. The skirt's two copper pieces, cut in a size and shape matching the abalone pendants, are unusual. The effect of these pendants is more than visual: they make an impressive sound as the woman moves. IJ

166. HORN PURSE

Yurok
Antler, pigment, L. 4¾, Diam. 1¼
Purchased from Frank Gist in Arcata, California, August 21, 1905
05.588.7436

Culin went to see Frank Gist, a purchasing agent for the merchant Alexander Brizard, almost as soon as he arrived in Arcata. From him Culin bought

a number of small objects which he had collected for himself, but which he finally decided to sell. They comprised five finely carved horn spoons, two

stone chisel handles, a green stone knife,...a bone needle, elk horn wedge, so-called purse, and a tobacco basket....Gist had bought these at Orleans [Karok country], Morek and Weitchpec [Yurok territory], and knowing their value, I did not hesitate to secure them in advance of my prospective visit. Gist gave me much useful information about my trip down the River (1905:61).

Horn purses held the strings of dentalium-shell money. They were closed with a strip of thin antler or bone and secured by a wrapped hide thong (missing on the example shown here). This purse has the characteristic Hupa/Yurok style of geometric decoration, with a lovely patina. Culin bought two more purses from George Gumey, who "was said by Shan to be the richest man on the Klamath": "I bought two old elk-horn money purses from him, he carefully removing two strings of long decorated dentalium shells, which he said were worth $20.00" (1905:70–71). Evidently, Gumey's reputation was well earned. IJ

167–70. HORN SPOONS
Yurok (No. 167:Yurok?)
Antler
No. 167: L. 8½, W. 2¾
Purchased from Frank Gist in Arcata,
California, August 21, 1905
05.588.7429

No. 168: L. 6¾, W. 2¼
Purchased in Klamath River area,
California, August 1905
05.588.7535

No. 169: L. 6¾, W. 2¼
Purchased in Johnsons, California, August
1905
05.588.7589

No. 170: L. 7, W. 2½
Purchased from George Gumey in Pekwan,
California, August 27, 1905
05.588.7578

Elk-horn spoons were used by men for eating acorn mush; women used spoons of mussel shell and animal skull. The rich kept especially elaborate sets for entertaining guests at a feast. Elk antlers were steamed and bent into shape, much as Northwest Coast horn spoons were. Their handles were then carved into a variety of geometric shapes, in a more or less free expression of the carver's personal creativity.
Although Culin's documentation for these spoons is sparse, he would not let a lack of catalogue information hinder his acquisition of a beautiful object. IJ

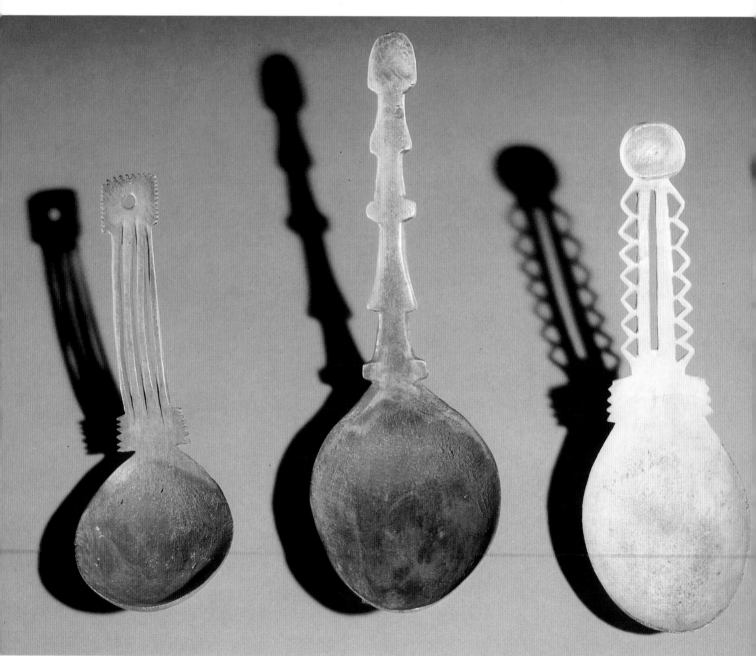

169 167 170

171. Paint Cup
Yurok
Stone, red and blue-green pigments, L. 9½,
W. 2¾
Purchased from George Gumey in Pekwan,
California, August 27, 1905
05.588.7581

At Pekwan, Culin found only the
old man George Gumey (see No.
166) and his wife at home. "His wife
spoke English, but he himself did
not appear to understand a word. I
bought a new horn spoon from him,
and he opened his tool boxes, dis-
closing stone paint and glue cups,
bone whistles, soapstone pipe ends
and a profusion of small objects"
(1905:71). Among Culin's purchases
from Gumey were this paint cup,
which was used to hold pigment for
painting ceremonial regalia, bows,
and other articles made by men. IJ

172. Knife
Made by Capelle George; Yurok
Stone, iris-fiber twine?, hide, pigment,
L. 11, W. 3
Purchased from Capelle George in Capelle
Bar, California, August 27, 1905
05.588.7561

On the trip down the Klamath
River, Culin stayed overnight at the
house of Capelle George, who
"spoke English well and appeared to
be a particularly shrewd man"
(1905:58). As an example of this trait,
Culin noted that he seemed to be
using the frame house he was rent-
ing for gambling. Culin bought a
number of things that George had
made, among them a wooden
sword, this "double pointed stone
dagger, the middle wrapped with
cord, [and] a deer skin quiver to
contain this object" (1905:69). The
wrapping and the quiver suggest
that this may be some version of a
ceremonial knife.[1] IJ

1. Noted by Lee Davis, Lowie Museum,
University of California at Berkeley.

168

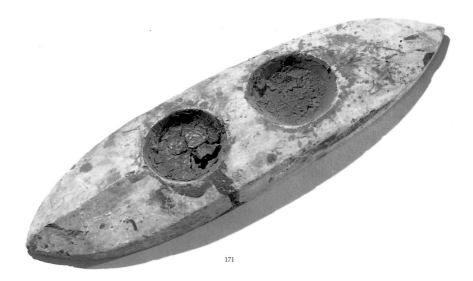

171

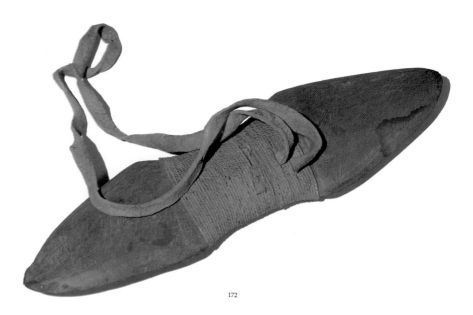

172

173. HAIR COMB

Yurok
Horn or antler, snail shells, cotton string,
L. 5¼, W. 1¾ (comb only)
Purchased in Johnsons, California, August
27, 1905
05.588.7601

Of this beautiful but enigmatic object Culin wrote: "At Johnson's I went the round of the houses....At another house I bought three objects described as Indian combs. These are long oval placques, one of horn and the others of wood, worked thin, and polished by use, and attached to necklaces of shell beads" (1905:72–73). Although it is difficult to see how this object might be used as a comb, it could be the implement for a Hupa girl's puberty ceremony described by Pliny Goddard. During her ritual seclusion, she must follow many proscriptions, including the injunction not to touch her face or hair with her hands. Consequently, "a piece of bone or horn is worn suspended from her neck that it may be at hand for dressing her hair."[1] Such a ritual use is suggested by the fine,

polished form of the horn and the decorative necklace. Another possibility is that this is a "louse crusher." Otis T. Mason described a similar form that was used to crush hair lice against a paddle-like scraper.[2] Similar bone spatulas in museum collections are also listed as sweat scrapers for the sweat lodges, suggesting that the same artifact type may have been used for several functions. IJ

1. Goddard 1903:53.

2. Mason 1889:214. This same specimen, in the National Museum of Natural History, Smithsonian Institution, is called a louse crusher but is described as a tool that the girl used to avoid scratching herself (Heizer 1978:173).

174. HAIR-BRAID ORNAMENTS?

Yurok
Hide, abalone shells and clamshells, bear grass, iris fiber?, L. 27, W. 3
Purchased from Brizard's store in Arcata, California, August 30–September 2, 1905
05.588.7635

At the end of his Klamath River trip, Culin bought this object, along with a similar one, from the Brizard store. Though he recorded them as necklaces, they were probably hair ornaments. As Culin noted, the women at Hupa "wear their hair in two rolls, formerly wrapped with colored braid, hanging down the sides of the face or the ears" (1905:66). Normally this hair tie was a long strip of buckskin terminating at both ends with shell pendants.[1] Apparently, this braid was cut into two separate pieces and tied together. Discrepancies like this one and that concerning the hair comb or louse crusher could be expected when Culin purchased from dealers and/or did not have a chance to question the Indians. IJ

1. Goddard 1903:20.

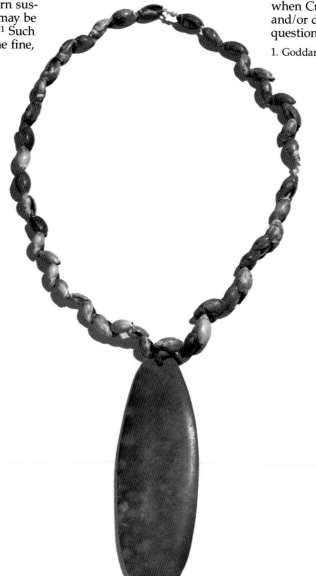

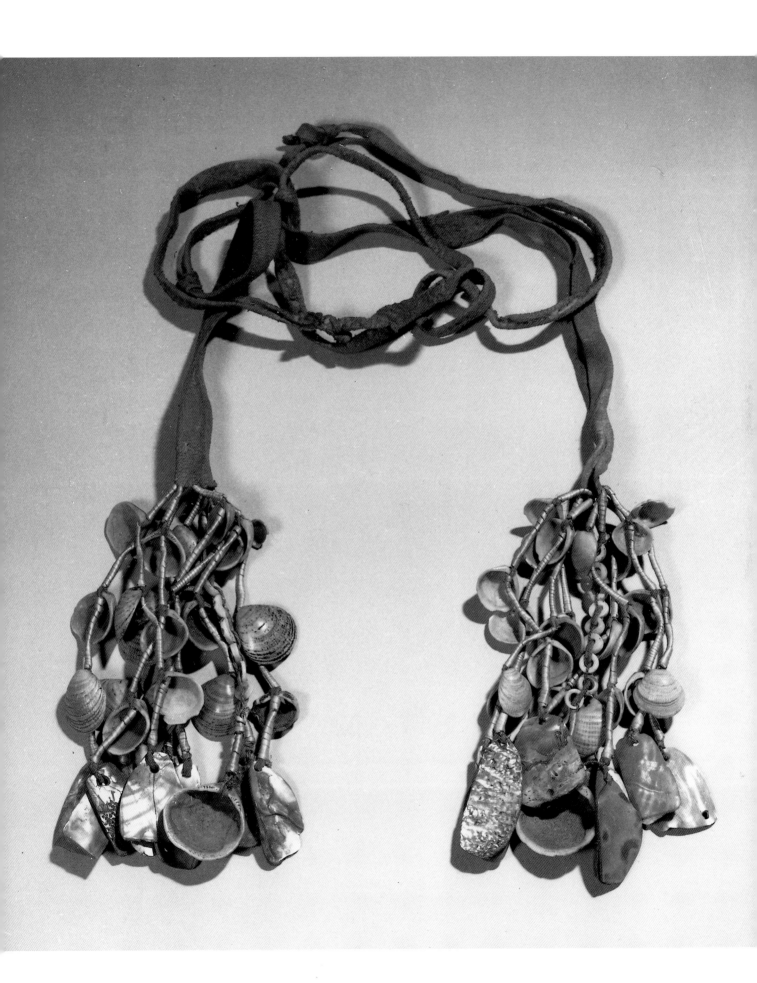

POMO

175. UNFINISHED MAT
Made by Mrs. Broom John; Pomo
Twined: tule, L. 27, W. 26, Diam. of roll 6½
Purchased from Mrs. Broom John in Upper
Lake, California, August 5, 1907
07.467.8353

The village at Upper Lake was by far Culin's primary Pomo collecting site. An independent, communally owned rancheria since 1878, it was inhabited by predominantly Eastern Pomo speakers and was located a few miles from Clear Lake. In contrast to other Pomoan groups, their material culture was marked by an extensive use of the reed called tule, which grew in abundance on the margins of the lake.[1] Tule was used for food, hunting and fishing implements, canoes, house coverings and furniture, baskets, mats, clothing, cradles, and toys.

Mats, which were made without any implements, came in several varieties, both coarse and fine: small rectangular plates for fish; coverings for floors, walls, and doors; and sleeping mats (1906a:67). Trying to obtain one of the "fine mats," Culin heard that the wife of Broom John had some of the necessary material (the outer skin of the young tule) and could make one. However, "she was not very willing to make a mat,

saying she had not enough. I explained that an unfinished fragment would do" (1907a:131). Several days later Culin found that Mrs. Broom John "had not finished it, as she could make $1.50 per day in the bean field, and was not sure I would be willing to pay for her work at this rate. I told them to tell her to leave it unfinished, and that I would take it as it is" (1907a:138).

Culin related the final negotiation: Broom John hunted me up and asked me to go with him to his camp to get the mat his wife had ready for me. He is a shrewd trader, and, unlike most of the others here now, usually asks more than he expects to receive. He asked eight dollars for the unfinished mat, ga-thlow, and a bundle of the material, ti-bai-pa-tsi. I compromised by paying five dollars. He said his wife worked four days on the fragment. The Indian women who saw it inspected the ga-thlow and admired it (1907a:143). IJ

1. Barrett 1952:156–59. As Barrett explains, the Pomo from the Clear Lake area exploit three species of tule. *Scirpus lacustris* (the bulrush), with a round stem, is used for weaving mats and baskets early in the season when the stems are pliable. When they become more rigid, the material is used for balsa building. *Scirpus robustus*, with a triangular stem, is relatively soft, and is thus used for padding and shredding. The third

species is cattail rush, *Typha latifolia*. Both the triangular and circular tule are used for mats. Culin's consultants gave him similar information (1906a:67). The current name for the genus *Scirpus* is *Schoenoplectus*, but the former name is more common in the literature on California Indian material culture.

176. PAIR OF TULE LEGGINGS
Made by Nancy Graves; Pomo
Tule (probably cattail), Indian hemp?,
L. 13½, W. 10½
Purchased from Nancy Graves in Upper
Lake, California, August 7, 1907
07.467.8369a–b

Culin's interest in "old things" frequently led him to commission objects that no longer existed. While most artists he employed probably were fashioning artifacts they had once made, others may have created objects they had only seen or heard about. Culin's expedition reports are sufficiently detailed that we can often follow the sources of the artists' knowledge and the differences in native opinion.

At the end of Culin's first trip, Dr. Hudson told him that "the Indians formerly had tule sandals." However, "at the Lake those I asked denied that they ever had any foot covering" (1906a:92). The following year Nancy Graves said "that they did wear tule sandals in the old days, and promised to make me a pair. She also said

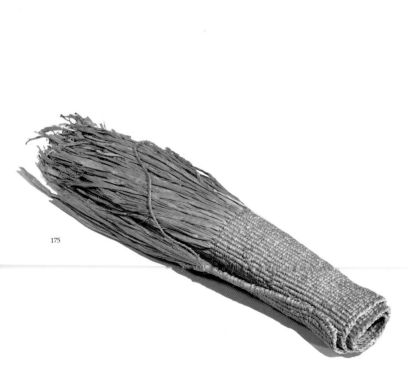

175

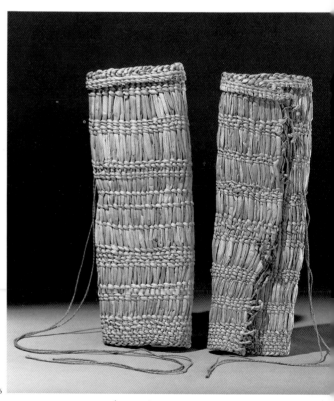

176

186

they wore tule leggings" (1907a:132). Culin commissioned her to make a pair of each.[1] In handing over the leggings, Nancy told him that "they were the old style used here and not the Pitt River kind. There they used skins" (1907a:147). Essentially flat mats that are tied at the ends, these leggings have been folded in fourths.

Culin himself was not satisfied that the sandals were aboriginal but concluded that "they are so perfectly made she must have made similar shoes before" (1907a:140). Taking them over to the camp, Culin sampled opinions. While some corroborated Nancy Graves, other denied that the Pomo ever had footwear of tule. Although there is little direct commentary on the leggings, we can assume that their status paralleled that of the sandals (see California essay). IJ

1. Nancy Graves was the first wife of Penn Graves.

177. SLING FOR KILLING MARSH HENS
Made by Penn Graves; Pomo
Tule, Indian hemp, L. 3¾, W. 1¼, D. 1¼
Purchased from Penn Graves in Upper Lake, California, October 4, 1906
06.331.8213

178. BASKET FOR CLAY BALLS
Made by Susana Graves; Pomo
Twined: tule (bulrush), H. 5, Diam. 8½
Purchased from Susana Graves in Upper Lake, California, May 26, 1908
08.491.8612

179. CLAY BALLS (10) FOR KILLING MARSH HENS
Made by Penn Graves; Pomo
Baked clay, plant fiber, Diam. 1½
Purchased from Penn Graves in Upper Lake, California, May 26, 1908
08.491.8581.1–.10

This set of objects, made of materials growing around Clear Lake, was used by hunters in balsa boats to kill waterfowl. The set was built up over several years, with one object leading to the next. In late August 1906, Culin was talking to Penn Graves about slings.[1] Graves, Culin's principal Pomo consultant, made many artifacts for The Brooklyn Museum. He explained that birds "were secured by throwing stones with a sling or snared" (1906a:28) and agreed to make a tule sling used for killing mud or marsh hens (a kind of duck). In October he sent the completed sling to Culin in Ukiah, after he had left Upper Lake (1906a:95). The following year Culin tried to get the clay balls for the sling, but Penn Graves did not have them ready (1907a:145).

Finally, in 1908 Culin obtained the balls and the basket that contained them. About a week after they were ordered, Penn Graves delivered them to Culin's hotel room (1908:11, 18). Graves and his wife cooperated on the commission; he made the balls and his wife, the basket. Susana Graves, who was "an expert basket maker," according to Culin (1906a:28), is especially well represented in the collection by her many tule items—clothing, mats, baskets, and toys. The basket shown here was one of the few that Culin commissioned. Almost all are, like this one, fairly coarse, as they could be woven in a relatively short time, though—again like this one—they are often nicely made. The basket is filled with shredded tule; Graves explained that "the clay balls are laid out on this when the balls are put in the canoe." While the balls were not fired in a kiln, the clay was mixed with some plant fiber and hardened by exposure to a fire. This set of balls originally numbered eleven. IJ

1. Because he misheard his name, Culin consistently miswrote his names as "Pengraves," a spelling that has been preserved in direct quotations.

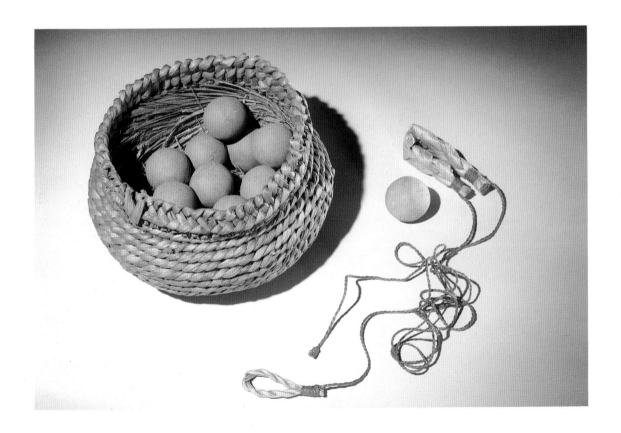

180. Burden-Basket Headband

Made by Jim Burris or Jim Bucknell; Pomo
Indian hemp, clamshell beads, L. 38, W. 1¾
Purchased from the Reverend H. C.
Meredith in Lakeport, California, August
22, 1906
06.331.8018

One of the other major plant
materials exploited by the Pomo was
masha, made from the inner bark of
the dogbane, commonly called
Indian hemp (*Apocynum can-
nabinum*). *Masha* was the dominant
Pomo cordage material, and Culin
often had nonaboriginal materials
such as jute or hop twine replaced
with it.

This "new burden net for the coni-
cal storage basket" was made of
masha (1906a:21). A kind of tumpline,
the band wrapped around a
woman's forehead to help support
the large seed-gathering basket (see
Fig. 52 and the toy version, No. 214).
While most burden nets are plain,
some, such as this one, are deco-
rated with clamshell beads. Carl
Purdy, a collector and authority on
Pomo baskets, noted that by the turn
of the century hop twine was
"almost universally" substituted for
the *masha* in these headbands.[1] The
fact that this one was new and made
of *masha* suggests that it may have
been made for sale.

The seller, the Reverend H. C.
Meredith (1861–1908), was a local
clergyman who also dealt in native
crafts (see Nos. 201, 202). Most of
Culin's purchases from Meredith,
including this one, come from Upper
Lake. There is some confusion over
the maker. While Culin's catalogue
card lists Old Jim Burris, his expedi-
tion report names Jim Bucknell
(1906a:21–22). IJ

1. Purdy 1902:42, 44.

181, 182. Mush Paddles

Pomo
No. 181: Hardwood, plant-fiber string, L.
23½, W. 3½
Collected by John Hudson in Potter Valley,
California; obtained by exchange from the
Field Museum of Natural History, 1905
The Brooklyn Museum, By Exchange
05.589.7736

No. 182: Oak, abalone shell, resin, L. 17½,
W. 2¾
Purchased from John Hudson in Ukiah,
California, 1907
07.467.8568

Dr. John W. N. Hudson (1857–
1936), a retired physician living in
Ukiah, dedicated most of his life to
collecting and studying the culture
of the local Pomo and other Califor-
nia Indians. Although most of the

forty or so objects that he sold or
gave to Culin were special or
unusual in some way, these mush
paddles, two of the ten that Culin
acquired, are among the more ordi-
nary specimens he collected. Mush
paddles were used for stirring acorn
mush while it cooked in baskets into

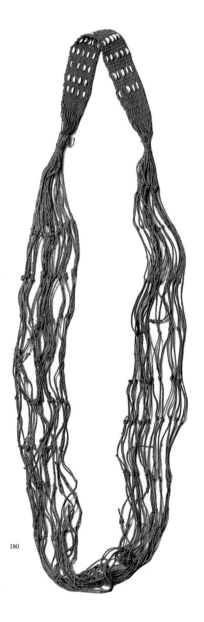

180

which heated rocks were placed.
Usually of hardwood, they were
most often plain and undecorated,
elegant in their simplicity. Culin
obtained No. 181 as part of two
exchanges with the Field Museum in
1905 and 1907. These included a
good bit of California material,
almost all of which was collected by
Hudson. Thus, even though Culin
was a good friend of Dr. Hudson, he
obtained objects from him by sec-
ondary means—a fairly common
form of museum acquisition at the
time. The other paddle is unusual
for both the openwork carving and
the abalone-shell inlays (on front
and back). IJ

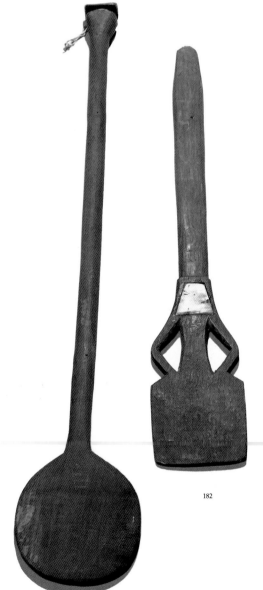

181

182

183, 184. INVITATION STICKS

Pomo
No. 183: Wood, cotton, pigments, L. 25½
(long stick); L. 5, W. 2 (large stick bundle)
Purchased from John Hudson in Ukiah,
California, 1907
07.467.8571

No. 184: Made by Ed de Shields
Wood, bird quills, Indian hemp, L. 13¼
(long stick); L. 2¼, W. 1 (quill bundle)
Given by John Hudson in Ukiah,
California, July 19–20, 1908
08.491.8910
Gift of Dr. John W. Hudson

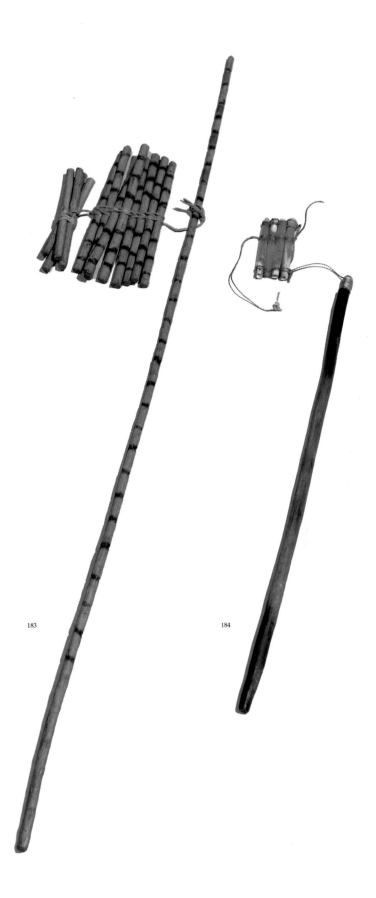

183 184

Evidently it was Dr. Hudson who first told Culin about Pomo invitation sticks in 1906: "In reference to counting, a tribal chief will knot sticks to cords and send them out as invitations to a dance, or feast. The head of a family send [*sic*] out similar cords for funerals. They are called hai di-ka-mu, 'invitation sticks'" (1906a:92).[1] Culin made several unsuccessful attempts the next year to acquire an invitation stick. In early 1908, however, Dr. Hudson sent him three that he had commissioned.[2]

On his catalogue cards Culin noted that these sticks were generally carried in the hand until the bearer was within reach of the destination, when they were stuck upright into the hair so that all would see it (cf. 1908:98). Culin gave the significance of No. 183 as follows: "Come! on the fifth day we celebrate [a ceremony], lasting the customary four days." The other two specified that the guests were to come in three or seven days, either to a feast or to discuss affairs of "state, finance, treaty, punishment, war, etc."

During Culin's next Pomo expedition later that summer, Dr. Hudson presented him with another kind of invitation stick as a gift. This one had quill instead of wood; Hudson explained that quill was "symbolic of ceremony or gaiety." It had been made in Yokaya, and Hudson "observed that each of the tribes probably has a different kind of stick" (1908:99). Culin left the stick with a Pomo in order to replace the hop twine with which it was wrapped with *masha*. IJ

1. Barrett 1917a:402.
2. J. W. Hudson to S. Culin, "07 ult." and January 18, 1908, Object Files: Hudson Collection.

185. Doctor's Box

Pomo
Elk antler, L: 7, W. 4¾
Purchased from John Hudson in Ukiah, California, 1907
07.467.8576.1

As a physician himself, John Hudson was particularly interested in Pomo medicine. He sold Culin this hollowed bone container with a doctor's mantle made of hide. As he explained in a letter,

The box was a genuine surprise to me. A young Indian seeing your antler [some elk antler Culin had sent Hudson for making artifacts] asked if I had a "doctor's box." He had me send him a section of antler and disappeared. About a month later he brought the box saying his uncle (on the coast) had made it. Later he brought me the knife and several roots etc. that were as new and delightful as the box, explaining he had [gotten] them out of his uncle's stores.

The box was originally wrapped with a mink skin and contained a medicinal root and an obsidian knife. Hudson added that it was kept with other paraphernalia in a boat-shaped basket.[1] IJ

1. J. W. Hudson to S. Culin, January 18, 1908, Object Files: Hudson Collection.

186. Carved Stone Ball

Pomo
Stone, H. 6, W. 5½, D. 4¾
Given by John Hudson in Ukiah, California, February 1, 1913
13.1081
Gift of Dr. John W. Hudson

This striking object proved to be an elusive puzzle for Culin's Pomo collection. He initially saw it at the end of his first trip, when Hudson borrowed it to show him. "Dr. Hudson pronounced it to be an anchor for the tule boat, the Indians at Upper Lake having a tradition that they formerly used anchor stones carved with a human face" (1906a:89). Culin saw it in Ukiah the following year in the Palace saloon, whose barkeeper reported that "the Indians appeared afraid of it and those who had seen it kept away from the place" (1907a:106). Hudson tried to purchase it from the owner, the proprietor of the tavern, but he failed (1907a:150). Meanwhile Culin was asking the Pomo about the object. William Benson, Goose, and Jim Bucknell all denied that the Pomo ever had anchors (1907a:101, 125, 132), stating that the tule boats on Clear Lake were hauled up on shore or tied up to a long pole stuck in the mud.

Finally, when Culin was visiting Hudson in 1913, the doctor presented him with the stone (1913:423–25), which he had been able to buy when its owner was run out of town and his effects auctioned. The stone had resided for several years in the Ukiah saloon, having been ploughed up in a field. "Dr. Hudson believed that it came from Clear Lake in Lake County, and that it was the only known specimen of this kind of carving from this section of Califor-

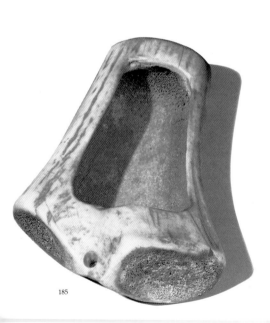

185

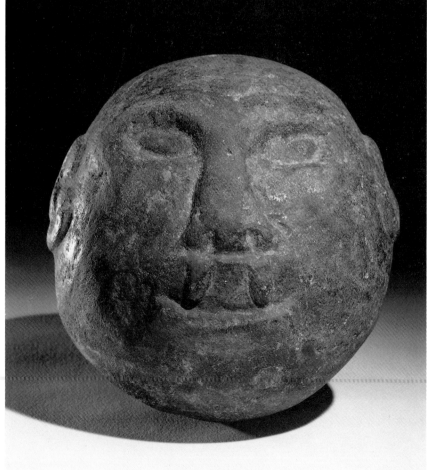

186

nia" (1913:424). He reported that the Indians regarded it with the same interest and fear they held for other odd stones turned up in fields (see No. 220).

Hudson supplied Culin with extensive data on this piece. According to him, it represented the head of a large lake-dwelling monster. When used as an anchor, it was wrapped in a basketry netting, with the face exposed. "It was believed to have power to scare away all the spirits of the lake that might frighten the fish....Dr. Hudson said he thought such a stone as the one he gave me belonged to a clan" (1913:425).

The stone ball seems unique among Pomo artifacts in museum collections. Thus, it could be a fake, produced by a white man or an Indian, or, conversely, just a very rare example of a little-known native tradition. It is quite conceivable that it was an archaeological survival from a much earlier period. The detail of Culin's documentation allows us to consider alternative possibilities. IJ

187. UNFINISHED MAT
Made by William Benson; Pomo
Twined: tule, L. 29¾, W. 11½, Diam. 5
Purchased from William Benson in Yokaya, California, May 20, 1908
08.491.8585

In addition to his frequent service as an anthropological consultant, William Benson (ca. 1862–1937) was a skilled artist. A technical virtuoso, Benson worked in a wide range of media, including basketry, an art form usually practiced by women. Though Culin bought relatively few objects from him, their fine quality reveals the range of craftsmanship possible in Pomo traditions.

On his last Pomo trip, Culin drove to the Yokaya rancheria to see Benson, who sold him this "strip of fine, unfinished mat" (1908:13). When Culin had visited him the previous year, Benson had on hand "a very fine mat, only partly finished, and ornamented with duck and woodpecker feathers and given to girls to sit on by their mother or sister at the period of puberty" (1907a:99). Ben-

son's superb artistry is apparent when his unfinished mat is compared with the one made by Mrs. Broom John. Both are of the same type and material. The technique of both is close, simple twining (Benson's also has occasional rows of diagonal twining). Although Mrs. Broom John's mat was regarded as a very finely made example, Benson's is even finer.[1] IJ

1. Although both mats seem to be made of the same tule shoots, their appearances differ. The materials may be from different species, from different life stages of the same plant, or from different parts of the same plant.

188. PLECTRUM FOR MUSICAL BOW
Made by William Benson; Pomo
Bone, pigment, L. 6¼, Diam. ¼
Purchased from William Benson in Yokaya, California, July 13, 1907
07.467.8309

After meeting Benson in 1907, Culin left with him a long list of objects that the artist "promised to start making at once," one of which was a musical bow (1907a:98). Benson said musical bows were made by boys out of a stalk of tule and, of course, were not preserved (1907a:102). About a week later Benson brought a much more elaborate version of the bow that he had been working on. This is the bone plectrum that was used to pluck the bow. According to Benson, the principal design on the plectrum is "waves." At the end is the "arrow head half," and below this is the checkered diamond pattern (1907a:112).[1] IJ

1. For a picture of the musical bow, see Barrett 1952:477.

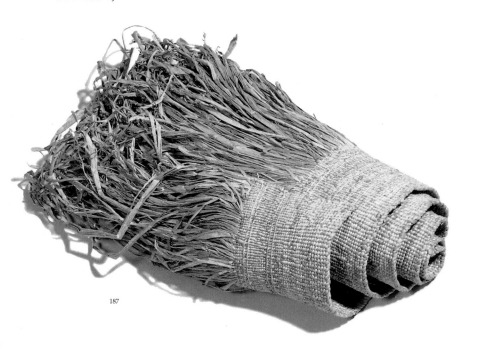

187

188

191

189. BEAR-DOCTOR'S DAGGER

Made by William Benson; Pomo
Elk antler, otter skin, milkweed-fiber twine,
pigment, L. 13½, W. 2
Purchased from William Benson in Yokaya,
California, 1908
08.491.8668

The Pomo bear doctor and the elk-horn dagger he carried have left a trail of confusion and mystery in the scholarly literature, perhaps echoing his reported role in Pomo society. Dr. Hudson's summary is typical: "The bear men belonged to a secret organization with a representative in each tribe. He preyed on the community, and if he was killed by an outsider, another was elected to take his place, and the man who killed him was secretly destroyed. The object of the society was to kill objectionable persons in the tribe" (1908:99).[1]

At the end of his last Pomo collecting trip, Culin was told of a cave near Ukiah where a bear doctor made his headquarters, supposedly containing at least two entire bear doctors' outfits. "Dr. Hudson told me that these consisted of the bear skin, of a basket, a dagger made of antler,...a short skirt of willow bark, a mask of oak rods, and a cuirass, also of oak" (1908:98–99). A search of the cave turned up nothing.

Bear doctors were said to have carried one or sometimes two elk-horn daggers, six to ten inches long, suspended around the neck or hung from a belt. The elk-horn tips were sharpened, rubbed on grinding stones, and smoothed.[2] Dr. Hudson was Culin's liaison in the commissioning of a pair of daggers. Culin had obtained the elk horn from Otis T. Mason of the U.S. National Museum, who in turn acquired it from the National Zoo.[3] Hudson then turned it over to Benson.[4] When Culin arrived in Ukiah in May of 1908, he picked up the two engraved elk-horn daggers from Hudson (1908:12).

William Benson appears to be the creator of all six Pomo bear doctor's daggers in museum collections.[5] Culin collected at least two, giving one to the U.S. National Museum, probably in exchange for sending the elk horn, but he is also listed as the 1910 donor of the dagger in the British Museum. The realistic style of incising, impeccably rendered, is very characteristic of Benson's work. It is found on his bone ear sticks in Ukiah and Denver and on the Brooklyn bone plectrum (No. 188).[6] Several of Benson's daggers have the same or a similar design: a very realistic arrow on one side and two rows of triple diamonds on the other.[7]

Benson's daggers are clearly museum "models," not objects made for native use. Because native testimony concerning the institution of the bear doctor is so spotty and contradictory and because Benson, the sole creator of surviving bear doctors' daggers, is well known for his atypical craftsmanship, we may never be able to evaluate this object properly. IJ

1. See Barrett 1917b; Loeb 1926:335–38; Cody 1940; McLendon and Lowy 1978:318.

2. Barrett 1917b:457. Several of Benson's daggers have dark fur on the handle (see the Smithsonian's in Bean and Vane, in Heizer 1978:667). The Brooklyn dagger once had fur, as well, as indicated by small bits hidden under the twine wrapping and by photographs of it in Culin's original California Indian exhibit.

3. O. T. Mason to S. Culin, April 24, 1907, Departmental Records.

4. J. W. Hudson to S. Culin, "07 ult." and Feb. 1908, Object Files: Hudson Collection.

5. In addition to the dagger at Brooklyn, there is one at the Smithsonian, one at the Peabody Museum at Harvard, one at the British Museum, and two at the Museum of the American Indian. The Peabody also has a related Benson dagger in deerhorn and obsidian. There may be others.

6. Bates notes that bone incising died out about 1900.

7. Though slightly different, the one in the Smithsonian was clearly made at the same time as Brooklyn's. The British Museum dagger is also very similar, with a realistic arrow.

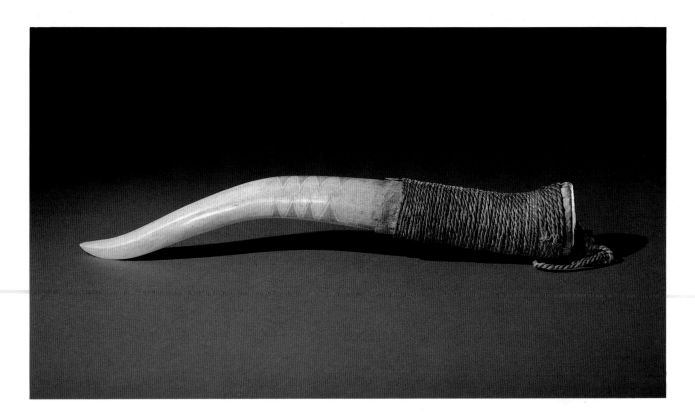

190. CLAMSHELL
Pomo
Clamshell, L. 5½, W. 3¾
Purchased from Joe Augustine in Lakeport,
California, August 22, 1906
06.331.8011.1

191. CLAMSHELL BLANKS FOR BEADS
Pomo
Clamshell, Diam. ¾, D. ¼
Purchased from Goose in Upper Lake,
California, 1906
06.331.8160.1–.81

192. CLAMSHELL BEADS
Pomo
Clamshell, cotton string, L. 132, Diam. ¾
Purchased in Upper Lake, California,
August 16, 1906
06.331.7958

Culin documented the entire process of bead making, from raw material to finished objects. Pomo told him that clamshell beads came in three sizes, which were graduated in thickness. Only the thinnest was used as money, in trading or gambling, or for decoration, as in bracelets and on dance regalia. The other kinds were buried with the dead.[1]

Bead making was one of the few native crafts that was still actively practiced during Culin's visit. Joe Augustine, the man who sold him the clamshell (No. 190) (probably *Saxidomus nuttallii*), "made shell beads from large shells which he bought from a man who got them at the Coast, and paid him a dollar a dozen for them." Culin also "bought some blanks, both unperforated and perforated, from him" (1906a:21). The group of clamshell blanks (No. 191) includes just a few of the seventy or so in the set. They represent the first stage, after the shell has been chipped, but before the holes have been drilled and they have been polished. The string of thick beads (No. 192) is not a necklace, but a string of money.

One morning during his first trip, Culin watched a man—Vicente—making shell beads at Upper Lake:

The old blind man was seated on the ground in front of an iron bar with a square head which was driven in the ground so as to project some 18 inches. This was the anvil. Beside him was a flat slab of white sandstone. He had three pieces of iron, heavy fragments of knife blades with dull edges. With one of these, using the dull edge, he would break off a fragment of the clamshell. Then, holding the little piece against the square head of the anvil, he would chip it round and round with the same implement until it was nearly circular. The final operation of shaping the disk was performed by rubbing its edge repeatedly on the sandstone slab. The process of shaping the disk for drilling must have taken some ten minutes (1906a:62–63).

Next came the drilling of the central holes, and the smoothing of the beads.[2] IJ

1. Pomo also had another kind of bead: thick stone cylinders made out of the mineral magnesite. Its processing was also represented in Culin's collection.
2. See Hudson 1897. As Sally McLendon points out, Culin seems to have garbled his account, as the smoothing on the sandstone slab takes place *after* the holes are drilled and the rough beads strung on grass or wire.

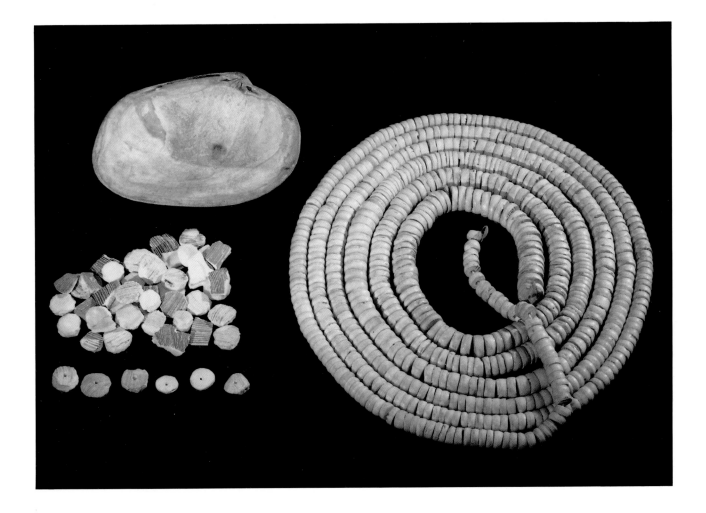

193–96. BASKETRY MATERIALS

Pomo

No. 193: Willow root (natural and processed), tied with cattail?, W. 1½, Diam. 5¼ (natural); W. 1, Diam. 3½ (processed)
Purchased from Nancy Graves in Upper Lake, California, August 5, 1907
07.467.8341.1–.2

No. 194: Sedge root, L. 14½, W. 4, D. 1¾
Purchased in Upper Lake, California, September 14, 1906
06.331.8131

No. 195: Bulrush root, tied with Indian hemp, L. 14¾, Diam. 2½
Purchased from Susana Graves in Upper Lake, California, August 31, 1906
06.331.8063

No. 196: Redbud stems, tied with Indian hemp?, W. 1½, Diam. 7
Purchased in Upper Lake, California, September 23, 1906
06.331.8146

Whenever Culin collected Californian basketry, he also acquired the raw materials. The four examples illustrated are the most common materials used in Pomo basketry. Willow (*Salix* sp.) is the principal foundation element, used for the vertical warps in twining and the rod foundation in coiling. While the shoots of the willow are employed for basket foundations and warps, the roots are used as a weft element in utilitarian baskets by some Pomoan groups. At Vicente's camp Culin found that "Nancy Graves had two women preparing some willow roots for me. They were splitting them with their teeth" (1907a:133). A few days later he bought the two bundles of white willow roots, "one in its natural state, and the other prepared for basket making" (1907a:140). The processed willow has its outer covering or "bark" removed and the root split.

Sedge (*Carex barbarae* or *mendocinensis*) is the preferred weaving element, producing a light, buff background.[1] Bulrush (*Scirpus pacificus*) and redbud (*Cercis occidentalis*) are the two most common dark elements used to produce the designs. Bulrush, which grows in moist areas around Clear Lake, is the same plant as one kind of tule, but the part used for basketry is the root. Though naturally dark, it is blackened even further by dyeing. Redbud, as the name implies, is a small pink-blossomed bush with a shiny red bark. The bark in this coil still has a thin strip of stem on the inner side; four or more bundles have been rolled into one coil.

As Pomo weavers say, "the basket is in the roots":[2] the gathering and processing of basketry materials is not a simple task, and its success greatly determines the quality of the final basket even before the weaving is begun. Stands of willow or beds of sedge were cultivated by cutting and trimming repeatedly so that the new growth is abundant and of the

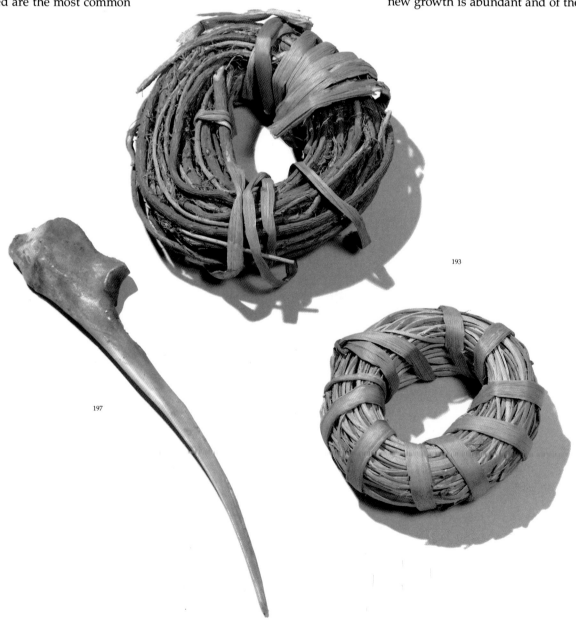

193

197

proper length and thickness. It must be gathered at the proper times of year. Materials are split and trimmed, with teeth and/or a blade (formerly obsidian; later with pieces of glass or metal knives), and stored in coiled bundles. When working, basket weavers keep materials moist by soaking them in a container of water.

The difficulty of obtaining suitable materials greatly affected, and still affects, the production of baskets. Noticing in 1907 that the baskets in Hopland were generally of poor quality, Culin was told that "the Indians here were making very few baskets....They declared they could not get the root they required for them" (1907a:108). Pomo have long traded basketry materials. Buying a bundle of white material in Hopland that had been gathered there, Culin was informed, "The red they told me they bought from the Indians at Upper Lake, paying them $1.50 a bundle" (1906a:24). Today, changing patterns of ownership and land use have made it even harder for Pomo weavers to obtain materials for baskets. IJ

1. However, the sample Culin purchased would be unsuitable for basketmaking; it is too short and unprocessed. Weavers try to gather roots that are as long as possible, which they roll into coils (see Peri and Patterson 1976).

2. Peri and Patterson 1976.

197. BASKETRY AWL
Pomo
Deer or elk bone, L. 8, W. 1½
Purchased from Broom John in Upper Lake, California, 1907
07.467.8325

Awls were used for coiling, a kind of sewing. Weavers split the fibers already on the basket in order to insert the sewing strand. This awl was made from the ulna (the inner of two forelimb bones) of a member of the deer family. The bone was left in its natural state at the end where the awl was grasped in the hand, while the opposite end was sharpened to a fine point. Goose, one of Culin's main consultants, showed him "a deer bone awl he said the women used in basket making before they had steel....He declared the women usually had a number of these awls" (1906a:38) IJ

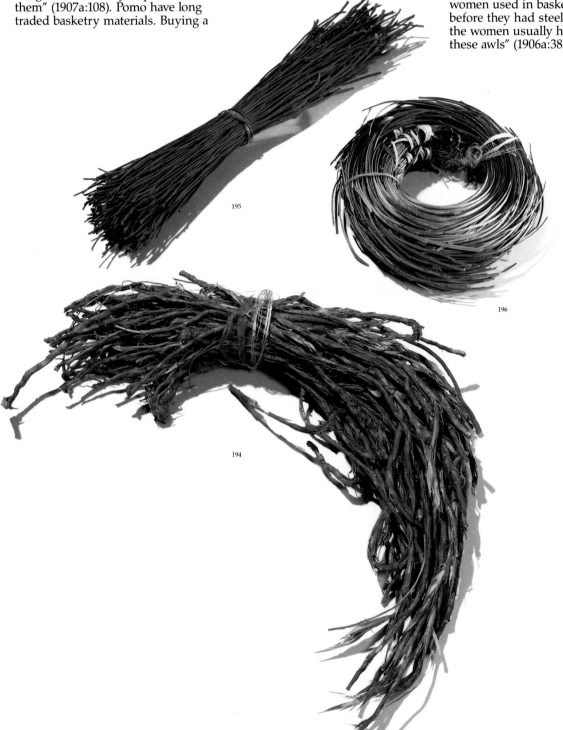

195

196

194

198. DOWRY BASKET

Made by Jenny; Pomo
Twined: willow, sedge root, redbud bark, clamshell beads, glass beads, cotton string, H. 13¾, Diam. 27
Purchased from Malpas and B. C. Cosgrove in Ukiah, California, July 12, 1907
07.467.8305

This is one of six baskets Culin bought in Ukiah, two of which he found in the local hotel. While he preferred to purchase baskets directly from the makers or users, Culin was also quick to acquire fine baskets from non-Indian sources. By the time of his collecting, the market for Pomo basketry, which had begun in the 1880s, was quite active.[1] Unlike many other curators, Culin almost never bought entire collections, preferring to pick among dealers' stocks for baskets that were especially beautiful or unusual, or those that would fill gaps in his planned exhibitions.

"Upon Dr. Hudson's warm recommendation," Culin bought this large globular basket from the proprietor of the hotel in Ukiah. According to Hudson, this was called a "chi-mo" (literally, "son-in-law"), and "was given him by his mother-in-law or the nearest relative of the bride. After the gift of this basket, they may not speak or even look at each other again" (1907a:111). Culin was told that the maker was Jenny ("a Tsetum Poma of Potter Valley") of Pinoleville.[2]

Twined "dowry" baskets are among the largest of Pomo baskets. This one was woven in lattice twining (called ti weave, from the Northern Pomo term), in which two flexible weft strands twist around an additional, rigid element as well as the vertical warps. This considerably strengthens the basket wall, as well as producing a special decorative effect.

Designs on Pomo twined baskets often consist of horizontal bands composed of geometric shapes in complex patterns. Most Pomo twined baskets with horizontal bands have an intentional change in the design pattern, called a *dau*.[3] While the significance is obscure, it has been regarded as a door through which the spirits of the basket could enter and inspect the basket or escape through when it was destroyed.[4] *Daus* are present on both this basket and No. 206, and on the toy burden basket (No. 214). IJ

1. Hudson 1893:564; Purdy 1902:19.
2. She was perhaps the Jenny Miller who lived in Pinoleville (1908:20).
3. Winter 1985.
4. McLendon and Holland 1979:115, citing Hudson and Purdy.

199. PUBERTY BASKET

Made by Mrs. Sam Hughes; Pomo
Coiled: willow, sedge root, bulrush root, acorn-woodpecker scalp feathers, valley-quail topknot feathers, clamshell beads, cotton string, H. 7, Diam. 14½
Purchased from Malpas and B. C. Cosgrove in Ukiah, California, July 12, 1907
07.467.8308

From John Hudson, Culin learned about a basket that Pomo girls used during puberty for bathing. Directed to the Hotel Cecile in Ukiah, which had such a basket in its showcase, Culin went with Hudson to examine it, "with the result of my purchasing it at the price asked, $30" (1907a:111). Referring to this acquisition, along with the dowry basket (No. 198) and a doctor's basket he got from Hudson, Culin was able to state with satisfaction, "I thus acquired for the

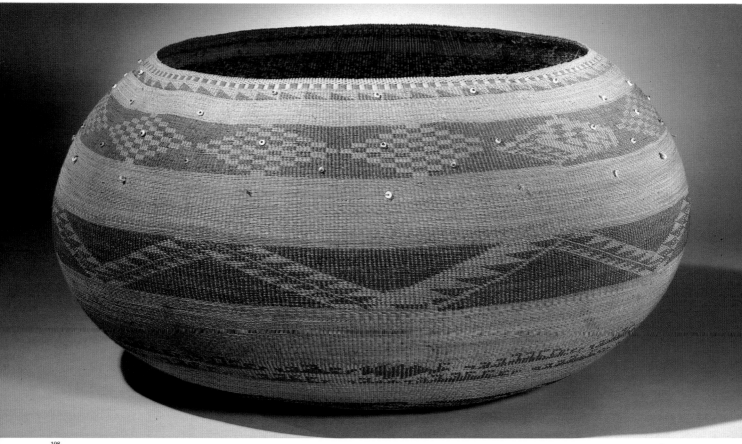

198

Museum to-day three very beautiful Pomo baskets, each having a definite use, and each the finest obtainable specimen of its kind" (1907a:111).

The next morning Culin went to see the collector of the puberty basket, the druggist J. R. Matthews, who said that he had displayed it in his shop window the previous summer. It had been made by the wife of Sam Hughes, living in Potter Valley. "He paid $30 for it, and asked $35, but had not been able to sell it, and, at last, had placed it in Mr. Cosgrove's hands, offering it for sale at $30, if he could not get more. Many people had examined it and he had had a photograph made of it by Mr. Carpenter" (1907a:111).[1]

Culin received differing information from William Benson and Dr. Hudson concerning this basket. "Dr. Hudson said that a woman must destroy it at the end of her menstrual period. If she keeps it she suffers and is likely to die" (1907a:111). Benson said, however, that the name given by Hudson, "kol-chu," meant "menstruation" and was not the name of the basket. As he also told Culin, "It originally

formed part of a set of four baskets which were given to a girl at a ceremony…at her first menstruation. The girl was put away in a little green tule house for a period of eight days, during which she was not permitted to comb her hair or feed herself" (1907a:112). The largest of the four, of the type Culin bought, served as a water basket, a similar but slightly smaller one was used to bathe in, a smaller one of the same shape was a drinking cup, and a round basket held food. "These four baskets were not destroyed, but were handed by a mother to her daughter. In Potter Valley, if the girl died they were burned."[2] Benson also said "with the baskets the girl was given a fine mat to sit upon" (1907a:112). In fact, at the time Benson was weaving one of these elaborately decorated mats (see No. 187).

Despite all the above testimony, this basket was not necessarily used for a puberty ceremonial, though it is of the customary general type and its feathers and shell beads indicate some ceremonial function. Goose, one of Culin's main consultants, told him, "The puberty ceremony for the

girl is not observed at all now. Goose said he had heard of it. He understood it was performed for the daughter of a man reputed rich on account of his possessions of beads, etc." (1907a:135). Thus, at this time puberty baskets were probably not being made for traditional use. While Mrs. Hughes may have intended her basket for such a purpose, there is no physical evidence that it was ever used to hold water, and it is also likely that the basket was made for sale, as an aestheticized version of a traditional form.[3]

IJ

1. Culin included a copy of this photo in his expedition report.

2. According to McLendon and Holland (1979:113), these water baskets were "saved throughout the girl's childbearing years and used only during her menses."

3. Writing in the early 1890s, Dr. Hudson insisted that the finest Pomo baskets were made for native use, not for sale (1893:564). While this could be true in some cases, one can also imagine situations in which the market (especially with an educated buyer) allowed the weaver to take greater pains with her work.

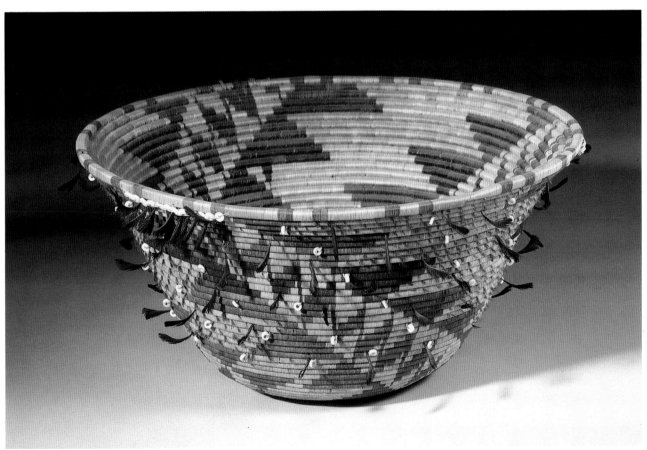

199

200. BOAT-SHAPED BASKET

Pomo
Coiled: willow, sedge root, redbud, H. 5¾,
L. 21, W. 12
Purchased from Mr. Foster in Ukiah,
California, June 9–21, 1911
11.694.9083

Boat-shaped baskets were commonly used to store ceremonial paraphernalia, especially of doctors' implements. During his brief visit in 1911 Culin bought this one from a Ukiah storekeeper named Foster:

Dr. Hudson bought the basket for me, securing a reduction of three dollars from the dealer's price.... The boat-shaped basket I bought from Foster is somewhat coarser than either of the two I already acquired [cf. No. 201]. I hear there is a constant decline in the quality of the Pomo Indian baskets. At the same time the baskets I saw at Foster's were all excellent, although none of them were extremely fine (1911a:65–66).

By this time the "basket craze" was almost over. While tastes in home decor and collecting were shifting,[1] attractive and well-made baskets continued to be produced, as Culin noted. IJ

1. See Washburn 1984 and Gogol 1985.

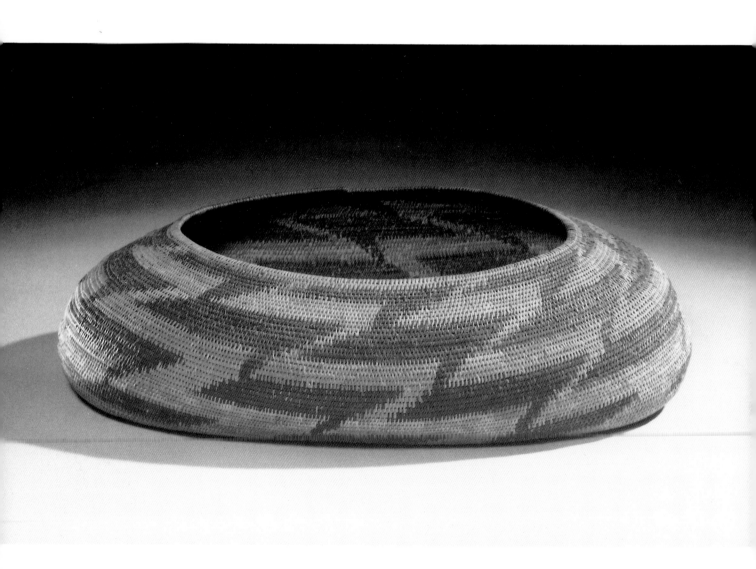

201. Boat-shaped Basket
Pomo
Coiled: willow, sedge root, bulrush root, redbud, H. 4¼, L. 17½, W. 10¼
Purchased from the Reverend H. C. Meredith in Lakeport, California, August 22, 1906
06.331.8016

202. Basket
Pomo
Coiled: willow, sedge root, bulrush root, clamshell beads, cotton string, H. 3¼, Diam. 10
Purchased from the Reverend H. C. Meredith in Lakeport, California, September 10, 1906
06.331.8117

Culin bought five baskets, along with other artifacts, from the Reverend H. C. Meredith, a "dealer in Indian curios, a retired clergyman" (1906a:21). Henry Clarkson Meredith (1861–1908), a Methodist Episcopal minister, came to California about 1894 and settled in Lakeport about ten years later for his health. He was a field missionary of the Northern California Indian Association. "One of their objects was to aid the Indian in disposing of his manufactures, buying them from him and selling them at a small advance. He had an intimate personal acquaintance with all the Indians in the region" (1906a:21). Culin continued to visit him on each of his trips, making small but important purchases. When he stopped in mid-May 1908, he found him ill with cancer, with his wife "keeping up his business in baskets" (1908:9). Meredith died about two weeks later.

Benson had a poor opinion of Meredith, whom he accused of trying to pay less for baskets he had commissioned. Meredith would engage a woman to make a basket, but "when it was finished he would declare it was not satisfactory, and decline to take it except for much less than its value." In this Culin concurred: "I satisfied myself last year that Meredith's philanthropic scheme of enabling the Indians to secure a market for their baskets was a mere pretense, and that he was engaged, like any other trader, in buying as cheaply as possible" (1907a:101).

All of Meredith's baskets, at least in Culin's collection, have a gummed oval paper label stuck to the bottom with a code of letters and numbers, the sign of a "professional" basket dealer or collector. Meredith's baskets stand out for their fineness. Clearly Culin was relying on them to supplement his own field collection. This collecting was thus doubly mediated: first by Meredith's selection from what he found among the Indians, and then by Culin's selection from Meredith's inventory. Oddly enough, though Meredith dealt with baskets from all over California, each of the five Culin bought from him come from Upper Lake. Perhaps Culin was purposely trying to further strengthen his collection from that community. IJ

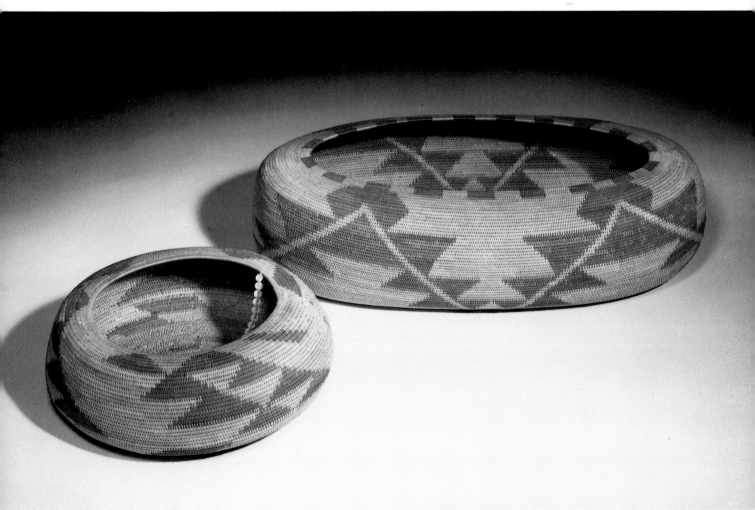

202

201

199

203. Basket Tray

Pomo
Coiled: willow, sedge root, bulrush root, H.
3¾, Diam. 15½
Purchased from Vicente in Upper Lake,
California, August 19, 1906
06.331.7983

Of the 117 Pomo baskets that Culin bought, almost half (48) came from Upper Lake—more, by far, than from any other community.[1] They represent a wide range of functional types and weaves. Although scholars have suggested that the different Pomoan language groups and communities had distinctive basketry styles, they have still not been precisely defined, for the most part.[2]

Culin bought this basket sifter from a blind old man (1906a:16).

Open, flat baskets such as this one had multiple uses: sifting acorn flour, parching seeds, serving food. Though more often twined, they could also be coiled, like this especially elegant example. IJ

1. In addition to this example and No. 204, Upper Lake baskets in this catalogue include the tule basket with clay balls (No. 178), the two that Culin bought from Meredith (Nos. 201, 202), and most of the miniature and toy baskets (Nos. 210–13).

2. See McLendon and Holland 1979:124–25.

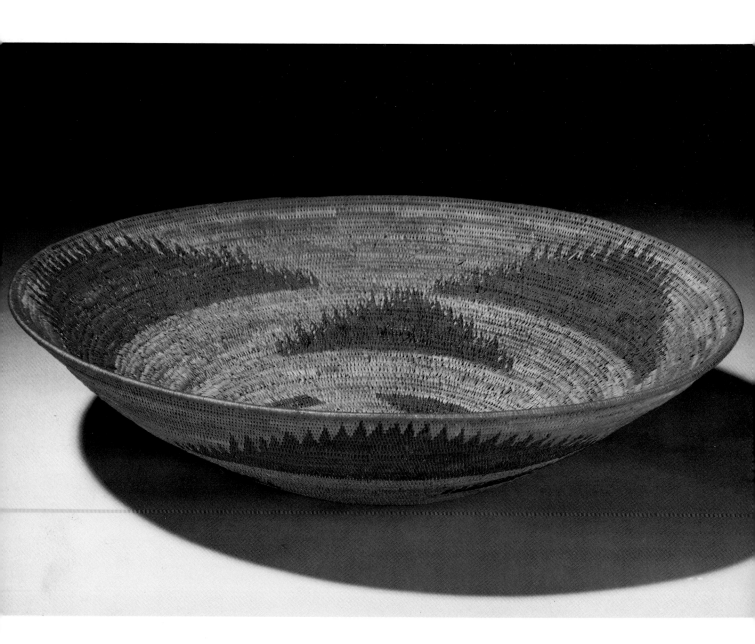

204. CEREMONIAL BASKET
Pomo

Coiled: willow, sedge root, bulrush root, acorn-woodpecker scalp feathers, valley-quail topknot feathers, clamshell beads, cotton string, H. 4½, Diam. 9¾
Purchased from Sulphur Bank Tony in Upper Lake, California, September 14, 1906
06.331.8134

Although Culin purchased this fine ceremonial basket in Upper Lake, it was not necessarily made there. "I went to the bean field at six o'clock tonight, looking for Sulphur Bank Tony whom I heard from Dick had two baskets he wanted to show me. I followed him with the women over to their house, about a mile southwest of the town....Tony showed me the two baskets, and I bought one of them, a globular three-stick basket ornamented with feathers, for $10" (1906a:71).[1] This provenance shows that Indians still possessed fine ceremonial baskets, similar to the puberty basket that Culin bought in Ukiah (No. 199), although the strength of the market is indicated by the fact that Tony offered the baskets to Culin.

The attractive trefoil pattern on the bottom is primarily an expression of the artist's own creative interests. As baskets were usually made to be seen resting on the ground, it would not have been visible normally. However, designs on the bottom are characteristic of many Pomoan baskets.[2] IJ

1. According to Sally McLendon, Sulphur Bank Tony was Tony Francisco, related to Mary Francisco (see No. 213) and a Southeastern Pomo speaker. His name was derived from the village of Sulphur Bank at the eastern end of Clear Lake.

2. McLendon and Holland 1979:123.

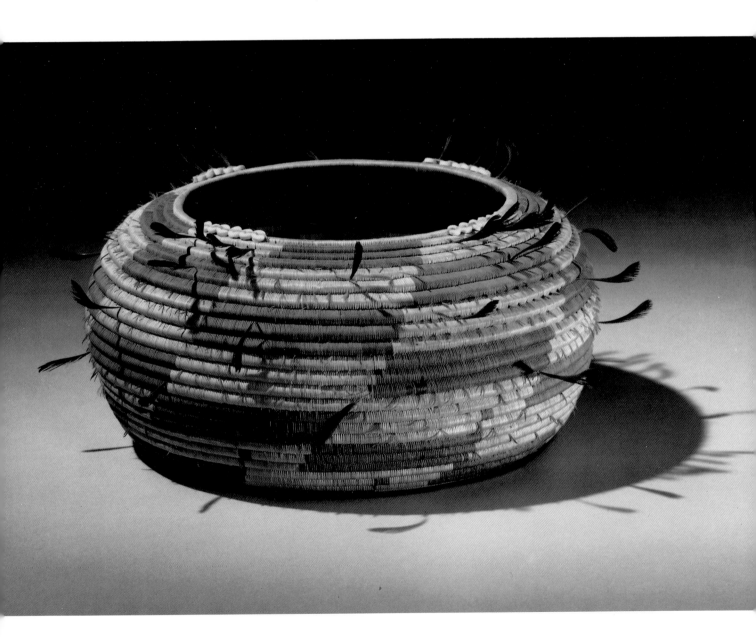

205. BASKET BOWL
Made by Elsie [Lake?]; Pomo
Coiled: willow, sedge root, redbush bark,
H. 4½, Diam. 9¼
Purchased from Elsie [Lake?] in Potter
Valley, California, May 29, 1908
08.491.8639

206. MUSH BASKET
Made by Elsie [Lake?], Pomo
Twined: willow, sedge root?, redbud bark,
H. 6¼, Diam. 9
Purchased from Elsie [Lake?] in Potter
Valley, California, May 29, 1908
08.491.8640

Pomo women usually specialized in either coiling or twining,[1] but Elsie, the maker of these two baskets, clearly excelled in both techniques. Twining was perhaps more common, particularly for utilitarian ware. While coiling was used for some cooking and eating containers, it was especially employed for ceremonial and gift baskets.

These are two of the six baskets Culin obtained in Potter Valley. On his last major Pomo trip, he went with Dr. and Mrs. Hudson to the rancheria in Potter Valley, where Mrs. Hudson had grown up. "At another house, Lake's, I bought from Elsie, a very beautiful basket she had made with a 'waves' pattern," and a meal basket (1908:21).[2] Both are very fine examples of their type, but their relative market values are apparent from the differing prices: the coiled basket cost five dollars and the mush basket, a dollar and a half. Though they look so different, the materials are the same, and the designs on both are in redbud. As on the dowry basket from Ukiah, the design on the mush bowl was made from redbud, which was alternately twisted over to the reverse side, revealing the buff underside of the redbud bark—a common decorative technique in Pomo baskets. IJ

1. McLendon 1981:208.

2. Because Culin does not say that Elsie made the meal basket, it is possible that she sold him a basket she obtained from another weaver.

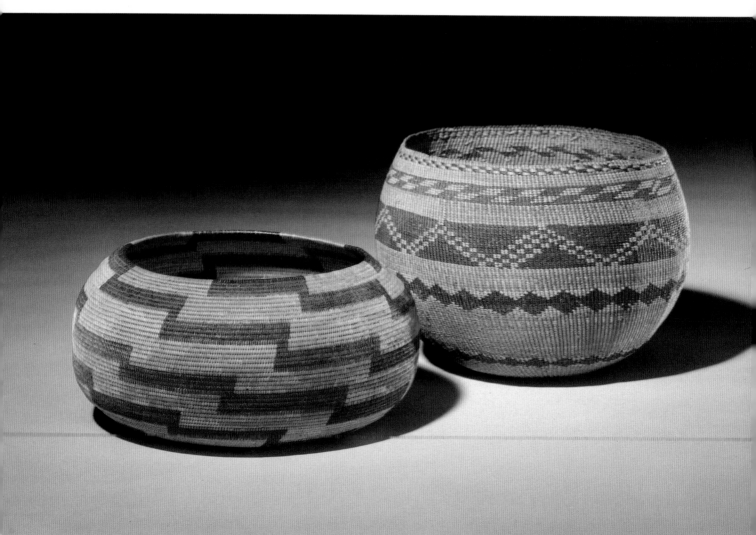

205

206

202

207. SEED FLAIL

Pomo
Wicker: plant fibers, cotton string, resin,
L. 18½, W. 11
Purchased in Yokaya, California, October 2,
1906
06.331.8197

The eighteen baskets that Culin bought in Yokaya constituted the second-largest group he acquired from a single Pomo community (the largest came from Upper Lake). One should not assume from the worn appearance of the flail and the mush basket (No. 208) that the Yokaya rancheria was a poor one. On the contrary, it was a thriving, independent community, just south of Ukiah. In fact, Dr. Hudson felt in 1899 that the finest Pomoan baskets were being made in Yokaya.[1] Unlike many of Culin's Pomo purchases,

neither of these objects was commissioned; instead, they typify the "old things" by which he sought to document native culture.

Accompanied by the Hudsons, as he so often was in his trips to Yokaya, Culin "drove first to the summer houses on the river where

he found only two old women in one house, from whom I bought a small basket, a very good stone pestle, and an old seed beater" (1906a:91). Pomo women used these flails to beat seeds from plant stalks into a large conical burden basket (see toy version, No. 214). One man at Upper Lake told Culin that the "seed flail was no longer made, but they remembered seeing it," and when he was buying "a rough basket flail," another told him that "they used to have fine ones, but had sold them all" (1906a:35, 34). Although Culin had the "American cord" replaced on one flail he bought, the handle of this one is wrapped with cotton twine. IJ

1. Quoted in McLendon and Holland 1979:11.

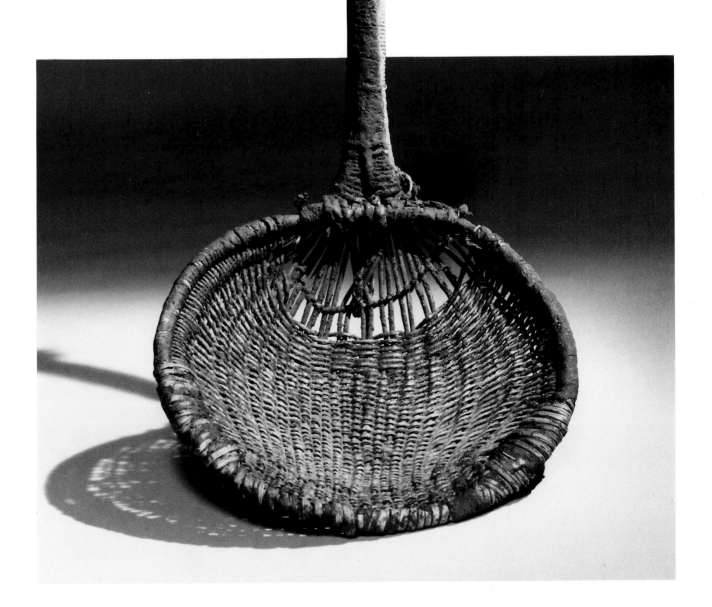

208. Mush Bowl

Pomo
Twined: plant fibers (including redbud),
H. 8½, Diam. 14
Purchased in Yokaya, California, June 1, 1908
08.491.8661

Driving with Dr. Hudson to the Yokaya rancheria, Culin stopped "at the house next to old Joe's, where Jeff Dick and [his wife] Joseppa once lived" (1908:23). In 1903 Culin had purchased a set of hand-game bones and a cat's cradle from Jeff Dick when the couple was demonstrating at the Harvey Hotel in Albuquerque. Joseppa, a famous basket weaver, had died in 1905 (see Fig. 44).[1] At this house Culin found "two old women, one blind, and an old man"

(1908:23–24), probably relatives of Joseppa's. According to Dr. Hudson, "they were destitute and anxious to sell some old worn baskets which appeared about their only possessions. I bought the lot, a seed-collecting basket, hopper, parcher, two sifters, a basket bowl, and a basketry plate for three dollars" (1908:24). While Culin's purchase was primarily an act of charity, it also serves as a record of the household inventory of a poor family.

The worn basket, used for cooking acorn mush, with hot rocks, is notable for its native repairs. Though

such mends are not uncommon in Pomo baskets, they are somewhat unusual on examples in museum collections, which were often chosen with beauty in mind. While the repaired basket was probably no longer watertight, it could still be used for holding food, as is attested by the heavy incrustation of food residue. The large hole at the bottom of one side was patched with the "start," or beginning, of a basket. As the start of the basket and the patch are different, the original weaver and the repairer were probably not the same person.[2] IJ

1. McLendon 1981:203–8.
2. This point was suggested by Sally McLendon.

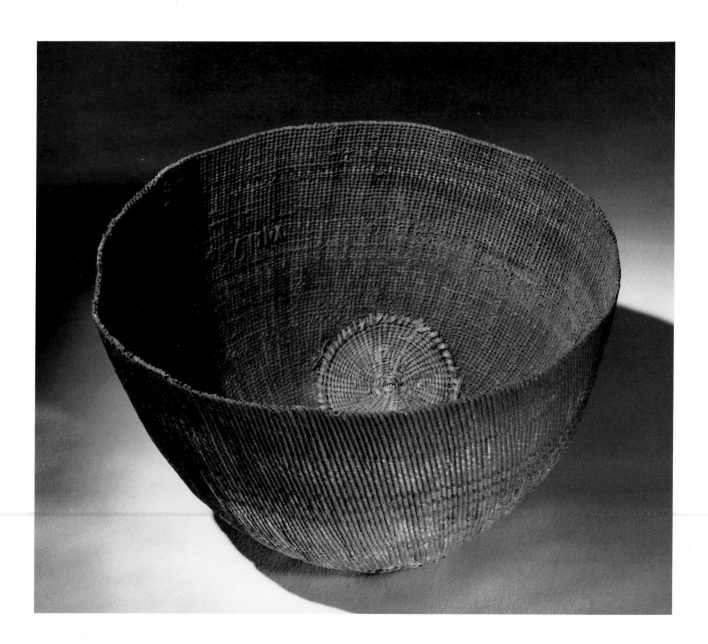

204

209. DOLL IN TOY CRADLE
Made by Susana Graves; Pomo
Manzanita wood, clamshell beads, tule
(cattail), Indian hemp, willow, cotton
string?, L. 10¼, W. 7, D. 5½ (cradle)
Purchased from Susana Graves in Upper
Lake, California, August 31, 1906
06.331.8065

Many of the Pomo artifacts Culin collected concerned Pomo children; these included cradles, toys and dolls, and even objects made by children. Given the importance of basketry in Pomo life, it is not surprising to see the many miniature baskets that girls used to practice the skills they would need as mature women. The relative abundance of such toys in Culin's collection and his own observations indicate that the transmission of Pomo culture was still viable at the time of his expeditions.

Culin recorded the use of these toys and dolls and the great concern that Pomo showed for their children. In September 1906, he found Penn Graves with his wife and sick daughter in their tent. "He would not leave it, even to do work necessary for his support. No one could be more devoted to their children than these Indians" (1906a:64). Later in the month Susana Graves "made some toys of tule for her little sick girl which I bought. Penn Graves told me that when tule is ripe the women make them for their children" (1906a:82). A few days later Graves sponsored a feast for his daughter, giving away twenty-five watermelons and thirty loaves of bread "to aid her recovery. He

expressed surprise when I asked him if the custom was a common one. He said it was, and universal" (1906a:80). Despite the feast, his girl worsened, but, when Culin visited the next year, he learned that she had survived (1906a:81; 1907a:125).

This doll was one of two "old style" dolls made by Mrs. Graves for Culin. They consisted of a wooden board, usually manzanita, with clamshell eyes and bedding of shredded tule (1906a:38).[1] The larger one was also bound into a toy cradle. Pomo babies were, and still are, tied into a larger version of these simple containers of bent willow rods secured with cordage.[2] IJ

1. For a photograph of the doll, see Barrett 1952:469.

2. The round hoop on this cradle was broken at some point in its history.

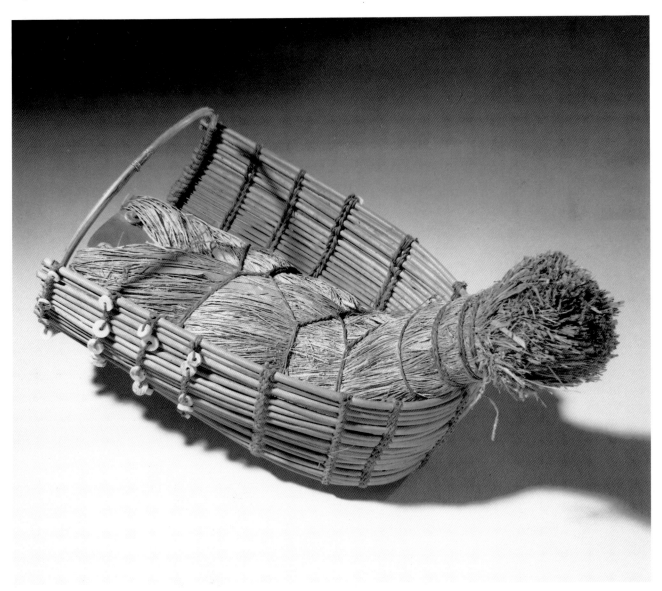

210. Toy Baskets (3)
Made by Susana Graves; Pomo
Twined: tule, H. 1½, Diam. 3½, H. 3,
Diam. 3, H. 1, Diam. 1¾
Purchased from Susana Graves in Upper
Lake, California, September 26, 1906
06.331.8163.1–.3

211. Toy Cradle
Made by Susana Graves; Pomo
Twined: tule, H. 1¾, L. 4¼, W. 2½
Purchased from Susana Graves in Upper
Lake, California, September 26, 1906
06.331.8167.1

212. Toy Basket
Made by Nancy Graves; Pomo
Twined: tule, Indian hemp, clamshell
beads, H. 2½, Diam. 2½
Purchased from Nancy Graves in Upper
Lake, California, August 1, 1907
07.467.8329

At Vicente's camp in Upper Lake, Culin noticed a little girl and half-grown girl "playing with dolls." They "had a number of miniature baskets which they were using as toys as white children would do" (1906a:43). Perhaps with this in mind, Culin commissioned Susana Graves to make him a set of toy baskets of tule: the carrying or burden basket, the hopper or mortar rim, the basket with flaring sides, and the round basket (the first three are exhibited here). This set of miniatures was modeled after the range of Pomo forms used for processing acorns. Mrs. Graves also made him three toy tule versions of the larger toy cradle she had constructed—which is itself a scaled-down version of a functional cradle.

Penn Graves's former wife, Nancy, also made Culin a toy basket of tule. This "she filled with the earth, maar, used as baking powder [for making acorn bread]. She said this kind of a basket, but larger, was used regularly to hold this substance. I bought one of these larger baskets from a woman in the camp" (1907a:131). The larger version was very similar to the basket Susana Graves made to hold the clay balls (No. 178).[1] It is unusual for a work basket to have clamshell beads, which are generally reserved for ceremonial containers.
IJ

1. The rim of this toy basket was finished the same way as that on No. 178.

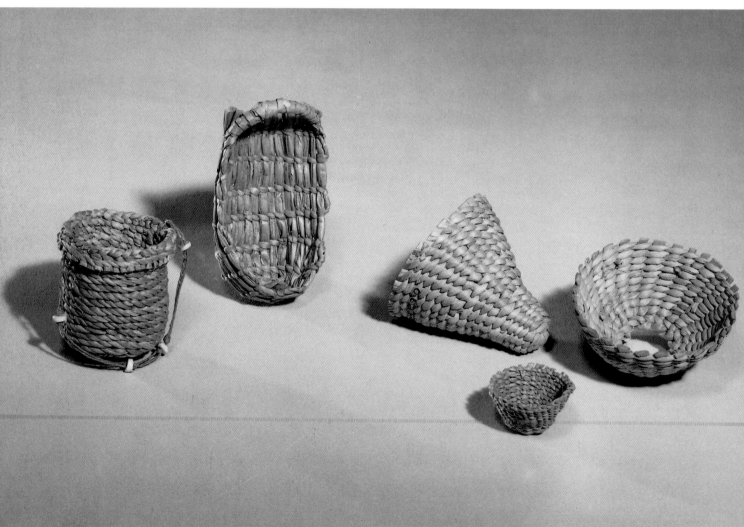

212 211 210

213. MINIATURE BASKET

Made by Mary Francisco's daughter; Pomo
Coiled: willow, sedge root, bulrush root,
H. 1¼, Diam. 2¼
Purchased from Mary Francisco in Upper
Lake, California, September 14, 1906
06.331.8136

Miniatures can take many forms; among the most common are children's toys or tourists' models. A relatively new Pomo genre of baskets during Culin's time was that of the miniatures made by adults, primarily for sale, as examples of technical virtuosity. Evidently Charles Wilcomb, a San Francisco curator, collected the first of these in 1902.[1] Most of the miniature baskets made for sale are coiled. Other than these toys, Culin collected very few (if any) "ethnographic" or tourist miniatures—reduced-scale models made for sale to whites. Instead, when he wanted a model, he commissioned a full-size version.

This basket seems to mix some categories. Mary Francisco "showed me two little baskets, toys, made by her little girl who would be seven years old next spring. I bought one of them for 75 cents" (1906a:71). As Sally McLendon noted, the fact that the "start" of the coil, on the bottom, is much finer than the rest of the basket, suggests that Mary Francisco probably began the basket and let her daughter finish it (see Fig. 53). Though Culin refers to it as a toy, such baskets are also the way Pomo girls learn the vital craft of basketry, which they will practice for the rest of their lives. IJ

1. Bernstein 1979:79

214. TOY BURDEN BASKET

Pomo
Twined: willow, sedge root, redbud bark,
Indian-hemp cord, H. 8, Diam. 9
Purchased from grandchild of Nancy in
Yokaya, California, October 2, 1906.
06.331.8198

From Nancy, an old woman, Culin bought a bowl, and from her grandchild, a little girl, he purchased this toy carrying basket,[1] which, he noted, "was very finely woven" (1906a:91). In fact, it is so well done that, unlike the crude tule version (No. 210), it may have been used by a slightly older child to actually gather seeds. However, as Sally McLendon notes, Pomoan people also made especially fine small-scale baskets for their children and grandchildren. Like the other twined Pomo baskets in this exhibition, this burden basket also has a *dau* break in several of the zigzag bands. IJ

1. Nancy was a Matsuta Pomo, a Northern Pomo group.

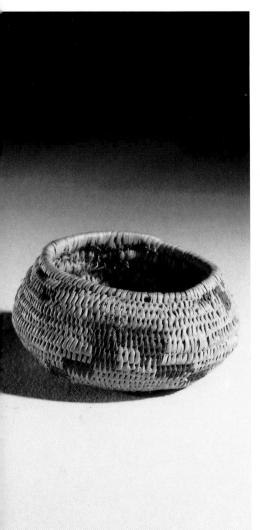

213

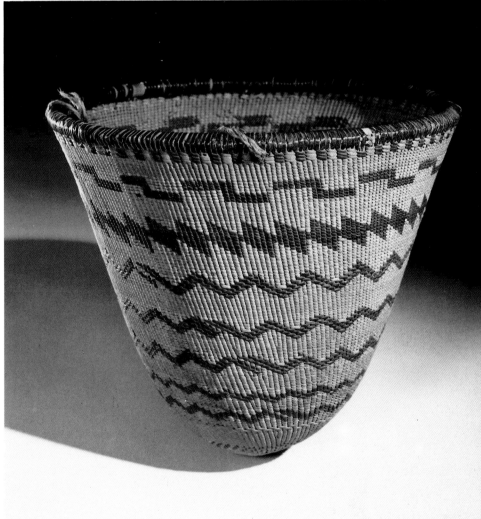

214

207

215. SALMON-BONE CATCHING GAME

Pomo
Salmon vertebrae, wood, twine, L. 9½, W.
1¼ (handle); L. 5¼, Diam. ⅜ (bones)
Purchased from Helen M. Carpenter in
Ukiah, California, 1906
06.331.7932

Following his great passion, Culin collected a full set of Pomo games. As many were no longer practiced, he was forced to commission those examples. Nos. 215–17 were among the old gaming devices he was lucky to find.

Dr. Hudson had told him that the Upper Lake Indians had the salmon-bone game, "although I failed to get it there" (1906a:87). Though this was one of the first Pomo objects listed in Culin's ledger, there is no further mention of it in his expedition reports. The collector, Mrs. Carpenter, had come to Pomo country in 1859 and was the mother-in-law of Hudson, who probably sold it to Culin.

This set has four lengths of salmon vertebrae tied to four sticks.

When Culin collected another salmon-bone game, the seller demonstrated its use: "He held it horizontally with the points directed toward his face, the bones hanging down, and then threw it upward so that the bones might catch on the points" (1908:97). This was a more elaborate form of the salmon-bone game that Culin collected among the Hupa (No. 160). Culin was also told of a variant form, with a perforated hide and ball of tule caught on a pin. IJ

216. BONES FOR HAND GAME

Lake Miwok
Bird bone, cotton string, pigment, L. 2¾,
Diam. ½
Purchased from Henry Knight in Coyote
Valley, California, September 9, 1906
06.331.8110a–d

One game that was still actively played in native California at the time of Culin's trips was the hand game. He bought this set in the mall Lake Miwok rancheria south of Clear Lake. The vendor, Henry Knight, was the son of a Lake Miwok mother from Coyote Valley and a Southeastern Pomo father

from Sulphur Bank (1906a:54). Given the close relations between the Lake Miwok and several Pomo groups, their material culture is quite similar. The following is a lengthy account of the playing of this game. Descriptions of native behavior are very rare in Culin's Californian expedition reports, and he probably produced this record because of his interest in games:

> After I had established friendly relations with the men, I asked them about the hand or grass game, shoka. They told me they called it klitka, and Henry at last produced a set of bones, three new and one old, which he said were crane bones.[1] One of the bones, only, was tied. He tied a cord about one of the others, rubbed the bones with charcoal to blacken the new cord, and then said if I would put up $1 as a stake, they would play a game for my amusement, the two men against the two women. I agreed. The small boy broke off twelve small willow sticks as counters. The stake, a silver dollar, was put on a piece of leather on the ground, and the two men seated themselves on the ground with the two women facing them about

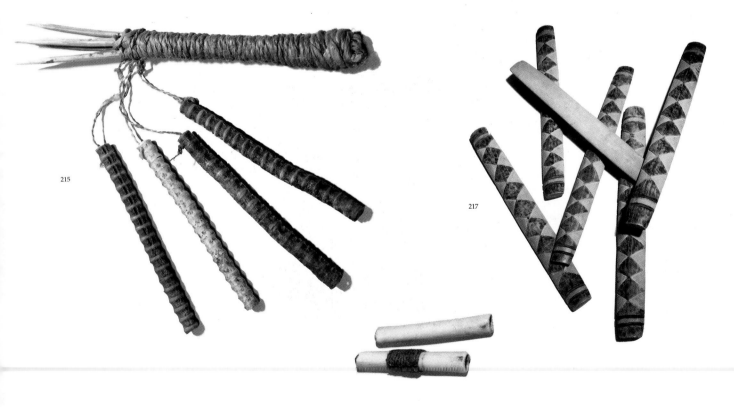

215

217

216

ten feet apart with the stake midway between. I did not attempt to follow the game, of which I had a good description from Dr. Hudson, the play being extremely complicated.

The men and women hid the bones alternatively, the other side guessing. The guess was indicated either by a cry or by a motion of the extended hands or fists. The songs varied, the women singing in a very sweet low strain. When a successful guess was made, the side holding the bones would throw them across to their opponents. The small boy paid the gains by tossing one or two of the sticks to the winning side until they were exhausted. The players continued the game, winning and losing from one to the other, until the men won all the sticks and the game. When the man guessed they would sway their bodies, and contort their faces. The women moved their entire bodies with a motion similar to that of the danse du ventre.... The game was played with great animation and laughter, and the players seemed to enjoy it greatly. At first, Knight told me they did not play the game, having given it up on account of their having become Christians, joining the church" (1906a:56–57). IJ

1. Culin's catalogue card contradicts this expedition report; there he says that one bone was new. His successor, H. J. Spinden, recatalogued five bones with the same Culin number. Four have been chosen here to match Culin's documentation and our knowledge of Californian Indian games.

217. STICK DICE
Pomo
Wood, pigment, L. 12¼, W. 1¼
Purchased in Redwood Valley, California, May 28, 1908
08.491.8632a–f

This is the oldest and perhaps the finest of the dozen sets of stick dice that Culin collected among the Pomo; all except this one were acquired in 1906. Most appear to be little used but not made especially for him. Traveling to Redwood Valley with Dr. Hudson, Culin bought this "very fine old set of stick dice" from an elderly woman (1908:20).

The twelve sets Culin bought reveal a great variety of designs. "The patterns on these sticks were formerly burned by applying clay to the light or white parts of the patterns" (1906a:97). The dark features were produced where the fire was able to reach the wood. This set is the only one that also has the surface raised in shallow relief. Like basketry designs, the patterns are named after objects in nature, but they carry no special significance for the game. At Vicente's camp at

Upper Lake, Culin asked "one of the women about the kedai [stick dice] patterns. She gave me names for all I had figured in my book, I showing her the proofs. They did not agree with Goose's or Pengraves' and I conclude that they vary greatly" (1906a:81).

Stick dice, or staves, always come in sets of six, with sets of plain counting sticks to keep track of the score. Like Western dice games, the score is counted by the combinations of marked sides that fall faceup. For many Californian groups, it was once a woman's game but today is played by both sexes. Played by two individuals or opposing sides, it was usually accompanied by a great deal of betting.[1] IJ

1. See Culin 1907c:131–36; Barrett 1952:343–44; Peri 1987.

218. DOCTOR'S HOOP
Made by Sam Tony; Pomo
Wood, feathers (including flicker), obsidian, cotton string, pigment, Diam. 23
Purchased from Sam Tony in Upper Lake, California, August 28, 1906
06.331.8048

The Pomo had two main kinds of medical specialists: sucking doctors, who cured by sucking the illness through the patient's skin, and singing, or outfit, doctors.[1] As the name implies, the outfit doctor based his cure on the manipulation of objects and medicines of various kinds, combined with ritual singing. Culin bought a great many doctoring implements from Sam Tony, a Pomo singing doctor.[2] Singing doctors acquired their positions through inheritance or apprenticeship, and

Sam Tony received his outfit from a Dr. Joe, who had died in 1879 (1907a:115).

This unique hoop is perhaps the most interesting of the items that Culin bought from Tony. In response to Culin's question about some feather bundles he had, Tony "explained he tied [them] to a hoop made of poison oak together with obsidian blades and coyote feet, and put over the patient's head" (1906a:15). However, the construction of this ring was not merely a matter of technological processes: "In making this hoop he had to sing; the songs occupied the greater part of a day. In addition, he required the service of an old man who sang with him. On this account he wanted $7 to make the single hoop, and $16 for the object complete with the feathers, etc. attached" (1906a:15). "In a spirit of fun," Penn Graves suggested that Culin "should buy the songs when I bought the medicine outfits" (1906a:29). About a week later, Culin ordered the ring, which he picked up at the bean camp ten days after that (1906a:29).

Unfortunately, Sam Tony could not speak much English and "was unable to give much information about the ring" (1906a:26). However, Culin was able to note how Tony and other Pomo reacted to it. Shortly after it was made, "one of the women who was washing at the hotel pulled the things out of my boxes and at last picked up the doctor's hoop, asking what it was. She recognized it when I told her and instantly dropped it in evident terror, rushed to the sink and washed her hands repeatedly. Sam Tony,

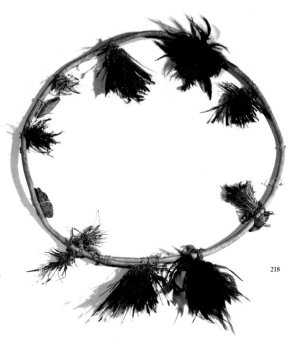
218

when he made the ring, kept it in the bushes some distance from the camp, saying that the children must not see it" (1906a:48). Upon seeing it with Culin's purchases, Dr. Hudson remarked that he "had never heard of the doctor's ring I bought from Sam Tony, and it interested him greatly" (1906a:86).

Traditional Pomo medical practices often proved ineffectual against diseases introduced by the white man.[3] Sam Tony "did not have much confidence in his treatment, for he had just taken his little girl to Lakeport to secure medical advice for her" (1906a:15), and the following year his little boy was sick all summer. Although he continued to sing over his child, Tony took him to doctors in Upper Lake and Lakeport and asked Culin for help (1906a:77). Culin sadly commented, "The scene was pathetic and depressing" (1906a:78) IJ

1. Barrett 1952:354–71.

2. In 1906 Culin "selected everything of interest and value" from the sacks in which Tony stored his paraphernalia: hairpins, one bag put over the doctor's head and another for the patient, a whistle, clapper, stone pestles for medicine, obsidian blades, coyote's feet, and a medicinal root (1906a:14). The following year Culin supplemented his collection from Tony with more stones, a cocoon rattle, a mud puppy, and other objects (1907a:127).

3. Among the Eastern Pomo, "virtually all illness was attributed to human causes," either by some transgression of the sick person or by some malevolent action of others (McLendon and Lowy 1978:319).

219. DOCTOR'S COUNTING STICKS
Made by Joe Beatty; Pomo
Wood, L. 6, Diam. ¼
Purchased from Joe Beatty in Yokaya, California, June 1, 1908
08.491.8653.1–.59

Though superficially just a plain set of twigs, these sticks were expressions of the ultimate reference points of Pomo cosmology. Physically, they most closely resemble the counters used to keep track of the score in gambling games, but they are also related to invitation sticks, moon counting sticks, and other forms of Pomo mnemonic devices.

In addition to a rattle, Culin bought a bundle of sixty counting sticks from Old Joe Beatty, who had been a doctor's assistant. Culin explained their use:

These twigs are used by the doctor's assistant in counting off the doctor's ceremonial movements... In these movements, the doctor started at the

east, and then repeats the same movements, four to each quarter, toward the north, west, south, above and below. This uses up twenty-four sticks, which the assistant drops, one at a time, in a pile. The assistant, who also counts and prompts the doctor, sits at one side, and shakes the cocoon rattle. After the first series of movements, the doctor repeats the same movements each three times, in the same order, this using eighteen sticks. Then he repeats them twice, using twelve sticks, and finally once, using six sticks, the total number being sixty, corresponding with the sixty sticks in the bundle (1908:22-23).[1] IJ

1. There is some confusion over the cataloguing of the sticks shown here, for the same Culin number has been associated with several sets of sticks (illustrated in Barrett 1952:477). One group of smaller sticks consists of six bundles of eight sticks each (making a total of forty-eight). While Barrett says that the set illustrated here of larger sticks numbers fifty, it actually numbers fifty-nine. Therefore it most likely corresponds to Culin's set of sixty, described in the above quote, one of which has been lost.

220. DOCTOR'S STONES (3)
Pomo
Stone, L. 3, W. 1¼; L. 4, W. 1½ ; L. 2½, W. 1½
Purchased from John Stevenson in Pinoleville, California, July 14, 1907
07.467.8311; 07.467.8312; 07.467.8313

Like the doctor's counting sticks (No. 219), these stones—many of them natural and unworked—were part of elaborate Pomo beliefs and actions. The Pomo took a keen interest in odd-shaped stones, which they "extensively employed to insure success in doctoring, hunt-

ing, fishing, and gambling."[1] The Reverend H. C. Meredith supplied Culin with a good bit of information on them:

He said the Indians tell remarkable stories about these stones. If a man other than a doctor finds one, he will mark the place and hasten for a doctor to secure the stone. Sometimes it will have disappeared. Sometimes such stones have been traced, moving like a mole under the surface of the ground. Any curious stone whether worked or natural is esteemed by the Indians and regarded as lucky (1906a:74–75).

Looking for doctor's stones, Culin drove over to Pinoleville to see an old man, John Stevenson.[2] At first Stevenson declined to sell any, saying that "they belonged to a doctor who was dead, and he would not disturb them" (1907a:107), but he relented, and Culin was able to buy these three stones. One, with a name meaning "blue clay," was in the

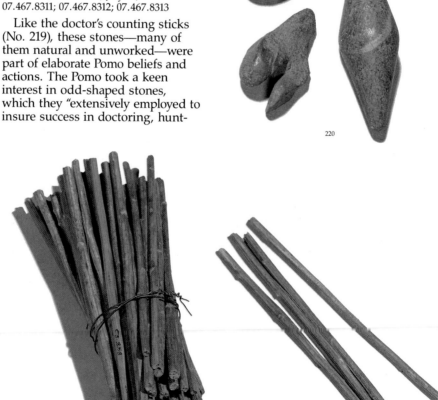

220

219

common plummet, or sinker, form, with a hole at one end. Meredith told Culin that this was the shape of "the typical charm or luck stone of the area" (1906a:74). Stevenson said that the end of the double-pointed stone "was applied to the afflicted part" in healing. Several people told Culin that doctors heated these stones and touched them to a patient's body (1906a:72, 73; 1907a:127). When Culin suggested that it "might have been brought into this country from the south," the old man denied it, saying that it came from Potter Valley, "where it was found" (1907a:117).[3] The forked reddish stone, apparently hematite, was called "coyote-forearm stone" (1907a:116). IJ

1. Barrett 1952:116.
2. Stevenson's outfit had belonged to his father-in-law, a doctor who had died in 1879. When Culin commented on the similarity to Sam Tony's set, Stevenson's son told him that his grandfather had taught Sam Tony and others who practiced with this kind of outfit (1907a:115).

3. However, William Benson told Culin that "Curious stones passed from hand to hand around the Indians and were often found at great distances from the place where they were originally made" (1907a:101).

221. DANCE HEADDRESS
Pomo
Flicker feathers, cotton string, plant fibers, wool, wood pin, H. 5, Diam. 8¼ (rosette)
Purchased from Captain Tack in Hopland, California, August 24, 1906
06.331.8027d

The Eastern Pomo seem to have given their last traditional ceremonials sometime before 1900, but new ritual forms took their place.[1] During his expedition, Culin was able to acquire a representative selection of regalia. Some pieces, like this headdress, are quite beautiful. Captain Tack, the fifty-two-year-old headman of the Shanel (Central Pomo), lived in Hopland. He showed Culin "a number of dancing suits," which he kept in a locked chest in his house, and Culin "picked out a complete

one, taking the best things.... The suit, a man's, consisted of a feather headdress, of long feathers, a pair of head plumes made of wire, a feather kilt, the feathers attached to fish net, a broad band of yellow hammer [flicker] feathers, a wooden stick rattle, a small double cane flute stopped with gum and a fine net containing down" (1906a:23). Evidently this headdress was the feather topknot worn by men at the back of the head.[2] The long wooden pin secured it to the hair net.

On a number of occasions Culin followed this practice of assembling a "complete" set from assorted ceremonial items; Sam Tony's doctoring implements and Billy Preacher's Maidu dance regalia were other instances. Thus the sets are reflections of Culin's own ethnological preconceptions and/or aesthetic taste as much as they are records of native culture of the time. IJ

1. McLendon and Lowy 1978:320.
2. Barrett 1952:306.

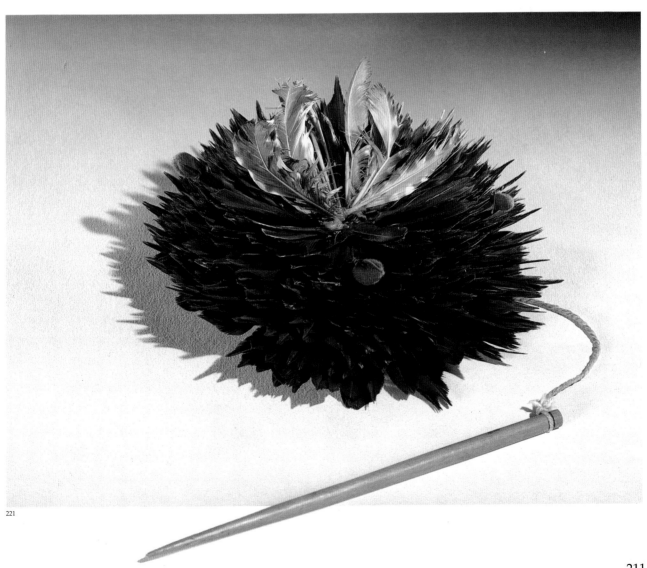

221

222. WOMAN'S DANCE HEADDRESS
Pomo
Fur, red-shafted flicker feathers and quills, glass beads, wool yarn, iron wire, cotton and wool cloth, cotton string, H. 4¾, W. 12, Diam. 9¼
Purchased from John Boxer in Upper Lake, California, September 1, 1906.
06.331.8076

Pomo women's dance costumes generally consist of the same regalia as men's.[1] This distinctive headband is among the few items of regalia restricted to women. It was one of two that Culin bought from John Boxer, whose sister had previously owned them. Before he bought them, however, Culin had Boxer repair them (1906a:41). The quill decorations are common on many articles of dance regalia in central California. Pomo ceremonialism was in a state of transition during Culin's visits. Tom Harness, who sold him some dance regalia, told Culin, "The Indians do not dance now, but three years ago they had a dance at Lakeport on the Fourth of July, when a number of the boys dressed up" (1906a:17). IJ

1. Barrett 1952:311. However, as Sally McLendon noted, Barrett apparently forgot that some forms were restricted to men, such as flicker headbands and feather dance skirts.

223. FEATHER HEADDRESS
Pomo
Feathers, redbud or dogwood, wood, cotton string, Indian hemp, H. 25, L. 39, W. 29
Purchased from John Hudson in Ukiah, California, 1908
08.491.8952

Culin tried doggedly to secure a feather headdress that he called a Big-Head. The term has been applied to several large Californian headdresses. The one Culin wanted was used for the Pomo Kuksu ceremony, involving the impersonation of a god.[1] This figure was painted black, wore a feather headdress and a shredded tule cape on his back, carried a long staff or cane, and used a whistle. The Kuksu Big-Head was different from the Big-Head headdresses that the Pomo later employed in the Bole-Maru, or Ghost Dance, complex.

Culin bought his first Big-Head at Upper Lake in 1906 from Charlie Williams, but he was told by Dr. John Hudson that it was only a doctor's headdress (1906a:89). The following year he commissioned another one from Jim Bateman as part of a complete Kuksu costume but was given the same verdict by Dr. Hudson (1907a:149). When he first saw it, Culin felt it was too small and used the wrong kind of feathers, but by then he had come to accept that objects he had commissioned would not be made correctly: "I am quite prepared for this now with everything I buy" (1907a:139–40).

It was not until 1908 that Culin was able to buy one that he thought could be used for the Kuksu. In late July, he went with Dr. Hudson to the house of Tom Mitchell in Yokaya, who was making a Big-Head: "The mask was constructed by Mitchell under the direction of an old man who did the praying" (1908:98). Mitchell wanted fifty dollars for his headdress, which he said would be finished in two days, but as Culin had to leave before he was done, he came away empty-handed again. Culin, however, was interested in another Big-Head, already in Hudson's possession:

The Doctor had had such a head made recently, and I saw it at his house. This is the object I tried to secure in Lake county. Both last year and the year before I had ordered such heads made. They had turned out to be ordinary dance head dresses when completed,

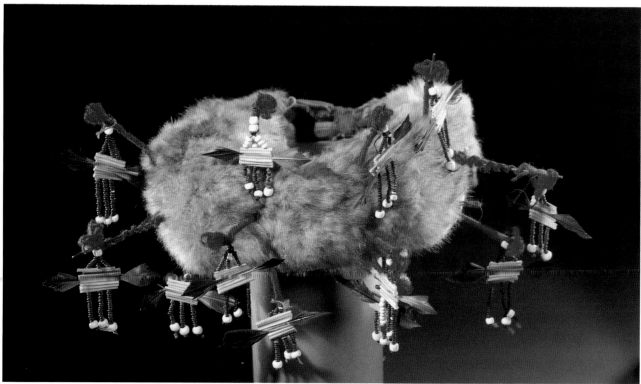

222

and not what I wanted. The person making the Big Head must fast seven days before making it. The feathers in it are rare and expensive. Dr. Hudson told me he had furnished the feathers (1908:97).

Mrs. Hudson had gathered the gull feathers in San Francisco, "having obtained permission from the game warden to kill a gull (1908:15). After Culin's departure, Hudson wrote him: "I have completed my notes on the Kuksu shna [Big-Head headdress] and as the Indian has not finished his nor will probably till Winter I will send on mine," which he offered at a cost, about forty-six dollars.[2] The feathers on this headdress are attached to a twined redbud or dogwood framework, and a projecting "snout," representing the long nose of the Kuksu spirit, is composed of short feathers attached to a stick.[3]

Sally McLendon has suggested a number of ways to evaluate the three headdresses Culin bought. Culin's source of cultural authority in the matter was Dr. Hudson, who may have been mistaken or may have been referring to customs of a different Pomoan group. The artists were in a position to know what they were doing: Charlie Williams and Jim Bateman were doctors, and Bateman was a member of the secret society entitled to make and wear Kuksu regalia. Bateman and Williams may have deliberately omitted details to render the headdress ritually neutral, or the artists may have misunderstood what Culin wanted—especially likely, considering the number of distinct objects covered by the English term *Big-Head*. ɪJ

1. See Barrett 1917a:423–25; Loeb 1926:366, 394, 397; Heizer 1978:666.

2. J. W. Hudson to S. Culin, Aug. 29 and Sept. 9, 1908, Object Files: Hudson Collection. The catalogue card notes that this headdress was made in Pinoleville.

3. Finally, in late December, Tom Mitchell brought his Big-Head in to Hudson. Although he thought it "not quite so well done" as Culin's, Hudson gave him a chance to buy it before offering it to the Smithsonian, which acquired it in 1909. Mitchell told him that it had to be destroyed within three months of its inception if not disposed of by its maker (J. W. Hudson to S. Culin, Dec. 28, 1908?; Feb. 5, 1909, Object Files: Hudson Collection).

223

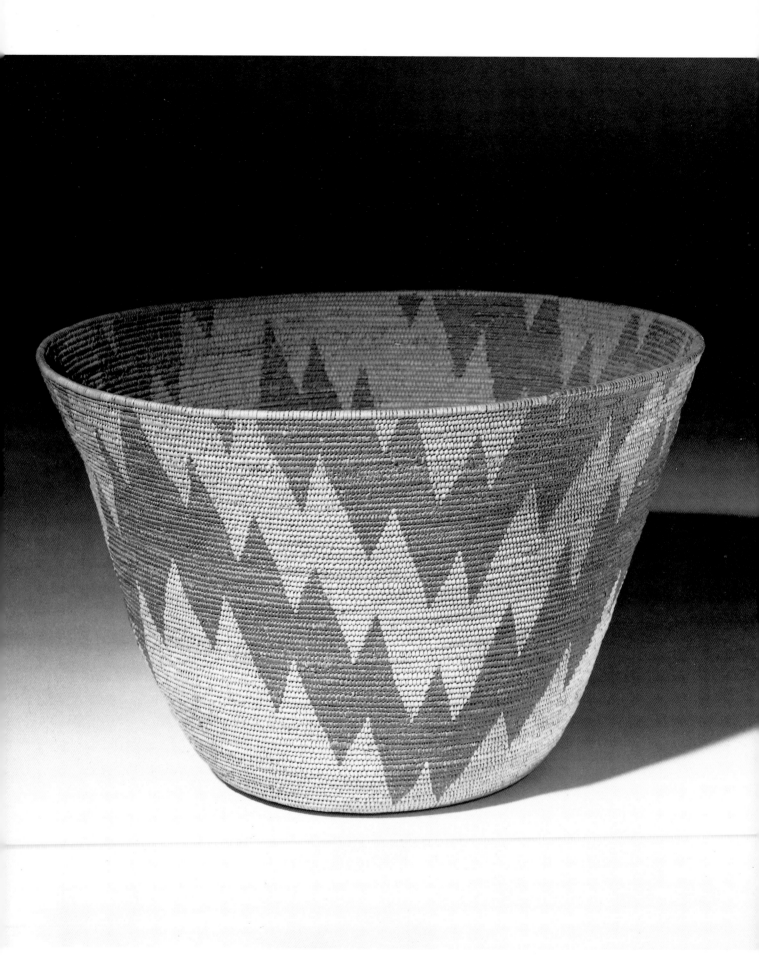

MAIDU

224. COOKING BASKET

Made by Amanda Wilson?; Maidu
Coiled: maple sucker shoots, redbud bark,
willow shoots?, H. 10½, Diam. 16¼
Purchased from Amanda Wilson in Chico,
California, June 6, 1908
08.491.8677

Stewart Culin purchased twenty-nine baskets in Chico from eight individuals. The first house he entered belonged to Amanda Wilson (1860s–1946). The daughter of a Konkow mother and a white father, Amanda Wilson lived her entire life at Chico, her birthplace. She was an important consultant for Culin and many other ethnographers and was also well known as a basket weaver. She continued to weave baskets until shortly before her death.[1] "Mrs. Wilson showed me four large baskets, but told me that she was using them and would not sell them" (1908:26). In the end, though, Culin bought more baskets—eight—from her than from anyone else in Chico.

While most of the vendors were also the weavers, such was not always the case.[2] For instance, while Culin bought this basket from Mrs. Wilson, it may not be one of her own (although Bates had attributed it to her).[3] Of the type called *tsu-li*, it was used for cooking acorn mush. Another Chico weaver also favored this decoration, called *bo-tso*, or "arrowhead," pattern. In any case, it is a bold and attractive design. The main zigzag band entirely encircles the basket, with three smaller, echoing motifs at the rim.

Culin's well-documented collection allows us to try to sort out the range of a Chico style of basketry and the nature of individual variation within it. For instance, one given is that all the coiled baskets from Chico have three-rod foundations of willow-shoot warps and sewing strands of sedge.[4] Within this basic style, it is difficult to firmly differentiate weavers. Only by taking into account all factors—materials, techniques, form, and design—can one get a feel for personal styles. IJ

1. Bates and Bibby 1984:43.

2. Thus, for ease of reference, "Mrs. Cooper's baskets" here denotes "the baskets that Mrs. Cooper sold to Culin" (which are also likely to have been made by her).

3. Bates and Bibby 1984:39. All the artists' attributions in the Maidu section are by Bates, except for the Chapman basket and the Azbill ear pendants.

4. Bates and Bibby 1983:51.

225. ACORN-FLOUR SIFTING TRAY

Made by Amanda Wilson; Maidu
Coiled: maple, redbud bark, willow, Diam.
14¼, H. 2
Purchased from Amanda Wilson in Chico,
California, June 6, 1908
08.491.8680

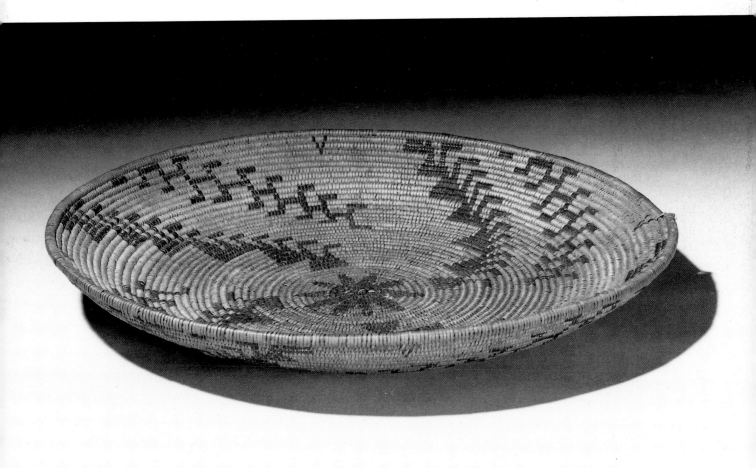

226, 227. COOKING BASKETS
Made by Amanda Wilson; Maidu
No. 226: Coiled: sedge root, redbud, willow
shoots?, H. 7, Diam. 15

No. 227: Coiled: sedge root, briar root,
willow shoots?, H. 6¾, Diam. 13¼
Purchased from Amanda Wilson in Chico,
California, June 6, 1908
08.491.8683; 08.491.8679

Amanda Wilson has employed the quail-plume, or topknot, motif on these two cooking baskets (of the type called a *bush-ka*), as well as on the acorn-flour sifting tray. On No. 226, which she said "was new…and belonged to her husband," are mountain–quail heads (1908:27). No. 227 has two patterns: valley-quail topknot and "grape leaves" (the diamonds). Baskets such as this one, with two or more distinct patterns, seem to be characteristic of the Maidu community of Mikchopdo at Chico.[1]

The quail plume was Wilson's best-known basket design. It appeared in different patterns: some are called mountain quail and others, the more common valley quail. Although basket designs are not necessarily attempts at representation, differences in the birds' feathers are evident in Wilson's designs. The mountain-quail topknot is very long and straight, while the valley-quail plume is curved and thick. Bates suggests that she may have favored this design as a kind of personal emblem; her Maidu name, Oymutnee, meant "the sound made by a quail."[2] IJ

1. Bates and Bibby 1984:43.
2. Ibid.

228. COOKING BASKET
Maidu
Coiled: sedge root, briar root, willow
shoots?, H. 10½, Diam. 17¼
Purchased from Ann Barber in Chico,
California, July 2, 1908
08.491.8811

Mrs. George Barber, the stepmother of Amanda Wilson, sold Culin four baskets, including three large acorn-mush bowls. Like Amanda Wilson's cooking basket (No. 227), this one (the largest of the three) has two designs, placed in alternating pairs on opposite sides of the container. Mary Azbill told Culin that it has "a device like a tree, which she says represents bo-shom-yek-yek-i, arrow chip. The other device on this basket is ba-hu, grape-vine leaf" (1908:71).

While some designs were favored by particular artists, as the quail plume by Amanda Wilson, forms

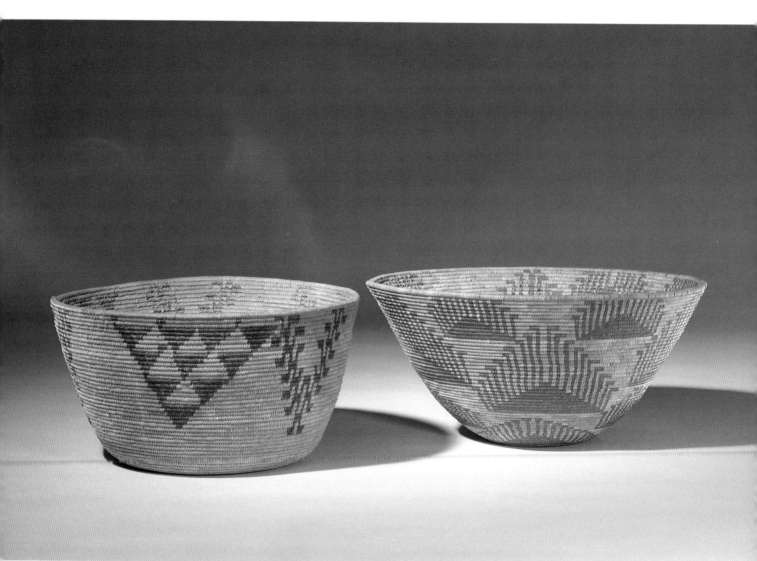

227

226

and designs were generally shared among the Chico Maidu. The grape-vine leaf was a particularly popular motif, also found on baskets by Amanda Wilson (No. 227), and Mary Azbill (No. 229), as well as on the feather belt (No. 246). Wilson's baskets are the only ones shown here in which the leaf diamonds are oriented downward. Barber and Azbill orient theirs with the point upward, although Ann Barber, like Amanda Wilson, combined the grape-leaf motif with another design. Thus, while there is a strong community style at work here, individual artists were free to vary and combine shapes and patterns, within the rules. IJ

229. COOKING BASKET

Made by Mary Azbill; Maidu
Coiled: sedge root, briar root, maple?, willow shoots?, H. 6¾, Diam. 12¾
Purchased from Mary Azbill in Chico, California, July 2, 1908
08.491.8822

From Mary Azbill (1864–1932), Culin bought six baskets—the most from any one vendor except her cousin Amanda Wilson. Azbill's mother was a Konkow Maidu who married a native Hawaiian. Widely traveled and fluent in many languages, she was one of Culin's principal Maidu consultants and, as he noted, "an expert basket maker" (1908:35).

This mush bowl was one of three that Culin bought from Mary Azbill.[1] Like several of the Chico baskets, it has a grape-leaf design. It also happens to be an example of what Bates and Bibby suggest was a

distinctive Chico style: "Many of the cooking baskets are of a squat, almost straight-sided shape, rather than the flaring truncated cone so common with most Maidu cooking vessels. Oval starts, used to begin round baskets, appear frequently and often in association with the distinctively shaped cooking baskets, suggesting a style indicative of the Maidu people of the Chico region."[2] Two of the baskets in this catalogue combine the oval start and the straight-sided, squat shape: one by Amanda Wilson (No. 227) and this one by her cousin. IJ

1. For a photograph of this basket with Mary Azbill and her son, taken about 1906, see Bates and Bibby 1983:52.
2. Ibid.

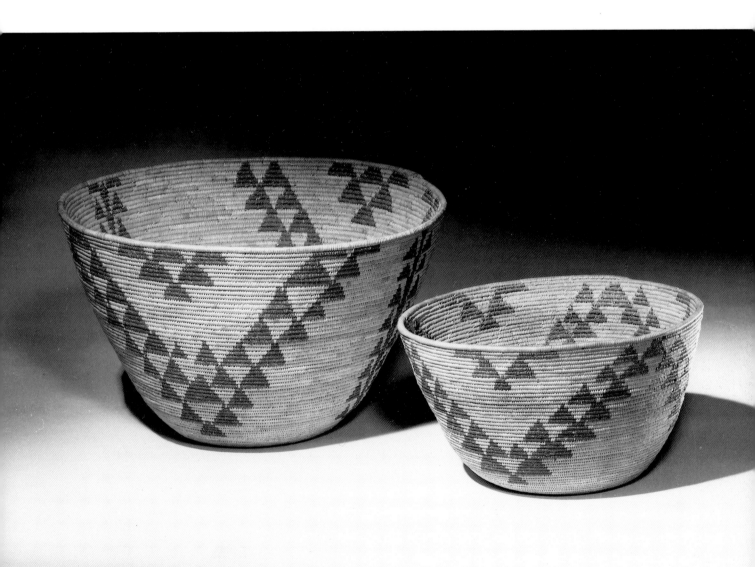

228

229

230. PRESENTATION BASKET
Made by Mary Azbill?; Maidu
Coiled: sedge root, briar root, willow
shoots, H. 8, Diam. 14¾
Purchased in Upper Lake, California,
August 1906
06.331.8050

This especially fine basket has been attributed to Mary Azbill by Craig Bates, who bases his opinion on a comparison with the materials, techniques, form, and style of documented examples of her work.[1] To take one example, the dark design elements are woven in briar root, which has a limited distribution. While it is hard to trim and work with, it was a favorite material of Mary Azbill's, especially on the several baskets she made as gifts for family and friends.

Presentation baskets are invariably fancier than everyday culinary containers, as can be seen in a comparison between this object and Azbill's other food basket (No. 229). While that basket has food residues inside, this one appears never to have been used, and the fineness in the weave and the exactness in the design layout indicate a great deal of planning and patience. Bates suggests that such special pieces tend to be more distinctive of an artist's work than her usual products.

Unfortunately, this basket's surviving documentation is confusing. The object itself has only the number given to it by Culin's successor, Herbert Spinden, in the 1930s. Spinden lists its original Culin number as 8050, with a Pomo and Upper Lake

provenance. Without a firm vendor on Culin's catalogue card, it is difficult to find mention of the object in his expedition report; some evidence indicates that he bought it from Mrs. Penn Graves, whom he noted was "an expert basket maker" (1906a:28); other data suggest that it might be from H. C. Meredith, the clergyman and basket dealer.

Even if the basket came from these Pomo sources it could still quite plausibly be an Azbill basket. The weaver often visited the Clear Lake area, and the intertribal trade in Californian baskets is well documented.[2] Culin himself collected a Pomo basket on the Klamath River and a Maidu boiling basket in the Pomo community of Pinoleville. The Bucknell family of Upper Lake pos-

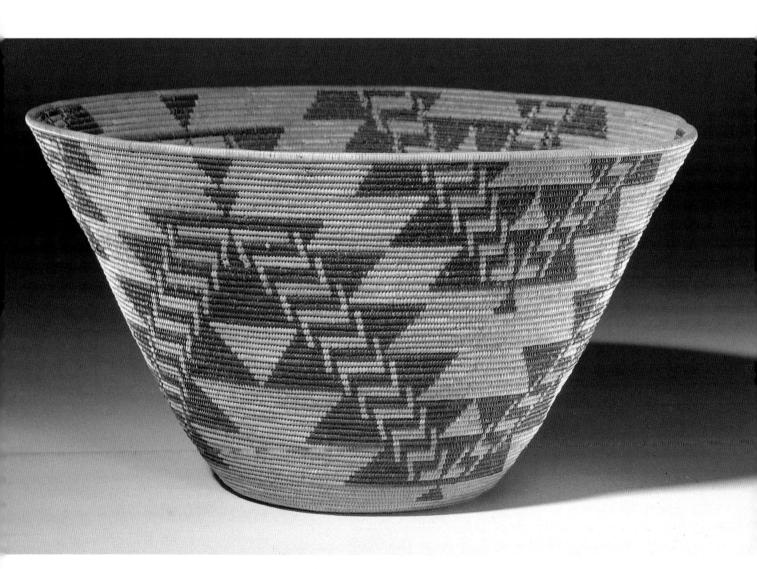

sessed several Maidu objects, such as the feather-and-bead belt (see No. 246). Of course, white traders were also instrumental in the movement of baskets and other artifacts. Whatever its true provenance, this example is without doubt one of the finest baskets that Culin collected in California. IJ

1. The following discussion is based largely on conversations with Bates.

2. See Merriam on Indians as basket collectors (1955:106–9).

231. UNFINISHED BURDEN BASKET
Made by Mary Azbill; Maidu
Twined: willow, pine root, sedge root, bear grass, redbud bark, L. 14, W. 10, D. 5
Given by Mary Azbill in Chico, California, June 8, 1908
08.491.8838
Gift of Mary Azbill

This unfinished burden basket may be the small basket Mary Azbill was making when Culin met her— "the only really fine basket I have seen in all this region" (1908:35). This particular piece was a gift, but Culin would have been eager to collect such an interesting object that clearly revealed the process of manufacture. On the interior one can see the untrimmed ends, which are cut off when the basket is finished. Although this example has become flattened, burden baskets are conical (like the Pomo toy version, No. 214).

Craig Bates has pointed out that this object is a unique combination of materials and techniques. This type of basket is not made by the Konkow Maidu. While both they and the Mountain Maidu make burden baskets, the Konkow do not use the overlay technique, in which a decorative weft element is placed over a twined foundation (cf. Nos. 157, 158). The light overlay material is bear grass, but the material does not grow within fifty miles of Chico. Azbill must have obtained some traded material, perhaps from her husband. In addition, the Mountain Maidu generally use conifer for the foundation, instead of sedge root, as here. This, the only basket of its kind from Chico, is an expression of Mary Azbill's cosmopolitan experience and her personal creativity. IJ

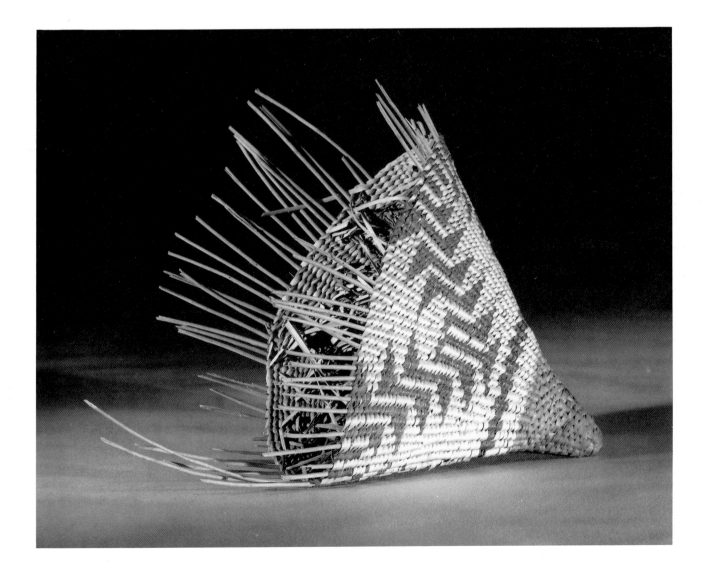

232, 233. Baskets
Maidu
Coiled: sedge root, briar root, willow shoots?
No. 232: H. 3½, Diam. 6½
Purchased from Mrs. Cooper in Chico, California, June 6, 1908
08.491.8675

No. 233: H. 3½, Diam. 7
Purchased from Mary Azbill in Chico, California, July 1908
08.491.8823

234. Storage Basket
Maidu
Coiled: sedge root, redbud, willow shoots?, H. 9¾, Diam. 12¾
Purchased from Ann in Chico, California, June 6, 1908
08.491.8691

For these three baskets, Culin gives a native name of "tu-tu." All happen to be globular, and Nos. 232 and 233 are quite similar in size and shape.

In addition to two *tsu-li* (cooking baskets) and a sifter, Mrs. Cooper[1] sold Culin No. 232, a "small globular basket she called tu-tu, with a pattern designated as lu-lu-ku, 'speckled geese'" (1908:27). Small globular baskets were used for a variety of purposes: for example, serving as food bowls or women's work baskets. The fine condition of this basket suggests that it was little used when Culin bought it.

Although No. 233 was probably made by Mary Azbill, there is some confusion about it. According to its number, the object should be a *tsu-li*, bought from Mary Azbill with a "quail plume and wing" design. However, it closely resembles Mrs. Cooper's *tu-tu* basket (No. 232). Around the same time Culin "also bought from Mrs. Asbel for myself a

small basket of fine work with a black pattern" (1908:60). Its design "was wah-tso, arrow head. This basket is used for pinole [a porridge made of wild seeds], and is called tu-tu" (1908:72). Perhaps Culin's personal Azbill basket at some point was mixed up with his institutional specimen.

Ann, an old woman, sold Culin three baskets: a large boiling basket, a *tsu-li*, and No. 234, a "nearly globular basket, tu-tu, with a pattern designated as o-du" (1908:26). Its three zigzag bands resemble the design placement on Amanda Wilson's large basket with the arrow pattern (No. 224). Culin was told by Amanda Wilson that Ann's husband had paid ten dollars for the basket; this fact suggests that Ann did not make the basket. We know that baskets circulated among the native

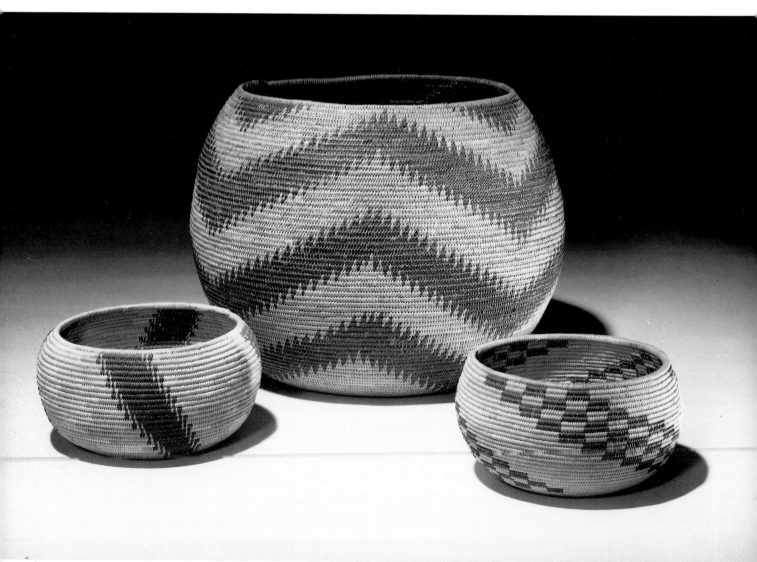

233 234 232

population; they were a common gift item and were also sold. Culin said that Ann's husband "asked me $12 for it, and accepted ten. It appears that the prices these Indians ask me are about those at which their baskets are current among themselves" (1908:26). IJ

1. Bates and Bibby note that this may be Emma Cooper, a well-known Chico basket weaver, or some relative of her husband (1984:40).

235. BASKET
Made by mother or mother-in-law of Hardy Chapman; Maidu
Coiled: maple, bracken-fern root, redbud bark, H. 5¾, Diam. 12½
Purchased from Hardy Chapman in Taylorsville, California, June 17, 1908
08.491.8742

There is no evidence that any of the baskets Culin collected in Chico were made for sale. On the other hand, the heavy trade in Mountain Maidu baskets stimulated the creation of many new baskets for sale, as Culin noted (1908:53). Of the baskets in one "Greenville collection" he wrote, "They were all new and made for sale, but most of them were fine and had good designs" (1908:46). This large basket is a rare artifact type in Culin's collection: an object made neither for native use nor for Culin, but for sale to whites. It is a relatively early version of an innovative style stimulated by the market; a number of Maidu examples with this bicolor decoration were collected around the time of the Panama-Pacific Exposition in 1915.[1]

This basket was offered to Culin by an Indian:

A good-looking and intelligent half-breed drove up with his wife, a very attractive, almost pretty, woman. He explained his wife had some baskets to sell. I accompanied him to his house, also in the town, and bought some six baskets from her for $20. One of these baskets he asked $14 for [illustrated here], and I bought it at this price, with a small, well-made trinket basket thrown in. This basket had a diagonal design in brown and red, and was beautiful, both in form and decoration. The man, whose name was Hardy Chapman, told me that either his or his wife's mother made it, and had completed it last winter (1908:45).

Culin's expedition reports quite often contain indications like this of his personal aesthetic tastes, which were pronounced. IJ

1. The attribution and this comment are from Craig Bates.

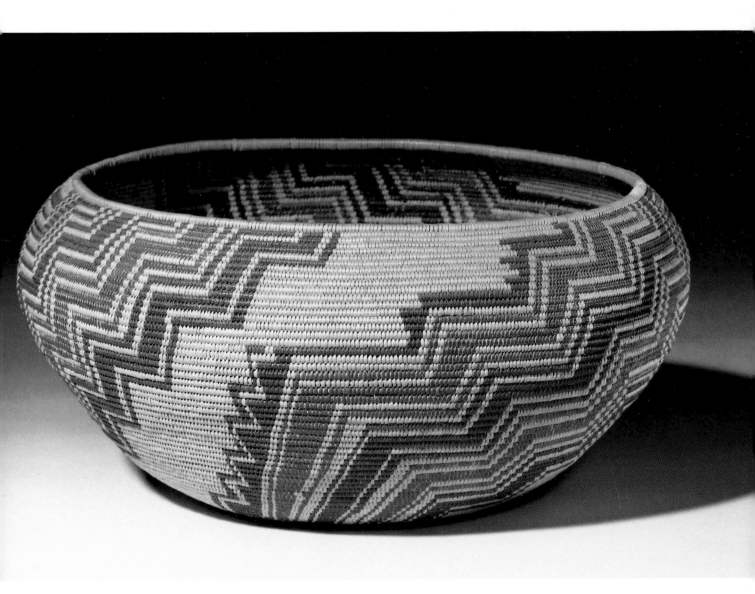

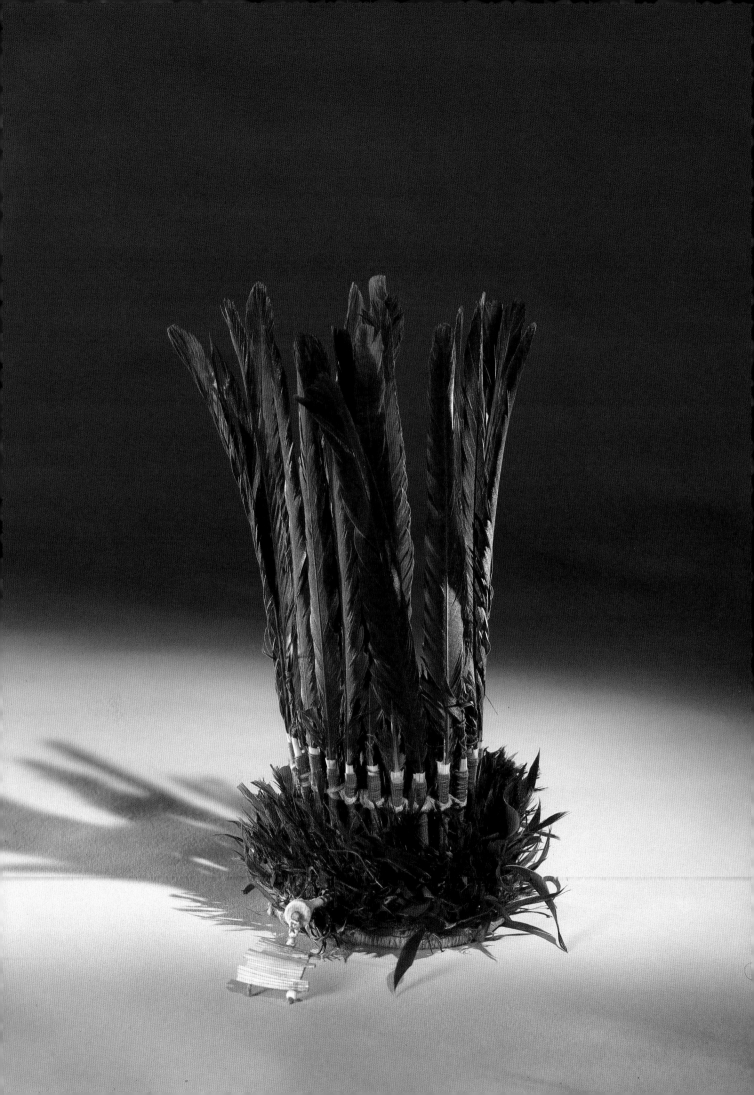

236. FEATHER HEADDRESS

Made by Billy Preacher; Maidu
Magpie feathers, red-shafted flicker quills,
goose quills, clamshell beads, glass beads,
cotton cord, plant-fiber twine, willow rod,
L. 12, W. 7, D. 8½
Purchased from Billy Preacher in Chico,
California, June 6, 1908
08.491.8693

The first Maidu man to sell Culin ceremonial regalia was Billy Preacher, the highest-ranking member of the dance society at Chico.[1] Chico Maidu dances were organized by the Kumeh, a secret society of initiated men, whose proper performances ensured the well-being of the world. Describing his encounter, Culin wrote: "Going over to the rancheria this morning to meet an old man named Billy Preacher. He took me in a frame building back of his house and showed me a lot of dance paraphernalia" (1908:28). Among the regalia that Culin bought were a heron-feather bustle and this headdress. Of two wooden pins, each with three projecting white feathers, Culin recounted, "The price of this, he said, was $8, but I bought it for $5 on account of its not being as fresh as it should be" (1908:28).

Preacher's headdress was worn perpendicularly at the back of the head, not vertically on the crown, as is common with American Indian headdresses or the very similar variety worn by the Yokuts of Central California. In general structure it resembles the Pomo headdress of Captain Tack (No. 221), with the feathers tied onto a string framework. Unfortunately, the headdress is now somewhat worn; originally the ruff feathers were bushier and the tail feathers fuller and more rigid.[2] IJ

1. Bates and Bibby 1983:51.
2. Culin supplied only very minimal information about the construction and use of the Maidu ceremonial regalia. Unlike Dixon (1905:149–54, 283–85), he appears to have been little interested in it. Of course, by his time, the people in Chico had given up dancing, and he was only there for a week and a half. Consultant Craig Bates has supplied almost all the information on the materials identification (especially feathers), use, and comparative collections for the Maidu ceremonial objects (Nos. 236–46). While references are made to his numerous publications, many of his unpublished comments have also been incorporated here. Unless attributed to Culin in direct quotations, statements about these objects are derived from Bates.

237. WOMAN'S DANCE HEADBAND

Maidu
Acorn-woodpecker tail and scalp feathers,
bird quills, clamshell beads, glass beads,
cotton and silk cloth, plant fiber, W. 3½,
Diam. 10
Purchased from Ann Barber in Chico,
California, June 7, 1908
08.491.8696

Culin bought two of these *wot-so-li*, a distinctive type of headband found only among the Chico Maidu. The first came from Ann. The following day, Amanda Wilson took Culin "to her mother's house where I bought a woman's dance head band." Amanda Wilson's stepmother was Mrs. George Barber, also named Ann. As he noted, her headband "was in better condition and more aboriginal in its appearance than the one I bought from Ann" (1908:31). Perhaps not accidentally, these objects resemble the Pomo women's headbands (see No. 222). Both types have pendants attached to a round band tied around the head. This *wot-so-li* has five crosses of quills, beads, and feathers. The only other one in museum collections was acquired a few years earlier by Roland Dixon for the American Museum of Natural History, New York. IJ

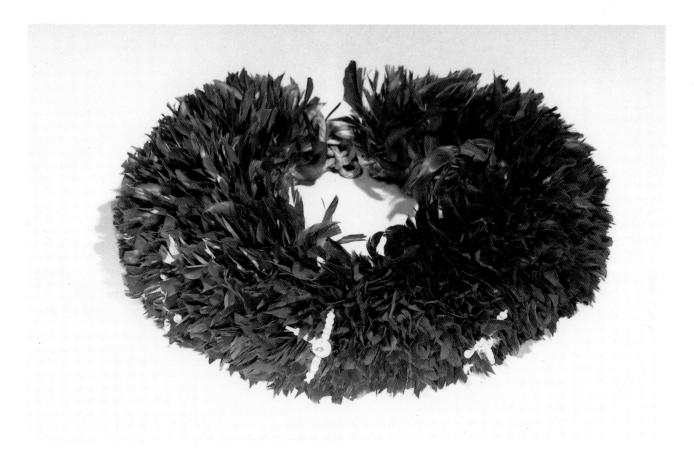

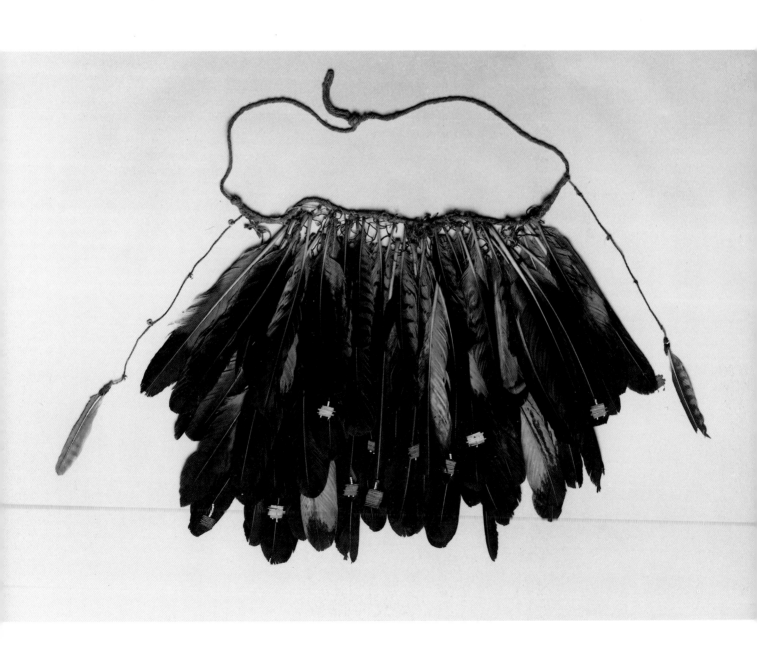

238. CEREMONIAL DANCE CAPE
Made by George Barber; Maidu
Bald- and golden-eagle feathers, red-tailed hawk feathers, prairie-falcon feathers, acorn-woodpecker scalps, red-shafted-flicker quills, clamshell beads, glass beads, cotton string, hemp twine, Indian-hemp twine, dye, L. 22, W. 21
Purchased from George Barber in Chico, California, July 2, 1908
09.491.8799

Culin's success in obtaining the unique set of ceremonial regalia shown in Nos. 238–44 depended on circumstances and the misfortune of others. With the death of Holai Lafonso and the subsequent destruction of the dance house at Chico, many members of the secret society decided to give up dancing. George Barber (ca. 1833–1918), the society's second in rank, was one of them, and he sold Culin a feather mantle (No. 238), a hairpin (No. 241), two plumed pins, a single plumed stick (No. 242), a knitted cap, and another plume stick. After supper, Culin returned and bought from Barber two more plumes (No. 240), "a hair ornament" (No. 239), and "a very fine ceremonial pin for twelve dollars" (No. 243) (1908:60–61).

Maidu dance regalia was owned individually (not communally), generally made by the user, stored for repeated use (not made afresh), and destroyed at the owner's death (not handed down). The set Culin purchased consisted of most of George

Barber's regalia for the Toto dance. (The Toto, also called the Common Dance, is the least sacred of the Maidu sacred dances and can be given at any time of the year.)[1] As Bates and Bibby write, "This is particularly significant as the regalia provides a rare opportunity to observe one man's aesthetic employed in the manufacture of a complete ceremonial outfit. The quality of materials, workmanship, and the artistic imagination of George Barber are quite evident in these pieces."[2] Actually the set is unique so we cannot compare it to similar *sets*, but comparisons to individual pieces can be made. Most of these objects had been in use for many years, perhaps decades, when Culin acquired them.

A common form of Californian ceremonial regalia, this cape was worn at the dancer's back, covering the buttocks. Such regalia was first made when a dancer was initiated into the dance society, as a teenager. Although new pieces could be made when they wore out, this particular piece has seen a lot of use. Evidence of native repairs with Indian-hemp fiber can be found on the net. Within the basic style, there was room for personal taste. Barber's style can be seen in the diversity of quill flags, each made differently, in different sizes, shapes, and ornamentation. IJ

1. See Kroeber 1925:434.

2. Bates and Bibby 1983:51.

239. FLICKER-FEATHER HEADBAND
Made by George Barber; Maidu
Flicker feathers, quills, cotton string, plant-fiber twine, L. 31¼, W. 5¼
Purchased from George Barber in Chico, California, July 2, 1908
08.491.8808

A common type of ceremonial regalia in central California, flicker-feather bands were worn horizontally over the forehead, down over the eyes, with the two ends flapping loosely at the side.[1] Pomo and Maidu versions are practically identical. The vivid contrast of colors—orange from stripped shafts, black from the natural-shaped tails—is produced by using different feathers of the same bird.

Though flicker bands were often made by specialists, George Barber probably made his own. Commenting on Barber's personal style, Craig Bates has noted several features of this band. The fiber ties are usually at the temples, but these are so long that they would tie in back of the ears, meeting the owl-feather bunches (No. 240), and covering all of the hair net. Another Barber characteristic was his omission of tail feathers at the end. Bates suggests that this is where they would break off when the band is rolled up in storage. IJ

1. Bates and Bibby 1980.

240–42. CEREMONIAL HAIR
ORNAMENTS
Made by George Barber; Maidu
No. 240: Head plume
Barn-owl feathers, acorn-woodpecker scalp,
clamshell beads, glass beads, cotton string,
L. 15, W. 14

No. 241: Ceremonial hairpin
Stripped red-shafted-flicker tail feathers,
acorn-woodpecker scalp feathers, valley-
quail topknot feathers, abalone shell, glass
beads, oak pin, iron wire, cotton string,
wool yarn and cloth, H. 11½, W. 5¾, D. 4¾

No. 242: Head plume
Acorn-woodpecker scalps, prairie-falcon
feathers, quail topknot feathers, hide, glass
beads, cotton string, wool, dye, iron wand,
wood, L. 16¼, W. 2
Purchased from George Barber in Chico,
California, July 2, 1908
08.491.8807; 08.491.8801.1; 08.491.8802

These various items are selections
from the set of feathered plumes that
are stuck into the hair net at the
back of the head. The visual impres-
sion of the dancer's headgear was
dominated by the three owl-feather
pins—which fit into one another,
making the entire mass that much
larger and impressive (No. 240 and
two more). This tripartite arrange-
ment was another characteristic of
Barber's individualistic treatments of
Toto regalia. The owl feathers are
tied to a small network of quills
wrapped with string. Hidden in the
middle of the bunch is an acorn
woodpecker scalp on a beaded
string—simultaneously a prayer-
offering and a sign of wealth (there

is another in the plume stick, No.
244). George Barber was the only
one to make these offerings in his
regalia.
 At either side of this owl bunch
are one or two pairs of triple-
pronged hairpins (No. 241). Wire is
used because the desired effect is to
make them tremble as the dancer
moves.
 Stuck into the bunch of owl
feathers and standing straight up at
the back is the feathered pin (No.
242). According to Bates, this head
plume probably indicates one's posi-
tion in the secret society. As such, it
is functionally similar to the wand
(No. 243), which it resembles. Com-
pleting the costume was the flicker
band on the forehead, and several
more plume sticks held in the hand.
IJ

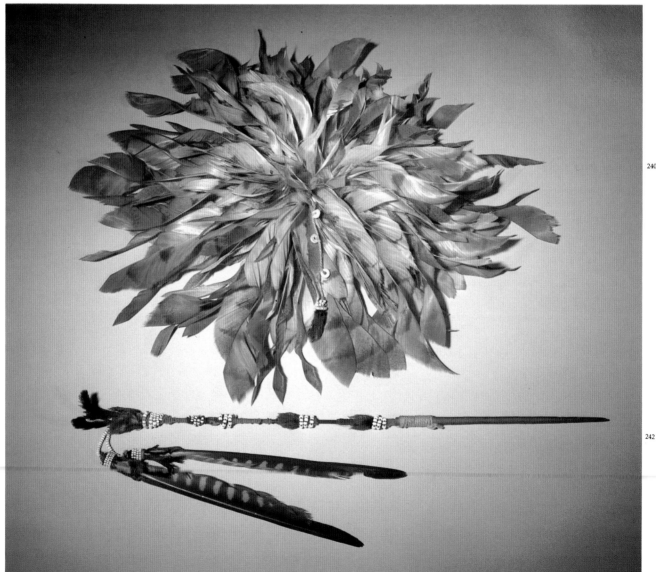

240

242

241

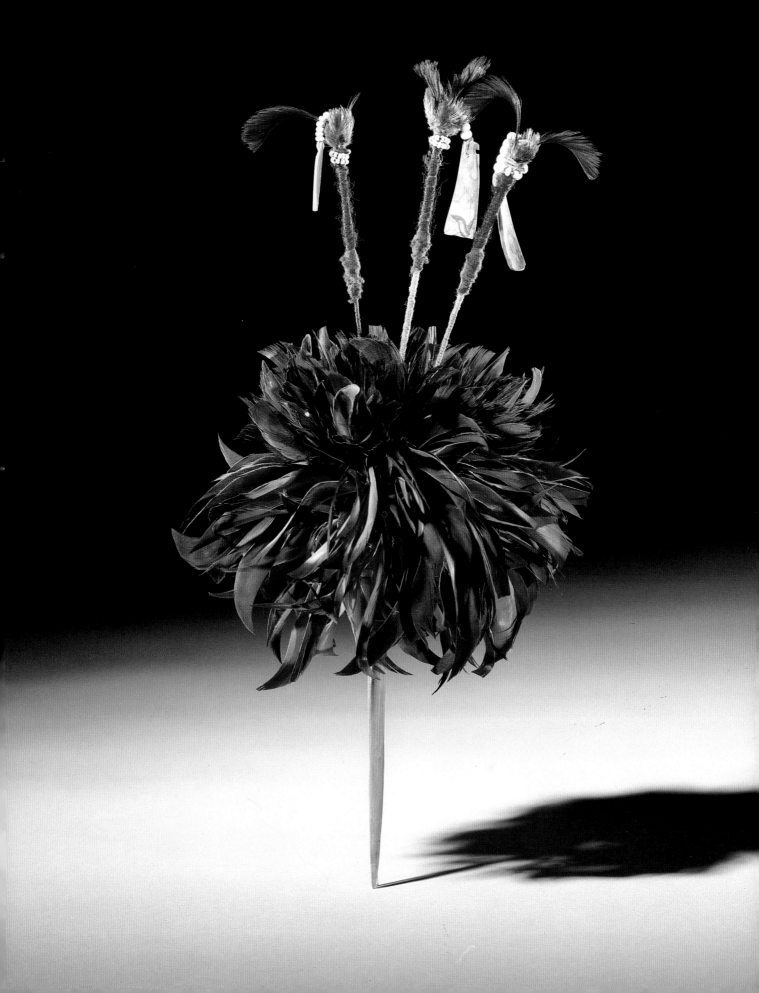

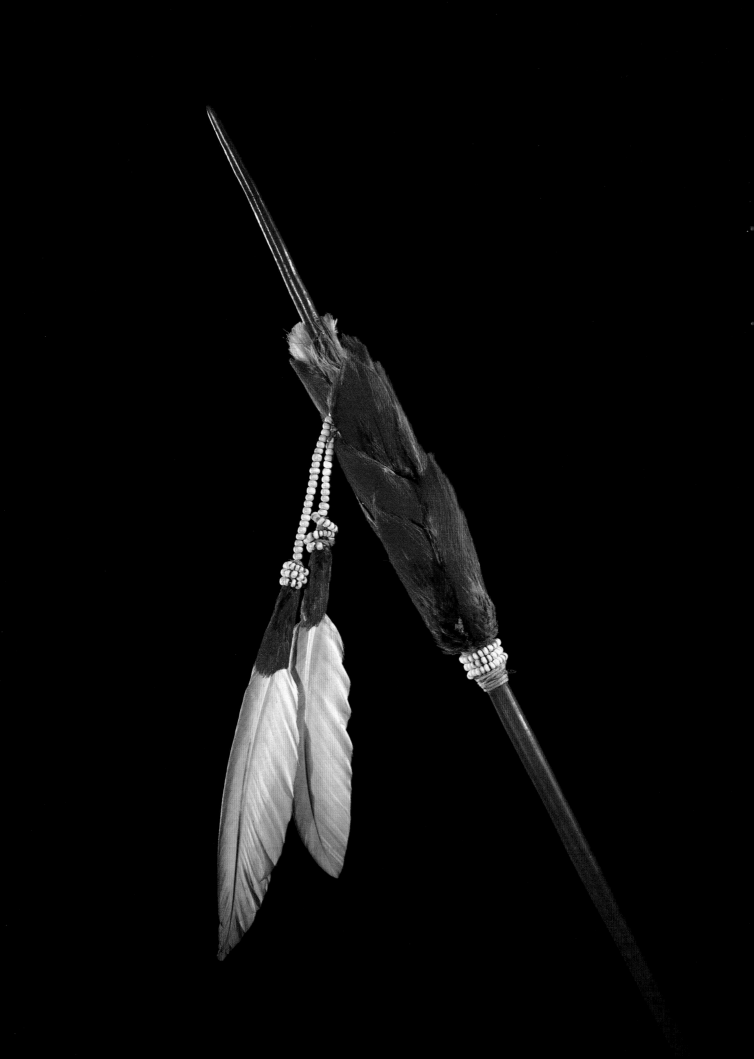

243. HEAD PLUME
Made by George Barber?; Maidu
Manzanita wood, pileated- and acorn-
woodpecker scalps, swan feathers, glass
beads, cotton string, L. 19¼, W. 3,
Diam. 1½
Purchased from George Barber in Chico,
California, July 2, 1908
08.491.8812

Culin was excited to get this "very fine ceremonial pin," which was worn straight across the back of the head, stuck into the hair net. "This pin I understood George to say was his insignia as captain, and had been a gift" (1908:61). If the pin was indeed a gift, then it was not likely to have been created by Barber. Bates indicates that one used it while singing, not dancing, and that it was not part of the Toto regalia.

The raw materials are responsible for much of the effect of wealth and prestige. As the larger pileated woodpecker does not live around Chico, its feathers must be traded from the mountains. The pin employs sixteen of the scalps—a multiple of four, the sacred number. The manzanita wood for the shaft is especially hard and difficult to carve. IJ

244. PLUME STICK
Made by George Barber; Maidu
Great-horned-owl feathers, hawk feathers,
woodpecker scalp feathers, glass beads,
wood, cotton string, L. 21¾, W. 11½, D. 7
Purchased from George Barber in Chico,
California, July 6, 1908
08.491.8841

Although Culin commissioned this hand-held plume, the initial result was not to his liking: "I also bought a plume called wa-pol-do from Barber, one that he had recently made for me. It was mounted on a wire rib of an umbrella, and I left it with him to replace the wire with an oak stick" (1908:67). Maidu people seem to have appreciated iron wire shafts, although they were not aboriginal, because they bounced around freely. For his exhibitions of the "vanishing Indian," Culin needed artifacts that appeared to predate contact with the white man.

This plume, like many pieces of regalia made by George Barber, has a woodpecker scalp and beads buried inside. IJ

245. WOMEN'S CEREMONIAL EAR PENDANTS

Made by Mary Azbill; Maidu
Crane wing bones, sedge root, acorn-woodpecker scalp feathers, abalone shell, clamshell beads, glass beads, cotton string, plant fiber, pigment, L. of bone 9, W. of disk 1½
Purchased from Mary Azbill in Chico, California, July 2, 1908
08.491.8826.1–.2

Worn by both men and women, tubes of bone or wood pushed through a hole in the ear were a common form of personal adornment in central California, and Culin acquired several Pomo and Maidu examples. Long bone tubes such as these were worn by wealthy Maidu women in the dance society. They are especially impressive, with their heavy shell-and-bead pendants and woodpecker scalps, signifying wealth. The crisscrossing patterns on the shaft were made by pyroengraving the bone with a hot wire.

Culin commissioned this set, the only Maidu one of its kind in a museum collection.[1] Although Mary Azbill had the two basket and feather ends, she lacked the bones. These Culin supplied, having acquired them earlier from a local hotel owner. However, on the day before he was to leave, Mrs. Azbill had still not finished them, so Culin "gave her an express tag, with my name, and the museum address," so that she could mail them to him when she had finished them (1908:75). More than fifty years later, Mary's son, Henry, remembered Culin's visit, when he was then about ten: "Henry was so impressed with his mother's artistry that he tried to persuade her to keep the earrings and give them to him; but she staunchly refused, saying that they were made for the man in New York, and that that was where they were going."[2] IJ

1. Bates and Bibby 1983:53.
2. Ibid.

246. CEREMONIAL FEATHER BELT

Maidu
Mallard-duck feathers, acorn-woodpecker scalp feathers, glass beads, native hemp or jute twine, cotton cordage, L. 67, W. 6
Purchased from Ann Barber in Chico, California, July 6, 1908
08.491.8925

Culin first saw a Maidu feather-and-bead belt in 1906. A Pomo man in Upper Lake had one, which Culin declared was "the finest and most beautiful thing I have seen" (1906a:35), and the following year he decided to buy it for $100, the most he ever paid for a single Indian object (1907a:127).[1] The owner had bought the belt from the Chico Maidu, and when Culin finally arrived in Chico during 1908, he was very excited to find that another existed. Mrs. George Barber "had a belt hung up on the porch of her house to show me.... This belt is the finest of the three I have seen, and is of nearly the same size and quality

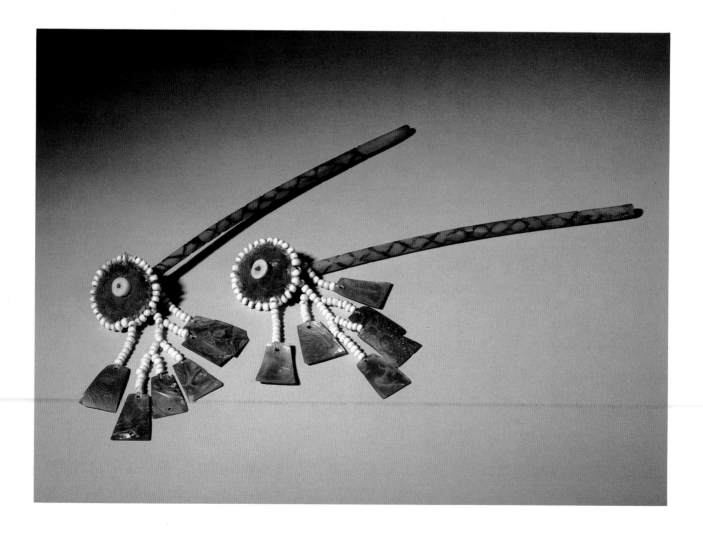

as the one I bought last summer" (1908:31). Returning to Chico after his trip to the Mountain Maidu, Culin entered into negotiation with the Barbers for the belt. He offered $50, and George Barber came down from his price of $100 to $60. "After much discussion I bought the belt for $55" (1908:66).

Culin was able to gather a great deal of information on the belt's history and symbolism. According to Mrs. Azbill,

when she first came in the country everybody of any wealth and importance had a belt. People married with them. The man gave it. Men wore it in the War dance. This was the only way they used it. It was a woman's belt. The belt I bought had been given to Mrs. Barber by her first husband, Pomaho, who married her with it. When he died, she fell heir to it. People said she should have buried the belt with her husband (1908:71).

Bates and Bibby note that it was wrapped around the waist of the dancer twice, for the Hesi, Toto, or Kenu dances.[2]

George Barber explained that "the patterns on the belts were the same as those on baskets." The red triangles, composed of the scalp feathers of twenty-five woodpeckers, were called grapevine leaves; the two narrow green strips, composed of duck feathers, were named after the tongs "used to lift the stones in boiling mush" (1908:66). White glass beads completed the design.[3] William Benson gave Culin information about "the belt I had bought on Upper Lake" that also applies to this example: "[It] was made on a loom. . . . The knot on this belt, where the threads came together at one end, was called the navel" (1908:15).

Mrs. Bidwell, the patron of the Maidu community at Chico, told Culin that "she had recently purchased a feather belt, after trying for some thirty years to secure one. The last maker of these belts was an old man named To-no-ko who died some years since and the art perished with him" (1908:34). Craig

Bates estimates that the Barber belt was made between 1855 and the 1870s. Culin did find another feather belt in Chico, but as it was not as large nor as fine as the one he had, he gave up negotiations when the owner would not lower his price (1908:69).

Feather belts were the supreme Maidu representation of wealth and, as such, were prime candidates for destruction at death. They are thus very rare, and of those extant, Culin's belt is one of the most beautiful and is certainly the best documented.[4] IJ

1. This belt was exchanged with the Museum of the American Indian, New York, in 1960.

2. Bates and Bibby 1983:49–51.

3. The weft is cotton. While George Barber told Culin that the warps were made of "Indian cord called poo or lak-lak-a" (1908:66), they may be commercial twine or a mixture of native and commercial cordage.

4. For a review of Californian feather belts, see Bates 1981.

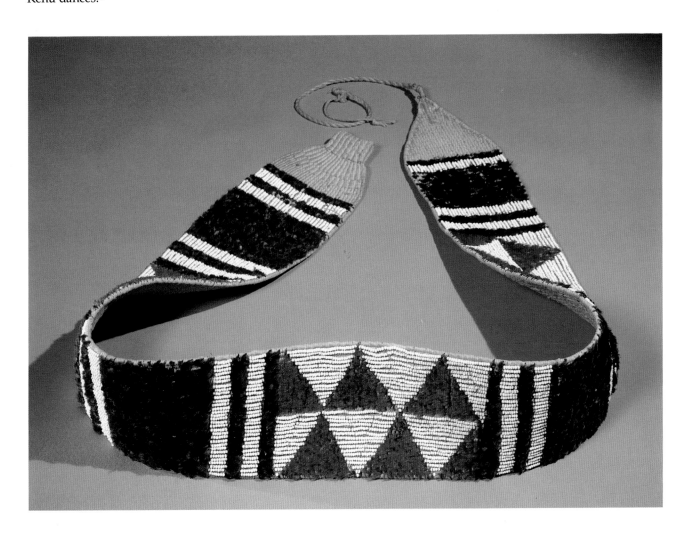

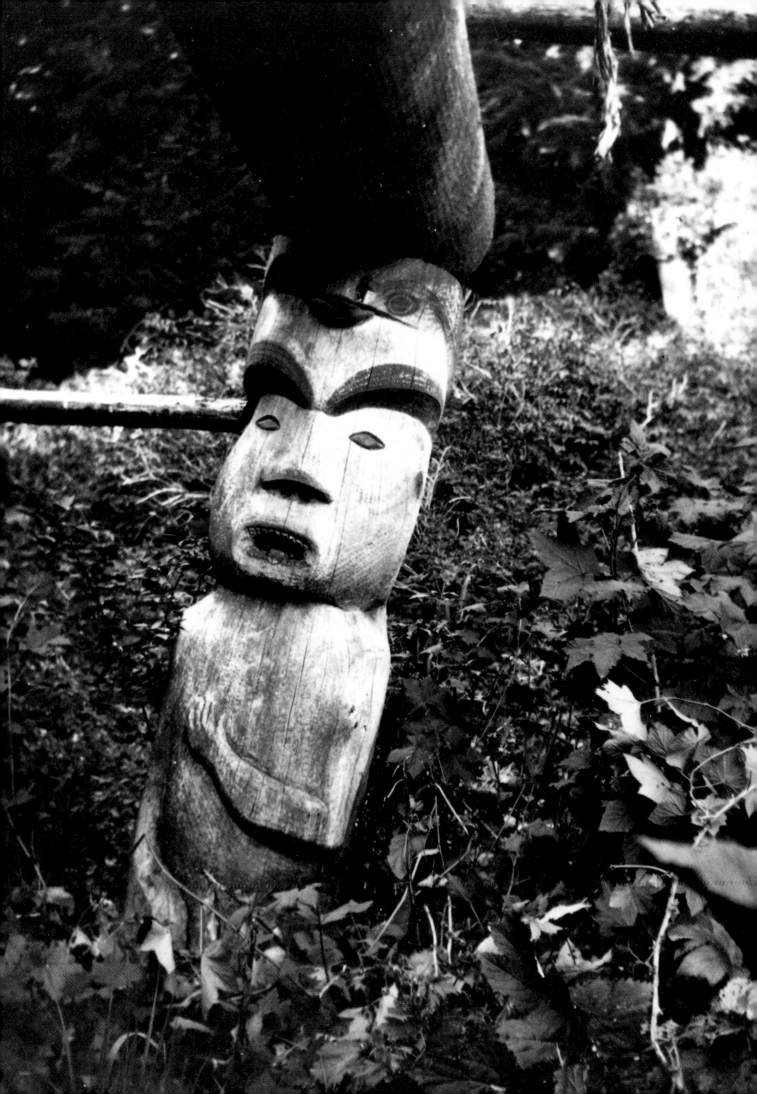

THE NORTHWEST COAST

Ira Jacknis

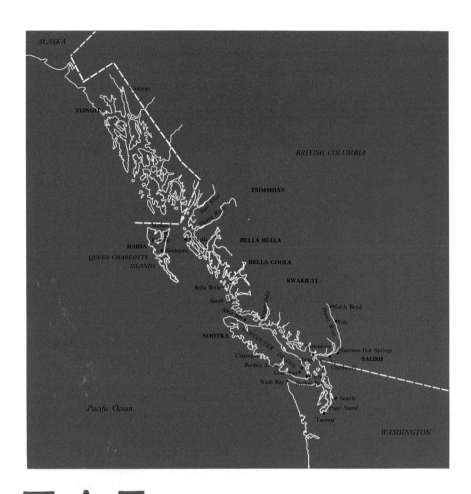

WHEN STEWART CULIN ARRIVED at The Brooklyn Museum, the collections held virtually nothing from the Northwest Coast, just four baskets from the Thompson River. Fearing perhaps that they had too much material from the Southwest, the trustees suggested to Culin that he visit Alaska for his 1904 field season.[1] Although he successfully convinced them of the need for further southwestern acquisitions, Culin undoubtedly realized that it was necessary to include the impressive and distinctive art of the Northwest Coast in order to have a representative American Indian collection. Accordingly, he journeyed to the region in 1905, 1908, and 1911.

Culin had first visited the Northwest Coast in 1900 (1901a:144–54). Collecting for the Museum of the University of Pennsylvania, he had traveled with George Dorsey of the Field Museum, who had visited the area in 1897 and 1899. While the pair stopped in Portland, Tacoma, Seattle, Victoria, and Vancouver, the major episode of the trip was the day spent on the Makah reservation at Neah Bay, at the northwesternmost tip of Washington State.

In Victoria, Dorsey introduced Culin to Dr. Charles F. Newcombe (1851–1924), a retired physician.[2] The English-born Newcombe had begun

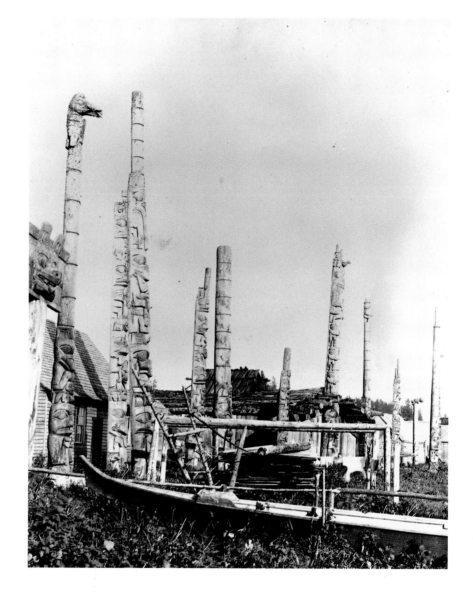

collecting natural and ethnic specimens upon his arrival in Oregon in 1884, and his interest deepened when he moved to Victoria in 1889. From 1897 on, he dedicated his life to collecting Northwest Coast Indian artifacts for the world's museums. In fact, he would soon be retained by Dorsey as the principal Northwest Coast collector for the Field Museum, a role he performed from 1901 to 1905. He guided the two ethnologists to nearby Indian reserves, local curio shops, and the British Columbia Provincial Museum, and sold Culin nearly two hundred items, including two Haida totem poles.[3] Charles Newcombe would play a crucial part in the formation of Culin's Northwest Coast collection for Brooklyn.

Creating a Collection, 1905

On an expedition devoted mostly to California and the Southwest in the summer of 1905, Culin spent three days in Victoria (August 12–15). In making the journey, he hoped to secure an important Northwest Coast collection at a single stroke, by acquiring specimens from the stocks Newcombe had accumulated over more than a decade of collecting. Thus he allowed only enough time to review Newcombe's collection and come to an understanding.

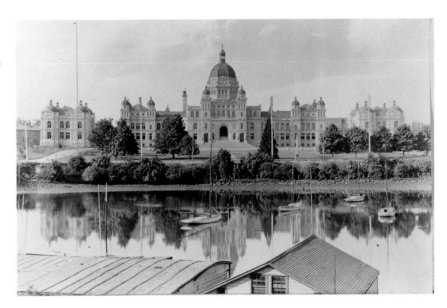

Although Culin examined other museums' holdings and was probably familiar with the literature, his basic knowledge of Northwest Coast cultures and artifacts came overwhelmingly from Newcombe. His repeated visits amounted to an ongoing seminar: "Dr. Newcombe has devoted much attention to the analysis of Haida design. He showed me the successive steps by which he identified the figures on the silver 'coppers' [ceremonial shields] as referring to the dogfish" (1908:92). Even when Culin himself bought directly from native owners, he was usually accompanied by Newcombe. Culin thoroughly trusted his friend's judgment; in 1911, after he had returned to New York, he relied on Newcombe to make a suitable selection of Haida boxes in a local curio shop.

Culin's rhetoric in his expedition report clearly was meant to heighten the trustees' appreciation for the Newcombe collection: "My visit was an opportune one. He was anxious to sell his collection, but, unwilling to dispose of it to dealers, had declined all their offers." Only a few days before Culin's arrival, he noted, the Pasadena dealer Grace Nicholson had been in Victoria, "extremely anxious to buy it all," but Newcombe, who sold only to museums, refused her (1905:43).

Newcombe's collection, stored in his backyard barn, numbered 1,060

Fig. 59. Kwakiutl house post, Smith Inlet, B.C. Charles F. Newcombe photograph, 1905, from 1905 expedition report. Newcombe sold this post to Culin in 1905. The Surrealist artist Max Ernst bought it in 1942, after The Brooklyn Museum deaccessioned it. In 1975 Ernst donated the sculpture to the Musée de l'Homme, Paris.

objects, which he was offering at a price of $4,500. "This original catalogued collection he would only sell in one lot," noted Culin:

> His more recently acquired, uncatalogued material he had intended to add to it. I carefully examined this valuable and most desirable collection of objects from the Northwest Coast that remains to be acquired by our museum... Convinced that I could not too strongly recommend its purchase to the Trustees of our Museum, and so informing Dr. Newcombe, I persuaded him to agree to sell me the new, uncatalogued, objects... with the understanding that I would urge the purchase of his entire collection, the specimens which I would bring back giving an idea of the wealth of the major part (1905:44).[4]

An added attraction for Culin was the excellent state of Newcombe's collection documentation. With his background in natural science, the objective and meticulous Newcombe always supplied valuable information with his specimens. Generally he offered object type, tribal origin, native name, collection locality, and some comments on iconography or use. Like most collectors of his time, however, he omitted the names of native owners or makers.[5]

Drawing on this documentation, the two men proceeded to catalogue the collection, which came to a total of 184 specimens, worth $752.75.[6] Tribally diverse, the collection contained objects from the Haida, Kwakiutl, Nootka, and Salish (as well as some Tlingit, Tsimshian, and Athapaskan). Among the more important objects, Culin singled out a Tsimshian doctor's outfit for the cannibal dance (No. 284), a Tsimshian chief's frontlet (No. 285), two carved Haida clubs (No. 280), and a series of Salish spindle whorls (Nos. 269, 270) (1905a:44–45). However, he felt "the largest and most important things" were the two house posts (Fig. 59) and speaker figure (Fig. 60, No. 292) that Newcombe had just brought down from Kwakiutl territory.

Significantly, Culin declined Dr. Newcombe's invitation to make a two days' trip to the Salish village at Cowichan. With the Newcombe collection in hand, his mission had been accomplished. Though relatively modest, the fine quality of this collection allowed him to make a proper representation of the Northwest Coast in his American displays.

Filling In the Gaps, 1908

In setting out his plan of work for the 1908 season, Culin expressed his desire to travel to "one of the Indian towns on the Northwest Coast, probably on Vancouver Island," as well as to visit Dr. Newcombe in Victoria.[7] Keenly aware that he still lacked tall totem poles, he wished to acquire one, as well as another house post. (At this time, the Northwest Coast collection consisted of 184 objects obtained from Newcombe and 30 other pieces.) He also pointed to the necessity for "much additional information" from the field for labels and sketch material for H.B. Judy's murals.

On this journey to the region, Culin doubled the time he spent, to a total of six days in Victoria (July 10–15), during which he purchased forty-eight objects.[8] As on each of his Northwest Coast expeditions, the first thing Culin did was visit Newcombe. The doctor recommended a trip to the curio shops, to be followed by one to the local Indian camps. As Newcombe explained, Indians stopped in Victoria on their way to and from the hop fields and canneries of the south. Now was a particularly good time to collect, as "they are poor and need money, and have things they have brought to sell. Returning they have money, are full of whiskey, and indifferent" (1908:79).

All of the objects that Culin bought from Indians on this trip came

Fig. 60. Kwakiutl speaker figure (No. 292), Smith Inlet, B.C. Charles F. Newcombe photograph from 1905 expedition report.

from the several Nootkan (Hesquiat, Ehatisaht) encampments and the Salish on the Indian reserve across the river from Victoria. These local Songhees Salish, as well as more northern natives who had been coming down to Victoria for decades, were urban Indians. Culin found the camps and houses on the local reserve "in the highest degree picturesque." Though attracted to several old communal houses, he proclaimed one "inexpressibly filthy." Next to it were neat cottages "indistinguishable from those of the white people adjacent." Many natives were living in tents, their canoes drawn up nearby. The women in the Hesquiat encampment were selling small grass trinket baskets, "all, without exception disfigured with aniline dyes, so that I looked in vain for one that I could put in the museum collection or employ as a present." All around him Culin saw fish, "in every stage of desiccation and decay." In fact, "the fishing industry and basketry furnished about the only material emblems of their old culture" (1908:81–82).

Culin's collections were quite miscellaneous: a fish club, bows and arrows, adzes (No. 249), bark beaters, hats, mats, a paddle, a cradle, a basket, and stone fishing-line sinkers. While most were the kind of domestic implements that Indians happened to have on hand, several objects were commissioned—a cedar-bark raincoat, counting sticks, a cradle cover.

Perhaps the most systematic collection was his set of eight games, representing his special interest, though this haul was somewhat fortuitous. At the Hesquiat camp Culin commissioned a man to make a set of counting sticks for the hand game and a battledore and shuttlecock set. When he went to pick them up, he found that the seller "had passed the word around among the men of the camp that I wanted games" (1908:90), and he came away with shinny sticks and balls, bones for the hand game, bone dice (No. 250), tops, buzzes, and guessing-game sticks. Many of these ephemeral objects had been constructed especially for him, as they were often made up anew for each use.

Having begun with a round of the curio shops, Culin waited until the end of his visit to make his purchases. Northwest Coast Indian artifacts had been firmly entrenched in a thriving and competitive commercial market since the early 1880s, and Culin visited the local emporia on each of his trips. "Dr. Newcombe was anxious that I should visit the curio shops that I might see the prices they asked and discover for myself the character of the material they are now offering" (1905:46). Culin's favorite shop was the establishment of Frederick Landsberg (Fig. 61). In 1905 he found that he was "favorably remembered" from his first visit in 1900, when he had made a substantial purchase for Philadelphia.

Culin's selections from Landsberg's stock were few and discriminating. Among the nine mostly Haida and Kwakiutl objects were a Haida helmet, a Kwakiutl grave marker in the shape of a copper, a Tlingit beaded pouch (No. 247), and several Haida spoons (No. 260). Although he had just picked up for himself six silver pins at the Hesquiat camp, Culin bought some Haida silver jewelry from Landsberg: a bracelet ("the best old one that he had") for himself and, for the Museum, an eagle and two pins in the form of coppers. Landsberg's, he felt, were much finer (1908:92, 90). Such "arts of acculturation" are rare in Culin's collection. Many curators thought that nonaboriginal materials such as silver and novel media such as Haida argillite stone carving were not "traditional." Aside from these silver pieces, there are no such types in Culin's Northwest Coast collections.

By chance, while Culin was in Victoria he encountered his old boss from the Chicago World's Fair—Frederic Ward Putnam, director of Harvard's Peabody Museum. Putnam asked about the items that Newcombe

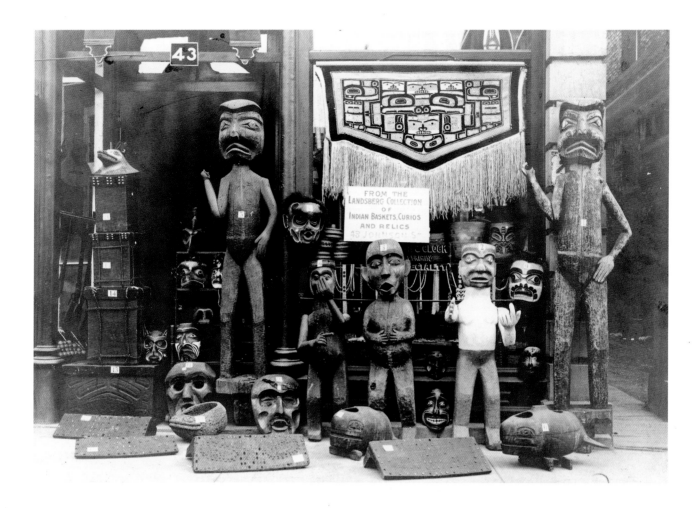

Fig. 61. Frederick Landsberg's curio shop, Victoria, B.C. Photograph from 1908 expedition report.

had set aside for Culin, and as ever, competition spurred Culin on: "The knowledge that Putnam was after these things led me to conclude this purchase" (1908:92). Though few in number, most of the nine objects Culin bought from Newcombe on this trip were spectacular: a Kwakiutl thunderbird mask (No. 288) and whale mask (No. 287), a pair of Nootka masks (No. 289), a Haida carved chest (No. 290), a large piece of worked jade, two Haida fish traps, and two Salish cradles.

Other sources of native art tempted Culin. On his way north to Victoria that year, he had again stopped off in Tacoma to see the D. F. Tozier collection at the Ferry Museum. This collection runs like a leitmotif through his expedition reports, as he visited it on every one of his Northwest trips. Tozier had used his job as captain for the U.S. Customs Service to scavenge curios from coastal villages. Hearing in 1905 via Grace Nicholson that "extremely valuable objects" could be purchased "for a song," Culin had convinced Newcombe to accompany him to review the collection. Its prospective sale was an "opportunity... not to be neglected." Though he "coveted" seven "large Kwakiutl house posts, old, black with age, admirably carved and highly interesting in design," Culin found little of interest, and almost all was without documentation (1905:48–50). Generally, Tozier's prices were double what Landsberg was asking for comparable pieces. Culin felt that many of the objects would be of interest to the Museum if offered for less and asked Newcombe to keep him informed of the posts and some of the smaller carvings. In the end, he bought nothing from the Tozier collection, which was ultimately acquired by George Heye in New York. Instead, he turned to curio dealers or Newcombe himself to fill the gaps in his representation of Northwest Coast Indian culture.

Closing Out the Collection, 1911

Although Culin's next trip to the Northwest Coast was his longest stay in
the region, his acquisitions were relatively modest and have the appearance
of an afterthought. Perhaps his mind was elsewhere, on Japan, which he
had visited for the first time in 1909–10. This time he stayed for fourteen
days: one week in Victoria (July 4–10) and another week in the Fraser River
valley and Vancouver (July 11–17). This trip netted a total of seventy-six
specimens.[9]

Arriving in Victoria, Culin immediately went to see Dr. Newcombe,
who showed him the two Haida totem poles and four Bella Bella house
posts that he had obtained for the Museum earlier in the year. Newcombe
also had other things for Culin: principally, twenty-four specimens from
the Ohiat, a Nootkan group of Barkley Sound. A highlight of this collection
was its whaling implements.

Even in the few years since 1908 much had changed in the region. The
Indians on the Songhees reserve had been moved over to a new location in
nearby Esquimalt and were asking "a relatively high price" for things, "as
they have plenty of money from the sale of the reserve" (1911a:111). Lands-
berg had gone out of business and was selling real estate. Eager to sell, he
offered his remaining stock at low prices to Culin, who picked out one
wooden rattle, two Haida helmets, and five boxes. The helmets especially
interested him. Though the dealer assured him that they had been worn,
"Dr. Newcombe afterwards told me that Landsberg had had them made
and that they were only models." Still, "they were correct in every particu-
lar, they were excellent museum specimens, the best that could be procured
now" (1911a:114).

From A. Aaronson, the other leading curio merchant, Culin bought a
miscellaneous group of objects, including spoons, baskets, game stones,
and a "coffin basket," even though he "could not see that any great change
had been made in the stock since I examined it some three years ago."[10] At
the store of H. Stadthagen, who Culin felt to be the most unscrupulous of
the three, Newcombe advised him against purchasing a Haida stone
mortar, feeling that its provenance was doubtful (1911a:111–13).

Dr. Newcombe then accompanied Culin over to Vancouver. As they
traveled up the Fraser River valley, the two collected together, Newcombe
for the British Columbia Provincial Museum. Their first stop was the Salish
Indian reserves around Chilliwack, where Culin made the bulk of his
purchases. Here the native settlement consisted of orderly frame houses

HARRISON HOT SPRINGS

St Alice Hotel
Owned and Operated by
The Harrison Hot Springs Company Ltd.

BRITISH COLUMBIA
CANADA

CLELAND & WELSH. VANCOUVER. B. C.

Fig. 63. *Pamphlet for Saint Alice Hotel, Harrison Hot Springs, B.C. From 1911 expedition report.*

surrounding a Catholic church. "The people spoke English and there were no external indications of their former aboriginal life" (1911a:119). Culin made his first acquisitions at the neighboring village of Skau-kail: a child's basketry rattle and a fine stone hammer. Much of his collecting was devoted to fiber objects such as raw hemp fiber, balls of hemp twine, and fishing nets made of the material. Other objects related to weaving: a spindle whorl, net shuttle and net mesh measure, a mat creaser and needles, and a basketry awl. Here Culin was following his ethnological interest in materials and techniques. This modest grouping of objects was the largest and most systematic collection of his 1911 trip.

The pair wandered off along many detours, coming away with little or nothing for all their efforts. Newcombe seems to have done most of the collecting. Complaining constantly of the terrible swarms of mosquitoes, Culin evidently tried to console himself with trout fishing and mineral baths (Fig. 63). As they traveled through Yale, Hope, and Ruby Creek, they visited local curio collections. Newcombe assured his friend that they would find in the resort of Harrison Hot Springs a store that had "the best assortment" of new baskets "to be found anywhere in the province" (1911a:129), but Culin was disappointed: "They all appeared coarse, and lacking in artistic qualities." The trip ended back in Vancouver, where they met with several ethnologists and collectors. Ever hoping for a great find, Culin was excited by a "fine" and "desirable" basket offered by dealer Thomas H. Allice, who promised to alert Culin to an imminent shipment (1911a:132). Though in the main he had completed his Northwest Coast acquisitions, Culin continued to refine the collection when opportunity arose.

Collecting after 1911

Although he acquired relatively few American Indian objects after 1911, Culin purchased a few choice items from Newcombe, from collector G. T. Emmons, and from art galleries in New York, and received donations, especially of Tlingit baskets, from local Museum patrons. Already on hand were the Northwest Coast specimens from the two Field Museum exchanges (twenty-seven in 1905, and fifty in 1907). Included in this material were several pieces that Culin must have seen at the Chicago World's Fair of 1893: eight of the set of Haida house models collected by James Deans and masks collected by Johan and Fillip Jacobsen for Carl Hagenbeck.[11] Many of the others came from Dr. Newcombe. Unlike the California components of the Field Museum exchanges, the Northwest Coast collections did not fill any gaps. In fact, most seem to be of noticeably lesser aesthetic quality.[12]

After 1911 Culin continued to visit his friend Newcombe, stopping off several times on the way to and from the Orient. There he would review occasional purchases, which Newcombe eventually sent on, sometimes after much delay. For instance, Newcombe removed a set of Nootkan house posts and fragments of the house frame from the village of Ecool on Barkley Sound, Vancouver Island, in late 1912 or early 1913 (see p. 232), yet they did not reach the Museum until the spring of 1915, owing to the vicissitudes of shipping. The copper ceremonial shield that Newcombe promised Culin in 1911 did not arrive until early 1916. At least through 1914, Culin remained actively interested in acquiring totem poles from his Victoria agent.

In addition to Newcombe, Culin resorted to Lieutenant George Thornton Emmons (1852–1945), probably the most active collector of Northwest Coast artifacts.[13] After many years of Naval service in Alaska, the lieutenant retired to his ancestral home in Princeton, New Jersey. From there he continued to make a living selling to museums. Addressing Culin as

Doctor, Emmons seems to have had a cordial relationship with the curator, whom he had known in Philadelphia.

In 1908 Culin visited Lieutenant Emmons's home to review his latest collection. He wrote enthusiastically to Herman Stutzer, a trustee who was especially interested in his Northwest Coast collecting, about this group of 1,850 "minutely catalogued and described," mostly Tlingit, pieces: "Altogether it is probably the most important collection that will ever be obtained from Alaska. The price is $15,000. I cannot too strongly commend its purchase."[14] Stutzer examined the collection in the fall and, while impressed, was worried about the cost.[15] Emmons exhibited the objects at the 1909 Alaska-Yukon-Pacific Exposition in Seattle, and it was subsequently acquired by the University of Washington.[16]

Throughout 1915 Lieutenant Emmons offered Culin a stream of "fine and old" items. In January he sent the Museum three masks (a Kwakiutl cannibal raven and *tsonoqua* (No. 295), and a Tsimshian wolf), which Stutzer agreed to buy, and a few weeks later sent Culin several "very fine and old ethnological pieces from the N.W. Coast" that he had just received.[17] Though he desired them, Culin had no available purchase funds. In October he kept the four he wanted, which included a Tsimshian set of "very old gambling sticks" of bone. Emmons continued to offer objects to The Brooklyn Museum right up until Culin's death. A master manipulator of collecting rhetoric, Emmons evinced a keen appreciation of the nature of Culin's Northwest Coast collection when he wrote, "I know that your idea is to have a small representative collection of individually choice pieces rather than a larger general collection."[18]

The Northwest Coast Collection in Perspective

Totaling 308 objects (from his three field expeditions), plus another 77 transferred from the Field Museum, Culin's Northwest Coast collection is relatively small. Although it contained many spectacular and important pieces, it was secondary in comparison to those he created in the Southwest and California, and it was also small when compared to the three major Northwest Coast collections in the United States: those of the U.S. National Museum, Washington, D.C.; the American Museum of Natural History, New York; and the Field Museum, Chicago. The U.S. National Museum was at the forefront of systematic collecting in the region, acquiring James G. Swan's collections exhibited at the Philadelphia Centennial Exposition of 1876, and it continued to acquire large collections that had been assembled by traveling government personnel. Building on important early holdings from the Northwest Coast, the American Museum took the lead among the three institutions with its purchases in 1888 and 1894 of two large collections assembled by G.T. Emmons. These were vastly increased between 1895 and 1905, during the tenure of Franz Boas, who directed the large-scale Jesup North Pacific Expedition. The Field Museum, founded in 1894, had inherited the rich collections gathered for the Chicago World's Fair, and George Dorsey and Charles Newcombe built on them in their fierce competition with the American Museum.[19] By 1905, just as Stewart Culin was setting out on his first expedition to the region, the great period of Northwest Coast collecting was winding down.[20]

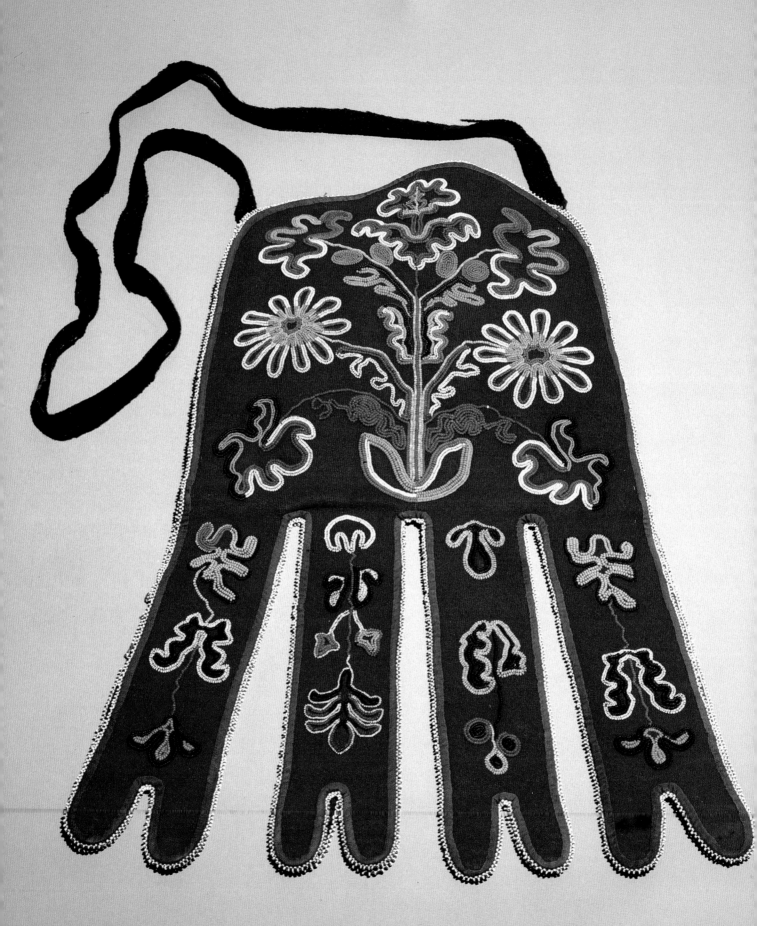

247. OCTOPUS BAG
Tlingit
Cloth, glass beads, L. 17¾, W. 10½
Purchased from Frederick Landsberg in
Victoria, British Columbia, July 15, 1908
08.491.8896

Made entirely of trade materials, these distinctive cloth pouches were accessories for ceremonial costumes. They were called octopus bags because of their four pairs of tentacle-like fringes. Culin obtained this bag in Frederick Landsberg's curio shop in Victoria (Fig. 61). Because of its source on the secondary market, it came with virtually no documentation; in his card catalogue and ledger Culin lists no ethnic group. Floral designs and beadwork are not usually associated with Northwest Coast groups, but some of their objects, especially among the Tlingit, reveal influences from interior Athapaskan groups to the east. While this design style—with its color breaks in an irregular foliate pattern and plain cloth areas within the beaded pattern—could be Athapaskan, it is more likely Tlingit. The reverse side of the bag is plain. IJ

248. BASKETRY HAT
Ehatisaht, Nootka
Twined: red-cedar bark, rush, H. 6, Diam. 12¾
Purchased in Victoria, British Columbia, July 10, 1908
08.491.8870

In 1908 Culin bought two nearly identical hats from a Nootkan group that had been camped on the local Indian reserve in Victoria all winter. Newcombe had told him that the Ehatisaht "were among the most backward on the entire coast, the place where they live being particularly rough and inhospitable" (1908:82). At the time of his visit, many of the women were weaving baskets for sale, and the two hats Culin purchased may have been so intended, as they are both apparently unused. Such hats were meant for everyday wear, to keep off rain or sunlight, unlike the Haida ceremonial basketry hat (No. 263). The weaver has employed the two weft colors (brown cedar bark and buff rush) for a subtle decorative effect. While the exterior is mostly cedar and the interior mostly rush, a few rush wefts have been twined to the exterior around the crown and start. An intricate basketry rim on the underside of the crown secures the hat in place. IJ

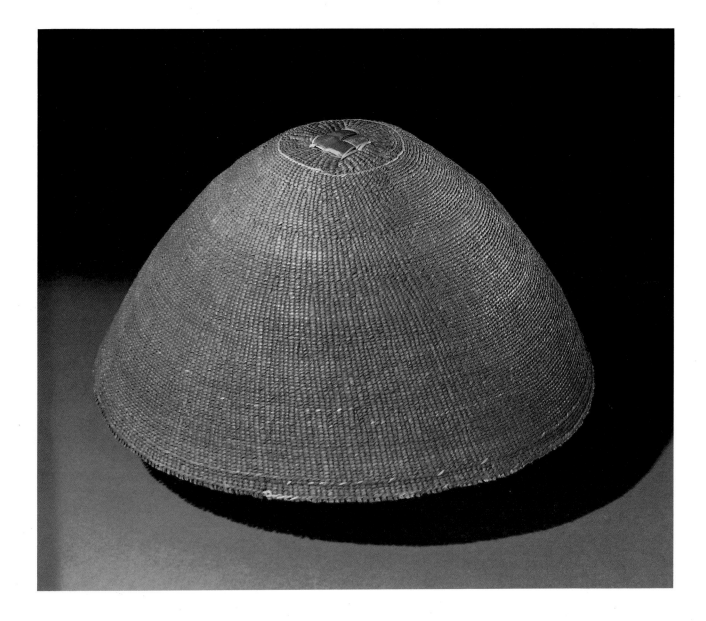

249. HAND ADZE
Ehatisaht, Nootka
Hardwood, bear bone, cotton twine,
pigment, iron nails, H. 4¼, L. 11½, W. 2¼
Purchased in Victoria, British Columbia,
July 11, 1908
08.491.8874

This is one of the three adzes that
Culin bought on his 1908 trip to Vic-
toria. He wrote that "the vendor
replaced the iron blade with one
of bear shin bone" (1908:84),
undoubtedly at his request, though
he does not say. Northwest Coast
Indians had long since switched
from bone and tooth to iron blades
for their wood-carving tools, but
Culin, with his archaistic interests,
considered iron less desirable for his
museum specimens. Without his
detailed collecting narrative, we
would never guess at this replace-
ment, but according to Bill Holm,
these replacements are not quite
right: the blade is too long, the cord-
age is not aboriginal, but commercial
fishing twine, and the wrapping
would be abraded by proper use.
The iconography of the figures on

the handle is quite interesting: on
top of a wolf's head are the upper
torsos of a pair of dancers wearing
wolf masks, which come in pairs
(see the set Culin bought from New-
combe, No. 289). IJ

250. BONE DICE
Hesquiat, Nootka
Bone, pigment, H. ¼, L. 2½, W. ½
Purchased in Victoria, British Columbia,
July 15, 1908
08.491.8888a–d

This set of four bone dice with
twenty counting sticks was one of
the many games Culin purchased on
the reserve in Victoria. The dice
"form a direct link between the bone
staves and the beaver teeth dice"
(1908:91). In his expedition report
Culin explained the counts in a foot-
note: "These dice were marked in
pairs on one side, the other side
being blank. One pair was marked
with transverse lines, and the other
with dots, and one with lines had a
piece of dyed cedar bark tied around
it." (It is not known whether the dice
were tied with cedar bark when
Culin collected the set.) Each team
received from one to four sticks,
depending on which combinations
of blank, dotted, and lined sides fell
face up. IJ

251. STONE MAUL
Salish
Stone, H. 6¾, Diam. 4
Purchased in Skau-kail (near Chilliwack),
British Columbia, July 12, 1911
11.694.9214

From an old man Culin bought
this "very finely polished old stone
hammer" that "had been dug up
near by" (1911a:120). Such simple
mauls are a very ancient artifact type
on the Northwest Coast, and this
one could be prehistoric in origin.
Though quite elegant, they are per-
fectly formed to fit comfortably in
the hand for heavy pounding. IJ

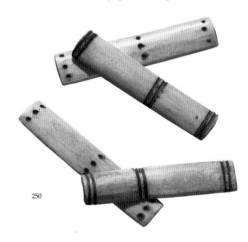

250

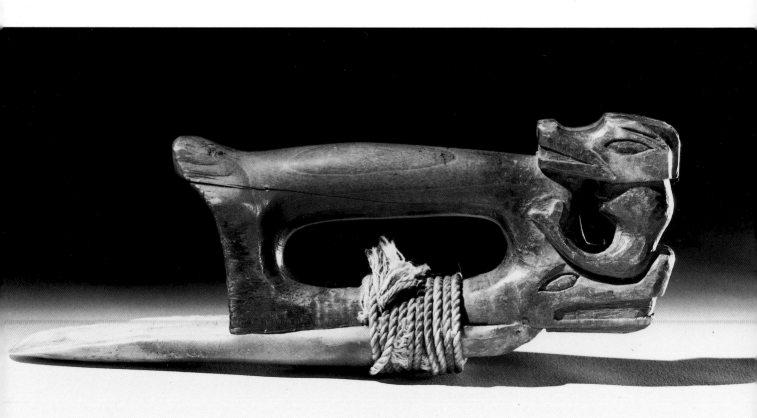

249

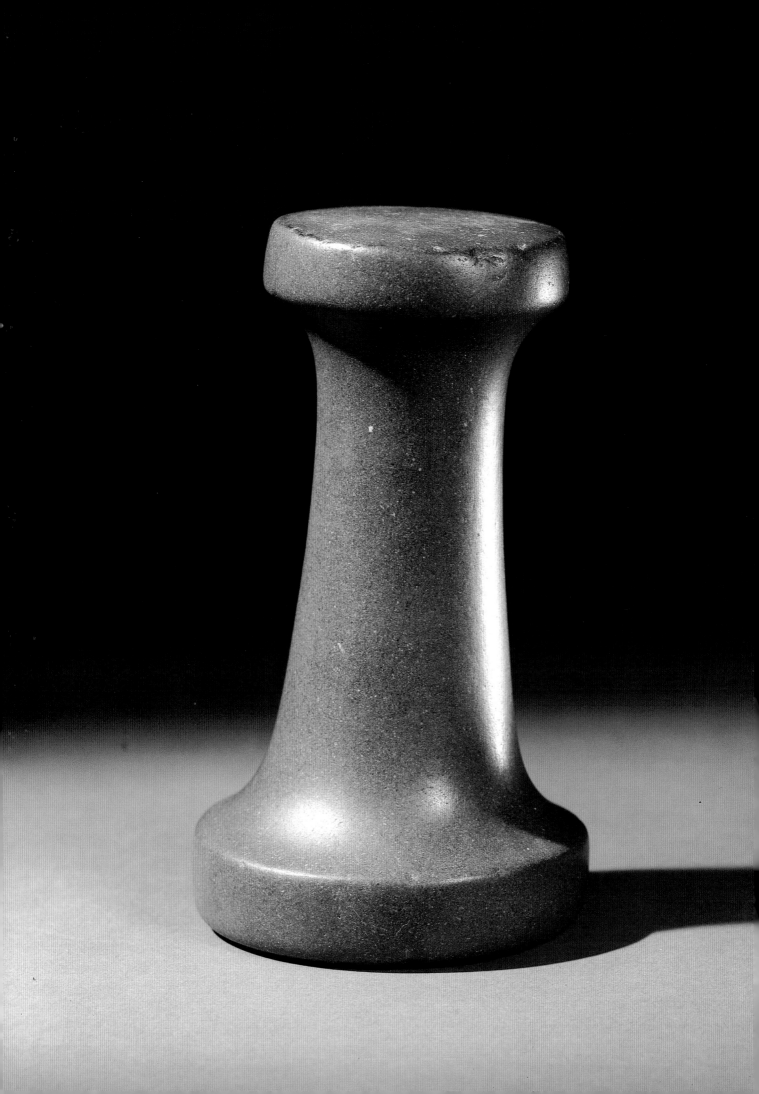

252. Ball of Cordage
Salish
Rush fiber, L. 11, Diam. 5¾
Purchased in Yale, British Columbia, July 13, 1911
11.694.9229

The old wife of a chief sold Culin this ball of cordage. He noted that this material would be "used as a warp for the rush mats," and contained enough for five (1911a:125). Rush or cattail mats were widely used on the southern Coast and nearby Plateau area for many functions—as floor coverings, seats and bedding, linings for house interiors, and partitions. This is one of several weaving materials and implements that Culin collected on his Fraser River trip. ɪJ

253, 254. BENT-CORNER BOWLS
Haida

No. 253: Yellow cedar?, pine?, sea-snail opercula, plant fiber and cotton twine, H. 8½, L. 19½, W. 17

No. 254: Softwoods, fiber twine, H. 2¼, L. 4, W. 2¼
Collected by C. F. Newcombe in Skidegate, British Columbia; purchased in Victoria, August 13, 1905
05.588.7312; 05.588.7317

Though at first glance they may appear to have been carved out of a single piece of wood, both of these bowls were made by the distinctively Northwest Coast process called kerfing. A single plank of wood was first trimmed, notched, steamed, and bent. The bottoms and sides were then pegged or sewn with tree root (here, probably spruce). The box or bowl was finally decorated with painting, carving, or both; the bulging sides of these bowls were deeply carved out. According to Newcombe,[1] the larger bowl was used for dried food, while the small one held grease and berries. Though he notes that the design on the larger one represents a killer whale, it is so highly stylized as to be abstract. A hawk is depicted on the smaller one, which has acquired a rich, oil patina.[2] IJ

1. Throughout Northwest Coast entries, information cited from Newcombe is from his catalogue.

2. On the box's underside, Newcombe has written *Skidegate, 1897* (see No. 280).

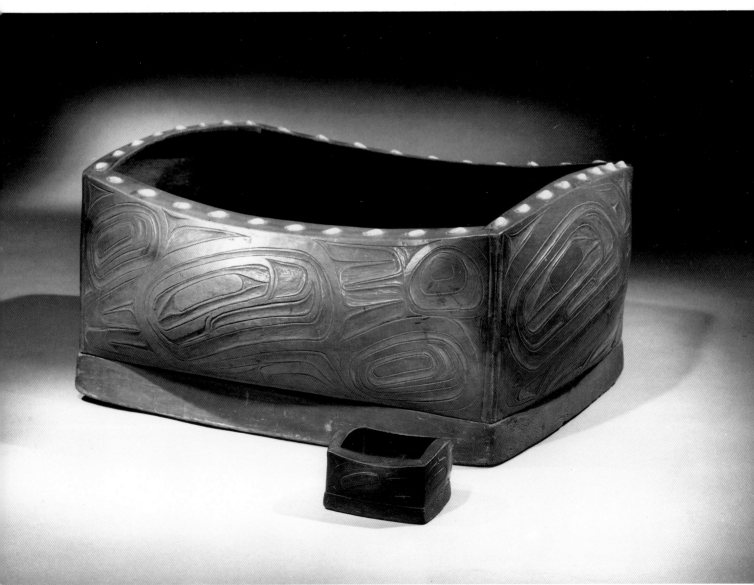

253 254

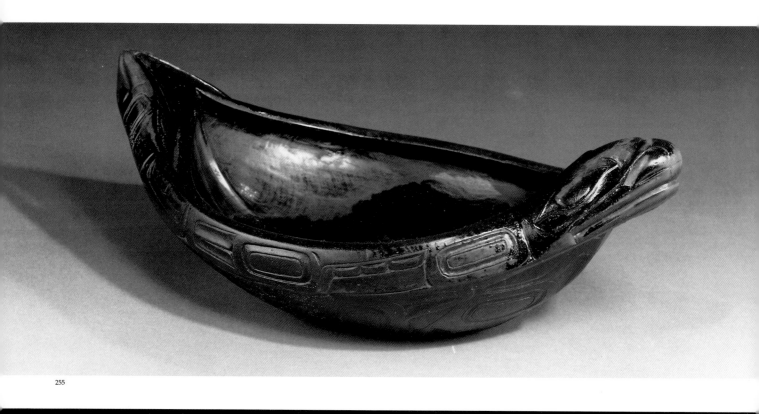

255

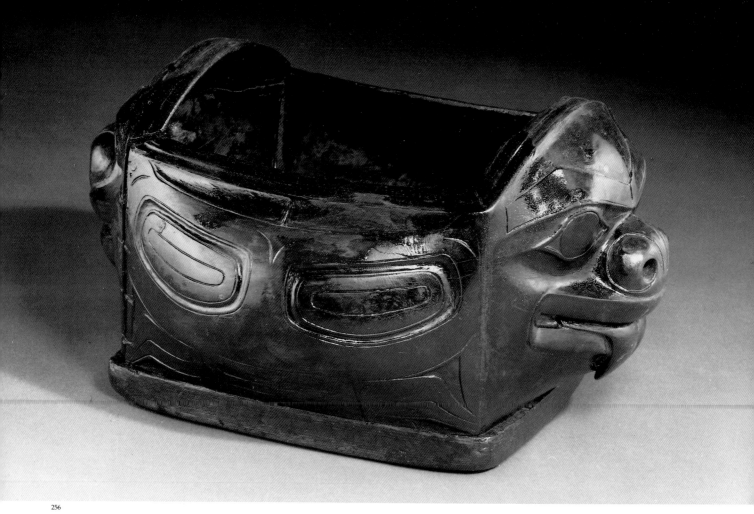

256

248

255. SEAL BOWL

Haida
Wood, H. 5¼, L. 14¾, W. 8¼
Collected by C. F. Newcombe in Skidegate,
British Columbia; purchased in Victoria,
August 13, 1905
05.588.7321

This characteristic Northwest Coast bowl form takes the shape of a seal, highly prized for its meat and blubber. According to Newcombe, this bowl was used for grease and berries. Northwest Coast Indians used the oil of the eulachon fish, seal, or whale to moisten dried food such as fish or berries. So saturated was the wood in this bowl that even after many decades, the oil continues to well out. The interior surface is decorated with elegant fluting. IJ

256. BENT-CORNER BOWL

Haida
Wood, plant-fiber twine, L. 14, W. 12,
H. 7¼
Collected by C. F. Newcombe?; purchased in Victoria, British Columbia, August 13, 1905?
05.251

The documentation on this piece is uncertain. It may be a dish that Newcombe bought in Skidegate (Culin No. 7320). That dish was used for grease and berries, and like that one, this kerfed and deeply carved dish represents a bear, which can be recognized by its protruding tongue. Like No. 255, this example is saturated with oil. IJ

257. CARVED AND PAINTED BOX PANEL

Kwakiutl?
Cedar wood, pigment, L. 12¾, W. 26¾,
D. ½
Collected by C. F. Newcombe?; purchased in Victoria, British Columbia, August 13, 1905?
05.258

This panel is clearly a fragment from a kerfed box. If the current catalogue documentation listing it as a coffin board from Knight Inlet is correct, it is almost certainly one of the two coffin boards that Newcombe bought there (Culin No. 7414). If it comes from Knight Inlet, however, it most likely was not made by a Kwakiutl, for it is a very fine example of the graphic style characteristic of the northern tribes of the Northwest Coast: Haida, Tlingit, and Tsimshian. Alternatively, it may be the carved panel from a Haida chest that Culin bought from G. T. Emmons in 1915. IJ

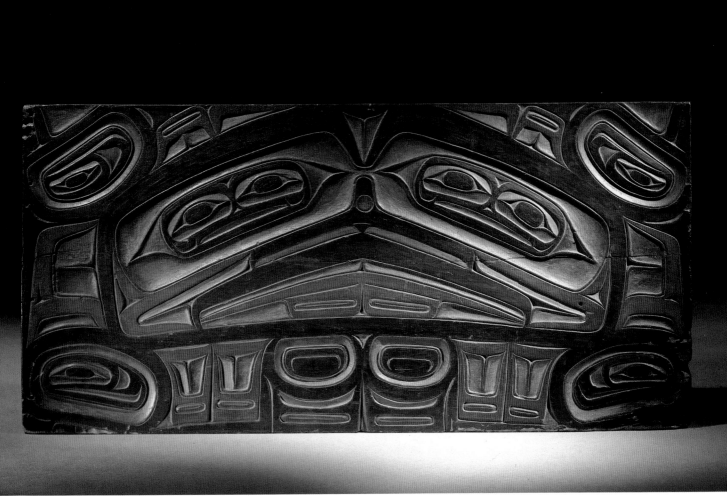

257

258, 259. SOAPBERRY SPOONS
Hardwood
No. 258: Tlingit
H. ¾, L. 16, W. 1¾
Collected by C. F. Newcombe in Klukwan, Alaska; purchased in Victoria, British Columbia, August 13, 1905
05.588.7301

No. 259: Haida
H. ¼, L. 13, W. 1¼
Collected by C. F. Newcombe in Skidegate, British Columbia; purchased in Victoria, August 13, 1905
05.588.7336.1

These distinctive elongated spoons come in sets (No. 259 is one of a set of three), and are used to eat the whipped soapberry dessert at feasts. Though sometimes plain, they are more often painted, and some are even elaborately carved, like No. 258, which is especially large. While it depicts a fairly abstract animal, No. 259 is simply but elegantly carved in the shape of a "copper," or ceremonial shield. IJ

260. HORN SPOON
Haida
Mountain-goat horn, metal pins, L. 10¼, W. 2½, D. 1
Collected by C. F. Newcombe?; purchased in Victoria, British Columbia, August 13, 1905?
05.304

Feast spoons were made of mountain-sheep and mountain-goat horns, which were steamed, bent into shape, cooled in a mold, and then carved. The bowl and handle of this one are two pieces of mountain-goat horn, riveted together. One can see in this particularly fine example the same monumental style of carving found in Haida totem poles. In the visual punning common to Northwest Coast art, the body of the bird at the tip is also the head of the animal below, which peers down. It is unclear to which creature the flukes in the middle belong. At the base is a large animal with protruding tongue.

Newcombe collected many of these spoons (eight are in the 1905 collection), though Culin also acquired some from dealers in Victoria and New York. When buying six at a high price from A. Aaronson, the Victoria curio dealer, Culin justified his purchase with the remark that "no more are to be obtained from the Indians" (1911a:113). IJ

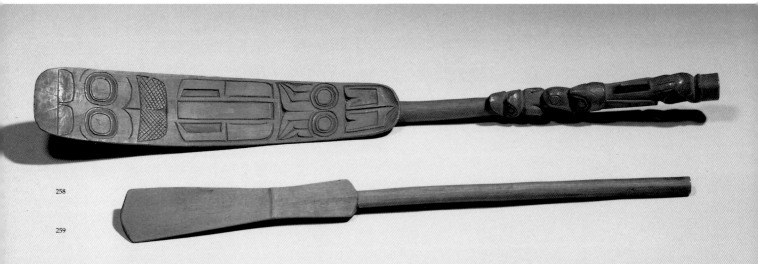

258

259

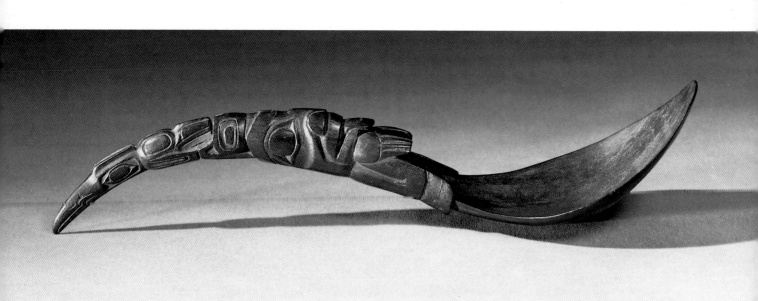

260

250

261, 262. Feast Spoons
Made by Tom Price; Haida
Wood, pigment, L. 10½; W. 2½; L. 12½;
W. 3
Collected by C. F. Newcombe in Skidegate,
British Columbia; purchased in Victoria,
August 13, 1905
05.588.7331; 05.588.7332

Tom Price (1857–1927), like most traditional Northwest Coast artists, never signed his work,[1] and unfortunately Dr. Newcombe did not give the artist's name for any of the specimens he sent to Culin. However, Bill Holm has attributed these two spoons and the basketry hat (No. 263) to Price, one of the leading Haida artists of the turn of the century. As Newcombe collected a number of pieces from Price and lists the source of these pieces as Skidegate, Price's hometown, the attribution is quite plausible. The work of several artists may have been associated with Price's name. In any case, these spoons and the hat all seem to have been painted by a single individual, the same artist who made Newcombe a set of drawings now in the Royal British Columbia Museum, Victoria. According to Newcombe, the design on No. 261 is the family crest of the "true whale" (as opposed to a killer whale) and that on No. 262, a wolf crest. IJ

1. Gessler 1981; Holm 1981:193–97.

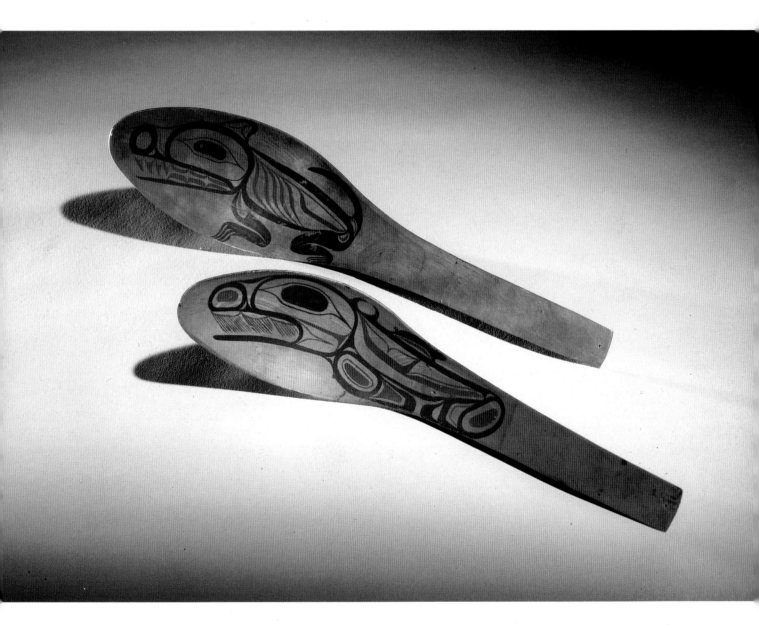

251

263. BASKETRY HAT

Made by Tom Price and wife?; Haida
Twined: spruce root, pigment, H. 6¾,
Diam. 17
Collected by C. F. Newcombe in Skidegate,
British Columbia; purchased in Victoria,
August 13, 1905
05.588.7322

On the Northwest Coast finely woven basketry hats were worn at feasts and other ceremonial occasions. Ceremonial hats, woven by women, were painted by men, usually their husbands.[1] The crest symbols painted on them were associated with leading families; this one depicts Tcamaos, the mythological personification of submerged driftwood. Tcamaos could assume various forms; here it is represented graphically as a combination of a sea-grizzly bear with a stick arising from its head. The five-pointed star on the crown is diagnostic of Tom Price's hats.[2] The green paint, visible around the eyes, has almost completely flaked off. The decorative effect in the weaving comes from a diagonal twining technique called a skip-stitch. IJ

1. In fact, this example, like some other American Indian baskets in museum collections, has strands of the weaver's hair caught between the warps and wefts.
2. Holm 1983:47–48.

264. BAIT AND HOOK BAG

Nootka
Plaited: red-cedar bark, L. 15, W. 14¼
Collected by C. F. Newcombe in Clayoquot,
British Columbia; purchased in Victoria,
August 13, 1905
05.588.7270

Flat bark bags like this example came in several sizes and were used by fishermen and whalers for storing tackle and other equipment. Here several kinds of plaiting create a decorative effect. IJ

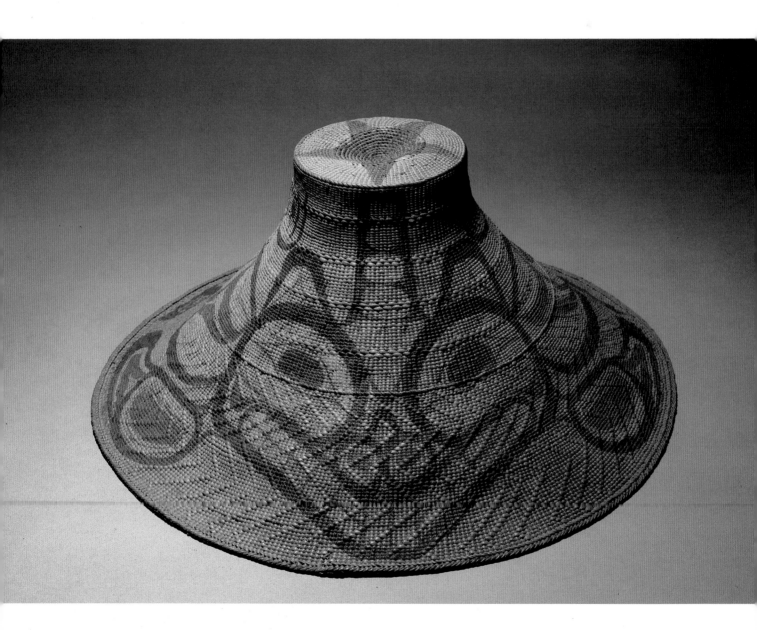

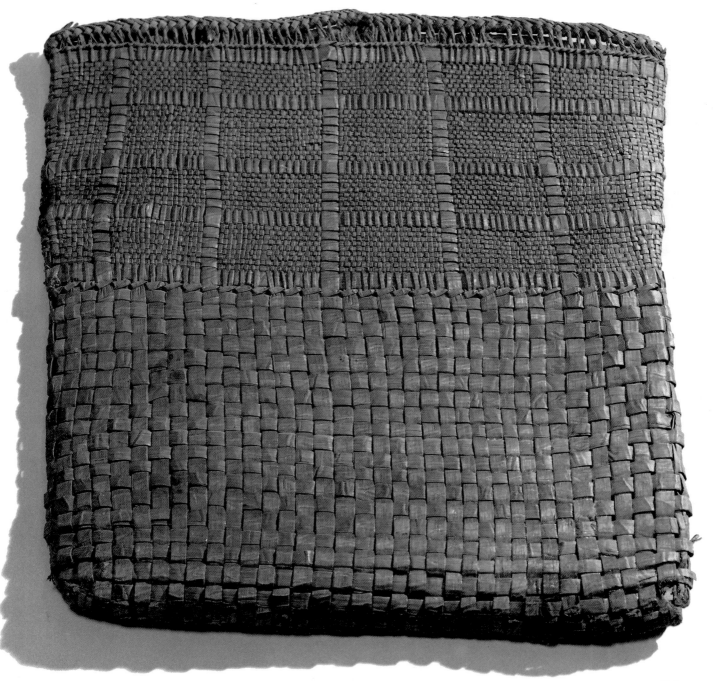

265. BASKET
Haida
Twined: spruce root, H. 5, Diam. 5½
Collected by C. F. Newcombe in Masset,
British Columbia; purchased in Victoria,
August 13, 1905
05.588.7326

This very finely twined container is one of seven Haida baskets and bags in the 1905 collection. Newcombe noted that it was used "for berries and small valuables when new and clean." A graduated set of baskets was employed for berry picking; this one was one of the smaller containers. The design comes from alternating bands of plain and dyed wefts, and the diagonal decorative pattern in the upper section is achieved by the same skip-stitch twining found in the Haida hat (No. 263). IJ

266. WOMAN'S BONE KNIFE
Haida
Bone, L. 9½, W. 1
Collected by C. F. Newcombe in Skidegate,
British Columbia; purchased in Victoria,
August 13, 1905
05.588.7337

267. BASKETRY AWL
Salish
Elk antler, L. 9½, W. 1
Collected by C. F. Newcombe in North
Bend, British Columbia; purchased in
Victoria, August 13, 1905
05.588.7391

The function of each of these implements is uncertain. Newcombe said No. 266 was "used in basketry, etc.," but it is very blunt for a knife. The design appears to represent a killer whale. Newcombe noted that No. 267 was "used in basketry" and

"recent," but Bill Holm thinks it is more likely to be a bark peeler, used to separate the layers of cedar bark for making baskets and mats. Whatever its function, its sinuous curves are quite elegant. IJ

268. NET SHUTTLE
Salish
Bone, L. 13½, W. 2
Collected by C. F. Newcombe in Becher
Bay, British Columbia; purchased in
Victoria, August 13, 1905
05.588.7394

Though Newcombe referred to this as a "bone needle, used in making nets" it is more accurately referred to as a net shuttle. Such distinctive double-pronged sticks made of wood or bone constitute a common native artifact type and are also found in Culin's California collections. IJ

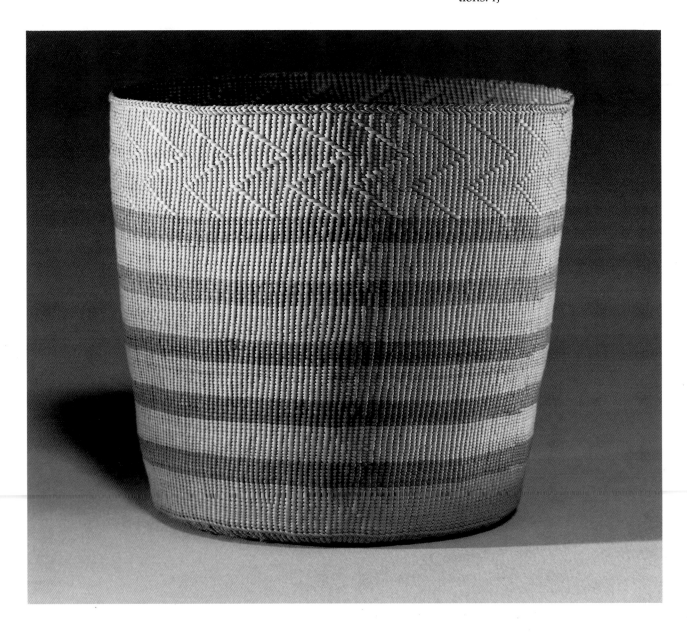

267

266

268

269, 270. SPINDLE WHORLS
Salish
No. 269: Hardwood, pigment, Diam. 8¾

No. 270: Hardwood, Diam. 7¼
Collected by C. F. Newcombe in
Chemainus, British Columbia; purchased in
Victoria, August 13, 1905
05.588.7382; 05.588.7383

These are two of a set of seven
Salish spindles and whorls from the
1905 Newcombe collection. Used for
spinning yarn blankets of mountain-
goat hair, they are covered with the
distinctive Salish style of shallow
relief carving. Many whorls are
plain, while others have geometric
patterns; both types are represented
in the Culin collection. The design
of No. 269 is a common one on spin-
dle whorls—a humanoid
surrounded by a "two-headed mon-
ster" (according to Newcombe) or
two wolves. No. 270 is covered with
a series of whales. Both designs have
a bipolar orientation, so that the pat-
tern can be read from either top or
bottom. This feature was probably
related to the fact that the patterns
were meant to be seen when the
whorls were spinning. IJ

271. BLANKET
Salish
Dyed wool yarn, cloth, L. 50, W. 47
Collected by C. F. Newcombe from wife of
Billy Supass in Skau-kail, near Chilliwack,
British Columbia, July 12, 1911?
X763

In 1908 Newcombe commissioned
a Salish blanket for Culin; the plain
white blanket with a cloth stripe
came from the Fraser River commu-
nity of Yale (see Fig. 17). He bought
several more in 1911 while traveling
with Culin on the river. On July 12,
Newcombe purchased a blanket for
twelve dollars from the wife of old
chief Billy Supass of Skau-kail. Its
description seems to match this
example with red, white, and blue
checks (1911a:120). Although Culin
noted in his expedition report that
he bought a small blanket for
seventy-five cents, in his ledger book
at the place where this would be
listed is a blanket for twelve dollars.
In 1975 the blanket shown here was
found without a number, stored
with the Navajo textiles. It is quite
likely that through some exchange
Newcombe gave the checkered blan-
ket to Culin.

It is commonly stated that the
Salish wove blankets with the hair of
a specially bred white dog. However,
virtually all extant seem to have
been woven of mountain-goat hair
(as in Culin's first blanket) or sheep
wool. Although Culin noted that
Newcombe's checkered blanket was
goat hair, this one was woven of
commercial sheep wool.[1] IJ

1. Gustafson 1980:79,81.

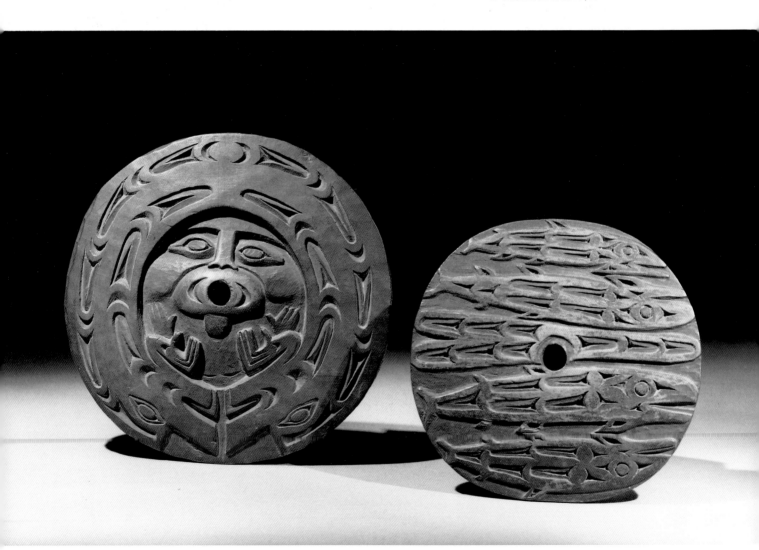

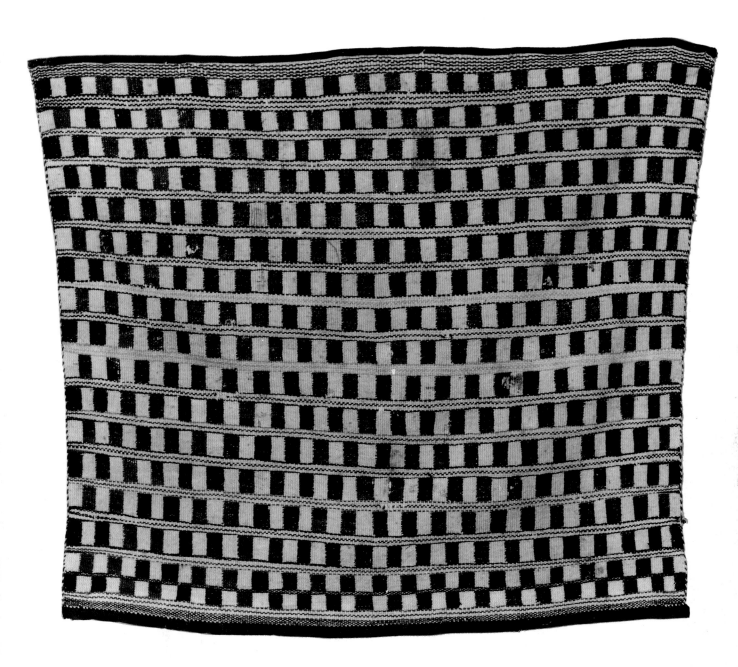

272. Gambling Sticks in Hide Bag
Tsimshian
Maple wood, abalone shell, pigment; hide, thread, pigment, tooth, L. 8½, W. 6¾, D. 2½ (bag); L. 5, Diam. ¼ (sticks)
Collected by C. F. Newcombe in Kitkatla, British Columbia; purchased in Victoria, August 13, 1905
05.588.7348.1–.66

273. Gambling Mat
Tsimshian
Hide, pigment, L. 19, W. 7¼
Collected by C. F. Newcombe in Kitkatla, British Columbia; purchased in Victoria, August 13, 1905
05.588.7349

Dr. Newcombe was Culin's chief consultant on Northwest Coast

Indian games, and he supplied the Brooklyn curator with several gaming sets and many historical references. As there are few good descriptions of the playing of the stick game shown here, Newcombe's collection notes are especially valuable: "When bundle of sticks is indicated as holding the trump, the sticks are thrown down on the sloping exterior of the mat one by one, thus showing the contents of his hand." He reported that the sticks belonged to Chief Shakes.

Despite their even perfection, these sixty-five sticks were made without machine tools. The abalone inlay on nine of them probably served a function in the game, but its significance is now unknown. The hide bag that contains the sticks was made of leather recycled from an older object, perhaps a tunic or hide armor. The design is hard to make out, but it may contain part of a face. According to Newcombe, the painted design on the leather mat is a killer whale, which may be identified clearly by its blowhole and flukes. The painting style resembles that of Bella Bella, which is near Kitkatla. IJ

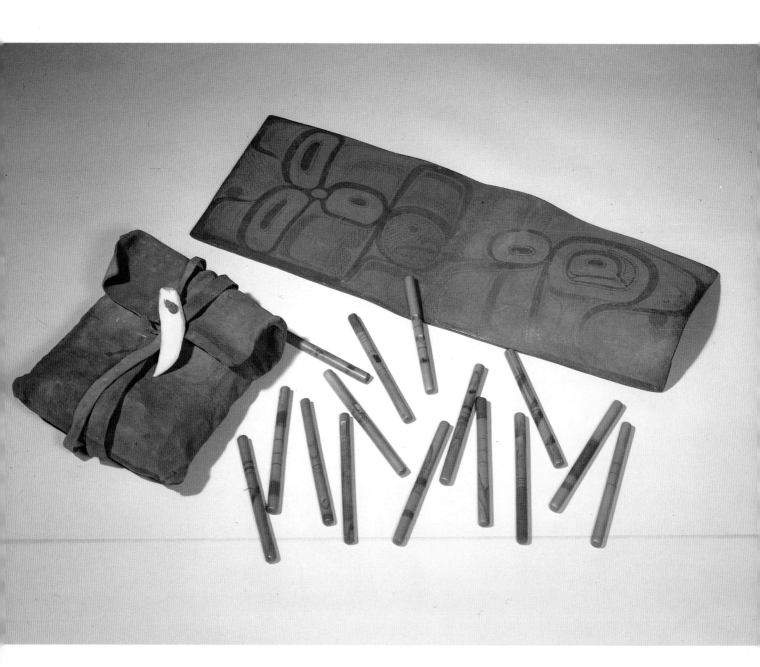

274, 275. TWO PAIRS OF HAND-GAME BONES
Kwakiutl
Bone (whale?), pigment, L. 2¾, Diam. 1¼;
L. 3, Diam. 1¼
Collected by C. F. Newcombe in Alert Bay,
British Columbia; purchased in Victoria,
August 13, 1905
05.588.7287a–b; 05.588.7288a–b

The hand game is one of the most popular games of western Native America. The playing pieces are basically the same throughout the region, though they are more often hollow than solid. Still played, the game employs two sets of paired bones (one marked, one plain). Perhaps significantly, Culin catalogued both of these sets on a single card.

Two teams compete in a game to guess which hand holds the unmarked bone, with the score kept by a bundle of sticks. Much gambling and exuberant socializing accompanies the games. IJ

276. BIRD RATTLE
Nootka
Hardwood, brass tacks, pigment, stone rattles, cord, H. 5¾, L. 17¼, W. 5¼
Collected by C. F. Newcombe; purchased in Victoria, British Columbia, August 13, 1905
05.588.7260

Among the Nootka, ceremonial rattles usually took the form of sim-

ple yet elegant birds. Often of bare wood or minimally painted, they might be decorated, as here, by the distinctive ripple effect produced by the rhythmic striking of the artist's "crooked" knife. This rattle, which has picked up a rich patina, was used by a "second chief," according to Newcombe. IJ

274 275

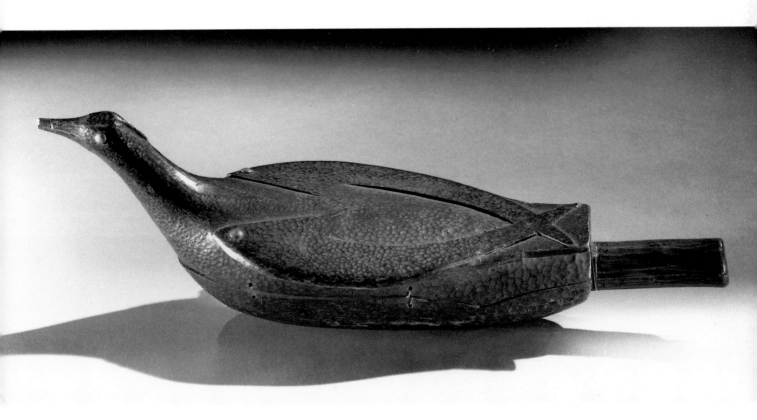

277. RAVEN RATTLE

Bella Bella
Wood, pigment, rattles, cotton twine,
H.5½, L. 14, W. 4
Collected by C. F. Newcombe in Bella Bella,
British Columbia; purchased in
Victoria, August 13, 1905
05.588.7292

Found throughout the Northwest Coast, the raven rattle is most often used at potlatch ceremonies and the less-sacred sections of winter dances by chiefs, typically with a frontlet and Chilkat blanket. According to Newcombe, this "chief's rattle" represents "the sea raven, mountain demon, hawk, toads, and a kingfisher." Although subject to many variations, the raven rattle constitutes a common formal and iconographic combination. This example is unusual, however, for its many frogs. The reclining human often holds a frog on his chest, but on this rattle frogs also appear on his feet and in the raven's mouth. The raven usually holds a rectangle in its bill, referring to the myth of Raven releasing daylight from a box. Although this rattle is documented as coming from Bella Bella, it is not carved in a distinctively Bella Bella style. IJ

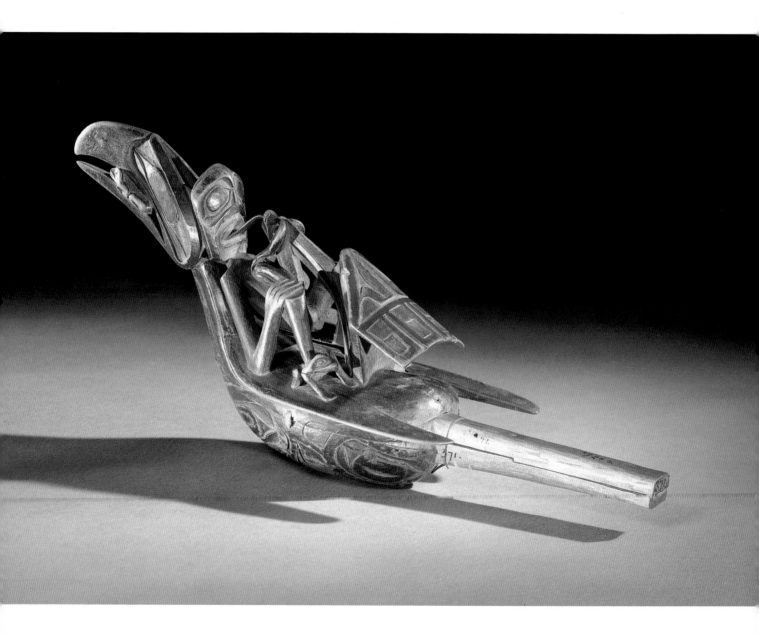

278, 279. HAMATSA WHISTLES
Kwakiutl
No. 278: Cedar wood, cotton cord, resin,
L. 8¼, W. 2¾, D. 2½
Collected by C. F. Newcombe in Alert Bay,
British Columbia; purchased in
Victoria, August 13, 1905
05.588.7351

No. 279: Cedar wood, cord, pigment,
L. 8¼, W. 2, D. 3¼
Collected by C. F. Newcombe (in Alert
Bay?); purchased in Victoria, August 13,
1905
05.588.7354

Used in the winter ceremonials to produce the voice of invisible spirits, whistles are not meant to be seen by the audience. These are two of five Kwakiutl whistles in Newcombe's 1905 collection. No. 278 is in the form of a human face with an open mouth, while No. 279 takes the shape of a whale. The placement of sound holes in these whistles is thoroughly appropriate: the sound comes out of the whale's blowhole and the man's mouth. The latter whistle was used with a bellows. Although both were used during the Hamatsa, or cannibal ceremonials (see No. 283), according to Newcombe, the whale whistle was employed in the "whale dance." IJ

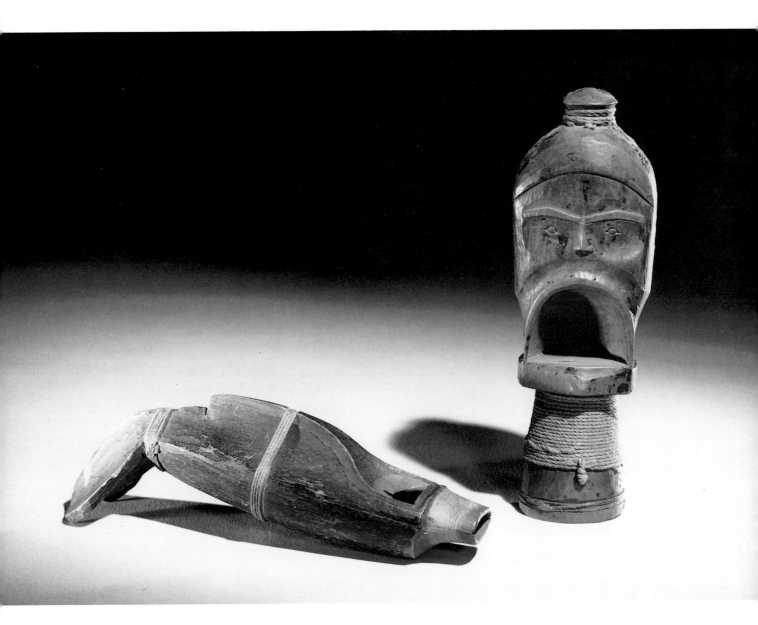

280. CLUB

Haida
Hardwood, L. 22¼, W. 2½, D. 3¼
Collected by C. F. Newcombe in Masset,
British Columbia; purchased in
Victoria, August 13, 1905
05.588.7307

Clubs for killing seals and sea
otters were often elaborately carved
with designs of the sea lion, a rival
marine predator. Although this club
was found in the Museum without
documentation, it is probably one of
the pair of Haida sea-otter clubs that
Newcombe purchased in Masset.[1]
Newcombe said that they depicted a
sea lion with other creatures. Small
human figures are intertwined on
the upper and lower surfaces of the
animal. Despite the lack of positive
identification, "Masset, '97" is writ-
ten on this club in what appears to
be Newcombe's handwriting. In 1897
Newcombe made his first eth-
nographic collecting trip to Masset
and other Queen Charlotte Island
villages. IJ

1. For the other, see Walker Art Center
1972:115.

281. WAR CLUB

Nitinat, Nootka
Whalebone, L. 19½, W. 2½
Collected by C. F. Newcombe; purchased in
Victoria, British Columbia, August 13, 1905
05.588.7267

This distinctive type of war club
was collected during the early,
seventeenth-century, voyages to
Nootka Sound. Carved at the top is
a small bird, perhaps a thunderbird,
and a partially broken-off animal
head. Many clubs have an upside-
down head at the bottom, along
with incised geometric designs. The
rich patina attests to this example's
age and use, and Culin must have
been very pleased to obtain such an
ancient specimen. IJ

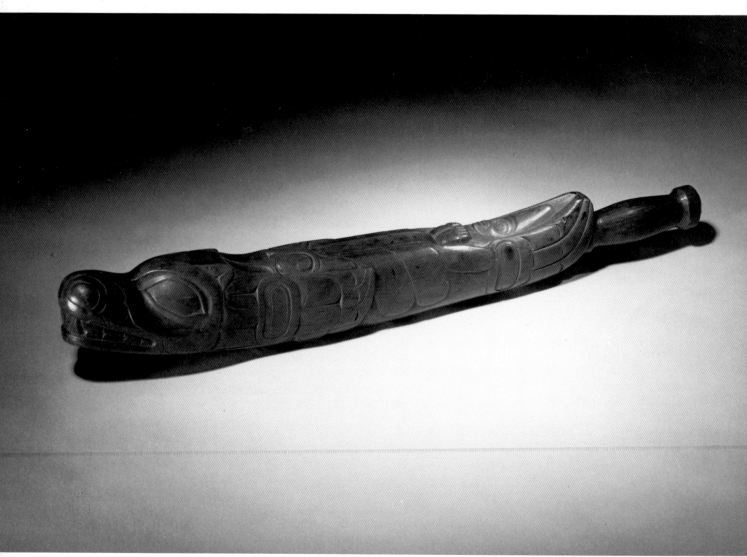

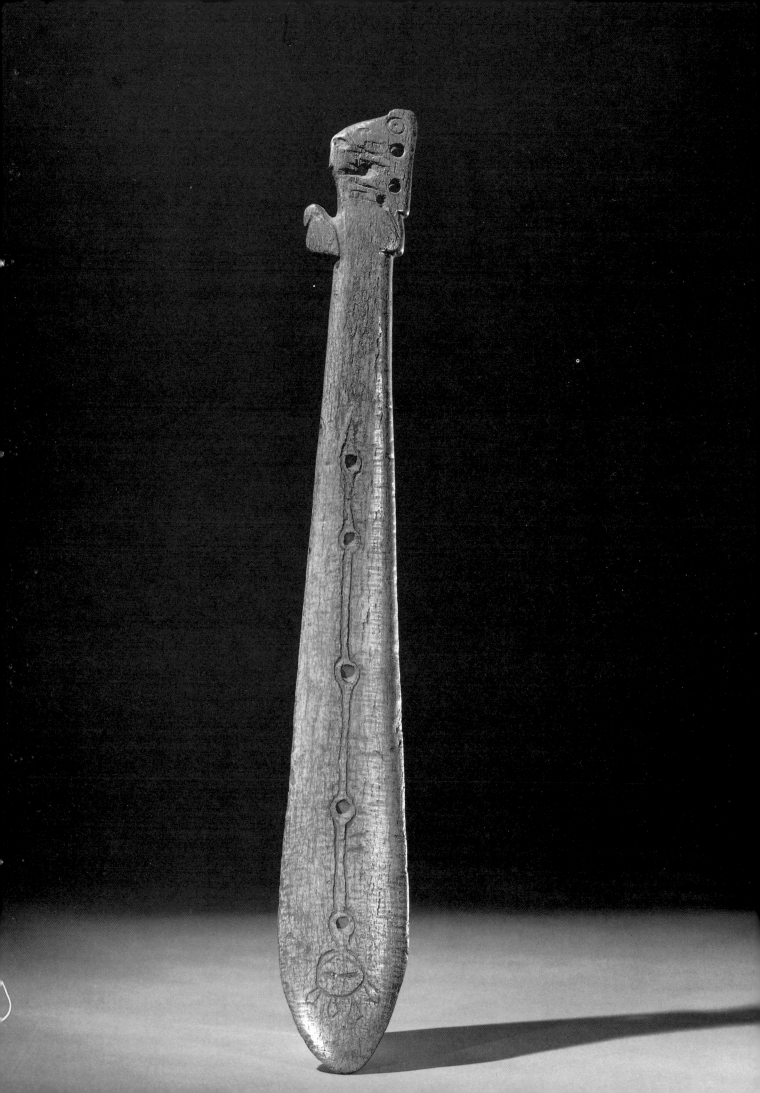

282. "Slave Killer"

Kwakiutl
Stone, wood, abalone shell, hair, pigment, resin, L. 20, W. 11, D. 4¼
Collected by C. F. Newcombe; purchased in Victoria, British Columbia, August 13, 1905
05.588.7289

Although commonly called slave killers in the literature, these objects were probably not used for that purpose. The Kwakiutl did have slaves, whom they did kill ceremonially on occasion, but by the late nineteenth century these clubs were used as "copper breakers," knives to cut symbolically the copper shields that had taken the place of slaves in rit-

uals. Newcombe described the design of this club as a "sea lion holding pointed stone in mouth, human face on lower side [visible in this view]." It is likely that an older stone blade was refitted with a contemporary wood hafting in the late nineteenth century. Its relatively high price of thirty dollars indicates its rarity and desirability. IJ

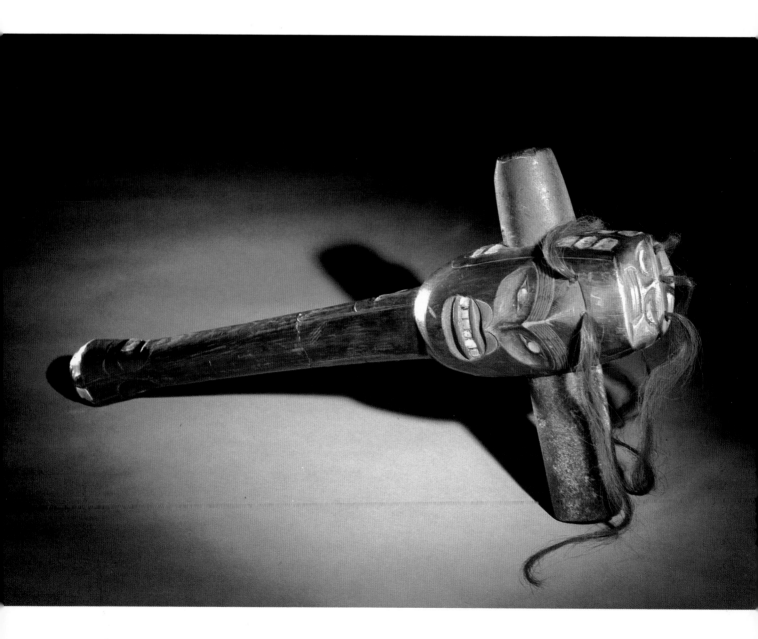

283. SKULL LADLE
Bella Bella
Cedar wood, bear fur (restored), cord, pigment, L. 28, W. 9, D. 8
Collected by C. F. Newcombe in Bella Bella, British Columbia; purchased in Victoria, August 13, 1905
05.588.7297

This striking object, which Newcombe calls a grease ladle, was used in the cannibal complex of winter ceremonials on the Northwest Coast. Skull imagery is common in these rites, during which the initiate becomes possessed by a man-eating spirit. This ladle is replete with skulls: a skull-like head carving at the tip of the handle; a skeletal face painted on the handle; and the large skull in the bowl (a separate piece attached through a hole in the bowl's base). Another face is painted on the bowl's exterior. IJ

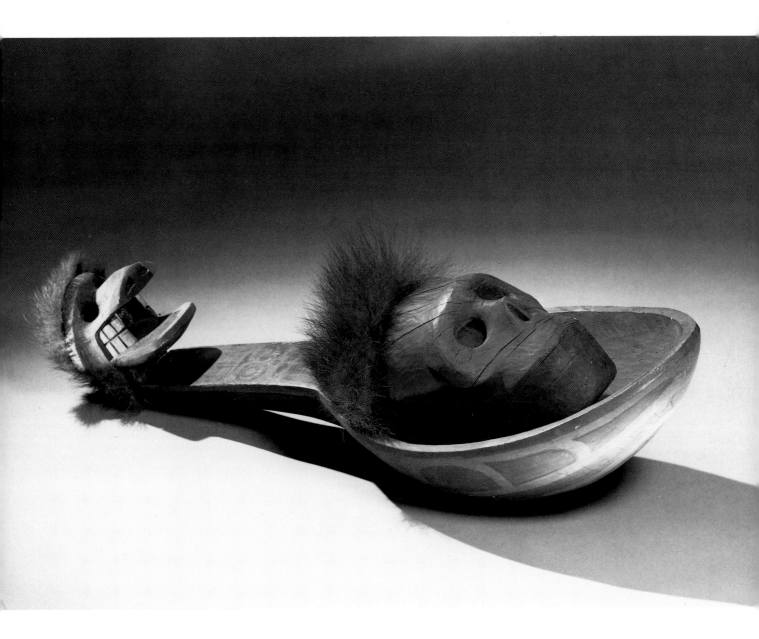

284. SKULL HEADDRESS

Tsimshian
Wood, metal, H. 6½, W. 6, D. 6¾
Collected by C. F. Newcombe on Nass River, British Columbia; purchased in Victoria, August 13, 1905
05.588.7366

Newcombe collected this skull headdress as part of a ceremonial set, which included three cedar bark headbands, a neckband, a pair of armbands, a mask, ten whistles, and a bellows for the whistles. These pieces may have been a part of the Nass River collection that Newcombe's son, William, had just assembled in 1905.[1] Like the Bella Bella skull ladle, this headdress and the rest of its set are part of the cannibal complex, which diffused from the Northern Kwakiutl area. An unusual feature in this piece is the inverted metal-bowl support for the wood sculpture. IJ

1. Cole 1985:223.

285. FRONTLET

Tsimshian
Wood, abalone shell, ermine skins, sea-lion whiskers, flicker feathers, cord, felt hat crown, pigment, H. 14¼, W. 7½, D. 9¼ (frontlet only)
Collected by C. F. Newcombe on Nass River, British Columbia; purchased in Victoria, August 13, 1905
05.588.7413

When Culin first saw Newcombe's 1905 collection, he singled out this frontlet, for which he paid the relatively high price of forty dollars. According to Newcombe, it is a "chief's head dress, used in a friendly dance on receiving visitors," and has a grizzly-bear crest. Bill Holm pointed out that an unusual feature is the sewing together of the ermine skins from end to end; they are more often sewn to a cloth. On stylistic grounds, he doubts a Tsimshian origin, thinking Tlingit or Northern Haida more likely. As Newcombe's documentation is generally reliable, it is probable that this piece was traded to the Tsimshian. IJ

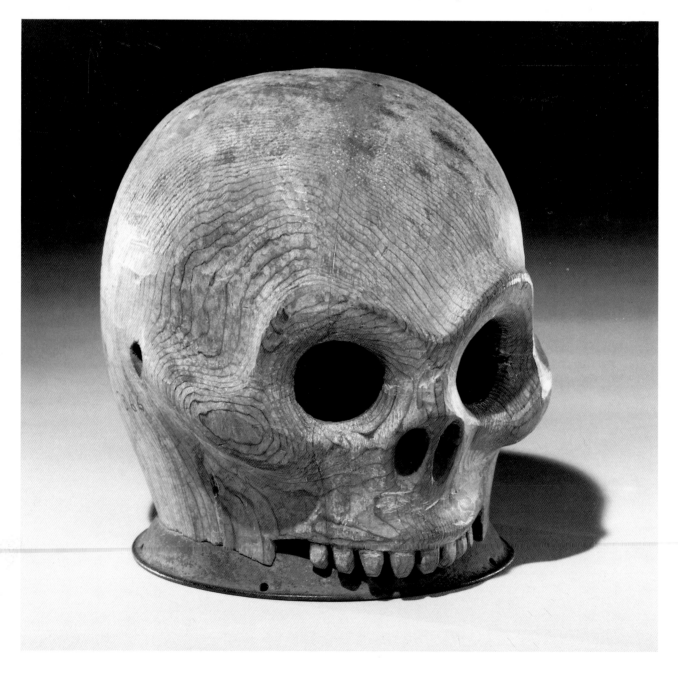

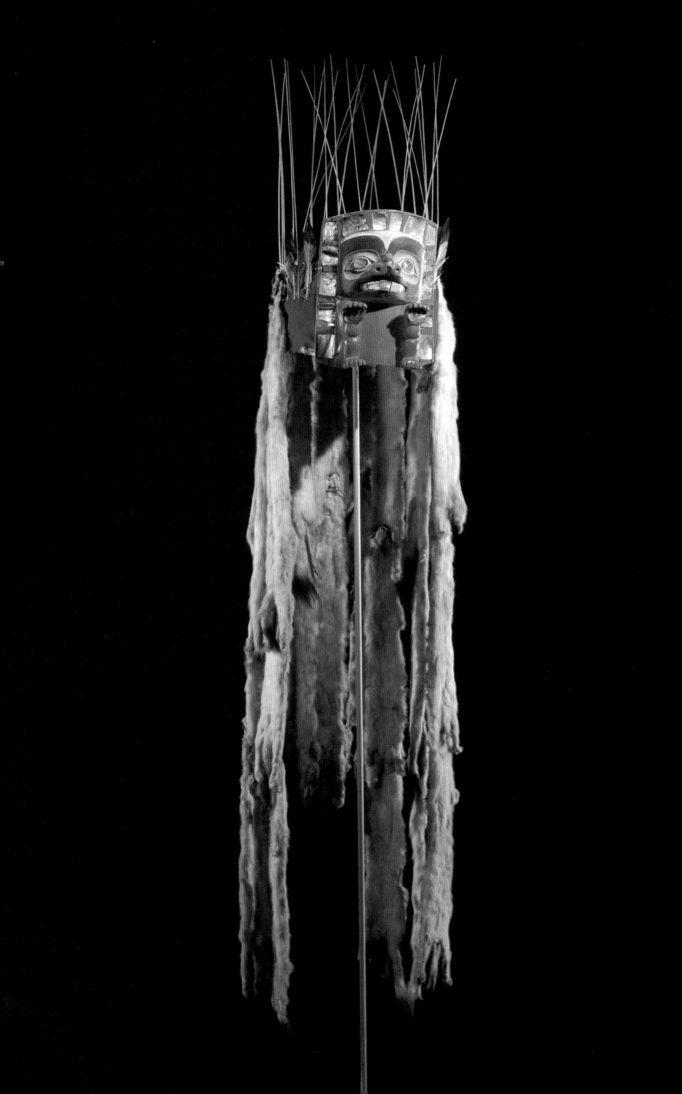

286. SHAMAN'S STAFF

Haida
Wood, pigment, L. 57¼, W. 2, H. 2¾
Collected by C. F. Newcombe in Skidegate,
British Columbia; purchased in Victoria,
August 13, 1905
05.588.7308

Given the paucity of good accounts of Northwest Coast curing sessions, the exact use of this doctor's staff is moot. Newcombe noted that it depicted a raven, which may be recognized by the large beak and the flattened wings on the side. Most of the greenish paint has come off. IJ

287. WHALE MASK

Tenaxtax, Kwakiutl
Cedar wood, hide, cotton cord, leather,
nails, pigment, H. 24, L. 68, W. 28¼
Collected by C. F. Newcombe in Knight
Inlet, British Columbia; purchased in
Victoria, July 15, 1908
08.491.8901

Articulated masks like this one are a Kwakiutl specialty. The whale's flukes and pectoral fins move, and the mouth opens; the dorsal fin can also be moved slightly. The cord that controls the rear flukes emerges from the dorsal-fin opening at the top of the back and runs through a groove down to the tail. A small face borders the blowhole. These elaborate masks were worn over the dancer's head and back in the more "secular" kinds of winter dances, which displayed family privileges. Newcombe's 1905 collection included another, somewhat similar, killer-whale mask, but this baleen-whale mask is larger and more impressive. IJ

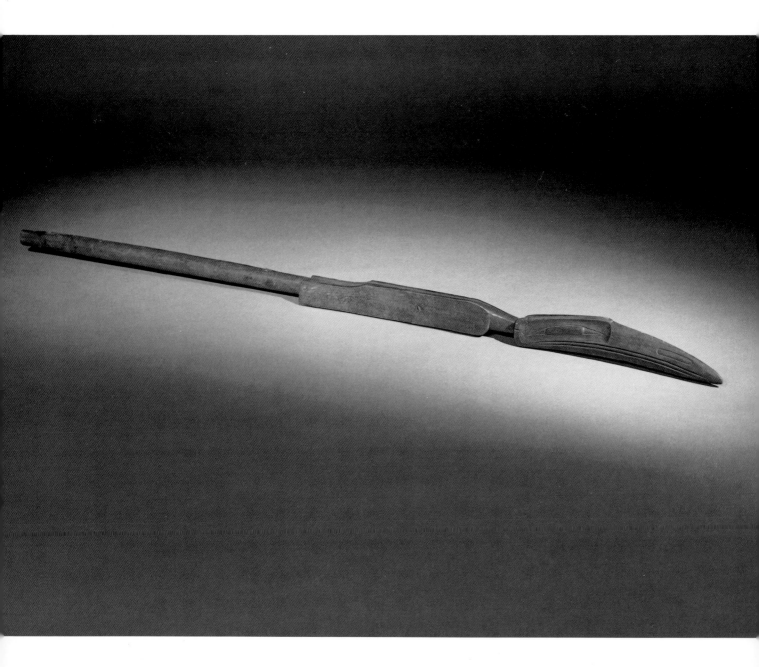

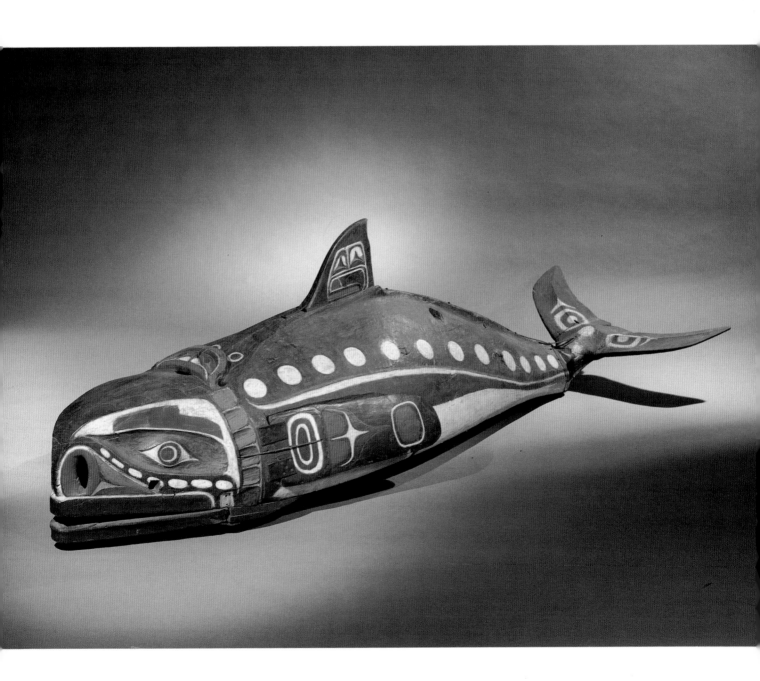

288. THUNDERBIRD
TRANSFORMATION MASK
Nimpkish, Kwakiutl
Cedar wood, pigment, leather, nails, metal
plate, H. 17, L. 29½, W. (closed) 12½, W.
(open) 71.
Collected by C. F. Newcombe in Alert Bay,
British Columbia; purchased in Victoria,
July 15, 1908
08.491.8902

Of all the objects that Newcombe
sold to Culin, the most extensively
documented is this dramatic mask.
Newcombe reported that he had col-
lected it in 1905 from the Gigilgam
lineage of the Nimpkish. Although
he indicated that it could only be
shown during a mourning ceremony,
Bill Holm thought that it could be
used at other times as well. New-
combe wrote of the ceremony:

> First, when the people are all assem-
> bled, a chief stands up and calls the
> name of the dead member of the family.
> Then a whistle is immediately heard to
> sound in the woods at the back of the
> house.... Next some one wearing the
> thunderbird mask comes into the house
> and while all the people are watching
> he opens the beak and shows the man
> painted on the inside, who is supposed
> to be the dead person.

Following this description, New-
combe recounted the ancestral story
told by the chief to the assembled
group. After the flood at Creation,
the thunderbird flew down to a spot
on the Nimpkish River where a man
was building a house. The man said
to the thunderbird, "Oh wonderful
bird, I wish that you were a man so
that you would help me to build this
house. Without help I shall not be
able to raise this beam." The thun-
derbird put back its head—a
movement that perhaps corresponds
to the opening of the mask—and
revealed that he was a man. Then he
put his head forward again and flew
up with the great house beam
grasped in his talons, placing it on
the upright posts. He flew down
again, took his thunderbird coat off
and sent it flying through the air.
There the account ends.[1]

While the exterior of this mask
clearly represents a thunderbird, the
iconography of the interior is less
definite. Although Newcombe sup-
plied the associated myth, its exact
correspondence to the design is still
ambiguous. On either side are the
two heads of the *sisiutl*, or lightning
snake, often associated with thun-
derbirds. The center is a human face
(perhaps the thunderbird in its
human guise, or merely the center

head of the *sisiutl*), and a small man
fills the top section (probably the
ancestor or deceased chief), with a
paired birdlike creature at the bot-
tom. When the mask was collected,
it had cord rigging to open its parts.
There are two similar masks at the
Denver Art Museum[2] and Mil-
waukee Public Museum,[3] possibly
by the same artist. IJ

1. Newcombe Papers, box 1, file 36, British
Columbia Archives and Records Service,
Victoria.
2. Conn 1979:310–11.
3. Ritzenthaler and Parsons 1966:42.

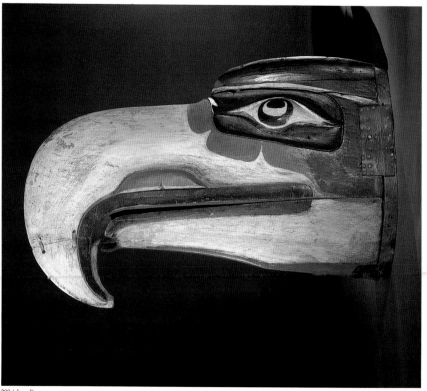

288 (closed)

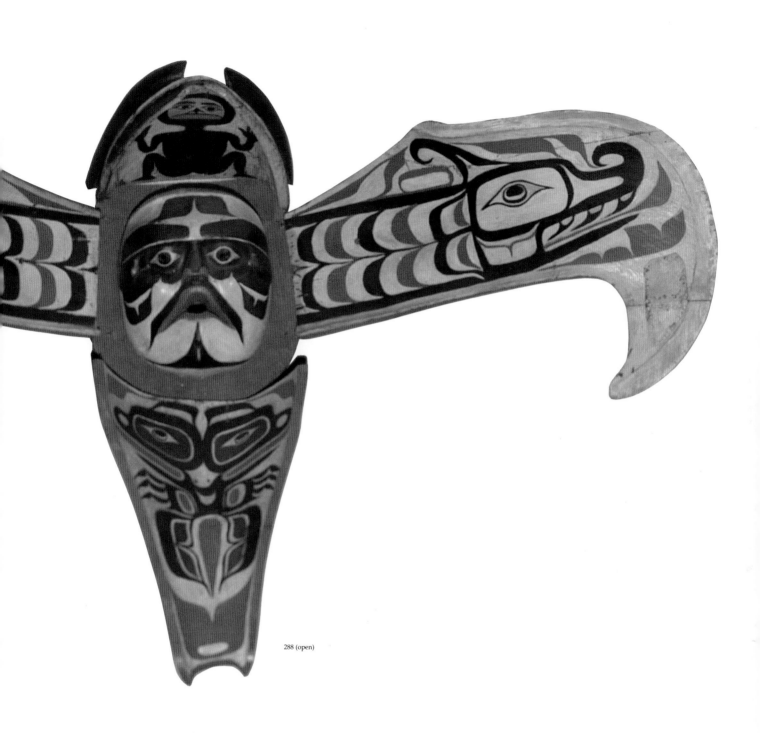

288 (open)

289. PAIR OF WOLF MASKS

Nootka
Cedar wood, pigment, plant fiber, cotton
string and cloth, iron nails, L. 26¼, W. 8½,
H. 10; L. 25¾, W. 9, H. 9¾
Collected by C. F. Newcombe on Vancouver
Island, British Columbia; purchased in
Victoria, July 15, 1908
08.491.8905a–b

As Culin noted in his expedition
report, "Dr. Newcombe told me that
the West Coast [of Vancouver Island]
masks always occur in pairs, a fact
that has been ignored almost alto-
gether in museums" (1908:93). With
this set, Culin was able to remedy
this museological oversight. These
panel masks are very characteristic
of the Nootkan winter ceremonials,
but there is a great deal of uncer-
tainty as to whether they represent
supernatural wolves or lightning ser-
pents. Though the two masks closely
resemble each other, there are many
differences between them, as well as
between the two sides of each mask.
IJ

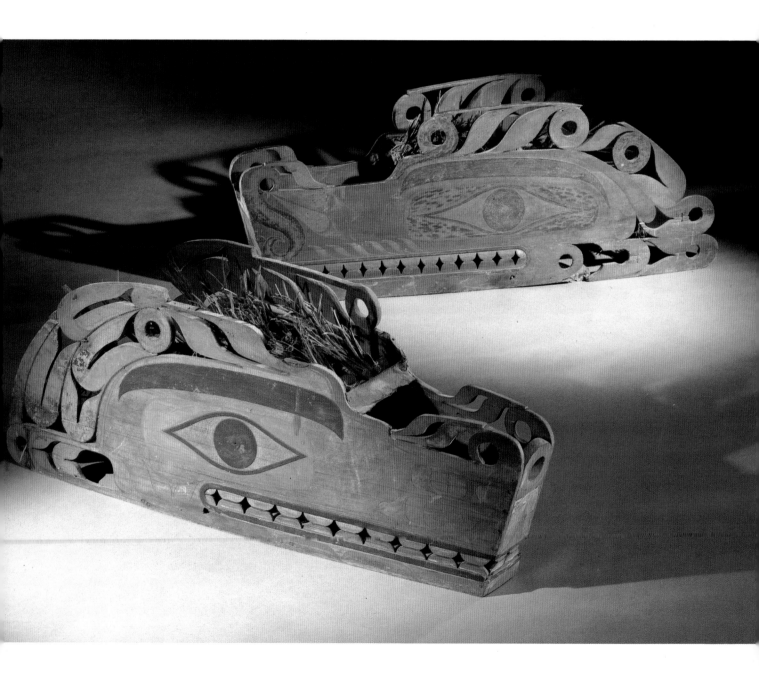

290. Chest

Haida
Cedar wood, pigment, H. 23¼, L. 36,
W. 22¼
Collected by C. F. Newcombe in Masset,
British Columbia; purchased in
Victoria, British Columbia, July 15, 1908
08.491.8903

This great kerfed chest is one of the masterpieces of the Newcombe collection. The central element of its design is a large head, below which is the creature's body, with appendages to the sides. Each side is bilaterally symmetrical, but the front and back are different. Though its designs are ambiguous in significance, the chest is clearly an exemplar of classical Haida style.

Culin discussed the chest in his report:

> The carved box, a very fine one, Dr. Newcombe let me have for twenty dollars, much less than it would ordinarily have been worth. This was on account of its having a piece cut out at the back and loosely fitted in. It had been employed, Dr. Newcombe said, in a performance in which a child had been put in the box and knives thrust through, like the well known Hindu basket trick. The Haidas had had it for a long time, and he thought it of native American origin (1908:93).

While the Kwakiutl are the Northwest Coast group best known for their dramatic illusion, such tricks were not uncommon among more northerly peoples.

Newcombe probably collected the chest in Masset in 1906, to judge from his annotation of the photographic print mounted in Culin's expedition report. The Field Museum owns a similar chest with a hinged back, also from Masset. The chest has undergone a good bit of restoration over the years; it was collected with a missing section on the lower left corner of the rear. IJ

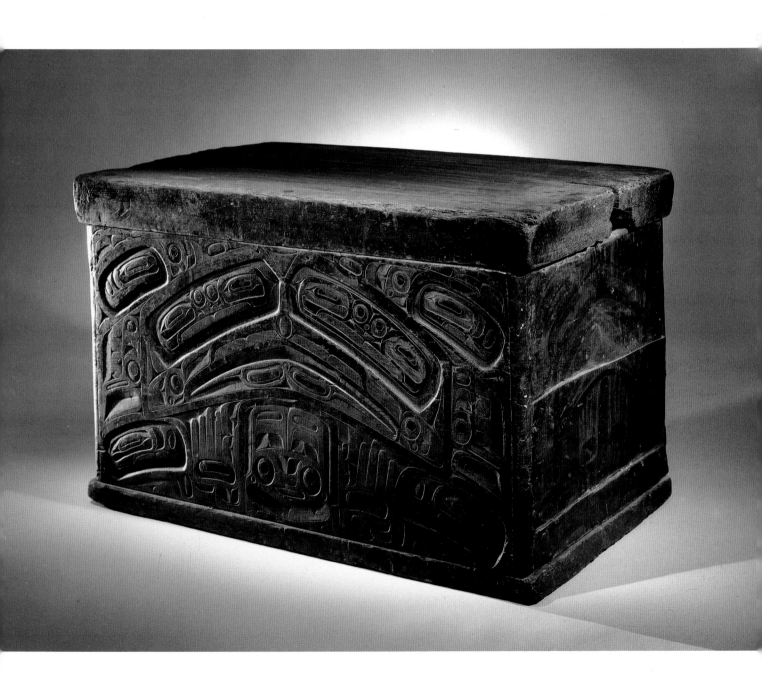

291. COPPER

Haida
Copper (alloy?), pigment, H. 29¾, W. 22¼
Collected by C. F. Newcombe in Skidegate,
British Columbia, 1911; purchased in 1916
16.749.1
Museum Collection Fund

It took many years for Culin to finally obtain a "copper." These ceremonial shields, displayed at potlatches, were prized as counters and emblems of wealth on the Northwest Coast. Among the Kwakiutl they have individual names and histories. In 1908 Culin bought a Kwakiutl wooden grave marker in the form of a copper from Frederick Landsberg. He wanted to buy the copper he saw in A. Aaronson's shop in 1911, but "Dr. Newcombe told me he would visit the copper country shortly, and could get one for me...for less" (1911a:113). Later that year, on a trip to the Queen Charlotte Islands, Newcombe did find a copper for Culin. However, it was not until early 1916 that the copper arrived in Brooklyn, as he waited to send it along with other things he was collecting for the Museum. In the end, though, Newcombe had done well for Culin, offering his copper at twenty dollars instead of the fifty Aaronson was asking.

As Newcombe noted, "Like every specimen I have ever bought it has no claims to be other than white man's. I saw two very old ones, and I thoroughly believe of genuine *Alaskan* copper."[1] Newcombe meant that this copper—like all extant examples—was made of trade materials, although Northwest Coast Indians were familiar with some form of forging technology. On this example, black paint covers most of the surface, with the design appearing over an area of bare copper. The distinctly Haida design may depict a bear. IJ

1. C. F. Newcombe to S. Culin, Sept. 24, 1911, Object Files: Newcombe Collection.

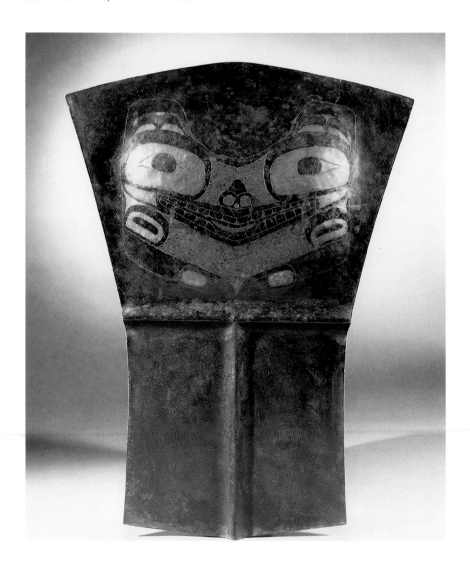

292. SPEAKER FIGURE

Gwasila, Kwakiutl
Cedar wood, pigment, H. 116
Collected by C. F. Newcombe in Smith
Inlet, British Columbia; purchased in
Victoria, August 13, 1905
05.588.7418

Culin considered this figure to be one of the prizes of his 1905 collection.[1] Newcombe had purchased it from a Gwasila Kwakiutl woman named Quolstitsas, along with two house posts from the same village. He noted that it "represents the speaker at a potlatch." The chief or his orator would speak through its mouth, announcing the names and entering guests at a potlatch. The rippled decorative effect on the surface was produced from the rhythmic strokes of the adze, and the lack of extensive weathering suggests that the sculpture was used inside the house. IJ

1. For an *in situ* photograph, see Fig. 60.

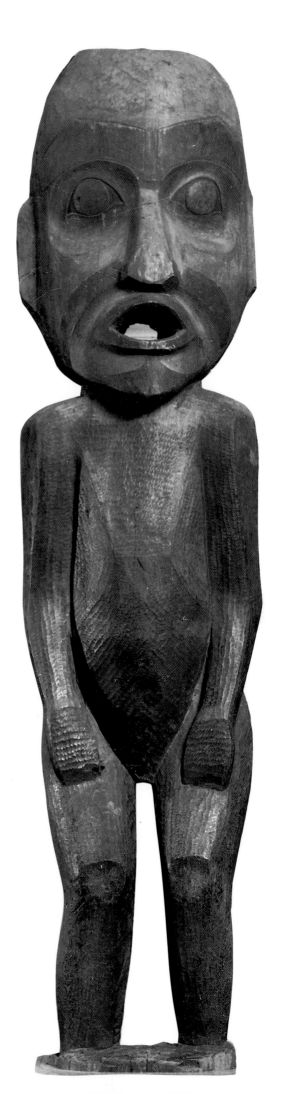

293. Set of Four House Posts

Bella Bella
Cedar wood, H. 98, W. 35¼, D. 17½
(11.696.1), H. 91½, W. 31½, D. 17¼
(11.696.2), H. 103½, W. 34, D. 16 (11.696.3),
H. 105¾, W. 32¾, D. 21 (11.696.4)
Collected by C. F. Newcombe in Bella Bella,
British Columbia; purchased in Victoria,
1911.
11.700.1–.4

On the Northwest Coast a set of four house posts, carved with ancestral crests, supported the beams of the great plank houses. Although the iconographic complex on these posts is a very common Kwakiutl motif, its significance is uncertain. What appears to be a supernatural bird, with humanoid face and recurved beak, may be a wild-man figure, and while the small man on the copper shield may be a slave, there is little hard evidence for this identification. With little support for his associations, Marius Barbeau published one pair as a bear mother and cubs, and the other, with the beak and copper, as a thunderbird and a man.[1] A series of *in situ* photographs from about 1875 to 1910 record the recent history of these posts.[2] The set is even more valuable in light of the relative rarity of Bella Bella art in museums. IJ

1. Barbeau 1953:140, 225.

2. Copies preserved in the ethnohistoric photography collection, Anthropological Collections Section; Royal British Columbia Museum, Victoria.

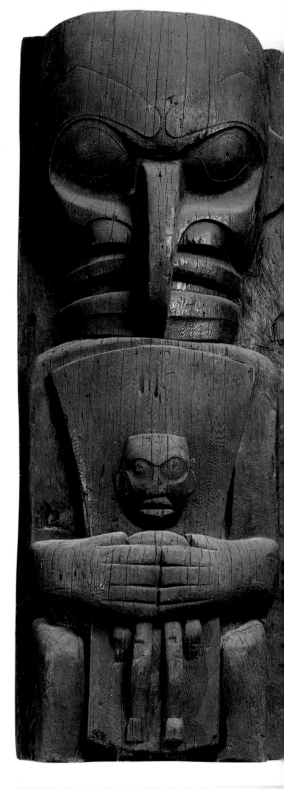

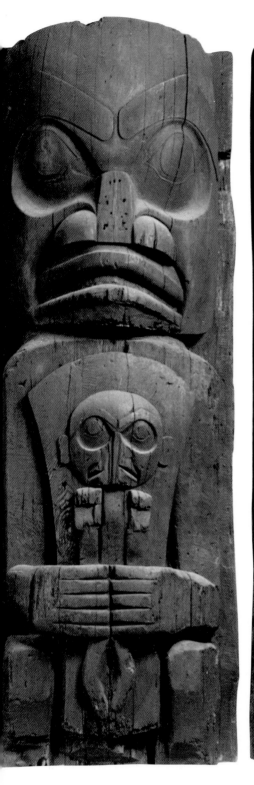
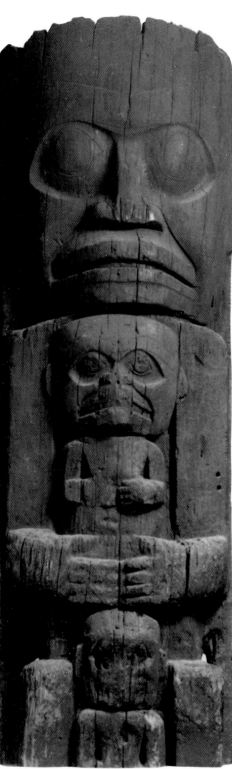
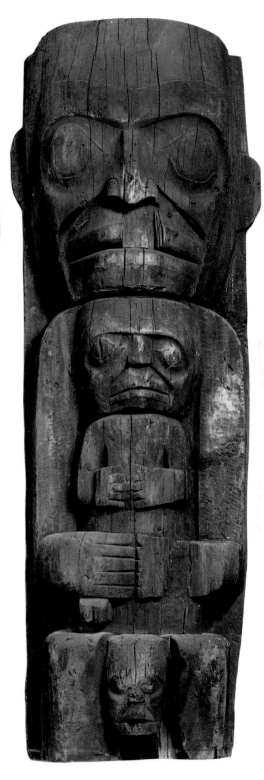

294. Totem Pole (top and bottom halves)
Haida
Cedar wood, H. 264, W. 39 (top); H. 233, Diam. 40½ (bottom)
Collected by C. F. Newcombe in Kayang, near Masset, British Columbia; purchased in Victoria, 1911
11.703a–b
Purchased with funds given by Robert B. Woodward

This pole is one of two that Dr. Newcombe obtained for Culin in early 1911, and it was by far the largest, most spectacular, and, at $400, most expensive object in Culin's Northwest Coast collection. Both poles came from the village of Kayang, outside of Masset. Newcombe was forced to cut the poles in two in order to ship them, but Culin seems to have reerected them for his first installation. Colonel Woodward, the pole's donor, was an uncle of the trustee Herman Stutzer, who was very supportive of Culin's Northwest Coast collecting.

George MacDonald has identified this pole as the frontal pole for the "Beaver House," owned by T'uwa of the Up-Inlet Point Town People, of the Raven moiety.[1] The identification of its creatures is debatable, but according to MacDonald they are, from the top: large bird (perhaps thunderbird); large bear holding a small bear; large bear with a long protruding tongue; large beaver; small bear; and large bear with extended tongue. The very bottom of the pole was probably left uncarved. The bird on the top, which is now separate, was probably carved that way originally. Several iron clamps mending a large split in the side appear to be native repairs.
IJ

1. MacDonald 1983:156–59.

295. *Tsonoqua* Mask
Kwakiutl
Cedar wood, fur (restored?), hide, pigment, iron nails, L. 19½, W. 14, D. 7¾
Collected for G. T. Emmons in Knight Inlet, British Columbia; purchased in January 1915
15.513.1
Gift of Herman Stutzer

This was one of three "fine and old" masks that Lieutenant George T. Emmons sent to Culin in January 1915. Though he reported that he had just received the set, the mask was clearly created many decades earlier, judging from the decay on the interior. A common motif in Kwakiutl art, the *tsonoqua* (or canni-bal woman) was a dangerous mythological monster who ate children but whose power could be tamed to bring wealth. Its large size would suggest that this object was used as a feast-dish cover, yet a hide chin strap and hide thongs on the interior sides indicate that it was a dance mask. Large *tsonoqua* masks are also used by chiefs during potlatch oratory. IJ

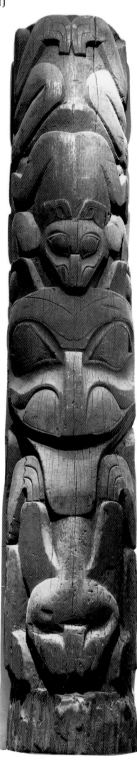

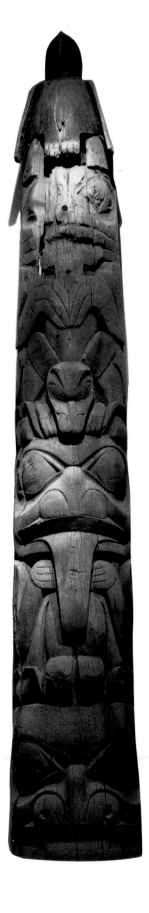

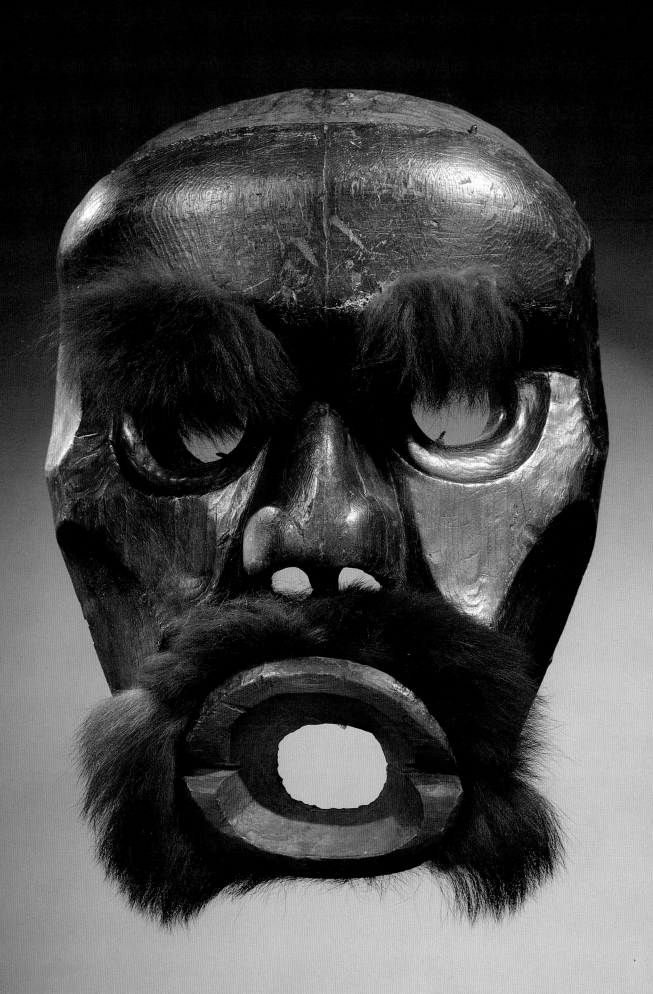

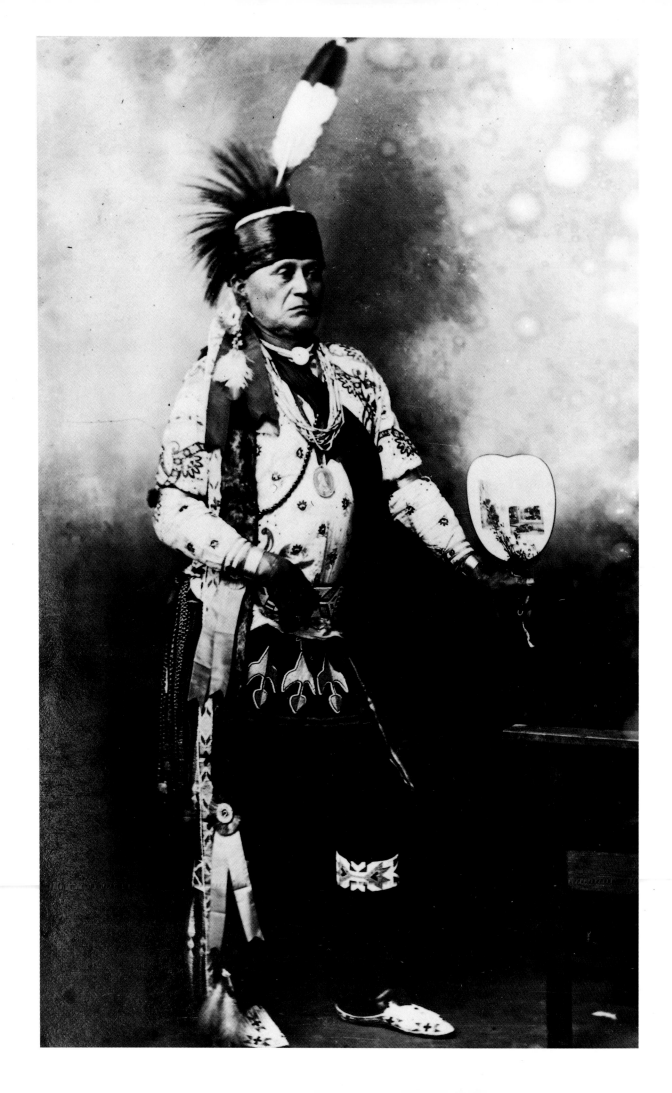

THE OSAGE OF OKLAHOMA

Lise M. Breen

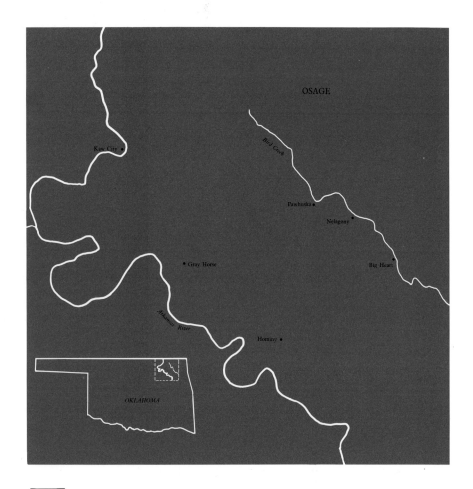

Saucy Calf. Photograph from 1911 expedition report. Culin watched Saucy Calf prepare to lead a dance. The Osage man slipped a silver peace medal over his neck in addition to a tight-fitting bead necklace with a white shell disk and a long necklace of red beads. His careful toilet included the application of perfume and paint.

I N EARLY MAY OF 1911 Stewart Culin boarded a train west to collect North American objects for a final season. By this time, his interest in the North American Indian was waning. The Brooklyn Museum halls were overflowing with objects selected during his visits to the Southwest, Northwest Coast, and California, but Culin intended to fill in some of the regional gaps in the collection before turning his interest elsewhere.

Two months before, Culin had requested and received funds to "inspect with a view to purchase" the Great Lakes collection of T. R. Roddy (also known as White Buffalo), a dealer based in Nebraska.[1] After receiving word that Roddy had moved to northern Oklahoma to collect among the Osage, Culin decided to follow him there.

Spurred by the knowledge that the Osage community was undergoing rapid change, Culin hoped to collect their "old things" while he could. The census takers predicted that the Osage would rapidly assimilate; by 1910 the number of "mixed-blood" tribal members outnumbered the 800 "full-bloods" by more than a two-to-one margin (1911a:46).[2] Culin also realized that the tribe's growing wealth profoundly affected tribal life. The Osage held more than 1.5 million acres of some of the best grasslands in the

Fig. 64. Francis La Flesche.

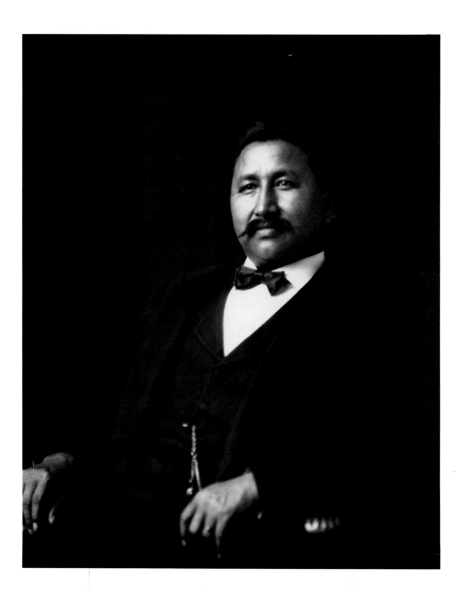

Plains, and after oil was discovered on their reservation in 1897, they were called the richest people in the world (1911a:49).[3] The Osage had transformed themselves from buffalo hunters and horticulturalists to oil barons and ranchers in less than a generation, and Culin feared that the last vestiges of their traditional life would soon disappear.

Culin also knew that the ethnologist Francis La Flesche (Fig. 64) held many of the same concerns. La Flesche was just beginning his eighteen-year task of preserving Osage ceremonies for the Smithsonian's BAE. Raised as an Omaha, a group linguistically and culturally related to the Osage, La Flesche was recording and transcribing Osage songs and recitations from several elderly individuals, many of whom had not performed the lengthy rituals for years. It was not long before he realized that Osage ritual embodied the central tenets of Osage intellectual life.[4]

Culin had heard about La Flesche's work and hoped that the two of them could help one another. In order to make a systematic study of Osage ritual life, La Flesche wanted to examine a large number of sacred objects, but such material was difficult to find and acquire. Both ethnologists recognized the threat of the decree by the Native American Church (which Culin referred to as the Mescal society) to burn all relics of the older religion (1911a:30).[5] Through La Flesche's introductions, Culin planned to

purchase examples of Osage sacred objects (see Fig. 66), By working together, they reasoned, La Flesche could compare a larger body of material and Culin could deposit the objects in the Museum for posterity.[6]

Upon his arrival at the "flourishing" town of Pawhuska (Fig. 65), with its "well-built" and "attractive" homes, Culin found it "amusing" to see the men "dressed in blankets, with a feather stuck in their cap, riding in...automobiles" (1911a:14). Yet he had conflicting notions about the state of Osage affairs. With an outsider's view, he wrote that his worst fears were confirmed:

> These Indians are in a pitiable state. They do no work of any kind, spend their days in town, eating enormously and taking no kind of exercise. Supported by the income of their large tribal fund, they employ white laborers, even having their washing done by white women laundresses. Work of every sort is absolutely abandoned. Their old ways of living are entirely gone, and their ceremonies have almost disappeared. Many of them have joined the Mescal society....Here they sit around and sing, drinking the tea made of mescal until they vomit (1911a:14).[7]

When introduced to Osage individuals, with La Flesche at his side, however, Culin took on a different voice. Rather than generalize, he evaluated the character of the individual. He described one Osage man as "distinguished," a couple as "vigorous and attractive" (Fig. 67) and another man as "very jolly." A firsthand look revealed homes that were "well-appointed" and "thrifty," and farms that were "industrious." Nevertheless, he continued to lament the "decline of the Osage"—perhaps to impress the trustees of the value of his collection (1911a:32).

Serving as guide, translator, negotiator, and teacher, La Flesche met Culin almost every day so that they could do their "usual rounds." They spent the cool mornings going from door to door asking the prices of any objects that caught Culin's eye. Late in the afternoons, La Flesche secured them invitations to dine at Osage tables and offers to fish in Osage streams. Limited by his BAE budget, La Flesche purchased just a handful of objects.[8] Culin, in contrast, swept up nearly a hundred items during his two-week stay.[9]

Owing to La Flesche's familiarity with the community, Culin was able to document the names of more than forty individuals from whom he collected material.[10] When he could, he added ethnographic detail. He noted in his forty-page expedition report the date, cost, and owner's name of almost every object. "In general," he wrote, "I pay what the people ask without bargaining...[and] their prices are remarkably fair and reasonable" (1911a:22).

In fact, Culin could not always strike a bargain. A meticulous chronicler, he noted even those individuals who had objects he coveted but who rejected his offers (see Fig. 68). Although Culin had coincidentally timed his visit before the distribution of the quarterly annuity checks so that the "Indians were especially hard up," many Osage people refused to sell him their precious heirlooms. Mrs. Pryor, the school interpreter's wife, would not part with her mother's dice bowl (1911a:11). Nor did Mrs. Red Corn care to sell her beribboned red flannel blanket, which had covered her bridegroom's horse on her wedding day (1911a:18). Moreover, several people, "impelled by superstitious reasons, chiefly fear," refused to sell Culin their sacred objects (1911a:21).

Like many collectors, Culin eagerly snapped up a number of spectacular costume elements, but unlike most, he did not ignore mundane household items. Besides finely beaded moccasins, ribboned leggings, and feathered headdresses, Culin packed a wooden ladle for skimming tallow, a hairbrush bound from the stems of wild oats, and a rack for drying boiled

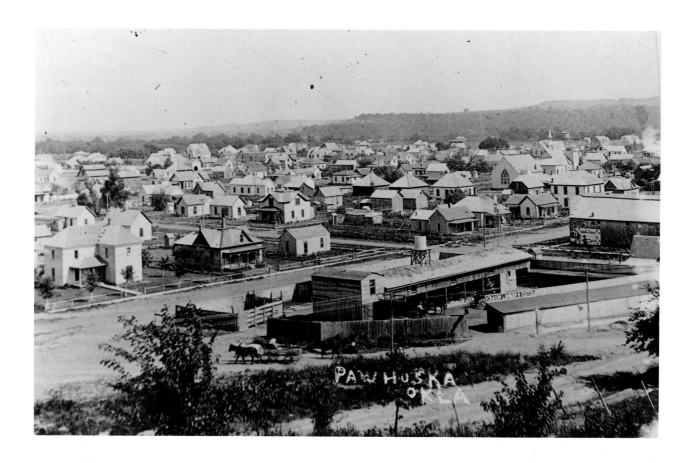

turnips fashioned from sticks and sinew. He picked up an unfinished flute that he found lying discarded on the road, and he paid twenty-five cents for a bundle of elm bark he spied on a rooftop.

Culin treasured the artifacts of an age past; a grandmother's hide scraper, an old flint and steel, and a pack of old iron arrowheads "formerly used for the arrows of the buffalo hunt" appealed to his scientific curiosity (see Fig. 69). When Culin could not find a particular object made in the old way, however, he did not hesitate to order the piece remade to represent his version of the authentic. Discovering that six strands of Wynashi's (Fig. 70) wampum had been strung on white cord, he asked another Osage to restring it with sinew, and after hearing that shinny balls were once made from a "knob from the root of the grapevine," he commissioned some in that material (1911a:11). Nevertheless, his efforts at reproducing the authentic were not altogether successful. Aunt Sophy "abstracted" a strand of wampum before its return, and Nash Kash's ball cracked, "not being made at the proper time of year" (1911a:43).

Culin purchased many of his objects from the men who explained Osage religious life to La Flesche. Among them were Bacon Rind (Wa-tse-mo-i) (Fig. 71); Saucy Calf (or Playful Calf) (Fig. 72), who called La Flesche "Son"; and Dog Thief, who called La Flesche "Nephew."[11] Culin never acknowledged the contribution that La Flesche and these religious professionals were making to the scientific community, however.

Culin's arrogance often clouded his judgment of both character and situation. In one instance, he reported that Bacon Rind offered him a bargain on a buckskin jacket (No. 312) because he "wished to placate La Flesche." According to Culin, Bacon Rind "had taken to drink and his habits had become so bad" that La Flesche "could not be seen in public with him." Culin explained that Bacon Rind had recently reformed, so that this

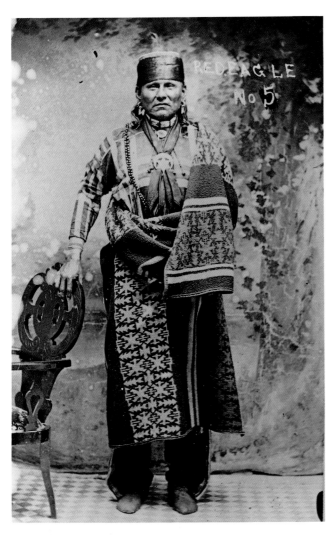

Fig. 66. *Red Eagle. Photograph from 1911 expedition report. Culin and La Flesche went to Big Heart to visit Red Eagle, the second chief of the Osage, to broach the sale of a medicine bundle. They found that the bundle belonged to his wife but she was not prepared to sell it at that time.*

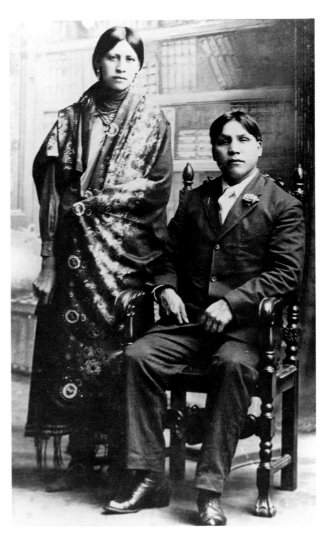

Fig. 67. *Andrew Kenworthy and his wife. Photograph from 1911 expedition report. La Flesche secured an invitation for Culin to witness the Methodist wedding of a white woman and an Osage man.*

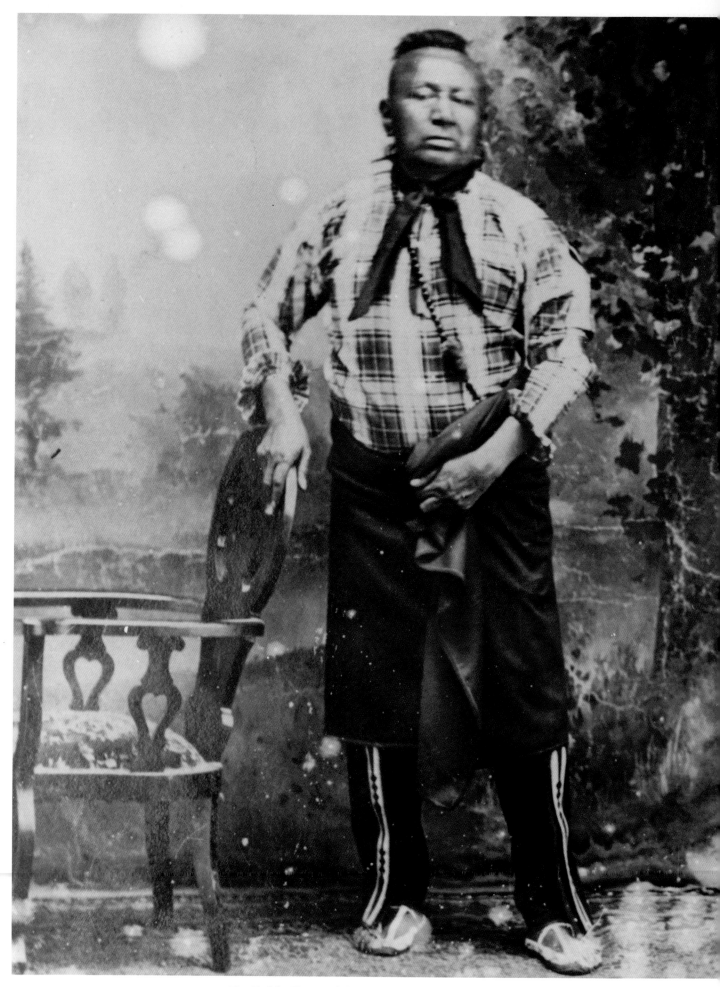

Fig. 68. Sahe. Photograph from 1911 expedition report. Sahe refused to sell Culin his song stick, a mnemonic device used to recite ritual songs, but he sold his valuable bear claw necklace (No. 304).

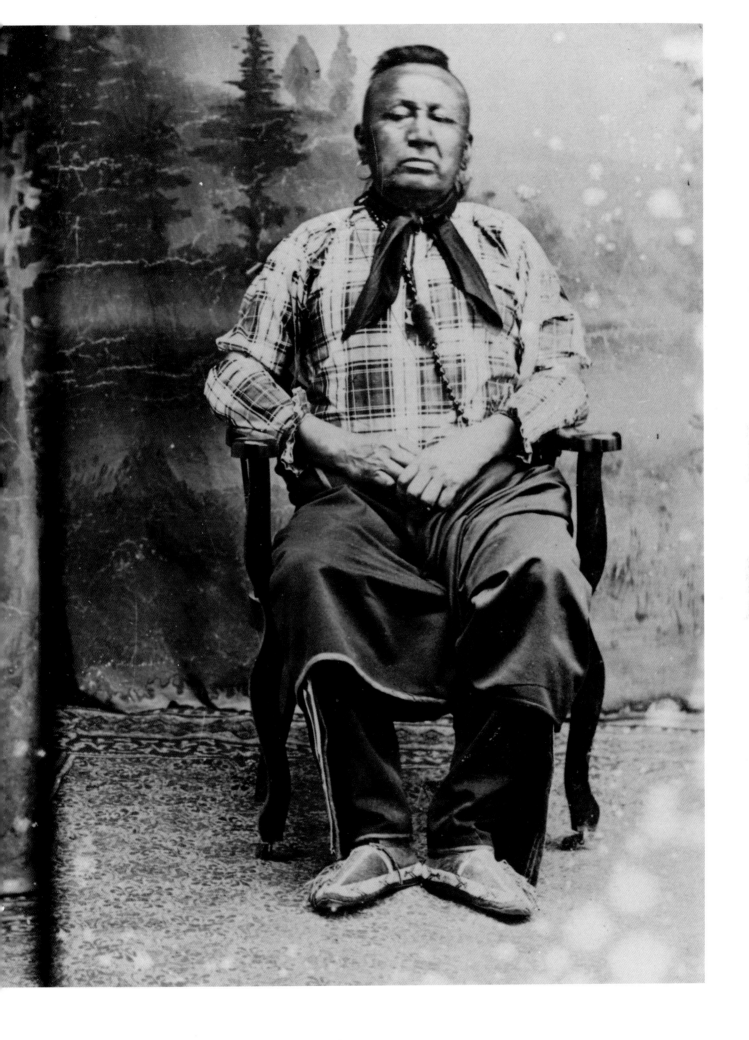

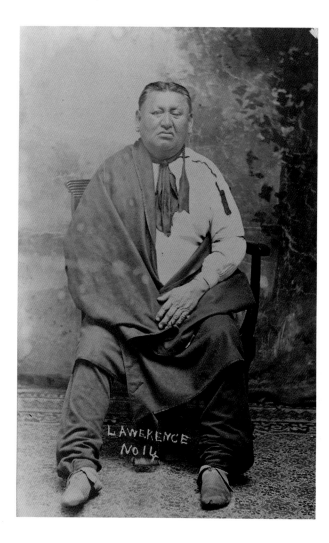

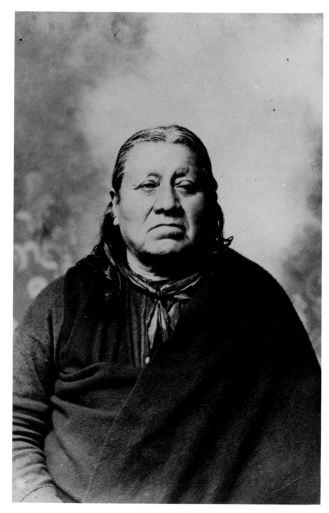

Fig. 69. Lawrence. Photograph from 1911 expedition report. Lawrence sold Culin an old buffalo-hide saddlebag, a wooden ladle for skimming tallow, and iron arrowheads once used for buffalo hunting.

Fig. 70. Wynashi. Photograph from 1911 expedition report.

was the first time La Flesche had been in his house since "he broke" with him (1911a:22). In his correspondence, however, La Flesche offered a less lurid explanation of this "break." Bacon Rind had been "sorely hurt" when La Flesche took Saucy Calf to Washington to record religious recitations. When they returned, La Flesche refused Bacon Rind's offer of help because Saucy Calf had found errors in Bacon Rind's recitations and because Saucy Calf was "professional and Bacon Rind [was] not."[12]

In another instance, Culin described Saucy Calf's preparation for leading a dance as "the costuming of an Indian dandy. In spite of his years," he continued, "pursuit of women is his chief employment, his only other passion being drink" (1911a:37; see p. 280). In contrast, La Flesche understood that the old man's "true desire" was to record Osage ritual life so that the Osage "would know what their ancestors thought and said and did."[13]

Culin's misreading of Saucy Calf's character obscured the fact that they shared the same ambition: Saucy Calf recorded his ritual knowledge, while Culin searched for ritual objects. The Osage were deeply riven by both men's actions. Even as their religious traditions were disappearing, the Osage dreaded the improper appropriation of sacred objects and knowledge by outsiders. Culin noted the conflict in his expedition report:

Mr. La Flesche tells me that the Osage are about through with the medicine bags, will have only one more ceremony, and then discard them forever. A young man...recommended that the tribe should collect all the old things and hand them over to the Government to be kept in the National Museum or some

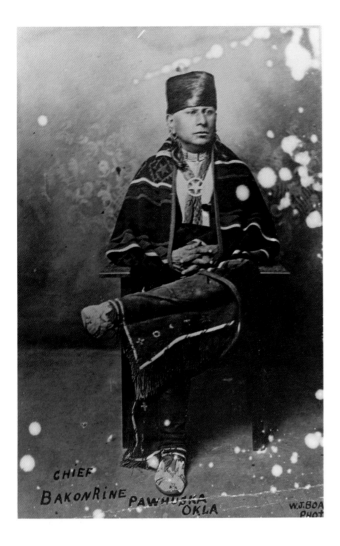

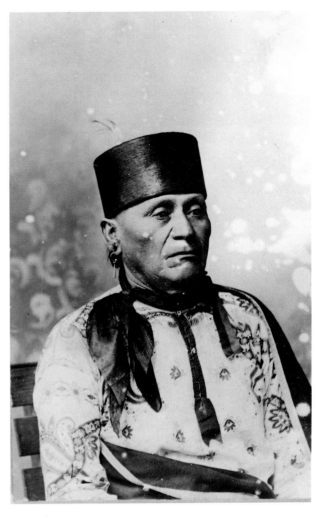

Fig. 71. Bacon Rind. W. J. Boag photograph from 1911 expedition report. Culin purchased a number of photographic portraits of Osage individuals from the Pawhuska studio photographer, William John Boag.

Fig. 72. Saucy Calf. Photograph from 1911 expedition report.

similar depository. Mr. La Flesche explained to me that they are so divided that such a plan was impossible. They are anxious to sell them and are only deterred by the fear that some harm will come to them if they let go (1911a:33).

Indeed, Saucy Calf, who continued to work with La Flesche, died in February 1912, under mysterious circumstances, and at least one scholar is convinced that he was murdered for revealing sacred material in an improper manner.[14]

Culin witnessed firsthand an Osage woman's painful anxiety concerning the sale of a medicine bundle, or "portable shrine." In this instance, La Flesche had broached the possibility of the sale with the bundle's keeper long before Culin's arrival, but the negotiation was prolonged, nonetheless:

> She laid the bag in my hands, but I made no attempt to open it, and without delay, said I would take it at her price. A period of suspense followed. The woman seemed to experience very violent emotion. She held the bag in her arms and nursed it as if it was a child. The men said nothing. It was the woman's affair...At last, after a great effort, she yielded (1911a:27).[15]

Culin entertained his quest for the rare and the sacred throughout his stay. His last cash outlay was for $100, paid to La Flesche for seeing through the sale of another medicine bundle. Culin's penultimate payment of six dollars for an old mat roof covering was worth its "possibly excessive" cost because La Flesche told him that "he doubted if there was another like it" (1911a:47). He considered the acquisition of both pieces a personal triumph

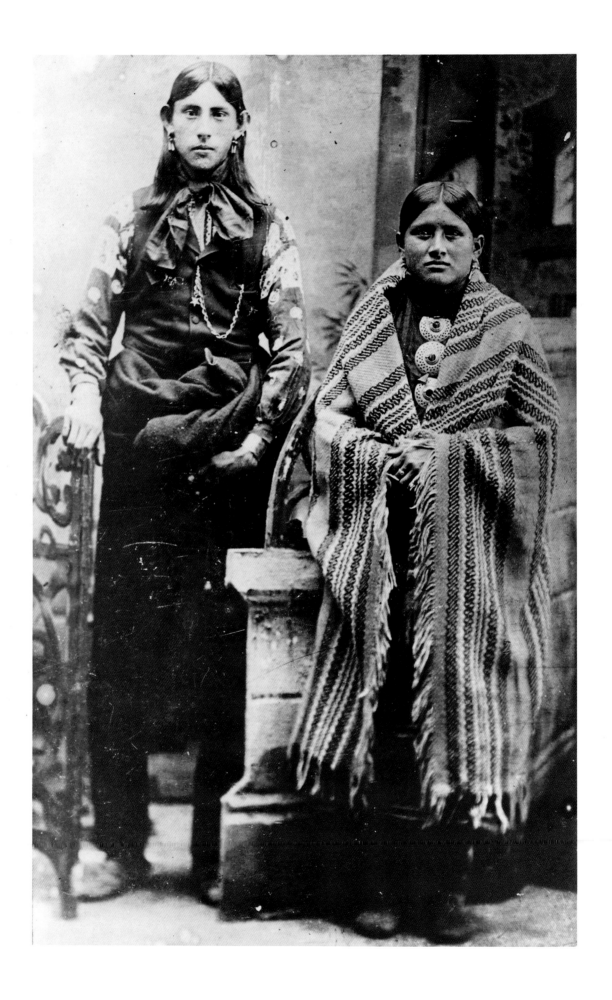

despite their disparate functions and widely ranging price tags.

By the end of his two-week stay, it was clear that Culin had ignored his initial assignment to select Winnebago objects from a dealer's collection. Instead, with La Flesche's guidance, he selected ninety-six items from about thirty Osage households for a total cost of just over $1,050.

Culin admitted that he was "glad to leave" Pawhuska because "on the whole" he did not like the community (1911a:49). He noted with disapproval that "the white population of the town in no small part, lives off the Indian," and then launched into a familiar diatribe of the times, with acts of Osage hospitality forgotten: "The Indian, with a few exceptions is hopelessly indolent, extravagant and untrustworthy. At bottom I think he hates the whites. He shows few evidences of gratitude or obligation for favors." Culin concluded that the Osage were "all anxious for money, not to hoard but to spend and ready to sell practically anything they have to receive it" (1911a:49). That accusation is unfounded: we know from Culin's own entries that many of his entreaties for treasured heirlooms and sacred objects were refused (see Fig. 73).

Certain of the "decline of the Osage," Culin knew his collection to be of true historical value, and he was particularly pleased with the few ceremonial objects that he managed to gather. Fresh from the field, he examined a dealer's Osage collection and remarked, "He has no sacred things, no strictly ceremonial things, nothing in fact like what I got among the Osages" (1911a:139).[16] A few weeks later, in Cambridge, he shrugged off the Peabody Museum's Osage collection, saying, "There are a few objects from the Osages, but nothing of any particular importance" (1911a:172).

Despite Culin's intentions, it is not certain whether the Museum ever exhibited its Osage collection.[17] Once Culin returned to Brooklyn, his interest in the Orient preoccupied him, and he paid little attention to the objects from Oklahoma. Indeed, he waited fifteen years before extending an invitation to a colleague to "share the pleasure of opening" the Osage medicine bundles, explaining that he had had only the "barest glimpse" of the religious "society treasures."[18]

Several years after Culin's death, the Osage bundles were opened once again by Samuel Barrett and George A. West from the Milwaukee Public Museum. Somehow Culin's careful documentation had become separated from the objects, and his original catalogue cards were lost. The two researchers had never heard of Culin's 1911 collecting trip or of his expedition report. They guessed correctly that the bundles had come from Oklahoma but carped, ironically, that the objects were acquired "when complete data was not considered as important as at the present time."[19] They then repacked the bundles and left them in a Museum storage room, where they languished for another fifty years. For the most part, objects from Culin's Osage collection are now on display for the first time.

296. BOWL AND DICE

Osage; Sauk and Mesquakie (small turtle)
Wood; bone with pigment (dice), Diam. 11;
¾–1 (dice)
Purchased from Mrs. William Pryor in
Osage Village, Oklahoma, May 15, 1911;
Purchased from Mrs. John Wagashi in
Osage Village, Oklahoma, May 19, 1911
(small turtle)?
11.694.8974.1.2a–f; 11.694.9006.1 (small
turtle)

297. DICE

Osage
Bone with pigment, Diam. ¾–1¼
Purchased from Mrs. Nash Kash in Osage
Village, Oklahoma, May 17, 1911
11.694.9000.1a–g

Researching his long-standing
interest in games, Culin ascertained
that shinny-stick and dice games
were the only native games played
by the Osage. Almost immediately,
he set out to collect these
"survivals."

On his first full collecting day,
Culin bought a dice-game set from
the school interpreter's wife. Mrs.
Pryor brought out an old bowl game
with several sets of dice, each con-
sisting of two carved pieces and
seven disks. Culin chose the oldest
set, noting that it was made of buf-
falo bone, that the carved pieces
represented turtles, and that the
reverses of the dice were painted
alike in either blue, green, or red
(1911a:10–11).

Although Mrs. Pryor refused to
sell her mother's very old dice bowl,
Culin was able to purchase her own
bowl, together with the dice. Yet
Culin wrote that when it came time
to pack up his shipment for
Brooklyn, Mrs. Pryor attempted to
substitute a "worthless common
American wooden bowl" for the dice
bowl he had purchased and a
shinny stick was missing. After
some delay, a Pryor boy retrieved the
shinny stick from under the bed and
Culin managed to pack the proper
bowl (1911a:44).

From Culin's description, it
appears that several sets of dice may
have been mixed together at the
Museum. Culin also bought dice
that included both turtle and bird
shapes from Mrs. Nash Kash
(1911a:19). In addition, he purchased
a dice set from John Wagashi's wife,
who told him that her dice were
made by the Sauk and Mesquakie
(1911a:20). LMB

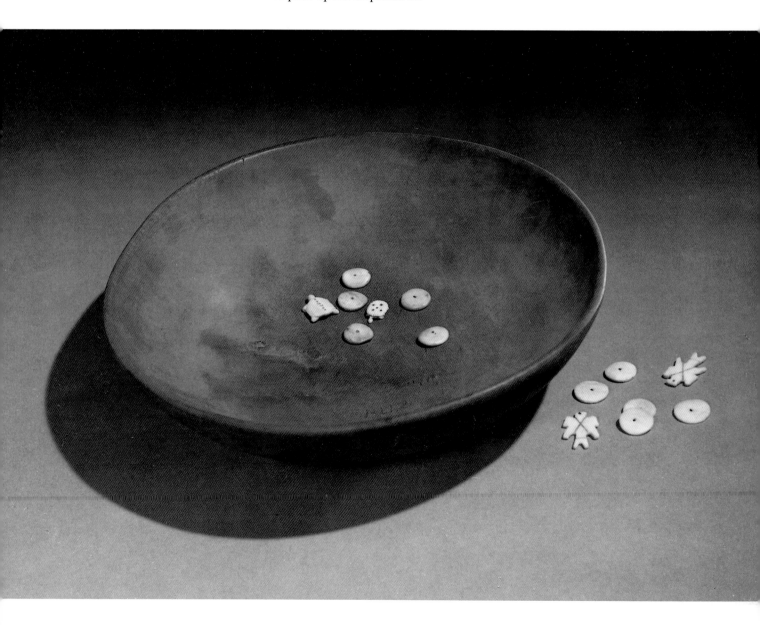

292

298. FEATHER FAN
Osage
Eagle feathers, glass beads, wood, wool,
hide, pigment, L. 23¾, W. 6½
Purchased from Francis La Flesche in
Pawhuska, Oklahoma, May 16, 1911
11.694.8977

Culin bought this feather fan from
BAE ethnologist Francis La Flesche,
upon whom he depended for gen-
eral guidance and translations. La
Flesche had commissioned the
eagle-feather fan and had paid
twelve dollars for it; he allowed
Culin to buy it at cost. This is per-
haps the only example of an object
commissioned by La Flesche. Per-
haps by way of compensation for his
help, Culin bought a Yankton Sioux
pipe that La Flesche had received as
a gift at the same time (1911a:15).

This may be the "handsome Eagle
feather fan" that La Flesche had
hoped to trade for Red Eagle's medi-
cine pack in 1910.[1] LMB

1. F. La Flesche to A. Fletcher, Oct. 7 and
Oct. 10, 1910, MS 4558, box 28, 90, National
Anthropological Archives, National
Museum of Natural History, Smithsonian
Institution, Washington, D.C. Many
thanks to Kathleen T. Baxter, Reference
Archivist, for help in locating these papers.

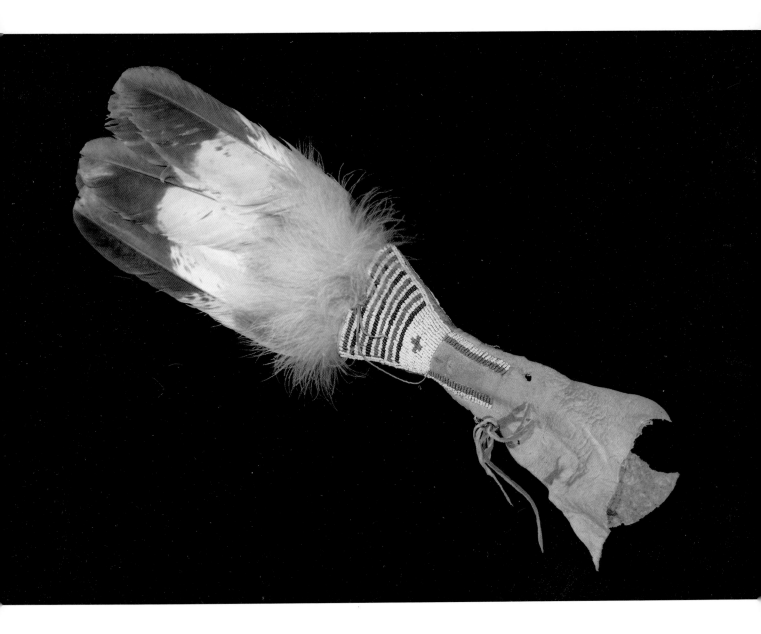

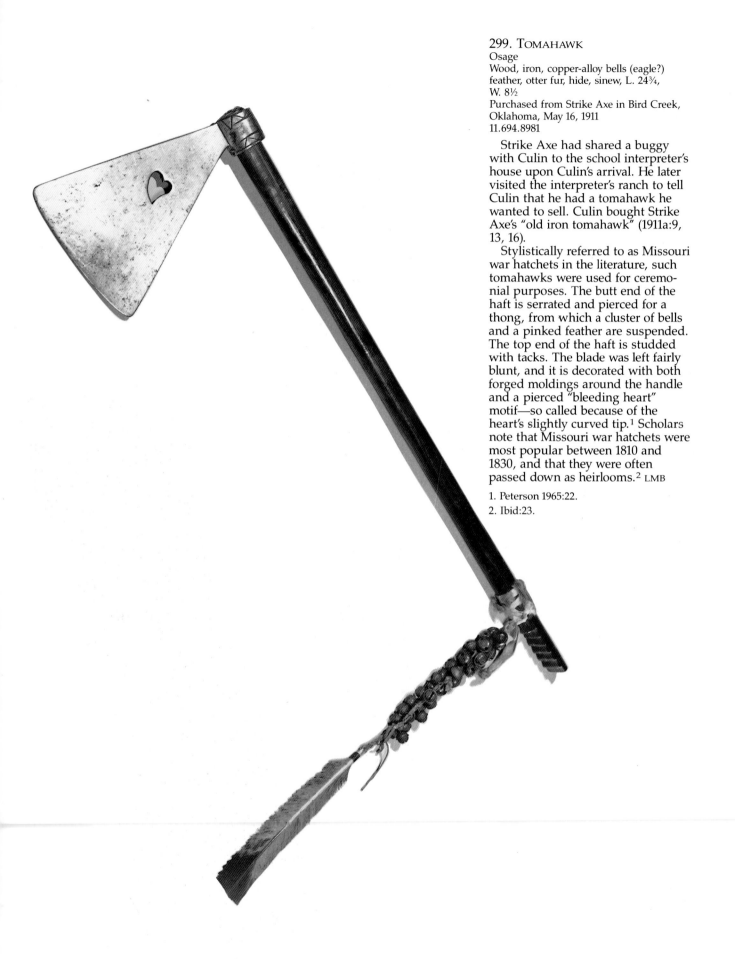

299. Tomahawk

Osage
Wood, iron, copper-alloy bells (eagle?)
feather, otter fur, hide, sinew, L. 24¾,
W. 8½
Purchased from Strike Axe in Bird Creek,
Oklahoma, May 16, 1911
11.694.8981

Strike Axe had shared a buggy with Culin to the school interpreter's house upon Culin's arrival. He later visited the interpreter's ranch to tell Culin that he had a tomahawk he wanted to sell. Culin bought Strike Axe's "old iron tomahawk" (1911a:9, 13, 16).

Stylistically referred to as Missouri war hatchets in the literature, such tomahawks were used for ceremonial purposes. The butt end of the haft is serrated and pierced for a thong, from which a cluster of bells and a pinked feather are suspended. The top end of the haft is studded with tacks. The blade was left fairly blunt, and it is decorated with both forged moldings around the handle and a pierced "bleeding heart" motif—so called because of the heart's slightly curved tip.[1] Scholars note that Missouri war hatchets were most popular between 1810 and 1830, and that they were often passed down as heirlooms.[2] LMB

1. Peterson 1965:22.
2. Ibid:23.

300. VISITING STICKS

Osage
Wood, blue pigment, hide, membrane
(snakeskin?), L. 9½, Diam. of bundle 1½
Purchased from Red Corn in Osage Village,
Oklahoma, May 17 or 18, 1911
11.694.8994

301. VISITING TOBACCO

Osage
Unanalyzed plant material wrapped in
printed cotton fabric, L. (with strap) 11,
H. 2¼
Given by Charlie Michel in Osage Village,
Oklahoma, May 19, 1911
11.694.9025
Gift of Charlie Michel

Taking shelter in a sudden storm, Culin and La Flesche stopped at Red Corn's house. A large number of trunks piled at one end of the room were opened and their contents displayed. Culin bought ten items, among them these visiting sticks and some visiting tobacco, for two dollars (perhaps originally contained in the membrane bag attached to the sticks).

Culin wrote that such visiting sticks were sent by a messenger when a traveler was within a day's journey of his destination (1911a:18). His hosts were expected to give him a present ranging from a small token of goodwill to an expensive blanket or a horse. Although the sticks were sometimes sent along with tobacco, La Flesche stated that usually the guest and his hosts only went through the form of smoking when the gifts were acknowledged. Upon rare occasions when the pipe was smoked, tobacco was mixed with dried sumac leaves.[1]

This tiny bag of visiting tobacco was given to Culin by Charlie Michel when the collector visited him at home (1911a:21). At their first meeting, two days earlier, Michel had refused Culin's offer of fifty dollars for his wampum, although he did part with an old buffalo-horn spoon for two dollars.

Undoubtedly the gift was reciprocated: Culin "always" traveled with a bounty of small gifts, "Durham tobacco, several pounds of the best stick candy and a quantity of masquerade bells."[2] The goodwill gesture may have helped to lead to a deal: two days later, Culin bought Michel's buffalo-hide beaded blanket strip. LMB

1. F. La Flesche, "Visiting Customs," MS 4558, box 22, 76.
2. A. Fletcher to F. La Flesche, May 7, 1911, ibid., box 28, 90.

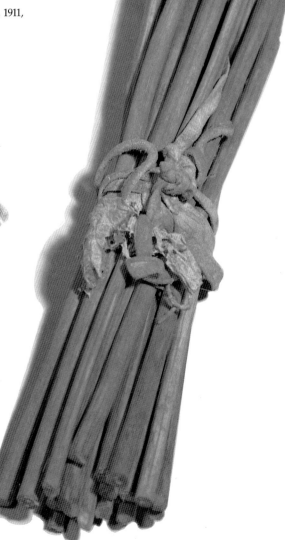

302. DOLL MOCCASINS

Osage?
Hide, glass beads, silk, cotton, L. 4, W. 1¾
Purchased from George Pitts in Osage
Village, Oklahoma, May 19, 1911
11.694.9014a–b

At George Pitt's house, Culin bought three pairs of beaded legging bands and this pair of miniature moccasins for a doll.

After arranging to hire Pitts to guide them to a distant village, Culin and La Flesche accepted an invitation to stay for supper of good coffee, pancakes, meat, rice, and stewed corn. Culin could not resist adding that "it was cooked by a white woman servant, a sad-faced creature, with a pretty little white child" (1911a:20). LMB

303. OTTER-SKIN TRAILER

Osage
Otter fur, indigo wool trade cloth, glass beads, commercially woven cotton trade cloth, silk ribbons, hide, dyed feathers, sinew, L. 54, W. 6
Purchased from Paul Albert in Osage Village, Oklahoma, May 17, 1911
11.694.8985

Culin recorded his purchase of this "otter-skin cap tail," "worn on the otter fur cap" and said nothing further about the piece (1911a:17). Culin did, however, include a photograph of Saucy Calf wearing a fur trailer and turban in his expedition report (p. 280).

Dark otter fur is highly valued by the Osage and trailers are still made but they are generally worn tied

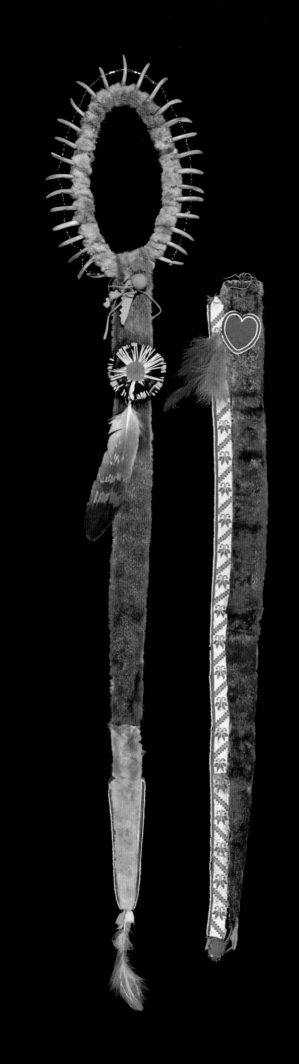

around the neck or to a choker. This is a particularly handsome piece containing two subtle design twists: the cloth heart is fully beaded on its reverse in bright blue; and the loom beadwork design along the trailer's edge flips the direction of its amber diagonal. The support material, almost completely hidden under the fur, is covered with reverse appliqué ribbonwork, concealing the fur fold and any seams. LMB

1. Feder 1961:87, 94–96.

304. BEAR-CLAW NECKLACE
Osage?
Fur, bear claws, silk ribbon, hide, cloth, feathers, glass beads, L. 77½, W. 11
Purchased from Sahe in Osage Village, Oklahoma, May 21, 1911
11.694.9032

One of the prizes of Culin's Osage collection was Sahe's bear-claw necklace "with a long tail of otter skin," worn down the back, which Culin bought "after some negotiation" for the high sum of sixty dollars. Bear claws—particularly yellow-bear claws—were highly valued throughout the Plains and Central Woodlands.[1]

Because of the danger and difficulty in obtaining the claws, a necklace was worn as an emblem of courage. The trailer, consisting largely of rich, dark brown otter fur, is lengthened by the addition of a lighter fur backed by a wedge of cloth trimmed with a white bead edging.

Along with the necklace, Culin bought several other extraordinary items of Sahe's costume: "a pair of otterskin pendants that are tied to the scalp lock, a dried paroquet with thongs attached, that is tied in the hair," and a pair of beaded moccasins (No. 307) (1911a:24).

While choosing objects to sell, Sahe unpacked his song stick, a mnemonic device for ceremonial recitation. "Sahe took up this stick, and traversing the marks, one by one, recited what appeared to be part of a ritual. Mr. La Flesche made some notes and explained to me afterward that this was a kind of catechism which he obtained entire from Sahe. This stick the man declined to sell" (1911a:25). LMB

1. In fact, one ethnographer observed that "in recent years the Osage have bought them at enormous prices, and they are greatly desired by all the neighboring tribes" (Skinner 1923:129).

305. WOMAN'S SASH

Osage?
Commercial wool yarns, glass beads,
L. 61½, W. 6½
Purchased from Little Wing in Osage
Village, Oklahoma, May 19, 1911
11.694.9017

Culin purchased this sash, two gourd rattles, and an elkbone head ornament from Little Wing, a "celebrated dancer...who danced with a light foot, although he was enormously heavy, weighing, I was told, some 400 pounds" (1911a:20–21).

It is unclear just why Little Wing had a woman's sash as his possession. Perhaps he was selling it for the "old woman" whom Culin saw at his house. She "insisted on selling [Culin] an old flint and steel," but she refused his offer for her medicine bag with "expressive grunts and gestures" (1911a:21).

Culin confessed that this interlaced sash was "good, but not as old and fine as the one La Flesche got at George Pitts."[1] Nevertheless, it contains a lovely variation on the common chevron design, and its white beads are interwoven into the pattern to good effect. Although it may have been made by an Osage woman, the Osage often commissioned such sashes from Oto or Ponca women.[2] LMB

1. Culin believed that the sash La Flesche had purchased had been made by an "old woman in her youth, a woman who had died recently at the reputed age of 100 years" (1911a:20). In fact, La Flesche states that it had belonged to the mother of his primary Osage consultant, Saucy Calf, who was deeply affected by her death on February 9, 1911 (MS. 4558, box 28, 90). La Flesche's sash is now in the National

Museum of Natural History, Smithsonian Institution (catalogue No. 276519) and is noted as having been made about 1850. Thanks to Felicia Pickering of the Department of Anthropology Processing Laboratory for locating this sash and other objects La Flesche collected.

2. Conn 1963:13.

306. PAIR OF BEADED BAGS

Cheyenne?, L. 18, W. 6½; L. 15, W. 6½
Purchased from Wynashi in Osage Village,
Oklahoma, May 20, 1911
11.694.9026.1–.2

La Flesche told Culin these bags could be employed for any purpose, but Wynashi, the man who sold them to Culin, used them to hold paint. Despite this information, Culin entered them in his ledger book as tobacco bags.

The bags are of special interest because they may have been manu-

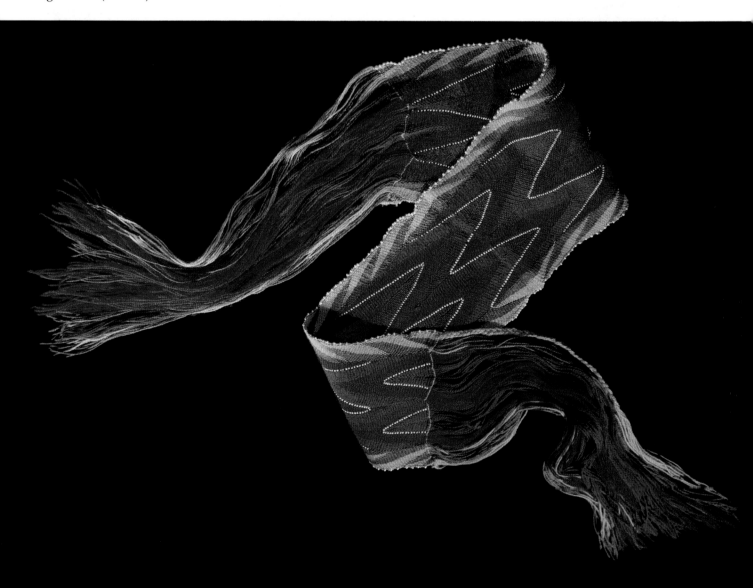

factured from another article.[1] The beadwork is especially fine, yet at least eight rows on each bag have been removed. The original seams and the beads were sewn on with sinew, but the fringe was attached to the base by machine, as was the drawstring pocket closing. It has been suggested that these bags were originally cut from beaded leggings and reworked. LMB

1. Gary Galante thought that the beadwork on these pieces was typically Cheyenne and suggested that they may have been fashioned from leggings. Comments attributed to Gary Galante in the catalogue entries are based on conversations with the author during his visit to the Museum on April 3, 1989.

307. MAN'S MOCCASINS
Cheyenne?
Hide, glass beads, vestiges of red paint, sinew?, L. 10½, W. 4
Purchased from Sahe in Osage Village, Oklahoma, May 21, 1911
11.694.9035a–b

The "old man" Sahe, who "wore his hair cut in the old way," sought out La Flesche to tell him that he had some items for sale. Culin bought several items from him, including this pair of beaded moccasins, "decorated with patterns representing the falco furcatus" (1911a:24). For the Osage, the hawk symbolized the courage of the warrior.[1] La Flesche explained, "The Osage warrior adores the hawk for the power he displays when 'far above the earth he spreads his wings,' in search of his prey; for his courage and the intrepidity with which he drops upon his victim and strikes it with unerring precision."[2]

These moccasins appear to be Cheyenne-made. Similar pairs are pictured on Osage men in many vintage photographs. This pair varies slightly from the norm in its use of a zoomorphic motif.[3] LMB

1. La Flesche 1921:pl. 9.

2. La Flesche 1930:574, wherein he quotes a line from an Osage song.

3. Gary Galante kindly provided the cultural attribution.

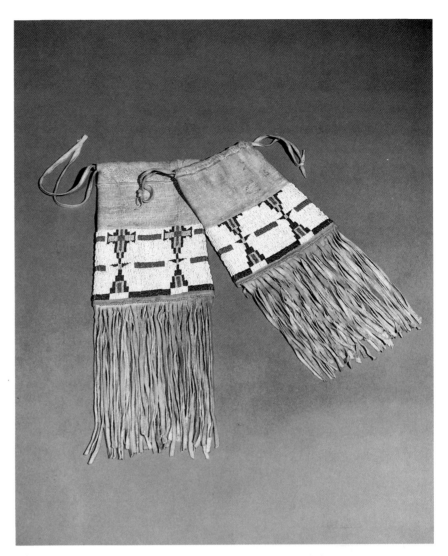

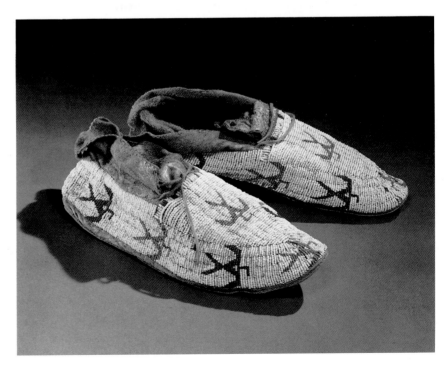

308. INNER CASE, PORTABLE SHRINE
Osage
Rush, native dyes, dyed red wool, L. 26½, W. 22
Purchased in Oklahoma, May 1911
11.702

The *waxobe* (hawk medicine bundle) of the Osage held a number of sacred articles used in a rite to prepare and protect young warriors. The most important of these objects was a dried and painted hawk carried by a commanding officer on his back during attacks.

The mat case displayed is one of several containers that forms a portable altar for the hawk, pipe, and other sacred objects. While other cases are fashioned from buffalo hair or hide or animal skins with fur, the mat case is woven from rush fibers and is the holiest of the coverings.[1]

The mat case was seen as a kind of holy "shield for the warrior" and so its creation was ritually regulated. These rituals emphasized the importance of the woman weaver's relationship to the male warrior and her contribution to the survival of the Osage people. If a woman consented to weave or repair a mat, she fasted and secluded herself for four days to weave.[2] When she cut the poles for the loom, "the tree is struck by her with her axe as if striking an enemy,—every chip is the scalp of an enemy."[3] Upon completing the mat, she sang to celebrate her creation of a new shrine "emblematic of the visible universe, and of life, amidst which the sacred hawk shall lie in safety."[4]

The matting is divided by symbolic designs into two equal parts; one represents the earth, the other the sky. The section of the mat covered with geometric designs represents the clouds and stars. The two parts also symbolize night and day. "The portion of the matting that symbolizes the day is left undyed. Across the entire width of this portion of the mat are woven, equidistant, narrow dark lines that represent night.... The space within the pocket symbolizes the expanse between the earth and the sky into which all life comes through birth and departs therefrom by death."[5]

There is some confusion regarding the source of this mat bag. Culin collected three Osage medicine bundles, and two were shipped to him by La Flesche after he examined them. This bag had a tag identifying it as "sacred bundle number 2." It probably corresponds to Culin catalogue number 9076 or 9077. LMB

1. La Flesche 1930:682.

2. Ibid.:693–95.

3. F. La Flesche to A. Fletcher, March 6, 1911, MS 4558, box 28, 90.

4. La Flesche 1930:698.

5. Ibid.:531, 683. The mat bag is missing some of its red wool closures. One side of the pocket should be fastened with six knots, while the other side is closed with seven knots. Each side represents one of the two tribal divisions. The rush of the mat bag itself represents the water on the earth (La Flesche 1930:682–83: cf. La Flesche 1921:71–73).

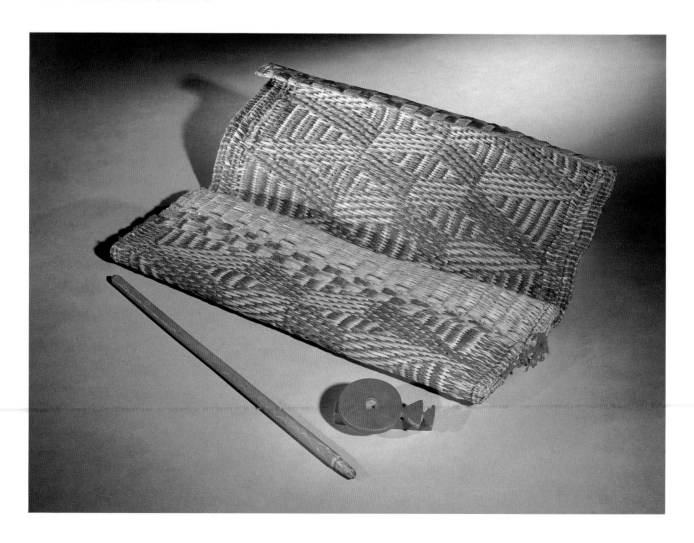

309. PIPE DISK
Osage
Catlinite, L. 4¼, W. 3
Purchased in Oklahoma, May 21, 1911
11.694.9043a

310. PIPE STEM
Osage
Wood, L. 19, Diam. ½
Purchased in Oklahoma, May 21, 1911
11.694.9043b

For the Osage, the pipe served as a means by which smoke offerings are made to the divinity.[1] A stanza recited in one prayer reads:

I am the person who has made of the
 red boulder his body
When you also make of it your body,
The malevolent gods in their destructive
 course,
Shall pass by and leave you,
 unharmed.[2]

The red catlinite pipe, then, is seen as a "symbol of endurance and of the sun, the emblem of never-ending life."[3] In times of war, "the pipe was to symbolize a man, conscious of his own limitations and seeking the aid of the All-Powerful."[4] At the same time, it signified the unity of warriors in their quest for the safety of the entire tribe.

With La Flesche's help, Culin was able to secure the Osage medicine bundle that contained this red catlinite pipe. The owner of the bundle that contained this pipe stem "caressed it as she would a child as the negotiation for it was in process" and asked if it would be "neglected or thrown away or desecrated in any way."[5] Afterward, La Flesche unpacked the bundle and described it in some detail. He reported that the pipe stem and bowl did not fit each other, which "might indicate that the two do not belong to each other." He also noted that the stem was made of ash and the zigzag mark was "very much like that made on arrow shafts."[6]

La Flesche added this note concerning the medicine bag's history:

This wa-xo-be is called wa-xo-be-pi-zhi or bad wa-xo-be, because whenever it is transferred and the ceremony is performed either the man to whom it was transferred or his wife would die soon after. This wa-xo-be was at one time carried on the war-path and the...leader who was carrying it was shot....The wa-xo-be was recovered but ever since that time death would follow its transfer.[7] LMB

1. La Flesche 1920:71.
2. La Flesche 1921:61.
3. Ibid.

4. La Flesche 1920:71.
5. MS 4558:84; see Osage essay for further detail.
6. Ibid.; cf. Paper 1988:87.
7. Ibid.

311. PARFLECHE
Kaw?,
Hide, paint, L. 25½, W. 11¾
Purchased in Osage Village, Oklahoma,
May 22, 1911
11.694.9042

Culin did not pass up any opportunity to buy other Plains peoples' objects while collecting among the Osage. The Kaw, a neighboring group, frequently visited the Osage, and from such a visitor Culin purchased this parfleche painted with typical Siouan designs, along with "an old worsted bag" filled with clothes and fragments of cloth (1911a:26). Although Culin did not ask the Kaw man why he had come to Osage territory, he glimpsed at least two Kaw participating in an Osage "Stomp Dance" with some seventy spectators (1911a:38).[1] Culin added that difficult circumstances surrounded the parfleche's purchase: "Mr. La Flesche told me that Leven Miles, who accompanied us to the Kaw's house had been urging the Indians not to sell us their old things, and had interfered with the trade I made with the Kaw. He said he would buy nothing from Miles in consequence" (1911a:26) LMB

1. La Flesche notes that on May 4, a horse-race was held in the Kaws' honor (MS 4558, box 28, 90).

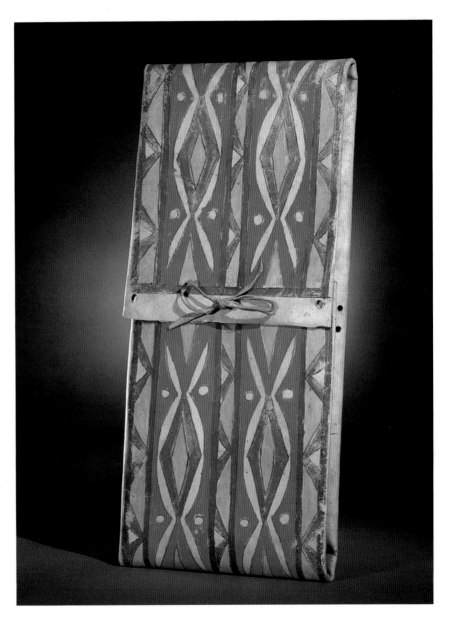

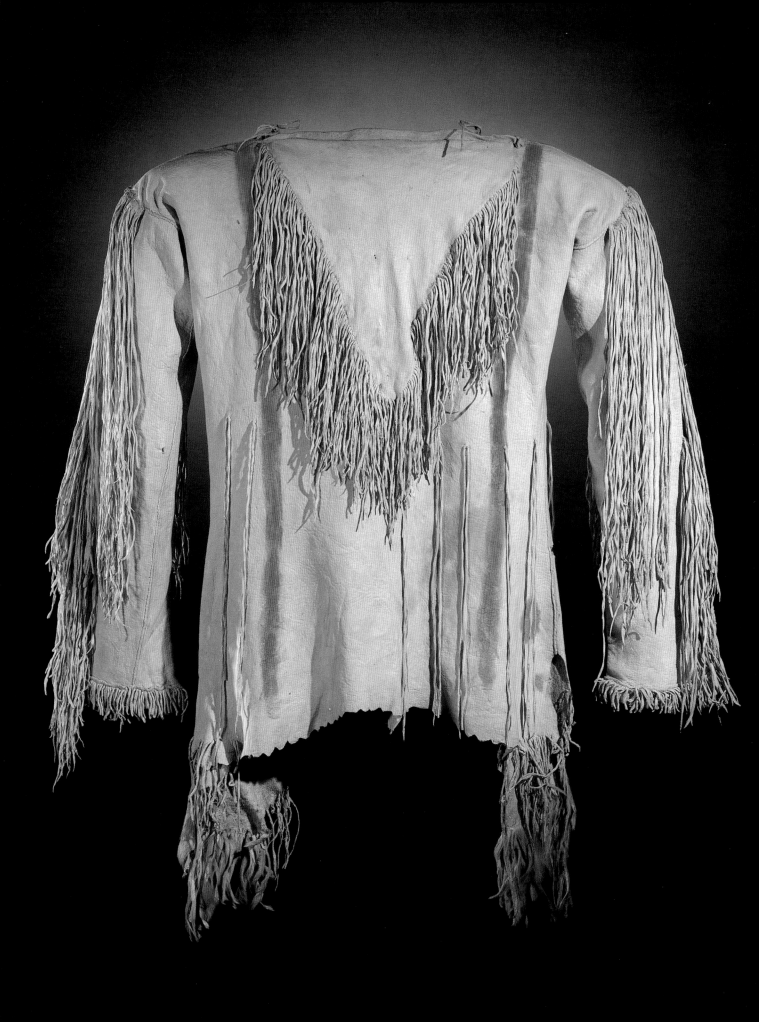

312. SHIRT

Pawnee?
Hide, hair, pigments, L. 32, W. 16
Purchased from Bacon Rind in Osage
Village, Oklahoma, May 19, 1911
11.694.9022

313. HEADDRESS

Osage?
Wool felt and cloth, feathers, hair, glass
beads, hide, fur, silk, sinew, H. 16½,
Diam. 22
Possibly purchased from Bacon Rind in
Osage Village, Oklahoma, May 19, 1911
11.694.9021

Culin purchased this handsome shirt (No. 312) and "feather war bonnet" (No. 313) for a total of thirty dollars from Bacon Rind, otherwise known as Fat on Skin or Star That Travels. He was a "very handsome, distinguished-looking man whom Mr. La Flesche introduced to me as one of the most influential members of the tribe" (1911a:21). Culin also bought Bacon Rind's otter-skin headband and an old cane whistle (1911a:23).

Culin noted that Bacon Rind's mother-in-law, who was the daughter of the Saint Louis trader Edward Chocteau, said that Bacon Rind "had paid $50 for the buckskin shirt to the Pawnees, The 'wild' Indians, she called them. He [Bacon Rind] either wanted money badly, or else wished to placate Mr. La Flesche in offering the shirt so cheap" (1911a:21–22).

Culin states that the "wild Indians" referred to by "the old lady" were Pawnee. Certainly, with its tight sleeves and undulating hem, the shirt is typical of Southern Plains style during the second half of the nineteenth century.[1]

The headdress had lost its tag over the years, but it may be Bacon Rind's, as it matches the dimensions cited on a catalogue card. Culin paid just ten dollars for Bacon Rind's headdress. When this price is compared to those he paid for other headdresses collected among the Osage—among them a Ponca headdress from William Pryor for forty dollars and the horn-and-hair headdress for fifty dollars from Dog Thief (No. 315)—it seems likely that Bacon Rind offered this as a bargain, as well. LMB

1. Hail 1980:77; Frederic Douglas noted on a catalogue card that this shirt typified Taos style; Gary Galante thought this piece was perhaps of Kiowa or Comanche manufacture.

314. WOMAN'S HIGH MOCCASINS
Comanche?
Yellow painted hide, sinew, glass beads, fur,
H. 24¼, L. 9½, W. 3¼
Purchased from Mrs. Nash Kash in Osage
Village, Oklahoma, May 23, 1911
11.694.9055a–b.

Culin sought out the "old man" Nash Kash and commissioned him to make two wooden shinny balls. When Culin came to pick up the balls, one had split, "not being made at the proper time of year." Culin had better luck with his wife, from whom he bought dice, an elk-horn headdress ornament, her mother's hide scraper, beaded garters, and this "pair of very beautiful Osage woman's leggings" (which he lists in his ledger as moccasins). Culin

noted that they were "entirely sewed with sinew, even the simple bead-work being strung on sinew instead of thread" (1911a:31, 43).

The moccasins were probably manufactured by the Comanche.[1] Comanche style moccasins remain popular among Osage women, although Osage men have preferred to buy Cheyenne style moccasins.[2]
LMB

1. Evans 1962.
2. Gary Galante offered this information.

315. HORN HEADDRESS
Osage
Dyed horsehair, dyed (rooster?) feathers, (hawk?) bird skin (including feathers and some bones), hide, glass beads, fur, horn, silk, wool, cotton, sinew, L. 49, W. 9
Purchased from Dog Thief, one-half mile east of Hominy, Oklahoma, May 23, 1911
11.694.9050

La Flesche escorted Culin to the home of the old man Shong kai-moi (Dog Thief). Culin noted that Dog Thief was a "warm friend of Mr. La Flesche and called him nephew." They stayed for lunch, and then Dog Thief brought out this horn head-dress and put it on: "Although the horns were beef horns, they were old and the headdress very beauti-ful.... While I was discussing its purchase the old man put it on my head, and excited much mirth." La Flesche told Culin that he once saw a similar headdress among the Omaha and that horn headdresses were also worn by the Pawnee, Oto, and Kaw (1911a:30). LMB

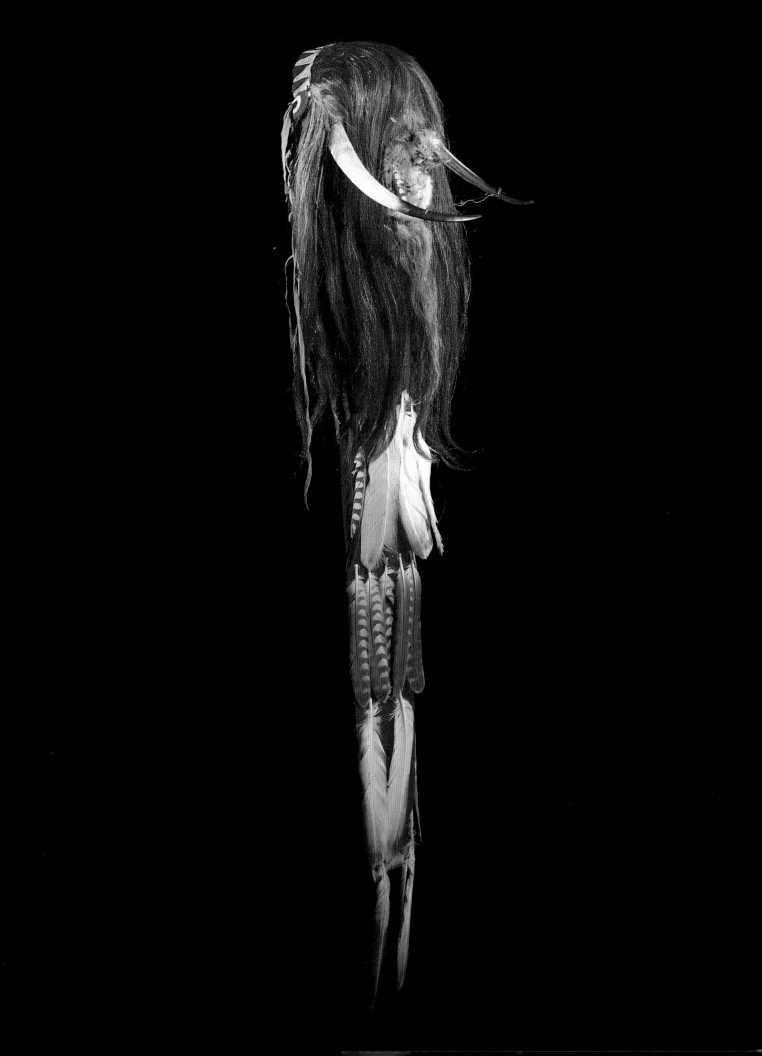

316, 317. TWINED BAGS
Osage,
No. 316: Wool, cotton, and nettle?, L. 14½
W. 15½

No. 317: Wool, cotton, L. 22¼, W. 17
Purchased from Mr. Nash Kash in Osage
Village, Oklahoma, May 24, 1911
11.694.9061; 11.694.9062

When Culin went to pick up the two wooden shinny balls he had commissioned from the "old man, Nash Kash," he was also shown "three woven bags made of colored American cord, but displaying Osage patterns." Disappointed because one of the balls had split, Culin made up for his loss by purchasing these rare bags (1911a:43).

Culin paid special attention to the smaller bag because he believed its warp, linked at the rim, was constructed from dyed inner elm bark.[1] Both of the bags illustrated here were twill-twined, but the smaller bag was twill-woven, as well, from a combination of wool and cotton yarns. The bags are finished at the rim by twisting and looping the warps together. The larger bag mimics the effect of the bast looped rim through the use of a dark brown hand-spun yarn wool.

Osage bags, boldly patterned and colorful, have not been produced since about the turn of the century and are comparatively rare.[2] The few examples in museum collections are

generally woven in dark blue and white in broad bands, separated by narrow bands of red and yellow.[3] Culin's bags, with their striking and varied color combinations, are particularly unusual. LMB

1. Technical analysis did not determine if the warp was, in fact, elm bark, but it did not discount this possibility. Douglas (1938) suggests that it superficially resembles the warp in the Osage rush mats stated by La Flesche to be the nettle fiber *Urtica gracilis*. Examination indicated that the fiber closely resembled a species of Urtica.

2. Douglas 1938.

3. Whiteford 1978:38.

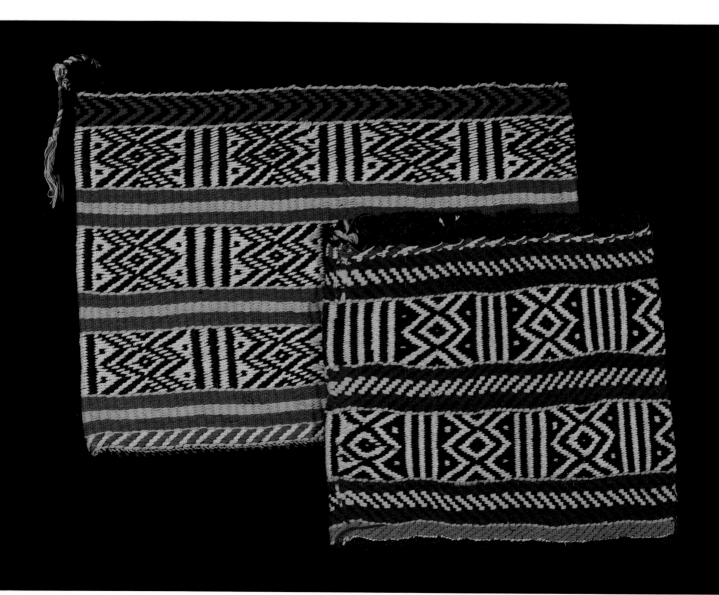

318. PEYOTE RATTLE
Osage
Gourd, glass beads, inscribed metal tag,
feathers, brass, sinew, nut or seed, cork,
L. 34½, Diam. 3¾
Purchased from Saucy Calf in Osage
Village, Oklahoma, May 23, 1911
11.694.9059

In the winter of 1910–11, Saucy Calf had accompanied Francis La Flesche to Washington to share his religious knowledge. La Flesche highly valued Saucy Calf's work, and the two men had become very close. Culin reported that La Flesche urged him to buy Saucy Calf's gourd rattle for ten dollars as a "favor." The rattle was used in the religion that became the Native American Church (called the Mescal society by Culin), which combined Roman Catholic and native beliefs:

It was a rattle of the Mescal society in which [Saucy Calf] had been a member, but from which he had withdrawn. He had paid a man named Hom-he-wa-la, an Osage, $10 to make it. This man claimed to have visited heaven and thus acquired the necessary knowledge.

Saucy Calf explained the symbolism of the rattle to Mr. La Flesche. The gourd was banded with a zigzag line of red paint which…represented the crown of thorns. The handle is covered with beads…worked with two zigzag lines, [representing] lightning, divided into two parts by a band in the middle.

The lower part of this band represents the earth and the upper part, with the gourd, heaven, [illustrating] men ascending from earth to heaven.

Saucy Calf took the rattle and sang one of the Mescal songs, which Mr. La Flesche called a hymn. There was a refrain of ho-ha-ni, which Mr. La Flesche thinks is hosanna! (1911a:35).

Culin neglected to describe the metal tag attached to the rattle. It is inscribed *Behold! the Heart of Jesus is with me.* LMB

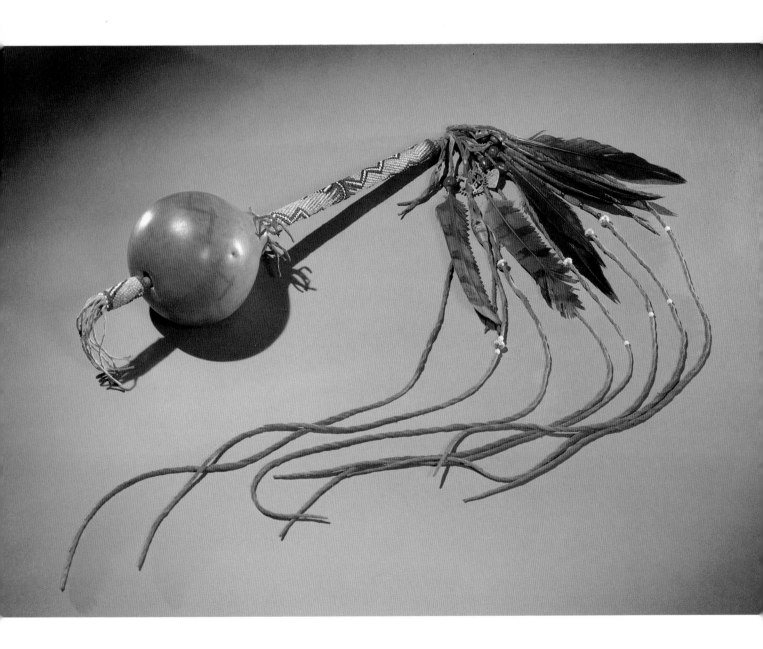

The abbreviation "Culin Archives" has been used to indicate the Stewart Culin Archival Collection, The Brooklyn Museum Archives. All correspondence cited is from Culin Archives unless otherwise specified. Citations from Culin Archives include series (and sometimes file) information (e.g. Object Files: Emmons Collection). *The Museum News* cited is a publication of The Brooklyn Institute of Arts and Sciences.

THE LANGUAGE OF THINGS: STEWART CULIN AS COLLECTOR

1. *Brooklyn Daily Eagle*, Feb. 18, 1903, Professional Activities Scrapbook, 1898–1903, Culin Archives.

2. Dorsey 1913:37.

3. Culin 1887a, 1887b, 1890. For reprints of these articles and an assessment of Culin's place in the history of folklife scholarship, see Bronner 1987:87–103. For a review of his role in ethnological collecting, see Bronner 1989.

4. Culin 1924:96.

5. There is some question about the extent of Culin's mastery of Chinese. In 1887 a newspaper account singled him out as "one of the few Americans who have mastered the jaw-breaking elements of the celestial language," but Culin himself may have provided this information (*Philadelphia Inquirer*, March 2, 1899, Professional Activities Scrapbook, 1898–1903, Culin Archives). The poet Ernest Fenollosa reportedly considered Culin the only person he knew capable of interpreting "certain Chinese symbols" (E. Niblack to S. Culin, Sept. 18, 1904, Correspondence). This opinion, given secondhand, is also difficult to evaluate.

6. Culin 1887b:595.

7. Culin [1920–25]:67.

8. The scrapbooks are in the Culin Archives.

9. Culin 1890:191.

10. Culin [1920–25]:160.

11. I am grateful to Ira Jacknis for many valuable discussions about Culin's career in Philadelphia and his place in museum anthropology.

12. At the same exhibition, the Eakins portrait of F. H. Cushing in Zuni dress (Fig. 5) was shown. The subsequent history of the Culin portrait is confusing. It was reportedly stolen in the late 1930s and still has not been located (Goodrich 1982:135).

13. In 1904 Culin defined ethnology as "a branch or subdivision of the science of anthropology, or the science of mankind." "It is the work of the ethnologist," he stated, "to collect, classify and compare information concerning the traits and customs of the different races of man, his work throwing light upon the origin and migration of man and upon the principles which underlie the development of human society and civilization" (1904b:1).

14. Darnell 1970:80.

15. Culin's authority as director was limited. He was in charge of the building and the department of Asian and General Ethnology but had no control over the other curatorial departments.

16. S. Culin to F. Putnam, June 15, 1892, Frederic W. Putnam Papers, Harvard University Archives.

17. S. Culin to F. Putnam, April 27, 1892, Frederic W. Putnam Papers, Harvard University Archives.

18. Truman 1893:256.

19. Culin 1894:56.

20. Ibid.:52.

21. Quoted in Hodge 1900:366.

22. Culin's study of games was reprinted by Dover Publications in 1975. It is reportedly used today in schools on Indian reservations.

23. Culin's curriculum vitae, submitted to the Brooklyn Institute in 1903, Culin Archives.

24. Culin published reports on his 1900 field trip (Culin 1901a) and on his Cuban trip (Culin 1902a). Although he wrote reports on the two trips to the Southwest, they were not published; the typescripts are in the Culin Archives.

25. *Ledger*, Nov. 1, 1901, Professional Activities Scrapbook 1898–1903, Culin Archives.

26. *Philadelphia Evening Telegraph*, Jan. 30, 1903, ibid.

27. Quoted in Roth 1988:33.

28. *Brooklyn Daily Eagle*, May 31, 1903, Professional Activities Scrapbook, 1898–1903, Culin Archives.

29. The Brooklyn Museum, Annual Report for 1904:21.

30. S. Culin to F. Hooper, Feb. 27, 1903, Departmental Records.

31. *Record*, Aug. 5, 1900, Professional Activities Scrapbook, 1898–1903, Culin Archives.

32. Hinsley 1981:213.

33. S. Culin to R. C. H. Block, April 3, 1900, Museum of the University of Pennsylvania, Philadelphia.

34. Catlin 1973:3.

35. Quoted in Rydell 1984:23–24.

36. Quoted in Feder 1964:10.

37. Parezo 1986:12.

38. F. Cushing to S. Culin, Oct. 1894, Cushing Correspondence.

39. Cole 1985:288.

40. Culin 1927:49.

41. S. Culin to F. Hooper, June 4, 1903; F. Hooper to S. Culin, June 11, 1903, Departmental Records.

42. M. C. Stevenson 1904:381.

43. The Brooklyn Museum, Annual Report for 1905:26.

44. Departmental Report, [1920?], Departmental Records, Culin Archives.

45. The Brooklyn Museum, Annual Report for 1904:23.

46. S. Culin to L. de Forrest, Feb. 28, 1922, Research and Writings.

47. Culin 1924:94.

48. Culin 1927:42.

49. Culin 1924:27.

50. S. Culin to L. de Forrest, Feb. 28, 1928, Research and Writings.

51. S. Culin to Mindt, Nov. 9, 1925, Research and Writings.

52. *Record*, Aug. 5, 1900, Professional Activities Scrapbook, 1898–1903, Culin Archives.

53. James Mooney, a newspaperman and ethnologist for the BAE, for example, advised caution about a game he had sent Culin: "I do not vouch for it as a typical specimen, as it was made for me as a souvenir gift and I never saw it among the Wichitas." Mooney suspected that the actual game was "probably larger and perhaps not so ornate" (J. Mooney to S. Culin, Feb. 2, 1901, Correspondence). Alfred Kroeber of the University of California made it clear that he saw no place for replicas in Berkeley's museum: "Our circumstances as regards collections from North America outside of California," he wrote to Culin regarding a proposed exchange, "are such that we feel it necessary to try to restrict them to specimens that have seen use, and to exclude models" (A. Kroeber to S. Culin, May 1, 1907, Correspondence).

54. S. Culin to F. Cushing, Oct. 4, 1894, Hodge/Cushing Papers, Southwest Museum, Los Angeles.

THE ROAD TO BEAUTY: STEWART CULIN'S AMERICAN INDIAN EXHIBITIONS AT THE BROOKLYN MUSEUM

1. Culin 1927:41.

2. S. Culin to H. B. Judy, Jan. 20, 1922, Research and Writings. Culin's expedition reports are full of illuminating comments on museum methods, ranging from the quality of the collections on display to their order and arrangements, labeling, and condition.

3. From Italy in 1910, Dorsey wrote to his friend, "Some day—we may have to wait another incarnation—you and I will have a museum of our own" (G. Dorsey to S. Culin, March 16, 1910, Correspondence).

4. S. Culin to F. Hooper, Sept. 8, 1903; S. Culin to F. Hooper, July 17, 1903, Departmental Records.

5. S. Culin, "Color in Window Display," May 1926, Research and Writings, Culin Archives. Culin's belief on this point was long-standing. In 1894 he wrote, "the details being so much influenced by questions of expense, light, space, etc. that they can only be worked out experimentally" (S. Culin to F. Cushing, Oct. 4, 1894, Hodge/Cushing Papers, folder 273, Southwest Museum, Los Angeles).

6. S. Culin to [Robert?] de Forest, March 20, 1922, Research and Writings.

7. Culin 1927:43.

8. S. Culin to F. Hooper, Feb. 26, 1903, Departmental Records.

9. Culin 1927:41.

10. These dates cannot be exact, however, as the halls usually opened to public view in a partial state of completion and were often worked on for several years thereafter. Gen-

erally, the objects were installed first, then the murals, and finally the labels. One reason for this process was the Museum's constant lack of storage space; thus the collections were, in effect, "stored" in the exhibit halls, even if they had not been fully processed.

11. S. Culin to F. Hooper, Aug. 15, 1903, Departmental Records.

12. The Brooklyn Museum, Annual Report for 1905:26.

13. Culin 1907e:106; The Brooklyn Museum, Annual Report for 1905:26.

14. The Brooklyn Museum, Annual Report for 1904:21.

15. The Brooklyn Museum, Annual Report for 1908:25. In reply to a trustee's question, Culin remarked in early 1912, "There is practically no duplicate ethnological material in the Museum. I may say that very shortly all the ethnological material collected by the Curator of Ethnology, except the Plain's [sic] Indian material, will be placed on exhibition" (S. Culin to E. L. Morris, Jan. 18, 1912, Departmental Records). Evidently, the Plains collection never was exhibited during Culin's time.

16. In these other museums, "the stored material greatly exceeds that on exhibition." S. Culin, "Plans for Collecting Trip, 1920," Research and Writings, Culin Archives.

17. Culin 1911b:101.

18. Culin 1907e:111.

19. S. Culin, The Brooklyn Museum, Annual Report for 1906:20.

20. The Brooklyn Museum, Annual Report for 1905:26.

21. The Museum News 1(3):31 (1905).

22. For the guide (Culin 1907e), see The Museum News 3(1):8 (1907); for the lists, see The Brooklyn Museum, Annual Report for 1906:20.

23. There were rare exceptions. The label for the pair of turquoise earrings (No. 62) noted that they were "made in Zuni in 1907."

24. Jacknis 1985:81.

25. S. Culin to F. Hooper, June 25, 1903, Departmental Records.

26. S. Culin to F. Hooper, July 3 and June 25, 1903, Departmental Records.

27. Culin 1903:106; see also S. Culin to F. Hooper, June 7, 1903, Departmental Records. On Dumarest's sculptural abilities and previous work, see Culin 1903:49. Dumarest was the brother of Father Noel Dumarest, whose manuscript on Cochiti Pueblo Culin acquired (Dumarest 1919).

28. S. Culin to F. Hooper, July 3, 1903, Departmental Records.

29. S. Culin to F. Hooper, June 25, 1903, Departmental Records.

30. Culin 1903:122; see also S. Culin to F. Hooper, July 25, 1903, Departmental Records.

31. Culin made plans to acquire Cushing's Zuni figures from the U.S. National Museum, but there is no evidence that they ever arrived (S. Culin to W. Holmes, April 17, 1912, Departmental Records). He did, however, obtain some life casts of Indian heads on exchange from the Museum (S. Culin to F.

Lucas, March 3, 1908; Culin to W. Holmes, Oct. 16, 1911, Departmental Records).

32. He noted that "those at the American Museum are exceptions" (S. Culin to F. Hooper, June 25, 1903, Departmental Records).

33. Judy, of Swiss descent, was born as H. B. Tschudy in Ohio. Trained as an architect, he spent much of his life as a painter in oils and watercolors, specializing in landscapes of the American West. In a career at The Brooklyn Museum that spanned 1899 to 1935, Judy served successively as a cataloguer and attendant, artist, curator of paintings and sculpture, and the Museum's first curator of contemporary art.

34. The Brooklyn Museum, Annual Report for 1905:26.

35. The Brooklyn Museum, Annual Report for 1906:10.

36. For the American Museum of Natural History, see Anon. 1913 and Wissler 1915a; for the Milwaukee Public Museum, see Lurie 1983:46–49.

37. The Brooklyn Museum, Annual Report for 1905:14.

38. The Brooklyn Museum, Annual Report for 1906:20.

39. S. Culin to C. F. Newcombe, May 14, 1910, Departmental Records. Worried about his twenty-seven-foot ceiling, Culin warned his field agent, "I don't want the poles to go to the top." In the end, the Haida poles he obtained were forty-one and thirty-four feet tall, and so were probably erected off to the side in or near the stairwell. As Culin wrote, "The totem poles look extremely well. The line of division can not be seen" (S. Culin to W. A. Newcombe, Jan. 3, 1912, C. F. Newcombe Papers, British Columbia Archives and Records Service, Victoria).

40. Culin 1907e:111.

41. S. Culin to C. F. Newcombe, May 4, 1911, C. F. Newcombe Papers; see Culin 1911a:110–11.

42. These dramatic effects were probably influenced by design developments in Victoria. In 1905 Culin had been very favorably impressed with the lieutenant governor's house, which incorporated native motifs into its decoration. The walls of the ballroom were covered with stylized coppers, eagles, and other tribal designs. Culin remarked that it was "the first application of native Indian ornament that I knew of to such a purpose" (1905a:47). On his 1908 trip he made a special effort to see the totem poles in the lobby of the new Empress Hotel. These he found "well placed…effective as decorations" (1908:94).

43. F. Lucas in The Brooklyn Museum, Annual Report for 1910:8.

44. S. Culin, "Color in Window Display."

45. Culin 1911a:171, 172.

46. Dorsey 1913:37.

47. S. Culin to L. Hubbell, June 3, 1905, box 22, University of Arizona Archives, Tucson.

48. "Museum Opens Exhibit of American Ethnology," Brooklyn Daily Eagle, June 2, 1905; "A Zuni Indian Exhibit," New York Evening Post, May 31, 1905; "Institute Museum Opens

New Ethnological Hall," [Brooklyn Daily Eagle?], [June] 1905. All from Clippings, 1905, Culin Archives.

49. "Museum Opens Exhibit of American Ethnology." Brooklyn Daily Eagle, June 2, 1905, Clippings, 1905, Culin Archives.

50. New York Sun, June 2, 1905, Clippings, 1905, Culin Archives.

51. The Brooklyn Museum, Annual Report for 1920:12.

52. S. Culin to G. T. Emmons, April 12, 1926, Research and Writings.

53. S. Culin to W. H. Fox, April, 5, 1916, Research and Writings.

54. S. Culin, "Plans for Dept. of Ethnology, 1916," Departmental Records; Culin 1917:24.

55. The Brooklyn Museum, Annual Report for 1910:9, see Annual Report for 1913:8.

56. S. Culin to Dr. Le Coq, Dec. 25, 1926, Research and Writings.

57. See Culin 1927. His inaugural display in the new galleries was to have been an exhibition on color and oriental textiles; see S. Culin to M. D. C. Crawford, Feb. 27 and March 1, 1925, Research and Writings. For my discussion of the Rainbow House and Culin's career in the 1920s, I am greatly indebted to Lise Breen, who researched these subjects in The Brooklyn Museum Archives.

58. For the removal of the collections from the American halls to the new wing, see Ethnology Dept. Monthly Reports for the period, Sept. 1925–Oct. 1926, Research and Writings, Culin Archives.

59. On his plans for the Chinese Hall, see S. Culin to W. H. Fox, Feb. 24, 1926, file no. 27, Records of the Office of the Director.

60. S. Culin to Miss Holt, Feb. 26, 1926, Research and Writings.

61. Culin 1927:49.

62. "New Ethnological Gallery Dedicated," Brooklyn Eagle-Union, Dec. 9, 1925, Research and Writings.

63. Culin 1927:44.

64. Rydell 1984:121, 134–37.

65. S. Culin to [Lockwood] de Forest, Feb. 5, 1926, Research and Writings. However, Culin noted that "These pictures which furnished the basis for the color scheme of the new Gallery were painted without any idea of their employment in the Museum" (S. Culin to W. H. Fox, Jan. 3, 1927, file no. 27, Records of the Office of the Director).

66. The Brooklyn Museum, Annual Report for 1913:8.

67. S. Culin, "Color in Window Display"; see his essay on color (1925). For his 1923 exhibition, see Culin 1923a. Culin reproduced the Rainbow House scheme for the 1927 Sesquicentennial of American Independence held in Philadelphia. As artistic adviser (at first unofficially), he referred to the Palace of Fashion and Industry as the Rainbow House, a term that was then generalized so that the entire fair was called the Rainbow City.

68. S. Culin, "Color in Window Display." See Harris 1978 for a good review of the interplay between museums, expositions, and depart-

ment stores around the turn of the century. See Leach 1989 for the development of department store display during the same period.

69. S. Culin, "Color in Window Display."

70. S. Culin to [Lockwood] de Forest, Feb. 5, 1926, Research and Writings.

71. S. Culin to M. D. C. Crawford, Oct. 9, 1925, Research and Writings.

72. Ethnology Dept. Monthly Report, May 1926, Research and Writings, Culin Archives.

73. Culin 1904a:41.

74. Culin 1927:43. See Culin 1907b:19, 344.

75. Culin 1927:43.

76. S. Culin to Dr. Le Coq, Dec. 25, 1926, Research and Writings.

77. S. Culin, "Color in Window Display."

78. Helen Appleton Read, "Pratt Students Inspired to Unique Poster Designs," *Brooklyn Daily Eagle*, May 22, 1927, Research and Writings, Culin Archives.

79. Stocking 1976.

80. For Milwaukee, see Lurie 1983:46–50; for the Museum of the American Indian, see Wilcox 1978; and for The Denver Art Museum, see Conn 1979.

81. "Museum Gallery Ablaze with Color," *The New York Times*, Aug. 7, [1927?]; M. D. C. Crawford, "New Ethnological Gallery Opens in Brooklyn Museum," Dec. 8, [1925?], [*Women's Wear Daily*?], Research and Writings.

82. S. Culin to de Forest, Feb. 17, 1927, Research and Writings.

83. S. Culin to Dr. Straubenmuller, Oct. 26, 1925, Research and Writings.

84. The Brooklyn Museum, Annual Report for 1922:7; 1923:8.

85. Helen Appleton Read, "Pratt Students Inspired to Unique Poster Designs."

86. *The Brooklyn Museum Quarterly* 14(3):112 (1927).

87. S. Culin to Mr. Pratt, March 18, 1926, Research Writings.

88. Willensky 1986:23–24.

89. S. Culin to Gertrude Ford, Oct. 29, 1928, Research and Writings.

90. From an address to the International Exposition of Industrial and Decorative Arts in Pittsburgh in 1926, quoted in S. Culin, "Department Store Called Our Greatest Cultural Influence," *Women's Wear Daily*, Nov. 22, 1926, Research and Writings, Culin Archives.

91. For the nineteenth-century context, see Cantor 1974. For the Metropolitan, see Laidlaw 1988:90. For Dana, see Alexander 1983:377–411. Culin and Dana shared a friendly correspondence in the twenties, but their similar ideas were apparently independent responses to this movement.

92. Spinden 1919.

93. M. D. C. Crawford to S. Culin, Jan. [no day] 1922; see S. Culin to M. D. C. Crawford, Jan. 20, 1922, Research and Writings. Culin and Crawford had been working together since about 1915; see Crawford [1947], Riley

1966:100–107; M. D. C. Crawford, "Design Department," *Women's Wear Daily*, Jan. 22, 1920, Research and Writings.

94. Sponsored by the National Merchandise Buyers Fair, it was held at the Grand Central Palace, New York. See brochures and correspondence in Research and Writings, Culin Archives.

95. Enclosed with S. Culin to M. D. C. Crawford, Jan. 26, 1922, Research and Writings.

96. Though Culin's magnum opus on North American Indian games was published in 1907 and included some Brooklyn specimens, most of it had been written before his arrival in Brooklyn. From time to time Culin mentioned plans to publish his American Indian research—his 1904 course of popular lectures on "The Indians of the Southwest," a paper on the Navajo medicine man's outfit, and a "descriptive handbook of the [Cliff Dwellers, possibly Southwestern] collections" (The Brooklyn Museum, Annual Report for 1904:22–24). None of this came to fruition, however.

97. Culin 1923b. However, the Cincinnati Art Museum had exhibited both African and American Indian objects since the 1890s; see Cincinnati Art Museum 1981:68.

98. Culin's death was also noted in *The New York Times*, *Brooklyn Museum Quarterly*, *El Palacio*, and *Journal de la Société des Américanistes*.

THE SOUTHWEST

1. Quoted in Jackson 1881:443.

2. Cushing 1883:12.

3. Thomas V. Keam, Dec. 10, 1899, Object Files: Keam Collection.

4. Cather [1925] 1973:220. There is a long tradition of presenting ethnological data in fictional form in the literature on the Southwest, beginning with the pioneer anthropologist Adolf F. Bandelier's novel, *The Delight Makers*, published in 1890, and continuing to the present day with Tony Hillerman's popular detective mysteries, which are set on the Navajo reservation. For a general review of the Indian as a theme in English literature, see Fiedler 1988: 573–81.

5. S. Culin, "Masks," Feb. 9, 1927, p. 16, Research and Writings, Culin Archives.

6. Warburg 1939:277. The lecture, entitled "Reminiscences from a Journey to the Pueblo Indians," was delivered in April of 1923 and published after Warburg's death in 1939.

7. Cushing 1896:378.

8. For an earlier expression of the theme, see M. C. Stevenson 1904:18.

9. Culin 1911b:100.

10. S. Culin to F. Hooper, Feb. 23, 1903, Departmental Records.

11. For a more detailed description of the Riggs collection, see The Brooklyn Museum Annual Report for 1904: 19. For background on Riggs and the collection, see Object Files: Riggs Collection, Culin Archives.

12. O. T. Mason to F. Hooper, Feb. 5, 1898, Departmental Records.

13. See C. A. Shieren to A. G. Mayer, Oct. 28, 1902; A. G. Mayer to C. A. Schieren, Oct. 29, 1902; A. G. Mayer to C. A. Deane, Nov. 5, 1902, Departmental Records.

14. C. A. Deane to A. G. Mayer, Feb. 10, 1903, Departmental Records.

15. S. Culin, "Mummy Cave Cavern," p. 10, Fiction, Culin Archives.

16. F. W. Hooper to S. Culin, June 2, 1903, Departmental Records.

17. F. Hooper to S. Culin, May 31, 1903, Departmental Records.

18. The Brooklyn Museum Annual Report for 1905: 26–27. Noel Dumarest's three notebooks were eventually translated by Elsie Clews Parsons. Entitled *Notes on Cochiti, New Mexico*, the publication includes a brief preface by Culin and several illustrations by Noel Dumarest's brother Michael (Miguel) that Culin had pasted into his expedition report for 1905 (see Fig. 28).

19. The Brooklyn Museum Annual Report for 1907: 23.

20. Manuscripts Culin collected include A. M. Stephen's Hopi Journal (ed. by Parsons; see Stephen 1936), Father Juvenal Schnorbus's "Origin of the Navajo Order of Naal' oi' baka," and English and Zuni and English and Navajo vocabularies compiled by A. Vanderwagen. Among the photographers represented in Culin's expedition reports are Brother Simeon Schwemberger, Ben Wittick, and A. C. Vroman.

21. Matthews 1902:4.

22. S. Culin to F. Hooper, Feb. 27, 1903, Departmental Records.

23. S. Culin to F. Hooper, April 16, 1903, Departmental Records.

24. S. Culin to F. Hooper, April 24, 1903, Departmental Records.

25. Ibid.

26. Ibid.

27. Franciscan Fathers 1910:7.

28. S. Culin to F. Hooper, April 24, 1903, Departmental Records.

29. Culin must have been disappointed in 1905, when H. B. Judy, the museum artist who accompanied him to the Southwest, was in charge of the expedition's photography. According to an article in *The Photographer*, "When the plates began to leave the dark room…it was found that the game had escaped. The camera had been out of focus, the pictures were no good, and there was really nothing doing in the photographic development of the Indian this trip" (Nov. 21, 1905, Clippings, 1905, Culin Archives).

30. In 1910 Culin learned that "Brother Simeon had left the convent and the order, and had set up as a photographer in Gallup. He had become infatuated with a girl at St. Michaels, the sister of the husband of Father Weber's cousin, who did the cooking, and followed her to Gallup, carrying all his photographic negatives with him" (1910:7).

31. The Brooklyn Museum Annual Report for 1904:19–20.

32. S. Culin to F. L. Babbott, Sept. 19, 1927, Research and Writings.

33. Culin 1927:47.

34. Ibid.:48.

35. For a review of early anthropologists at Zuni, see Pandey 1972.

36. M. C. Stevenson to S. Culin, dated "Monday evening," Correspondence.

37. S. Culin to F. Hooper, July 3, 1903, Departmental Records.

38. Whereas Culin thought the influence of the Navajo medicine man was harmful, he did not see anything threatening in Zuni religious practices, which expressed the communal values of settled agriculturalists. He was aware, however, that "the charge of witchcraft" was a common accusation in Zuni and reported in "Zuni Notes," "It is the duty of the War Chiefs to apprehend witches, who are subjected to a kind of trial, and hung up by the wrists from behind above the ground until they confess" (1907b:365).

39. S. Culin to F. Hooper, May 1, 1903, Departmental Records.

40. S. Culin to F. Hooper, Aug. 15, 1903, Departmental Records.

41. F. Lucas to S. Culin, June 9, 1906, Departmental Records.

42. Culin 1907e: 106–7. Culin was mistaken in thinking that the columns had been moved from Hawikuh.

43. S. Culin to F. Hooper, July 3, 1903, Departmental Records.

44. Culin 1907e:105.

CALIFORNIA

1. Mason 1904.

2. Wilcomb's personal collection was exhibited first at the Golden Gate Park Museum in San Francisco and then acquired by Robert C. Hall in Pittsburgh. Owned since 1963 by the California State Parks Department, the Wilcomb-Hall collection has been exhibited recently in the California State Indian Museum in Sacramento. He made another collection for The Oakland Museum between 1908 and his death in 1915. See Frye 1979.

3. Thoresen 1975.

4. For Merriam, see Merriam 1955, Griset 1986; for Nicholson, see McLendon and Holland 1979, McLendon 1981.

5. On basketry collecting, see Washburn 1984, McLendon 1981, Gogol 1985.

6. Each of Culin's Pomo trips was shorter than the last: his first Pomo trip in 1906 lasted fifty-seven days, August 13–October 9, with 297 entries in his catalogue. The following year he spent thirty-eight days, July 4–August 12, collecting 95 objects. And his 1908 trip lasted eighteen days (May 15–June 3), plus another three following his return from the Maidu area and British Columbia (July 18–21), with 108 entries. He also made brief visits to Ukiah on the way to and from the Orient between 1909 and 1915. (All the totals for Culin's collections cited in this chapter correspond to his catalogue entries. As he often assigned one number to a group of several related objects, the actual number of individual pieces is actually much higher.)

7. Between August 22 and 29, 1905, Culin spent three days among the Hupa (78 objects) and three among the Yurok (133 specimens). His 1906 catalogue lists another 16 entries (sent by a dealer or made the year before), making a total of 211 objects. His Maidu trip lasted from June 5 to July 8, 1908.

8. Culin visited the Yokuts between June 22 and 30, 1911. He referred to them as the Tulare, their older Spanish name, and also as the Mariposan groups, using the old BAE term for their language family.

9. In fact, Goddard's meeting with Culin in 1900 encouraged him to leave Hupa and study anthropology at the University of California (Kroeber 1929:2).

10. Coincidentally, this was not the first time a Yurok suit of armor had been ordered, never picked up, and then purchased by a subsequent collector. Dr. Hudson bought one that had been commissioned by Pliny Goddard.

11. Some of the following account has been drawn from the excellent review of Culin's Chico Maidu collection by Bates and Bibby (1983).

12. Also spelled as Miktsopdo or Michoopda. While the community was primarily composed of Konkow Maidu, it also included Maidu and other Indians from elsewhere.

13. After the destruction of the dance house (see below), those Chico Maidu who had not completely given up native ceremonials traveled to neighboring rancherias. Gradually basketry and other traditional crafts also became moribund. With the death of Mrs. Bidwell in 1918, the Mikchopdo rancheria was passed on to its Indian residents. The land was held in trust for them until the 1960s, when the federal termination policy broke it up into private sections.

14. This account is drawn from Culin's expedition report (1908:35, 75–76) and Bates and Bibby 1983:47. Culin spells Azbill's name as Mary Asbel and says she was formerly known by her maiden name of Mary Kelly.

15. This account is based on Bates and Bibby 1984.

16. Bates and Bibby 1983:48.

17. Ibid.

18. Bates and Bibby 1984:40.

19. The principal monograph on Pomo material culture, by Samuel Barrett (1952), makes extensive use of Culin's collection, and should be consulted for further comments on many of the pieces in this catalogue.

20. Ukiah is a variant of the Central Pomo name for the valley in which it is located. The Indian community of Yokaya, which Culin usually spelled as Yokeye, is about six miles south of Ukiah. It was one of three self-owned communities on land bought back from whites by the Indians between 1878 and 1881 (McLendon and Oswalt 1978:282; Bean and Theodoratus, in Heizer 1978:300).

21. McLendon and Oswalt 1978:274–77; McLendon and Holland 1979:106.

22. McLendon and Holland 1979:111.

23. This is drawn from McLendon and Lowy 1978:321. According to McLendon and Lowy, "The community seems to have flourished until 1912 when several houses and the dance house were destroyed by fire." This coincided with the offer of government-bought reservation land. Some members of the community lingered on until after World War II.

24. Hudson's relationship with the Field Museum began in August 1899, when George Dorsey was collecting in the Ukiah area. Dorsey offered Hudson a great deal of advice on the procedures of ethnological collecting. See Barter 1987 and Dept. of Anthropology Archives, Field Museum, Chicago.

25. S. Culin to W. J. McGee, Feb. 5 and March 18, 1902, BAE correspondence, National Anthropological Archives, Smithsonian Institution, Washington, D.C.; also Nov. 1902, Hudson correspondence, Department of Anthropology Archives, Field Museum, Chicago. Two years later Culin saw the doctor again in Chicago (1904a:130).

26. Culin No. 8913. Some of the documentation suggests that William Benson made the basket. He at least supervised its construction (see 1908:14, 24, 95–96).

27. J. Hudson to S. Culin, Dec. 3, [1908], Object Files: Hudson Collection.

28. J. Hudson to S. Culin, March 7, 1909, Object Files: Hudson Collection. See also the clipping from the San Francisco Chronicle, March 14, 1909, in Culin's expedition report (1908:96).

29. J. Hudson to S. Culin, April 21 or 27 [1909], Object Files: Hudson Collection.

30. The granary remained on exhibit until 1925 but does not seem to have been transferred to Culin's new display.

31. Although their letters indicate that Culin sent money and Hudson sent him the costumes in 1914, there is no sign that they were ever accessioned by the Museum.

32. On Benson, see McLendon and Holland 1979:112–13, McLendon 1981, Bernstein 1989:12. An exhibition on Benson opened in 1990. Mary Jane Lenz and Carmen Gasser at the Museum of the American Indian, New York.

33. Benson "told me that the magnesite beads Dr. Hudson had shown me were drilled and polished by the Doctor himself on a wheel, and were not, as I inferred, of Indian manufacture." He also said that Hudson had made two steatite dishes (1907a:100).

34. But, added Culin, "He has notions, however, as the result of his education: believes that America was discovered by the Northmen, etc., etc." (1907a:103).

35. Culin's encounter with Penn Graves was oddly like his fortuitous meeting with his major Chico Maidu consultant, Mary Azbill.

36. Sally McLendon was especially helpful with biographical information on Penn Graves.

37. However, as McLendon (1981:202) points out, collections show that an individual's possessions were not always destroyed at death.

38. Barrett reports: "In the lake region there was also used upon very rare occasions, as far as could be determined, a woven-tule moccasin (or sandal) and a woven-tule legging.... They have been out of use for so long that no details concerning them were

secured" (1952:296, pl. 29). See also McLendon and Lowy 1978:309.

39. Boynton 1978:51, and Mrs. Helen McCowen Carpenter, "Naming Indians," acc. 23,509 (M-12), archival collection, Grace Hudson Museum/The Sun House, Ukiah, Cal. I would like to thank Suzanne Abel-Vidor and her staff for assisting in my research on Culin Mitchell. On Culin Mitchell, see Boynton 1978:79–81. According to two newspaper clippings supplied to me by Ms. Abel-Vidor, as an adult Culin Mitchell was also known as Caroline, married Leonard Bechtol, had four children, and lived in Santa Rosa. There is some confusion concerning her year of birth. Boynton's date of 1910 would seem plausible, given the years of Culin's friendship with the Hudsons and his Pomo travels, but the earlier date comes from family testimony.

THE NORTHWEST COAST

1. F. Hooper to S. Culin, Jan. 25, 1904, Departmental Records.

2. See Low 1982.

3. By chance, in their few hours in Vancouver Dorsey and Culin ran into Franz Boas, collecting for the American Museum of Natural History.

4. In the end the smaller, uncatalogued collection was all the trustees felt they could afford, the rest going to Canada's national museum (the Victoria Memorial) in Ottawa.

5. In many cases their identities can be reconstructed from his field diaries. Nevertheless, when compared to the wealth of data in Culin's field journals, Newcombe's documentation is relatively sparse. Though he was a conscientious collector, Newcombe's other collections (especially at the Field Museum) seem to be better documented.

6. Culin gave the figure as 194 in his expedition report (1905:44). Either he miswrote or the first ten items (field nos. 128–37) were deleted from the collection, for all the available documentation lists 184 entries: 7245–7428, field nos. 128–321.

7. S. Culin to F. Lucas, March 10, 1908, Departmental Records.

8. Of the total of forty-eight objects he purchased, Culin himself collected thirty-two items. He also bought nine from Dr. Newcombe and another nine from Frederick Landsberg, a curio dealer.

9. Culin himself collected twenty-three Salish pieces on the Fraser River trip, purchasing twenty-seven from Newcombe, eight pieces from Landsberg, and eighteen from A. Aaronson, another dealer.

10. Culin may have had a good memory of the stock, but he was also in the habit of keeping lists of items that he might want to purchase in the future, as he did from Landsberg (1908:91).

11. See Cole 1985:122–33.

12. Though a friend of Culin's, George Dorsey assured his director that the museum was getting an advantageous exchange (G. Dorsey to F. Skiff, Nov. 16, 1904, Accession no. 898, Dept. of Anthropology Archives, Field Museum of Natural History, Chicago).

13. See Low 1977.

14. S. Culin to H. Stutzer, April 24, 1908, Departmental Records.

15. G. T. Emmons to S. Culin, Sept. 2, 1908, Departmental Records.

16. See Holm 1987.

17. G. T. Emmons to S. Culin, Feb. 9, 1915, Object Files: Emmons Collection.

18. G. T. Emmons to S. Culin, Feb. 21, 1915, Object Files: Emmons Collection. Although Emmons often made inflated and misleading claims in his appeals to curators, here he was precisely correct.

19. While the Field Museum was a model for Culin, his relation to the American Museum of Natural History was more adversarial. First there was his personal and intellectual distance from Franz Boas, and second, there was a natural intraurban competition with the Manhattan institution. By the time of Culin's hire at Brooklyn, the Museum of Natural History already had its primary ethnological strength in the Northwest Coast. So, for institutional as well as personal reasons, Culin chose to emphasize the Southwest in his museum and, beyond a basic representation, to leave the Northwest for other museums. See Jonaitis 1988 for a history of the Northwest Coast collections at the Museum of Natural History.

20. Cole 1985:212.

THE OSAGE OF OKLAHOMA

1. Minutes of the Board of Trustees, The Brooklyn Institute of Arts and Sciences, March 3, 1911, The Brooklyn Museum Archives. Roddy had also corresponded with Culin from Black River Falls, Wisconsin, and Culin described him as a "Winnebago chief" (1904a:147).

2. Cf. La Flesche 1921:46.

3. Cf. Bailey 1978:201.

4. La Flesche 1921:47–51.

5. By the turn of the century, several religious movements had attracted Osage adherents. Most popular was the Peyote religion—later recognized as the Native American Church—which combined traditional Plains animism with Christian elements and whose members eat peyote in communal worship as a sacrament. Although Culin reported that the Native American Church enjoyed wide popularity among the Osage at this time, he specifies only one instance where a couple had nothing to sell because they "had burned all their old things" (1911a:30). Later, La Flesche and Culin attended a Native American Church meeting, where Culin described the participants as having "nothing unusual about their appearance...except that all looked clean, were well dressed, and showed no marks of alcoholic dissipation" (1911a:39–41).

6. A. Fletcher to F. La Flesche, May 6 and May 7, 1911, MS 4558, box 3, 3, National Anthropological Archives, Smithsonian Institution, Washington, D.C.

7. Compare Culin's statement to one written by the more evenhanded La Flesche: "[The Osage] really cannot carry their share of such a burden [state taxes] unless they change their extravagant habits and buckle down to steady work. If they would set to work they could easily keep abreast with their white neighbors over whom they have the advantage in many ways. In the face of their wealth their condition is really pitiable and their future is shadowy" (F. La Flesche to A. Fletcher, Feb. 6, 1911, MS 4558, box 28, 90).

8. The National Museum telegraphed La Flesche $300 to purchase material because "there is a man [Roddy?] here after Osage curios, so I took responsibility [to buy two medicine bundles for a total of $100]" (F. La Flesche to A. Fletcher, Feb. 9, 1911, MS 4558, box 28, 90).

9. Culin reported the names of the individuals from whom La Flesche purchased an old lariat, a pair of ceremonial moccasins, and a fine old sash (1911a:13, 34, 20). These are in the National Museum of Natural History, Smithsonian Institution, Washington, D.C.

10. Culin visited some of the same individuals his friend George Dorsey had interviewed in 1902. The Osage they both met included Charlie Michel (Culin's spelling; spelled "Michell" by Dorsey) and William Pryor.

11. As is proper for all ceremonial initiates, La Flesche referred to Saucy Calf as "father...following the idea that a father is in duty bound to instruct his son in the mysteries of life" (La Flesche 1930:533). Their relationship was trusting on other levels as well; La Flesche reported that Saucy Calf treated him "like a son," loaning him his five horses and buggy (F. La Flesche to A. Fletcher, Feb. 10, 1911, MS 4558, box 28, 90).

12. F. La Flesche to A. Fletcher, Jan. 9 and 14, 1911, ibid.

13. La Flesche 1930:537; Saucy Calf quoted in La Flesche 1930:532. Culin seemed unaware of the reason why Saucy Calf had joined La Flesche in Washington, D.C., that winter. "Badgered" by other traditionalists, Saucy Calf wanted to recite and sing the rituals (F. La Flesche to A. Fletcher, Feb. 15, 1911, MS 4558, box 28, 90), "to which he had a proprietary right," unimpeded (La Flesche 1930:537).

14. Liberty 1978a:51; cf. Mathews 1961:778.

15. This description of events is corroborated by La Flesche. He added that before agreeing to the sale, the owner asked if the bag would be "neglected or thrown away or desecrated in any way" (F. La Flesche, description of Osage waxobe, MS 4558, box 26, 84).

16. Culin referred here to the collection of Joseph Henry Sharp, the painter, whom Culin visited in Montana.

17. S. Culin to W. H. Fox, May 6, 1926, File 27, Records of the Office of the Director.

18. S. Culin to M. D. C. Crawford, April 12, 1926, Research and Writings.

19. West and Barrett 1934:213.

References Cited

See Notes for explanation of "Culin Archives" and *The Museum News*. Full title has been given for Culin expedition report 1903. For Culin 1904a, 1905, 1906a, 1907a, 1908, 1910, 1911a, 1913, 1917, "Brooklyn Institute Museum" and "By Stewart Culin" has been omitted in title.

Alexander, Edward P.
1983 *Museum Masters: Their Museums and Their Influence*. Nashville: American Association for State and Local History.

Anonymous
1913 "Art in a Natural History Museum, With Special Reference to Mural Decorations in the Indian Halls." *The American Museum Journal* 13(3):99–101.

Baily, Garrick
1978 "John Joseph Mathews." In *American Indian Intellectuals*, ed. by Margot Liberty, 205–25. Saint Paul: West Publishing Co.

Barbeau, Marius
1953 *Haida Myths: Illustrated in Argillite Carvings*. National Museum of Canada, Bulletin no. 127 (Anthropological Series, no. 32). Ottawa.

Barrett, Samuel A.
1908a *The Ethno-Geography of the Pomo and Neighboring Indians*. University of California Publications in American Archaeology and Ethnology, vol. 6, no. 1. Berkeley.
1908b *Pomo Indian Basketry*. University of California Publications in American Archaeology and Ethnology, vol. 7, no. 3. Berkeley.
1917a *Ceremonies of the Pomo Indians*. University of California Publications in American Archaeology and Ethnology, vol. 12, no. 10. Berkeley.
1917b *Pomo Bear Doctors*. University of California Publications in American Archaeology and Ethnology, vol. 12, no. 11. Berkeley.
1952 *Material Aspects of Pomo Culture*. Bulletin of the Milwaukee Public Museum, vol. 20. Milwaukee.

Barter, Eloise Richards
1987 "California Collections in The Field Museum, Chicago." *News from Native California* 1(3):17.

Bates, Craig D.
1981 "Feather Belts of Central California." *American Indian Art Magazine* 7(1):46–53, 86.

Bates, Craig D., and Brian Bibby
1980 "Flicker Quill Bands of the Maidu: Ceremonial Art of Central California." *American Indian Art Magazine* 5(4):62–67.
1983 "Collecting Among the Chico Maidu: The Stewart Culin Collection at The Brooklyn Museum." *American Indian Art Magazine* 8(4):46–53.
1984 "Amanda Wilson: Maidu Weaver." *American Indian Art Magazine* 9(3):38–43, 69.

Batkin, Jonathan
1987 *Pottery of the Pueblos of New Mexico, 1700–1940*. Colorado Springs: The Taylor Museum of the Colorado Springs Fine Arts Center.

Bernstein, Bruce
1979 "A Native Heritage Returns: The Wilcomb-Hall-Sheedy Collection." In *Natives and Settlers: Indian and Yankee Culture in Early California: The Collections of Charles P. Wilcomb*, ed. by Melinda Young Frye, 69–87. Oakland: The Oakland Museum.
[1986] 1989 "Ethnographic Museum Collections and Their Use by Anthropologists." *Museum Anthropology* 13(1):2–17.

Boyd, E.
1974 *Popular Arts of Spanish New Mexico*. Santa Fe: Museum of New Mexico Press.

Boynton, Searles
1978 *The Painter Lady: Grace Carpenter Hudson*. Eureka: Interface California Corporation.

Bronner, Simon J.
1989 "Object Lessons: The Work of Ethnological Museums and Collections." In *Consuming Visions: Accumulation and Display of Goods in America, 1880–1920*, ed. by Simon J. Bronner, 217–54. New York: W.W. Norton, for The Henry Francis du Pont Winterthur Museum.

Bronner, Simon J., ed.
1987 *Folklife Studies from the Gilded Age: Object, Rite, and Custom in Victorian America*. Ann Arbor: UMI Research Press.

Bunzel, Ruth L.
1929 *The Pueblo Potter: A Study of Creative Imagination in Primitive Art*. Columbia University Contributions to Anthropology, vol. 8. (Reprinted, New York: Dover Publications, 1972.)
1932 *Zuni Katcinas*. 47th Annual Report of the Bureau of American Ethnology for the Years 1929–30, 837–1086. Washington, D.C.

Cantor, Jay
1974 "Art and Industry: Reflections on the Role of the American Museum in Encouraging Innovation in the Decorative Arts." In *Technological Innovation and the Decorative Arts*, Winterthur Conference Report 1973, ed. by Ian M. G. Quimby and Polly Anne Earl, 331–54. Charlottesville: University Press of Virginia.

Cather, Willa
[1925] 1973 *The Professor's House*. New York: Random House, Vintage Books.

Catlin, George.
[1841] 1973 *Letters and Notes on the Manners, Customs, and Conditions of the North American Indians*. London: Tosswill and Myers. Reprinted, New York: Dover Publications.

Chatfield, Jennifer
1953 "Sculptured Quartz Frog from the Southwest." *The Brooklyn Museum Bulletin* 14(2):1–9.

Cincinnati Art Museum
1981 *Art Palace of the West: A Centennial Tribute, 1881–1981*. Cincinnati: Cincinnati Art Museum.

Cody, Bertha Parker
1940 "Pomo Bear Doctors." *Masterkey* 14(4):132–37.

Cole, Douglas
1985 *Captured Heritage: The Scramble for Northwest Coast Artifacts*. Seattle: University of Washington Press.

Conn, Richard
1963 "Braided Sashes, Part 1." *American Indian Tradition* 9(1):5–14.
1979 *Native American Art in The Denver Art Museum*. Denver: The Denver Art Museum.

Crawford, Morris De Camp
[1947?] *The Brooklyn Museum and the Decorative Art Industries*. Brooklyn: The Brooklyn Museum.

Culin, Stewart
1887a "The Practice of Medicine by the Chinese in America." *Medical and Surgical Reporter* 56:355–57.
1887b "Chinese Drug Stores in America." *American Journal of Pharmacy* 59(12):593–98.
1890 "Customs of the Chinese in America." *Journal of American Folklore* 3(10):191–200.
1891 *The Gambling Games of the Chinese in America*. Publications of the University of Pennsylvania, Series in Philology, Literature and Archaeology, vol. 1, no. 4. Philadelphia.
1894 "Retrospect of Folk-Lore of the Columbian Exposition." *Journal of American Folklore* 7(24):51–59.
1900 "The Origin of Ornament." *Bulletin of the Free Museum of Science and Art of the University of Pennsylvania* 2(4):235:42.
1901a "A Summer Trip Among the Western Indians." *Bulletin of the Free Museum of Science and Art of the University of Pennsylvania* 3:1–22, 88–122, 143–75.
1901b "Report of Archaeological and Ethnological Trips in 1901." Culin Archives.
1902a "The Indians of Cuba." *Bulletin of the Free Museum of Science and Art of the University of Pennsylvania* 3(4):185–226.
1902b "Report on a Visit to the Indians of New Mexico and Arizona in 1902." Culin Archives.
1903 "Brooklyn Institute Museum. Report on a Collecting Expedition among the Indians of New Mexico and Arizona, April–September, 1903. By Stewart Culin." Culin Archives.
1904a "Report on a Collecting Expedition among the Indians of New Mexico and Arizona, May–September, 1904." Culin Archives.
1904b "The Indians of the Southwest: A Course of Lectures Delivered in the Museum of the Brooklyn Institute of Arts and Sciences." Culin Archives.
1905 "Report on a Collecting Expedition among the Indians of Arizona and California, June 18–October 6, 1905." Culin Archives.
1906a "Report on a Collecting Expedition among the Indians of Arizona and California [August–October, 1906]." Culin Archives.
1906b "Hopi Indian Masks from a Cave in the Cañon de Chelly, Arizona." Unsigned article. *The Museum News* 1(6):80–81.
1907a "Report on a Collecting Expedition among the Indians of New Mexico and California, May 4–September 29, 1907." Culin Archives.
1907b "Zuni Notes." 2 vols. Culin Archives.
1907c *Games of the North American Indians*. 24th Annual Report of the Bureau of American Ethnology for the Years 1902–1903, 1–

846. (Reprinted, New York: Dover Publications, 1975.)

1907d "Dolls of the Zuni Indians." Unsigned article. *The Museum News* 2(5):78–79.

1907e *Guide to the Southwestern Indian Hall.* Brooklyn: The Brooklyn Museum. (Reprinted, *The Museum News* 2(7):105–11.)

1907f "Hopi Ceremonial Frames and Standard from a Cave in the Cañon de Chelly, Arizona." Unsigned article. *The Museum News* 2(7):112–13.

1908 "Report on a Collecting Trip among the Indians of California, April 26–August 4, 1908." Culin Archives.

1910 "Report on a Collecting Trip in China and Japan, June 3, 1909–March 21, 1910." Culin Archives.

1911a "Report on a Collecting Trip among the Indians of Oklahoma, New Mexico, California, and Vancouver, May 3–July 28, 1911. Culin Archives.

1911b "What Is a Museum?" Unsigned article. *The Museum News* 6(7):99–101.

1913 "Report on a Collecting Trip in Japan, Including a visit to the Kurile Islands and the Hokaido, May 4, 1912–January 31, 1913." Culin Archives.

1917 "Report on a Collecting Trip on Long Island and in New England, June 5–September 18, 1917." Culin Archives.

1918 "The Story of the Carved Pilasters from the Franciscan Church of Our Lady of Guadalupe at Zuni, New Mexico." *Good Furniture* 10:233–39.

[1920–25] "The Road to Beauty." Culin Archives.

1923a "European Costumes and Keramics, Museum Exhibition, 1923." *The Brooklyn Museum Quarterly* 10(2):61–70.

1923b "Negro Art." *The Brooklyn Museum Quarterly* 10(3):119–32.

1924 "Creation in Art." *The Brooklyn Museum Quarterly* 11(3):91–100.

1925 "The Magic of Color." *The Brooklyn Museum Quarterly* 12(2):99–103.

1927 "The Road to Beauty." *The Brooklyn Museum Quarterly* 14(2):41–50.

Cushing, Frank Hamilton

[1882–83] 1967 "My Adventures in Zuni." *Century Illustrated Monthly Magazine* 25 (1882):191–207, 500–511; 26 (1883):28–47. Facsimile Reprint in Book Form, with Introduction by Okah L. Jones, Jr. Palmer Lake, Colo.: Filter Press.

1883 "Zuñi Fetishes." In 2d Annual Report of the Bureau of American Ethnology for the Years 1880–81, 9–45. Washington, D.C.

1886 "A Study of Pueblo Pottery as Illustrative of Zuñi Culture-Growth." In 4th Annual Report of the Bureau of American Ethnology for the Years 1882-83, 473–521. Washington, D.C.

1896 "Outlines of Zuñi Creation Myths." In 13th Annual Report of the Bureau of American Ethnology for the Years 1891–92, 321–447. Washington, D.C.

Darnell, Regna

1970 "The Emergence of Academic Anthropology at the University of Pennsylvania." *Journal of the History of the Behavioral Sciences* 6:80–92.

Dixon, Roland B.

1905 *The Northern Maidu.* Bulletin of the American Museum of Natural History, vol. 17, no. 3.

Dorsey, George A.

1913 "Stewart Culin." *The American Magazine* 45(3):36–37.

Douglas, Frederic [and Frances Raynolds]

1938 *An Osage Yarn Bag.* Material Culture Notes, no. 7. Denver: The Denver Art Museum.

Dumarest, Noël

1919 *Notes on Cochiti, New Mexico.* Ed. by Elsie Clews Parsons. Memoirs of the American Anthropological Association, vol. 6, no. 3, 137–237.

Evans, Denis

1962 "Southern Plains Women's Boots." *American Indian Tradition* 8(5):181–93.

Faris, James C.

1990 *The Nightway: A History and a History of Documentation of a Navajo Ceremonial.* Albuquerque: University of New Mexico Press.

Feder, Norman

1961 "Otter Fur Turbans." *American Indian Tradition* 7(3):84–96.

1964 *Art of the Eastern Plains Indians: The Nathan Sturges Jarvis Collection.* Brooklyn: The Brooklyn Museum.

Fewkes, J. Walter

1898 *Archaeological Expedition to Arizona in 1895,* 17th Annual Report of the Bureau of American Ethnology for the Years 1895–96, Pt.2, 519–742. Washington, D.C.

1901 "The Lesser New-Fire Ceremony at Walpi." *American Anthropologist* n.s. 3(3):438–53.

1903 *Hopi Katcinas Drawn by Native Artists.* 21st Annual Report of the Bureau of American Ethnology for the Years 1899–1900, 13–126. Washington, D.C.

1906 "Hopi Ceremonial Frames from Cañon de Chelly, Arizona." *American Anthropologist* n.s. 8(4):664–70.

Fiedler, Leslie A.

1988 "The Indian in Literature in English." In *History of Indian-White Relations,* ed. by Wilcomb Washburn, 573–81. Vol. 4, *Handbook of North American Indians,* ed. by William C. Sturtevant. Washington, D.C.: Smithsonian Institution.

Fletcher, Alice, and Francis La Flesche

1911 *The Omaha Tribe.* 27th Annual Report of the Bureau of American Ethnology for the Years 1905–6. Washington, D.C.

Fox, Nancy

1978 *Pueblo Weaving and Textile Arts.* Santa Fe: Museum of New Mexico Press.

Franciscan Fathers

1910 *An Ethnologic Dictionary of the Navaho Language.* Saint Michaels, Ariz.: Saint Michael's Press. (Reprinted, 1968.)

Frye, Melinda Young, ed.

1979 *Natives and Settlers: Indian and Yankee Culture in Early California. The Collections of Charles P. Wilcomb.* Exh. cat. Oakland: The Oakland Museum.

Gessler, Trisha

1981 *The Art of Nunstints.* Exh. cat. Skidegate, B.C.: Queen Charlotte Islands Museum.

Goddard, Pliny E.

1903 *Life and Culture of the Hupa.* University of California Publications in American Archaeology and Ethnology, vol. 1, no. 1. Berkeley.

Gogol, John M.

1985 "1900–1910, The Golden Decade of Collecting Indian Basketry." *American Indian Basketry Magazine* 5(1):12–29.

Goodrich, Lloyd

1982 *Thomas Eakins.* Published for the National Gallery of Art, Washington, D.C. Harvard University Press. 2 vols.

Griset, Suzanne

1986 "Preventative Conservation Measures for an Ethnographic Collection." *The International Journal of Museum Management and Curatorship* 5(4):371–82.

Gustafson, Paula

1980 *Salish Weaving.* Seattle: University of Washington Press.

Hail, Barbara A.

1980 *Hau, Kola!: The Plains Indian Collection of the Haffenreffer Museum of Anthropology.* Providence, R.I.: Haffenreffer Museum, Brown University.

Haile, Father Berard

1947 *Head and Face Masks in Navaho Ceremonialism.* Saint Michaels, Ariz.: Saint Michael's Press.

Hardin, Margaret Ann

1983 *Gifts of Mother Earth: Ceramics in the Zuni Tradition.* Exh. cat. Phoenix: The Heard Museum.

Harris, Neil

1978 "Museums, Merchandising, and Popular Taste: The Struggle for Influence." In *Material Culture and the Study of American Life,* ed. by Ian M. G. Quimby, 140–74. New York: W. W. Norton, published for The Henry Francis du Pont Winterthur Museum.

Heizer, Robert F., ed.

1978 *California.* Vol. 8, *Handbook of North American Indians,* ed. by William C. Sturtevant. Washington, D.C.: Smithsonian Institution.

Hinsley, Curtis M., Jr.

1981 *Scientists and Savages: The Smithsonian Institution and the Development of American Anthropology, 1846–1910.* Washington, D.C.: Smithsonian Institution Press.

Hodge, Frederick Webb, ed.

1900 "In Memoriam: Frank Hamilton Cushing." *American Anthropologist* n.s. 2:345–79.

Holm, Bill

1981 "Will the Real Charles Edensaw Please Stand Up?: The Problem of Attribution in Northwest Coast Indian Art." In *The World Is as Sharp as a Knife: An Anthology in Honour of Wilson Duff,* ed. by Donald N. Abbott, 175–200. Victoria, B.C.: British Columbia Provincial Museum.

1983 *The Box of Daylight: Northwest Coast Indian Art.* Exh. cat. Seattle. Seattle Art Museum and University of Washington Press.

1987 *Spirit and Ancestor: A Century of Northwest Coast Indian Art at the Burke Museum.* Seattle: University of Washington Press.

Hough, Walter

1918 "The Hopi Indian Collection in the United States National Museum." *Proceed-*

ings of the United States National Museum, vol. 54, no. 2231, 235–96.

Hudson, John W.
1893 "Pomo Basket Makers." *Overland Monthly*, 2d ser., 21(126):561–78.
1897 "Pomo Wampum Makers: An Aboriginal Double Standard." *Overland Monthly*, 2d ser., 30(176):101–8.

Jacknis, Ira
1985 "Franz Boas and Exhibits: On the Limitations of the Museum Method of Anthropology." In *Objects and Others: Essays on Museums and Material Culture*, ed. by George W. Stocking, 75–111. History of Anthropology, vol. 3. Madison: University of Wisconsin.

Jackson, Helen Hunt
1881 *A Century of Dishonor: A Sketch of the United States Government's Dealings with Some of the North American Tribes*. New York: Harper and Brothers.

Jonaitis, Aldona
1988 *From the Land of the Totem Poles: The Northwest Coast Indian Art Collection at the American Museum of Natural History*. New York: American Museum of Natural History; Seattle: University of Washington Press.

Kaemlein, Wilma R.
1967 *An Inventory of Southwestern American Indian Specimens in European Museums*. Tucson: Arizona State Museum.

Kent, Kate Peck
1983a *Prehistoric Textiles of the Southwest*. School of American Research Southwest Indian Art Series. Santa Fe: School of American Research; Albuquerque: University of New Mexico Press.
1983b *Pueblo Indian Textiles: A Living Tradition*. Santa Fe: School of American Research Press.
1983c "Spanish, Navajo, or Pueblo?: A Guide to the Identification of Nineteenth-Century Southwestern Textiles." In *Hispanic Arts and Ethnohistory*, ed. by Marta Weigle, 135–67. Santa Fe: Ancient City Press.
1985 *Navajo Weaving: Three Centuries of Change*. Santa Fe: School of American Research Press.

Kessel, John L.
1980 "Zuni." In *The Missions of New Mexico Since 1776*, 206–14. Albuquerque: University of New Mexico Press.

Kluckhohn, Clyde, W. W. Hill, and Lucy W. Kluckhohn
1971 *Navaho Material Culture*. Cambridge, Mass.: Belknap Press of Harvard University Press.

Kroeber, Alfred L.
1925 *Handbook of the Indians of California*. Bureau of American Ethnology Bulletin no. 78. Washington, D.C.
1929 "Pliny Earle Goddard." *American Anthropologist* 31(1):1–8.

La Flesche, Francis
1920 "The Symbolic Man of the Osage Tribe." *Art and Archaeology* 9:68–72.
1921 *The Osage Tribe*. Part One: "Rite of the Chiefs; Sayings of the Ancient Men." 36th Annual Report of the Bureau of American Ethnology for the Years 1914–15, 43–597.

Washington, D.C.
1925 *The Osage Tribe*. Part Two: "The Rite of Vigil." 39th Annual Report of the Bureau of American Ethnology for the Years 1917–18, 37–630. Washington, D.C.
1930 *The Osage Tribe*. Part Three: "Two Versions of the Child-Naming Rite." 43d Annual Report of the Bureau of American Ethnology for the Years 1927–28, 529–833. Washington, D.C.
1939 *War Ceremony and Peace Ceremony of the Osage Indians*. Bureau of American Ethnology Bulletin no. 101. Washington, D.C.

Laidlaw, Christinel Wallace
1988 "The Metropolitan Museum of Art and Modern Design: 1917–1929." *The Journal of Decorative and Propaganda Arts* 8:88–103.

Lambert, Marjorie
1981 "Spanish Influences on the Pottery of San Jose de los Jemez and Guisewa, Jemez State Monument (LA 679), Jemez Springs, New Mexico." In *Collected Papers in Honor of Erik Kellerman Reed*, ed. by Albert H. Schroeder, 215–36. Papers of the Archaeological Society of New Mexico, no. 6. Albuquerque.

Leach, William
1989 "Strategists of Display and the Production of Desire." In *Consuming Visions: Accumulation and Display of Goods in America, 1880–1920*, ed. by Simon J. Bronner, 99–132. New York: W.W. Norton, for The Henry Francis du Pont Winterthur Museum.

Liberty, Margot
1978a "Francis La Flesche: The Osage Odyssey." In *American Indian Intellectuals*, ed. by Margot Liberty, 44–59. Saint Paul: West Publishing Co.
1978b "Native American Informants: The Contribution of Francis La Flesche." In *American Anthropology: The Early Years*, ed. by John V. Murra, 99–110. Saint Paul: West Publishing Co.

Loeb, Edwin M.
1926 *Pomo Folkways*. In University of California Publications in American Archaeology and Ethnology, vol. 19, no. 2. Berkeley.

Low, Jean
1977 "George Thornton Emmons." *The Alaska Journal* 7(1):2–11.
1982 "Dr. Charles Frederick Newcombe." *The Beaver* 312(4):32–39.

Lurie, Nancy Oestreich
1983 *A Special Style: The Milwaukee Public Museum, 1882–1982*. Milwaukee: Milwaukee Public Museum.

MacDonald, George
1983 *Haida Monumental Art*. Vancouver, B.C.: University of British Columbia Press.

McLendon, Sally
1977 *Ethnographic and Historical Sketch of the Eastern Pomo and their Neighbors, the Southeastern Pomo*. Contributions of the University of California Archaeological Research Facility, no. 37. Berkeley.
1981 "Preparing Museum Collections for Use as Primary Data in Ethnographic Research." In *The Research Potential of Anthropological Museum Collections*, ed. by Anne-Marie Cantwell, J. B. Griffen, and

Nan A. Rothschild. Annals of the New York Academy of Sciences, vol. 376, 201–27. New York.

McLendon, Sally, and Brenda Holland
1979 "The Basketmaker: The Pomoans of California." In *The Ancestors: Native Artisans of the Americas*, ed. by Anna C. Roosevelt and James G. E. Smith, 103–29. Exh. cat. New York: Museum of the American Indian.

McLendon, Sally, and Michael J. Lowy
1978 "Eastern Pomo and Southeastern Pomo." In *California*, ed. by Robert F. Heizer, 306–23. Vol. 8, *Handbook of North American Indians*, ed. by William C. Sturtevant. Washington, D.C.: Smithsonian Institution.

McLendon, Sally, and Robert L. Oswalt
1978 "Pomo: Introduction." In *California*, ed. by Robert F. Heizer, 274–88. Vol. 8, *Handbook of North American Indians*, ed. by William C. Sturtevant. Washington, D.C.: Smithsonian Institution.

McNitt, Frank
1962 *The Indian Traders*. Norman, Okla.: University of Oklahoma Press.

Mark, Joan
1982 "Francis La Flesche: The American Indian as Anthropologist." *Isis* 73:497–510.
1988 *A Stranger in Her Native Land*. Lincoln, Nebr.: University of Nebraska Press.

Mason, Otis T.
1889 *The Ray Collection from the Hupa Reservation*. Annual Report of the Smithsonian Institution for 1886, part 1, 205–39. Washington, D.C.
1904 "Aboriginal American Basketry: Studies in a Textile Art without Machinery." In Report of the U.S. National Museum, Smithsonian Institution, for the Year 1902, 171–548. Washington, D.C.

Mathews, John Joseph
1961 *The Osages: Children of the Middle Waters*. Norman, Okla.: University of Oklahoma Press.

Matthews, Washington
1887 *The Mountain Chant: A Navaho Ceremony*. 5th Annual Report of the Bureau of American Ethnology for the Years 1883–84, 379–467. Washington, D.C.
1902 *The Night Chant: A Navaho Ceremony*. Memoirs of the American Museum of Natural History, vol. 6. New York.

Maurer, Evan
1979 "A Mimbres Altar Group." *Bulletin of The Art Institute of Chicago* 73(4):2–6.

Merriam, C. Hart
1955 *Studies of California Indians*. Berkeley: University of California Press.

Moneta, Daniela P., ed.
1985 *Chas. F. Lummis: The Centennial Exhibition Commemorating His Tramp Across the Continent*. Exh. cat. Los Angeles: Southwest Museum.

O'Neale, Lila M.
1932 *Yurok-Karok Basket Weavers*. University of California Publications in American Archaeology and Ethnology, vol. 32, no. 1. Berkeley.

Ortiz, Alfonso, ed.
1979 *Southwest*. Vol. 9, *Handbook of North American Indians*, ed. by William C. Sturte-

vant. Washington, D.C.: Smithsonian Institution.
1983 *Southwest*. Vol. 10, *Handbook of North American Indians*, ed. by William C. Sturtevant. Washington D.C.: Smithsonian Institution.

Pandey, Triloki Nath
1972 "Anthropologists at Zuni." *Proceedings of the American Philosophical Society* 116(4):321–37.

Paper, Jordan
1988 *Offering Smoke: The Sacred Pipe and Native American Religion.* Moscow, Idaho: University of Idaho Press.

Parezo, Nancy J.
1986 "Now Is the Time to Collect." *Masterkey* 59(4):11–18.

Parsons, Elsie C.
1925 *The Pueblo of Jemez.* Papers on the Phillips Academy Southwestern Expedition, no. 3. New Haven: Published for the Phillips Academy by Yale University Press.

Peri, David W.
1987 "The Game of Staves." *News from Native California* 1(3):5–7.

Peri, David W., and Scott M. Patterson
1976 "The Basket Is in the Roots, That's Where It Begins." *Journal of California Anthropology* 3:17–32.

Peterson, Harold L.
1965 *American Indian Tomahawks.* Contributions from the Museum of the American Indian, Heye Foundation, vol. 19. New York.

Powers, Stephen
1877 *Tribes of California.* Contributions to North American Ethnology, vol. 3. Washington, D.C.: U.S. Geographical and Geological Survey of the Rocky Mountain Region.

Purdy, Carl
1902 *Pomo Indian Baskets and Their Makers.* Los Angeles: C. M. Davis Co. Press. (Reprinted, Ukiah, Calif.: Mendocino County Historical Society, n.d.)

Riley, Robert
1966 "The Design Laboratory." *The Brooklyn Museum Annual for 1965–1966,* no. 7:100–117.

Ritzenthaler, Robert, and Lee Parsons, eds.
1966 *Masks of the Northwest Coast: The Samuel A. Barrett Collection.* Milwaukee: Milwaukee Public Museum.

Roth, Leland M.
1988 "McKim, Mead, & White and The Brooklyn Museum, 1893–1934." In *A New Brooklyn Museum: The Master Plan Competition,* ed. by Joan Darragh, 26–51. Brooklyn: The Brooklyn Museum.

Rydell, Robert W.
1984 *All the World's a Fair: Visions of Empire at American International Expositions, 1876–1916.* Chicago: University of Chicago Press.

Skinner, Alanson
1923 "Observations on the Ethnology of the Sauk Indians." *Bulletin of the Milwaukee Public Museum* 5(1):–157.

Smith, Watson, Richard S. Woodbury, and Nathalie F. S. Woodbury
1966 *The Excavation of Hawikuh by Frederick Webb Hodge.* Contributions from the Museum of the American Indian, Heye Foundation, vol. 20. New York.

Spinden, Herbert J.
1919 "Creating a National Art." *The American Museum Journal* 19:622–54.

Stephen, Alexander M.
1936 *Hopi Journal of Alexander M. Stephen.* Ed. by Elsie Clews Parsons. Columbia University Contributions to Anthropology, vol. 23. New York.

Stevenson, James
1883 *Illustrated Catalogue of Collections Obtained from Indians of New Mexico and Arizona in 1879.* 2d Annual Report of the Bureau of American Ethnology for the Years 1880–81, 307–422. Washington, D.C.
1884 *Illustrated Catalogue of Collections Obtained from the Pueblos of Zuni, New Mexico and Walpi, Arizona in 1881.* 3d Annual Report of the Bureau of American Ethnology for the years 1881-82, 511–94. Washington, D.C.

Stevenson, Matilda Coxe
1904 *The Zuni Indians: Their Mythology, Esoteric Fraternities, and Ceremonies.* 23d Annual Report of the Bureau of American Ethnology for the Years 1901–2, 1–634. Washington, D.C.
[1879] 1987 "Dress and Adornment of the Pueblo Indians," ed. by Richard V. N. Ahlstrom and Nancy J. Parezo. *The Kiva* 52(4):275–312.

Stocking, George W., Jr.
1976 "Ideas and Institutions in American Anthropology: Thoughts Toward a History of the Interwar Years." In *Selected Papers from the American Anthropologist, 1921–1945,* ed by G.W. Stocking, 1–53. Washington, D.C.: American Anthropological Association.

Taylor, Lonn, and Dessa Bokides
1987 *New Mexican Furniture, 1600–1940: The Origins, Survival, and Revival of Furniture Making in the Hispanic Southwest.* Santa Fe: Museum of New Mexico Press.

Thoresen, Timothy H. H.
1975 "Paying the Piper and Calling the Tune: The Beginnings of Academic Anthropology in California." *Journal of the History of the Behavioral Sciences* 11(3):257–75.

Truman, Ben C.
1893 *History of the World's Fair.* Philadelphia: Mammouth Publishing Co.

Turnbaugh, Sarah Peabody, and William A. Turnbaugh
1986 *Indian Baskets.* West Chester, Pa.: Schiffer Publishing Ltd.

Voth, H. R.
1912 *The Oraibi Marau Ceremony.* Field Museum of Natural History Anthropological Series, vol. 11, no. 1, 1–88. Chicago.

Walcott, Ronald
1981 "Francis La Flesche, American Indian Scholar." *Folklife Center News* 4(1):9–11.

Walker Art Center, and the Minneapolis Institute of Arts
1972 *American Indian Art: Form and Tradition.* Exh. cat. New York: E. P. Dutton.

Warburg, Aby
1939 "A Lecture on Serpent Ritual." *Journal of the Warburg Institute* 2(4):277–92.

Washburn, Dorothy
1984 "Dealers and Collectors of Indian Baskets at the Turn of the Century in California: Their Effect on the Ethnographic Sample." *Empirical Studies of the Arts* 2(1):51–74.

Washburn, Wilcomb, ed.
1988 *History of Indian-White Relations.* Vol. 4, *Handbook of North American Indians,* ed. by William C. Sturtevant. Washington, D.C.: Smithsonian Institution.

West, George A., and Samuel Barrett
1934 *Tobacco, Pipes and Smoking Customs of the American Indians.* Bulletin of the Milwaukee Public Museum, vol. 17. Milwaukee.

Whiteford, Andrew H.
1978 "Tapestry-Twined Bags, Osage Bags and Others." *American Indian Art Magazine* 3(2):32–39, 92.
1988 *Southwestern Indian Baskets: Their History and Their Makers.* Santa Fe: School of American Research Press.

Wiegers, Robert P.
1988 "A Proposal for Indian Slave Trading in the Mississippi Valley and Its Impact on the Osage." *Plains Anthropologist* 33(120):187–202.

Wilcox, U. Vincent
1978 "The Museum of the American Indian, Heye Foundation." *American Indian Art Magazine* 3(2):40–49, 78–79, 81.

Willensky, Elliot
1986 *When Brooklyn Was the World, 1920–1957.* New York: Harmony Books.

Winther, Barbara
1985 "Pomo Banded Baskets and Their Dau Marks." *American Indian Art Magazine* 10(4):50–57.

Wissler, Clark
1915a "In the Home of the Hopi Indians." *The American Museum Journal* 15(7):343–47.
1915b "Explorations in the Southwest by the American Museum." *The American Museum Journal* 15(8):395–98.

Wright, Barton
1979 *Hopi Material Culture: Artifacts Gathered by H.R. Voth in the Fred Harvey Collection.* Flagstaff: Northland Press.
1985 *Kachinas of the Zuni.* Flagstaff: Northland Press.

Wyman, Leland C.
1983 *Southwest Indian Drypainting.* School of American Research Southwest Indian Art Series. Santa Fe: School of American Research; Albuquerque: University of New Mexico Press.

INDEX

(Page numbers in *italics* indicate illustrations.)

Aaronson, A., 239, 250, 274, 312 n. 9
Abel-Vidor, Suzanne, 312 n. 39
Acoma, New Mexico, 49, 130
Alaska-Yukon-Pacific Exposition, Seattle, 241
Albert, Paul, 297
Albuquerque, New Mexico, 156, 204
Alcott, Mr., 114
Alert Bay, British Columbia, 259, 261, 270
Allantown, Arizona, 68
Allice, Thomas H., 240
American Anthropological Association, 15, 43
American Association for the Advancement of
 Science, 15
American Folk-Lore Society, 15, 17
American Museum of Natural History, New
 York, 21–22, 34, 37, 41, 42, 162, 223, 241, 312
 nn. 3 and 19
American Philosophical Society, Philadelphia, 15
Anasazi, 64, 66–68, 90, 125
Ann (Maidu), 220, 221
Antelope House, Arizona, 64
Apache, 47, 139, 158; Western Apache, 139
Arcata, California, 163, *163*, 181, *182*, 184
Asbel, Mary, *see* Azbill, Mary
Athapaskans, 236, 243
Augustine, Joe, 193
Azbill, Henry, 230
Azbill, Mary, 165, 215, 216–20, 230, 231, 311 n.
 14, 312 n. 35
Aztecs, 148

Bacon Rind, 284, 288, *289*, 303
BAE, *see* Bureau of American Ethnology
Bandelier, Adolf F., 310 n. 4
Barber, Ann, 166, 216–17, 223, 230–31
Barber, George, 166, 225–29
Barkley Sound, British Columbia, 239, 240
Barrett, Samuel, 41, 168, 169, 291
Barth, *see* Ling and Barth
Bateman, Jim, 212, 213, 219
Bates, Craig, 215, 218, 219, 221 n. 1, 223 n. 2,
 225, 226, 229
Beatty, Joe, 170, 210
Beautiful Mountain, New Mexico, 90, 90 n. 1
Becher Bay, British Columbia, 254
Bechtol, Leonard, 312 n. 39
Bella Bella, British Columbia, 35, 239, 258, 260,
 265, 276
Benson, Mary Knight, 171
Benson, William, 171–72, *172*, 174, 190–92, 197,
 199, 211 n. 3, 231, 312 nn. 26, 32, and 33
Bidwell, Annie Kennedy, 165, 166, 231, 311 n. 13
Bidwell, John, 165
Big Heart, Oklahoma, 285
Big Valley, California, 169
Bird Creek, Oklahoma, 294
Black Horse, 54, *55*
Black Rock, New Mexico, 57
Boas, Franz, 18, 43, 241, 312 nn. 3 and 19
Bobitza, *see* Naspee, George
Boxer, John, 212
Brinton, Daniel, 15, 24, 26
British Columbia Provincial Museum, Victoria,
 234, 239, 251
British Museum, London, 192, 192 nn. 5 and 7
Brizard, Alexander, 163, 164, 181, 184
Broom John, 186, 195
Broom John, Mrs., 186, 191
Brown, Sam, 178–79
Bucknell, Jim, 188, 190
Bucknell family, 218
Bureau of American Ethnology, Washington,
 D.C., 16, 22, 34, 46, 49, 143, 149 n. 1, *172*, 282,
 309 n. 53, 311 n. 8
Burris, Jim, 188
Burton, Charles E., 146
Butte County, California, 167

Cache Creek, California, 169
California, University of, Berkeley, 162, 311 n. 9
California State Indian Museum, Sacramento,
 311 n. 2
Canyon de Chelly, Arizona, 34, 47, 48, *48*, 49,
 64, 67, 73, 74
Canyon del Muerto, Arizona, 48, 52, 64–65
Canyon Tom, 164, 176
Capelle Bar, California, 183
Capelle George, 183
Capitan (Zuni), 124
Captain Jack, 174
Captain John, *160*, 164
Captain Tack, 211, 223
Carpenter, Aurelius O., 197; photograph by, *168*
Carpenter, Grace, *see* Hudson, Grace Carpenter
Carpenter, Helen M., 208
Catlin, George, 20
Centennial Exposition, Philadelphia, 20, 21, 241
Central Pomo, *see* Pomo
Chapman, Hardy, 215, 221
Chaves, Francisco, 86
Chemainus, British Columbia, 256
Cheyenne, 298–99, 304
Chicago World's Fair, 15–16, 17, 33, 105, 237,
 240–41
Chico, California, 164–65, 166–67, *172*, 175, 215–
 17, 219–20, 221, 223–31, 311 n. 13, 312 n. 35
Chilliwack, British Columbia, 239–40, 244, 256
Chinese community, Philadelphia, 14–15, 308
 n. 5
Chinle, Arizona, 34, 48, 51, *52*, 52, 64, 70–71,
 73, 74–78, 80, 85, 88, 93, 94
Chin Lee, Arizona, *see* Chinle, Arizona
Chocteau, Edward, 303
Chublock, Mr., 85
Chuyati (Zuni), 138
Cincinnati Art Museum, 310 n. 97
Clayoquot, British Columbia, 252
Clear Lake, California, 34, 169, 186, 187, 190, 194,
 208, 218
Cliff Dwellers, 32, 310 n. 96; *see also* Anasazi
Cochiti, New Mexico, 49, *49*, 86, 133, 154, 309
 n. 27
Columbian Historical Exposition, Madrid, 15
Comanche, 303 n. 1, 304
Contemporary Club, Philadelphia, 15
Cooper, Mrs., 220, 221
Cooper, Emma, 221 n. 1
Corn Mountain, New Mexico, 119
Cosgrove, B. C., and Malpas, 196–97
Cottonwood Pass, Arizona, 94
Cowichan, British Columbia, 236
Cow's Head, New Mexico, *24*
Coyote Valley, California, 169, 208
Crane, Billy, 124
Crawford, Morris de Camp, 41, 42, 43, 313 n. 18
Cronemeyer and Schember, 68
Cuba, 18, 308 n. 24
Culin, Alice Mumford Roberts, *20*, 38, 39, 43
Culin, John, 14
Curtis, Edward, 74
Cushing, Frank Hamilton, 16–17, *18*, *19*, *20*, 21,
 24, 26, 33, 35, 38, 45–46, 56–63, 70, 98, 107,
 122, 126, 137, 143–44, 308 n. 12, 309 n. 31

Dana, John Cotton, 42, 310 n. 91
Davis, Lee, 183 n. 1
Day, Charles L., 48–49, 51, 52, *52*, *53*, *54*, 64, 65,
 70, 71, 72, 73, 74, 77, 88, 90, 92–94
Day, Sam, 64–65
Deane, Charles, 48
Deans, James, 240
Denison, John, 174
Denver Art Museum, 41, 192, 270
Dick, Jeff, *166*, 204
Dick, Joseppa, *166*, 204
Dixon, Roland, 162, 213, 223
Doctor Joe, 209
Dog Bite, 68
Dog Thief, 284, 303, 304
Dorsey, George A., 13, 17–18, 29, 33, 35, 36, 47,
 170, 233–34, 241, 309 n. 3, 311 n. 24, 312 nn. 3
 and 12, 313 n. 10

Double Cave Ruin, Arizona, 64
Douglas, Frederic, 303 n. 1
Dumarest, Michael, *26*, 33, *49*, 154, 309 n. 27,
 311 n. 18
Dumarest, Noel, 49, *49*, 154, 309 n. 27, 311 n. 18

Eakins, Thomas, 15, *18*, 35, 43, 62, 63, 144, 308
 n. 12
Eastern Association on Indian Affairs, 43
Eastern Pomo, *see* Pomo
Ecool, British Columbia, *232*, 240
Ehatisaht, *see* Nootka
Elsie (Pomo), *see* Lake, Elsie
Emmons, George Thornton, 240–41, 249, 278
Empress Hotel, Victoria, 309 n. 42
Ericson, Augustus W., photographs by, *160*, *163*
Ernst, Max, *236*
Esquimalt, British Columbia, 239

Farny, Henry F., 144 n. 4
Faris, James, 95 nn. 3, 4, and 6
Fenellosa, Ernest, 308 n. 5
Ferry Museum, Tacoma, 238
Fewkes, Jesse W., 48, 69, 74 n. 1, 149 n. 1
Field Columbian Museum, Chicago, 13, 17, 22,
 29, *30*, 33, 36, 41, 47, 62, 95 n. 1, 130, 162, 163,
 168, 170, 171, 188, 233, 234, 240, 241, 273, 311
 n. 24, 312 nn. 5 and 19
Field Museum of Natural History, *see* Field
 Columbian Museum
First Mesa, Arizona, 34, 69, 146–50, 152
Fisherman Jim, 174
Foley, Joe B., *25*, 66
Foster, Mr., 198
Francisco, Mary, *173*, 201 n. 1, 207
Francisco, Tony, 201 n. 1
Fraser River, British Columbia, 239, 246, 256, 312
 n. 9

Gachupin, Alcario, 158
Galante, Gary, 299 nn. 1 and 3, 303 n. 1, 304 n. 2
Gallup, New Mexico, 23, 33, 56, 62, 66, 109, 124–
 25, 154, 311 n. 30
Ganado, Arizona, 83, 92, 93, 134
Gates, Mrs., 147 n. 2
Gist, Frank, 181, 182
Goddard, Pliny, 164, 176, 179, 184, 311 nn. 9
 and 10
Golden Gate Park Museum, San Francisco, 311
 n. 2
Goode, George Brown, 29
Goose (Pomo), *173*, 174, 190, 193, 195, 197, 209
Graham, Douglas, 26, 56, 57, 63
Graham, Nick, 26, 57–60, *61*, 103, 122, 124, 125,
 133, 136, 138, 141
Grand Central Palace, New York, 310
Gran Quivira, New Mexico, 48
Graves, Eliot, 172
Graves, Nancy, 186, 194–95, 206, 218
Graves, Penn (Pennsylvania Graves), 172–73,
 174, 187, 205, 206, 209, 312 n. 35
Graves, Susana Bucknell, 172, 187, 194–95, 205–
 6, 218
Greenville, California, 167, 221
Groll, Albert L., 148 n.1
Guam, New Mexico, 124
Gumey, George, 181, 182, 183
Gunn, John M., 155
Gwasila, *see* Kwakiutl

Hagenbeck, Carl, 240
Haida, 31, 34, 37, 236, 237, 238, 239, 247–49,
 250–54, 262, 268, 273–74, 278, 309 n. 39;
 Northern Haida, 266
Haile, Berard, 53, 59; 86, 92, 95
Hall, Robert C., 311 n. 2
Hano, Arizona, 148, 152
Harness, Tom, 212
Harrison Hot Springs, British Columbia, 240
Hartman, C. S., 167
Harvard University, *see* Peabody Museum
Harvey Hotel, Albuquerque, 204
Hashke Yazhe, *57*
Ha-ta-tsi Ya-zhi, *see* Little Singer

Hawikuh, New Mexico, 58, 63, 99, 100, 134
Hazzard, C. D., 167
Healy, A. Augustus, 49
Henshaw, Henry W., photographs by, *163, 166, 172*
Hesquiat, *see* Nootka
Heye, George, 238
Hillerman, Tony, 310 n. 4
Hillers, John K., 50
Hohokam, 67
Holbrook, Arizona, 82, 150
Holm, Bill, 244, 251, 254, 266, 270
Holmes, William H., 16, 33
Hom-he-wa-la (Osage), 307
Hominy, Oklahoma, 304
Hoopa, California, 163
Hoopa Valley, California, 163, 164, *166,* 176–79
Hoopa Valley Indian Reservation, California, *163*
Hooper, Franklin W., 18, 22, 48, 49, 69
Hope, British Columbia, 240
Hopi, *21, 34, 43, 46,* 47, 49, 62, 69, 71, 74, 82, 103, 130, 146–52
Hopi-Tewa, 147, 148
Hopland, California, 169, 173, 195, 211
Hubbell, J. Lorenzo, 54–55, 68, 83, 75, 92, 94, 134
Hudson, Grace Carpenter, 169, 170, 175, *175,* 202, 213
Hudson, John W. N., 161–62, 163, 164, 165, 168–70, *170, 171,* 173, 174, 186, 188–91, 196, 197, 198, 202, 203, 204, 208, 209, 210, 212–13, 311 nn. 10 and 24, 312 nn. 31, 33, and 39
Hughes, Sam, 197
Hughes, Mrs. Sam, 196–97
Hunter's Point, Arizona, *see* Red Rock, Arizona
Huntington, Archer M. and Collis P., 162
Hupa, 160, 162, 163–65, 176–81, 184, 208, 311 nn. 9 and 12

Isleta, New Mexico, 34, 148

Jacobsen, Fillip, 240
Jacobsen, Johan, 240
James, George Wharton, 162
Japan, 31, 239
Jarvis, Nathan Sturgis, 21
Jasha-a (Zuni), 134
Jefferson, Mike, 166
Jemez, New Mexico, 26, 49–50, *50,* 156–58
Jemez Hot Springs, New Mexico, 50, 157
Jemez River, New Mexico, 156
Jenny (Pomo), 196
Jesup North Pacific Expedition, 241
Johnsons, California, 182, 184
Jones, Billy, 74
Judd, James, 130
Judy, Herbert B., *13,* 34, *35,* 37, 66, 129, 142, *167,* 236, 309 n. 33, 311 n. 29
Juillard, Father, photograph by, *26*

Karok, 163, 181
Kaw, 301, 304
Kayang, British Columbia, 278
Keam's Canyon, Arizona, 69
Kelly, Mary, *see* Azbill, Mary
Kelseyville, California, 171
Kennedy, Annie, *see* Bidwell, Annie Kennedy
Kenworthy, Andrew, *285*
Kiowa, *19,* 303 n. 1
Kitkatla, British Columbia, 258
Klamath River, California, 163, *163,* 164, 165, 176, 181, 182, 183, 218
Klukwan, Alaska, 250
Knight, Henry, 208, 209
Knight Inlet, British Columbia, 249, 268, 278
Konkow, *see* Maidu
Kroeber, Alfred, 162, 164, 176, 309 n. 53
Kwakiutl, 35, 137, 236, 237, 238, 241, 249, 259, 261, 264, 270, 273, 274–78; Gwasila, 275; Nimpkish, 270; Northern Kwakiutl, 266; Tenaxtax, 268
Kyselka, Frank, 179

La Flesche, Francis, 282–91, *282,* 293, 297–301, 304, 307, 312 nn. 5 and 7
Lafonso, Holai, 165–66, 225
Laguna, New Mexico, 34, 49, 153, 155
Lake, Elsie, 202
Lake County, California, 171, 190
Lake Miwok, California, 208–9
Lakeport, California, 168, 188, 193, 199, 210, 212
Landsberg, Frederick, *237, 238,* 239, 243, 274, 312 nn. 8, 9, and 10
Laughing Doctor, 94
Lawrence (Osage), *288*
Ling, Reamer, 67, 68
Ling and Barth, 67
Little Singer, 33, 52–53, *53,* 70, 71, 73, 77, 83, 85
Little Wing, 298
Lomawiya (Hopi), 148
Los Angeles, California, 162
Louisiana Purchase Exposition, *see* Saint Louis World's Fair
Lower Lake, California, 168
Lukachukai Mountains, Arizona, 54
Lummis, Charles F., 68, 162

MacDonald, Natalie, *29*
McKim, Mead & White, 18
McLendon, Sally, 193 n. 2, 201 n. 1, 204 n. 2, 207, 212 n. 1, 213, 312 n. 36
Maidu, 162, 165–68, 211, 215–21, 311 nn. 6, 7, 11, 12, and 13; Konkow (Northwest Maidu), 165, 215, 217, 219, 311 n. 12; Mountain (Northeast Maidu), 165, 167, 219, 221, 231; Nisenan (Southern Maidu), 165; Northern Maidu, 162
Makah, 233
Ma-li-na (Zuni), 60, *62,* 126, 134 n. 1
Malpas, *see* Cosgrove, B. C., and Malpas
Manta (Zuni), 100, 101
Mariposan groups, *see* Yokuts
Mary (Hupa), 176, 178
Mason, Otis T., 21, 48, 161, 184, 192
Masset, British Columbia, 34, *234,* 254, 262, 273, 278
Matthews, J. R., 197
Matthews, Washington, 50–51, 93, 94, 95 n. 3
Maynard, Richard, photograph by, *234*
Meddaugh, O. E., photograph by, *174*
Mendocino County, California, 168, 171
Meredith, Henry Clarkson, 172, 174–75, 188, 199, 200, 210, 211, 218
Merriam, C. Hart, 162
Mesquakie, 292
Metropolitan Museum of Art, New York, 42, 310 n. 91
Michel, Charlie, *290,* 295, 313 n. 10
Miera y Pacheco, Bernardo, 143
Mikchopdo, California, 165, 216, 311 n. 13; *see also* Chico, California
Miktsopdo, *see* Mikchopdo
Miles, Leven, 301
Milwaukee Public Museum, 34, 41, 270, 291
Mimbres, 68–69
Mineral, Arizona, 68
Mishongnovi, Second Mesa, Arizona, *46,* 152
Mitchell, Culin, 175, *175,* 312 n. 39
Mitchell, Tom, 175, 212, 213 n. 3
Mochoopda, *see* Mikchopdo
Montzheimer, A., 95 n. 1
Mooney, James, 309 n. 53
Moore, J. B., 94
Morek, California, 181
Mountain Maidu (Northeast Maidu), *see* Maidu
Mummy Cave Ruin, Arizona, *47,* 49, 64, 65
Musée de l'Homme, Paris, *236*
Museum of the American Indian, New York, 41, 192 n. 5, 231 n. 1
Mushtown, California, 169

Nambe, Arizona, 148
Nancy (Pomo), 207
Nash Kash, 284, 292, 304, 306
Naspee, George, 149
Nass River, British Columbia, 266

National Merchandise Buyers Fair, New York, 310 n. 94
National Museum of Natural History, *see* United States National Museum
National Zoo, Washington, D.C., 192
Navajo, 22, 23, 32, 33, 35, 43, *44,* 47, 49, 50–55, 68, 70–97, 102, 103, 104, 118, 129, 130, 156, 158, 310 nn. 4 and 96, 311 nn. 20 and 38
Navarro River, California, 170
Neah Bay, Washington, 233
Newark Museum, 42
Newcombe, Charles F., 233–41, 244, 247–78, 312 nn. 5, 8, and 9; photographs by, *236, 237*
Newcombe, William, 266
Nicholson, Grace, 162, 167, 171–72, *172,* 235, 238
Nick (Zuni), *see* Graham, Nick
Night Chanter, 94
Nimpkish, *see* Kwakiutl
Nisenan, *see* Maidu
Nitinat, *see* Nootka
Nootka, 236–37, 238, 239, 243–44, 252, 259, 262, 272; Ehatisaht, 237, 243–44; Hesquiat, 237, 244; Nitinat, 262; Ohiat, 239
Nootka Sound, British Columbia, 262
North Bend, British Columbia, 254
Northern California Indian Association, 199
Northern Haida, *see* Haida
Northern Kwakiutl, *see* Kwakiutl
Northern Maidu, *see* Maidu
Northern Pomo, *see* Pomo
Numismatic and Antiquarian Society, Philadelphia, 15
Nutria, New Mexico, 56
Nuu-chah-nulth, *see* Nootka

Oakland Museum, 311 n. 2
Ojo Caliente, New Mexico, 56, 107, 122, 123, 130
Old Molly (Maidu), *167*
Omaha, 282, 304
Oriental Club, Philadelphia, 15
Orleans, California, 163, 181
Oroville, California, 167
Osage, 23, 281–307
Osage Village, Oklahoma, 292, 295–307
Ostermann, Father Leopold, 71, 94
Oto, 298, 304
Owen, Samuel E., 66
Oymutnee, *see* Amanda Wilson

Pabetsa, George, 147, 148, 149
Paiute, 92, 139, 158
Palin, Miss, 114
Panama-Pacific Exposition, San Francisco, 221
Pan-American Exposition, Buffalo, 38
Parsons, Elsie Clews, 147 n. 2, 158, 311 n. 18
Pasadena, California, 162, 171
Pasaina, Percy, 146, 147 n. 2
Patwin, 169
Pawhuska, Oklahoma, 282, 283, *284,* 291, 293
Pawnee, 303, 304
Peabody Museum, Harvard University, 29, 32, 35, 192 n. 5, 237, 291
Pekwan, California, 182–83
Pengraves, William, *see* Graves, Penn
Pennsylvania, Museum of the University of, Philadelphia, 13, 15, 17, 18, 19, 23, 38, 60, 70, 144, 163, 233, 237
Pennsylvania Academy of the Fine Arts, Philadelphia, 15
Perea, New Mexico, 157
Pescado, New Mexico, 56
Philadelphia, Pennsylvania, 13–18, 19, 20, 21, 30, 43, 63
Piney (Maidu), *167*
Pinoleville, California, 169, 196, 210, 213 n. 2, 218
Pipkin, Emmet, 58
Pitkina, *see* Tinabi
Pit River, California, 167
Pitt Rivers Museum, Oxford, 102
Pitts, George, 296, 298
Plumas County, California, 167
Pomaho (Maidu), 231

Pomo, 31, 35, 43, 161, 162, 164, 166, *167*, 168–75, 178, 186–213, 218, 225, 230, 311 n. 6; Central Pomo, *163, 168,* 169, 172, 211, 311 n. 20; Eastern Pomo, *165,* 169, 171, 172, 173, 174, 175, 186, 210 n. 3, 211; Northern Pomo, 169, 173, 174, 196; Southeastern Pomo, 169, 208; Tsetum Poma, 196
Ponca, 298, 303
Portland, Oregon, 233
Potter Valley, California, 169, 173, 188, 196, 197, 202, 211
Powell, John Wesley, 16
Powers, Stephen, 161
Pratt Institute, New York, *29*
Prattville, California, 167
Preacher, Billy, 166, 211, 223
Price, Tom, 251–52
Prospect, Arizona, 67
Pryor, Mrs. William, 283, 292
Pryor, William, 303, 313 n. 10
Purdy, Carl, 162, 168, 188
Putnam, Frederic Ward, 29, 237–38

Queen Charlotte Islands, British Columbia, 34, *234,* 262, 274
Quincy, California, *167*
Quolstitsas (Kwakiutl), 275

Rainbow House, *29, 36,* 37–41, 43, 310 n. 67
Read, Helen Applegate, 40–41
Red Corn, 295
Red Corn, Mrs., 283
Red Eagle, *285,* 293
Red Rock, Arizona, *25,* 66, 86
Red Round Rock, Arizona, *see* Red Rock, Arizona
Redwood Valley, California, 169, 209
Riggs, C. W., 48, *48,* 68
Rio Grande Pueblos, New Mexico, 31, 133
Roberts, Alice Mumford, *see* Culin, Alice Mumford Roberts
Roddy, T. R., 281, 312 n. 1, 313 n. 8
Round Rock, Arizona, 84, 90, 92
Royal British Columbia Museum, Victoria, *see* British Columbia Provincial Museum
Ruby Creek, British Columbia, 240

Sacramento Valley, California, 165
Sahe (Osage), *286,* 287, 297, 299
Saint Alice Hotel, Harrison Hot Springs, British Columbia, 240
Saint Johns, Arizona, 67, 68
Saint Louis World's Fair, 171
Saint Michaels, Arizona, *44, 51, 53, 53, 56, 57, 58,* 66, 69, 71, 79, 81, 84, 86, 92–94, 311 n. 30
Salish, 236–37, 238, 239–40, 244–45, 254, 256; Songhees, 237, 239
Salmagundi Club, New York, 15, 144
Sanders, New Mexico, 68
San Felipe, New Mexico, 135, 154
Santa Clara, New Mexico, 156
Santo Domingo, New Mexico, 135, 154
Saucy Calf, *280,* 284–89, *289,* 297, 298 n. 1, 307, 313 nn. 11 and 13
Sauk, 292
Schember, *see* Cronemeyer and Schember
Schieren, Charles, 48
Schwemberger, Simeon, 54, 69, 311 nn. 20 and 30; photographs by, *24, 35, 44, 51, 53, 54, 56, 57*
Scorse, Harry, 82
Seattle, Washington, 233
Second Mesa, Arizona, *21,* 152
Seowtewa, Alex, 143
Shakes (Tlingit), 250
Shan Paktah, 176, 181
Shanel, *see* Pomo, Central Pomo
Sharp, Joseph Henry, 313 n. 16
Shasta, 162
Shields, Ed de, 189
Shields, J. M., 157
Sichomovi, Arizona, 74 n. 1, 148; *see also* First Mesa, Arizona

Skau-kail, British Columbia, 240, 244, 256
Skeat (Navajo), 101
Skidegate, British Columbia, 247–49, 250, 251–52, 254, 268, 274
Smith Inlet, British Columbia, *236, 237,* 275
Smithsonian Institution, Washington, D.C., 33, 43, 69, 143, 192 nn. 2, 5, and 7, 213 n. 3, 313 nn. 8 and 9; *see also* United States National Museum
Somes Bar, California, 163
Songhees, *see* Salish
Southeastern Pomo, *see* Pomo
Southwest Museum, Los Angeles, 68
Speech Man, *see* Tsaigi, Harry
Spinden, Herbert, 42, 209, 218
Stadthagen, H., 239
Stephen, Alexander M., 148, 149
Stevenson, James, 57, 95 n. 3, *102,* 104, 118, 141, 143
Stevenson, John, 210–11
Stevenson, Matilda Coxe, 57, 60, 102, 112, 128, 130, 137, 144
Strike Axe, 294
Stutzer, Herman, 241, 278
Sulphur Bank, California, 201, 208
Sulphur Bank Tony, 169, 201
Supass, Billy, 256
Supela, Harry, 148 n. 1
Swan, James G., 241

Tabira, New Mexico, *see* Gran Quivira, New Mexico
Tacoma, Washington, 233, 238
Taylorsville, California, 167, 221
Tenaxtax, *see* Kwakiutl
Thacker, Ed, *24*
Thompson River, British Columbia, 233
Tinabi (Hopi), 147
Tiwasmi (Hopi), 148
Tjiyoni (Navajo), 83
Tlingit, 236, 237, 240, 241, 243, 249, 250, 266
To-no-ko (Maidu), 231
Tony, Sam, *174,* 209–11
Towoyalnai, *see* Corn Mountain
Toya, José Reyes, 26, 158
Tozier, D. F., 238
Trinity River, California, 163, 164, 176, 181
Tsaigi, Harry, 94–95
Tschudy, Herbert B., *see* Judy, Herbert B.
Tsetum Poma, *see* Pomo
Tsimshian, 236, 241, 249, 258, 266
Tsinehe, *see* Zuni Dick
Tulare, *see* Yokuts
Tule River Indian Reservation, 163
Tumahka, *see* Graham, Nick
T'uwa (Haida), 278

Ukiah, California, 23, 162, 165, 168, *168,* 169, 170, 172, 187, 188–91, 192, 196–98, 201, 202, 208, 212, 311 nn. 6, 20, and 24
United States National Museum, Washington, D.C., 29, 38, 40–41, 48, 49, 161, 169, 184, 192, 241, 298, 309 n. 31; *see also* Smithsonian Institution
University Museum, *see* Pennsylvania, Museum of the University of, Philadelphia
Upper Lake, California, 165, *167,* 168, 169, 170, *172,* 173, 174, 186–87, 188, 190, 193–95, 199, 200–201, 203, 205, 206, 207, 209, 210, 212, 218, 230, 231, 309 n. 53, 311 n. 23
Ute, 92

Vancouver, British Columbia, 233, 239–40, 272, 312 n. 3
Vancouver Island, British Columbia, 236, 272
Vanderwagen, Andrew, 56, 60, *61,* 62, 100, 101, 105 n. 2, 107–18, 134, 144, 311 n. 20
Vélez de Escalante, 143
Vicente (Pomo), 193, 194, 200, 206, 209
Victoria, British Columbia, 35, 233–39, 243–44, 247–78, 309 n. 42
Victoria Memorial Museum, Ottawa, 312
Vroman, Adam C., 49, 311 n. 20; photograph by, *50*

Wagashi, Mrs. John, 292
Walpi, First Mesa, Arizona, 46
Wanamaker, John, 18, 38
Warburg, Aby, 46, 310 n. 6
Waring, T. A., 124–25
Washington, University of, Seattle, 241
Weber, Anselm, 69, 94, 311 n. 30
Weitchpec, California, 163, 176, 181
Welsh, Mr., 84, 90
West, George A., 291
Western Apache, *see* Apache
Wetzler Brothers, 150
White, Joe, 66, 86, 92
White Buffalo, *see* Roddy, T. R.
White House, Arizona, 64
Wichitas, 309 n. 53
Wilcomb, Charles P., 161, 207, 311 n. 2
Wilkin, Joe, 90
Williams, Charlie, 212, 213
Wilson, Amanda, 165–66, 215–16, 217, 220, 223
Wilson, Santa, 165
Winnebago, 291, 312 n. 1
Wittick, Ben, *59,* 311 n. 20; photographs by, *47, 52*
Woodward, Robert B., 278
World's Columbian Exposition, *see* Chicago World's Fair
Wynashi (Osage), 284, *288,* 298

Yale, British Columbia, 240, 246, 256
Yankton Sioux, 293
Yepa, Felipe, 158
Yokaya, California, *163, 166, 168,* 169, 170, 171, 175, 189, 191–92, 203–4, 207, 210, 212, 311 n. 20
Yokeye, California, *see* Yokaya, California
Yokuts, 162–63, 223, 311 n. 8
Yurok, 162, 163–65, 176, 181–85, 311 nn. 7 and 10

Zia, 156
Zuni, 16, 20, 22, 23, 26, 31, 32, 33, 34, 35, 37, 38, 39, 43, 45–46, 47, 49, 50, 56–63, 65, 74, 83, 98–144, 308 n. 12, 309 nn. 23 and 31, 311 nn. 20 and 38
Zuni Dick, 33, 57, 104

Photograph Credits

All illustrations from expedition reports and from The Brooklyn Museum Archives (Figs. 2, 7, 15, 19, 21, 23, 24, 27, 47, 50) were photographed by Patty Wallace. Any other photograph without a credit below is courtesy of the institution cited in the caption.

The maps were drawn by Frank Bruno and Frank Cagnetto.

Nos. 46, 114, 137, 247, 263: Patricia Layman Bazelon. All other illustrations of objects in the catalogue, and Figs. 3 and 6, by Justin Kerr.

Fig. 1
National Anthropological Archives, Smithsonian Institution, Portraits No. 19.
Fig. 4
The University Museum, University of Pennsylvania, neg. no. 139791.
Fig. 14
Courtesy, Field Museum of Natural History, neg. no. 23954, USA.
Fig. 16
Courtesy of the Grace Hudson Museum, Ukiah, Cal.
Fig. 17
The Brooklyn Museum, Library Collection, Lantern Slide Collection.
Fig. 22
Courtesy of the National Museum of the American Indian, Smithsonian Institution, N.Y.
Fig. 38
Photograph courtesy of St. Michaels Mission, St. Michaels, Arizona.
Fig. 55
Reproduction courtesy of the Grace Hudson Museum, Ukiah, Cal.
Fig. 64
National Anthropological Archives, Smithsonian Institution, neg. no. 4802.